BLACKWELL ANTHOLOGIES IN ART HISTORY

The *Blackwell Anthologies in Art History* series presents an unprecedented set of canonical and critical works in art history. Each volume in the series pairs previously published, classic essays with contemporary historiographical scholarship to offer a fresh perspective on a given period, style, or genre in art history. Modeling itself on the upper-division undergraduate art history curriculum in the English-speaking world and paying careful attention to the most beneficial way to teach art history in today's classroom setting, each volume offers ample pedagogical material created by expert volume editors – from substantive introductory essays and section overviews to illustrations and bibliographies. Taken together, the *Blackwell Anthologies in Art History* will be a complete reference devoted to the best that has been taught and written on a given subject or theme in art history.

1 *Post-Impressionism to World War II*, edited by Debbie Lewer
2 *Asian Art: An Anthology*, edited by Rebecca Brown and Deborah Hutton
3 *Sixteenth-century Italian Art*, edited by Michael Cole
4 *Architecture and Design in Europe and America, 1750–2000*, edited by Abigail Harrison Moore and Dorothy Rowe

Forthcoming

5 *Fifteenth-century Italian Art*, edited by Robert Maniura, Gabriele Neher, and Rupert Shepherd
6 *Late Antique, Medieval, and Mediterranean Art*, edited by Eva Hoffman

Post-Impressionism to World War II

Edited by *Debbie Lewer*

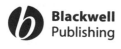

Blackwell
Publishing

Editorial material and organization © 2006 by Debbie Lewer

BLACKWELL PUBLISHING
350 Main Street, Malden, MA 02148-5020, USA
9600 Garsington Road, Oxford OX4 2DQ, UK
550 Swanston Street, Carlton, Victoria 3053, Australia

First published 2006 by Blackwell Publishing Ltd

1 2006

Library of Congress Cataloging-in-Publication Data

Post-Impressionism to World War II / edited by Debbie Lewer.
 p. cm.—(Blackwell anthologies in art history)
 Includes bibliographical references and index.
 ISBN-13: 978-1-4051-1153-9 (hard cover : alk. paper)
 ISBN-10: 1-4051-1153-4 (hard cover : alk. paper)
 ISBN-13: 978-1-4051-1152-2 (pbk. : alk. paper)
 ISBN-10: 1-4051-1152-6 (pbk. : alk. paper)
1. Art, European—20th century. 2. Art, European—19th century. I. Lewer, Debbie.
II. series

 N6758.P68 2005
 709'.03'4—dc22

 2004030885

A catalogue record for this title is available from the British Library.

Set in 10.5/13 pt Galliard
by SPI Publisher Services, Pondicherry, India
Printed and bound in the United Kingdom
by TJ International Ltd, Padstow, Cornwall

The publisher's policy is to use permanent paper from mills that operate a sustainable forestry policy, and which has been manufactured from pulp processed using acid-free and elementary chlorine-free practices. Furthermore, the publisher ensures that the text paper and cover board used have met acceptable environmental accreditation standards.

For further information on
Blackwell Publishing, visit our website:
www.blackwellpublishing.com

Contents

Series Editor's Preface viii
Preface ix
Acknowledgments xii

Part I: Programs and Manifestos
Introduction 1

1 Post-Impressionism 13
 Roger Fry

2 Why Are We Publishing a Journal? 18
 Ver Sacrum editorial

3 Notes of a Painter 21
 Henri Matisse

4 The Founding and Manifesto of Futurism 28
 F. T. Marinetti

5 Dada Manifesto 33
 Hugo Ball

6 The Work Ahead of Us 35
 Vladimir Tatlin

7 First Manifesto of Surrealism 36
 André Breton

8 Introduction to "New Objectivity": German Painting
 since Expressionism 50
 Gustav Hartlaub

Part II: Spirit and Subjectivity

Introduction 53

9 Gustave Moreau 69
 Joris-Karl Huysmans

10 Symbolism in Painting: Paul Gauguin 71
 G.-Albert Aurier

11 From *Abstraction and Empathy: A Contribution to the*
 Psychology of Style 79
 Wilhelm Worringer

12 From *On the Spiritual in Art* 93
 Wassily Kandinsky

13 Mystery and Creation 128
 Giorgio de Chirico

14 From Cubism and Futurism to Suprematism: The New
 Painterly Realism 130
 Kazimir Malevich

15 Neo-Plasticism: The General Principle of Plastic Equivalence 146
 Piet Mondrian

Part III: Mass Culture and Modernity

Introduction 155

16 The Mass Ornament 165
 Siegfried Kracauer

17 The Work of Art in the Age of Mechanical Reproduction 174
 Walter Benjamin

18 Avant-Garde and Kitsch 188
 Clement Greenberg

19 Modernism in the *Work* of Art 201
 Victor Burgin

20 The Hidden Dialectic: Avantgarde–Technology–Mass Culture 218
 Andreas Huyssen

Part IV: Politics and the Avant-Garde

Introduction 231

21 The Politics of the Avant-Garde 240
 Raymond Williams

22 From *Theory of the Avant-Garde* 253
 Peter Bürger

23 Jugglers' Fair Beneath the Gallows 265
 Ernst Bloch

24 Towards a Free Revolutionary Art 270
 André Breton, Diego Rivera, and Leon Trotsky

25 The Birth of Socialist Realism from the Spirit of the Russian
 Avant-Garde 274
 Boris Groys

Part V: Identity and Appropriation
Introduction 297

26 Going Native 304
 Abigail Solomon-Godeau

27 Virility and Domination in Early Twentieth-Century
 Vanguard Painting 320
 Carol Duncan

28 Men's Work? Masculinity and Modernism 337
 Lisa Tickner

29 What the Papers Say: Politics and Ideology in Picasso's
 Collages of 1912 349
 David Cottington

30 Dada as "Buffoonery and Requiem at the Same Time" 366
 Hanne Bergius

31 Surrealism: Fetishism's Job 381
 Dawn Ades

Index 400

Series Editor's Preface

The *Blackwell Anthologies in Art History* series is intended to bring together writing on a given subject from a broad historical and historiographic perspective. The aim of the volumes is to present key writings in the given subject area while at the same time challenging their canonical status through the inclusion of less well-used texts, including relevant contemporary documentation and commentaries, that present alternative interpretations or understandings of the period under review.

Post-Impressionism to World War II skillfully navigates one of the most complex and frequently taught periods in art history. The well-chosen selection of texts, some of which appear for the first time in English, brings together key primary sources and "canonical" criticism as well as more recent critical interventions from a range of methodological perspectives.

The thematic structure is extremely coherent and useful and the introductory essays to each of the five parts set out the historical and cultural origins of the texts as well as exploring the methodological approaches represented. Consequently, the anthology provides a valuable, stimulating resource for students and teachers alike and offers new perspectives on the established canon, as well as being a useable anthology of interpretations of modernism. As one of the initial volumes to be published it is an important standard-bearer for the series.

Dana Arnold
2004

Preface

This anthology is intended to provide teachers and undergraduate students with an accessible, stimulating, and diverse collection of texts to support study of the period in European art from Post-Impressionism to World War II. It brings together three main kinds of text, in thematic sections that have been composed – it should be emphasized – to be suggestive rather than prescriptive. First, there are primary historical sources. These include texts written by practitioners, such as the manifestos so central to avant-garde practice, and other statements and reflections by individual artists. They appear along with relevant examples of contemporary criticism, in Parts I and II, loosely thematized as "Programs and Manifestos" and "Spirit and Subjectivity," (though the manifesto genre also resurfaces in Part IV, "Politics and the Avant-Garde"). These texts have been selected to provide a "core" of sample material and are included because such primary sources are immensely valuable for the light they shed on the interplay between theory and practice in the period. They allow for readers to make comparisons between their content and between the different ways in which texts functioned (and continue to function, not least through anthologies such as this one) as part of the wider discourse of modernism and the avant-garde. They can be read in isolation, but it is especially hoped that their selection will encourage students to explore the interrelationships between different groups, tendencies, working methods, and concepts. Examples of productive comparisons in this manner might include reading F. T. Marinetti's Futurist manifesto, Hugo Ball's Dada manifesto, and Wassily Kandinsky's *Concerning the Spiritual in Art*. In this case they could be used, for example, to consider the relationship between Futurism, Dada, and Expressionism. Alternatively, in a more specialized context they might suggest focused investigation of the impact that the ideas of both Kandinsky and Marinetti had on Ball and the origins of Dada in Zurich. From other perspectives, Tatlin (Part I), Malevich (Part II), and Groys (Part IV) or Aurier (Part II) and Solomon-Godeau (Part V) would be similarly fruitful combinations that could well be used as a basis for seminar

discussion, and there are many other such possibilities offered by the materials collected here.

The second kind of text is of influential contemporary criticism. The inclusion of criticism by writers such as Roger Fry, G.-Albert Aurier, Wilhelm Worringer, Gustav Hartlaub, and Clement Greenberg allows students to consider the often decisive role of the critic in the development and affirmation of aesthetic terms and categories. Some of these writers – Worringer is a glaring case in point – are frankly unfashionable objects of art-historical investigation, but their influence has been very powerful in their historical contexts. Nonetheless, the categories and concepts such texts have produced are often strikingly arbitrary: Post-Impressionism, Symbolism, Expressionism, the so-called "New Objectivity" (*Neue Sachlichkeit*), and the "avant-garde" are among the most problematic. Meanings for the latter term, contested and promiscuous as it is through this period, are explored in several texts in this volume, providing, it is hoped, another level for discussion. The vexed nature of many such concepts is highlighted from a range of historical and critical perspectives by other texts in this volume.

The third kind of text in this anthology is the broadest and most heterogeneous. These essays are grouped, again, in thematic constellations intended not to impose divisions, but to suggest crosscurrents, in Parts III to V. Ranging in their analysis across visual culture, from painting and sculpture to film and photography, these essays date from the 1920s to the 1990s. Methodologically, they involve a range, and sometimes a combination, of Marxist, feminist, structuralist, psychoanalytical, and other theoretical procedures. The texts in Parts III and IV are specialized in their focus on (mainly) the visual culture of the 1920s and 1930s, but they have been selected to encourage informed consideration of key issues relevant to wider study of the period; first, of the dialectic between modern art practice and mass culture and, second, what constitutes the "avant-garde" in respect of cultural and state politics. Part V, finally, brings together a small selection of essays, which can be read either discretely as case studies, or as a means for considering different methodological approaches to the practice of art history. Included here are important, but now fairly well-rehearsed, considerations of issues of race and gender, for example. These have been selected for the clarity of their arguments' emphasis, along with other essays concentrating in an accessible manner on key considerations of market, taste, and appropriations of concepts from wider culture, making them particularly appropriate for, for example, seminar discussion with students beginning study in history of art.

The introductory essays to each section are less intended to provide blanket "background information" or biographical details than to highlight some of the key points of each text and, in places, to point to unusual or more commonly overlooked elements. They also seek to suggest interesting ways in which their arguments may be seen to confirm or challenge those in other texts in the volume. It is hoped that this may lead students themselves to recognize further commonalities and contradictions between the various interpretive methods and critical positions represented. Finally, the commentary seeks to encourage

independent, critical reading to students by suggesting, where appropriate, some of the perspectives from which the writer's argument has been or could be challenged. Readers are encouraged to refer to the notes to each section for further reading.

It should be self-evident that an anthology such as this does not provide a "definitive" history or overview of a period. What this volume does offer is a series of reference points for positioning this complex period of modernism in its interpretive contexts. The focus is on western Europe and Russia – a separate volume in this series will deal with the United States – and there is most emphasis on France, Russia, and Germany. The most recent developments in the more abstractly theorizing branches of the discipline are largely avoided, since this collection is intended to reflect historically on the practice and theory of art. However, it is hoped that the juxtaposition here of canonical, "classic" texts with some lesser-known sources, in thematic groupings of a suggestive nature, will help to stimulate interest and provoke discussion of one of the richest and most contested periods of cultural history.

Acknowledgments

The editor and publisher gratefully acknowledge the permission granted to reproduce the copyright material in this book:

1. Roger Fry, extracts from "Post-Impressionism," *Fortnightly Review* 89 (May 1911), pp. 856–67.

2. *Ver Sacrum* editorial, "Why Are We Publishing a Journal?" pp. 917–20 in Charles Harrison and Paul Wood with Jason Gaiger (eds.), *Art in Theory 1815–1900*. Oxford: Blackwell, 1998. Translated by Jason Gaiger from *Ver Sacrum – Organ der Vereinigung bildende Künstler Österreichs*, vol. 1 (Jan. 1898), pp. 5–7. Reprinted by permission of Blackwell Publishing.

3. Henri Matisse, "Notes of a Painter" (originally published in 1908), pp. 35–40 from Jack D. Flam, *Matisse on Art*. Oxford: Phaidon, 1973. © 1973 by Phaidon Press Limited.

4. F. T. Marinetti, "The Founding and Manifesto of Futurism," originally published in *Le Figaro*, Feb. 20, 1909, and subsequently in R. W. Flint (ed.), *Marinetti: Selected Writings by F. T. Marinetti*, translated by R. W. Flint and Arthur A. Coppotelli. London: Farrar, Straus & Giroux, 1972. Translation copyright © 1972 by Farrar, Straus & Giroux, Inc. Reprinted by permission of Farrar, Straus and Giroux, LLC.

5. Hugo Ball, "Dada Manifesto" (originally published 1916), pp. 220–1 from John Elderfield (ed.), *Flight Out of Time: A Dada Diary by Hugo Ball*. Berkeley: University of California Press, 1996. First published in English by Viking Press 1974. Reprinted by permission of J. Christopher Middleton.

6. Vladimir Tatlin, "The Work Ahead of Us" (originally published 1920), pp. 206–7 in John E. Bowlt (ed. and trans.), *Russian Art of the Avant-Garde: Theory and Criticism, 1902–1934* (revised and enlarged edition). London: Thames and Hudson, 1991. First published in English by The Viking Press in *The Documents of 20th-Century Art* series, 1976. Reprinted by permission of Thames and Hudson. Ltd.

7. André Breton, pp. 3–6, 9–14, 15–16, 21–7, 29–30, 36–40, and 47 from "[First] Manifesto of Surrealism" (originally published 1924) in André Breton, *Manifestoes of Surrealism*, trans. Richard Seaver and Helen R. Lane. Ann Arbor: University of Michigan Press, 1972. Reprinted by permission of University of Michigan Press.

8. Gustav Hartlaub, "Introduction to 'New Objectivity': German Painting since Expressionism" (first published in German 1925), pp. 491–3 from Anton Kaes, Martin Jay, and Edward Dimendberg (eds.), *The Weimar Republic Sourcebook*. Berkeley: University of California Press, 1995. © 1994 by The Regents of the University of California.

9. Joris-Karl Huysmans, "Gustave Moreau," pp. 17–20 from Huysmans, *Certains*. Paris: Stock, 1889. This version is taken from pp. 45–7 in Henri Dorra (ed.), *Symbolist Art Theories: A Critical Anthology*. Berkeley: University of California Press, 1994. Reprinted by permission of University of California Press.

10. G.-Albert Aurier, "Symbolism in Painting: Paul Gauguin" (originally published in 1891), pp. 195–203 in Henri Dorra (ed.), *Symbolist Art Theories: A Critical Anthology*. Berkeley: University of California Press, 1994. Reprinted by permission of University of California Press.

11. Wilhelm Worringer, pp. 3–25, 136–8 (notes) from *Abstraction and Empathy: A Contribution to the Psychology of Style* (originally published in German 1908), trans. Michael Bullock. London: Routledge and Kegan Paul, 1953. Reprinted by permission of Thomson Publishing Services on behalf of Routledge.

12. Wassily Kandinsky, pp. 63–102; 103–7 (excerpted notes) from "Vasilii Kandinsky, *On the Spiritual in Art (Painting)*" (Russian version first published 1911), trans. John E. Bowlt and published in John E. Bowlt and Rose-Carol Washton Long (eds.), *The Life of Vasilii Kandinsky in Russian Art: A Study of On the Spiritual in Art*. Newtonville, MA: Oriental Research Partners, 1980. Reprinted by permission of Oriental Research Partners.

13. Giorgio de Chirico, "Mystery and Creation," 1913. Originally published in André Breton, *Le Surréalisme et la Peinture* (Paris: Gallimard, 1928). This English translation is from *London Bulletin* 6 (Oct. 1938), p. 14.

14. Kazimir Malevich, "From Cubism and Futurism to Suprematism: The New Painterly Realism" (originally published 1915), pp. 118–35 in John E. Bowlt (ed. and trans.), *Russian Art of the Avant-Garde: Theory and Criticism, 1902–1934* (revised and enlarged edition). London: Thames and Hudson, 1991. First published in English by The Viking Press in *The Documents of 20th-Century Art* series, 1976. Reprinted by permission of Thames and Hudson.

15. Piet Mondrian, "Neo-Plasticism: The General Principle of Plastic Equivalence" (originally published 1920), pp. 132–47 (extracts) in Harry Holtzman and Martin S. James (eds. and trans.), *The New Art – The New Life: The Collected Writings of Piet Mondrian*. London: Thames and Hudson, 1987. Reprinted by permission of Thames and Hudson.

16. Siegfried Kracauer, "The Mass Ornament" (originally published 1927), pp. 75–86 in Thomas Y. Levin (ed. and trans.), *The Mass Ornament: Weimar Essays*. Cambridge, MA: Harvard University Press, 1995. Reprinted by permission.

17. Walter Benjamin, extracts from "The Work of Art in the Age of Mechanical Reproduction" (originally published in 1936), pp. 211–20, 227–35 in Walter Benjamin, *Illuminations*. © 1955 by Suhrkamp Verlag, Frankfurt am Main. English translation © 1968 by Harry Zohn and renewed 1996 by Harcourt, Inc. Reprinted by permission of Harcourt, Inc. and The Random House Group.

18. Clement Greenberg, "Avant-Garde and Kitsch" (originally published in 1939), pp. 3–21 from Clement Greenberg, *Art and Culture: Critical Essays*. Boston: Beacon

Press, 1961. © 1961, 1989 by Clement Greenberg. Reprinted by permission of Beacon Press, Boston.

19. Victor Burgin, "Modernism in the *Work* of Art" (originally published in 1976), pp. 1–16, 23–8, 205–8 (notes) from Victor Burgin, *The End of Art Theory: Criticism and Postmodernity.* Atlantic Highlands, NJ: Humanities Press International, 1986. Reprinted by permission of Palgrave Macmillan.

20. Andreas Huyssen, "The Hidden Dialectic: Avantgarde–Technology–Mass Culture," pp. 3–15 in Huyssen, *After the Great Divide: Modernism, Mass Culture, Postmodernism.* Bloomington: Indiana University Press, 1986. This essay was first published in Kathleen Woodward (ed.), *The Myths of Information: Technology and Postindustrial Culture* (Madison, WI: Coda Press, 1980), pp. 151–64. Reprinted by permission of Thomson Publishing Services on behalf of Routledge.

21. Raymond Williams, "The Politics of the Avant-Garde," pp. 49–63 from Raymond Williams, *The Politics of Modernism: Against the New Conformists.* London: Verso, 1989. Reprinted by permission of Verso.

22. Peter Bürger, pp. 47–54, 73–82 from *Theory of the Avant-Garde*, trans. Michael Shaw. Minneapolis: University of Minnesota Press, 1984. English translation © 1984 by the University of Minnesota. Originally published in German as *Theorie der Avantgarde*, © 1974, 1980 by Suhrkamp Verlag.

23. Ernst Bloch, "Jugglers' Fair Beneath the Gallows" (originally published in German 1937), pp. 75–80 in Bloch, *Heritage of Our Times*, trans. Neville and Stephen Plaice. Cambridge: Polity Press, 1991. English translation © 1991 by Polity Press. Reprinted by permission of Polity Press and University of California Press.

24. André Breton, Diego Rivera, and Leon Trotsky, "Towards a Free Revolutionary Art" (originally published 1938). This English translation by Dwight MacDonald was first published in New York in *Partisan Review* IV, no. 1 (Fall 1938), pp. 49–53 and in the *London Bulletin* (Dec. 1938–Jan. 1939).

25. Boris Groys, "The Birth of Socialist Realism from the Spirit of the Russian Avant-Garde," from Hans Günther, *Culture of the Stalin Period.* New York: St. Martin's Press and London: Macmillan, 1991. Reprinted by permission of Palgrave Macmillan.

26. Abigail Solomon-Godeau, "Going Native," originally published in *Art in America* 77 (July 1989), pp. 119–29, 161 (notes). Reprinted by permission of Brant Publications, Inc.

27. Carol Duncan, "Virility and Domination in Twentieth-Century Vanguard Painting." First published in *Artforum* (Dec. 1973), pp. 30–9; the version reprinted here was later revised and reprinted in Norma Broude and Mary Garrard (eds.), *Feminism and Art History: Questioning the Litany.* New York: Harper and Row, 1982. Reprinted by permission of Carol Duncan.

28. Lisa Tickner, extracts (pp. 46–56, 70–6 [excerpted notes]) from "Men's Work? Masculinity and Modernism" in Norman Bryson, Michael Ann Holly, and Keith Moxey (eds.), *Visual Culture: Images and Interpretations.* Hanover, NH: Wesleyan University Press, 1994. © 1994 by Wesleyan University Press and reprinted by permission of Wesleyan University Press.

29. David Cottington, "What the Papers Say: Politics and Ideology in Picasso's Collages of 1912," pp. 350–9 from *Art Journal* (Winter 1988), published by the College Art

Association. © 1988 by David Cottington. Reprinted by permission of David Cottington.

30. Hanne Bergius, "Dada als 'Buffonade und Totenmesse zugleich'," pp. 208–20 from Stefanie Poley (ed.), *Unter der Maske des Narren*. Stuttgart: Verlag Gerd Hatje, 1981. English translation © 2005 by Debbie Lewer. Reproduced by permission of Hanne Bergius.

31. Dawn Ades, "Surrealism: Fetishism's Job," pp. 67–87 from Anthony Shelton (ed.), *Fetishism: Visualising Power and Desire*. London: South Bank Centre and The Royal Pavilion, Art Gallery and Museums, Brighton in association with Lund Humphries Publishers, 1995. Reprinted by permission of Dawn Ades.

Every effort has been made to trace copyright holders and to obtain their permission for the use of copyright material. The publisher apologizes for any errors or omissions in the above list and would be grateful if notified of any corrections that should be incorporated in future reprints or editions of this book.

Part I
Programs and Manifestos

Introduction

The short texts in this section are a selection of manifestos and other program-matic statements made by groups or individuals. They were produced in widely varying cultural contexts and articulate very diverse positions on the practice, theory, and politics of art. Their demands range across the constructive, utopian, antirational, and pragmatic. They also vary considerably in form. Most of the texts in this section are by artists or writers rationalizing – or revolutionizing – their practice, asserting a group identity, or defending their impetus. But they are in turn illuminating of the often transitional contexts in which they were produced; ranging here from fin-de-siècle Vienna to postrevolutionary Russia. The first and last texts, by Roger Fry and Gustav Hartlaub, are the work of art-historian curators attempting in different ways to identify, elucidate, and champion recent developments in painting practice.

Roger Fry (1866–1934) was a painter, critic, art historian, and curator who explored through his writings an immense range of the visual arts, ancient and modern, Western and non-Western. His most important work included the essays in his *Vision and Design* (1920)[1] and his monograph on Cézanne (1927).[2] A key member of the liberal Bloomsbury circle, as a critic, Fry's own influences were varied and international; they included Leo Tolstoy,[3] Heinrich Wölfflin, Bernard Berenson,[4] Maurice Denis,[5] and Julius Meier-Graefe.[6] Together with his more audacious friend, Clive Bell, Fry was crucial to the development of formalist art criticism, and as such he provided some of the fundamental hypotheses for modernist art histories of the mid-twentieth century (see Part III).

The essay here, "Post-Impressionism," is an early attempt by Fry to appraise and defend the recent art that, in his view, addressed itself "directly to the imagination through the senses" as something distinct from Impressionism, which was "ob-jective." The article is based on one of a series of lectures given by Fry in the context

of the exhibition he organized, "Manet and the Post-Impressionists," at the Grafton Galleries in London from November 1910 to January 1911. Besides Manet, the exhibition included works by Gauguin, Van Gogh, Cézanne, Vlaminck, Denis, Matisse, Picasso, and more. Although some of the older painters were already known in England, the show came as a shock to a public more used to the Pre-Raphaelites and, in the case of its organizer, to Fry's connoisseurial expertise on the Old Masters.[7] It was met with "paroxysms of rage and laughter," a "storm of abuse," and the inevitable diagnoses of insanity on the part of the artists as well as Fry himself.[8] For his part, Fry regarded such responses as an "outbreak of militant Philistinism."[9] One critic wryly remarked that in contrast to the French, "We in England don't have movements if we can help it."[10] A second exhibition was held at the same venue the following year.[11] Better organized and more positively received, the notion, at least, of a "Post-Impressionist movement" was there consolidated, even while the precise meaning of the phrase remained ill-defined.[12] It is important to note that Fry's term "Post-Impressionism" was provisional even at the moment of its coinage for the 1910 exhibition. The term "Expressionism" had even been an option at one point.[13] Artists did not declare themselves "Post-Impressionists" in the manner of the younger, self-proclaimed Futurists, Vorticists, and Dadaists. This elastic designation was used by Fry, Bell, and others after them very liberally to describe "the group of vital artists who immediately follow the Impressionists."[14] In practice this could stretch from the "big four" of the emerging Post-Impressionist canon; Cézanne, Gauguin, Van Gogh, Seurat, to almost any modern European artist to have emerged since Impressionism, such as Picasso, Brancusi, Kandinsky, Goncharova, and, tellingly, young British artists including Fry himself.[15] As such, the concept of "Post-Impressionism" with its deceptive connotations of a uniformity of style, aesthetic hierarchy, and linearity of historical progression is problematic. This becomes even more apparent in the light of more recent art-historical approaches that foreground social processes and factors such as class, gender, and race over internal formal characteristics. From such critical perspectives, "Post-Impressionism" as an episode in the seamless narrative, or "heroic fiction," of modernism has proved an unsatisfactory category that obscures difference and complexity and fails to take account of the specific historical conditions of the production of meaning.[16] The extract included here is significant as one of the earliest examples of its use.

In the course of his efforts to distinguish the Post-Impressionists from the Impressionists, Fry touches on an idea that was to be popularized by Bell and that became widely associated with Post-Impressionism: that of "significant form."[17] Here, "significant and expressive form" is the "discovery of Cézanne's that has recovered for modern art a whole lost language of form and colour." The statement contains the essence of two further ideas that reverberated through much of Fry's and his contemporaries's writing: first, that Cézanne was the key to this revolution in art and second, that the newness of Post-Impressionism was tied up with the reclamation of a "lost language" or "lost inheritance" promised by the "primitive artists" – the early Italians. They are, for Fry, the "means of

expression...denied [to artists] ever since the Renaissance."[18] It is telling that already two years before Fry baptized the Post-Impressionist "movement," he had been defending Cézanne and Gauguin as "proto-Byzantines rather than Neo-Impressionists."[19] Here was a working premise for a history of art that described a route of decline and ascent between the twin peaks of Giotto and Cézanne. It is one that has proved remarkably tenacious. From this premise, and dismissing out of hand 400 years of art, Bell could declare: "Before the late noon of the Renaissance art was almost extinct. Only nice illusionists and masters of craft abounded. That was the moment for a Post-Impressionist revival."[20]

Other longings for revival, renewal, and regeneration were central to the proclaimed ethos of the Vienna Secession, founded in 1898. The editorial passage "Why Are We Publishing a Journal?" comes from the first issue of the Secession's journal, *Ver Sacrum* (Sacred Spring), published in January of that year. The journal title refers to a Roman ritual in which a band of spring-born youths was dedicated by the people to the gods for the salvation of the city.[21] Mustering the heroic image of an eternal Rome flourishing from an eternal spring, and dynamized by the wider cultural movement of *die Jungen* (the young) against the old in Vienna, the Secession proclaimed its regenerative function for their own city, but, as Carl E. Schorske writes: "Where in Rome the elders pledged their children to a divine mission to save society, in Vienna the young pledged themselves to save culture from their elders."[22]

Motivated by a mixture of idealism and pragmatism and encouraged by the independent Impressionist exhibitions in the 1870s and 1880s in Paris as a precedent, Secessions became a feature of German and Austrian art in the 1890s. Those in Munich (1892), Vienna (1898), and Berlin (1899) were the most important. Of these, the Vienna Secession, led by Gustav Klimt, was the most stylistically distinctive and presented to the public the most unified group identity. The impassioned statement that appears here seeks to justify not only the publication of the journal, but also the foundation of the Secession itself.[23] As such, it enunciates other important principles of the Secession's rationale: It was to act as an antidote to the perceived provincialism and cultural isolation of Vienna "behind the Kahlenberg." It was to promote international art for the benefit of domestic art, and it was to be contemporary, modern, and true to its time, a principle encapsulated in the Secession's motto adorning in gold letters the entrance to its temple-like headquarters in Vienna: "*Der Zeit ihre Kunst, der Kunst ihre Freiheit*" (To the Age Its Art, to Art Its Freedom).

The *Ver Sacrum* editorial is anonymous, reinforcing its effect as a group statement, but was probably written by Hermann Bahr and Alfred Roller.[24] Roller produced the woodcut that appeared on this first issue's cover. Its stylized imagery symbolizes both the Secessionists's predicament and their ideal. A verdant sapling adorned with three empty heraldic shields symbolizing Architecture, Painting, and Sculpture bristles with such vigorous growth that its searching roots have begun to burst apart the restrictive confines of the barrel-like pot in which it grows.[25] The cant of cleansing destruction, cultivation, fertility, new growth, and

vigorous youth, intoned with a Nietzschean cadence, resonates through this and other Secessionist statements.

However, in the wider context of how we might understand the Secession movement in relation to the later development of the European avant-garde and of art-historical accounts of the period, we should also recognize the ambivalence in parts of the text. This is an undercurrent in certain passages that wavers between a radical call to arms and a reconciliation between the old and the new. Indeed, the institution of the Secession sought to offer both a brave new modern identity and a refuge *from* modernity.[26] A further stumbling block, one which proved to be critical for the twentieth-century avant-gardes, is also evident in this text: that of the Secession's elitism on the one hand and its egalitarianism on the other.[27] Put simply, to the extent that the "high cultural mission" was wrapped in an expensive luxury product for an elite, cultured audience (as *Ver Sacrum* and other Secession products were), it failed in realizing its stated aim of bringing art to the "midst of life," abolishing distinctions between "high" and "low" art, and making art the "property of everyone." One of the most important issues of the period covered by this book, the problem reemerges in several of the texts in this volume.

A different kind of statement of ideals, by Henri Matisse, follows. Matisse was one of the artists dubbed "les Fauves." However, his "Notes of a Painter," written in 1908, is very much the statement of a single individual. It is also a rare example of Matisse writing for publication.[28] Sandwiched between preemptive disclaimers and defenses against his critics (such as the notorious and exotic "Sar" Péladan, who gets a few doses of his own medicine here), the main body of the "Notes" is primarily an exploration of the theoretical basis of Matisse's technical practice. It is clear that his recurrent concerns are with questions of *form*. Rejecting literary or anecdotal content in painting, Matisse is concerned with "essentials": the "organization" or "condensation of sensations" and the central importance of "expression." Interestingly, these ideals are related to influential contemporary writing about and quotation of Cézanne.[29] More broadly, they are linked to the rejection of the fleeting, fugitive quality of Impressionism in favor of a more "stable" art. As such, Matisse was in tune with some of the concerns that were preoccupying Roger Fry and Clive Bell in England just a few years later.

More recent commentators have noted the primacy that Matisse's work has assumed in high-modernist art histories and curatorial practices, relating this to the artist's expressed belief in art's separateness from the contingencies of the social and material world. What James Herbert has criticized as the "modernist concept of transcendentalism that was so much a product of Matisse"[30] (the notion of the highest art existing in an autonomous, even sanctified realm), can be detected in several passages of the text here. Particular examples are in the paragraphs on his approach to painting the human figure and the subsequent defence of his now-famous ideal: "an art of balance, of purity and serenity."

The difference between the painter Matisse's tentative but conscientious *notes* and the poet F. T. Marinetti's lambasting *manifesto* of one year later could hardly

be greater. Marinetti's audacious publication on the front page of *Le Figaro* of "The Founding and Manifesto of Futurism" was the act that brought the movement into existence and, crucially, established the status for the avant-garde of the genre of the manifesto. Echoes of the popularized ideas of the two most fashionable and widely-consumed philosophers of the period, Henri Bergson and Friedrich Nietzsche, resound through the text.[31] They are there in the vital exaltation of the senses and intuition over "deceitful mathematics" and the "horrible shell of wisdom," in the faith in constant evolution and revolution and in the championing of the "beauty" of struggle, violence, and war.

Marinetti's artistic origins in Symbolist poetry are evident here. However, by virtue of its genre, this text, which was to be the first of dozens of Futurist manifestos on all manner of topics, established a direct means for public and politically inflected communication. As Futurism gained momentum, manifestos printed on the page or declaimed on stage fused the performative and political (anarcho-syndicalist) dimensions of the movement. The combination of exaggerated rhetoric and list of enumerated demands was common. Drawing on historical political precedent and emphasizing future action and live experience, the manifestos amplified the authors' aspirations to operate in the public sphere and beyond the confines of art.[32]

The glorification of war and the destructive power of technology that appears here must be understood in its pre-World War I context. However, it remained part of Futurist politics and aesthetics after the interventionist campaign and the experience of war (which killed several major Futurists) and into the era of Mussolini's fascism. Walter Benjamin's 1936 essay "The Work of Art in the Age of Mechanical Reproduction" (Part III) concludes with his diagnosis of Marinetti's and fascism's aestheticization of war as both a symptom and means for gratification of a self-alienated society. The overt masculinity and virility of this and other Futurist manifestos may also be considered in the light of Lisa Tickner's discussion of masculinity and British modernism, including the Vorticism on which Futurism exerted an important influence (Part V).

The next text in this section is a Dada manifesto that is not as widely known in English translation as some of the more pugnacious, bruitist, and sensational manifestos of Tristan Tzara, Walter Serner, Richard Huelsenbeck, Raoul Hausmann, and others.[33] It was written by Hugo Ball, arguably the founder of Dada, in neutral Zurich, as war raged in Europe. He probably read it at the first Dada soirée held outside the regular Cabaret Voltaire where Dada had begun.[34] Tzara's (characteristically hyperbolic) record of the evening is reminiscent of accounts of Futurist demonstrations:

> In the presence of a compact crowd Tzara demonstrates, we demand we demand the right to piss in different colours...shouting and fighting in the hall, first row approves second row declares itself incompetent the rest shout, who is the strongest, the big drum is brought in, Huelsenbeck against 200.... The newspapers dissatisfied simultaneous poem for 4 voices + simultaneous work for 300 hopeless idiots.[35]

5

In terms of something approaching a theory for Dada's practice, the key passages in Ball's manifesto are those towards the end, dealing with language, "the word," and Ball's will to free its constituents and cleanse language of the "filth" that clings to it. Ball's "poems without words" or "sound poems" were his attempts to do this, and thus both to critique and potentially redeem language, which he regarded as corrupted by journalism and imperialist sloganeering. At the soirée, several performances used with startling effect *simultaneity* and *bruitism*. Besides the soirée's music, prose, and dance elements, the most spectacular turns must have been a simultaneous poem "La fièvre puerpérale" and two *chants nègres* performed by Ball, Huelsenbeck, Marcel Janco, and Tzara. Ball himself performed his *Gadji Beri Bimba* "poems without words" in his extraordinary homemade "cubistic costume"[36] (see figure 1):

> gadji beri bimba
> glandridi lauli lonni cadori
> gadjama bim beri glassala
> glandridi glassala tuffm i zimbrabim
> blassa galassasa tuffm i zimbrabim . . . [37]

Catalyzed by the conditions created by the Revolution of 1917, and building on existing, though diffuse, "constructive" tendencies in art, "Constructivism" was gaining common currency in Soviet Russia by 1920.[38] The short text by Vladimir Tatlin (co-signed by three of his assistants), "The Work Ahead of Us," articulates several of the broad concerns of the movement but also acts as a specific commentary to one of the most spectacular unbuilt monuments of the twentieth century, Tatlin's *Monument to the Third International*. The wooden model of the tower, which quickly became a potent symbol for the dynamic spirit of revolution as a kind of endless "becoming," had recently been moved from Petrograd to Moscow for the Eighth Congress of Soviets. It was in the Congress's daily bulletin that the text first appeared.[39]

The text is both diagnostic and prescriptive of conditions for nothing less than the creation of a "new world." As such, it parallels the emerging constructivist approach to social reorganization as a material process.[40] Tatlin and his colleagues define the conditions for their work negatively in terms of loss of unity between the arts and between the artist and his materials. Individualism, degradation, distortion, and decoration are the results of this breakdown. The remedial process of the "investigation of material, volume and construction" may be seen to refer to Tatlin's own work in the years following his encounter with Cubism in Paris in 1914, such as his "corner counter-reliefs." However, the most important point comes in the closing statements. Here, the restorative potential of the unification of "purely artistic forms with utilitarian intentions," as exemplified by the project for the *Monument to the Third International*, is asserted. (That Tatlin's monument was overtly utopian and entirely unbuildable on the scale envisaged underscores its symbolic and programmatic character as well as highlighting the problem of the

Figure 1 Hugo Ball in cubist costume, Zürich, 1916. (Kunsthaus Zürich, Dada-Archive.
© Kunsthaus Zürich. All rights reserved.)

shortfall between vision and practicalities.) Crucially, the new aesthetic is situated not in the individual forms of art, but in the collective dimension of everyday life. Two further texts in this volume can be usefully considered in relation to this. On a theoretical level, this concluding assertion is related to what Peter Bürger (Part IV) detected as a crucial impetus of the "historical avant-garde": the attempt to eradicate the distance between art and life. In a different argument, one that challenges the more common celebration of the Russian avant-garde of which Tatlin was a part, Boris Groys (Part IV) suggests that the Socialist Realism that replaced avant-garde movements such as Constructivism and Suprematism in Russia in the 1930s actually fulfilled and extended this project.

While in Russia, progressive artists were concerned to ensure a central role for art in the reorganization of society, the Surrealist movement, just beginning to emerge in Paris, was primarily literary at its inception and concerned with nothing less than the liberation of the mind. André Breton's "First Manifesto of Surrealism" of 1924 is a crucial document in the movement's early phase and has taken on the status of a kind of founding manifesto.[41] Although Breton's ideas about Surrealism and the politics and practices it embraced were to change and internal divisions as well as the movement's international dissemination made it extraordinarily heterogeneous, this text articulates the core features of Surrealist strategy (with echoes of Dada), to subvert and critique logic, rationalism, determinism, authority, and "realism" in its broad sense.[42]

True to the tradition of the manifesto genre, it is a polemic. It is also very long; unabridged, it runs to over 40 pages. Its concerns are philosophical, poetic, esoteric, moral, political, "scientific," and ironic, but chiefly literary – the idea of an explicitly Surrealist painting practice was yet to be developed. Breton, described by Dawn Ades (Part V) as "someone who is convinced by his imagination," mounts an assault on the "reign of logic" and "absolute rationalism" in the name of childhood, desire, experience, and the "marvellous." But it also has an exploratory quality in keeping with its privileging of experience and desire over knowledge and chance over certainty. This was the text that established Breton as leader of the Parisian group of writers, including Louis Aragon and Philippe Soupault, around the magazine *Littérature* and (just after the publication of the *Manifesto*) its successor, *La Révolution Surréaliste*. It even proposed a succinct definition of Surrealism as "psychic automatism," although Breton himself later qualified the importance of pure automatism.

The "First Manifesto of Surrealism" has been variously interpreted. Hal Foster views Breton's examples in the text of the "marvellous" from the perspective of the Freudian notion of the uncanny,[43] while other readings have emphasized the underlying Hegelian idealism and, later, dialectical materialism (by way of Friedrich Engels) in Breton's writing in the 1920s, developing, as it did, under the growing influence of Marxism.[44] While this manifesto exemplifies what Breton called the "intuitive" phase, by the time he came to write the "Second Surrealist Manifesto" in 1930, Surrealism had entered its "reasoning" phase and had spread far beyond literary Paris.

In 1925, the director of the Mannheim Kunsthalle, Gustav Hartlaub, staged an exhibition of contemporary German painting. He gave it the title "Neue Sachlichkeit" (New Objectivity). The phrase caught on in art criticism, in Weimar journalism, and even in songs and revues; for many it seemed to encapsulate the post-Expressionist era, and what has also been called "the new sobriety" of the period of relative stability in Germany in the mid-1920s.[45] The final text in this section was Hartlaub's introduction to the exhibition and one of the clearest statements on what has long been for historians of German art and literature a difficult phenomenon to pin down, stylistically as much as politically.[46] Not the least of the problems with the concept was that it seemed from the start to signify defeat, or at least resignation.[47] If Expressionism had been a hot-tempered and idealist adolescence, Neue Sachlichkeit could all too quickly be understood as a kind of cynical, business-like adulthood.

Hartlaub had first used the phrase in May 1923, in a notice to artists, dealers, and curators published in a high-profile art magazine, *Das Kunstblatt*:

> I would like to mount a medium-sized exhibition of paintings and graphic art which might perhaps have the title "Die Neue Sachlichkeit." I am interested in bringing together representative works by those artists who over the last ten years have been neither Impressionistically vague, nor Expressionistically abstract, neither sensuously superficial nor constructivistically introverted. I want to show those artists who have remained – or who have once more become – avowedly faithful to positive, tangible reality.[48]

Within this definition lies the problem of claims for the so-called "New Objectivity," for Hartlaub is much clearer on what this art is *not*, than on what it *is*. The term remained difficult to apply; after all, it could be used as much to describe the polemic graphic art of George Grosz as the monumental canvases of Max Beckmann or the quasi-Surrealist and highly technical industrial landscapes of Carl Grossberg. It was also used widely in architectural discourse in the 1920s as well as in literature. After many delays and problems, the exhibition eventually took place and included 124 works by 32 artists. Its full title was *New Objectivity: German Painting Since Expressionism*. It traveled on after Mannheim to other German cities, including Dresden; and to Dessau, to which the Bauhaus was just moving. It is important to note that Hartlaub had originally envisaged an international (European) exhibition, not an exclusively German one.

The programs and manifestos in this section were important vehicles for the articulation of group identities and aspirations. In some cases, their declamatory form has to do with the growing politicization of progressive art practice in the period (see Parts III and IV), but as the texts here show, whether their function was to stake out territory, assail the public, rile opponents, or win converts, such statements were important defining documents for an increasingly self-conscious avant-garde and modern art practice.

Notes

1 Roger Fry, *Vision and Design* [1920] (Harmondsworth: Penguin, 1937).
2 Roger Fry, *Cézanne: A Study of his Development* [1927] (London: The Hogarth Press, 1932).
3 Fry acknowledged Tolstoy's *What is Art?* (1898) as a source for his view of "the essential importance in art of the expression of the emotions." Roger Fry, "An Essay in Aesthetics" in *Vision and Design*, p. 32.
4 Hayden B. J. Maginnis, "Reflections on Formalism: The Post-Impressionists and the Early Italians," *Art History* 19, no. 2 (June 1996), pp. 191–207.
5 See Fry's introduction to and translation of Denis's "Cézanne," *Burlington Magazine* 16 (Jan./Feb. 1910), pp. 207–19, 275–80.
6 Benedict Nicolson, "Post-Impressionism and Roger Fry," *Burlington Magazine* 93 (Jan. 1951), pp. 11–15.
7 See Jacqueline V. Falkenheim, *Roger Fry and the Beginnings of Formalist Art Criticism* (Ann Arbor: UMI Research Press, 1980), esp. p. 3, and Nicolson, "Post-Impressionism."
8 Virginia Woolf, *Roger Fry: A Biography* [1940] (Oxford: Blackwell, 1995), pp. 124–5. For Fry's more detailed summary of the public reception of Post-Impressionism see his "Retrospect" in Fry, *Vision and Design*, pp. 229–44.
9 Fry in a letter to his mother, quoted in Woolf, *Roger Fry*, p. 125.
10 Laurence Binyon in the *Saturday Review* quoted in Lisa Tickner, *Modern Life and Modern Subjects: British Art in the Early Twentieth Century* (New Haven: Yale University Press, 2000), p. 188.
11 The "Second Post-Impressionist Exhibition" of "British, French and Russian Artists" at the Grafton Galleries, Oct.–Dec. 1912.
12 There were noticeable exclusions: neither of the Post-Impressionist exhibitions showed Toulouse-Lautrec, who as late as 1912 was still regarded as a "follower" of Degas; Nicolson, "Post-Impressionism," p. 11.
13 According to the recollections of Desmond MacCarthy, Fry's collaborator on the exhibition.
14 Clive Bell, *Art* [1914] (Oxford: Oxford University Press, 1987), p. 200.
15 E.g. Bell, *Art*, p. 200.
16 See e.g. Fred Orton and Griselda Pollock, "Les données Bretonnantes: la prairie de représentation" in Orton and Pollock, *Avant-Gardes and Partisans Reviewed* (Manchester: Manchester University Press, 1996), pp. 53–88.
17 Though it was championed repeatedly by Bell, Fry tended to avoid using the idea of "significant form" as a given. The aspirations pinned to the concept of "significant form" have also been questioned by more recent accounts; for "[t]he precipitation of 'significant form' from works of wildly differing cultures purged them of cognitive and historical significance; and the stress on aesthetic emotion produced a socially undifferentiated viewer." Tickner, *Modern Life*, p. 126.
18 On the importance of the Italian primitives and the significance of Bernard Berenson's and others' work for Fry's and Bell's criticism, see Maginnis, "Reflections on Formalism."

19 Fry in a letter to the Editor of *Burlington Magazine*, March 1908, in *Letters of Roger Fry*, ed. Denys Sutton, vol. 1 (London: Chatto and Windus, 1972), pp. 298–301, p. 300.

20 Bell, *Art*, p. 39. In fact, this characteristically bombastic remark obscures the fact that both Bell and Fry admitted select figures of the intervening period to their accounts of the heritage of "significant form," such as Poussin and Chardin.

21 See Max Buckhard, "Ver Sacrum" in *Ver Sacrum* 1 (Jan. 1898), pp. 1–3, trans. in *Art in Theory 1815–1900: An Anthology of Changing Ideas*, eds. Charles Harrison and Paul Wood with Jason Gaiger (Oxford: Blackwell Publishers, 1998), pp. 916–17.

22 Carl E. Schorske, *Fin-de-Siècle Vienna: Politics and Culture* (London: Weidenfeld and Nicolson, 1980), p. 215.

23 The publication of the first issue of *Ver Sacrum* actually preceded the Secession's first exhibition, which opened in March 1898.

24 Marian Bisanz-Prakken, *Heiliger Frühling. Gustav Klimt und die Anfänge der Wiener Secession 1895–1905* (Wien: Christian Brandstätter, 1999), p. 16.

25 An interesting comparison can be made between this image and, later, the woodcut by Lionel Feininger accompanying the Founding Manifesto of the Bauhaus in Weimar in 1919, the so-called "Cathedral of Socialism" with its three stars symbolizing the same trinity of the arts.

26 Schorske, *Fin-de-Siècle Vienna*, p. 219.

27 See Robert Waissenberger, "Ver Sacrum und die Abneigung gegen den Provinzialismus," in Historisches Museum der Stadt Wien, *Ver Sacrum. Die Zeitschrift der Wiener Secession 1898–1903*, (Wien: Museen der Stadt Wien, 1983), pp. 7–16.

28 Matisse was always wary of committing his ideas to print. Three years after the *Notes*, he refused an invitation from Kandinsky to contribute an article to the *Blaue Reiter Almanach* (see Part II) on the grounds that "in order to write one must be a writer!" Roger Benjamin, *Matisse's "Notes of a Painter": Criticism, Theory and Context, 1891–1908* (Ann Arbor: UMI Research Press, 1987), p. 167.

29 Benjamin, *Matisse's "Notes of a Painter,"* esp. pp. 178–83.

30 James D. Herbert, "Matisse without History" (review article), *Art History* 11, no. 2 (June 1988), pp. 297–302, p. 301.

31 Marinetti probably first read Nietzsche in Paris in the 1890s. By the early twentieth century in Italy, a "pseudo-Nietzschean Superhero cult" had gained currency and the writings of Bergson were being discussed and translated. See Günter Berghaus, *Futurism and Politics: Between Anarchist Rebellion and Fascist Reaction, 1909–1944* (Providence: Berghahn Books, 1996), pp. 23–5 and Paul Crowther, *The Language of Twentieth-Century Art: A Conceptual History* (New Haven: Yale University Press), ch. 3, "From Duration to Modernity: Bergson and Italian Futurism," pp. 51–70.

32 For a more detailed discussion of the genre of the avant-garde manifesto, see Martin Puchner, "Screeching Voices: Avant-Garde: Manifestos in the Cabaret," in *European Avant-Garde: New Perspectives*, ed. Dietrich Scheunemann (Amsterdam: Rodopi, 2000), pp. 113–35.

33 See *The Dada Painters and Poets: An Anthology*, ed. Robert Motherwell, (Cambridge, MA: The Belknap Press of Harvard University Press, 1981); *Dada Almanach* [1920], ed. Richard Huelsenbeck, English ed. intro. by Malcolm Green (London: Atlas Press, 1993); Hugo Ball et al., *Blago Bung Blago Bung Bosso Fataka! First Texts*

of German Dada by Hugo Ball, Richard Huelsenbeck, Walter Serner, trans. and intro. Malcolm Green (London: Atlas Press, 1995).

34 The soirée took place on July 14, 1916 at the Waag guildhouse in Zurich. On the significance of the various venues for Dada events in Zurich, see Debbie Lewer, "From the Cabaret to the Kaufleutensaal: 'Mapping' Zurich Dada," in *Dada Zurich: A Clown's Game from Nothing,* eds. Brigitte Pichon and Karl Riha (New York: G. K. Hall, 1996), pp. 45–59.

35 Tristan Tzara, "Zurich Chronicle," in *Dada Painters and Poets,* ed. Motherwell, pp. 236–7. Tzara's description and his figures should not be taken too literally.

36 It is likely that this and other performances were adapted from the Cabaret Voltaire and repeated at this soirée. Ball only recorded in his diary performing these poems at the cabaret on June 23, 1916, yet the program for the Waag soirée bills his performance as " 'Gadji beri Bimba' (Poems without words, in own costume)." See facsimile in *Dada in Zürich,* ed. Hans Bolliger et al. (Zürich: Arche, 1985), p. 255. Philip Mann concludes that the sound poems must have been performed by Ball at the cabaret on June 23, 1916, in a lesser-known makeshift costume, and at the Waag on July 14 in the "cubistic costume." P[hilip] H. Mann, "Hugo Ball and the 'Magic Bishop' Episode: A Reconsideration," *New German Studies* 4, no. 1 (Spring 1976), pp. 43–52.

37 From Hugo Ball, *Flight out of Time* (entry June 23, 1916), ed. and intro. by John Elderfield (Berkeley: University of California Press, 1996), p. 70.

38 For the origins, meaning, and history of the term "constructivism" see the Introduction to *The Tradition of Constructivism,* ed. Stephen Bann (New York: Da Capo Press, 1974), pp. xxv–xlix.

39 *Ezhednevnyi byulleten VIII-go sezda sovetov* 13 (Jan. 1, 1921).

40 See chapter on the Monument to the Third International in John Milner, *Vladimir Tatlin and the Russian Avant-Garde* (New Haven: Yale University Press, 1983), pp. 151–80.

41 Breton's own ideas about Surrealism and the movement's methods later modified the premises outlined here. Compare e.g. his "Second Surrealist Manifesto" of 1930.

42 Chance, montage, automatism, paradox, iconoclasm, irony, and nonsense are among the broad means and concepts used by writers and artists in Dada and Surrealism to effect this critique.

43 Hal Foster, *Compulsive Beauty* (Cambridge MA: MIT Press, 1995).

44 See e.g. Crowther, *The Language of Twentieth-Century Art,* ch. 5, "Dialectic and Surrealism: From Breton to Pollock," pp. 87–128.

45 John Willett, *The New Sobriety: Art and Politics in the Weimar Period 1917–33* (London: Thames and Hudson, 1978).

46 For an excellent discussion of the historiography of "Neue Sachlichkeit," see Jost Hermand, "Unity Within Diversity? The History of the Concept 'Neue Sachlichkeit'," in *Culture and Society in the Weimar Republic,* ed. Keith Bullivant (Manchester: Manchester University Press, 1977), pp. 166–82.

47 Ibid., p. 167.

48 Cited in Wieland Schmied, "Neue Sachlichkeit and the German Realism of the Twenties," in Hayward Gallery, *Neue Sachlichkeit and German Realism of the Twenties* (London: Arts Council of Great Britain, 1979), pp. 7–32, p. 9.

1

Post-Impressionism

Roger Fry

I believe that even those works which seem to be extravagant or grotesque are serious experiments – of course, not always successful experiments – but still serious experiments, made in perfectly good faith towards the discovery of an art which in recent times we have almost entirely forgotten.

My object in this lecture is to try to explain what this problem is and how these artists are, more or less consciously, attempting its solution. It is to discover the visual language of the imagination. To discover, that is, what arrangements of form and color are calculated to stir the imagination most deeply through the stimulus given to the sense of sight. This is exactly analogous to the problem of music, which is to find what arrangements of sound will have the greatest evocative power. But whereas in music the world of natural sound is so vague, so limited, and takes, on the whole, so small a part of our imaginative life, that it needs no special attention or study on the part of the musician; in painting and sculpture, on the contrary, the actual world of nature is so full of sights which appeal vividly to our imagination – so large a part of our inner and contemplative life is carried on by means of visual images, that this natural world of sight calls for a constant and vivid apprehension on the part of the artist. And with that actual visual world, and his relation to it, comes in much of the painter's joy, and the chief, though not the only, fount of his inspiration but also much of his trouble and a large part of his quarrel with the public. For instance, from that ancient connection of the painter's with the visual world it comes about that it is far harder to him to get anyone, even among cultivated people, to *look* at his pictures with the same tense passivity and alert receptiveness which the musician can count on from his auditors. Before ever they have in any real sense *seen* a picture, people are calling to mind their memories of objects similar to those which they see represented, and are measuring the picture by these, and generally – almost inevitably if the artist is original and has seen something with new intensity and

Roger Fry, extracts from "Post-Impressionism," *Fortnightly Review* 89 (May 1911), pp. 856–67.

13

emotion – condemning the artist's images for being different from their own preconceived mental images. That is an illustration of the difficulties which beset the understanding of the graphic arts, and I put it forward because to understand the pictures here exhibited it is peculiarly necessary that you should look at them exactly as you would listen to music or poetry, and give up for once the exhibition attitude of mind which is so often one of querulous self-importance. We must return to the question of the painter's relation to the actual visible world. . . .

Now it is precisely this inestimable boon that, if I am right, these artists, however unconsciously they may work, are gaining for future imaginations, the right to speak directly to the imagination through images created, not because of their likeness to external nature, but because of their fitness to appeal to the imaginative and contemplative life.

And now I must try to explain what I understand by this idea of art addressing itself directly to the imagination through the senses. There is no immediately obvious reason why the artist should represent actual things at all, why he should not have a music of line and color. Such a music he undoubtedly has and it forms the most essential part of his appeal. We may get, in fact, from a mere pattern, if it be really noble in design and vital in execution, intense aesthetic pleasure. And I would instance as a proof of the direction in which the post impressionists are working, the excellences of their pure design as shown in the pottery at the present exhibition. In these there is often scarcely any appeal made through representation, just a hint at a bird or an animal here and there, and yet they will arouse a definite feeling. Particular rhythms of line and particular harmonies of color have their spiritual correspondences, and tend to arouse now one set of feelings, now another. The artist plays upon us by the rhythm of line, by color, by abstract form, and by the quality of the matter he employs. But we must admit that for most people such play upon their emotions, through pure effect of line, color, and form is weak compared with the effect of pure sound. But the artist has a second string to his bow. Like the poet he can call up at will from out of the whole visible world, reminiscences and remembered images of any visible or visually conceivable thing. But in calling up these images, with all the enrichment of emotional effect which they bring, he must be careful that they do not set up a demand independent of the need of his musical phrasing, his rhythm of line, color, and plane. He must be just as careful of this as the poet is not to allow some word which, perhaps, the sense may demand to destroy the *ictus* of his rhythm. Rhythm is the fundamental and vital quality of painting, as of all the arts – representation is secondary to that, and must never encroach on the more ultimate and fundamental demands of rhythm. The moment that an artist puts down any fact about appearance because it is a fact, and not because he has apprehended its imaginative necessity, he is breaking the laws of artistic expression. And it is these laws, however difficult and undiscoverable they may be, which are the final standard to which a work of art must conform.

Now these post impressionist artists have discovered empirically that to make the allusion to a natural object of any kind vivid to the imagination, it is not only

not necessary to give it illusive likeness, but that such illusion of actuality really spoils its imaginative reality. . . .

A great part of illusive representation is concerned with creating the illusion of a third dimension by means of light and shade, and it is through the relief thus given to the image that we get the sensual illusion of a third dimension. The intrusion of light and shade into the picture has always presented serious difficulties to the artist; it has been the enemy of two great organs of artistic expression – linear design and color: for though, no doubt, color of a kind is consistent with chiaroscuro, its appeal is of quite a different order from that made when we have harmonies of positive flat color in frank opposition to one another. Color in a Rembrandt, admirable though it is, does not make the same appeal to the imagination as color in a stained glass window. Now if it should turn out that the most vivid and direct appeal that the artist can make to the imagination is through linear design and frank oppositions of color, the artist may purchase the illusion of third dimensional space at too great a cost. Personally I think he has done so, and that the work of the post impressionists shows conclusively the immense gain to the artist in the suppression or re-interpretation of light and shade. One gain will be obvious at once, namely, that all the relations which make up the unity of the picture are perceived as inhering in the picture surface, whereas with chiaroscuro and atmospheric perspective the illusion created prevents our relating a tone in the extreme distance with one in the near foreground in the same way that we can relate two tones in the same plane. It follows, therefore, that the pictures gain immensely in decorative unity. This fact has always been more or less present to the minds of artists when the decoration of a given space of wall has been demanded of them; in such cases they have always tended to feel the need for keeping the relations upon the flat surface, and have excused the want of illusion, which was supposed to be necessary for a painting, by making a distinction between decorative painting and painting a picture, a distinction which I believe to be entirely fallacious; a painting of any kind is bound to be decorative, since by decorative we really mean conforming to the principles of artistic unity. . . .

It appears then that the imagination is ready to construct for itself the ideas of space in a picture from indications even more vividly than it accepts the idea when given by means of sensual illusion. And the same fact appears to be true of plastic relief. We do not find, as a matter of empirical fact, that the outlines with which some of these artists surround their figures, in any way interfere with our imaginative grasp of their plastic qualities – particularly is this the case in Cézanne, in whom the feeling for plastic form and strict correlation of planes appears in its highest degree. His work becomes in this respect singularly near to that of certain primitive Italian artists, such as Piero della Francesca, who also relied almost entirely upon linear design for producing this effect.

Many advantages result to art from thus accepting linear design and pure color as the main organs of expression. The line itself, its qualities as handwriting, its immediate communication to the mind of gesture, becomes immensely enhanced, and I do not think it is possible to deny to these artists the practice of a

particularly vigorous and expressive style of handwriting. It is from this point of view that Matisse's curiously abstract and impassive work can be most readily approached. In his *Woman with Green Eyes* we have a good example of this. Regarded as a representation pure and simple, the figure seems almost ridiculous, but the rhythm of the linear design seems to me entirely satisfactory; and the fact that he is not concerned with light and shade has enabled him to build up a color harmony of quite extraordinary splendor and intensity. There is not in this picture a single brush stroke in which the color is indeterminate, neutral, or merely used as a transition from one tone to another.

Again, this use of line and color as the basis of expression is seen to advantage in the drawing of the figure. As Leonardo da Vinci so clearly expressed it, the most essential thing in drawing the figure is the rendering of movement, the rhythm of the figure as a whole by which we determine its general character as well as the particular mood of the moment. Now anything like detailed modeling or minute anatomical structure tends to destroy the ease and vividness with which we apprehend this general movement; indeed, in the history of painting there are comparatively few examples of painters who have managed to give these without losing hold of the general movement. We may say, indeed, that Michelangelo's claim to a supreme place is based largely upon this fact, that he was able actually to hold and to render clear to the imagination the general movement of his figures in spite of the complexity of their anatomical relief; but as a rule if we wish to obtain the most vivid sense of movement we must go to primitive artists, to the sculptors of the twelfth century, or the painters of the early fourteenth.

Now here, again, the Post Impressionists have recovered for us our lost inheritance, and if the extreme simplification of the figure which we find in Gauguin or Cézanne needed justification, it could be found in this immensely heightened sense of rhythmic movement. Perfect balance of contrasting directions in the limbs is of such infinite importance in estimating the significance of the figure that we need not repine at the loss which it entails of numberless statements of anatomical fact.

I must say a few words on their relation to the Impressionists. In essentials the principles of these artists are diametrically opposed to those of Impressionism. The tendency of Impressionism was to break up the object as a unity, and to regard the flux of sensation in its totality; thus, for instance, for them the local color was sacrificed at the expense of those accidents which atmosphere and illumination from different sources bring about. The Impressionists discovered a new world of color by emphasizing just those aspects of the visual whole which the habits of practical life had caused us to underestimate. The result of their work was to break down the tyranny of representation as it had been understood before. Their aim was still purely representative, but it was representation of things at such a different and unexpected angle, with such a new focus of attention, that its very novelty prepared the way for the Post Impressionist view of design.

How the Post Impressionists derived from the Impressionists is indeed a curious history. They have taken over a great deal of Impressionist technique,

and not a little of Impressionist color, but exactly how they came to make the transition from an entirely representative to a non-representative and expressive art must always be something of a mystery, and the mystery lies in the strange and unaccountable originality of a man of genius, namely, Cézanne. What he did seems to have been done almost unconsciously. Working along the lines of Impressionist investigation with unexampled fervor and intensity, he seems, as it were, to have touched a hidden spring whereby the whole structure of Impressionist design broke down, and a new world of significant and expressive form became apparent. It is that discovery of Cézanne's that has recovered for modern art a whole lost language of form and color. Again and again attempts have been made by artists to regain this freedom of imaginative appeal, but the attempts have been hitherto tainted by archaism. Now at last artists can use with perfect sincerity means of expression which have been denied them ever since the Renaissance. And this is no isolated phenomenon confined to the little world of professional painters; it is one of many expressions of a great change in our attitude to life. We have passed in our generation through what looks like the crest of a long progression in human thought, one in which the scientific or mechanical view of the universe was exploited for all its possibilities. How vast, and on the whole how desirable those possibilities are is undeniable, but this effort has tended to blind our eyes to other realities; the realities of our spiritual nature, and the justice of our demand for its gratification. Art has suffered in this process, since art, like religion, appeals to the non-mechanical parts of our nature, to what in us is rhythmic and vital. It seems to me, therefore, impossible to exaggerate the importance of this movement in art, which is destined to make the sculptor's and the painter's endeavor once more conterminous with the whole range of human inspiration and desire.

17

2

Why Are We Publishing a Journal?

Ver Sacrum editorial

The merry war has been raging for years along the whole front, from London to Munich, from Paris to St Petersburg. It is only in Vienna – enveloped in quiet contemplation and a 'noble' silence – that not a single breath of its spirit has been felt. The thundering spring tempest has everywhere torn a liberating path through the domain of art. Like a deep release of breath it has convulsed the spiritual atmosphere with the first fertile rains of the storm, with illuminating flashes of lightning and the loud tidings of thunder, bringing everywhere life, movement, hope, and the thirst for action and exuberance. Only to Vienna it did not come, and here everything remained calm.

And yet it was not the calm of the grave. Here, too, there was a deep yearning and an intimation of coming events. Artists and writers who ventured to look beyond the bounds of the city brought tidings of something different, something new and timely, which here and there awoke a response, passing like a whisper from person to person: perhaps there is something on the other side of the Kahlenberg – perhaps, finally, even such a thing as modern art!

This is not the place to repeat the story of what then took place, of how the stifling pressure weighing upon artists finally led them to take a decisive step within the Association. But the publication of a journal requires a justification – and we want to try to provide it, so far as the explanation of an artistic undertaking can be given by means of words.

The shameful fact that Austria does not possess a single illustrated journal that meets its particular needs and which is intended for the broadest possible circulation has made it impossible until now for artists to make their work known to wider circles. This journal is intended to remedy this situation. It will, for the first time,

Ver Sacrum editorial, "Why Are We Publishing a Journal?" pp. 917–20 in Charles Harrison and Paul Wood with Jason Gaiger (eds.), *Art in Theory 1815–1900*. Oxford: Blackwell, 1998. Translated by Jason Gaiger from *Ver Sacrum – Organ der Vereinigung bildende Künstler Österreichs*, vol. 1 (Jan. 1898), pp. 5–7. Reprinted by permission of Blackwell Publishing.

allow Austria to appear as an artistic factor independent of countries abroad, in contrast to the neglect which it has previously suffered almost everywhere in this regard. As the organ of the *Vereinigung bildender Künstler Österreichs* [Union of Austrian Artists], this journal is a summons to the artistic sensibility of the people to encourage, promote and propagate artistic life and artistic independence.

We wish to declare war on deedless idleness and rigid Byzantinism and on all lack of taste and we count upon the energetic support of all those who understand that art is a high cultural mission and who recognize it as one of the great educative tasks of a civilized nation.

We do not want to compose any long-winded program music, and this also holds true for this introductory essay. The treatment of particulars will be discussed at the appropriate place. There has been enough discussion and making of resolutions. Now is the time for deeds.

First, we need the necessary strength for destruction and annihilation. One cannot build upon a rotten foundation, and new wine cannot be kept in old skins. Then, however, once the ground has been prepared, cleared, and tilled we require the power of the beneficent sun and of constructive labour, the powers of creation and preservation. Like all work of building, this requires as its presupposition the removal of what stands in the way. But it is nonsensical to claim that contemporary art pursues destructive tendencies, that it dissolves form and colour, has no respect for the past and preaches the radical transformation of everything already standing. Art does not seek to preach at all. It seeks to create. All art is, in its innermost essence, constructive, not destructive. For this reason, every genuine artist honours and respects the great masters of the past, loves them with childlike reverence, and bows down before them in respectful admiration.

Whoever rails against the Old Masters is a buffoon. Since time immemorial buffoons have accompanied every world movement. They also accompany the present one, just as the fool follows behind the King's procession or dances in front of it. When the heroes ride into a tournament, the shield carriers rattle their lances. However, as soon as the knights enter the arena, the noise ceases and the real work begins, and then one sees nothing more of the squires and the shield carriers.

BUT EVERY TIME POSSESSES ITS OWN SENSIBILITY. Our goal is to awaken, encourage and propagate the artistic sensibility of OUR TIME, and this is the fundamental reason why we are publishing a journal. To all those who strive towards the same goal, even if they travel along different paths, we gladly stretch out the hand of solidarity.

We want an art without subservience to foreigners but also without fear or hatred of them either. Art of other countries should stimulate us and lead us to reflect upon ourselves; we want to acknowledge it and admire it when it deserves admiration; only we do not want to imitate it. We want to bring art from abroad to Vienna, not for the sake of artists, intellectuals and collectors alone, but to educate the great mass of the people who are receptive to art, thereby awakening that dormant yearning for beauty and freedom in thought and feeling which already lies in every human breast.

19

And for this we turn to all of you, without distinction of status or wealth. We do not recognize any distinction between 'higher art' and 'low art', between art for the rich and art for the poor. Art is the property of everyone.

We wish to break at last with the old habit of Austrian artists, of lamenting the public's lack of interest in art without trying to effect a change. With burning tongues we will tell you again and again that art is more than an external, piquant charm, more than a mere dispensable perfume of your existence, that it is, rather, the necessary outward realization of the life of an intelligent people, as self-evident and indispensable as its language and customs. We ask that you give us the crumbs of time which fall from the table of your life, often so resplendent and yet so impoverished; and if just once you give these crumbs, if you extend to us only your smallest finger, then we shall seek to fill these brief minutes with such delight and splendour that you will realize the miserable emptiness of your life hitherto – and we will seek to gain the whole of your hand, your heart, yourselves!

And if one of you says, 'But what need do I have of artists? I do not like paintings', we shall answer, 'If you do not like paintings, we will decorate your walls with splendid carpets; you will take pleasure, perhaps, in drinking your wine from an artistically shaped glass; come to us, we know the right shape for the vessel which is worthy of a noble draught. Or you wish for an exquisite piece of jewellery, or some special material to adorn your wife or your beloved? Then speak, try it just once, and we will show that you have learnt a new world, that you too may contemplate and possess things whose beauty you have never experienced!'

The artist's sphere of influence is not the misty haze of the intoxicated enthusiast, rather he must stand in the midst of life; he must be familiar with everything exalted and splendid and with everything ugly which it hides; he must search deep in the storming turmoil. We wish to teach you to join fast with us, like a tower of iron, to join those who recognize, know and understand, who are adepts and masters of the spirit. This is our mission.

It lies in the hands of each of you to exercise influence in your own sphere and to win supporters, not for the personal advantage of the individual, but for the great, magnificent goal that is longed for, not only by ourselves, but by thousands of others as well. There are amongst you many more than know themselves, who in their hearts are for us. All of you, who in the dense struggle of this life belong to the vast army of the toiling and oppressed – amongst the rich and envied of this world just as much as amongst the poor – you all thirst to drink from the fountain of youth which gives eternal beauty and truth. You are all our natural allies in the great struggle that we are waging. On us it falls to march ahead of you. You may rely upon our loyalty to the flag, for we have dedicated all our energy and hopes for the future, and everything that we are, to the 'SACRED SPRING'.

3

Notes of a Painter

Henri Matisse

A painter who addresses the public not just in order to present his works, but to reveal some of his ideas on the art of painting, exposes himself to several dangers.

In the first place, knowing that many people like to think of painting as an appendage of literature and therefore want it to express not general ideas suited to pictorial means, but specifically literary ideas, I fear that one will look with astonishment upon the painter who ventures to invade the domain of the literary man. As a matter of fact, I am fully aware that a painter's best spokesman is his work.

However, such painters as Signac, Desvallières, Denis, Blanche, Guérin and Bernard have written on such matters and been well received by various periodicals. Personally, I shall simply try to state my feelings and aspirations as a painter without worrying about the writing.

But now I forsee the danger of appearing to contradict myself. I feel very strongly the tie between my earlier and my recent works, but I do not think exactly the way I thought yesterday. Or rather, my basic idea has not changed, but my thought has evolved, and my modes of expression have followed my thoughts. I do not repudiate any of my paintings but there is not one of them that I would not redo differently, if I had it to redo. My destination is always the same but I work out a different route to get there.

Finally, if I mention the name of this or that artist it will be to point out how our manners differ, and it may seem that I am belittling his work. Thus I risk being accused of injustice towards painters whose aims and results I best understand, or whose accomplishments I most appreciate, whereas I will have used them as examples, not to establish my superiority over them, but to show more clearly, through what they have done, what I am attempting to do.

Henri Matisse, "Notes of a Painter" (originally published in 1908), pp. 35–40 from Jack D. Flam, *Matisse on Art*. Oxford: Phaidon, 1973. © 1973 by Phaidon Press Limited.

What I am after, above all, is expression. Sometimes it has been conceded that I have a certain technical ability but that all the same my ambition is limited, and does not go beyond the purely visual satisfaction such as can be obtained from looking at a picture. But the thought of a painter must not be considered as separate from his pictorial means, for the thought is worth no more than its expression by the means, which must be more complete (and by complete I do not mean complicated) the deeper is his thought. I am unable to distinguish between the feeling I have about life and my way of translating it.

Expression, for me, does not reside in passions glowing in a human face or manifested by violent movement. The entire arrangement of my picture is expressive: the place occupied by the figures, the empty spaces around them, the proportions, everything has its share. Composition is the art of arranging in a decorative manner the diverse elements at the painter's command to express his feelings. In a picture every part will be visible and will play its appointed role, whether it be principal or secondary. Everything that is not useful in the picture is, it follows, harmful. A work of art must be harmonious in its entirety: any superfluous detail would replace some other essential detail in the mind of the spectator.

Composition, the aim of which should be expression, is modified according to the surface to be covered. If I take a sheet of paper of a given size, my drawing will have a necessary relationship to its format. I would not repeat this drawing on another sheet of different proportions, for example, rectangular instead of square. Nor should I be satisfied with a mere enlargement, had I to transfer the drawing to a sheet the same shape, but ten times larger. A drawing must have an expansive force which gives life to the things around it. An artist who wants to transpose a composition from one canvas to another larger one must conceive it anew in order to preserve its expression; he must alter its character and not just square it up onto the larger canvas.

Both harmonies and dissonances of colour can produce agreeable effects. Often when I start to work I record fresh and superficial sensations during the first session. A few years ago I was sometimes satisfied with the result. But today if I were satisfied with this, now that I think I can see further, my picture would have a vagueness in it: I should have recorded the fugitive sensations of a moment which could not completely define my feelings and which I should barely recognize the next day.

I want to reach that state of condensation of sensations which makes a painting. I might be satisfied with a work done at one sitting, but I would soon tire of it; therefore, I prefer to rework it so that later I may recognize it as representative of my state of mind. There was a time when I never left my paintings hanging on the wall because they reminded me of moments of over-excitement and I did not like to see them again when I was calm. Nowadays I try to put serenity into my pictures and re-work them as long as I have not succeeded.

Suppose I want to paint a woman's body: first of all I imbue it with grace and charm, but I know that I must give something more. I will condense the meaning of this body by seeking its essential lines. The charm will be less apparent at first

glance, but it must eventually emerge from the new image which will have a broader meaning, one more fully human. The charm will be less striking since it will not be the sole quality of the painting, but it will not exist less for its being contained within the general conception of the figure.

Charm, lightness, freshness – such fleeting sensations. I have a canvas on which the colours are still fresh and I begin to work on it again. The tone will no doubt become duller. I will replace my original tone with one of greater density, an improvement, but less seductive to the eye.

The Impressionist painters, especially Monet and Sisley, had delicate sensations, quite close to each other: as a result their canvases all look alike. The word 'impressionism' perfectly characterizes their style, for they register fleeting impressions. It is not an appropriate designation for certain more recent painters who avoid the first impression, and consider it almost dishonest. A rapid rendering of a landscape represents only one moment of its existence [*durée*]. I prefer, by insisting upon its essential character, to risk losing charm in order to obtain greater stability.

Underlying this succession of moments which constitutes the superficial existence of beings and things, and which is continually modifying and transforming them, one can search for a truer, more essential character, which the artist will seize so that he may give to reality a more lasting interpretation. When we go into the seventeenth- and eighteenth-century sculpture rooms in the Louvre and look, for example, at a Puget, we can see that the expression is forced and exaggerated to the point of being disquieting. It is quite a different matter if we go to the Luxembourg; the attitude in which the sculptors catch their models is always the one in which the development of the members and tensions of the muscles will be shown to greatest advantage. And yet movement thus understood corresponds to nothing in nature: when we capture it by surprise in a snapshot, the resulting image reminds us of nothing that we have seen. Movement seized while it is going on is meaningful to us only if we do not isolate the present sensation either from that which precedes it or that which follows it.

There are two ways of expressing things; one is to show them crudely, the other is to evoke them through art. By removing oneself from the literal *representation* of movement one attains greater beauty and grandeur. Look at an Egyptian statue: it looks rigid to us, yet we sense in it the image of a body capable of movement and which, despite its rigidity, is animated. The Greeks too are calm: a man hurling a discus will be caught at the moment in which he gathers his strength, or at least, if he is shown in the most strained and precarious position implied by his action, the sculptor will have epitomized and condensed it so that equilibrium is re-established, thereby suggesting the idea of duration. Movement is in itself unstable and is not suited to something durable like a statue, unless the artist is aware of the entire action of which he represents only a moment.

I must precisely define the character of the object or of the body that I wish to paint. To do so, I study my method very closely: If I put a black dot on a sheet of white paper, the dot will be visible no matter how far away I hold it: it is a clear

notation. But beside this dot I place another one, and then a third, and already there is confusion. In order for the first dot to maintain its value I must enlarge it as I put other marks on the paper.

If upon a white canvas I set down some sensations of blue, of green, of red, each new stroke diminishes the importance of the preceding ones. Suppose I have to paint an interior: I have before me a cupboard; it gives me a sensation of vivid red, and I put down a red which satisfies me. A relation is established between this red and the white of the canvas. Let me put a green near the red, and make the floor yellow; and again there will be relationships between the green or yellow and the white of the canvas which will satisfy me. But these different tones mutually weaken one another. It is necessary that the various marks I use be balanced so that they do not destroy each other. To do this I must organize my ideas; the relationship between the tones must be such that it will sustain and not destroy them. A new combination of colours will succeed the first and render the totality of my representation. I am forced to transpose until finally my picture may seem completely changed when, after successive modifications, the red has succeeded the green as the dominant colour. I cannot copy nature in a servile way; I am forced to interpret nature and submit it to the spirit of the picture. From the relationship I have found in all the tones there must result a living harmony of colours, a harmony analogous to that of a musical composition.

For me all is in the conception. I must therefore have a clear vision of the whole from the beginning. I could mention a great sculptor who gives us some admirable pieces: but for him a composition is merely a grouping of fragments, which results in a confusion of expression. Look instead at one of Cézanne's pictures: all is so well arranged that no matter at what distance you stand or how many figures are represented you will always be able to distinguish each figure clearly and to know which limb belongs to which body. If there is order and clarity in the picture, it means that from the outset this same order and clarity existed in the mind of the painter, or that the painter was conscious of their necessity. Limbs may cross and intertwine, but in the eyes of the spectator they will nevertheless remain attached to and help to articulate the right body: all confusion has disappeared.

The chief function of colour should be to serve expression as well as possible. I put down my tones without a preconceived plan. If at first, and perhaps without my having been conscious of it, one tone has particularly seduced or caught me, more often than not once the picture is finished I will notice that I have respected this tone while I progressively altered and transformed all the others. The expressive aspect of colours imposes itself on me in a purely instinctive way. To paint an autumn landscape I will not try to remember what colours suit this season, I will be inspired only by the sensation that the season arouses in me: the icy purity of the sour blue sky will express the season just as well as the nuances of foliage. My sensation itself may vary, the autumn may be soft and warm like a continuation of summer, or quite cool with a cold sky and lemon-yellow trees that give a chilly impression and already announce winter.

My choice of colours does not rest on any scientific theory; it is based on observation, on sensitivity, on felt experiences. Inspired by certain pages of Delacroix, an artist like Signac is preoccupied with complementary colours, and the theoretical knowledge of them will lead him to use a certain tone in a certain place. But I simply try to put down colours which render my sensation. There is an impelling proportion of tones that may lead me to change the shape of a figure or to transform my composition. Until I have achieved this proportion in all the parts of the composition I strive towards it and keep on working. Then a moment comes when all the parts have found their definite relationships, and from then on it would be impossible for me to add a stroke to my picture without having to repaint it entirely.

In reality, I think that the very theory of complementary colours is not absolute. In studying the paintings of artists whose knowledge of colours depends upon instinct and feeling, and on a constant analogy with their sensations, one could define certain laws of colour and so broaden the limits of colour theory as it is now defined.

What interests me most is neither still life nor landscape, but the human figure. It is that which best permits me to express my almost religious awe towards life. I do not insist upon all the details of the face, on setting them down one-by-one with anatomical exactitude. If I have an Italian model who at first appearance suggests nothing but a purely animal existence, I nevertheless discover his essential qualities, I penetrate amid the lines of the face those which suggest the deep gravity which persists in every human being. A work of art must carry within itself its complete significance and impose that upon the beholder even before he recognizes the subject matter. When I see the Giotto frescoes at Padua I do not trouble myself to recognize which scene of the life of Christ I have before me, but I immediately understand the sentiment which emerges from it, for it is in the lines, the composition, the colour. The title will only serve to confirm my impression.

What I dream of is an art of balance, of purity and serenity, devoid of troubling or depressing subject matter, an art which could be for every mental worker, for the businessman as well as the man of letters, for example, a soothing, calming influence on the mind, something like a good armchair which provides relaxation from physical fatigue.

Often a discussion arises as to the value of different processes, and their relationship to different temperaments. A distinction is made between painters who work directly from nature and those who work purely from imagination. Personally, I think neither of these methods must be preferred to the exclusion of the other. Both may be used in turn by the same individual, either because he needs contact with objects in order to receive sensations that will excite his creative faculty, or his sensations are already organized. In either case he will be able to arrive at that totality which constitutes a picture. In any event I think that one can judge the vitality and power of an artist who, after having received impressions directly from the spectacle of nature, is able to organize his sensations

25

to continue his work in the same frame of mind on different days, and to develop these sensations; this power proves he is sufficiently master of himself to subject himself to discipline.

The simplest means are those which best enable an artist to express himself. If he fears the banal he cannot avoid it by appearing strange, or going in for bizarre drawing and eccentric colour. His means of expression must derive almost of necessity from his temperament. He must have the humility of mind to believe that he has painted only what he has seen. I like Chardin's way of expressing it: 'I apply colour until there is a resemblance.' Or Cézanne's: 'I want to secure a likeness', or Rodin's: 'Copy nature!' Leonardo said: 'He who can copy can create.' Those who work in a preconceived style, deliberately turning their backs on nature, miss the truth. An artist must recognize, when he is reasoning, that his picture is an artifice; but when he is painting, he should feel that he has copied nature. And even when he departs from nature, he must do it with the conviction that it is only to interpret her more fully.

Some may say that other views on painting were expected from a painter, and that I have only come out with platitudes. To this I shall reply that there are no new truths. The role of the artist, like that of the scholar, consists of seizing current truths often repeated to him, but which will take on new meaning for him and which he will make his own when he has grasped their deepest significance. If aviators had to explain to us the research which led to their leaving earth and rising in the air, they would merely confirm very elementary principles of physics neglected by less successful inventors.

An artist always profits from information about himself, and I am glad to have learned what is my weak point. M. Péladan in the *Revue Hébdomadaire* reproaches a certain number of painters, amongst whom I think I should place myself, for calling themselves 'Fauves', and yet dressing like everyone else, so that they are no more noticeable than the floor-walkers in a department store. Does genius count for so little? If it were only a question of myself that would set M. Péladan's mind at ease, tomorrow I would call myself Sar and dress like a necromancer.

In the same article this excellent writer claims that I do not paint honestly, and I would be justifiably angry if he had not qualified his statement by saying, 'I mean honestly with respect to the ideal and the rules.' The trouble is that he does not mention where these rules are. I am willing to have them exist, but were it possible to learn them what sublime artists we would have!

Rules have no existence outside of individuals: otherwise a good professor would be as great a genius as Racine. Any one of us is capable of repeating fine maxims, but few can also penetrate their meaning. I am ready to admit that from a study of the works of Raphael or Titian a more complete set of rules can be drawn than from the works of Manet or Renoir, but the rules followed by Manet and Renoir were those which suited their temperaments and I prefer the most minor of their paintings to all the work of those who are content to imitate the *Venus of Urbino* or the *Madonna of the Goldfinch*. These latter are of no value to anyone,

for whether we want to or not, we belong to our time and we share in its opinions, its feelings, even its delusions. All artists bear the imprint of their time, but the great artists are those in whom this is most profoundly marked. Our epoch for instance is better represented by Courbet than by Flandrin, by Rodin better than by Frémiet. Whether we like it or not, however insistently we call ourselves exiles, between our period and ourselves an indissoluble bond is established, and M. Péladan himself cannot escape it. The aestheticians of the future may perhaps use his books as evidence if they get it in their heads to prove that no one of our time understood anything about the art of Leonardo da Vinci.

4

The Founding and Manifesto of Futurism

F. T. Marinetti

We had stayed up all night, my friends and I, under hanging mosque lamps with domes of filigreed brass, domes starred like our spirits, shining like them with the prisoned radiance of electric hearts. For hours we had trampled our atavistic ennui into rich oriental rugs, arguing up to the last confines of logic and blackening many reams of paper with our frenzied scribbling.

An immense pride was buoying us up, because we felt ourselves alone at that hour, alone, awake, and on our feet, like proud beacons or forward sentries against an army of hostile stars glaring down at us from their celestial encampments. Alone with stokers feeding the hellish fires of great ships, alone with the black spectres who grope in the red-hot bellies of locomotives launched down their crazy courses, alone with drunkards reeling like wounded birds along the city walls.

Suddenly we jumped, hearing the mighty noise of the huge double-decker trams that rumbled by outside, ablaze with coloured lights, like villages on holiday suddenly struck and uprooted by the flooding Po and dragged over falls and through gorges to the sea.

Then the silence deepened. But, as we listened to the old canal muttering its feeble prayers and the creaking bones of sickly palaces above their damp green beards, under the windows we suddenly heard the famished roar of automobiles.

'Let's go!' I said. 'Friends, away! Let's go! Mythology and the Mystic Ideal are defeated at last. We're about to see the Centaur's birth and, soon after, the first flight of Angels! . . . We must shake the gates of life, test the bolts and hinges.

F. T. Marinetti, "The Founding and Manifesto of Futurism," originally published in *Le Figaro*, Feb. 20, 1909, and subsequently in R. W. Flint (ed.), *Marinetti: Selected Writings by F. T. Marinetti*, translated by R. W. Flint and Arthur A. Coppotelli. London: Farrar, Straus & Giroux, 1972. Translation copyright © 1972 by Farrar, Straus & Giroux, Inc. Reprinted by permission of Farrar, Straus and Giroux, LLC.

Let's go! Look there, on the earth, the very first dawn! There's nothing to match the splendour of the sun's red sword, slashing for the first time through our millennial gloom!'

We went up to the three snorting beasts, to lay amorous hands on their torrid breasts. I stretched out on my car like a corpse on its bier, but revived at once under the steering wheel, a guillotine blade that threatened my stomach.

The raging broom of madness swept us out of ourselves and drove us through streets as rough and deep as the beds of torrents. Here and there, sick lamplight through window glass taught us to distrust the deceitful mathematics of our perishing eyes.

I cried, 'The scent, the scent alone is enough for our beasts.'

And like young lions we ran after Death, its dark pelt blotched with pale crosses as it escaped down the vast violet living and throbbing sky.

But we had no ideal Mistress raising her divine form to the clouds, nor any cruel Queen to whom to offer our bodies, twisted like Byzantine rings! There was nothing to make us wish for death, unless the wish to be free at last from the weight of our courage!

And on we raced, hurling watchdogs against doorsteps, curling them under our burning tyres like collars under a flatiron. Death, domesticated, met me at every turn, gracefully holding out a paw, or once in a while hunkering down, making velvety caressing eyes at me from every puddle.

'Let's break out of the horrible shell of wisdom and throw ourselves like pride-ripened fruit into the wide, contorted mouth of the wind! Let's give ourselves utterly to the Unknown, not in desperation but only to replenish the deep wells of the Absurd!'

The words were scarcely out of my mouth when I spun my car around with the frenzy of a dog trying to bite its tail, and there, suddenly, were two cyclists coming towards me, shaking their fists, wobbling like two equally convincing but nevertheless contradictory arguments. Their stupid dilemma was blocking my way – Damn! Ouch! . . . I stopped short and to my disgust rolled over into a ditch with my wheels in the air. . . .

O maternal ditch, almost full of muddy water! Fair factory drain! I gulped down your nourishing sludge; and I remembered the blessed black breast of my Sudanese nurse. . . . When I came up – torn, filthy, and stinking – from under the capsized car, I felt the white-hot iron of joy deliciously pass through my heart!

A crowd of fishermen with handlines and gouty naturalists were already swarming around the prodigy. With patient, loving care those people rigged a tall derrick and iron grapnels to fish out my car, like a big beached shark. Up it came from the ditch, slowly, leaving in the bottom, like scales, its heavy framework of good sense and its soft upholstery of comfort.

They thought it was dead, my beautiful shark, but a caress from me was enough to revive it; and there it was, alive again, running on its powerful fins!

And so, faces smeared with good factory muck – plastered with metallic waste, with senseless sweat, with celestial soot – we, bruised, our arms in slings, but unafraid, declared our high intentions to all the *living* of the earth:

MANIFESTO OF FUTURISM
1. We intend to sing the love of danger, the habit of energy and fearlessness.
2. Courage, audacity, and revolt will be essential elements of our poetry.
3. Up to now literature has exalted a pensive immobility, ecstasy, and sleep. We intend to exalt aggressive action, a feverish insomnia, the racer's stride, the mortal leap, the punch and the slap.
4. We say that the world's magnificence has been enriched by a new beauty: the beauty of speed. A racing car whose hood is adorned with great pipes, like serpents of explosive breath – a roaring car that seems to ride on grapeshot is more beautiful than the *Victory of Samothrace.*
5. We want to hymn the man at the wheel, who hurls the lance of his spirit across the Earth, along the circle of its orbit.
6. The poet must spend himself with ardour, splendour, and generosity, to swell the enthusiastic fervour of the primordial elements.
7. Except in struggle, there is no more beauty. No work without an aggressive character can be a masterpiece. Poetry must be conceived as a violent attack on unknown forces, to reduce and prostrate them before man.
8. We stand on the last promontory of the centuries!... Why should we look back, when what we want is to break down the mysterious doors of the Impossible? Time and Space died yesterday. We already live in the absolute, because we have created eternal, omnipresent speed.
9. We will glorify war – the world's only hygiene – militarism, patriotism, the destructive gesture of freedom-bringers, beautiful ideas worth dying for, and scorn for woman.
10. We will destroy the museums, libraries, academies of every kind, will fight moralism, feminism, every opportunistic or utilitarian cowardice.
11. We will sing of great crowds excited by work, by pleasure, and by riot; we will sing of the multicoloured, polyphonic tides of revolution in the modern capitals; we will sing of the vibrant nightly fervour of arsenals and shipyards blazing with violent electric moons; greedy railway stations that devour smoke-plumed serpents; factories hung on clouds by the crooked lines of their smoke; bridges that stride the rivers like giant gymnasts, flashing in the sun with a glitter of knives; adventurous steamers that sniff the horizon; deep-chested locomotives whose wheels paw the tracks like the hooves of enormous steel horses bridled by tubing; and the sleek flight of planes whose propellers chatter in the wind like banners and seem to cheer like an enthusiastic crowd.

It is from Italy that we launch through the world this violently upsetting incendiary manifesto of ours. With it, today, we establish *Futurism*, because we want to

free this land from its smelly gangrene of professors, archaeologists, *ciceroni* and antiquarians. For too long has Italy been a dealer in second-hand clothes. We mean to free her from the numberless museums that cover her like so many graveyards.

Museums: cemeteries!...Identical, surely, in the sinister promiscuity of so many bodies unknown to one another. Museums: public dormitories where one lies forever beside hated or unknown beings. Museums: absurd abattoirs of painters and sculptors ferociously slaughtering each other with colour-blows and line-blows, the length of the fought-over walls!

That one should make an annual pilgrimage, just as one goes to the graveyard on All Souls' Day – that I grant. That once a year one should leave a floral tribute beneath the *Gioconda*, I grant you that...But I don't admit that our sorrows, our fragile courage, our morbid restlessness should be given a daily conducted tour through the museums. Why poison ourselves? Why rot?

And what is there to see in an old picture except the laborious contortions of an artist throwing himself against the barriers that thwart his desire to express his dream completely?...Admiring an old picture is the same as pouring our sensibility into a funerary urn instead of hurling it far off, in violent spasms of action and creation.

Do you, then, wish to waste all your best powers in this eternal and futile worship of the past, from which you emerge fatally exhausted, shrunken, beaten down?

In truth I tell you that daily visits to museums, libraries, and academies (cemeteries of empty exertion, Calvaries of crucified dreams, registries of aborted beginnings!) are, for artists, as damaging as the prolonged supervision by parents of certain young people drunk with their talent and their ambitious wills. When the future is barred to them, the admirable past may be a solace for the ills of the moribund, the sickly, the prisoner....But we want no part of it, the past, we the young and strong *Futurists*!

So let them come, the gay incendiaries with charred fingers! Here they are! Here they are!...Come on! set fire to the library shelves! Turn aside the canals to flood the museums!...Oh, the joy of seeing the glorious old canvases bobbing adrift on those waters, discoloured and shredded!...Take up your pickaxes, your axes and hammers and wreck, wreck the venerable cities, pitilessly!

The oldest of us is thirty: so we have at least a decade for finishing our work. When we are forty, other younger and stronger men will probably throw us in the wastebasket like useless manuscripts – we want it to happen!

They will come against us, our successors, will come from far away, from every quarter, dancing to the winged cadence of their first songs, flexing the hooked claws of predators, sniffing doglike at the academy doors the strong odour of our decaying minds, which will already have been promised to the literary catacombs.

But we won't be there....At last they'll find us – one winter's night – in open country, beneath a sad roof drummed by a monotonous rain. They'll see us

crouched beside our trembling aeroplanes in the act of warming our hands at the poor little blaze that our books of today will give out when they take fire from the flight of our images.

They'll storm around us, panting with scorn and anguish, and all of them, exasperated by our proud daring, will hurtle to kill us, driven by a hatred the more implacable the more their hearts will be drunk with love and admiration for us.

Injustice, strong and sane, will break out radiantly in their eyes.

Art, in fact, can be nothing but violence, cruelty, and injustice.

The oldest of us is thirty: even so we have already scattered treasures, a thousand treasures of force, love, courage, astuteness, and raw will-power; have thrown them impatiently away, with fury, carelessly, unhesitatingly, breathless, and unresting.... Look at us! We are still untired! Our hearts know no weariness because they are fed with fire, hatred, and speed!... Does that amaze you? It should, because you can never remember having lived! Erect on the summit of the world, once again we hurl our defiance at the stars!

You have objections? – Enough! Enough! We know them.... We've understood!... Our fine deceitful intelligence tells us that we are the revival and extension of our ancestors – Perhaps!... If only it were so! – But who cares? We don't want to understand!... Woe to anyone who says those infamous words to us again!

Lift up your heads!

Erect on the summit of the world, once again we hurl defiance to the stars!

5

Dada Manifesto

Hugo Ball

Dada is a new tendency in art. One can tell this from the fact that until now nobody knew anything about it, and tomorrow everyone in Zurich will be talking about it. Dada comes from the dictionary. It is terribly simple. In French it means "hobby horse." In German it means "good-by," "Get off my back," "Be seeing you sometime." In Romanian: "Yes, indeed, you are right, that's it. But of course, yes, definitely, right." And so forth.

An international word. Just a word, and the word a movement. Very easy to understand. Quite terribly simple. To make of it an artistic tendency must mean that one is anticipating complications. Dada psychology, dada Germany cum indigestion and fog paroxysm, dada literature, dada bourgeoisie, and yourselves, honored poets, who are always writing with words but never writing the word itself, who are always writing around the actual point. Dada world war without end, dada revolution without beginning, dada, you friends and also-poets, esteemed sirs, manufacturers, and evangelists. Dada Tzara, dada Huelsenbeck, dada m'dada, dada m'dada dada mhm, dada dera dada, dada Hue, dada Tza.

How does one achieve eternal bliss? By saying dada. How does one become famous? By saying dada. With a noble gesture and delicate propriety. Till one goes crazy. Till one loses consciousness. How can one get rid of everything that smacks of journalism, worms, everything nice and right, blinkered, moralistic, europeanized, enervated? By saying dada. Dada is the world soul, dada is the pawnshop. Dada is the world's best lily-milk soap. Dada Mr. Rubiner, dada Mr. Korrodi. Dada Mr. Anastasius Lilienstein.[1]

In plain language: the hospitality of the Swiss is something to be profoundly appreciated. And in questions of aesthetics the key is quality.

Hugo Ball, "Dada Manifesto" (originally published 1916), pp. 220–1 from John Elderfield (ed.), *Flight Out of Time: A Dada Diary by Hugo Ball*. Berkeley: University of California Press, 1996. First published in English by Viking Press 1974. Reprinted by permission of J. Christopher Middleton.

I shall be reading poems that are meant to dispense with conventional language, no less, and to have done with it. Dada Johann Fuchsgang Goethe. Dada Stendhal. Dada Dalai Lama, Buddha, Bible, and Nietzsche. Dada m'dada. Dada mhm dada da. It's a question of connections, and of loosening them up a bit to start with. I don't want words that other people have invented. All the words are other people's inventions. I want my own stuff, my own rhythm, and vowels and consonants too, matching the rhythm and all my own. If this pulsation is seven yards long, I want words for it that are seven yards long. Mr. Schulz's words are only two and a half centimeters long.

It will serve to show how articulated language comes into being. I let the vowels fool around. I let the vowels quite simply occur, as a cat miaows. . . . Words emerge, shoulders of words, legs, arms, hands of words. Au, oi, uh. One shouldn't let too many words out. A line of poetry is a chance to get rid of all the filth that clings to this accursed language,[2] as if put there by stockbrokers' hands, hands worn smooth by coins. I want the word where it ends and begins. Dada is the heart of words.

Each thing has its word, but the word has become a thing by itself. Why shouldn't find it? Why can't a tree be called Pluplusch, and Pluplubasch when it has been raining? The word, the word, the word outside your domain, your stuffiness, this laughable impotence, your stupendous smugness, outside all the parrotry of your self-evident limitedness. The word, gentlemen, is a public concern of the first importance.

Notes

1 A comparison with Ball's manuscript shows that he had originally added Marinetti's name here but crossed it out when revising the text.
2 Near this point, Ball added between the lines of his manuscript a phrase meaning "Here I wanted to drop language itself." It is omitted here because its intended position is uncertain.

6

The Work Ahead of Us

Vladimir Tatlin

The foundation on which our work in plastic art – our craft – rested was not homogeneous, and every connection between painting, sculpture and architecture had been lost: the result was individualism, i.e. the expression of purely personal habits and tastes; while the artists, in their approach to the material, degraded it to a sort of distortion in relation to one or another field of plastic art. In the best event, artists thus decorated the walls of private houses (individual nests) and left behind a succession of "Yaroslav Railway Stations" and a variety of now ridiculous forms.

What happened from the social aspect in 1917 was realized in our work as pictorial artists in 1914, when "materials, volume and construction" were accepted as our foundations.

We declare our distrust of the eye, and place our sensual impressions under control.

In 1915 an exhibition of material models on the laboratory scale was held in Moscow (an exhibition of reliefs and contre-reliefs). An exhibition held in 1917 presented a number of examples of material combinations, which were the results of more complicated investigations into the use of material in itself and what this leads to: movement, tension, and a mutual relationship between.

This investigation of material, volume and construction made it possible for us in 1918, in an artistic form, to begin to combine materials like iron and glass, the materials of modern Classicism, comparable in their severity with the marble of antiquity.

In this way an opportunity emerges of uniting purely artistic forms with utilitarian intentions. An example is the project for a monument to the Third International (exhibited at the Eighth Congress).

The results of this are models which stimulate us to inventions in our work of creating a new world, and which call upon the producers to exercise control over the forms encountered in our new everyday life.

Vladimir Tatlin, "The Work Ahead of Us" (originally published 1920), pp. 206–7 in John E. Bowlt (ed. and trans.), *Russian Art of the Avant-Garde: Theory and Criticism, 1902–1934* (revised and enlarged edition). London: Thames and Hudson, 1991. First published in English by The Viking Press in *The Documents of 20ᵗʰ-Century Art* series, 1976. Reprinted by permission of Thames and Hudson Ltd.

7

First Manifesto of Surrealism

André Breton

So strong is the belief in life, in what is most fragile in life – *real* life, I mean – that in the end this belief is lost. Man, that inveterate dreamer, daily more discontent with his destiny, has trouble assessing the objects he has been led to use, objects that his nonchalance has brought his way, or that he has earned through his own efforts, almost always through his own efforts, for he has agreed to work, at least he has not refused to try his luck (or what he calls his luck!). At this point he feels extremely modest: he knows what women he has had, what silly affairs he has been involved in; he is unimpressed by his wealth or poverty, in this respect he is still a newborn babe and, as for the approval of his conscience, I confess that he does very nicely without it. If he still retains a certain lucidity, all he can do is turn back toward his childhood which, however his guides and mentors may have botched it, still strikes him as somehow charming. There, the absence of any known restrictions allows him the perspective of several lives lived at once; this illusion becomes firmly rooted within him; now he is only interested in the fleeting, the extreme facility of everything. Children set off each day without a worry in the world. Everything is near at hand, the worst material conditions are fine. The woods are white or black, one will never sleep.

But it is true that we would not dare venture so far, it is not merely a question of distance. Threat is piled upon threat, one yields, abandons a portion of the terrain to be conquered. This imagination which knows no bounds is henceforth allowed to be exercised only in strict accordance with the laws of an arbitrary utility; it is incapable of assuming this inferior role for very long and, in the vicinity of the twentieth year, generally prefers to abandon man to his lusterless fate.

André Breton, pp. 3–6, 9–14, 15–16, 21–7, 29–30, 36–40, and 47 from "[First] Manifesto of Surrealism" (originally published 1924) in André Breton, *Manifestoes of Surrealism*, trans. Richard Seaver and Helen R. Lane. Ann Arbor: University of Michigan Press, 1972. Reprinted by permission of University of Michigan Press.

Though he may later try to pull himself together upon occasion, having felt that he is losing by slow degrees all reason for living, incapable as he has become of being able to rise to some exceptional situation such as love, he will hardly succeed. This is because he henceforth belongs body and soul to an imperative practical necessity which demands his constant attention. None of his gestures will be expansive, none of his ideas generous or far-reaching. In his mind's eye, events real or imagined will be seen only as they relate to a welter of similar events, events in which he has not participated, *abortive* events. What am I saying: he will judge them in relationship to one of these events whose consequences are more reassuring than the others. On no account will he view them as his salvation.

Beloved imagination, what I most like in you is your unsparing quality.

The mere word "freedom" is the only one that still excites me. I deem it capable of indefinitely sustaining the old human fanaticism. It doubtless satisfies my only legitimate aspiration. Among all the many misfortunes to which we are heir, it is only fair to admit that we are allowed the greatest degree of freedom of thought. It is up to us not to misuse it. To reduce the imagination to a state of slavery – even though it would mean the elimination of what is commonly called happiness – is to betray all sense of absolute justice within oneself. Imagination alone offers me some intimation of what *can be*, and this is enough to remove to some slight degree the terrible injunction; enough, too, to allow me to devote myself to it without fear of making a mistake (as though it were possible to make a bigger mistake). Where does it begin to turn bad, and where does the mind's stability cease? For the mind, is the possibility of erring not rather the contingency of good?

There remains madness, "the madness that one locks up," as it has aptly been described. That madness or another.... We all know, in fact, that the insane owe their incarceration to a tiny number of legally reprehensible acts and that, were it not for these acts their freedom (or what we see as their freedom) would not be threatened. I am willing to admit that they are, to some degree, victims of their imagination, in that it induces them not to pay attention to certain rules – outside of which the species feels itself threatened – which we are all supposed to know and respect. But their profound indifference to the way in which we judge them, and even to the various punishments meted out to them, allows us to suppose that they derive a great deal of comfort and consolation from their imagination, that they enjoy their madness sufficiently to endure the thought that its validity does not extend beyond themselves. And, indeed, hallucinations, illusions, etc., are not a source of trifling pleasure. The best controlled sensuality partakes of it, and I know that there are many evenings when I would gladly tame that pretty hand which, during the last pages of Taine's *L'Intelligence*, indulges in some curious misdeeds. I could spend my whole life prying loose the secrets of the insane. These people are honest to a fault, and their naiveté has no peer but my own. Christopher Columbus should have set out to discover America with a boatload of madmen. And note how this madness has taken shape, and endured.

It is not the fear of madness which will oblige us to leave the flag of imagination furled. [...]

We are still living under the reign of logic: this, of course, is what I have been driving at. But in this day and age logical methods are applicable only to solving problems of secondary interest. The absolute rationalism that is still in vogue allows us to consider only facts relating directly to our experience. Logical ends, on the contrary, escape us. It is pointless to add that experience itself has found itself increasingly circumscribed. It paces back and forth in a cage from which it is more and more difficult to make it emerge. It too leans for support on what is most immediately expedient, and it is protected by the sentinels of common sense. Under the pretense of civilization and progress, we have managed to banish from the mind everything that may rightly or wrongly be termed superstition, or fancy; forbidden is any kind of search for truth which is not in conformance with accepted practices. It was, apparently, by pure chance that a part of our mental world which we pretended not to be concerned with any longer – and, in my opinion by far the most important part – has been brought back to light. For this we must give thanks to the discoveries of Sigmund Freud. On the basis of these discoveries a current of opinion is finally forming by means of which the human explorer will be able to carry his investigations much further, authorized as he will henceforth be not to confine himself solely to the most summary realities. The imagination is perhaps on the point of reasserting itself, of reclaiming its rights. If the depths of our mind contain within it strange forces capable of augmenting those on the surface, or of waging a victorious battle against them, there is every reason to seize them – first to seize them, then, if need be, to submit them to the control of our reason. The analysts themselves have everything to gain by it. But it is worth noting that no means has been designated a priori for carrying out this undertaking, that until further notice it can be construed to be the province of poets as well as scholars, and that its success is not dependent upon the more or less capricious paths that will be followed.

Freud very rightly brought his critical faculties to bear upon the dream. It is, in fact, inadmissible that this considerable portion of psychic activity (since, at least from man's birth until his death, thought offers no solution of continuity, the sum of the moments of dream, from the point of view of time, and taking into consideration only the time of pure dreaming, that is the dreams of sleep, is not inferior to the sum of the moments of reality, or, to be more precisely limiting, the moments of waking) has still today been so grossly neglected. I have always been amazed at the way an ordinary observer lends so much more credence and attaches so much more importance to waking events than to those occurring in dreams. It is because man, when he ceases to sleep, is above all the plaything of his memory, and in its normal state memory takes pleasure in weakly retracing for him the circumstances of the dream, in stripping it of any real importance, and in dismissing the only *determinant* from the point where he thinks he has left it a few

hours before: this firm hope, this concern. He is under the impression of continuing something that is worthwhile. Thus the dream finds itself reduced to a mere parenthesis, as is the night. And, like the night, dreams generally contribute little to furthering our understanding. This curious state of affairs seems to me to call for certain reflections:

1) Within the limits where they operate (or are thought to operate) dreams give every evidence of being continuous and show signs of organization. Memory alone arrogates to itself the right to excerpt from dreams, to ignore the transitions, and to depict for us rather a series of dreams than the *dream itself*. By the same token, at any given moment we have only a distinct notion of realities, the coordination of which is a question of will.[1] What is worth noting is that nothing allows us to presuppose a greater dissipation of the elements of which the dream is constituted. I am sorry to have to speak about it according to a formula which in principle excludes the dream. When will we have sleeping logicians, sleeping philosophers? I would like to sleep, in order to surrender myself to the dreamers, the way I surrender myself to those who read me with eyes wide open; in order to stop imposing, in this realm, the conscious rhythm of my thought. Perhaps my dream last night follows that of the night before, and will be continued the next night, with an exemplary strictness. *It's quite possible*, as the saying goes. And since it has not been proved in the slightest that, in doing so, the "reality" with which I am kept busy continues to exist in the state of dream, that it does not sink back down into the immemorial, why should I not grant to dreams what I occasionally refuse reality, that is, this value of certainty in itself which, in its own time, is not open to my repudiation? Why should I not expect from the sign of the dream more than I expect from a degree of consciousness which is daily more acute? Can't the dream also be used in solving the fundamental questions of life? Are these questions the same in one case as in the other and, in the dream, do these questions already exist? Is the dream any less restrictive or punitive than the rest? I am growing old and, more than that reality to which I believe I subject myself, it is perhaps the dream, the difference with which I treat the dream, which makes me grow old.

2) Let me come back again to the waking state. I have no choice but to consider it a phenomenon of interference. Not only does the mind display, in this state, a strange tendency to lose its bearings (as evidenced by the slips and mistakes the secrets of which are just beginning to be revealed to us), but, what is more, it does not appear that, when the mind is functioning normally, it really responds to anything but the suggestions which come to it from the depths of that dark night to which I commend it. However conditioned it may be, its balance is relative. It

[1] Account must be taken of the *depth* of the dream. For the most part I retain only what I can glean from its most superficial layers. What I most enjoy contemplating about a dream is everything that sinks back below the surface in a waking state, everything I have forgotten about my activities in the course of the preceding day, dark foliage, stupid branches. In "reality," likewise, I prefer to *fall*.

39

scarcely dares express itself and, if it does, it confines itself to verifying that such and such an idea, or such and such a woman, has made an impression on it. What impression it would be hard pressed to say, by which it reveals the degree of its subjectivity, and nothing more. This idea, this woman, disturb it, they tend to make it less severe. What they do is isolate the mind for a second from its solvent and spirit it to heaven, as the beautiful precipitate it can be, that it is. When all else fails, it then calls upon chance, a divinity even more obscure than the others to whom it ascribes all its aberrations. Who can say to me that the angle by which that idea which affects it is offered, that what it likes in the eye of that woman is not precisely what links it to its dream, binds it to those fundamental facts which, through its own fault, it has lost? And if things were different, what might it be capable of? I would like to provide it with the key to this corridor.

3) The mind of the man who dreams is fully satisfied by what happens to him. The agonizing question of possibility is no longer pertinent. Kill, fly faster, love to your heart's content. And if you should die, are you not certain of reawaking among the dead? Let yourself be carried along, events will not tolerate your interference. You are nameless. The ease of everything is priceless.

What reason, I ask, a reason so much vaster than the other, makes dreams seem so natural and allows me to welcome unreservedly a welter of episodes so strange that they would confound me now as I write? And yet I can believe my eyes, my ears; this great day has arrived, this beast has spoken.

If man's awaking is harder, if it breaks the spell too abruptly, it is because he has been led to make for himself too impoverished a notion of atonement.

4) From the moment when it is subjected to a methodical examination, when, by means yet to be determined, we succeed in recording the contents of dreams in their entirety (and that presupposes a discipline of memory spanning generations; but let us nonetheless begin by noting the most salient facts), when its graph will expand with unparalleled volume and regularity, we may hope that the mysteries which really are not will give way to the great Mystery. I believe in the future resolution of these two states, dream and reality, which are seemingly so contra-dictory, into a kind of absolute reality, a *surreality*, if one may so speak. It is in quest of this surreality that I am going, certain not to find it but too unmindful of my death not to calculate to some slight degree the joys of its possession.

A story is told according to which Saint-Pol-Roux, in times gone by, used to have a notice posted on the door of his manor house in Camaret, every evening before he went to sleep, which read: THE POET IS WORKING.

A great deal more could be said, but in passing I merely wanted to touch upon a subject which in itself would require a very long and much more detailed discussion; I shall come back to it. At this juncture, my intention was merely to mark a point by noting the *hate of the marvelous* which rages in certain men, this absurdity beneath which they try to bury it. Let us not mince words: the marvelous is always beautiful, anything marvelous is beautiful, in fact only the marvelous is beautiful. [. . .]

At an early age children are weaned on the marvelous, and later on they fail to retain a sufficient virginity of mind to thoroughly enjoy fairy tales. No matter how charming they may be, a grown man would think he were reverting to childhood by nourishing himself on fairy tales, and I am the first to admit that all such tales are not suitable for him. The fabric of adorable improbabilities must be made a trifle more subtle the older we grow, and we are still at the stage of waiting for this kind of spider. . . . But the faculties do not change radically. Fear, the attraction of the unusual, chance, the taste for things extravagant are all devices which we can always call upon without fear of deception. There are fairy tales to be written for adults, fairy tales still almost blue.

The marvelous is not the same in every period of history: it partakes in some obscure way of a sort of general revelation only the fragments of which come down to us: they are the romantic *ruins*, the modern *mannequin*, or any other symbol capable of affecting the human sensibility for a period of time. In these areas which make us smile, there is still portrayed the incurable human restlessness, and this is why I take them into consideration and why I judge them inseparable from certain productions of genius which are, more than the others, painfully afflicted by them. They are Villon's gibbets, Racine's Greeks, Baudelaire's couches. [. . .]

One evening [. . .] before I fell asleep, I perceived, so clearly articulated that it was impossible to change a word, but nonetheless removed from the sound of any voice, a rather strange phrase which came to me without any apparent relationship to the events in which, my consciousness agrees, I was then involved, a phrase which seemed to me insistent, a phrase, if I may be so bold, *which was knocking at the window.* I took cursory note of it and prepared to move on when its organic character caught my attention. Actually, this phrase astonished me: unfortunately I cannot remember it exactly, but it was something like: "There is a man cut in two by the window," but there could be no question of ambiguity, accompanied as it was by the faint visual image[2] of a man walking cut half way up by a window perpendicular to the axis of his body. Beyond the slightest shadow of a doubt,

[2] Were I a painter, this visual depiction would doubtless have become more important for me than the other. It was most certainly my previous predispositions which decided the matter. Since that day, I have had occasion to concentrate my attention voluntarily on similar apparitions, and I know that they are fully as clear as auditory phenomena. With a pencil and white sheet of paper to hand, I could easily trace their outlines. Here again it is not a matter of drawing, *but simply of tracing.* I could thus depict a tree, a wave, a musical instrument, all manner of things of which I am presently incapable of providing even the roughest sketch. I would plunge into it, convinced that I would find my way again, in a maze of lines which at first glance would seem to be going nowhere. And, upon opening my eyes, I would get the very strong impression of something "never seen." The proof of what I am saying has been provided many times by Robert Desnos: to be convinced, one has only to leaf through the pages of issue number 36 of *Feuilles libres* which contains several of his drawings (*Romeo and Juliet, A Man Died This Morning,* etc.) which were taken by this magazine as the drawings of a madman and published as such.

what I saw was the simple reconstruction in space of a man leaning out a window. But this window having shifted with the man, I realized that I was dealing with an image of a fairly rare sort, and all I could think of was to incorporate it into my material for poetic construction. No sooner had I granted it this capacity than it was in fact succeeded by a whole series of phrases, with only brief pauses between them, which surprised me only slightly less and left me with the impression of their being so gratuitous that the control I had then exercised upon myself seemed to me illusory and all I could think of was putting an end to the interminable quarrel raging within me.[3]

Completely occupied as I still was with Freud at that time, and familiar as I was with his methods of examination which I had had some slight occasion to use on some patients during the war, I resolved to obtain from myself what we were trying to obtain from them, namely, a monologue spoken as rapidly as possible without any intervention on the part of the critical faculties, a monologue consequently unencumbered by the slightest inhibition and which was, as closely as possible, akin to *spoken thought*. It had seemed to me, and still does – the way in which the phrase about the man cut in two had come to me is an indication of it – that the speed of thought is no greater than the speed of speech, and that thought does not necessarily defy language, nor even the fast-moving pen. It was in this frame of mind that Philippe Soupault – to whom I had confided these initial conclusions – and I decided to blacken some paper, with a praiseworthy disdain for what might result from a literary point of view. The ease of execution did the rest. By the end of the first day we were able to read to ourselves some fifty or so pages obtained in this manner, and begin to compare our results. All in all, Soupault's pages and mine proved to be remarkably similar: the same over-construction, shortcomings of a similar nature, but also, on both our parts,

[3] Knut Hamsum ascribes this sort of revelation to which I had been subjected as deriving from *hunger*, and he may not be wrong. (The fact is I did not eat every day during that period of my life). Most certainly the manifestations that he describes in these terms are clearly the same:

"The following day I awoke at an early hour. It was still dark. My eyes had been open for a long time when I heard the clock in the apartment above strike five. I wanted to go back to sleep, but I couldn't; I was wide awake and a thousand thoughts were crowding through my mind.

"Suddenly a few good fragments came to mind, quite suitable to be used in a rough draft, or serialized; all of a sudden I found, quite by chance, beautiful phrases, phrases such as I had never written. I repeated them to myself slowly, word by word; they were excellent. And there were still more coming. I got up and picked up a pencil and some paper that were on a table behind my bed. It was as though some vein had burst within me, one word followed another, found its proper place, adapted itself to the situation, scene piled upon scene, the action unfolded, one retort after another welled up in my mind, I was enjoying myself immensely. Thoughts came to me so rapidly and continued to flow so abundantly that I lost a whole host of delicate details, because my pencil could not keep up with them, and yet I went as fast as I could, my hand in constant motion, I did not lose a minute. The sentences continued to well up within me, I was pregnant with my subject."

Apollinaire asserted that Chirico's first paintings were done under the influence of cenesthesic disorders (migraines, colics, etc.).

the illusion of an extraordinary verve, a great deal of emotion, a considerable choice of images of a quality such that we would not have been capable of preparing a single one in longhand, a very special picturesque quality and, here and there, a strong comical effect. The only difference between our two texts seemed to me to derive essentially from our respective tempers, Soupault's being less static than mine, and, if he does not mind my offering this one slight criticism, from the fact that he had made the error of putting a few words by way of titles at the top of certain pages, I suppose in a spirit of mystification. On the other hand, I must give credit where credit is due and say that he constantly and vigorously opposed any effort to retouch or correct, however slightly, any passage of this kind which seemed to me unfortunate. In this he was, to be sure, absolutely right.[4] It is, in fact, difficult to appreciate fairly the various elements present; one may even go so far as to say that it is impossible to appreciate them at a first reading. To you who write, these elements are, on the surface, *as strange to you as they are to anyone else*, and naturally you are wary of them. Poetically speaking, what strikes you about them above all is their *extreme degree of immediate absurdity*, the quality of this absurdity, upon closer scrutiny, being to give way to everything admissible, everything legitimate in the world: the disclosure of a certain number of properties and of facts no less objective, in the final analysis, than the others.

In homage to Guillaume Apollinaire, who had just died and who, on several occasions, seemed to us to have followed a discipline of this kind, without however having sacrificed to it any mediocre literary means, Soupault and I baptized the new mode of pure expression which we had at our disposal and which we wished to pass on to our friends, by the name of SURREALISM. I believe that there is no point today in dwelling any further on this word and that the meaning we gave it initially has generally prevailed over its Apollinarian sense. To be even fairer, we could probably have taken over the word SUPERNATURALISM employed by Gérard de Nerval in his dedication to the *Filles de feu*.[5] It appears, in fact, that Nerval possessed to a tee the spirit with which we claim a kinship, Apollinaire having possessed, on the contrary, naught but *the letter*, still imperfect, of Surrealism, having shown himself powerless to give a valid theoretical idea of it. Here are two passages by Nerval which seem to me to be extremely significant in this respect:

[4] I believe more and more in the infallibility of my thought with respect to myself, and this is too fair. Nonetheless, with this *thought-writing*, where one is at the mercy of the first outside distraction, "ebullutions" can occur. It would be inexcusable for us to pretend otherwise. By definition, thought is strong, and incapable of catching itself in error. The blame for these obvious weaknesses must be placed on suggestions that come to it from without.

[5] And also by Thomas Carlyle in *Sartor Resartus* ([Book III] Chapter VIII, "Natural Supernaturalism"), 1833–4.

I am going to explain to you, my dear Dumas, the phenomenon of which you have spoken a short while ago. There are, as you know, certain storytellers who cannot invent without identifying with the characters their imagination has dreamt up. You may recall how convincingly our old friend Nodier used to tell how it had been his misfortune during the Revolution to be guillotined; one became so completely convinced of what he was saying that one began to wonder how he had managed to have his head glued back on

...And since you have been indiscreet enough to quote one of the sonnets composed in this SUPERNATURALISTIC dream-state, as the Germans would call it, you will have to hear them all. You will find them at the end of the volume. They are hardly any more obscure than Hegel's metaphysics or Swedenborg's MEMORABILIA, and would lose their charm if they were explained, if such were possible; at least admit the worth of the expression....[6]

Those who might dispute our right to employ the term SURREALISM in the very special sense that we understand it are being extremely dishonest, for there can be no doubt that this word had no currency before we came along. Therefore, I am defining it once and for all:

SURREALISM, *n.* Psychic automatism in its pure state, by which one proposes to express – verbally, by means of the written word, or in any other manner – the actual functioning of thought. Dictated by thought, in the absence of any control exercised by reason, exempt from any aesthetic or moral concern.

ENCYCLOPEDIA. *Philosophy.* Surrealism is based on the belief in the superior reality of certain forms of previously neglected associations, in the omnipotence of dream, in the disinterested play of thought. It tends to ruin once and for all all other psychic mechanisms and to substitute itself for them in solving all the principal problems of life. The following have performed acts of ABSOLUTE SURREALISM: Messrs. Aragon, Baron, Boiffard, Breton, Carrive, Crevel, Delteil, Desnos, Eluard, Gérard, Limbour, Malkine, Morise, Naville, Noll, Péret, Picon, Soupault, Vitrac.

They seem to be, up to the present time, the only ones, and there would be no ambiguity about it were it not for the case of Isidore Ducasse, about whom I lack information. And, of course, if one is to judge them only superficially by their results, a good number of poets could pass for Surrealists, beginning with Dante and, in his finer moments, Shakespeare. *In the course of the various attempts I have made to reduce what is, by breach of trust, called genius, I have found nothing which in the final analysis can be attributed to any other method than that.*

Young's *Nights* are Surrealist from one end to the other; unfortunately it is a priest who is speaking, a bad priest no doubt, but a priest nonetheless.

[6] See also *L'Idéoréalisme* by Saint-Pol-Roux.

Swift is Surrealist in malice,
Sade is Surrealist in sadism.
Chateaubriand is Surrealist in exoticism.
Constant is Surrealist in politics.
Hugo is Surrealist when he isn't stupid.
Desbordes-Valmore is Surrealist in love.
Bertrand is Surrealist in the past.
Rabbe is Surrealist in death.
Poe is Surrealist in adventure.
Baudelaire is Surrealist in morality.
Rimbaud is Surrealist in the way he lived, and elsewhere.
Mallarmé is Surrealist when he is confiding.
Jarry is Surrealist in absinthe.
Nouveau is Surrealist in the kiss.
Saint-Pol-Roux is Surrealist in his use of symbols.
Fargue is Surrealist in the atmosphere.
Vaché is Surrealist in me.
Reverdy is Surrealist at home.
Saint-Jean-Perse is Surrealist at a distance.
Roussel is Surrealist as a storyteller.
Etc.

I would like to stress this point: they are not always Surrealists, in that I discern in each of them a certain number of preconceived ideas to which – very naively! – they hold. They hold to them because they had not *heard the Surrealist voice,* the one that continues to preach on the eve of death and above the storms, because they did not want to serve simply to orchestrate the marvelous score. They were instruments too full of pride, and this is why they have not always produced a harmonious sound.[7] [...]

SECRETS OF THE MAGICAL SURREALIST ART

Written Surrealist composition
or
first and last draft

After you have settled yourself in a place as favorable as possible to the concentration of your mind upon itself, have writing materials brought to you. Put yourself in as passive, or receptive, a state of mind as you can. Forget about your

[7] I could say the same of a number of philosophers and painters, including, among these latter, Uccello, from painters of the past, and, in the modern era, Seurat, Gustave Moreau, Matisse (in "La Musique," for example), Derain, Picasso (by far the most pure), Braque, Duchamp, Picabia, Chirico (so admirable for so long), Klee, Man Ray, Max Ernst, and, one so close to us, André Masson.

genius, your talents, and the talents of everyone else. Keep reminding yourself that literature is one of the saddest roads that leads to everything. Write quickly, without any preconceived subject, fast enough so that you will not remember what you're writing and be tempted to reread what you have written. The first sentence will come spontaneously, so compelling is the truth that with every passing second there is a sentence unknown to our consciousness which is only crying out to be heard. It is somewhat of a problem to form an opinion about the next sentence; it doubtless partakes both of our conscious activity and of the other, if one agrees that the fact of having written the first entails a minimum of perception. This should be of no importance to you, however; to a large extent, this is what is most interesting and intriguing about the Surrealist game. The fact still remains that punctuation no doubt resists the absolute continuity of the flow with which we are concerned, although it may seem as necessary as the arrangement of knots in a vibrating cord. Go on as long as you like. Put your trust in the inexhaustible nature of the murmur. If silence threatens to settle in if you should ever happen to make a mistake – a mistake, perhaps due to carelessness – break off without hesitation with an overly clear line. Following a word the origin of which seems suspicious to you, place any letter whatsoever, the letter "l" for example, always the letter "l," and bring the arbitrary back by making this letter the first of the following word. [...]

1. It is true of Surrealist images as it is of opium images that man does not evoke them; rather they "come to him spontaneously, despotically. He cannot chase them away; for the will is powerless now and no longer controls the faculties."[8] It remains to be seen whether images have ever been "evoked." If one accepts, as I do, Reverdy's definition it does not seem possible to bring together, voluntarily, what he calls "two distant realities." The juxtaposition is made or not made, and that is the long and the short of it. Personally, I absolutely refuse to believe that, in Reverdy's work, images such as

In the brook, there is a song that flows

or:

Day unfolded like a white tablecloth

or:

The world goes back into a sack

reveal the slightest degree of premeditation. In my opinion, it is erroneous to claim that "the mind has grasped the relationship" of two realities in the presence of each other. First of all, it has seized nothing consciously. It is, as it were, from the

[8] Baudelaire.

fortuitous juxtaposition of the two terms that a particular light has sprung, *the light of the image*, to which we are infinitely sensitive. The value of the image depends upon the beauty of the spark obtained; it is, consequently, a function of the difference of potential between the two conductors. When the difference exists only slightly, as in a comparison,[9] the spark is lacking. Now, it is not within man's power, so far as I can tell, to effect the juxtaposition of two realities so far apart. The principle of the association of ideas, such as we conceive of it, militates against it. Or else we would have to revert to an elliptical art, which Reverdy deplores as much as I. We are therefore obliged to admit that the two terms of the image are not deduced one from the other by the mind for the specific purpose of producing the spark, that they are the simultaneous products of the activity I call Surrealist, reason's role being limited to taking note of, and appreciating, the luminous phenomenon.

And just as the length of the spark increases to the extent that it occurs in rarefied gases, the Surrealist atmosphere created by automatic writing, which I have wanted to put within the reach of everyone, is especially conducive to the production of the most beautiful images. One can even go so far as to say that in this dizzying race the images appear like the only guideposts of the mind. By slow degrees the mind becomes convinced of the supreme reality of these images. At first limiting itself to submitting to them, it soon realizes that they flatter its reason, and increase its knowledge accordingly. The mind becomes aware of the limitless expanses wherein its desires are made manifest, where the pros and cons are constantly consumed, where its obscurity does not betray it. It goes forward, borne by these images which enrapture it, which scarcely leave it any time to blow upon the fire in its fingers. This is the most beautiful night of all, the *lightning-filled night*: day, compared to it, is night.

The countless kinds of Surrealist images would require a classification which I do not intend to make today. To group them according to their particular affinities would lead me far afield; what I basically want to mention is their common virtue. For me, their greatest virtue, I must confess, is the one that is arbitrary to the highest degree, the one that takes the longest time to translate into practical language, either because it contains an immense amount of seeming contradiction or because one of its terms is strangely concealed; or because, presenting itself as something sensational, it seems to end weakly (because it suddenly closes the angle of its compass), or because it derives from itself a ridiculous *formal* justification, or because it is of a hallucinatory kind, or because it very naturally gives to the abstract the mask of the concrete, or the opposite, or because it implies the negation of some elementary physical property, or because it provokes laughter. Here, in order, are a few examples of it:

The ruby of champagne. (LAUTRÉAMONT)

Beautiful as the law of arrested development of the breast in adults, whose propensity to growth is not in proportion to the quantity of molecules that their organism assimilates. (LAUTRÉAMONT)

[9] Compare the image in the work of Jules Renard.

A church stood dazzling as a bell. (PHILIPPE SOUPAULT)

In Rrose Sélavy's sleep there is a dwarf issued from a well who comes to eat her bread at night. (ROBERT DESNOS)

On the bridge the dew with the head of a tabby cat lulls itself to sleep. (ANDRÉ BRETON)

A little to the left, in my firmament foretold, I see – but it's doubtless but a mist of blood and murder – the gleaming glass of liberty's disturbances. (LOUIS ARAGON)

In the forest aflame
The lions were fresh. (ROBERT VITRAC)

The color of a woman's stockings is not necessarily in the likeness of her eyes, which led a philosopher who it is pointless to mention, to say: "Cephalopods have more reasons to hate progress than do quadrupeds." (MAX MORISE)

Ist. Whether we like it or not, there is enough there to satisfy several demands of the mind. All these images seem to attest to the fact that the mind is ripe for something more than the benign joys it allows itself in general. This is the only way it has of turning to its own advantage the ideal quantity of events with which it is entrusted.[10] These images show it the extent of its ordinary dissipation and the drawbacks that it offers for it. In the final analysis, it's not such a bad thing for these images to upset the mind, for to upset the mind is to put it in the wrong. The sentences I quote make ample provision for this. But the mind which relishes them draws therefrom the conviction that it is on the *right track;* on its own, the mind is incapable of finding itself guilty of cavil; it has nothing to fear, since, moreover, it attempts to embrace everything.

2nd. The mind which plunges into Surrealism relives with glowing excitement the best part of its childhood. For such a mind, it is similar to the certainty with which a person who is drowning reviews once more, in the space of less than a second, all the insurmountable moments of his life. Some may say to me that the parallel is not very encouraging. But I have no intention of encouraging those who tell me that. From childhood memories, and from a few others, there emanates a sentiment of being unintegrated, and then later of *having gone astray,* which I hold to be the most fertile that exists. It is perhaps childhood that comes closest to one's "real life"; childhood beyond which man has at his disposal, aside from his laissez-passer, only a few complimentary tickets; childhood where everything nevertheless conspires to bring about the effective, risk-free possession of oneself. Thanks to Surrealism, it seems that opportunity knocks a second time. It is as though we were still running toward our salvation, or our perdition. In the shadow we again see a precious terror. Thank God, it's still only Purgatory. With a

[10] Let us not forget that, according to Novalis' formula, "there are series of events which run parallel to real events. Men and circumstances generally modify the ideal train of circumstances, so that it seems imperfect; and their consequences are also equally imperfect. Thus it was with the Reformation; instead of Protestantism, we got Lutheranism."

shudder, we cross what the occultists call *dangerous territory.* In my wake I raise up monsters that are lying in wait; they are not yet too ill-disposed toward me, and I am not lost, since I fear them. Here are "the elephants with the heads of women and the flying lions" which used to make Soupault and me tremble in our boots to meet, here is the "soluble fish" which still frightens me slightly. SOLUBLE FISH, am I not the soluble fish, I was born under the sign of Pisces, and man is soluble in his thought! The flora and fauna of Surrealism are inadmissible. [. . .]

Surrealism, such as I conceive of it, asserts our complete *nonconformism* clearly enough so that there can be no question of translating it, at the trial of the real world, as evidence for the defense. It could, on the contrary, only serve to justify the complete state of distraction which we hope to achieve here below. Kant's absentmindedness regarding women, Pasteur's absentmindedness about "grapes," Curie's absentmindedness with respect to vehicles, are in this regard profoundly symptomatic. This world is only very relatively in tune with thought, and incidents of this kind are only the most obvious episodes of a war in which I am proud to be participating. Surrealism is the "invisible ray" which will one day enable us to win out over our opponents. "You are no longer trembling, carcass." This summer the roses are blue; the wood is of glass. The earth, draped in its verdant cloak, makes as little impression upon me as a ghost. It is living and ceasing to live that are imaginary solutions. Existence is elsewhere.

8

Introduction to "New Objectivity": German Painting since Expressionism

Gustav Hartlaub

On the threshold of this exhibition of the most recent German painting, it is important to avoid a dangerous mistake. Simply because evidence is displayed here of artistic endeavors that became recognizable *after* expressionism, and which, in a certain sense, appear to represent a reaction against the latter, does *not* mean that a position is being taken against expressionism and the generation of artists adhering to it. It is very doubtful that expressionism is dead – further developments by its best representatives in the most recent period is cause for thought. If, however, it truly is supposed to have been "overcome" as a "tendency," as a world view, and as an artistic signature, then that still says nothing against the achievements and *values* that produced it or against the particular persons who embodied it.

Every tendency is tied to a generation, fades along with it into the background, and becomes outmoded in order perhaps to reappear later under a new aspect. But what is a tendency other than the sharing of specifically artistic articulations within the general state of consciousness of a generation as a whole, within the range of its desires and reactions? What is it other than simply the new, not yet exhausted, still supple springboard from which a new generation of artists takes the leap into art? All depends finally not on the springboard, but on the *height* of the leap achieved by the individual through the force of talent and character. The standards by which the height is measured remain the same; they are *timeless*. And the higher an individual has leapt, the more certainly he has surpassed spatial and temporal specificity to make contact with the realm of free and timeless values.

Gustav Hartlaub, "Introduction to 'New Objectivity': German Painting since Expressionism" (first published in German 1925), pp. 491–3 from Anton Kaes, Martin Jay, and Edward Dimendberg (eds.), *The Weimar Republic Sourcebook*. Berkeley: University of California Press, 1995. © 1994 by The Regents of the University of California.

50

And let us not forget that the designation of a tendency, of an -ism, is essentially the product of a retrospective historical construction dependent on the particular point of view of the observer! Thus may one concede that a few of the painters in our exhibition, in the manner of their approach to the things characteristic of our most immediate reality, have diverged sharply from the nonrepresentational, nearly supersensual expressive innovations of certain "expressionists." If, however, one sees the unbridled *intensity* with which the one projects his inner visions, the other his outer substantiations, or if one attends to the *constructional* bent, which the representational art of today emphasizes no less than the cubism or futurism of yesterday, then one finds much that they have in *common*, which could just as easily have been reduced to the lowest common denominator of an -ism. Just now – ourselves wholly under the influence of extremely dramatic transformations and variations in our lives and values – we see the distinctions more clearly: the timely, coldly verificational bent of a few, and the emphasis on that which is objective and the technical attention to detail on the part of all of them. It will soon become apparent that the germ of the new art was already present in the old and that much of the visionary fantasy of the old is preserved even in the verism of today.

The exhibition is not intended to provide a *cross-section* of all the artistic endeavors of the post-expressionists. It leaves aside the art of abstract, constructivist tendencies; these efforts, in which the new will to objectivity is proclaimed in a completely different way, are to be reserved for a separate exhibition. What we are displaying here is distinguished by the – in itself purely external – characteristic of the *objectivity* with which the artists express themselves. It is easy to identify two different *groups*. The first – one almost wants to speak of a "left-wing" – tears the objective from the world of contemporary facts and projects current experience in its tempo and fevered temperature. The other searches more for the object of *timeless* validity to embody the eternal laws of existence in the artistic sphere. The former have been called verists; classicists one could almost call the latter. But both designations are only *half* right, since they fail to focus the material sharply and could easily lead to a new domination of the aesthetic *concept* over the concrete plenitude of works. We do not want to commit ourselves to the new catchwords. What we are showing is solely *that art is still there*, that it is striving after the new and unexpressed, and that it is fighting for the rights of the new and unexpressed. That it is *alive*, despite a cultural situation that seems hostile to the essence of art as other epochs have rarely been. That artists – disillusioned, sobered, often resigned to the point of cynicism having nearly given up on themselves after a moment of unbounded, nearly apocalyptic hope – that artists in the midst of the catastrophe have begun to ponder what is most immediate, certain, and durable: truth and craft.

51

Part II
Spirit and Subjectivity

Introduction

This section brings together historical texts by artists and critics that articulate what we might broadly call a crisis of rationalism. The period from the fin-de-siècle to the immediate post-World War I years is littered with theories, programs, and movements within European modernism that seek to establish or to diagnose not only a "new art," but a "new spirit." One potent vehicle for this was the developing dialectic of abstraction and "the primitive." More broadly, the prerequisites for this larger transformation were frequently expressed as a change in *perception* and consciousness, or an "inner" revolution. This, in turn, was one reason why later critics of many political hues came to accuse some artists and writers, Expressionists in particular, of a reactionary retreat from politics and from the "real" revolution.[1] The reality of World War I and the class movements across Europe in its aftermath rendered for many the utopian and fantasist aspects of such projects of spiritual transformation untenable. Indeed, it is noteworthy that the texts here all date from before 1920. The Dadaist Raoul Hausmann (conspicuously relinquishing his own roots in German Expressionism) wrote in this spirit in the periodical *Der Dada*, in 1919, as Germany was undergoing its own strangulated revolution:

> After an enormous thinning of vital feeling in aesthetic abstractions and moral-ethical farces, there rises from the European soup the expressionism of the German patriot, who took a respectable movement started by the French, Russians and Italians and fabricated a small, profitable war industry in an endlessly plump enthusiasm. The hurdy-gurdy of pure literature, painting, and music is being played in Germany on an extremely fit business footing. But this pseudotheosophic, Germanic coffee klatsch, which got as far as achieving recognition among East Prussian

Junkers, should be a matter of indifference to us here, just like the businessman's machinations of Mr. [Herwarth] Walden, a typical German philistine who believes it necessary to wrap his transactions in a Buddhistic-bombastic little cloak...Were Walden and his writers' school revolutionary in the slightest, they would first have to comprehend that art cannot be the aesthetic harmonization of bourgeois notions of property.[2]

For all their diversity, the texts in this section share the conviction of the absolute superiority of "inner" over "outer" vision. Such dualities abound; another is "essence" and "appearance." As such, they articulate an idealism that often banked on faith in a universal, essential reality only obscured by the modern, empirical world and positivist modes of thought. But further, they also articulate a remarkable faith in the (as yet largely untapped) *power* of art. For in this discourse, art holds, potentially, the means for penetrating the veil of illusion to access or reveal these underlying truths.[3] This should be borne in mind in the light of the radical critique of art enacted by Dada, many of whose protagonists came from precisely such circles, Symbolism and Expressionism in particular.

Within the universalizing vision of Paul Klee, writing at the height of World War I, for example, cosmic *resolution* occurs with a kind of *dissolution* of the self and sensuality:

Do I radiate warmth? Coolness? There is no talk of such things when you have got beyond white heat. And since not too many people reach that state, few will be touched by me. There is no sensuous relationship, not even the noblest, between myself and the many. In my work I do not belong to the species, but I am a cosmic point of reference. My earthly eye is too farsighted and sees through and beyond the most beautiful things.[4]

The unavoidable paradox that elitism is the bedfellow of this transcendental universalism is noticeable here and in other texts of the period. Yet the ideal of art as a mode of spiritual envisioning is as decisive for the development of abstraction in modern art as are the radical formal possibilities opened up by Cubism.[5] The texts included here by Kandinsky, Malevich, and Mondrian show this in particular.

It is striking that these artists' attempts to overcome the positivist and materialist legacy of the nineteenth century often involved rehearsals of that era's own broadly antimaterialist tendencies, Romanticism and Symbolism.[6] The aesthetics of Charles Baudelaire and Richard Wagner exerted crucial influences.[7] Seductive philosophical foundations for artists seeking "revelation" over representation often lay in Arthur Schopenhauer and Friedrich Nietzsche, both widely read and popularized – in the latter's case, to the degree of hypertrophied "cult" status.[8] The philosophy of Henri Bergson was widely influential in the early twentieth century, particularly in France, but also in Italy, Germany, and Russia. His antimechanistic concept of time (as a subjectively experienced flux, or "duration" of past and present, rather than the constant passage of minutes and

hours), his emphasis on intuitive knowledge and his concept of *élan vital*, all proved highly suggestive to artists in search of a new visual language.[9] Though they are waters less charted by academic art history, we should not forget that esoteric and spiritual traditions discovered or revived in late nineteenth-century Europe have all been sources of imagery or method for modern artists. They include occultism, Theosophy, Anthroposophy, cabbala, astrology, alchemy, Mazdaznan, and aspects of Eastern spiritual practices, as well as the testimonies of individual mystics such as Emanuel Swedenborg.[10]

It is important to recognize that dualistic notions of, for example, imagination/intellect and art/science are more likely to limit our understanding of the complexity of art in modernity than to enhance it. As Charlotte Douglas writes:

> Misunderstanding of the multifaceted nature of the modern artists' spiritual orientation is a result, in part, of the contemporary Western dichotomy of vision. It is useless to insist, as some historians continue to do, that modernists were members of either the rational or the anti-rational camp. At the turn of the century no such well delineated camps existed. For a quarter of a century both poets and scientists strove for a holistic vision; the mystical world view and that of the new physical and biological sciences emphasized the unity of knowledge and presented the artist with strikingly similar and visual suggestions.[11]

The dialectical nature of several of the theories in this section is evident, even beyond the familiar yearnings for art as a synthesis of spirit and matter. The compilation of texts in this section is intended to highlight and stimulate reflection on the developing interrelationship of "spirit" and subjectivity with "the material" and objectivity as it relates to the aesthetics of Symbolism and abstract art. Furthermore, the texts help to show how artists' theory and practice is informed and dynamized by their engagement with the immediate conditions of modernity.

The first of the writings in this section is by Joris-Karl Huysmans (1848–1907). A poet, novelist, and art critic of Dutch-French birth, he was best-known for his spectacular novel mingling aestheticism and episodic depravity with liberal dashes of irony, *À Rebours* (1884). Oscar Wilde said, fittingly, "the heavy odour of incense" clung to its pages. Its hero, the aristocratic decadent Des Esseintes, spends many nights in a trance-like state of contemplation before two paintings by Gustave Moreau; one of his *Salomé*s and the water-color known as *The Apparition*.[12] This is premeditated pursuit of art-induced consciousness-expansion:

> For the delectation of his mind and the delight of his eyes, he had decided to seek out evocative works which would transport him to some unfamiliar world, point the way to new possibilities, and shake up his nervous system by means of erudite fancies, complicated nightmares, suave and sinister visions.[13]

Huysmans's article was written later (1889), *recollecting* and reinventing a heady past (1886) encounter with Moreau's water-colors. It appeared in the second of his three books of art criticism, *Certains*. Strikingly, it ends with an account of the

disorientation and fragmented perception experienced by the writer as he steps from the gallery into the street, his "intoxicated" vision projecting after-images like a retinal burn onto the urban fabric. As the subject (Huysmans) emerges from his reverie to confront misanthropically the horrors of modernity, he is endowed with a heightened perception nearing clairvoyance that enables him to "see" the avaricious, stupefied, or lustful thoughts of the men and women around him. Playing with paradoxes of the animate and inanimate, blindness and vision, and blurring the distinction between subjectivity and objecthood, Huysmans constructs an account of visionary transcendence that nonetheless retains a fixed attention to surface. It may be argued that this relationship between transcendent vision and surface is at the core of Symbolist aesthetics[14] (see Aurier, below), as well as the abstraction of Kandinsky, Malevich, and Mondrian.

It is interesting that Matisse studied under Moreau, to whom he was very loyal.[15] Matisse's emphasis on "expression" in his "Notes of a Painter" (Part I) may owe something to Moreau.[16] Another famous student, Georges Rouault, remembered Moreau taught "respect for a certain interior vision."[17] Moreau was admired perhaps most by writers – especially Symbolists and Surrealists such as Paul Valéry, Stéphane Mallarmé, and André Breton.[18] Together with Pierre Puvis de Chavannes and Odilon Redon,[19] Moreau provided an important precedent for the pictorial Symbolism of the 1890s as it was later formulated by G.-Albert Aurier and others.

Aurier (1865–92) was an influential poet, critic, and promoter of Symbolism, though his career was cut short by premature death. He came into contact with Gauguin, Van Gogh, and the Pont-Aven group through his friendship with the painter Émile Bernard.[20] Aurier wrote the longest and most serious article on Van Gogh during the artist's lifetime.[21] His article reproduced here was also one of the earliest championing Gauguin's work. It can be seen as part of a wider trend in the late 1880s. As Martha Ward has shown, this was a period "unprecedented in the demands experienced by independent painters to justify with aesthetic tenets their artistic practice. . . . In this regard, the increasing stake that *littérateurs* themselves had in discovering artists and in assimilating new programs is crucial."[22]

Aurier's article begins with a poetic exploration of the ecstatic and visionary properties of Gauguin's *Vision After the Sermon: Jacob Wrestling with the Angel* (1888) (figure 2 below), and proceeds from this premise to the difficult task of constructing what amounted to a theory and manifesto for pictorial Symbolism. While Symbolism is reasonably identifiable as a movement in literature, the question of whether there exists such a thing as a body of "Symbolist Art" is still debated today.[23] Nonetheless, with his insistence on the centrality of the neoplatonic, essentially spiritual "Idea," Aurier's attempt, aimed at an educated and enlightened readership, both augments and surpasses contemporary notions of "cloisonism" and "synthetism."[24]

For Aurier, then, Gauguin's art is "ideist." As such, it is both revelatory, capable of lifting the "symbolic veils," and predicated on "clairvoyance" or the

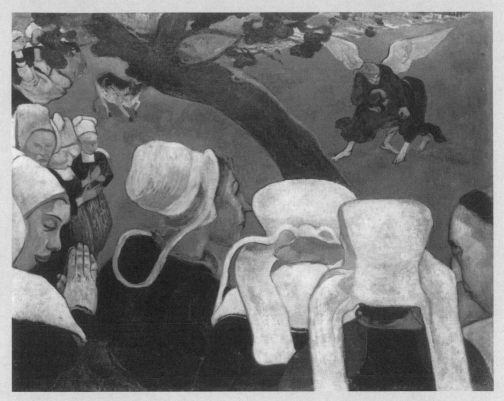

Figure 2 Paul Gauguin, *The Vision After the Sermon*, 1888. (National Galleries of Scotland, Edinburgh. Reproduced by permission.)

vision of the mystic Emanuel Swedenborg's "inner eye of man." Aurier calls for an art that eschews illusionism and instead uses all the means necessary (including simplification, exaggeration, and distortion) for the expression of the Idea. We can also find in Aurier's definition of "the strict duty of the ideist painter . . . to use in his work only the lines, forms, general and distinctive colors that enable him to describe precisely the ideic significance of the object," a close equivalent to the concept of "significant form" in the work of Fry and Bell more than 20 years later (Part I). The high estimation of the "primitives" of the quattrocento is also common to all three critics. Aurier's elevation of "decorative" painting and his final demand to give Gauguin "walls! walls!" is compatible with Gauguin's own working methods, for as Maurice Denis recalled: "[Gauguin] loved the matte effect of frescoes and that is why he prepared his canvases with thick coats of white gesso. . . . His art contains more of tapestries and stained glass than it does of oil painting."[25]

The next text in this section is an extract from Wilhelm Worringer's (1881–1965) *Abstraction and Empathy: A Contribution to the Psychology of Style*, a book that made a great impact in Germany, where it was widely read by artists and intellectuals of the Expressionist generation and proved highly influential,

although Worringer is today rather neglected. Originating in his doctoral thesis, the first of many editions was published in 1908. Some of Worringer's points were developed further in the case of the German Gothic in his next book, *Form in Gothic* (1912).[26] Drawing on the work of Alois Riegl,[27] Worringer asserted that the stylistic differences between the art of European-Classical culture and of "primitive" and Oriental cultures can be accounted for by an understanding of differences in *volition* or the "will to form" that roughly approximates to Riegl's concept of the *Kunstwollen*. For Worringer, the key factor was the psychological relationship of man to nature. As a "pole" to Theodor Lipps's theory of empathy, Worringer proposed an aesthetics of man's "urge to abstraction." Thus, Worringer's thesis developed the idea that in Occidental, Graeco-Roman art, naturalistic, organic, "empathetic" forms are produced by artists and for people at ease with their environment, while in Oriental and "primitive" cultures, abstract, geometric forms express or seek to alleviate a fundamental alienation or terror in the face of nature.

The importance of Worringer's treatise for contemporary art lay, first, in its affirmation of those who felt or presented their *own* condition to be one of alienation from their (modern) environment; second, in its *positive* evaluation of "primitive" art; and third, in its placing of abstraction at the "pure" beginning of the development of art. Expressionist artists and architects of the years just before and during World War I found in Worringer inspiration and justification for their own crystalline, abstract forms as the potentially redemptive expression of a society in a state of spiritual crisis. Furthermore, the implication that "primitive" art was inherently "higher," more attuned to the "spiritual" than the material, opened up interest in the art of medieval Europe, Africa, and the South Seas. As Richard Sheppard has put it:

> The implications of Worringer's highly influential thesis are clear. Aboriginal and premodern cultures, though technologically less advanced than the modern West, may in fact be better equipped to deal with the totality of a universe in which humanity is not at home, of which it is not the centerpiece, and in the face of which it inevitably experiences a profound sense of angst.[28]

E. L. Kirchner, Wassily Kandinsky, Franz Marc, and Emil Nolde were among the many artists who took on board Worringer's argument. The "primitive" was, of course, the product of European imaginations, an ideal variously informed by colonial values, exoticizing fantasies and underlying racism. (See Part V.)

By the time Worringer's *Abstraction and Empathy* appeared, Kandinsky had already begun the notes that led to his first book, *Über das Geistige in der Kunst*, or *On the Spiritual in Art*, finally published in Munich at the end of 1911 as Kandinsky was exploring increasing abstraction in his painting.[29] Most English translations are from this German text. Included here, however, is the distinct Russian version, *O dukhovnom v iskusstve*. It was delivered as a lecture in Petrograd in 1911 and published in Russia in 1914. It is not as widely known as it

should be, having been translated into English only in 1980.[30] It differs considerably from the German version in style and content – it is shorter and more lucid – but the key arguments are common to both. In Kandinsky's absence his lecture was read by Nikolai Kulbin, himself an influential theorist (and painter) whose concerns with the psychophysical effects of art on the viewer, sound–color affinities, and creative intuition affiliated him with Kandinsky and influenced Malevich's concept of Suprematism (see below).[31]

Drawing on Theosophist, Nietzschean, mystical, biblical, musical, and quasi-scientific sources, Kandinsky's ideas about the spiritual renewal of art in the face of materialism have their roots in the Symbolist movements of 1900s Russia and Germany.[32] The messianic tone in which he wrote earned Kandinsky both ridicule and veneration. The brief responses from the Congress at the end of the text here give a glimpse of this. What is more surprising is that these reactions were found amongst *both* conservatives and radicals.[33]

Underpinning *On the Spiritual in Art* is Kandinsky's principle of "inner necessity."[34] In keeping with the dialectical nature of Kandinsky's concept of the creative spirit, "inner necessity" involves both the universal and individual. It is an eternal "invariable law of art" inherent to the creative work itself[35] *and* an active, incessantly changing, creative force of emotion in the artist. For Kandinsky, this was thus no less than the foundation for "the expression of the

Figure 3 Wassily Kandinsky, *Improvisation 19*, 1911. (Inv. no. GMS 79. Städtische Galerie im Lenbachhaus, Munich. Reproduced by permission.)

Epoch of the Great Spiritual."[36] More generally, it points to a *leitmotiv* of Kandinsky's writing and a key component of Expressionist aesthetics, namely, the transcendental and redemptive function of art. This has echoes of Worringer's *Abstraction and Empathy*, and Kandinsky, along with many of his friends and contemporaries, read and admired Worringer.[37] Moreover, the "healing," therapeutic, and shamanistic aspects of Kandinsky's theories and iconography have been highlighted by recent studies,[38] and Hugo Ball (a friend and admirer of Kandinsky's) probably had these in mind when he wrote in his diary: "Always apply theories, e.g., Kandinsky's, to people and to the individual so as not to be sidetracked into aesthetics. We are dealing with men, not with art. At least not first and foremost with art."[39]

Finally, it is worth considering the correspondences between Kandinsky's concept of the spiritual in art and French painting. Not only does Kandinsky evoke Matisse's "Notes of a Painter" (Part I) in a discussion of expression within the text, but Aurier's "ideist" art, though based on different premises, has a striking affinity with Kandinsky's emphasis, two decades later, on the "vibrations in the soul" effected by painting. This is perhaps clearest when we consider Aurier's pronouncement (in his text in this section) that the artist must have the gift of "a transcendental capacity for emotion so great and so precious that it causes the soul to quiver in the presence of the undulating drama of abstractions."

A short text is included here by Giorgio de Chirico (1888–1978), whose distinctive early paintings of 1911–18, characterized by disconcerting stillness, incongruous juxtapositions in architectural spaces, and "casual fatality," so gripped the Surrealist imagination.[40] De Chirico was Italian, but grew up in Greece before moving to Munich, then Italy, Paris, and back to Italy, where he founded *Pittura Metafisica* with the ex-Futurist Carlo Carrà in 1917.[41] After the war, "Metaphysical Painting" was a crucial influence on Realist painters in Germany, France, and the Netherlands.[42] He was attracted to the "Northern" Symbolism of Max Klinger and Arnold Böcklin, but de Chirico's reading of Nietzsche and Schopenhauer was most decisive for his own ideas about the uniquely-endowed artist's ability to *reveal* an essential, underlying reality that is also a "great madness . . . behind the inexorable screen of matter."[43] In notes from 1912, de Chirico reflected on a "Nietzschean method" for painting and quoted Schopenhauer: "To have original, extraordinary, and perhaps even immortal ideas, one has but to isolate oneself from the world for a few moments so completely that the most commonplace happenings appear to be new and unfamiliar, and in this way reveal their true essence."[44] "Mystery and Creation," written in 1913 and published by Breton in his *Surrealism and Painting* in 1928, opens with a bold testimony to just this ideal of dislocation followed by breakthrough to the heightened perception of "childhood vision and dream." The day at Versailles recounted at the end of the text then roots in the artist's own experience the dissolution of subject and object and awareness of "true essence" in the commonplace.[45]

Figure 4 Kazimir Malevich, *Dynamic Suprematism*. (T02319 © **Tate, London, 2003.**)

If for de Chirico expression of a heightened, essential reality lay in a kind of *amplification* of the object, its presence in space intensified by its isolation or casting of dark shadows, in Russia, Kazimir Malevich advocated a psychologically liberating *renunciation* of the object. This is an art of purity and autonomy, yet his essay "From Cubism and Futurism to Suprematism: The New Painterly Realism" conceives the aim of "objectless" painting within a clearly historicizing framework. This is already signaled by the title, and indeed Suprematism is presented as the "zero" of form: that is, marking both the culmination of the process of the object's disintegration catalyzed by Cubism and Futurism, and a blank slate for a new beginning. As such, Suprematism is a good example of a self-declared movement or "flag" intended to signal a new, higher stage in the evolution of contemporary art.[46] It was launched after months of intensive painting in 1915.

61

This was at the portentously-titled *0.10* [zero-ten] *The Last Futurist Exhibition* in Petrograd, which included a room full of freshly-painted Suprematist works (with Malevich's *Black Square* straddling an upper corner like an icon). The essay here was first published for the occasion. After the 1917 revolution, Malevich explored the possibilities for wider, more utilitarian applications of Suprematism in architecture and the applied arts. In view of the passionate abhorrence of Renaissance art Malevich expresses in this text, it is profoundly ironic that he "regressed" to precisely this manner of painting in the final years of his life.[47] Boris Groys (Part IV) also discusses Malevich, in relation to Socialist Realism.

The final text in this section is extracted from a 14-page pamphlet written by Piet Mondrian in 1920, dedicated "*Aux hommes futurs*," in which he expounded the ideas that comprised his aesthetic credo and life-philosophy, "*nieuwe beeldung*," poorly translated as Neo-Plasticism.[48] Several studies acknowledge the importance of Mondrian's involvement with Theosophy for his early work. His 1911 triptych *Evolution* (with its long record of affronting high modernists) is the clearest example, and like Kandinsky he was attracted to the related Anthroposophy of Rudolf Steiner.[49] Soon after publication, Mondrian sent a copy of "Neo-Plasticism" to Steiner. In his accompanying letter he wrote: "Neo-Plasticism seems to me to be the art of the near future for all true Anthroposophs and Theosophs."[50] At this time Mondrian was best known in his native Holland and in Germany through his activities with Theo van Doesburg and the *De Stijl* group and journal, but he wrote the text in Paris, having moved there for a second time after the end of the war. With it, he effectively introduced his version of Neo-Plasticism to a French readership.[51]

Mondrian's theoretical worldview is founded on essentialism. His writing is also some of the most repetitive in the literature of European modernism. In the text, his essentialism (and his repetitiveness!) emerges in his echoing affirmations of "constants" such as the "universal" and the "immutability" of art lying behind the veils of subjective reality. But Mondrian is concerned with processes, with becoming. Here, the repeating dynamic of Neo-Plasticism is *dialectic*; an example (and the keynote of the text) is the synthesis of "equilibrated opposition" between the universal and the individual. The problems with Mondrian's unassailable faith in the pristine, self-evident dualities (such as spirit–matter, inside–outside, male–female) upon which a heroicized reconciliation in equilibrium is predicated are fairly obvious. Briony Fer has pinpointed the problem: "these are conventional, rather than absolute, oppositions – and part of a system of beliefs that was cultural rather than natural."[52] Particularly dubious, and in places downright offensive, are the gendered aspects of Mondrian's theorizing, where tangled relationships of opposition, domination, and longed-for equilibrium are set up between the "masculine" (such as "spirit") and "feminine" (such as "nature").[53] As Mark Cheetham has observed: "His ideal of equilibrium, in spite of his claims for equality, is an escape from difference – sexual, art historical, and ontological – into androgyny, where there can be no mimesis because all difference is conflated into one unit."[54]

From the texts in this section we can see how artists' and critics' pursuit of renewal in the arts was often based upon faith in essential, immaterial reality, the immanent purity of particular forms, the spiritual or musical properties of colors and a general skepticism about rational science and empirical reason. In preserving some of the core values of Romanticism, these various programs implicitly or explicitly questioned the empirical methods and modern subjects of Impressionism. From such perspectives, World War I was the culminating crisis of the industrialized civilization to which programs of spiritual and material renewal addressed themselves. Within this rhetoric throughout the period, "new" art, from Synthetism to Neo-Plasticism and other movements not touched upon here, is sanctified by the difficult process of purification and internal renewal it has undergone, often manifest in formal terms as increasing abstraction. The resulting aesthetic is – *ideally* – able to effect longed-for internal (spiritual) *and* external (social) renewal.

Notes

1 This view informed much of Dada's critique of Expressionism. It is also relevant to Russian cultural politics in the late 1920s and 1930s (see Boris Groys's essay in Part IV).
2 Raoul Hausmann, "The German Philistine Gets Upset" (1919) in *The Weimar Republic Sourcebook*, eds. Anton Kaes, Martin Jay, and Edward Dimendberg (Berkeley: University of California Press, 1995), pp. 482–3, p. 482. Herwarth Walden was the editor of the leading Expressionist periodical in Germany, *Der Sturm*.
3 The notion of a "veil of illusion" is close to the concept of "Mâyâ" as used by Schopenhauer (and others) and that occurs in Worringer's *Abstraction and Empathy* in this part.
4 Paul Klee, diary entry 1008 (1916, probably July or August), in *Voices of German Expressionism*, ed. Victor H. Miesel (Englewood Cliffs, NJ: Prentice-Hall, 1970), p. 83. Klee worked chiefly in graphic media. His early work was in a Symbolist vein. In 1912 he became part of the *Blaue Reiter* circle and in 1920 joined the Bauhaus in Weimar.
5 The Orphism of Sonia and Robert Delaunay, the circle of the Abbaye de Créteil, and artists associated with Cubism's later "synthetic" phase such as Gleizes, Metzinger, Gris, and Léger attest to the more subjective tendencies of Cubism beyond Picasso and Braque. See also e.g. Gladys Fabre, "Der literarische Zirkel der Abbaye – Der Okkultismus und die Avantgarde-Kunst in Frankreich 1906–1915" in *Okkultismus und Avantgarde. Von Munch bis Mondrian 1900–1915*, ed. Veit Loers, Schirn Kunsthalle Frankfurt, (Ostfildern: Edition Tertium, 1995), pp. 350–73.
6 For a detailed examination of this complex relationship, see Dee Reynolds, *Symbolist Aesthetics and Early Abstract Art: Sites of Imaginary Space* (Cambridge: Cambridge University Press, 1995).
7 Baudelaire's "forest of symbols" (from his poem "Correspondances" of ca. 1852–6), his "The Salon of 1859," and Wagner's concept of the *Gesamtkunstwerk* (total work of art) are among the key elements of this influence.

8 The so-called "Nietzsche cult" emerged in the 1890s, reached new heights upon his death in 1900, and has not entirely expired even today. See Steven E. Aschheim, *The Nietzsche Legacy in Germany 1890–1990* (Berkeley: University of California Press, 1992).

9 The key works had been widely translated by 1914. They include Henri Bergson, *Time and Free Will* (1889), *Creative Evolution* (1907), and *Introduction to Metaphysics* (1903).

10 Historians and critics of art have often given a wide berth to the "esoteric" sources and philosophies of modern art. It was noted as recently as 1995, for example, that there is no thorough and coherent historical account of the influence of Theosophy on painting, and that the state of academic knowledge is "fragmentary." Marty Bax, "Theosophie und Kunst in den Niederlanden 1880–1915," in *Okkultismus und Avantgarde*, ed. Loers, pp. 282–94. This exhibition and catalog partially redressed this.

11 Charlotte Douglas, *Swans of Other Worlds: Kazimir Malevich and the Origins of Abstraction in Russia* (Ann Arbor: UMI Research Press, 1976), p. 67.

12 J.-K. Huysmans, *Against Nature* [1884], trans. Robert Baldick (London: Penguin, 1959), ch. 5.

13 Ibid., p. 63.

14 See also Reinhold Heller, "Concerning Symbolism and the Structure of Surface," *Art Journal* 45 (Summer 1985), pp. 146–53.

15 Moreau began teaching late in life. He was remembered as a liberal and flexible teacher. Matisse studied in his atelier 1892–7; Moreau died in 1898. His other students included Rouault, Marquet, Camoin, and Manguin. See Frank Anderson Trapp, "The Atelier Gustave Moreau," *Art Journal* 22, no. 2 (Winter 1962–3), pp. 92–5.

16 On Moreau's firmly-held views on art, see Julius Kaplan, *The Art of Gustave Moreau: Theory, Style and Content* (Ann Arbor: UMI Research Press, 1982), ch. 2, "Theory of Art," pp. 5–20.

17 Cited in Trapp, "Atelier Gustave Moreau," p. 93.

18 Breton paid tribute to Moreau as a precursor of Surrealism in *L'Art magique* (1957).

19 Huysmans was the first critic to draw the public's attention to Redon, writing in "Le Salon official de 1881": "Another artist has recently come to the fore in France, as a painter of the fantastic; I speak of Mr. Odilon Redon. Here, nightmare is transported into art. If you blend, in macabre surroundings, somnambulistic figures vaguely related to those of Gustave Moreau, with an element of fear, you will perhaps form an idea of the bizarre talent of this singular artist." Annette Kahn, *J.-K. Huysmans: Novelist, Poet and Art Critic* (Ann Arbor: UMI Research Press, 1987), p. 109.

20 See Juliet A. Simpson, "Albert Aurier and Symbolism: From Suggestion to Synthesis in French Art," *Apollo* CXLII, no. 404 (Oct. 1995), pp. 23–7.

21 Interestingly, the text shows parallels with the heightened sensitivity of Huysmans's account of the experience of Moreau's paintings. For example, Aurier evokes Van Gogh's art in terms of heat, smells, noises, emotions, animals, minerals, and alchemy; he writes of "the impression the retina retains" after seeing it for the first time, and he contrasts these multiple sensations with his own sudden return to "the ignoble, muddy, razzle-dazzle of the dirty street and ugly real life" where fragments of verse emerge in his memory "as if in spite of myself." G.-Albert Aurier, "The Lonely Ones

– Vincent Van Gogh" [1890] in *Symbolist Art Theories: A Critical Anthology*, ed. Henri Dorra (Berkeley: University of California Press, 1994), pp. 220–6.

22 Martha Ward, *Pissarro, Neo-Impressionism, and the Spaces of the Avant-Garde* (Chicago: University of Chicago Press, 1996), pp. 107–8.

23 Sharon Hirsh, "Symbolist Art and Literature," *Art Journal*, 45 (Summer 1985), pp. 95–7.

24 "Synthetist" paintings had been exhibitied at the Café Volpini in Paris in June 1889. "Synthetism" was roughly synonymous with "cloisonism," which had recently been established by the painter Louis Anquetin and the critic Edouard Dujardin. The term derived from a technique of ceramic decoration whereby compartments or "*cloisons*" separated by strips are filled with flat, uniform colour. See Edouard Dujardin, "Cloisonism" [1888] and commentary in *Symbolist Art Theories*, ed. Dorra, pp. 177–81.

25 Maurice Denis, *Nouvelles Théories* (1922), quoted in Heller, "Concerning Symbolism," p. 148.

26 Wilhelm Worringer, *Form in Gothic*, ed. and intro. Herbert Read (London: G. P. Putman's Sons, 1927), was the first English translation of *Formprobleme der Gotik* (1912). In his introduction, Read wrote that this was "a revaluation of Gothic art in the light of an hypothesis which includes . . . an intuitive perception or recreation of the very conditions of Gothic art – not merely the social and economic conditions, but the general spiritual aspirations of Gothic man, his world and his will."

27 Alois Riegl, *Stilfragen* (Problems of Style) (1893) and *Spätrömische Kunstindustrie* (Late Roman Art Industry) (1901).

28 "Modernism as Diagnosis," in Richard Sheppard, *Modernism–Dada–Postmodernism*, (Evanston, IL: Northwestern University Press, 2000), pp. 31–70, esp. pp. 68–9.

29 Wassily Kandinsky, "On the Spiritual in Art" (1912), in *Kandinsky: Complete Writings on Art*, eds. Kenneth C. Lindsay and Peter Vergo, vol. 1 (1901–21) (London: Faber and Faber, 1982), pp. 119–219. See also the editors' introduction to the text for its key sources and the history of its coming to publication, ibid., pp. 114–18. The book came out in December 1911 but was given a publication date of 1912. Kandinsky said the notes accumulated over at least 10 years.

30 *The Life of Vasilii Kandinsky in Russian Art: A Study of "On the Spiritual in Art,"* eds. John E. Bowlt and Rose-Carol Washton-Long (Newtonville: Oriental Research Partners, 1980). The lecture was presented on Kandinsky's behalf by Dr. Nikolai Kulbin at the All-Russian Congress of Artists in St. Petersburg on December 29 and 31, 1911. It was published in 1914 in the transactions of the Congress.

31 See e.g. Nikolai Kulbin, "Free Art as the Basis of Life: Harmony and Dissonance," in *Russian Art of the Avant-Garde: Theory and Criticism*, ed. John E. Bowlt, rev. ed. (London: Thames and Husdon, 1991), pp. 13–17. On Kulbin's theories in relation to Malevich, see Douglas, *Swans of Other Worlds*, esp. pp. 68–71.

32 See *Life of Vasilii Kandinsky*, eds. Bowlt and Washton-Long; Peg Weiss, "Kandinsky and the Symbolist Heritage," *Art Journal* 45 (Summer 1985), pp. 137–45.

33 On the wider reception of Kandinsky in right-wing, expressionist, and anarchist circles in Germany, see Yule F. Heibel, " 'They Danced on Volcanoes': Kandinsky's Breakthrough to Abstraction, the German Avant-Garde and the Eve of the First World War," *Art History* 12, no. 3 (Sept. 1989), pp. 342–61.

34 In German, "*innere Notwendigkeit*," sometimes also translated as "internal necessity."

35 On the "inner life" of the creative work as "being," see section 8, "The Artist and Creativity," in Kandinsky's text.

36 Wassily Kandinsky, "Content and Form" (1910–11), in *Kandinsky: Complete Writings*, eds. Lindsay and Vergo, vol. 1, pp. 87–90, p. 90. This is also the phrase with which Kandinsky concluded the German version of *On the Spiritual in Art* (*Über das Geistige in der Kunst*) in ibid., p. 219.

37 Worringer and Kandinsky were both based in Munich and shared the same German publisher (Reinhard Piper), and in 1912 Kandinsky and Marc planned to invite Worringer to contribute to the second *Blaue Reiter Almanac* (not published). In February 1912 Franz Marc wrote to Kandinsky: "I am just reading Worringer's *Abstraktion und Einfühlung*, a good mind, who we need very much. Marvelously disciplined thinking, concise and cool, extremely cool." Klaus Lankheit, "A History of the Almanac," in *The Blaue Reiter Almanac*, eds. Wassily Kandinsky and Franz Marc (London: Thames and Hudson, 1974), pp. 11–48, p. 30.

38 Weiss, "Kandinsky and the Symbolist Heritage," and Peg Weiss, *Kandinsky and Old Russia: The Artist as Ethnographer and Shaman* (New Haven: Yale University Press, 1995). In connection with the *Blaue Reiter Almanac* compiled by Kandinsky and Marc (published 1912), one of the central documents of the complex relationship between primitivism, abstraction, and expressionism, Richard Sheppard writes that "the *Almanach*'s essays and illustrations had a visionary, prophetic, and therapeutic purpose. They were intended to proclaim that behind the materialism and escalating violence of modernity, a transcendent, healing power was at work which, once glimpsed through premodern, non-Western, and abstract artworks, could conjure and exorcise the forces of darkness as had happened in past ages through the communal *Gesamtkunstwerk* of religious ritual." Richard Sheppard, "Kandinsky's *Oeuvre* 1900–14: The Avant-Garde as Rear Guard," in Sheppard, *Modernism–Dada– Postmodernism*, pp. 145–70, p. 154. These are all, incidentally, elements that further underscore the affinity between Worringer and Kandinsky/Marc at this time. See also Worringer, *Form in Gothic*.

39 Hugo Ball (entry March 5, 1916). *Flight out of Time*, ed. John Elderfield (Berkeley: University of California Press, 1996), p. 55.

40 Maurice Nadeau, *The History of Surrealism* [1964] (Harmondsworth: Penguin, 1978), p. 21. De Chirico never regarded himself as a Surrealist, but he greatly influenced painters such as Ernst, Tanguy, Dali, and Magritte. Breton and Eluard owned important works by him and he was included in the first group exhibition at the Galerie Pierre in November 1925. See Laura Rosenstock, "De Chirico's Influence on the Surrealists," in *De Chirico*, ed. William Rubin (New York: Museum of Modern Art, 1982), pp. 111–29.

41 See Massimo Carrà, *Metaphysical Art* (London: Thames and Hudson, 1971), which includes many of the key documents of the movement.

42 On the influence on German "Neue Sachlichkeit" and "Magic Realist" painters in particular, see Wieland Schmied, "De Chirico and the Realism of the Twenties," in *De Chirico*, ed. Rubin, pp. 101–9.

43 Giorgio de Chirico, "On Metaphysical Art" (1919), in *Theories of Modern Art: A Sourcebook by Artists and Critics*, ed. Herschel B. Chipp (Berkeley: University of California Press, 1968), pp. 448–53, p. 449.

44 Giorgio de Chirico, "Meditations of a Painter" (1912), in ibid., pp. 397–401, p. 397. De Chirico quotes from Schopenhauer's *Parerga and Paralipomena* (1851). Of Nietzsche's writings, *The Birth of Tragedy* (1872) was particularly important for de Chirico's (and many of his contemporaries') ideas about the role of the artist.

45 Hal Foster reads this text and its underlying anxiousness from a Freudian perspective. He also considers de Chirico's reworking of perspective, stressing its "paranoid aspect (i.e., the sense that the viewer is watched in turn)." Hal Foster, *Compulsive Beauty* (Cambridge MA: MIT Press, 1995), pp. 57–98, 246.

46 In a letter dated September 24, 1915 Malevich wrote: "People in Moscow are beginning to agree with me that one must come out under a new flag. But the interesting thing is whether they will give it a new form. It seems to me that Suprematism is the most suitable, since it signifies dominance." Larissa A. Zhadova, *Malevich: Suprematism and Revolution in Russian Art 1910–1930* (London: Thames and Hudson, 1982), p. 123 n. 5. For an immediate prehistory for Suprematism and specifically his most radical painting, *Black Square on a White Background*, Malevich pointed to his set designs for the opera *Victory over the Sun* in 1913.

47 For a polemical essay attacking the return to figuration as politically regressive and authoritarian, see Benjamin H. D. Buchloh, "Figures of Authority, Ciphers of Regression: Notes on the Return of Representation in European Painting," *October* 16 (Spring 1981), pp. 39–68.

48 The term – now standard in English – is a translation of the French, as in Mondrian's title of this text: *Néo-plasticisme: principe général de l'équivalence plastique*. On the problems of the term and its translation see Paul Overy, *De Stijl* (London: Thames and Hudson, 1991), p. 42.

49 The Theosophical Society was founded by Madame Helena Blavatsky in 1875. The movement was eclectic and esoteric; key ideas were of a cosmic divinity or "world soul" and of a common ground between Eastern and Western religions. Steiner's Anthroposophy was based on theosophical premises with an emphasis on the individual's self-development towards renewed contact with the spiritual world.

50 Letter from Piet Mondrian to Rudolf Steiner, February 25, 1921, quoted (and illustrated) in Walter Kugler, "Wenn der Labortisch zum Altar wird – Die Erweiterung des Kunstbegriffs durch Rudolf Steiner," in *Okkultismus und Avantgarde*, ed. Loers., pp. 46–59, p. 51 (my translation).

51 Mondrian and Van Doesburg were listed as "collaborators" in early editions of *L'Esprit Nouveau* edited by Charles-Edouard Jeanneret (better known as Le Corbusier) and Amédée Ozenfant but the association dwindled. See Overy, *De Stijl*, pp. 174–5.

52 Briony Fer, "The Language of Construction," in Briony Fer, David Batchelor, and Paul Wood, *Realism, Rationalism, Surrealism: Art Between the Wars* (New Haven: Yale University Press, 1993), pp. 87–169, p. 157. A similar point is made, more in philosophical terms, about the ambiguities of Mondrian's dualities in Crowther, *Language of Twentieth-Century Art*, ch. 6: "The Dialectic of Abstract-Real in Mondrian," pp. 129–48, pp. 145–6.

53 See esp. Piet Mondrian, "The New Plastic in Painting" (1917), in *The New Art – The New Life: The Collected Writings of Piet Mondrian*, eds. Harry Holtzman and Martin S. James (London: Thames and Hudson, 1987), pp. 28–74.

54 Mark A. Cheetham, *The Rhetoric of Purity: Essentialist Theory and the Advent of Abstract Painting* (Cambridge: Cambridge University Press, 1991), p. 126.

9

Gustave Moreau

Joris-Karl Huysmans

Away from the maddening crowd [of Salon artists], which provides us during the month of Mary [May] with the intellectual ipecac of great art, Gustave Moreau for years has kept his canvases from becoming prisoners under the drab muslin tents hanging like miserable canopies in the glassed-in structure of the Palace of Industry.

He has also abstained from showing them in fashionable society exhibitions. As a result, his works, held by a few dealers, are rarely seen. In 1886, however, a series of his watercolors was exhibited by the Goupils in their galleries, rue Chaptal.

There the rooms were filled with immense skies lit by the flames of an auto-da-fé; squashed globes of bleeding suns, hemorrhages of heavenly bodies poured down in purple cataracts over scudding clouds.

Against the terrible bustle of such backgrounds, silent women went by, naked or dressed in gowns adorned with precious stones, like old Gospel-book bindings; women with hair of raw silk; with hard, steady gazes darting from pale blue eyes; with flesh as white and icy as the seminal fluid of fish; motionless Salomes holding in a cup the glowing head of the Precursor [Saint John the Baptist], macerated in phosphorus, under topiaries with twisted branches of green verging on black; goddesses riding hippogriffs and slicing with the lapis of their wings the swarms of agonizing clouds; feminine idols wearing tiaras, standing on thrones whose steps are awash in extraordinary flowers or else seated, in rigid poses, on elephants whose foreheads are weighted with green decorations, whose chests are cloaked in gold-embroidered chasubles, edged with pearls in the guise of jingle bells, elephants who stamp on their weighty image, reflected in the surface of the water they splash with their columnar ring-encircled legs.

Joris-Karl Huysmans, "Gustave Moreau," pp. 17–20 from Huysmans, *Certains*. Paris: Stock, 1889. This version is taken from pp. 45–7 in Henri Dorra (ed.), *Symbolist Art Theories: A Critical Anthology*. Berkeley: University of California Press, 1994. Reprinted by permission of University of California Press.

An identical impression arose from these various scenes, an impression of repeated spiritual onanism in a chaste flesh; the impression of a virgin endowed with a solemnly graceful body, with a soul exhausted by solitary secret thoughts; of a woman seated, murmuring to herself, under the pretense of the sacramental rhetoric of obscure prayers, insidious appeals for sacrilege, shameful orgies, torture, and murder.

Out of that gallery, in the bleak street, the dazed memory of these works persisted, but the scenes no longer appeared in their entirety; they became unremittingly fragmented into the minutiae of their strange details. The execution of these jewels, their outlines incised in the watercolor as if with the squashed nibs of pens; the thin elegance of these plants with intertwining stalks; the partially interwoven stems, embroidered like the lace surplices once made for prelates; the sweep of these flowers pertaining through their shape both to religious vessels and to aquatic flora, to water lilies and *pyxidates*, chalices and algae, all this surprising chemistry of supershrill colors, which, having reached their ultimate stage, went to the head and intoxicated the sight, causing the departing visitor, totally blinded by what he still saw projected along the new houses [lining the street] to grope for his way.

On second thought, as I went on strolling, as my eye found a new serenity and could look at, and size up, the shame of modern taste, the street – these boulevards where trees that have been orthopedically corseted in iron and fitted by the trussers of the Department of Public Works in cast-iron wheels [railings and circular grates placed around trees in Paris to protect them]; these roadways shaken by enormous horse-drawn buses and ignoble publicity carts; these sidewalks filled with a hideous crowd in quest of money: with women degraded by successive confinements, made stupid by horrible barters; with men reading vile newspapers or dreaming of fornications or of fraudulent operations [as they walked] along the shops and offices from which the officially sanctioned crooks of business and finance spy, the better to prey on them – one understood better the work of Gustave Moreau, which stands outside time, escapes into distant realms, glides over dreams, away from the excremental ideas oozing from a whole populace.

10

Symbolism in Painting: Paul Gauguin

G.-Albert Aurier

What do you think he would answer, if one were to tell him that, until then, he had only seen ghosts, that he now has before his eyes objects that are more real and closer to the truth? Would he not think that what he had seen earlier was more real than what he is shown now?

<div align="right">Plato</div>

Far away on a fabulous hill, its ground a scintillating vermilion, the biblical struggle of Jacob and the Angel unfolds. While these two legendary giants, who from a distance look like pygmies, engage in their formidable struggle, women watch them, curious, interested, and naive, doubtless not fully understanding what is going on over there, on this fabulous purpurescent hill. They are peasant women, Breton, to judge from the width of their white coifs spreading out like the wings of seagulls, the typical multicolored patterns of their shawls, and the shapes of their dresses and jackets. They are in the respectful attitudes and have the stunned expressions of simple creatures listening to extraordinary and some-what fantastic tales retold by some revered, unchallengeable fabulist. One might think of them as being in a church, such is their silent attentiveness, so thoughtful and devout their demeanor; thinking of them in church, one might imagine a vague smell of incense and prayer fluttering around the white wings of their coifs as the respected voice of the old priest glides over their heads . . . [Aurier's ellipsis]. Yes, of course, in a church, in some poor church in some little Breton village . . . [Aurier's ellipsis]. But then, where are the moldy green pillars? where

G.-Albert Aurier, "Symbolism in Painting: Paul Gauguin" (originally published in 1891), pp. 195–203 in Henri Dorra (ed.), *Symbolist Art Theories: A Critical Anthology.* Berkeley: University of California Press, 1994. Reprinted by permission of University of California Press.

are the milky walls and their diminutive chromolithographic stations of the cross? and the pine pulpit? and the old preacher, whose mumbling voice, to be sure, can be heard? Where is it all? And why, over there, far away, is there the soaring flank of the hill whose soil appears to be a scintillating vermilion? . . . [Aurier's ellipsis].

Ah! Because it happens that the moldy green pillars, the milky walls, the diminutive chromolithographic stations of the cross, the pine pulpit, and the old priest who preaches vanished a few minutes earlier, stopped existing for the good Breton peasant women! . . . [Aurier's ellipsis]. What a marvelously touching accent, what a luminous evocation, strangely adapted to the ears of the unsophisticated audience, this hemming and hawing village Bossuet has conjured up. All the ambient material realities have gone up in smoke, have disappeared. The evocator himself has faded away, and it is now his voice, his poor old pitiful spluttering voice, that has become visible, imposingly visible; and it is his voice that the peasant women in their white coifs hear in naive and devout admiration; and it is his voice that has been transformed into that rustically fantastic vision – the vision that has arisen over there, far away; and it is his voice, that fabulous vermilion hillside in that land of childish dreams where two biblical giants, transformed into pygmies because of the distance, engage in their harsh, fearful combat![. . .]

**

Before this marvelous canvas by Paul Gauguin, which truly highlights the enigma of the biblical poem of the paradisaical hours of primitive humanity; which reveals the inexpressible charms of the dream and of mystery and lifts the symbolic veils that the hands of simple souls only manage to half-raise; which resolves, for him who knows how to read, the eternal psychological problem posed by the potential human impact of religions, of politics and of sociology; which exposes, finally, the wild primordial beast overcome by the magical philters of the Chimera. Before this prodigious canvas – and I am not referring to some fat petit bourgeois banker taking pride in his important collection of Detaille (secure value) and Loustauneau (growth oriented), but to some art lover, reputedly intelligent, and so sympathetic to acts of youthful daring as to favor the harlequin vision of the pointillists [neo-impressionists] – such a visitor would exclaim:

– Oh no! by Jove! this is too much! Coifs and shawls from Ploërmel, and turn-of-the-century Breton women in a picture called *The Struggle of Jacob and the Angel!* Well, I dare say, I am not a reactionary; I accept the excesses of impressionism; in fact, I accept only impressionism, but . . . [Aurier's ellipsis].

– And who told you, my dear Sir, that this work has anything to do with impressionism?

Indeed, it might be time to dissipate an unfortunate ambiguity created by this word *impressionism* – a word too widely abused. [. . .]

Be that as it may, now that we are witnessing the agony of naturalism in literature and, simultaneously, the preparation of an idealist, even mystical, reaction, we should wonder whether the plastic arts are revealing a similar evolution. *The Struggle of Jacob and the Angel*, which I have attempted to describe by way of an introduction, is sufficient proof that this tendency exists, and one must understand why painters treading this new path reject this absurd label of impressionist, which implies a program diametrically opposed to theirs. This little discussion about words – which might appear ridiculous at first – is nevertheless, I believe, necessary, for everyone knows that the public, supreme judge in artistic matters, has the incurable habit of judging things according to their names. One must, therefore, invent a new term ending in *ist* (there are already so many of them that this will make no noticeable difference!) for the newcomers whose leader is Gauguin: synthetists, ideists, symbolists, as one likes best. [. . .]

**

Oh, how rare, in truth, among those who flatter themselves that they have "artistic dispositions," how rare are the blessed, the eyelids of their souls unsealed, who can exclaim with Swedenborg, the inspired seer: "This very night, the eyes of my inner man were opened: they became capable of peering into the heavens, into the world of ideas and into hell! . . . [Aurier's ellipsis]. And yet, is that not the preliminary and necessary initiation that the true artist, the absolute artist, must undergo? . . . [Aurier ellipsis].

Paul Gauguin seems to me one of those sublime travelers. He seems to me the initiator of an art, not so much new in the whole of history as in our own time. Let us analyze this art from a general aesthetic standpoint. This involves a study of the artist himself that will probably achieve more than the usual monograph composed of the description of some twenty canvases accompanied by ten flattering plates, such as today's school of criticism considers satisfactory.

It is obvious – and to state it is almost banal – that two major contradictory tendencies exist in the history of art, one depending on the blindness, the other on the clairvoyance of that "inner eye of man" to which Swedenborg refers: the realist and the ideist (I do not say idealist for reasons that will become apparent).

Without question, realist art, the art whose only purpose is to represent the outer aspects of matter, appearances perceptible to the senses, constitutes an interesting aesthetic manifestation. It reveals to us, almost by way of a reaction, the soul of the artist, since it exposes the distortions the object has undergone in its travel across that soul. Besides, no one contests that realism, if it has been a pretext for many monstrosities, as impersonal and banal as photographs, has also sometimes produced unchallengeable masterpieces that shine in the museum of all memories. And yet it is no less beyond question that ideist art appears purer and more elevated to whoever considers the matter fairly – purer and more elevated, just as all ideas are purer and more elevated than matter. One might even contend that the supreme art could only be ideist, art by definition (intuition

tells us) being but the material representation of what is most elevated and divine in the world, which, in the last analysis, is all that exists – the idea. As a result, do not those who neither see the idea nor believe in it deserve our compassion, like the unfortunate, stupid prisoners of Plato's allegorical cave?

Yet with the exception of most of the primitives and some of the great masters of the Renaissance, the general tendency of painting has been almost exclusively realist. Many individuals even admit that they cannot understand how painting, a *representational* art above all else, able to imitate to the point of illusionism all the visible attributes of matter, might be anything other than a faithful and exact reproduction of objective reality, an ingenious *facsimile* of the so-called real world. The idealists themselves (again I stress that one must not confuse them with the artists I call ideists) were most often, whatever they may say, nothing but realists. The goal of their art was the direct representation of material forms; they were satisfied to *arrange* objective reality according to conventional notions of quality. They prided themselves on representing *beautiful* objects, but those objects are *beautiful only inasmuch as they are objects*, the interest of their work residing always in the form – that is, in reality. Indeed, what they called ideal was only crafty makeup applied over ugly tangible things. In a word, they have painted a conventional objective reality, but objective reality nonetheless. If I may paraphrase one of them, Gustave Boulanger, ultimately the only difference between idealists and realists is the difference "that separates the helmet [*casque*] from the hunting cap [*casquette*]!"

The idealists too are the poor stupid prisoners of Plato's allegorical cave. Let them stultify themselves in contemplating shadows they mistake for reality and let us return to men who, having broken their chains, find ecstasy in contemplating the radiant sky of ideas, far from the cruel jail in which they were born.

The goal of painting, as of all the arts, as already pointed out, cannot be the direct representation of objects. Its end purpose is to express ideas as it translates them into a special language.

Indeed, in the eyes of the artist, of the one who must *express absolute entities*, objects, that is, relative entities that translate ideas (absolute and essential entities) in a way suited to our apprehension, have a significance only insofar as they are objects. The artist sees them only as *signs*, letters of an immense alphabet that only the genius knows how to read.

To write one's thought, one's poem, with those signs, all the while remembering that the sign, however indispensable, is nothing in itself and the idea alone is everything – such appears to be the task of the artist whose eye can determine the evocative potential of tangible objects. The first consequence of this principle is too obvious for us to have to ponder: it is, as one might have guessed, a necessary *simplification in the writing of the sign*. Indeed, were this not so, would the painter not resemble the naive literary figure who imagines that attention to his handwriting and the addition of futile calligraphic flourishes would contribute something to his work?

**

But even if the only real entities in this world are ideas, if objects only reveal the external appearance of these ideas and are thus important only as signs of ideas, it is no less true that to our myopic human eyes – that is, the eyes of the proud *shadows of pure entities* [that we are], shadows unconscious of the illusory condition in which they live and the beloved false tangible entities they encounter – objects mostly appear as objects, nothing but objects, independent of their symbolic significance – to such an extent that, despite our efforts, we sometimes cannot imagine them as signs.

This nefarious propensity in practical life to consider the object as nothing but an object is obvious and, one may say, almost general. Only the superior man, enlightened by the virtue the Alexandrians so aptly named ecstasy, knowns how to convince himself that he is but a sign, cast by some mysterious preordination into the midst of an innumerable crowd of signs; he alone, tamer of the monster illusion, knows how to stroll as a master in this fantastic temple

> in which living pillars
> Sometimes emit confused words

whereas the stupid human, fooled by the appearances that will make him repudiate essential ideas, remains blind as he travels through

> forests of symbols
> That observe him with familiar glances.

The work of art must not lend itself to such ambiguities, even in the eye of the popular herd. It so happens that the dilettante (who is not necessarily an artist and who, as a result, has no sense of symbolic correspondences) would find himself, before that work, in a situation like that of the crowd before the objects of nature. He would perceive the represented objects as nothing but objects – something it is important to avoid. It is therefore essential that this confusion be prevented from occurring in an ideist work. It is also necessary that we believe that the objects in the picture have no value as objects and are but signs, words, with no importance in themselves whatsoever.

As a result, certain laws must govern pictorial imitation. The artist, in every form of art, must carefully avoid the following [inherent] antinomies: concrete truth, illusionism, trompe-l'oeil. Indeed, he must not convey in his picture a false impression of nature that would act on the spectator like nature itself, without any suggestiveness, that is (forgive my barbaric neologism), ideicidally.

It is logical to imagine the artist fleeing the analysis of the object to protect himself from the perils of concrete truth. Indeed, in reality every detail is a partial symbol, irrelevant most of the time to the total signification of the object. In consequence, the strict duty of the ideist painter is to make a reasoned selection from the multiple elements of objective reality, to use in his work only the lines, forms, general and distinctive colors that enable him to describe precisely the ideic

significance of the object, in addition to a few partial symbols corroborating the general symbol.

Indeed, it is easy to deduce that the artist will always have the right to exaggerate, attenuate, and distort these directly signifying elements (forms, lines, colors, and so forth), not only according to his individual vision, his subjectivity (as happens even in realist art), but also according to the requirements of the idea to be expressed.

**

To sum up and conclude, the work of art as I have evoked it logically, is

1. *Ideist*, since its unique ideal is the expression of the idea;
2. *Symbolist*, since it expresses the idea by means of forms;
3. *Synthetic*, since it writes out those forms, these signs, according to a mode susceptible to general comprehension;
4. *Subjective*, since the object depicted is not considered as an object, but as a sign of an idea perceived by the subject;
5. And (as a consequence) *decorative* – inasmuch as decorative painting, as the Egyptians understood it and very probably the Greeks and the primitives, is only a manifestation of an art that is at once subjective, synthetic, symbolist, and ideist.

And decorative painting is, properly speaking, true painting. Painting can have been created only to *decorate* the bare walls of human edifices with thoughts, dreams, and ideas. Easel painting is an illogical refinement invented to satisfy the fantasy or the commercial spirit of decadent civilizations. In primitive societies the first attempts at picture making could only have been decorative.

This art that I have tried to legitimize and characterize, this art that may appear complicated and that some chroniclers would gladly call deliquescent, can therefore, in the last analysis, be reduced to the formula of simple, spontaneous, and primordial art. Such is the criterion of appropriateness in the aesthetic reasoning I present here. Ideist art, which had to be justified by abstract and complex arguments because it seems so paradoxical to our civilization, which happens to be both decadent and forgetful of any initial revelation, is therefore, irrefutably, the true and absolute art. Not only is it legitimate from the standpoint of theory, but it is also, in the last analysis, identical to primitive art, to art as it was intuited by the instinctive geniuses of the dawn of humanity.

But is this all? Is not some element missing that would transform an art so understood into what would truly be Art?

This man [Gauguin], who, thanks to his native genius and to all his acquired gifts, finds himself able, in the presence of nature, to read in each object an abstract signification of a dominating primordial idea – this man, who, through his intelligence and skill, knows how to use objects as a sublime alphabet to

express the ideas revealed to him – is he truly, in this very respect, a complete artist? The Artist?

Is he not rather a scientific genius, a supreme articulator who can write ideas like a mathematician? Is he not, in some way, an algebraist of ideas, and is not his work a marvelous equation, or rather a page of ideographic writing reminiscent of the hieroglyphic texts of the obelisks of ancient Egypt?

Yes, undoubtedly, the artist, if he has no other psychic gift, if he would be nothing but a *comprehensive articulator* is only that. Although comprehension complemented by the *power of expression* is sufficient for a man of learning, it is not for the artist.

To be worthy of this beautiful title of nobility (so polluted in our age of industrialization), the artist has to add to this power of comprehension an even more sublime gift, the *capacity for emotion* – not the capacity everyone experiences before illusory combinations of beings and things, not the capacity familiar to music-hall songsters and manufacturers of chromolithographs, but a transcendental capacity for emotion so great and so precious that it causes the soul to quiver in the presence of the undulating drama of abstractions. Oh, how few are they whose bodies and hearts are moved by the sublime vision of pure being and pure ideas! But this gift also happens to be the *sine qua non*, the spark that Pygmalion desired for his Galatea, the spiritual illumination, the golden key, the daimon, the Muse . . . [Aurier's ellipsis].

Thanks to this gift, symbols – that is, ideas – rise out of the darkness, become animated, start living a life that is no longer our contingent and relative life but a life of dazzling light that is the essential life, the life of art, the life of the being.

Thanks to this gift, the art that is complete, perfect, absolute finally exists.

One finds consolation in dreaming about such art, the art I like to imagine in the course of the compulsory strolls among the pitiful and depraved artsy-crafteries of our industrialist art exhibitions. Such is the art, I also believe – unless I have misinterpreted the thought underlying his output – that this great genius Paul Gauguin, endowed with the soul of a primitive being and to some extent that of a savage, has endeavored to introduce in our lamentable and putrefied nation.

*** ***

His output, already marvelous, I can neither describe nor analyze here. I shall content myself with characterizing and justifying the praiseworthy aesthetic conception that appears to guide him. How, indeed, can one suggest in words all that is inexpressible, the ocean of ideas that the clairvoyant eye can perceive in these magisterial works, the *Calvary, The Struggle of Jacob and the Angel*, the *Yellow Christ*; in these wonderful landscapes of Martinique and Brittany, in which all line, all form, all color is the word of an idea; in this sublime *Garden of Olives*, in which a red-haired Christ seated in a desolate site seems to convey through his tears the inexpressible sorrows of the dream, the agony of the Chimera, the betrayal of contingencies, the vanity of the real and of life, and, perhaps, of

the beyond. . . . How can one put into words the philosophy of the carving ironically titled *Be in Love and You Will be Happy*, in which lechery in full power, the struggle of flesh and thought, and all the suffering of sexual voluptuousness twist about and, so to speak, grind their teeth? How does one evoke that other wood carving, *Be Mysterious*, which glorifies the pure joys of esoterica, the troubling caresses of the enigma, the fantastic shadows of the forests of the problem? How can one explain, finally, the strange, barbaric, and savage ceramics in which, sublime potter that he is, he has kneaded the soul even more powerfully than the clay? [. . .]

**

Yet one must consider that however troubling, masterly, and marvelous his output, it amounts to little in comparison with what he could have produced in another civilization. Gauguin, like all ideist painters, is, above all, a decorator. His compositions are constrained by the restricted field of his canvases. One might sometimes be tempted to take them for fragments of enormous murals, and they almost always seem ready to burst the frames that unduly contain them . . . [Aurier's ellipsis].

Now then! In the course of our century we have produced only one great decorator, two, perhaps, when counting Puvis de Chavannes. And our imbecile society of bankers and *polytechniciens* refuses to provide for this rare artist the least palace, the most diminutive national shack, in which to display the sumptuous cloak of his dreams!

The walls of our Boeotian Pantheon are soiled by the ejaculations of the Lenepveus and the thingamajigs of the institute! . . . [Aurier's ellipsis]. Come on, have a little sense; you have among you a decorator of genius: walls! walls! give him walls! . . . [Aurier's ellipsis].

11

From *Abstraction and Empathy: A Contribution to the Psychology of Style*

Wilhelm Worringer

This work is intended as a contribution to the aesthetics of the work of art, and especially of the work of art belonging to the domain of the plastic arts. This clearly delimits its field from the aesthetics of natural beauty. A clear delimitation of this kind seems of the utmost importance, although most of the works on aesthetics and art history dealing with problems such as the one before us disregard this delimitation, and unhesitatingly carry the aesthetics of natural beauty over into the acsthetics of artistic beauty.

Our investigations proceed from the presupposition that the work of art, as an autonomous organism, stands beside nature on equal terms and, in its deepest and innermost essence, devoid of any connection with it, in so far as by nature is understood the visible surface of things. Natural beauty is on no account to be regarded as a condition of the work of art, despite the fact that in the course of evolution it seems to have become a valuable element in the work of art, and to some extent indeed positively identical with it.

This presupposition includes within it the inference that the specific laws of art have, in principle, nothing to do with the aesthetics of natural beauty. It is therefore not a matter of, for example, analysing the conditions under which a landscape appears beautiful, but of an analysis of the conditions under which the representation of this landscape becomes a work of art.[1]

Modern aesthetics, which has taken the decisive step from aesthetic objectivism to aesthetic subjectivism, i.e. which no longer takes the aesthetic as the starting-point of its investigations, but proceeds from the behaviour of the contemplating

Wilhelm Worringer, pp. 3–25, 136–8 (notes) from *Abstraction and Empathy: A Contribution to the Psychology of Style* (originally published in German 1908), trans. Michael Bullock. London: Routledge and Kegan Paul, 1953. Reprinted by permission of Thomson Publishing Services on behalf of Routledge.

subject, culminates in a doctrine that may be characterised by the broad general name of the theory of empathy. This theory has been clearly and comprehensively formulated in the writings of Theodor Lipps. For this reason his aesthetic system will serve, as *pars pro toto*, as the foil to the following treatise.[2]

For the basic purpose of my essay is to show that this modern aesthetics, which proceeds from the concept of empathy, is inapplicable to wide tracts of art history. Its Archimedian point is situated at *one* pole of human artistic feeling alone. It will only assume the shape of a comprehensive aesthetic system when it has united with the lines that lead from the opposite pole.

We regard as this counter-pole an aesthetics which proceeds not from man's urge to empathy, but from his urge to abstraction. Just as the urge to empathy as a pre-assumption of aesthetic experience finds its gratification in the beauty of the organic, so the urge to abstraction finds its beauty in the life-denying inorganic, in the crystalline or, in general terms, in all abstract law and necessity.

We shall endeavour to cast light upon the antithetic relation of empathy and abstraction, by first characterising the concept of empathy in a few broad strokes.[3]

The simplest formula that expresses this kind of aesthetic experience runs: Aesthetic enjoyment is objectified self-enjoyment. To enjoy aesthetically means to enjoy myself in a sensuous object diverse from myself, to empathise myself into it. 'What I empathise into it is quite generally life. And life is energy, inner working, striving and accomplishing. In a word, life is activity. But activity is that in which I experience an expenditure of energy. By its nature, this activity is an activity of the will. It is endeavour or volition in motion.'

Whereas the earlier aesthetics operated with pleasure and unpleasure, Lipps gives to both these sensations the value of tones of sensation only, in the sense that the lighter or darker tone of a colour is not the colour itself, but precisely a tone of the colour. The crucial factor is, therefore, rather the sensation itself, i.e. the inner motion, the inner life, the inner self-activation.

The presupposition of the act of empathy is the general apperceptive activity. 'Every sensuous object, in so far as it exists for me, is always the product of two components, of that which is sensuously given and of my apperceptive activity.'

Each simple line demands apperceptive activity from me, in order that I shall apprehend it as what it is. I have to expand my inner vision till it embraces the whole line; I have inwardly to delimit what I have thus apprehended and extract it, as an entity, from its surroundings. Thus every line already demands of me that inner motion which includes the two impulses: expansion and delimitation. In addition, however, every line, by virtue of its direction and shape, makes all sorts of special demands on me.

'The question now arises: how do I behave toward these demands. There are two possibilities, namely that I say yes or that I say no to any such demand, that I freely exercise the activity demanded of me, or that I resist the demand; that the natural tendencies, inclinations and needs for self-activation within me are in unison with the demand, or that they are not. We always have a need for self-activation. In fact this is the fundamental need of our being. But the self-activation demanded of me

by a sensuous object may be so constituted that, precisely by virtue of its constitution, it cannot be performed by me without friction, without inner opposition.

'If I can give myself over to the activity demanded of me without inward opposition, I have a feeling of liberty. And this is a feeling of pleasure. The feeling of pleasure is always a feeling of free self-activation. It is the directly experienced tonality or coloration of the sensation arising out of the activity that appears when the activity proceeds without inner friction. It is the symptom in consciousness of the free unison between the demand for activity and my accomplishment of it.'

In the second case, however, there arises a conflict between my natural striving for self-activation and the one that is demanded of me. And the sensation of conflict is likewise a sensation of unpleasure derived from the object.

The former situation Lipps terms positive empathy, and the second negative empathy.

In that this general apperceptive activity first brings the object into my spiritual possession, this activity belongs to the object. 'The form of an object is always its being-formed by me, by my inner activity. It is a fundamental fact of all psychology, and most certainly of all aesthetics, that a "sensuously given object", precisely understood, is an unreality, something that does not, and cannot, exist. In that it exists for me – and such objects alone come into question – it is permeated by my activity, by my inner life.' This apperception is therefore not random and arbitrary, but necessarily bound up with the object.

Apperceptive activity becomes aesthetic enjoyment in the case of positive empathy, in the case of the unison of my natural tendencies to self-activation with the activity demanded of me by the sensuous object. In relation to the work of art also, it is this positive empathy alone which comes into question. This is the basis of the theory of empathy, in so far as it finds practical application to the work of art. From it result the definitions of the beautiful and the ugly. For example: 'Only in so far as this empathy exists, are forms beautiful. Their beauty is this the ideal freedom with which I live myself out in them. Conversely, form is ugly when I am unable to do this, when I feel myself inwardly unfree, inhibited, subjected to a constraint in the form, or in its contemplation' (Lipps, *Aesthetik*, 247).

This is not the place to follow the system into its wider ramifications. It is sufficient for our purpose to note the point of departure of this kind of aesthetic experience, its psychic presuppositions. For we thereby reach an understanding of the formula which is important to us, which is to serve as a foil to the ensuing treatise, and which we shall therefore repeat here: 'Aesthetic enjoyment is objectified self-enjoyment.'

The aim of the ensuing treatise is to demonstrate that the assumption that this process of empathy has at all times and at all places been the presupposition of artistic creation, cannot be upheld. On the contrary, this theory of empathy leaves us helpless in the face of the artistic creations of many ages and peoples. It is of no assistance to us, for instance, in the understanding of that vast complex of works of art that pass beyond the narrow framework of Graeco-Roman and modern Occidental art. Here we are forced to recognise that quite a different psychic

process is involved, which explains the peculiar, and in our assessment purely negative, quality of that style. Before we begin to attempt a definition of this process, a few words must be said concerning certain basic concepts of the science of art, since what follows can only be understood once agreement has been reached on these basic concepts.

Since the florescence of art history took place in the nineteenth century, it was only natural that the theories concerning the genesis of the work of art should have been based on the materialist way of looking at things. It is unnecessary to mention what a healthy and rational effect this attempt to penetrate the essence of art exercised on the speculative aesthetics and aesthetic *bel espritisme* of the eighteenth century. In this manner a valuable foundation was ensured for the young science. A work like Semper's *Stil* remains one of the great acts of art history, which, like every intellectual edifice that has been grandly erected and thoroughly worked out, stands outside the historical valuation of 'correct' or 'incorrect'.

Nevertheless, this book with its materialistic theory of the genesis of the work of art, which penetrated into all circles and which, through several decades right down to our own time, has been tacitly accepted as the presupposition for most art historical investigations, is for us to-day a point of support for hostility to progress and mental laziness. The way to any deeper penetration into the innermost essence of art is barred by the exaggerated valuation placed upon secondary factors. Moreover, not everyone who bases his approach on Semper possesses Semper's spirit.

There are everywhere signs of a reaction against this jejune and indolent artistic materialism. The most considerable breach in this system is probably that made by the prematurely deceased Viennese scholar Alois Riegl, whose deep-delving and grandly planned work on the Late Roman art industry – to some extent through the difficulty of access to the publication – has unfortunately not received the attention merited by its epoch-making importance.[4]

Riegl was the first to introduce into the method of art historical investigation the concept of 'artistic volition'. By 'absolute artistic volition' is to be understood that latent inner demand which exists *per se*, entirely independent of the object and of the mode of creation, and behaves as will to form. It is the primary factor in all artistic creation and, in its innermost essence, every work of art is simply an objectification of this *a priori* existent absolute artistic volition. The materialistic method, which, as must be expressly emphasised, cannot be altogether identified with Gottfried Semper, but is partly based on a petty misinterpretation of his book, saw in the primitive work of art a product of three factors: utilitarian purpose, raw material, and technics. For it the history of art was, in the last analysis, a history of *ability*. The new approach, on the contrary, regards the history of the evolution of art as a history of *volition*, proceeding from the psychological pre-assumption that ability is only a secondary consequence of volition. The stylistic peculiarities of past epochs are, therefore, not to be explained by lack of ability, but by a differently directed volition. The crucial

factor is thus what Riegl terms 'the absolute artistic volition', which is merely modified by the other three factors of utilitarian purpose, raw material, and technics. 'These three factors are no longer given that positive creative role assigned to them by the materialist theory, instead they are assumed to play an inhibiting, negative one: they represent, as it were, the coefficients of friction within the total product' (*Spätrömische Kunstindustrie*).[5]

Most people will fail to understand why such an exclusive significance is given to the concept artistic volition, because they start from the firmly-embedded naive preconception that artistic volition, i.e. the aim-conscious impulse that precedes the genesis of the work of art, has been the same in all ages, apart from certain variations which are known as stylistic peculiarities, and as far as the plastic arts are concerned has approximation to the natural model as its goal.

All our judgements on the artistic products of the past suffer from this one-sidedness. This we must admit to ourselves. But little is achieved by this admission. For the directives of judgement that render us so biased, have so entered into our flesh and blood from long tradition that here a revaluation of values remains more or less cerebral labour followed only with difficulty by the sensibilities, which, at the first unguarded moment, scurry back into their old, indestructible notions.

The criterion of judgement to which we cling as something axiomatic, is, as I have said, approximation to reality, approximation to organic life itself. Our concepts of style and of aesthetic beauty, which, in theory, declare naturalism to be a subordinate element in the work of art, are in actual fact quite inseparable from the aforesaid criterion of value.[6]

Outside theory, the situation is that we concede to those higher elements, which we vaguely designate with the equivocal word 'style', only a regulative, modifying influence on the reproduction of the truths of organic life.

Any approach to art history that makes a consistent break with this one-sidedness is decried as contrived, as an insult to 'sound common sense'. What else is this sound common sense, however, than the inertia that prevents our spirits from leaving the so narrow and circumscribed orbit of *our* ideas and from recognising the possibility of other presuppositions. Thus we forever see the ages as they appear mirrored in our own spirits.

Before going any further, let us clarify the relation of the imitation of nature to aesthetics. Here it is necessary to be agreed that the impulse to imitation, this elemental need of man, stands outside aesthetics proper and that, in principle, its gratification has nothing to do with art.

Here, however, we must distinguish between the imitation impulse and naturalism as a type of art. They are by no means identical in their physical quality and must be sharply segregated from one another, however difficult this may appear. Any confusion of the two concepts in this connection is fraught with serious consequences. It is in all probability the cause of the mistaken attitude which the majority of educated people have toward art.

The primitive imitation impulse has prevailed at all periods, and its history is a history of manual dexterity, devoid of aesthetic significance. Precisely in the

earliest times this impulse was entirely separate from the art impulse proper; it found satisfaction exclusively in the art of the miniature, as for instance in those little idols and symbolic trifles that we know from early epochs of art and that are very often in direct contradiction to the creations in which the pure art impulse of the peoples in question manifested itself. We need only recall how in Egypt, for example, the impulse to imitation and the art impulse went on synchronously but separately next door to each other. Whilst the so-called popular art was producing, with startling realism, such statues as the Scribe or the Village Magistrate, art proper, incorrectly termed 'court art', exhibited an austere style that eschewed all realism. That there can be no question here either of inability or of rigid fixation, but that a particular psychic impulse was here seeking gratification, will be discussed in the further course of my arguments. At all times art proper has satisfied a deep psychic need, but not the pure imitation impulse, the playful delight in copying the natural model. The halo that envelops the concept art, all the reverent devotion it has at all times enjoyed, can be psychologically motivated only by the idea of an art which, having arisen from psychic needs, gratifies psychic needs.

And in this sense alone does the history of art acquire a significance almost equal to that of the history of religion. The formula which Schmarsow takes as the starting-point for his basic concepts, 'Art is a disputation of man with nature', is valid if all metaphysics is also regarded as what, at bottom, it is – as a disputation of man with nature. Then, however, the simple imitation impulse would have as much or as little to do with this impulse to enter into disputation with nature as, on the other hand, the utilisation of natural forces (which is, after all, also a disputation with nature) has to do with the higher psychic impulse to create gods for oneself.

The value of a work of art, what we call its beauty, lies, generally speaking, in its power to bestow happiness. The values of this power naturally stand in a causal relation to the psychic needs which they satisfy. Thus the 'absolute artistic volition' is the gauge for the quality of these psychic needs.

No psychology of the need for art – in the terms of our modern standpoint: of the need for style – has yet been written. It would be a history of the feeling about the world and, as such, would stand alongside the history of religion as its equal. By the feeling about the world I mean the psychic state in which, at any given time, mankind found itself in relation to the cosmos, in relation to the phenomena of the external world. This psychic state is disclosed in the quality of psychic needs, i.e. in the constitution of the absolute artistic volition, and bears outward fruit in the work of art, to be exact in the style of the latter, the specific nature of which is simply the specific nature of the psychic needs. Thus the various gradations of the feeling about the world can be gauged from the stylistic evolution of art, as well as from the theogony of the peoples.

Every style represented the maximum bestowal of happiness for the humanity that created it. This must become the supreme dogma of all objective consideration of the history of art. What appears from our standpoint the greatest

distortion must have been at the time, for its creator, the highest beauty and the fulfilment of his artistic volition. Thus all valuations made from our standpoint, from the point of view of our modern aesthetics, which passes judgement exclusively in the sense of the Antique or the Renaissance, are from a higher standpoint absurdities and platitudes.

After this necessary diversion, we shall return once more to the starting-point, namely to the thesis of the limited applicability of the theory of empathy.

The need for empathy can be looked upon as a presupposition of artistic volition only where this artistic volition inclines toward the truths of organic life, that is toward naturalism in the higher sense. The sensation of happiness that is released in us by the reproduction of organically beautiful vitality, what modern man designates beauty, is a gratification of that inner need for self-activation in which Lipps sees the presupposition of the process of empathy. In the forms of the work of art we enjoy ourselves. Aesthetic enjoyment is objectified self-enjoyment. The value of a line, of a form consists for us in the value of the life that it holds for us. It holds its beauty only through our own vital feeling, which, in some mysterious manner, we project into it.

Recollection of the lifeless form of a pyramid or of the suppression of life that is manifested, for instance, in Byzantine mosaics tells us at once that here the need for empathy, which for obvious reasons always tends toward the organic, cannot possibly have determined artistic volition. Indeed, the idea forces itself upon us that here we have an impulse directly opposed to the empathy impulse, which seeks to suppress precisely that in which the need for empathy finds its satisfaction.[7]

This counter-pole to the need for empathy appears to us to be the urge to abstraction. My primary concern in this essay is to analyse this urge and to substantiate the importance it assumes within the evolution of art.

The extent to which the urge to abstraction has determined artistic volition we can gather from actual works of art, on the basis of the arguments put forward in the ensuing pages. We shall then find that the artistic volition of savage peoples, in so far as they possess any at all, then the artistic volition of all primitive epochs of art and, finally, the artistic volition of certain culturally developed Oriental peoples, exhibit this abstract tendency. Thus the urge to abstraction stands at the beginning of every art and in the case of certain peoples at a high level of culture remains the dominant tendency, whereas with the Greeks and other Occidental peoples, for example, it slowly recedes, making way for the urge to empathy. This provisional statement is substantiated in the practical section of the essay.

Now what are the psychic presuppositions for the urge to abstraction? We must seek them in these peoples' feeling about the world, in their psychic attitude toward the cosmos. Whereas the precondition for the urge to empathy is a happy pantheistic relationship of confidence between man and the phenomena of the external world, the urge to abstraction is the outcome of a great inner unrest inspired in man by the phenomena of the outside world; in a religious respect it corresponds to a strongly transcendental tinge to all notions. We might describe

this state as an immense spiritual dread of space. When Tibullus says: *primum in mundo fecit deus timor*, this same sensation of fear may also be assumed as the root of artistic creation.

Comparison with the physical dread of open places, a pathological condition to which certain people are prone, will perhaps better explain what we mean by this spiritual dread of space. In popular terms, this physical dread of open places may be explained as a residue from a normal phase of man's development, at which he was not yet able to trust entirely to visual impression as a means of becoming familiar with a space extended before him, but was still dependent upon the assurances of his sense of touch. As soon as man became a biped, and as such solely dependent upon his eyes, a slight feeling of insecurity was inevitably left behind. In the further course of his evolution, however, man freed himself from this primitive fear of extended space by habituation and intellectual reflection.[8]

The situation is similar as regards the spiritual dread of space in relation to the extended, disconnected, bewildering world of phenomena. The rationalistic development of mankind pressed back this instinctive fear conditioned by man's feeling of being lost in the universe. The civilised peoples of the East, whose more profound world-instinct opposed development in a rationalistic direction and who saw in the world nothing but the shimmering veil of Maya, they alone remained conscious of the unfathomable entanglement of all the phenomena of life, and all the intellectual mastery of the world-picture could not deceive them as to this. Their spiritual dread of space, their instinct for the relativity of all that is, did not stand, as with primitive peoples, *before* cognition, but *above* cognition.

Tormented by the entangled inter-relationship and flux of the phenomena of the outer world, such peoples were dominated by an immense need for tranquillity. The happiness they sought from art did not consist in the possibility of projecting themselves into the things of the outer world, of enjoying themselves in them, but in the possibility of taking the individual thing of the external world out of its arbitrariness and seeming fortuitousness, of eternalising it by approximation to abstract forms and, in this manner, of finding a point of tranquillity and a refuge from appearances. Their most powerful urge was, so to speak, to wrest the object of the external world out of its natural context, out of the unending flux of being, to purify it of all its dependence upon life, i.e. of everything about it that was arbitrary, to render it necessary and irrefragable, to approximate it to its *absolute* value. Where they were successful in this, they experienced that happiness and satisfaction which the beauty of organic-vital form affords *us*; indeed, they knew no other beauty, and therefore we may term it their beauty.

In his *Stilfragen* Riegl writes: 'From the standpoint of regularity the geometric style, which is built up strictly according to the supreme laws of symmetry and rhythm, is the most perfect. In our scale of values, however, it occupies the lowest position, and the history of the evolution of the arts also shows this style to have been peculiar to peoples still at a low level of cultural development.'

If we accept this proposition, which admittedly suppresses the role which the geometric style has played amongst peoples of highly developed culture, we are

confronted by the following fact: The style most perfect in its regularity, the style of the highest abstraction, most strict in its exclusion of life, is peculiar to the peoples at their most primitive cultural level. A causal connection must therefore exist between primitive culture and the highest, purest regular art-form. And the further proposition may be stated: The less mankind has succeeded, by virtue of its spiritual cognition, in entering into a relation of friendly confidence with the appearance of the outer world, the more forceful is the dynamic that leads to the striving after this highest abstract beauty.

Not that primitive man sought more urgently for regularity in nature, or experienced regularity in it more intensely; just the reverse: it is because he stands so lost and spiritually helpless amidst the things of the external world, because he experiences only obscurity and caprice in the inter-connection and flux of the phenomena of the external world, that the urge is so strong in him to divest the things of the external world of their caprice and obscurity in the world-picture and to impart to them a value of necessity and a value of regularity. To employ an audacious comparison: it is as though the instinct for the 'thing in itself' were most powerful in primitive man. Increasing spiritual mastery of the outside world and habituation to it mean a blunting and dimming of this instinct. Only after the human spirit has passed, in thousands of years of its evolution, along the whole course of rationalistic cognition, does the feeling for the 'thing in itself' re-awaken in it as the final resignation of knowledge. That which was previously instinct is now the ultimate product of cognition. Having slipped down from the pride of knowledge, man is now just as lost and helpless *vis-à-vis* the world-picture as primitive man, once he has recognised that 'this visible world in which we are is the work of Maya, brought forth by magic, a transitory and in itself unsubstantial semblance, comparable to the optical illusion and the dream, of which it is equally false and equally true to say that it is, as that it is not' (Schopenhauer, *Kritik der Kantischen Philosophie*).

This recognition was fruitless, however, because man had become an individual and broken away from the mass. The dynamic force resting in an undifferentiated mass pressed together by a common instinct had alone been able to create from out of itself those forms of the highest abstract beauty. The individual on his own was too weak for such abstraction.

It would be a misconstruction of the psychological preconditions for the genesis of this abstract art form, to say that a craving for regularity led men to reach out for geometric regularity, for that would presuppose a spiritual-intellectual penetration of abstract form, would make it appear the product of reflection and calculation. We have more justification for assuming that what we see here is a purely instinctive creation, that the urge to abstraction created this form for itself with elemental necessity and without the intervention of the intellect. Precisely because intellect had not yet dimmed instinct, the disposition to regularity, which after all is already present in the germ-cell, was able to find the appropriate abstract expression.[9]

These regular abstract forms are, therefore, the only ones and the highest, in which man can rest in the face of the vast confusion of the world-picture. We

frequently find the, at first sight, astonishing idea put forward by modern art theoreticians that mathematics is the highest art form; indeed it is significant that it is precisely Romantic theory which, in its artistic programmes, has come to this seemingly paradoxical verdict, which is in such contradiction to the customary nebulous feeling for art. Yet no one will venture to assert that, for instance, Novalis, the foremost champion of this lofty view of mathematics and the originator of the dicta, 'The life of the gods is mathematics', 'Pure mathematics is religion', was not an artist through and through. Only between this verdict and the elemental instinct of primitive man, there lies the same essential difference that we have just seen to exist between primitive humanity's feeling for the 'thing in itself' and philosophic speculation concerning the 'thing in itself'.

Riegl speaks of crystalline beauty, 'which constitutes the first and most eternal law of form in inanimate matter, and comes closest to absolute beauty (material individuality)'.

Now, as I have said, we cannot suppose man to have picked up these laws, namely the laws of abstract regularity, from inanimate matter; it is, rather, an intellectual necessity for us to assume that these laws are also implicitly contained in our own human organisation – though all attempts to advance our knowledge on this point stop short at logical conjectures, such as are touched on in the second chapter of the present work.

We therefore put forward the proposition: The simple line and its development in purely geometrical regularity was bound to offer the greatest possibility of happiness to the man disquieted by the obscurity and entanglement of phenomena. For here the last trace of connection with, and dependence on, life has been effaced, here the highest absolute form, the purest abstraction has been achieved; here is law, here is necessity, while everywhere else the caprice of the organic prevails. But such abstraction does not make use of any natural object as a model. 'The geometric line is distinguished from the natural object precisely by the fact that it does not stand in any natural context. That which constitutes its essence does, of course, pertain to nature. Mechanical forces are natural forces. In the geometric line, however, and in geometrical forms as a whole, they have been taken out of the natural context and the ceaseless flux of the forces of nature, and have become visible on their own' (Lipps, *Aesthetik*, 249).

Naturally, this pure abstraction could never be attained once a factual natural model underlay it. The question is therefore: How did the urge to abstraction behave toward the things of the external world? We have already stressed the fact that it was not the imitation impulse – the history of the imitation impulse is a different thing from the history of art – that compelled the reproduction in art of a natural model. We see therein rather the endeavour to redeem the individual object of the outer world, in so far as it particularly arouses interest, from its combination with, and dependence upon, other things, to tear it away from the course of happening, to render it absolute.

Riegl saw this urge to abstraction as the basis of the artistic volition of the early civilisations: 'The civilised peoples of antiquity descried in external things, on the

analogy of what they deemed to be their own human nature (anthropism), material individuals of various sizes, but each one joined together into firmly cohering parts, into an indivisible unity. Their sense-perception showed them things as confused and abscurely intermingled; through the medium of plastic art they picked out single individuals and set them down in their clearly enclosed unity. Thus the plastic art of the whole of antiquity sought as its ultimate goal to render external things in their clear material individuality, and in so doing to respect the sensible appearance of the outward things of nature and to avoid and suppress anything that might cloud and vitiate the directly convincing expression of material individuality' (Riegl, *Spätrömische Kunstindustrie*).

A crucial consequence of this artistic volition was, on the one hand, the approximation of the representation to a plane, and on the other, strict suppression of the representation of space and exclusive rendering of the single form.

The artist was forced to approximate the representation to a plane because three-dimensionality, more than anything else, contradicted the apprehension of the object as a closed material individuality, since perception of three-dimensionality calls for a succession of perceptual elements that have to be combined; in this succession of elements the individuality of the object melts away. On the other hand, dimensions of depth are disclosed only through foreshortening and shadow, so that a vigorous participation of the combinative understanding and of habituation is required for their apprehension. In both cases, therefore, the outcome is a subjective clouding of the objective fact, which the ancient cultural peoples were at pains to avoid.

Suppression of representation of space was dictated by the urge to abstraction through the mere fact that it is precisely space which links things to one another, which imparts to them their relativity in the world-picture, and because space is the one thing it is impossible to individualise. In so far, therefore, as a sensuous object is still dependent upon space, it is unable to appear to us in its closed material individuality. All endeavour was therefore directed toward the single form set free from space.

Let anyone to whom this thesis of man's primal need to free the sensuous object from the unclarity imposed upon it by its three-dimensionality, by means of artistic representation seems contrived and far-fetched, recall that a modern artist, and a sculptor at that, has once more felt this need very strongly. I refer to the following sentences from Hildebrand's *Problem der Form*: 'For it is not the task of sculpture to leave the spectator in the incomplete and uneasy state *vis-à-vis* the three-dimensional or cubic quality of the natural impression, in which he must labour to form a clear visual notion; on the contrary, it consists precisely in furnishing him with this visual notion and thus depriving the cubic of its agonising quality. As long as a sculptural figure makes a primarily cubic impression on the spectator it is still in the initial stage of its artistic configuration; only when it has a flat appearance, although it is cubic, has it acquired artistic form.'

What Hildebrand here calls 'the agonising quality of the cubic' is, in the last analysis, nothing else than a residue of that anguish and disquiet which governed

89

man in relation to the things of the outer world in their obscure inter-relationship and interplay, is nothing else than a last memory of the point of departure of all artistic creation, namely the urge to abstraction.

If we now repeat the formula which we found to be the basis of the aesthetic experience resulting from the urge to empathy: 'Aesthetic enjoyment is objecti-fied self-enjoyment', we at once become conscious of the polar antithesis between these two forms of aesthetic enjoyment. On the one hand the ego as a clouding of the greatness of the work of art, as a curtailment of its capacity for bestowing happiness, on the other the most intimate union between ego and work of art, which receives all its life from the ego alone.

This dualism of aesthetic experience, as characterised by the aforementioned two poles, is – a remark which will serve to conclude this chapter – not a final one. These two poles are only gradations of a common need, which is revealed to us as the deepest and ultimate essence of all aesthetic experience: this is the need for self-alienation.

In the urge to abstraction the intensity of the self-alienative impulse is incom-parably greater and more consistent. Here it is not characterised, as in the need for empathy, by an urge to alienate oneself from individual being, but as an urge to seek deliverance from the fortuitousness of humanity as a whole, from the seeming arbitrariness of organic existence in general, in the contemplation of something necessary and irrefragable. Life as such is felt to be a disturbance of aesthetic enjoyment.

The fact that the need for empathy as a point of departure for aesthetic experience also represents, fundamentally, an impulse of self-alienation is all the less likely to dawn upon us the more clearly the formula rings in our ears: 'Aesthetic enjoyment is objectified self-enjoyment.' For this implies that the process of empathy represents a self-affirmation, an affirmation of the general will to activity that is in us. 'We always have a need for self-activation. Indeed this is the basic need for our nature.' In empathising this will to activity into another object, however, we *are* in the other object. We are delivered from our individual being as long as we are absorbed into an external object, an external form, with our inner urge to experience. We feel, as it were, our individuality flow into fixed boundaries, in contrast to the boundless differentiation of the individual con-sciousness. In this self-objectivation lies a self-alienation. This affirmation of our individual need for activity represents, simultaneously, a curtailment of its illim-itable potentialities, a negation of its ununifiable differentiations. We rest with our inner urge to activity within the limits of this objectivation. 'In empathy, there-fore, I am not the real I, but am inwardly liberated from the latter, i.e. I am liberated from everything which I am apart from contemplation of the form. I am only this ideal, this contemplating I' (Lipps, *Aesthetik*, 247). Popular usage speaks with striking accuracy of 'losing oneself' in the contemplation of a work of art.

In this sense, therefore, it cannot appear over-bold to attribute all aesthetic enjoyment – and perhaps even every aspect of the human sensation of happiness – to the impulse of self-alienation as its most profound and ultimate essence.

The impulse to self-alienation, which is extended over organic vitality in general, confronts the urge to self-alienation directed solely toward the individual existence, as revealed in the need for empathy, as its polar antithesis. The ensuing chapter will be devoted to a more detailed characterisation of this aesthetic dualism.[10]

Notes

1 Cf. Hildebrand, *Problem der Form*: 'The problems of form which arise during the architectonic fashioning of a work of art are not those immediately posed by nature and self-evident, but precisely those which belong absolutely to art.' Or: 'The activity of plastic art takes possession of the object as something to be illumined by the mode of representation, not as something that is already poetic or significant in itself.' One must not be misled by the word 'architectonic'; as employed by Hildebrand it embraces all those elements which distinguish a work of art from mere imitation. Cf. the disquisition in the Preface to the Third Edition, in which Hildebrand formulates his artistic credo in lucid propositions.

2 This limitation is a dictate of necessity. For this cannot be the place to weigh against one another the various systems that proceed from the psychic process of empathy. We must therefore renounce any critique of Lipps' system here, especially as we are making use only of its basic general ideas. The development of the problem of empathy extends back to Romanticism which, with artistic intuition, anticipated the fundamental outlook of contemporary aesthetics. The problem received scientific elaboration at the hands of men like Lotze, Friedrich Vischer, Robert Vischer, Volkelt, Groos, and finally Lipps. Further information concerning this development is contained in the lucid and meritorious Munich dissertation by Paul Stern, *Einfühlung und Assoziation in der modernen Ästhetik*, Munich, 1897.

3 The ensuing attempt at a characterisation reproduces the fundamental ideas of Lipps' theory, in part verbatim, in the formulations given to them by Lipps himself in a summary of his doctrine which he published in January 1906 in the weekly periodical *Zukunft*.

4 My essay rests at various points on the views of Riegl, as set out in *Stilfragen* (1893) and *Spätrömische Kunstindustrie* (1901). A knowledge of these works, if not absolutely necessary to the understanding of my essay, is at least highly desirable. Even if the author is not in agreement with Riegl over all points, he occupies the same ground as regards the method of investigation and it is to Riegl that the greatest incentives to the work are due.

5 Cf. Wölfflin in this connection: 'I am naturally far from denying a technological genesis of individual forms. The nature of the material, the method of working it, the construction will never be without influence. But what I wish to maintain – especially against certain new endeavours – is that technology never creates a style, but that where art is concerned a particular feeling for form is always the primary factor. The forms produced by technology must never contradict this feeling for form; they can endure only where they adapt themselves to this pre-existing taste in form' (*Renaissance und Barock*, II Aufl., 57).

6 One need only call to mind, for example, how bewildered even an artistically trained modern public is by such a phenomenon as Hodler, to name only one of a thousand instances. This bewilderment clearly reveals how very much we are accustomed to look upon beauty and truth to nature as a precondition of the artistically beautiful.

7 This is not intended to deny the fact that we are able to-day to empathise ourselves into the form of a pyramid, any more than the general possibility of empathy into abstract forms, which we shall discuss at length in the ensuing pages. Only everything contradicts the assumption that this empathy impulse was at work in the creators of the pyramidal form. (See the practical section of the book.)

8 In this context we may recall the fear of space which is clearly manifested in Egyptian architecture. The builders sought by means of innumerable columns, devoid of any constructional function, to destroy the impression of free space and to give the helpless gaze assurance of support by means of these columns. (Cf. Riegl, *Spätrö- mische Kunstindustrie*, Chapter I.)

9 This problem will be dealt with in greater detail in Chapter Two.

10 Schopenhauer's aesthetic offers an analogon to such a conception. According to Schopenhauer the felicity of aesthetic contemplation consists precisely in the fact that in it man is delivered from his will and remains only as pure subject, as the pure mirror of the object. 'And precisely thereby, he who is immersed in such contemplation ceases to be an individual, for the individual has lost himself in this contemplation: he is the pure, will-less, painless, timeless subject of cognition.' (Cf. Book Three of *The World as Will and Idea*.)

12

From *On the Spiritual in Art*

Wassily Kandinsky

A. General Part

1) Introduction

Every work of art is a child of its time. Often it is the mother of our feelings.

Every era of culture, therefore, creates its own, inimitable art. Any aspiration to resuscitate the principles of an art of the past can at best achieve only a work still-born. For example, we cannot feel and live inwardly as the Ancient Greeks did. Our efforts to apply the principles of Ancient Greece, albeit in sculpture, can produce forms only similar to those of the Greeks. The works themselves will remain forever lifeless. This kind of imitation is what monkeys do.

Look at a monkey – his movements are entirely human.

A monkey will sit holding a book. He will leaf through it. He will even assume a contemplative expression. But none of these movements possesses an inner meaning.

But there is another kind of outer similarity in artistic forms. At its basis lies absolute necessity: a similarity between *inner* aspirations throughout the moral and spiritual atmosphere, aspirations towards goals which, in essence, were once pursued and were then forgotten. In other words, a similarity in inner mood during a historical period may lead us naturally to use forms which served the same aspirations in bygone years. That's how – to a considerable extent – our

Wassily Kandinsky, pp. 63–102; 103–7 (excerpted notes) from "Vasilii Kandinsky, *On the Spiritual in Art (Painting)*" (Russian version first published 1911), trans. John E. Bowlt and published in John E. Bowlt and Rose-Carol Washton Long (eds.), *The Life of Vasilii Kandinsky in Russian Art: A Study of On the Spiritual in Art.* Newtonville, MA: Oriental Research Partners, 1980. Reprinted by permission of Oriental Research Partners.

sympathies, our comprehension and our inner relationship with the Primitives have arisen. Like us, these "pure" artists desired only the inner necessity – a condition whence the outer and the incidental were banished as a matter of course.

Nevertheless, this point of contact, whatever its importance, is that and no more. Our soul, which only now is awakening from a long period of materialism, conceals within itself the seeds of despair, of faithlessness, of purposelessness. The nightmare of materialist ideals has still not passed, and these are ideals which have made an evil, pointless joke out of the universe. The awakening soul is still very much under the influence of this nightmare. A light glimmers but faintly, a tiny speck in the vast blackness. This faint light is only a premonition and the soul lacks the courage to yield to it: perhaps this light is the dream and blackness the reality? Our doubts, our oppressive sufferings caused by the materialist philosophy force a deep division between our soul and the soul of the Primitives. Our soul is cracked. Should anyone touch it, it will resound like a cracked, precious vase recovered from the bowels of the earth. Hence, the attraction towards the primitive which we are now experiencing (in a rather derivative form) cannot last long.

The two kinds of resemblance to forms of past ages which modern art contains are diametrically opposed – which is immediately obvious. The first kind is an outward resemblance and, therefore, has no potential. The second kind is an inward resemblance and, therefore, contains the seeds of the future. After the era of materialist trial and temptation which seemed to enslave the soul, but which the soul, in fact, rejected as the temptation of Satan, the soul is being born again, refined by its struggle and its sufferings. The artist will become less attracted to vulgar feelings such as fear, joy and sadness which were available as subject-matter during the period of temptation. He now lives a more intricate and rather more refined life. And naturally his creations will arouse more delicate emotions – ones which defy description in our language.

Bur rarely is the spectator of today capable of such emotional vibrations. In his artistic consciousness he seeks either the downright imitation of nature which can serve a pragmatic aim (in mundane terms a portrait, etc.) or a conventional, Impressionist interpretation of nature (still an imitation); again, he might seek the spiritual conditions concealed within the forms of nature (what we call "mood"). All these forms of art, if they are truly artistic, fulfil their purpose and serve (even in the first case) as spiritual nourishment. This is particularly true in the third case, where the spectator finds harmony (or disharmony). Hence, these forms are not fruitless or entirely superficial: the "mood" of the work of art can intensify and, even more, sanctify the spectator's mood. In any case, such works restrain the soul from descending into vulgarity. They keep it at a certain pitch just as a tuning-fork does the string of a musical instrument. Nonetheless, the refinement and diffusion of this sound in time and space is unilateral and does not exhaust the possibilities of artistic effect.

The roots of the other kind of art, the one which is capable of further formations, are also to be found in its contemporary spiritual epoch. At the same time, this other

art is not merely the echo and the mirror of this epoch, it also bears a stirring *prophetic force* which radiates from far away and from deep down.

The spiritual life – one part of which is art (among the prime movers of the spiritual life) – is a complex movement, but it is a distinct one and can be expressed in a simple formula: forwards and upwards. This movement is the path of cognition. It can assume various forms, but at its basis there always lies the same inner meaning, the same aim.

Hidden in the blackness are the reasons why necessity moves forwards and upwards, why it moves through blood and sweat, through suffering, through evil and through what we call delusion. A new point is attained, heavy stones are shifted from the path – when suddenly some unseen hand flings huge boulders on to the path. It seems at times that the path has been lost forever and that it can never be followed again.

At such moments a certain man always comes upon the scene. He is just like one of us, he looks the same as everyone else, but upon him has been bestowed the secret gift of "seeing." And in seeing, he reveals. There are times when he would refuse this noble gift, for it can become a cross to bear. But he does not have the power to do this. Surrounded by malice and derision, he drags behind him the heavy burden of mankind, ever forwards, ever upwards.

Often, no traces of his physical "I" remain on earth. And then all means are employed to recreate his physical "I" in gigantic proportions out of marble, iron, bronze, stone. It is as if, for these servants of God, the *physical* "I" has particular value in the form of man, i.e., for those who manage to reject the physical and serve the *spiritual*. In any case, the moment people clarify these aims and seize the piece of marble is exactly when many of them attain the point where the object of their glory once stood.

2) Movement

A large, acute-angled triangle divided into unequal segments with the narrowest segment upwards – that is the spiritual life conceived as a precise scheme. The lower the segments of the triangle, the greater their breadth, volume and height.

The whole triangle moves forwards and upwards slowly, almost imperceptibly. At the point where "today" is, there begins the very next segment, i.e., "tomorrow."[1] In other words, what today was more elevated, what seemed to be senseless confusion to the other segments, tomorrow will become the content of the life of the second segment, one full of meaning and feeling.

Sometimes a man appears in complete isolation at the very apex of the upper segment. His joyous vision resembles an inward, eternal sadness. Even those who stand close to him do not understand him. In their indignation they accuse him of deceit and see him as a candidate for the mad-house. That's how Beethoven once stood in isolation, showered with abuse his whole life long. And he was not the only one.

How long it took for one of the more populous segments of the triangle to attain the point where he had once stood. And despite all the monuments to him, how many people have really reached that point?

Each segment contains all elements of the physical and the spiritual life in various quantitative combinations. Each segment, therefore, possesses its own artists. And he who sees beyond the boundaries of his environment is a prophet (within his segment) and helps to move the obstinate burden of mankind. If he lacks this perspicacious eye, or if the artist abuses his vision because of lowly aims and closes his eyes to that which summons him with the ceaseless resonance of the soul – then all his colleagues "understand" him and eulogize him and his creative works. This is one of the terrifying, tangible manifestations of the mysterious Spirit of Evil. The larger this segment (i.e., the lower it is at this particular time), the larger the mob who understands the artist's statement. It is quite clear that each segment possesses its own aspiration, its own spiritual hunger (conscious or, more often than not, unconscious) for spiritual bread.

This bread is provided by the "resident" artist. Tomorrow the adjacent segment will stretch out its hand for it.

Of course, this schematic representation does not exhaust the entire picture of spiritual life. It does not, incidentally, disclose one dark side, the great, dead *black spot*. Spiritual bread often becomes the food of those who already abide in the higher segment. For them this bread is poison: after a small dose its effect is such that the soul slowly descends from the higher segment to the lower; after a large dose this poison leads to degeneration, dragging the soul down ever deeper. It is at this juncture that the man's gift, his talent (in the Biblical sense) can become a curse – both for him who bears the gift and for all who partake of the poison bread. The artist uses his strength to serve vulgar demands; he introduces impure content into his ostensibly artistic form; he attracts weak forces; he continually mixes them up with evil forces; he deceives people and helps them deceive themselves into imagining that they suffer a spiritual thirst and that they can quench it at a pure spring. Such creative works do not assist the movements upwards. They impede it, they repel that which would forge ahead; they spread the plague.

In the spiritual world, these moments – when art is deprived of a noble creator and of the bread of enlightenment – are ones of decadence. Souls fall constantly from higher segments into lower ones. It seems that the whole triangle has stopped, motionless, that it is moving backwards, downwards. At such moments of silence and blindness people seek outward achievement (technological progress, which serves, and can serve, only the body), and they value these things with particular ardor. The purely spiritual forces are not appreciated or are not even noticed.

The "seers," standing in their grand isolation, seem ridiculous, insane. These solitary souls, whom sleep cannot conquer, who feel an obscure aspiration towards the spiritual life, towards knowledge, towards the attainment of a goal, sound pitiful and inconsolable amidst the vulgar choir of materialists. Gradually,

a spiritual night descends. These frightened souls are surrounded by a gloom growing ever thicker, ever deeper. And the torch-bearers are persecuted, exhausted by doubt and fear. As they seek escape from the gathering darkness, they often yield to an impulse to rush into the gloom.

Art, which at such moments leads a debased life, comes to be used exclusively for material ends. It seeks content in *solid matter* because it cannot see a finer one. Art sees its only aim in the reproduction of objects, and they become changeless. The "what" falls away as a matter of course. The only question remaining is "how" the artist can transmit this or that physical object. This question becomes a symbol of faith. Art loses its soul.

And so, art advances along this path of the "how." Art begins to specialize and becomes intelligible only to those same artists who complain of the spectator's indifference to their works. At such times the artist doesn't need to express very much. He gains a reputation built on that negligible word "otherwise." He brings to the fore a whole crowd of Maecenates who provide bounteous material blessings. As a result, a large number of gifted, skillful individuals suddenly throw themselves on art – for art seems as if it can be conquered with ease. In every "art center" live thousands upon thousands of such artists. For the most part, they are merely seeking a new manner and, without exultation, without passion, cold of heart, weary of soul, they create millions of works.

Competition is increasing. The crazy pursuit of success causes the search to be more and more external. Small groups of artists, who by chance have clambered out of the chaos of artists and paintings, build high walls around their newly won territory. Somewhere far behind the spectator gazes without comprehending and quietly turns his back.

Despite this blindness and confusion which is all that can be seen at the time, despite this crazy pursuit of fashion, the spiritual triangle moves slowly but surely forwards, upwards.

There is no need to mention the periods of decadence, the long days of temptation and of gloom when one stretches out ones hand for bread bestowed not from above, but from below. The result is an easy, happy-go-lucky slide downwards instead of an impulse to ascend.

But at this very moment of decadence one can perceive, here and there, the eternal aspiration towards a new expression, towards a new form, towards a new "how."

This current brings new seeds of salvation. Salvation – because the current has not dried up. Initially, this "how" might remain a purely formal one. Very soon, however, it is joined by the artist's spontaneous emotion or, better expressed, it sallies forth summoning the emotion to follow.

This "how" absorbs the artist's spontaneous emotion and manifests its ability to incite his finer experiences. At this point art reaches the path whereby it will rediscover its forgotten "what," i.e., that which is the spiritual bread for the new spiritual awakening. No longer will this be a material "what" of anachronistic objects, but will be an *artistic content*, the very soul of art. Without this its body

97

(the "how") can never lead a full, healthy life in the same way that a human being or a race of people do.

This "what" is a content which can be possessed only by art, which can be expressed only by art and only by its own, peculiar methods.

3) The turning-point

We are now living through this moment, i.e., the transition to the "what," the search for the "how." This is not an aimless search, but a conscious one whereby the "what" will be expressed through the "how." In brief, this "what" is matter infinitely refined (or, as it is increasingly called, spirituality) which defies concrete expression and which cannot be expressed in too material a form. An urgent need to find "new forms" has arisen. At the moment these "new" forms are simply the same "eternal" (for the time being), "pure" forms of art (its pure language) which have been scratched off the dense stratum of excessive matter. Gradually – although it seems but a single moment – the arts have begun to reject elements of expression which are fortuitous and alien to art. Instead, art is turning to those very media without which we cannot know a given work of art, without which we cannot conceive of it and which we acknowledge as eternal language: in literature – the word, in music – sound, in sculpture – volume, in architecture – line, in painting – color.

While forced to address ourselves to the limitations of these primary elements, we find new potentials, new richness in these very confines.

In painting these elements of impoverishment/enrichment are represented by form. The language of painting is created from two primary elements – color and form, from their combination, inter-subordination, inter-gravitation and inter-repulsion. We are now mastering this language syllable by syllable. We ourselves are forced to create the individual words in this language, a process which occurs particularly during the emergence or rebirth of native language.

For some mysterious reason this movement towards the refinement of the material (for the sake of brevity, let us call it the spiritual) has added to the arsenal of purely material media. This happens again and again; perhaps it happens all the time.

Impressionist aspirations appear in painting and replace the Realist ideals. Impressionist aspirations reach their culmination in a dogmatic form and in the purely naturalistic goals of the theory of Neo-Impressionism. At the same time, Neo-Impressionism bursts into abstraction. The aim of Neo-Impressionism (according to its theory, which it regards as a universal system) is to record not the fortuitous "slice of life," but the whole of nature in all its brilliance and splendour.

Three other phenomena manifest themselves almost simultaneously: 1) Rossetti, his pupil Burne-Jones and their disciples, 2) Böcklin, Stuck (who evolved from Böcklin) and their disciples, 3) the solitary Segantini and his stylistic imitators who have attached themselves to him like some pathetic appendage.

I have chosen these three names as being characteristic of the search in the realms of the non-material (I often have to resort to the terms "material," "non-material" and the divisions between them which I call "more" or "less" material, etc.). But isn't *everything* matter? Isn't everything spirit? Aren't the divisions which we assume to exist between matter and spirit perhaps only varying degrees of mere matter or mere spirit? An idea which, in positive science, is designated as a product of the spirit is also matter, and this has to be apprehended not by more vulgar, but by finer feelings. What cannot be touched by hand – isn't that spirit? I would ask only that very strict delineations be ignored, but that this necessary schematicism not be disregarded. Rossetti turned to the Pre-Raphaelites and sought to revive their abstract forms. In contrast to Rossetti, Böcklin escaped to the world of myth and fairy-tale, and dressed his abstractions in highly developed, material, physical forms. Segantini, *outwardly* the most material of all three, took ready-made forms of nature and worked on them with microscopic precision (his mountains, stones, animals). At the same time, almost in spite of this and in spite of the unobtrusive material form, he invariably created abstract images. As a result, he is *inwardly* the least material of this group.

Such are the seekers of the Inner in the Outer.

Cézanne, who sought a new law of form, approached this goal in a completely different manner, one very close to purely painterly methods. Out of a tea-cup he managed to produce an inspired creation or, more exactly, he discovered a precise creation. He raised the *nature morte* to a level where his objects animate what is inwardly *morte*.

Cézanne treated these objects as he would a human being because he possessed the gift of seeing the inner life of all things.

He imparted a vivid expression to these objects, one which created an *inner artistic note, a sound*. He pushed them, squeezed them into forms which raised them to the heights of abstract sounds, to a harmony of radiant, often mathematical formulae. It was not a man, an apple or a tree which he conceived. He just needed them to form something possessing an inner, painterly sound – a painting. Ultimately, that's how one of the greatest modern Frenchmen – Henri Matisse – refers to his works. He creates "paintings." In these paintings his aim is to transmit "The Divine." To attain this he renounces all conventional methods: he just uses the object (a man, etc.) as a starting-point and uses the media peculiar to painting alone (and only painting) – *color and form*.

4) *The pyramid*

Gradually, the arts are beginning to express what they and only they can express. Each art is using media peculiar only to itself.

And despite or, rather, thanks to this mutual estrangement, the arts have never been closer to each other than now, at this final hour of the spiritual turning-point.

All these things reflect an aspiration towards the anatural and the abstract, towards the *inner nature*. Consciously or unconsciously, the arts are obeying the words of Socrates: "Know Thyself." Consciously or unconsciously, artists of all the arts are gradually concentrating on their own materials, they are investigating and researching them; they are appraising the inner value of those very elements which bid the artist create art.

The logical outcome is to *compare* the elements of one art with those of another.

In this respect, music is the most instructive art. With some exceptions and deviations, music is an art which never uses its media to make a deceptive reproduction of natural phenomena. On the contrary, music always uses its own media to express the artist's emotional life and, out of these media, creates an original life of musical tones.

The artist who sees no point even in depicting nature artistically and, as a creator, seeks to effuse his *inner world* into the outer envies music – the most non-material of all the arts – in its facility to attain this aim. Understandably, he turns to it. He attempts to find out whether his own art does not possess the same media. Hence – our contemporary search for rhythm in painting, for a mathematical, abstract construction; hence – our recourse to the repeated color tone, our observations on *how* a color is given movement, etc.

This comparing of the media of the various arts and this mutual learning of one art from another can have complete success, complete victory. But it can do so only if this is not an outer process, but a general principle, i.e., one art must learn from another how it can use *its own* media. It must do this so that it can use *its own property* in accordance with a uniform principle. We must not forget that each medium conceals its own methods of application and that these, in turn, must be found.

This kind of deep introspection separates one art from the other. Comparing one art with another unites them in an *inner* aspiration. So, obviously, each art utilizes its own forces and these cannot possibly be replaced by those of another. Ultimately, we come to the fusion of the specific forces of the individual arts. With time, this fusion will produce an art – which we can already foresee: a truly *monumental* art. He who has entered the hidden, *inner* treasure-house of his art is to be envied, for he is engaged in the creation of the spiritual pyramid, now ascending to the heavens.

B. Painting

5) The effect of color

If you allow your eye to wander over the colors on the palette, you obtain two principal results:

1) A *purely physical* effect, i.e., the eye itself is touched and charmed by the beauty and by the other qualities of the color. The spectator experiences a feeling of satisfaction, just as a gourmet does after taking a tasty morsel into his mouth. Or the eye is irritated just as the palate is by spicy food. Subsequently, the spectator will again be calmed or cooled as a finger is after touching ice. Of course, these are physical sensations which can be of only short duration. At the same time, they are superficial and do not have a lasting effect, if the soul remains unopen. When your finger touches ice, you experience a sensation of physical cold which you forget as soon as you warm the finger. In exactly the same way, the physical effect of color is also forgotten as soon as the eye turns away. And just as the physical sensation of ice-cold, on penetrating more deeply, arouses other, more intense feelings and holds a number of psychic experiences, so the superficial impression of color can develop into a real experience.

Only everyday objects affect the man with average sensitivity in an entirely superficial manner. The objects with which we are first confronted arouse an immediate psychic impression in us. Hence, the world deeply impresses the child. For him every object is new. The child sees light. Light attracts him. The child wants to catch it, burns his fingers and is filled with fear and with respect for fire. Later on, the child sees that fire possesses friendly properties as well as hostile ones: it expels gloom, it lengthens the day, it has the power to roast and to boil, and to provide a delightful spectacle. Through this accumulation of experiences one acquaints oneself with fire, and these data are retained in the brain for future needs. This *vivid, intense* interest passes. Only the power of fire to create a joyous spectacle stops the advent of total indifference. So slowly but surely the mountains crumble. Everyone knows that trees cast shadows, that horses gallop swiftly, that motor-cars move even faster, that dogs bite, that the moon is a long way away, that the man in the mirror is not real.

And only as man develops, does the circle of properties within the various objects and living beings expand. At the higher level of development these objects and beings acquire an inner value and, ultimately, an *inner sound*. Exactly the same thing happens with color: at a low stage in the development of spiritual sensitivity, color can cause only a superficial effect, one which ceases soon after the stimulus is removed. But even in this simple condition this simple effect can be of various kinds. The eye becomes increasingly attracted to lighter, warmer colors. Vermilion attracts and irritates like a flame upon which a man fastens his hungry gaze. A bright lemon-yellow produces pain after a while, just as the high notes of a trumpet pain the ear. The eye grows excited, it cannot withstand the effect for long and seeks a deep peace in blue or green. The higher the development of this elementary effect, the deeper the more challenging the shock to the spirit. This leads to:

2) The second principal result of observing color, i.e., the *psychic* effect. This psychic force of color produces vibrations in the soul. Thus the first, elementary, physical force is transformed into a path leading color to the soul.

Perhaps the question – whether the second effect is a direct one as might be assumed from the above or whether it comes about through association – will

remain open. Since, as a rule, the soul is closely linked to the body, it is possible that a psychic shock arouses its counterpart through association. For example, red can arouse an emotional vibration, like a flame, because red is the color of flame. A warm red has an exciting effect, and it can rise to an agonizing torture perhaps because of its resemblance to bleeding. At this juncture red awakens the memory of another psychic agent and this always produces the impression of pain on the soul.

If this were really the case, then it would be easy to use the idea of association to explain other physical effects of color,[2] i.e., its effect not only on the optical apparatus, but also on the other sense organs. One might assume, for example, that light yellow arouses the sensation of acid in the taste organs because of its association with a lemon.

But it's not really possible to take this kind of explanation to its conclusion. As regards taste and color, we know various instances where this explanation cannot be applied. A certain Dresden doctor tells how one of his patients whom he characterizes as a man of "extraordinarily high spiritual stature," although blind-folded, invariably defines the taste of a given sauce by color, i.e., he perceives it as blue, and identifies it as an English sauce. Perhaps it could be possible to accept an analogous, although different explanation, i.e., the highly sophisticated man possesses direct communication with the soul. And the sensitivity of his soul can be aroused so quickly that this effect, the one attained via the taste organs, reaches the soul immediately and compels other, parallel waves (moving from the soul out towards the external organs, in this case, the eye) to harmonize. This would be like an echo or a response in a musical instrument when, without being struck itself, it vibrates in sympathy with another instrument which has been struck. People who can feel so strongly are like fine, mellowed violins which resound on the slightest contact with the bow, in every part and in every fiber. According to this explanation sight should harmonize not only with taste but also with all the other senses. Which is true. Certain colors do not appear smooth or biting, whereas others, on the contrary, are perceived as smooth and velvety, inviting one to stroke them (dark ultramarine, chromoxide green, madder-lake). The very difference between the warm and cold color tone is based on this perception. There are also colors which appear soft (madder-lake) and others which always seem harsh (green cobalt, green-blue oxide). This kind of paint, when freshly squeezed out of the tube, might even look as if it's dried up.

The expression "fragrant colors" is well-known.

Finally, it is a common phenomenon to hear a color. Nobody would seek an impression of bright yellow from the base notes of a piano, or would designate madder-lake by a soprano register.[3]

6) *The language of colors*

> The man that hath no music in himself,
> Nor is not moved with concord of sweet sounds,
> Is fit for treasons, stratagems, and spoils;

The motions of his spirit are dull as night,
And his affections dark as Erebus:
Let no such man be trusted. *Mark the music.*
 (Shakespeare).

The musical tone has direct access to the soul. It encounters an immediate response there because man "hath music in himself."

Everyone knows that yellow, orange and red inspire and represent the ideas of joy and plenty (Delacroix).

Both these quotations demonstrate the close affinities of the arts as a whole and of music and painting in particular. It was from this very obvious relationship, probably, that Goethe derived his idea: that painting must formulate its own counterpoint. Goethe's prophetic statement is a presentiment of that very condition in which painting now finds itself. This condition provides painting with a departure-point via which, assisted by its own media, it must attain art in the abstract sense. By advancing along this path, painting will, ultimately, attain a purely painterly *composition*.

In order to attain this composition painting has two media at its disposal:
1) Color,
2) Form.

An isolated, solitary form, as the representation of an object (real or not) or as a purely abstract delimitation of the volume of a plane, can exist independently. But color cannot. Color does not allow for unlimited expansion. Unlimited red can only be imagined and seen with the spirit when the word "red" is uttered. If a limitation becomes necessary, then this has to be conceived forcibly. On the other hand, the color red, when not seen materially but conceived in an abstract way, does produce a certain precise or imprecise concept which, in turn, possesses a specific, purely internal, psychic sound. The color red – resounding from the very word "red," does not, in itself, possess an independent or very pronounced tendency towards warm or cold. Such properties should be regarded as more refined inflections of the color red and as independent of its basic sound. That's why I call this spiritual vision imprecise. But, at the same time, it is precise because the inner sound remains distinct, freed from fortuitous inclinations towards warm and cold areas, etc. This inner sound is like the sound of the trumpet or of the instrument which we conjure up when we hear the word "trumpet" or suchlike (but we hear it without enharmonic intervals). At this juncture we conceive a sound without the enharmonics caused by its resonance outdoors, indoors, in isolation or in conjunction with other instruments sounded by the hunter, the soldier or the virtuoso.

If we need to present the color red in material form as in painting, then it must: 1) possess one definite tone selected from the infinite number of various red tones, i.e., it must, as it were, be identified subjectively; and 2) it must be delimited on a plane and separated from other colors; *inevitably*, these are present – they just cannot be avoided – and they cause the subjective character of the red to change both by confinement *and* by proximity.

103

This inevitable link between color and form leads us to observe the reactions which form stimulates in color. Form by itself even if it is totally abstract, like a geometrical form possesses its own inner sound. It is a spiritual being with properties identical with this form. The triangle (whether it's acute, obtuse or equilateral we shall not define here) is just such a being with its own, peculiar spiritual aroma. In combination with other forms this aroma remains distinctive. It acquires connotations and nuances, but, essentially, it remains constant, like the fragrance of a rose – which cannot be confused with the perfume of a violet. The same is true of the square, the circle and all other forms.

The interaction of form and color becomes very evident at this juncture.

A yellow triangle, a blue circle, a green square; or a green triangle, a yellow circle, a blue square, etc. These are beings which act in totally different ways.

In this context it is easily noticed that the effect of certain colors is emphasized by certain forms or dulled by others. In any case by their very nature sharp colors sound stronger in sharp forms, e.g., yellow in a triangle. Those colors which tend towards increasing intensity acquire a greater effect in round forms, e.g., blue in a circle.

Just as the number of colors and forms is infinite, so their combinations and their effects are too. This provides inexhaustible material.

In the narrow sense of the word, form is nothing more than the delimitation of one plane from another – that is how form can be defined externally. But since everything outside also conceals an inside which reaches outwards to a greater or lesser degree, so *every form has an inner content*. Hence, form is the outer expression of inner content. That is how it can be defined internally.

These two sides of form also constitute its two aims. Consequently, an outer delineation is most expedient when it advances the inner content with maximum expressivity.[4] The outer reality of form, i.e. the delimitation to which form serves as the means, can be extremely diverse.

Despite the differences which form can acquire, it can never transcend these two limitations:

1) by its delimitation form either serves to bring out the material object from the plane, i.e., to depict the material object on the plane; or 2) it remains abstract, i.e., it does not embody a concrete object on the plane, but is a completely abstract being. These abstract beings lead their own, independent life, exerting their own influence and effect. They are the square, the circle, the triangle, the rhombus, the trapezoid and numerous other forms (becoming more and more complex) not subject to mathematical denotation. All these forms are equal subjects in the kingdom of the spirit.

There is an infinite number of these forms and both elements are very evident in them. Sometimes the material, sometimes the abstract principle dominates. These forms constitute that arsenal whence the modern artist is deriving all the individual elements of his creative work.

At the moment the artist cannot confine himself to abstract forms. They are still too imprecise for him. To confine oneself exclusively to the imprecise means to

forgo the opportunity of excluding the purely human element. This impoverishes one's means of expression.

On the other hand, art cannot contain exclusively material forms. It is impossible to transmit material form with 100 percent accuracy. Willy-nilly, the artist is subject to *his own* eye, to *his own* hand. On this level they are more artistic than his soul which has no desire to transcend the limits of photographic aims. But the conscious artist, dissatisfied with the conventionalization of the material object, aspires to impart expression to the object he is depicting. At one time this was called idealization, then stylization and tomorrow it will be called something else.[5] This impossible aimlessness in art (copying the object without any particular reason), this aspiration to extract expressivity from the object – this is the departure-point whence the artist will embark on his search for purely artistic, so to say, painterly, aims. He will abandon the "literary" nuance of the object. This path leads us to the idea of composition.

A purely painterly composition, in its relation to form, must deal with two problems:

Firstly: the composition of the whole painting,

Secondly: the creation of adjacent, individual forms in various combinations subject to the composition of the whole. Thus the numerous objects in the painting, real or perhaps abstract, are subject to the *single* form of the whole. However, they change so much that they can be accommodated only by the single form – and they create it. The single form may have little individual resonance. First and foremost, it helps to create the total compositional form and must be examined in the main as an element of this form. This independent form is structured in this way not because *its* own inner sound dictates this independently of the whole composition, but mainly because it is required to serve as constructive material for the same. So the initial aim – the composition of the whole picture – is also the ultimate aim.[6]

In this way, the element of the abstract becomes more and more apparent. Until very recently, this element, demure and almost invisible, was disguised by purely material aspirations.

The evolution and, ultimately, the new preponderance of the abstract is quite natural. Because the more organic form moves into the background, the more the abstract element comes to the fore and *acquires* resonance.

But, as was mentioned above, the organic residue possesses its own inner sound. This can be identical with the second component of the same form (its abstract part) – making a simple combination of both elements; or it may be of a different nature – a complex combination or, perhaps, a necessarily disharmonic combination. In any case, the harmony of the organic principle can still be heard even if this principle is driven into the background. That's why the choice of concrete object is of the utmost significance. In the harmony (the spiritual concord) of both component parts of form the organic can support the abstract by harmony or disharmony or it can impede it. The object can provide only an incidental sound. Even if this incidental sound is replaced by another, the basic sound of the object will not change.

For example – we might make a rhomboid composition using several human figures. This raises the question: are these human figures really indispensable for the composition? Could they not be replaced by other organic forms so that the basic sound of the composition would not suffer? If the answer is yes, then we have a case where the object's sound not only does not contribute to the abstract sound, but is even pernicious to it. The neutral sound of the object weakens the sound of the abstract. This is a logical and an artistic fact. Hence, either one must find an object more appropriate to the abstract sound (appropriate in its consonance or anti-sonance), or the entire form has to become purely abstract.

The more this abstract element of form is exposed, the more purely and primitively it sounds. Consequently, in a composition where the physical body is more or less superfluous it is quite possible to do without the physical or to replace it by the purely abstract element (or by physical forms completely transposed into abstract ones). Each time this transposition or inter-arrangement of purely abstract form is contemplated, only feeling should serve as the judge, the index and the scales. Naturally, the more the artist uses these abstracted or abstract forms, the more he will feel at home in their kingdom. The deeper he will advance into their terrain.

Similarly, the spectator, guided by the artist, will assimilate a deeper knowledge of the abstract language and, ultimately, he will master it.

We are now confronted with the question: Should we not ignore the object completely? Should we not throw it to the wind, remove it from our conventions and accept only the purely abstract? Should we not expose this totally? This is, naturally, an urgent question which is now finding an answer in the resolution of the presonances in both elements of form (the objective and the abstract). Just as any spoken word (tree, sky, man) generates an inner vibration, so any object represented in a plastic manner does the same. To lose the opportunity of arousing these vibrations would be to forcibly impoverish the arsenal of media of expression. At least, that's how it is today. Apart from this, the above question can be answered by a solution which is eternal for all questions beginning with the word "should": in art there is no place for "should" for art is eternally free. Art flees this "should" just as day flees night.

When we examine the second problem of composition – the creation of individual, specific forms for the construction of the whole composition – we should note that the same form always sounds the same however varied the conditions. Only the conditions themselves vary. This produces two results:

1) the sound of the whole environment will change (inasmuch as the environment can be preserved) if the direction of the form is displaced; 2) the sound will change if the surrounding forms are displaced, increased, decreased, etc.

In turn, these two results produce a further result.

There is nothing absolute. In particular, the composition of forms (the composition being based on this issue of relativity) depends: 1) on the variability of the composition of forms, and 2) on the variability of each individual form right down to its smallest detail. Each form is as sensitive as a cloud of smoke. The

slightest displacement of any one part changes its very *substance*. This process is so intense that it is probably easier to create the same sound with different forms than to reproduce it by repeating the same form: a really accurate repetition lies beyond the bounds of possibility. Until we become especially sensitive just to the whole composition, the above remains of mere theoretical importance. When people begin to use and assimilate abstracted and totally abstract forms deprived of concrete interpretation, when they begin to apprehend in a more refined and more forceful manner, then what we have said above will acquire much greater practical significance. On the one hand, the problems of art will increase, but at the same time a wealth of forms and media of expression will develop in quantity and quality. The whole question of distorted drawing and of distorted nature will become redundant and will be replaced by another, truly artistic one: To what extent has the inner sound of the given form been veiled or exposed? This change of view will, in turn, lead to a greater enrichment of the means of expression because veiling is a tremendous force in art. The combined effect of veiling/exposing creates new possibilities in the *leitmotifs* used in the composition of forms.

A composition of forms would be impossible without this development. Anyone unaffected by the inner sound of form, physical or, in part, abstract, will regard such an arrangement as a senseless, illusory caprice. Indeed, the fruitless displacement of forms on the surface of the picture is an empty game. Once again we encounter that same principle which we find everywhere, a purely artistic principle, one free of peripheral elements: the *principle of inner necessity*.

If, for example, the features of the face or the various parts of the body are displaced or are distorted to serve artistic aims, then we are forced to confront the problem of anatomy as well as that of pure painting. This impedes painting. It raises irrelevant issues and considerations. But in our context all peripheral elements disappear of their own accord. Only the essential remains – the artistic aim. It is this possibility of displacing forms (which seems to be fortuitous but which, in fact, is subject to precise definition) that becomes a boundless source of purely artistic creation.

Thus, the plasticity of independent forms, their so-called inner, organic transformation, their direction in the painting (movement), the preponderance of the physical or the abstract in this or that independent form on the one hand, and on the other the juxtaposition of forms which constitute the configurations of the formal groupings (which, in turn, create the total form of the whole picture), the principles of the consonance or anti-sonance of all the above named elements, the combined effect of veiled/exposed, combinations of the rhythmic and the arhythmic on the same surface, combinations of abstract forms as purely geometric units (simple and complex) or as non-geometric ones, combinations of formal delimitations (sharpened or softened), etc. – these are elements which create the possibility of a purely graphic "counterpoint" and which, indeed, will lead us to this counterpoint. This will be one of black and white until color is introduced.

Color – which itself provides material for the creation of counterpoint, which contains boundless potential – color, integrated with graphic line, will lead us to the

great counterpoint of painting. Thanks to this, painting, too, will become composition and, as an authentic, pure art will be able to serve the divine. And the same steadfast guide will lead art to supreme heights: to the *principle of inner necessity.*

One can theorize on this subject until doomsday. And it is premature to contemplate the intricate details of the theory. Theory never advances before art and will never drag practice behind it. On the contrary.

Feeling is everything, especially at the beginning. Only through feeling can artistic truth be attained. A loose construction is possible in purely theoretical terms, but that extra ingredient (the real soul of creativity and, therefore, relatively speaking, its essence) can never be created by theory. It can never be found unless, unexpectedly, it is expanded into creation by feeling. Since art affects feeling, it (art) can be realized to the full perhaps only through feeling. True results can never be attained through cerebral activity or through deductive calculation – even with the most exact dimensions or the most accurate balances. We cannot calculate such dimensions, we cannot find such balances ready-made.

I would say that modern painting (drawing + color) has already expressed two clear aspirations: 1) towards rhythmicality, and 2) towards symmetry.

A particularly vivid example is Hodler who has developed both principles to a state of hypnotic obsession and, in some cases, almost to a nightmare condition. I say this not as a condemnation. I am merely indicating the artist's limitation in his choice of possibilities. Obviously, this limitation is a natural outgrowth of Hodler's soul.

We should not forget this. We should not think that these two principles are beyond art and time. We see these two principles in ancient art, beginning with the art of the savage, and at the climaxes to the various epochs of art. *At the moment* we should not object to them merely on principle. Just as the color white becomes particularly bright when it is reduced to its bare essence and surrounded by a limitless expanse of black, just as white, when extended into infinity, disintegrates into an unrelieved murkiness, so similar *principles* of construction are now being applied *indiscriminately* and are losing their resonance, their effect on the soul. Our contemporary soul is dissatisfied when only a single distinct sound reaches it. It longs for, it needs, a double echo. Just as white and black (like the angel's trumpet) sound in *antithesis,* so the whole graphic and painterly composition seeks the same antithesis. This antithesis has, it would seem, always been a principle of art, but differences in the emotional mood of various epochs have necessitated its varied application. That's why rhythm now desires a-rhythm. Symmetry – asymmetry. The hollow sound of our modern soul longs for *this* antithesis. Perhaps the art of today, after a long voyage, will reach the perfection, the flowering which every great and noble epoch experiences. It will then transpire that our hollow anti-sonance, our disharmony or a-harmony is, in fact, the harmony of our era, that our a-rhythm is rhythm, our asymmetry symmetry, and that this is something of extraordinary refinement and richness, full of the pervasive aroma of our own, nascent era.

That is why it is said that the construction within an equilateral triangle, the repetition of the same movement right and left (repetitive rhythm), the absolute, precise repetition of the same color tone or a capricious divergence therefrom, etc. is merely a bridge from Realism to the new art, a bridge borrowed from the old arsenal.

Dimensions, balances lie not outside the artist but within him. They are what can be called the sense of measure, the artistic beat. They are qualities intrinsic to the artist, raised by inspiration to revelations of genius. In this respect, we should try to understand Goethe's prophecy concerning the figured bass and the possibility of implementing it in painting. At the moment this kind of grammar vis-à-vis painting is mere conjecture. But when, finally, art grows up, its grammar will prove to be built not so much on physical laws as people have maintained as on the *laws of inner necessity*, which I calmly designate by the word *psychic*. Thus, we see that at the basis of every problem in painting, whether simple or complex, there lies the *inner* element. The path which we are already following constitutes the greatest fortune of our time. We will now shake off the outer element and replace it with the antithesis: the new basis of inner necessity. Just as the body grows stronger and develops through exercise, so the spirit does too. Just as the inactive body grows weak and, eventually, impotent, so the spirit does too. The artist's inner feeling is an evangelical talent and it is a sin to conceal it. The artist who does so is an idle slave.

So it is not only useful but indispensable for the artist to know where to begin these exercises.

To start off, the artist must weigh the material's inner value on the great scales of objectivity, i.e., in this case he must investigate color. In general, color never fails to affect any person.

There's no point in going into the profound and subtle intricacies of color, but it's enough to limit oneself to an elementary understanding of simple color.

First of all, the artist must concentrate on *color in isolation* and allow this to affect him. In this process he should keep to as simple a scheme as possible. The whole issue will be presented in as simple terms as possible.

Two major divisions in the color tone are immediately evident: 1) warm/cool, and 2) light/dark.

These produce the four main sounds of any color: color is either 1) *warm* and then a) *light* or b) *dark*; or it is 2) *cool* and then a) *light* or b) *dark*.

Generally speaking, the warm/cool aspects of a color are manifested in a tendency towards yellow or blue. This divergence is to be found, as it were, within one and the same plane, while the color itself preserves its basic sound, even though this sound varies in its materiality. This is a horizontal movement, one in which the warm tone on the surface moves towards the spectator, while the cool one moves away.

Those colors which stimulate this horizontal movement in other colors are themselves characterized by this movement. But they also possess another kind of

movement, one which distinguishes them from each other, i.e., in their inner effect. Consequently, they constitute the *first major antithesis* in inner value.

The *second major antithesis* is between white and black, i.e., those colors which produce a second pair of principal sounds: the tendency of a color to become lighter or darker. These are the same as the movements to and from the spectator, not in a dynamic form, however, but in a static and rigid one.

The second movement of yellow and blue which imparts a particular dynamism to the first major antithesis is their centrifugal and centripetal movements.[7] Take two circles of equal size. Paint one yellow, the other blue. After concentrating on them for a moment, you notice that the yellow circle radiates, begins to move from the center outwards and, almost tangibly, approaches you. Blue develops a centrifugal movement like a snail retreating into its shell and moves away from you. The first circle irritates the eye; the second immerses it.

This effect is heightened when a difference in lightness/darkness is added. The effect of yellow increases as it is lightened (in simple terms, as white is introduced); of blue as it is darkened (as black is introduced). This factor acquires even greater importance when one remembers that yellow has a very strong inclination towards lightness (white) and, in fact, dark yellow does not exist. In physical terms, yellow and white are very close, just as blue and black are, because blue can become deeper and deeper until it reaches black. Apart from this physical proximity, there is also a moral one. As far as the inner value is concerned, this produces a sharp distinction between the two pairs (yellow/white on the one hand, blue/black on the other) and brings the two units of each pair very close together (for further details see the discussion of white and black).

If one tries to make yellow colder (yellow being a typically warm color), it becomes greenish and immediately loses in its horizontal and centrifugal movements. It acquires a rather morbid and supersensual character, like a person full of energy and grand ambitions who is held back by external circumstances. Blue, as a totally antithetical movement, brakes the force of yellow. This will go on (as blue is introduced) until both antithetical movements destroy each other – resulting in complete immobility and tranquility. *Green appears.*

The same thing happens to white when it is dulled with black. It loses its constancy – until grey appears which, in its moral value, is very much like green.

But only green conceals yellow and blue which, like paralyzed forces, can be reactivated any time. Green contains greater potential – one which grey does not have at all. And grey does not possess this because it consists of colors which possess no purely active (mobile) forces. It consists of immobile resistance on the one hand and of irresistible immobility on the other, like a wall of infinite thickness receding into eternity or like a bottomless chasm.

Since both colors which create green are active and mobile, their spiritual effect can be established theoretically from the character of these movements. Exactly the same result will be obtained if the artist acts professionally and allows the colors to act upon him. In fact, the first movement of yellow (its movement *towards* the spectator, which can become obtrusive if the intensity of the yellow is

heightened), and its second one (its transcension of confines, its hurling of forces towards the circumference) are like the properties of any material force which is cast involuntarily on to any object and which is cast off in all directions.

On the other hand, yellow, when observed spontaneously in a geometric form, agitates the spectator, irritates the eye, arouses and exposes a force concealed in the color – a force which, ultimately, affects the soul in an obtrusive and insolent manner. This property of yellow (which tends towards lightness) can be heightened to a point unbearable either to the eye or to the soul.[8] At this level, yellow sounds like a shrill trumpet being blown harder and harder, or like a fanfare played at a very high pitch.[9]

Yellow is a typically earthly color. Yellow cannot be deepened. If it is cooled by the addition of blue, then – as mentioned above – it takes on a morbid tone. If an analogy can be made between yellow and the human psyche, then yellow might be used to express insanity, but not melancholy or hypochondria. It is an intense attack of insanity, of blind frenzy. The victim hurls himself at people, breaks everything within his reach and throws his physical strength in all directions, he expends his strength aimlessly until he has exhausted it. This is like the crazy vegetative growth of vivid autumn leaves during the last burst of summer, when they have already been deprived of that soothing blueness which has already ascended to the heavens. There are colors born of an insane power, ones which cannot be deepened.

But *blue* does deepen and, likewise (theoretically), at first in its physical movements: 1) away from the spectator, and 2) towards its center. The same when blue in any geometrical form is allowed to act upon the soul. The tendency of blue towards depth is so great that its intensity grows as its tone deepens and it becomes increasingly more characteristic. The deeper blue becomes, the more urgently it summons man towards the infinite, the more it arouses in him a longing for purity and, ultimately, for the supersensual. This is the color of the sky as we imagine it when we hear the word "sky."

Blue is a typical, heavenly color.[10] A very deep blue suggests the notion of peace. If it descends to the perimeter of black, it takes on the connotation of human sadness.

It becomes the infinite penetration into the absolute essence – where there is, and can be, no end.

In its transition towards lightness (to which it is less inclined), blue acquires a more nonchalant character and becomes remote and indifferent to the spectator – like the distant, azure sky. The lighter it is, the more soundless it becomes, until it reaches a soundless tranquility – and becomes white.

In musical terms, light blue is like the sound of the flute, dark blue of the cello. As it increases in depth, it begins to resemble the extraordinary notes of the double-bass. In its deep and majestic form the sound of blue is equal to that of the deep register of the organ.

Yellow becomes sharp immediately and cannot descend to any great depth. Blue can become sharp only with difficulty and cannot ascend to any great height.

111

The ideal balance of these two colors (so diametrically opposed) produces *green*. Horizontal movements are mutually destroyed. Centrifugal and centripetal forces are also destroyed. This is a logical result and, in theory, can easily be attained. The immediate effect on the eye and, through the eye, on the soul gives the same result. This has long been known not only to doctors (to oculists in particular), but also to the man in the street. Absolute green is the most peaceful color: it moves nowhere and has no connotation of joy, sadness or passion; it desires nothing, it beckons nowhere. This constant lack of movement is of benefit to the weary and to their souls, but it can grow tedious after a time. Paintings in green harmony are good proof of this. Just as a picture painted in yellow constantly radiates a certain warmth, or one painted in blue is too cool (i.e., in both cases there is an active effect), so green affects the spectator only by its monotony (a passive effect) – because man, an element of the universe, is summoned to continuous, perhaps eternal, movement. Passivity is the most characteristic property of absolute green, and this property is, so to speak, enhanced by a certain flabbiness and complacency. Hence, green – in the kingdom of colors – is what the bourgeoisie is in the kingdom of people: it is motionless, self-satisfied and extremely limited. It is like a big, fat, motionless cow which is capable only of chewing and rechewing the cud and of looking at the world with stupid, vacant eyes. Green is the principal color of summer when nature has already experienced her *Sturm und Drang*, its spring, and has sunk into a complacent peace.

If the balance of absolute green is destroyed, then it ascends either towards yellow and grows more alive, youthful, more cheerful, more active, or it descends into the bluish depths and begins to sound differently: it becomes serious and, as it were, contemplative; the active element reappears, but it is quite different from the one which appears when green becomes warmer.

Lightened or darkened, green still preserves its elementary character of nonchalance and tranquility. Accordingly, its first sound is amplified when lighter, its second sound when darker – which is quite natural because these changes are brought about by white and black. In musical terms, I would designate absolute green by the calm, *ritardando*, middle tones of the violin.

White and black have already been defined in general terms. *White* is often defined as a "non-color" (thanks especially to the Impressionists for whom "there is no white in nature").[11] Henceforth, it will be treated as a symbol of a world whither all colors, all material properties and substances have disappeared. This world is so far above us that no sound therefrom can reach us. Only a great silence. In material imagery, it is like a cold, ever receding wall which can neither be crossed, nor destroyed. White affects our psyche like the silence of great magnitude. For us this silence is absolute. Inwardly, it is rather like the silence of a musical rest which temporarily interrupts the progression of the piece or of its content, and is not the positive conclusion to the whole progression. This is not a dead silence. It is full of potential. White is like a silence which, suddenly, can be comprehended. It is something full of youth or, more exactly, is like something

112

which precedes birth, incipiency. Perhaps that's how the Earth sounded during the white Ice Age.

Like total emptiness, like the dead world after the sun has been extinguished, like an eternal silence devoid of future or hope – thus sounds inner *blackness*. In musical terms, it is like a full interval after which there follows the beginning of a new world. Since a totality is created and perfected by *this* interval, the circle is full. Black is something which has been extinguished like a bonfire, something motionless like a corpse lying beyond the confines of the perception of all events and past which life speeds. This is the silence of the body after death, after the end of life. Outwardly, black is the most soundless color. So that any other color put on black sounds stronger and more distinct. Not like white – on which all colors become dull in sound or which diffuse completely, leaving behind a weak, impotent sound.[12]

Not in vain was white chosen for the garments of pure joy and immaculate purity, black for the garments of great and profound sadness and for the symbol of death. The equilibrium of these two colors is *grey*. Naturally, this product cannot provide an outward sound or movement. Grey is soundless and motionless. But this immobility differs from the peace of green (produced by, and intersecting, the two active colors). Hence, grey is inconsolable immobility. And the darker it becomes, the more this quality dominates, to the point of asphyxiation.

As this grey grows lighter, so it becomes possible to breathe as if air has been let in, as if there is now a gleam of hope. This kind of grey appears when green and red are mixed optically: it derives from the spiritual mixture of complacent passivity and strong, ardent activity.[13]

Red (we conceive it as a limitless, typically warm color) has an inward effect. It is a vigorous, vivacious, stimulating color. It does not have the frivolous character of yellow flinging itself everywhere; but in its energy and intensity it manifests a definite tone of almost mechanical and extraordinary force.

This agitation and ardency (mainly *within itself* and not so much in outer directions) contains a steadfast maturity.

In reality this ideal red can tolerate major changes, deviations and differentiations. In its material form red is very rich and diverse.

Don't forget: saturn, vermilion, English red, madder-lake from lightest to darkest tones! To a considerable degree, red has the ability to preserve its basic sound and its character whether warm or cold.

Light, warm red (saturn) has a certain resemblance to mid-yellow (as a pigment it possesses a substantial amount of yellow) and arouses a sensation of force, energy, aspiration, decisiveness and (thunderous) triumph, etc. Musically it reminds us of a fanfare wherein the trumpet, as it were, sounds with a strong, persistent, obtrusive tone.

In its middle state red, like vermilion, gains in permanency and acuity of feeling. It is like the steady flame of passion. It is self-assured and cannot be outsounded, but it is easily extinguished by blue – just as molten iron is by water.

Generally speaking, middle red cannot bear anything cold because it loses its sound and sense through cold. In comparison with yellow, both reds are of like character, although their orientation towards the spectator is much weaker: red flares up, but more, as it were, *within itself*. In any case, it lacks the somewhat insane character of yellow.

That's why, probably, people like it more than yellow. It is often applied lovingly to popular ornament where, out of doors, it is especially consonant with green – to which red is a complementary color.

For the most part mid-red possesses a material character (i.e., red in isolation) and, like yellow, does not tend towards depth. It can adopt a deeper quality when it is placed within a higher sounding environment. There will be a danger if it is deepened by black because black, death, can easily extinguish ardency; and brown – dull, hard, scarcely capable of movement – may arise instead. Vermilion sounds like a trumpet and can be compared to strong drum-beats.

Like any cool color, a cool red such as madder-lake can be made much deeper especially by glazing. At this juncture it changes its character considerably: the impression of a deeper glow, of an inner white heat increases. But its activity decreases and, eventually, ceases. On the other hand, this activity does certainly not cease altogether as it does, for example, in dark green. It leaves behind the presentiment of a new burst of energy, something which is self-contained but which is forever alert, possessing the ability to make a wild leap forwards.

This is quite different from the intensity of blue because red gives the sensation of something physical. Nevertheless, red suggests the passionate middle and lower tones of the 'cello. Cool red, when lightened, becomes even more physical, but it is full of purity. It sounds like the pure joy of youth, like a pure, undefiled, young maiden. In musical terms this is expressed by the high, clear, singing tones of the violin. This color, heightened with a substantial admixture of white, is very popular for dresses for young girls.

Warm red, heightened by yellow, produces orange. It advances towards the threshold of movement by radiation, towards diffusion in the environment. But red, so important for orange, preserves a constant element of sobriety. It is like a man who is convinced of his own strength and hence gives the impression of great strength. Its sound is like the monotone of a middle bell or like a powerful alto (singer or instrument).

Just as orange emerges through red by pushing towards the spectator, so *violet* does the same by pushing away from the spectator, i.e., violet tends towards recession. However, the basic red must be cool, because to mix a warm red with a cool blue is impossible. Ultimately, it is impossible to do this with any technical device, just as it is in the realm of the spirit.

Consequently, in the physical and psychic sense, violet is a cooled red. And therefore it has a somewhat morbid sound – like something extinguished and sad. The Chinese use this color for their funeral clothes. It is like the sound of the cor anglais, of the reedpipe, and, in its depth, of the deep tones of ancient instruments like the bassoon.

The two latter colors, produced by a summation of red and yellow (or blue), are not very stable. When one mixes them, one always sees their tendency to lose equilibrium like a tight-rope dancer always balancing and awaiting danger left and right. Where does orange begin and yellow or red end? Where is the limit of violet, the limit which divides it from red and blue?

The two last colors (orange and violet) are the fourth and final contrast in the world of simple, primitive color tones. Physically, they are interdependent, like the two tones of the third antithesis (red and green), i.e., they are like complementary colors.

Like a huge circle, like a snake holding its tail in its teeth (a symbol of the infinite and the eternal), six colors stand before us, forming three pairs of major antitheses. To the right and left are the two great possibilities of silence: birth and death.

It is clear that all these definitions of simple colors are highly provisional, very rough and ready. The same with the feelings by which I designate colors (joy, sadness, etc.). These sensations are only the material condition of the soul. Color tones, like musical tones, are of a much subtler nature. They produce much finer vibrations in the soul and have no designation in our language. It is very possible that with time each tone will acquire a material, verbal designation, but there will always be something which cannot be entirely described by word, something which is not simply the superfluous luxuriance of this sound, but which is its very essence. And so words were and will be only allusions to, very external designations of, colors. In the impossibility of replacing the essence of a color by a word or by any other medium lies the possibility of monumental art. It is amongst the wealth of diverse combinations that we should seek the one which stands on a firm foundation. The same inner sound may be attained by different arts at any one moment. And, apart from its basic sound, each different art supplements its own individual value and thereby bequeathes a richness and strength to the general inner sound. These qualities cannot be attained if only one art is in operation.

We can all imagine what force and depth may be attained through the equal disharmonies and innumerable combinations of this harmony whether one art is dominant, whether contrasts of various arts are dominant or whether the silent consonance of other arts plays the major role, etc., etc.

People often speak of the possibility of replacing one art by another (or by a word, albeit in literary form) – so that the need to have various arts would fall by the wayside. This, in fact, is not the case. As stated above, it is impossible to make an exact repetition of the same inner sound of one art by others. Even if this were possible, then such a repetition would possess at least a different external color. If the reverse were true, i.e., if repetition of the same sound by various arts were always *absolutely* identical (outwardly and inwardly), this would still not be redundant. Because, actively or passively, different people are endowed with different arts, i.e., as transmitters and receivers of sound. And even if this were not the case, it would still be impossible to dismiss repetition completely. Repetition of the same sound – the accumulation of sound – makes the spiritual

atmosphere denser. It is essential for the maturation of feeling (even the most delicate) just as a denser atmosphere in the hot-house is necessary for the maturation of certain kinds of fruits. By way of example, let us take man as an individual: repeated actions, ideas and sensations (foreign to him, but still expressive) ultimately make a powerful impression on him, the more so if he finds it difficult to assimilate individual actions one by one. He is like a thick piece of cloth which absorbs the first drops of rain.

One should not confine oneself to this almost tangible representation of the spiritual atmosphere. It is like air which can be either pure or polluted with various foreign substances. Not only visible actions, ideas and sensations are capable of outward expression; hidden actions (which "no-one can know about"), unspoken thoughts, unexpressed feelings (i.e., actions deep down in man) are too – all these elements make up the spiritual atmosphere. Suicide, murder, violence, improper, vulgar thoughts, hate, hostility, egoism, envy, "patriotism", factionalism – these are spiritual beings, spiritual personages, *creators* of the atmosphere.[14] Conversely, self-sacrifice, helping others, pure, elevated thoughts, love, altruism, joy in the happiness of others, humaneness, justice – these are beings, personages who destroy the others, just as the sun destroys microbes, they purify the atmosphere.[15]

Different elements participating in different forms produce another complex repetition – in this case, different arts, i.e., epitomized in concrete, monumental art. This kind of repetition becomes more powerful when different arts are perceived in different ways. A more musical form produces one kind of art (with rare exceptions everyone responds to musical form), painting another, literature a third, etc. Furthermore, the hidden forces of the various arts are so radically different that even if each art acts independently, the same person will react in the desired manner.

This effect (very difficult to define) of individual, isolated colors is the basis on which different color tones are *harmonized*. Pictures painted in a local tone hold up well (whole interiors are done in this way in the world of design and industrial art). This tone is dictated by artistic sense. Saturation by one color tone, combining and mixing two adjacent colors have often formed the basis of color harmony. From what has been mentioned about color effect, from the fact that we live in a time of questioning, presentiment, allusion and hence contradiction (let us not forget the divisions of the spiritual triangle), we can infer that harmonization on the basis of a single color is less appropriate for our own epoch. We might listen to the works of Mozart with envy, with deep sympathy. For us they are a peaceful interlude in the storm of life, they are hope and consolation. Yet we listen to them as to the sounds of another, past age, one very remote. The conflict of tones, the disequilibrium, the loss of "principles," the unexpected beating of the drum, the great questions, the aspirations which, apparently, have become aimless, the searches which, apparently, have been broken off, the grief, the broken chains which unite so many things, the antitheses, the contradictions – this is our *harmony*.

Whether logically or anti-logically, the juxtaposition of two color tones must, therefore, derive from this. This principle of antilogic leads to the juxtaposition of colors which for a long time was regarded as dissonant. That's the case with red and blue, colors having absolutely no physical relationship to each other. Thanks to their great *spiritual antithesis*, they are now being chosen as a most effective and suitable harmony. In the main, our harmony rests on the principle of antithesis, a principle which has always played a powerful role in art. But our antithesis is an *inner* one. It stands before us in isolation. It rejects any assistance from other harmonizing principles as adulterative and superfluous.

It is remarkable that this juxtaposition of red/blue was much beloved by the Primitives (the Old German, Italian and other Masters), and that it has survived in the relics of that epoch, e.g., in popular German church sculpture. Very often in such pieces (painted sculpture and painting) one sees the Madonna in a red gown underneath a loose, blue cloak. It is as if the artist wished to show the heavenly grace bestowed upon an earthly being, to show mankind enwrapped in the divine.

7) Theory

A logical outcome of our modern harmony is that it is impossible to establish a very definite theory or to create a mechanical figured-bass for painting. This aspiration to elaborate such a principle would lead to results like the little spoons of da Vinci. Nevertheless, to assert that firm rules or something like principles in painting are impossible, and that they would lead to academism is a hasty decision. Music possesses a grammar although this does change with each historical era; in any case it is used as an auxiliary method, rather like a dictionary.

But our painting is in a different position: its *emancipation* from the direct dependence on "nature" is still just beginning. If, hitherto, color and form have changed as inner agents, this has been too often an unconscious process. The subordination of composition to geometric form was known even in the art of antiquity, even to the Persians. But construction on a purely spiritual basis is a long and difficult path which, at first, we can follow only by groping our way. Of course, in this respect the artist must cultivate not only his eye but also his soul, so that he will be able to weigh the inner elements of painting on his scales. His soul would thus become a definite force in the creation of his art as well as a receiver of outer impressions.

If we begin to sever our connection with "nature" today, to force our way through to freedom and to confine ourselves exclusively to the combination of pure colors and independent forms, the result would be works of geometric ornament resembling a necktie or a carpet (to put it bluntly). The beauty of color and form, despite the assertion of purist aesthetes and naturalists in search of beauty for beauty's sake, is not an adequate aim for art. Because of our rudimentary development in painting, we are still unable to acquire inner experience from a color/formal composition.

In this instance, too, of course, a nervous vibration will occur (as it will with works in design and industrial art), but it will remain that and little more, because the emotional shock-waves, the vibrations in the spirit aroused by such works will be too weak.

Ornament, of course, is by no means devoid of soul. Ornament does not lack its own inner life. But this life is either meaningless to us now (old ornaments) or is an alogical confusion; it is a world in which, metaphorically, adults revolve in the same society as embryos, in which beings deprived of limbs move on the same plane as individual noses, fingers and navels. It is a kaleidoscope of images in which physical accident and not the spirit has become the creator. Despite this incomprehensibility or inability to become comprehensible, ornament still has an immediate effect on us, even if it be fortuitous and irrational. Intrinsically, Eastern ornament differs from Swedish, Negro, Ancient Greek, etc. For example, there are sound reasons why material shapes in depiction are often designated by the adjectives cheerful, serious, sad, lively, etc, i.e., by those same adjectives which musicians use to indicate the manner of performance (*allegro, serioso, grave, vivace*, etc.). One may assume that ornament, for the most part, derived from nature (and modern applied artists are seeking motifs from the fields and forests). On the other hand, even if we assume that there was no other source for ornament apart from external nature, natural forms and colors are never just external in successful ornament, but are used rather as symbols. As such, of course, they attain an almost hieroglyphic appearance. That is why ornament gradually becomes less intelligible and we lose the secret key to its code. The Chinese dragon, for example, which contains much physical substance in its ornamental form, affects us very little, in our sitting-rooms and bedrooms we respond to it quite calmly and are impressed by it no more than by a tablecloth embroidered with daisies.

Perhaps a new kind of ornament will develop towards the end of our era whose dawn is just beginning but this will hardly consist of geometric combinations. At the moment any attempt to create this ornament coercively would be like trying to force open the bud of a flower.

At the moment we are tied too closely to external nature and we are compelled to derive our *forms* from her. The question is: How can this be done, i.e., to what extent can we free these forms? With which colors are we to link them?

In this freedom we can go as far as the artist's feeling allows us. This makes it very clear just how necessary it is to cultivate this feeling.

A few examples will, to a certain extent, answer the second part of the above question.

A warm red – which always excites when observed in isolation – will change its inner value if it is used not in isolation and not as an abstract sound, but as one element of a living being, i.e., if it is linked to a form of nature. This integration of red and various natural forms creates various inner effects. However, because of the sound of red (always observed in isolation), these effects will resemble each other. Let us link this red to the sky, to a flower, a dress, a face, a horse, a tree.

A red sky aroused association with the sunset or with fire, etc. Consequently, this combination provides a "natural" effect, in this case, one of formidable majesty. Of course, it is of the utmost significance how other elements are treated in the way they are combined with the sky. If they are placed in a causal connection and linked with appropriate colors, then the natural sound will be even stronger in the sky. If the other elements are removed from "nature," they might weaken the "natural" impression of the sky and even, perhaps, destroy it completely. Similarly, this might occur when red is linked to a face: red can give a face the impression of excitement and this would demand a specific justification. Such effects can only be destroyed and replaced by others via the greater abstraction of the other parts.

In contrast, red in a dress is quite a different matter because a dress can be of any color. In this case red will be justified simply by artistic necessity and will be treated entirely independently, without direct association with material aims. Nevertheless, there will occur an interaction of the red of the dress and the figure wearing the dress, and vice versa. If, for example, the general sound of a given painting is a minor one and if this sound is concentrated in the figure dressed in red (through the figure's position vis-à-vis the whole composition, its particular movement, the features of its face, the position of its head, its complexion, etc.), then the red of the dress will emphasize the melancholy of the whole painting and especially of the central figure by its inner antisound. Undoubtedly, any other color whose own effect is minor would only weaken the effect and decrease the dramatic element.

So we again encounter the principle of antithesis. The dramatic element is present thanks to the inclusion of red. Red in isolation, i.e., when it falls on to the mirror-like, silent surface of the soul, cannot function as a sad sound.

Again, red will act differently if applied to a tree. As in the above instances, the basic tone of red will be obvious. But in this case the moral value of autumn will take effect (because the very word autumn is a moral unit just as any concept is both real and abstract, both physical and non-physical). Color binds itself inextricably to the object and creates a distinct, active element without any dramatic connotation, except for the one I designated in the context of the red dress.

Finally – quite a different matter – a red horse. The very sound of these words transfers us to a different atmosphere. The incongruity of a red horse dictates, by analogy, an unnatural environment in which the horse will be placed. Otherwise, the general effect will either resemble a curio (i.e., merely superficial and unartistic) or it will be like an unsuccessful fairy-tale (i.e., a curio, well substantiated, but with an unartistic effect). A conventional naturalist landscape with figures carefully calculated and anatomically drawn, if combined with this horse, would produce an incongruity devoid of feeling and any possible unity. How this "unity" is to be understood and what its potentials are is clear from the above definition of our contemporary harmony. From this it is clear that the whole painting can be immersed in contradictions, can be split up, can be given all kinds of external surfaces and can be constructed on all kinds of external surfaces, but

the *inner* plane will remain distinctive. Elements of pictorial construction are not to be found in this outward aspect, they are present in its *inner necessity.*

The spectator is too accustomed to searching for the "meaning," i.e., for the outer interdependence of the pictorial parts. Both in life and in art this procedure has created a spectator who is unable to approach a painting spontaneously (especially the "connoisseur"). He seeks everything in a painting (imitation of nature, nature refracted through the artist's temperament – i.e., the temperament of direct construction, of "painting," anatomy, perspective, outer construction, etc., etc.). But he makes no attempt to feel the inner life of the painting, to allow the painting to affect him spontaneously. Blinded by the external means, his spiritual eye does not seek *that* which has acquired life via these means. When we carry on an interesting conversation with someone, we try to penetrate their soul, to find an inner creation, an image, thoughts and feelings, and we don't think about the fact that he's relying on words which consist of letters, that these letters are nothing more nor less than expedient sounds which require the action of air on the lungs for their effect (the anatomical aspect), the exhalation of air from the lungs and a particular position of the tongue, the lips, etc., for the formation of the aerial vibration (the physical aspect) – which, via the eardrum, reach our consciousness (the psychological aspect) and which evoke a nervous response (the physiological aspect) – *ad infinitum.* We know that in our conversation all these aspects are secondary and quite fortuitous. We use them as necessary, external media, knowing that what is essential in the conversation is the communication of ideas and feelings. This should also be our attitude to the work of art, so that we can perceive the immediate, abstract effect of the work. The possibility of speaking by purely artistic means will then develop. It will become unnecessary to borrow forms from external nature in order to express an inner language. At the moment these forms enable us to use form and color so as to diminish or intensify the inner value. The antithesis, like the red dress in the melancholic composition, can be infinite, but it must remain on one and the same moral plane.

The presence of this plane does not resolve the question of color. "Unnatural" objects and their corresponding colors can easily acquire a literary connotation if, for example, the composition evokes the impression of a fairy-tale. This transfers the spectator into a fairy-tale atmosphere which he easily recognizes. As a result he 1) looks for a plot; 2) becomes insensitive, or nearly so, to the pure effect of color. In any case, the immediate, pure, inner effect of color becomes impossible: the outer element simply dominates the inner. As a rule, man will not descend into the great depths. He prefers to stay on the surface because this requires least exertion. True, there's nothing more profound than superficiality, but this is the profundity of the marsh. On the other hand, is there any other art to which it is easier to relate than the "plastic" art? Once the spectator imagines himself to be in a fairy kingdom, he becomes immune to strong emotional vibrations. And the aim of the work is negated. So a form has to be found which, first and foremost, excludes the fairy-tale aura and which, secondly, does not impede the effect of color. To this end, the form, movement, color, the objects borrowed from nature

(real or not) must be absolutely free of the outer element or of the outward connection in the story. The less motivated the outer movement, the purer, the more profound and the more internal its effect. A simple movement towards an unknown goal produces the impression of great importance, of mystery and of majesty – insofar as its outer, practical goal remains unknown. At that point its effect is one of pure sound. A simple composite action (albeit preparations for lifting a heavy weight) is so mysterious, so dramatic and intriguing (while its practical goal remains unknown) that unconsciously one pauses as if before a vision, as before life on another plane. Then the charm suddenly evaporates, the practical explanation is given and, like a bolt from the blue, the hidden and enigmatic reason is exposed. A simple movement, devoid of outward motivation, contains a reserve of boundless possibilities. This very often occurs when one is lost in abstract thoughts. Such thoughts remove man from the practical expediency, the mundane ups and downs of his life. That is why he can observe these simple movements outside of their pragmatic value. But as soon as one recalls that enigma has no place in our city streets, interest in visible movement fades. Its practical meaning extinguishes its abstract one.

These examples of color application, the need to use "natural forms" in connection with the color-sound and the significance of this indicate:

1) where the path to painting lies, and 2) how, *in principle*, to embark upon this path. This path lies between two regions (at the moment – two danger zones). On the right there is, of course, the abstract and liberated use of color in geometric form (ornament), on the left – a more tangible use of color in "physical" form (fantasy) paralyzed by outer forms. Today, and perhaps only today, it is possible to turn right and go beyond, but it is also possible to turn left and go beyond. On the far right (I'm no longer being schematic) lies *pure abstraction* (i.e., more abstract than geometric forms), and on the left *pure realism* (i.e., more than fantasy – a fantasy in solid matter). Between them stretches a deep, limitless expanse, a wealth of potential. Whole regions of pure abstractions and of realism lie beyond them. Right now the artist has *everything* at his service. Today we have the kind of freedom which is possible only at the dawn of a great era. At the same time this freedom provides a strong cohesion, because this great potential within and beyond these boundaries grows from the same root, from the dictate of *Inner Necessity.*

That art stands above nature, i.e., is "higher than nature," is not a new discovery.[16] New principles never appear out of the blue, but are in a causal connection with the past and the future. They are a hidden and mysterious fulcrum, one which comes to use from the depths of necessity and from the heights of expediency. They are indissolubly linked to us. It is only a matter of what form the new principle will take and where it will lead us tomorrow. This principle (and this must be emphasized again and again) can never be used forcibly. If an artist can compose his soul in accordance with this tuning-fork, then his works will also sound at the same pitch.

8) *The artist and creativity*

A creative work is born from the artist in a very mysterious, enigmatic and mystical manner. Liberated from him, it takes on its own independent, spiritual being which also leads a material and concrete life. It is a *being*. Consequently, this is not an accidental phenomenon, indifferent and insensitive to spiritual life. But, like any being, it is a phenomenon which possesses its own creative, active forces. It lives, acts and participates in the creation of the spiritual atmosphere. This inner exclusivity provides us with an answer to the question – is such and such a work of art good or bad? If it's "bad" or weak in form, then this means that the form is too bad or too weak to arouse a pure, emotional sound-vibration of any kind.

Similarly, it is not the painting which is "well painted" which is true to its own *valeurs* (the inevitable French *valeurs*) or the one which demonstrates a specific, scientific division into warm and cool tones, but the painting which lives a complete, inner life. Similarly, only that drawing is "good" in which nothing can be changed without its inner life being disturbed. This is distinct from whether or not this drawing abuses anatomy, botany or any other science. It's not a question of whether a certain outer form and hence a merely accidental one has been abused, but simply whether or not the artist is using this form as it exists in its outward appearance. Similarly, colors must be applied not because they exist or do not exist as this sound in nature, but because *they are or are not necessary* to this sound in the painting. In brief, the artist is not only empowered, he is also *obliged to treat* forms *in whichever way they are essential to his aims*. Neither anatomy, etc. nor the doctrinaire refutation of such disciplines is necessary. What is necessary is the artist's *complete, unlimited freedom* in his choice of media.[17]

This necessity – the right to unlimited freedom – becomes a criminal act the moment it is divorced from the above principle. From an artistic standpoint this right constitutes the inner plane described above. This is the pure aim of the whole of life (and hence of art).

The senseless pursuit of scientific data, in particular, is not as pernicious as their senseless refutation. In the first case, the result is the imitation of nature (a material imitation) which can be utilized for various objectives. In the second case, the result is an artistic lie which is first in a long line of repulsive effects (like any crime). In the first case, there is a moral vacuum. It is like a stone. In the second case, the atmosphere fills with poison and disease.

Painting is an art. Art is not the senseless creation of things, diffused in a vacuum. It is a powerful force and has many aims. It should serve the development and refinement of the human soul – of the movement within the triangle. Art is a *language whereby we speak to the soul (in a form accessible and peculiar only to this language) of things which are the soul's daily bread and which it can acquire only in this form.*

When art rejects this task, a vacuum remains, because there is no other power and force which can replace it. At times of intense emotional life art always

becomes more vital because the soul and art are interconnected by an indissoluble chain of interaction and mutual embetterment. When the soul is neglected and suffocated by material considerations, by lack of faith and, consequently, by mere pragmatic aspirations, then people believe that art is given to man for no particular purpose – that it has no aim, that it exists only for itself (*l'art pour l'art*).

At this point the connection between art and the soul is half anaesthetized. But this is soon counteracted because the artist and the spectator, speaking to each other in the language of the soul, cease to understand each other. The latter turns his back on the former or regards him as an acrobat whose skill and aplomb are stunning.

First and foremost, the artist must endeavor to change his position. He must do this by acknowledging his debt to *art* and thus to *himself* also. He must not consider himself master of the situation, but the servant of nobler aims – a servant whose obligations are very distinctive, majestic and sacred. He must *nurture* himself and plumb the depths of his soul, he must conserve his soul and develop it so that his outer talent envelops substance and is not like a lost glove, the mere likeness of a hand.

The artist must have something he wishes to express since his task is not to possess form, but to adjust this form to the *content*.

The artist is not some special child of fortune. He has no right to live without obligations. His work is difficult and often becomes a cross which he must bear. He must realize that his every action, feeling and thought constitute the intangible and so very delicate material from which his art derives. And if he is free, then he is not so in life, only in art.

Hence it is very clear that the artist, compared to the non-artist, is thrice responsible. Firstly, he must return the talent bestowed upon him, secondly, his actions, thoughts and feelings form (as with any man) a spiritual atmosphere, one which they either illuminate or poison; thirdly, these actions, thoughts and feelings are the material for his art which also affect the spiritual atmosphere. He is "king," as Sar Péladan calls him, not only because his power is great, but also because his obligation is great.

If the artist is the priest of the "Beautiful," then this Beautiful is also sought by means of that same principle, *inner value*. This "Beautiful" is sought also by the yardstick of *inner* greatness and necessity, and hitherto this has been a faithful measurement.

The beautiful corresponds to the inner, emotional necessity. The beautiful is inwardly beautiful.[18]

One of the first fighters, one of the first sincere composers of modern art (whence the art of tomorrow is already emerging), M. Maeterlinck, says: "There is nothing upon earth which thirsts more fervently for the beautiful and which itself becomes beautiful more easily than the soul. . . . Hence few souls do not bow to the soul which has surrendered itself to beauty."

This is the oil which eases the movement of the spiritual triangle. And this movement, forwards and upwards, is slow, hardly visible and at times seems to have stopped. But it is constant.

123

The lecture aroused lively discussion. Prince S. M. Volkonsky, A. N. Kremlev, Professor D. V. Ainalov and N. I. Kulbin took part.

Prince S. M. Volkonsky. From the very beginning I was won over by Kandinsky and by the steadfast way in which he advanced without worrying about how his essay would be taken – although many might regard it as absurd.

In any case, when the theosophical principle is linked to something close to me, i.e., art, I'm always won over. The number 3, for example, has played a major role in every period of human history and lies at the basis of many credos. The triangle has always interested me personally. I was also taken by the division into the "what" and the "how." I support those who say that the "how" is the most important thing in art. In order to explain what constitutes the evolution of forms in art, it would be most interesting to assemble an entire gallery dealing with the same subject. Anyone would then be able to see that the important thing was not what was depicted, but how it was depicted. Finally, Kandinsky's lecture is interesting in that it represents one facet of a total worldview and one with a very broad foundation. However, I am aware of a certain absurdity which some of the details suggested, and I also have that terrifying feeling which arises whenever insanity borders on genius.

A. N. Kremlev does not agree with this kind of evaluation and refuses to recognize any scholarly merit in the paper – if Kandinsky is saying that talent must be understood as a kind of Gospel, that the triangle is the basis of everything, that certain colors wish to be caressed while others are sharp, that a sauce is blue, etc. A. N. Kremlev asks whether one can infer that there is an indissoluble link between the notes of a violin and a dramatic work from the fact that Chaev before writing a piece for dramatic theatre, used to play it on the violin.

Gentlemen, pardon me! Can one really say that yellow denotes joy and plenty? That's the same as saying that the troika denotes the road. Then we heard that the triangle was a being with its own, peculiar aroma. But the triangle is an object, not a being. We heard that the circle, the rhombus and triangles are equal citizens in the spiritual realm. Excuse me – I don't see anything scholarly in this. Sergei Mikhailovich points out that the figure 3 has some kind of magic meaning. If $4 + 4 = 8 \ldots$

Prince S. M. Volkonsky: Apologies. There is a Chaldean wisdom...

A. N. Kremlev: There is a popular wisdom and there is a wisdom of science. I would prefer that we talked only about science at our congresses.

Professor D. V. Ainalov, on the contrary, does not deny the scholarly merit of Kandinsky's lecture because at the basis of its color lies Waetzoldt's doctrine. The frequent mention of the triangle and the pyramid should not put anyone out. In art history one is constantly encountering the pyramidal construction of composition. In D. V. Ainalov's opinion Kandinsky's philosophical method is correct. The triangle is a means of expression and not a theosophical quantity. Essays such as Kandinsky's make an undoubted contribution to the cause.

N. I. Kulbin also agreed that Kandinsky's remarks were of high scientific value.

At the end of the discussions those assembled expressed the wish that Kandinsky's essay "On the Spiritual in Art" be published in the *Transactions of the Congress.*

Notes

1 In their intrinsic meaning this "today" and "tomorrow" resemble the Biblical "days" of Creation.
2 I deem it more correct to speak of paint and not color most of the time. Apart from abstract color, the concept of paint also contains the material consistency with which the artist operates.
3 A good deal of theoretical and practical work has been carried out in this field. There have been attempts to construct a specific counterpoint of painting on the basis of the many correlations, including the vibration of aerial and light waves. On the other hand, successful experiments have been carried out with unmusical children – to encourage them to memorize a melody with the help of color (or, at least, of *colors*). A. Zakharina-Unkovskaia has worked for many years on this project and has constructed a special, precise method of "notating music from the colors of nature and of painting from the sounds of nature, *to see sounds in color terms and to hear colors in musical terms.*" She has long used this method in her school and the St. Petersburg Conservatoire has recognized its expediency.
4 The word "expressive" should be understood correctly. Sometimes form is expressive when it is suppressed. Sometimes form gives maximum expression to necessity when it does not attain the final limit, but when it remains a mere allusion and simply points the way towards extreme expression.
5 The essential meaning of "idealization" used to be the aspiration to make organic form more beautiful, to make it ideal. This resulted in a schematic treatment and also in the dulling of the inner sound of the individual element. The primary aim of "stylization," which flourished on the soil of Impressionism, was not to magnify the beauty of organic form, but simply to intensify its characteristics – and it did this by rejecting fortuitous details. Our future attitude towards organic form and its transformation will expose the inner sound. At this point organic form will not serve as the immediate objective, but simply as an element of the divine tongue – which is in need of human expression, for man speaks to man.
6 A vivid example is Cézanne's *Bathers,* a triangular composition. This kind of construction according to geometric form is based on an old principle. At one time this principle was abandoned since it had degenerated into a rigid academic formula and had lost its inner meaning, its soul. When Cézanne applied this principle, he gave it a new soul and, moreover, he underlined in particular the purely painterly, compositional principle. In this important example, the triangle is not an auxiliary means of harmonizing the complex of images, but is the vivid expression of an artistic goal. This geometric form is also the means of the compositon: the center of gravity rests on a purely artistic impulse within a clear consonance of the abstract element. Cézanne, therefore, is right to change the human proportions: both the whole composition and the individual parts of the body must aspire towards the apex of the triangle (the higher this aspiration, the more intense it becomes, as if the bodies are being

carried upwards by a hurricane). They become lighter and, very visibly, become stretched.

7 All these assertions are the result of empirical, subjective perceptions and are not based on any positive science.

8 It is interesting that a lemon is yellow (sharp, acid), that a canary is yellow (shrill sound of its song). They are a very intense yellow.

9 This juxtaposition of colors and musical tones is, of course, relative. Just as a violin can develop very diverse tones corresponding to diverse colors, so, for example, the various shades of yellow can be expressed by different instruments.

10 " ... les nymbes ... sont dorés pour l'empereur et les prophètes (i.e., for mortals) et *bleu* de ciel pour les personnages symboliques" (i.e., for purely spiritual beings). N. Kondakoff, *Histoire de l'art byzantin considéré principalement dans les miniatures* (Paris: Librairie de l'Art, 1886–91).

11 In his *Letters* Van Gogh asks whether it isn't possible to paint a white wall just by using pure white. This question (which for the non-naturalist who uses paint for its inner sound, presents no problem) is, for the Impressionist and Naturalist, an audacious attempt on the life of nature. To these artists this seemed as revolutionary and as crazy as substituting blue shadows for brown ones had seemed (a favorite example – "the green sky and the blue grass"). Just as we recognize in this the transition from Academic Realism to Impressionism and Naturalism, so in Van Gogh's question we sense the beginning of the "transposition of nature," i.e., the tendency not to represent nature in her outer manifestations, but to extrapolate the dominant element of her *inner impression*.

12 For example, vermilion sounds dullish, dirty on white. On black it acquires a pure, vivid, striking force. Light yellow grows weaker and diffuses when placed on white. On black its effect is so strong that it simply takes off from the surface, floats in the air, arrests the eye.

13 Grey equals immobility and *peace*. Delacroix had a premonition of this: he wished to find peace by mixing green and red.

14 Periods of suicide, hostility and militancy occur. War and, to a lesser extent, revolution are the products of this atmosphere – which they corrupt still more. The measure which you apply to others will be applied unto you.

15 History is familiar with these moments too. Christianity bore even the weakest of the weak into spiritual battle: has there ever been anything greater in this respect? So in war, especially in revolution, there exist agents who cleanse the poison air.

16 Literature, in particular, *expressed* this principle a long time ago. For example, Goethe said: "The artist stands as a free spirit above nature and may use her in accordance with his aims. . . . he is both her slave and master. He is her slave inasmuch as he must use earthly means to make himself understood (N.B.!), but he is her master inasmuch as he subordinates these earthly means and forces them to serve his higher aims. The artist speaks to the world through a totality, but this he cannot find in nature. This is the fruit of his own spirit or, if you like, the fruit of the fertile inspiration given by the breath of God" (Karl Heinemann, 1899, p. 684). In modern times Oscar Wilde said: "Art begins where nature leaves off" (*De Profundis*). Similar thoughts are often met with in painting. Delacroix, for example, calls nature the artist's dictionary.

17 This unlimited freedom must be based on inner necessity (which is called integrity). This is a principle not just of art, but of life as well. This principle is, as it were, the great sword of the superman in his struggle with the philistine.

18 By "Beautiful" I don't mean outer or even an inner, popular moral, but *everything* that refines and enriches the soul in the most intangible form. In painting, for example, *any* color is inwardly beautiful because each color produces an *emotional* vibration, and *each vibration enriches the soul.* So anything which is "outwardly ugly" might be inwardly beautiful. As in art, so in life. In life there is nothing ugly in its inner result, i.e., in its effect on the soul.

13

Mystery and Creation

Giorgio de Chirico

To become truly immortal a work of art must escape all human limits: logic and common sense will only interfere. But once these barriers are broken it will enter the regions of childhood vision and dream.

Profound statements must be drawn by the artist from the most secret recesses of his being; there no murmuring torrent, no birdsong, no rustle of leaves can distract him.

What I hear is valueless; only what I see is living, and when I close my eyes my vision is even more powerful.

It is most important that we should rid art of all that it has contained of *recognizable material* to date, all familiar subject matter, all traditional ideas, all popular symbols must be banished forthwith. More important still, we must hold enormous faith in ourselves: it is essential that the revelation we receive, the conception of an image which embraces a certain thing, which has no sense in itself, which has no subject, which means *absolutely nothing* from the logical point of view, I repeat, it is essential that such a revelation or conception should speak so strongly in us, evoke such agony or joy, that we feel compelled to paint, compelled by an impulse even more urgent than the hungry desperation which drives a man to tearing at a piece of bread like a savage beast.

I remember one vivid winter's day at Versailles. Silence and calm reigned supreme. Everything gazed at me with mysterious, questioning eyes. And then I realized that every corner of the palace, every column, every window possessed a spirit, an impenetrable soul. I looked around at the marble heroes, motionless in the lucid air, beneath the frozen rays of that winter sun which pours down on us *without love*, like perfect song. A bird was warbling in a window cage. At that

Giorgio de Chirico, "Mystery and Creation," 1913. Originally published in André Breton, *Le Surréalisme et la Peinture* (Paris: Gallimard, 1928). This English translation is from *London Bulletin* 6 (Oct. 1938), p. 14.

moment I grew aware of the mystery which urges men to create certain strange forms. And the creation appeared more extraordinary than the creators.

Perhaps the most amazing sensation passed on to us by prehistoric man is that of presentiment. It will always continue. We might consider it as an eternal proof of the irrationality of the universe. Original man must have wandered through a world full of uncanny signs. He must have trembled at each step.

14

From Cubism and Futurism to Suprematism: The New Painterly Realism

Kazimir Malevich

Only when the conscious habit of seeing nature's little nooks, Madonnas, and Venuses in pictures disappears *will we witness a purely painterly work of art.*

I have transformed myself *in the zero of form* and have fished myself out of the *rubbishy slough of academic art.*

I have destroyed the ring of the horizon and got out of the circle of objects, the horizon ring that has imprisoned the artist and the forms of nature.

This accursed ring, by continually revealing novelty after novelty, leads the artist away from the *aim of destruction.*

And only *cowardly consciousness* and insolvency of creative power in an artist yield to this deception and establish *their art on the forms of nature*, afraid of losing the foundation on which the *savage and the academy* have based their art.

To produce favorite objects and little nooks of nature is just like a thief being enraptured by his shackled legs.

Only dull and impotent artists veil their work with *sincerity.* Art requires *truth*, not *sincerity.*

Kazimir Malevich, "From Cubism and Futurism to Suprematism: The New Painterly Realism" (originally published 1915), pp. 118–35 in John E. Bowlt (ed. and trans.), *Russian Art of the Avant-Garde: Theory and Criticism, 1902–1934* (revised and enlarged edition). London: Thames and Hudson, 1991. First published in English by The Viking Press in *The Documents of 20th-Century Art* series, 1976. Reprinted by permission of Thames and Hudson Ltd.

Objects have vanished like smoke; to attain the new artistic culture, art advances toward creation as an end in itself and toward domination over the forms of nature.

The Art of the Savage and Its Principles

The savage was the first to establish the principle of naturalism: in drawing a dot and five little sticks, he attempted to transmit his own image.

This first attempt laid the basis for the conscious imitation of nature's forms.

Hence arose the aim of approaching the face of nature as closely as possible.

And all the artist's efforts were directed toward the transmission of her creative forms.

The first inscription of the savage's primitive depiction gave birth to collective art, or the art of repetition.

Collective, because the real man with his subtle range of feelings, psychology, and anatomy had not been discovered.

The savage saw neither his outward image nor his inward state.

His consciousness could see only the outline of a man, a beast, etc.

And as his consciousness developed, so the outline of his depiction of nature grew more involved.

The more his consciousness embraced nature, the more involved his work became, and the more his experience and skill increased.

His consciousness developed in only one direction, toward nature's creation and not toward new forms of art.

Therefore his primitive depictions cannot be considered creative work.

The distortion of reality in his depictions is the result of weak technique.

Both technique and consciousness were only at the beginning of their development.

And his pictures must not be considered art.

Because unskillfulness is not art.

He merely pointed the way to art.

Consequently, his original outline was a framework on which the generations hung new discovery after new discovery made in nature.

And the outline became more and more involved and achieved its flowering in antiquity and the Renaissance.

The masters of these two epochs depicted man in his complete form, both outward and inward.

Man was assembled, and his inward state was expressed.

But despite their enormous skill, they did not, however, perfect the savage's idea:

The reflection of nature on canvas, as in a mirror.

And it is a mistake to suppose that their age was the most brilliant flowering of art and that the younger generation should at all costs aspire toward this ideal.

This idea is false.

It diverts young forces from the contemporary current of life and thereby deforms them.

Their bodies fly in airplanes, but they cover art and life with the old robes of Neros and Titians.

Hence they are unable to observe the new beauty of our modern life.

Because they live by the beauty of past ages.

That is why the realists, impressionists, cubism, futurism, and suprematism were not understood.

The latter artists cast aside the robes of the past, came out into modern life, and found new beauty.

And I say:

That no torture chambers of the academies will withstand the days to come.

Forms move and are born, and we are forever making new discoveries.

And what we discover must not be concealed.

And it is absurd to force *our* age into the old forms of a bygone age.

The hollow of the past cannot contain the gigantic constructions and movement of our life.

As in our life of technology:

We cannot use the ships in which the Saracens sailed, and so in art we should seek forms that correspond to modern life.

The technological side of our age advances further and further ahead, but people try to push art further and further back.

This is why all those people who follow their age are superior, greater, and worthier.

And the realism of the nineteenth century is much greater than the ideal forms found in the aesthetic experience of the ages of the Renaissance and Greece.

The masters of Rome and Greece, after they had attained a knowledge of human anatomy and produced a depiction that was to a certain extent realistic:

were overrun by aesthetic taste, and their realism was pomaded and powdered with the taste of aestheticism.

Hence their perfect line and nice colors.

Aesthetic taste diverted them from the realism of the earth, and they reached the impasse of idealism.

Their painting is a means of decorating a picture.

Their knowledge was taken away from nature into closed studios, where pictures were manufactured for many centuries.

That is why their art stopped short.

They closed the doors behind them, thereby destroying their contact with nature.

And that moment when they were gripped by the idealization of form should be considered the collapse of real art.

Because art should not advance toward abbreviation or simplification, but toward complexity.

The Venus de Milo is a graphic example of decline. It is not a real woman, but a parody.

Angelo's David is a deformation:
His head and torso are modeled, as it were, from two incongruent forms.
A fantastic head and a real torso.

All the masters of the Renaissance achieved great results in anatomy.
But they did not achieve veracity in their impression of the body.
Their painting does not transmit the body, and their landscapes do not transmit living light, despite the fact that bluish veins can be seen in the bodies of their people.

The art of naturalism is the savage's idea, the aspiration to transmit what is seen, but not to create a new form.

His creative will was in an embryonic state, but his impressions were more developed, which was the reason for his reproduction of reality.

Similarly it should not be assumed that his gift of creative will was developed in the classical painters.

Because we see in their pictures only repetitions of the real forms of life in settings richer than those of their ancestor, the savage.

Similarly their composition should not be considered creation, for in most cases the arrangement of figures depends on the subject: a king's procession, a court, etc.

The king and the judge already determine the places on the canvas for the persons of secondary importance.

Furthermore, the composition rests on the purely aesthetic basis of niceness of arrangement.

Hence arranging furniture in a room is still not a creative process.

In repeating or tracing the forms of nature, we have nurtured our consciousness with a false conception of art.

The work of the primitives was taken for creation.

The classics also.

If you put the same glass down twenty times, that's also creation.

Art, as the ability to transmit what we see onto a canvas, was considered creation.

Is placing a samovar on a table also really creation?

I think quite differently.

The transmission of real objects onto a canvas is the art of skillful reproduction, that's all.

And between the art of creating and the art of repeating there is a great difference.

To create means to live, forever creating newer and newer things.

And however much we arrange furniture about rooms, we will not extend or create a new form for them.

And however many moonlit landscapes the artist paints, however many grazing cows and pretty sunsets, they will remain the same dear little cows and sunsets. Only in a much worse form.

And in fact, whether an artist is a genius or not is determined by the number of cows he paints.

The artist can be a creator only when the forms in his picture have nothing in common with nature.

For art is the ability to create a construction that derives not from the inter-relation of form and color and not on the basis of aesthetic taste in a construction's compositional beauty, *but on the basis of weight, speed, and direction of movement.*

Forms must be given life and the right to individual existence.

Nature is a living picture, and we can admire her. We are the living heart of nature. We are the most valuable construction in this gigantic living picture.

We are her living brain, which magnifies her life.

To reiterate her is theft, and he who reiterates her is a thief – a nonentity who cannot give, but who likes to take things and claim them as his own. (Counterfeiters.)

An artist is under a vow to be a free creator, but not a free robber.

An artist is given talent in order that he may present to life his share of creation and swell the current of life, so versatile.

Only in absolute creation will he acquire his right.

And this is possible when we free all art of philistine ideas and subject matter and teach our consciousness to see everything in nature not as real objects and forms, but as material, as masses from which forms must be made that have nothing in common with nature.

Then the habit of seeing Madonnas and Venuses in pictures, with fat, flirtatious cupids, will disappear.

Color and texture are of the greatest value in painterly creation – they are the essence of painting; but this essence has always been killed by the subject.

And if the masters of the Renaissance had discovered painterly surface, it would have been much nobler and more valuable than any Madonna or Gioconda.

And any hewn pentagon or hexagon would have been a greater work of sculpture than the Venus de Milo or David.

The principle of the savage is to aim to create art that repeats the real forms of nature.

In intending to transmit the living form, they transmitted its corpse in the picture.

The living was turned into a motionless, dead state.

Everything was taken alive and pinned quivering to the canvas, just as insects are pinned in a collection.

But that was the time of Babel in terms of art.

They should have created, but they repeated; they should have deprived forms of content and meaning, but they enriched them with this burden.

They should have dumped this burden, but they tied it around the neck of creative will.

The art of painting, the word, sculpture, was a kind of camel, loaded with all the trash of odalisques, Salomes, princes, and princesses.

Painting was the tie on the gentleman's starched shirt and the pink corset drawing in the stomach.

Painting was the aesthetic side of the object.

But it was never an independent end in itself.

Artists were officials making an inventory of nature's property, amateur collectors of zoology, botany, and archaeology.

Nearer our time, young artists devoted themselves to pornography and turned painting into lascivious trash.

There were no attempts at purely painterly tasks as such, without any appurtenances of real life.

There was no realism of painterly form as an end in itself, and there was no creation.

The realist academists are the savage's last descendants.

They are the ones who go about in the worn-out robes of the past.

And again, as before, some have cast aside these greasy robes.

And given the academy rag-and-bone man a slap in the face with their proclamation of futurism.

They began in a mighty movement to hammer at the consciousness as if at nails in a stone wall.

To pull you out of the catacombs into the speed of contemporaneity.

I assure you that whoever has not trodden the path of futurism as the exponent of modern life is condemned to crawl forever among the ancient tombs and feed on the leftovers of bygone ages.

Futurism opened up the "new" in modern life: the beauty of speed.

And through speed we move more swiftly.

And we, who only yesterday were futurists, have reached new forms through speed, new relationships with nature and objects.

We have reached suprematism, abandoning futurism as a loophole through which those lagging behind will pass.

We have abandoned futurism, and we, bravest of the brave, *have spat on the altar of its art.*

But can cowards spit on their idols –

As we did yesterday!!!

I tell you, you will not see the new beauty and the truth until you venture to spit.

Before us, all arts were old blouses, which are changed just like your silk petticoats.

After throwing them away, you acquire new ones.

Why do you not put on your grandmothers' dresses, when you thrill to the pictures of their powdered portraits?

This all confirms that your body is living in the modern age while your soul is clothed in your grandmother's old bodice.

This is why you find the Somovs, Kustodievs, and various such rag merchants so pleasant.

And I hate these secondhand-clothes dealers.

Yesterday we, our heads proudly raised, defended futurism –

Now with pride we spit on it.

And I say that what we spat upon will be accepted.

You, too, spit on the old dresses and clothe art in something new.

We rejected futurism not because it was outdated, and its end had come. No. The beauty of speed that it discovered is eternal, and the new will still be revealed to many.

Since we run to our goal through the speed of futurism, our thought moves more swiftly, and whoever lives in futurism is nearer to this aim and further from the past.

And your lack of understanding is quite natural. Can a man who always goes about in a cabriolet really understand the experiences and impressions of one who travels in an express or flies through the air?

The academy is a moldy vault in which art is being flagellated.

Gigantic wars, great inventions, conquest of the air, speed of travel, telephones, telegraphs, dreadnoughts are the realm of electricity.

But our young artists paint Neros and half-naked Roman warriors.

Honor to the futurists who forbade the painting of female hams, the painting of portraits and guitars in the moonlight.

They made a huge step forward: they abandoned meat and glorified the machine.

But meat and the machine are the muscles of life.

Both are the bodies that give life movement.

It is here that two worlds have come together.

The world of meat and the world of iron.

Both forms are the mediums of utilitarian reason.

But the artist's relationship to the forms of life's objects requires elucidation.

Until now the artist always followed the object.

Thus the new futurism follows the machine of today's dynamism.

These two kinds of art are the old and the new – futurism: they are behind the running forms.

And the question arises: will this aim in the art of painting respond to its existence?

No!

Because in following the form of airplanes or motorcars, we shall always be anticipating the new cast-off forms of technological life. . . .

And second:

In following the form of things, we cannot arrive at painting as an end in itself, at spontaneous creation.

Painting will remain the means of transmitting this or that condition of life's forms.

But the futurists forbade the painting of nudity not in the name of the liberation of painting and the word, so that they would become ends in themselves.

But because of the changes in the technological side of life.

The new life of iron and the machine, the roar of motorcars, the brilliance of electric lights, the growling of propellers, have awakened the soul, which was suffocating in the catacombs of old reason and has emerged at the intersection of the paths of heaven and earth.

If all artists were to see the crossroads of these heavenly paths, if they were to comprehend these monstrous runways and intersections of our bodies with the clouds in the heavens, then they would not paint chrysanthemums.

The dynamics of movement has suggested advocating the dynamics of painterly plasticity.

But the efforts of the futurists to produce purely painterly plasticity as such were not crowned with success.

They could not settle accounts with objectism, which would have made their task easier.

When they had driven reason halfway from the field of the picture, from the old calloused habit of seeing everything naturally, they managed to make a picture of the new life, of new things, but that is all.

In the transmission of movement, the cohesiveness of things *disappeared* as their flashing parts hid themselves among other running bodies.

And in constructing the parts of the running objects, they tried to transmit only the impression of movement.

But in order to transmit the movement of modern life, one must operate with its forms.

Which made it more complicated for the art of painting to reach its goal.

But however it was done, consciously or unconsciously, for the sake of movement or for the sake of transmitting an impression, the cohesion of things was violated.

And in this breakup and violation of cohesion lay the latent meaning that had been concealed by the naturalistic purpose.

Underlying this destruction lay primarily not the transmission of the movement of objects, but their destruction for the sake of pure painterly essence, i.e., toward attainment of nonobjective creation.

The rapid interchange of objects struck the new naturalists – the futurists – and they began to seek means of transmitting it.

Hence the construction of the futurist pictures that you have seen arose from the discovery of points on a plane where the placing of real objects during their explosion or confrontation would impart a sense of time at a maximum speed.

These points can be discovered independently of the physical law of natural perspective.

Thus we see in futurist pictures the appearance of clouds, horses, wheels, and various other objects in places not corresponding to nature.

The state of the object has become more important than its essence and meaning.

We see an extraordinary picture.

A new order of objects makes reason shudder.

The mob howled and spat, critics rushed at the artist like dogs from a gateway. (Shame on them.)

The futurists displayed enormous strength of will in destroying the habit of the old mind, in flaying the hardened skin of academism and spitting in the face of the old common sense.

After rejecting reason, the futurists proclaimed intuition as the subconscious.

But they created their pictures not out of the subconscious forms of intuition, but used the forms of utilitarian reason.

Consequently, only the discovery of the difference between the two lives of the old and the new art will fall to the lot of intuitive feeling.

We do not see the subconscious in the actual construction of the picture.

Rather do we see the conscious calculation of construction.

In a futurist picture there is a mass of objects. They are scattered about the surface in an order unnatural to life.

The conglomeration of objects is acquired not through intuitive sense, but through a purely visual impression, while the building, the construction, of the picture is done with the intention of achieving an impression.

138

And the sense of the subconscious falls away.

Consequently, we have nothing purely intuitive in the picture.

Beauty, too, if it is encountered, proceeds from aesthetic taste.

The intuitive, I think, should manifest itself when forms are unconscious and have no response.

I consider that the intuitive in art had to be understood as the aim of our sense of search for objects. And it followed a purely conscious path, blazing its decisive trail through the artist.

(Its form is like two types of consciousness fighting between themselves.)

But the consciousness, accustomed to the training of utilitarian reason, could not agree with the sense that led to the destruction of objectism.

The artist did not understand this aim and, submitting to this sense, betrayed reason and distorted form.

The art of utilitarian reason has a definite purpose.

But intuitive creation does not have a utilitarian purpose. Hitherto we have had no such manifestation of intuition in art.

All pictures in art follow the creative forms of a utilitarian order. All the naturalists' pictures have the same form as in nature.

Intuitive form should arise out of nothing.

Just as reason, creating things for everyday life, extracts them from nothing and perfects them.

Thus the forms of utilitarian reason are superior to any depictions in pictures.

They are superior because they are alive and have proceeded from material that has been given a new form for the new life.

Here is the Divine ordering crystals to assume another form of existence.

Here is a miracle....

There should be a miracle in the creation of art, as well.

But the realists, in transferring living things onto the canvas, deprive their life of movement.

And our academies teach dead, not living, painting.

Hitherto intuitive feeling has been directed to drag newer and newer forms into our world from some kind of bottomless void.

But there has been no proof of this in art, and there should be.

And I feel that it does already exist in a real form and quite consciously.

The artist should know what, and why, things happen in his pictures.

Previously he lived in some sort of mood. He waited for the moonrise and twilight, put green shades on his lamps, and all this tuned him up like a violin.

But if you asked him why the face on his canvas was crooked, or green, he could not give an exact answer.

"I want it like that, I like it like that...."

Ultimately, this desire was ascribed to creative will.

Consequently, the intuitive feeling did not speak clearly. And thereafter its state became not only subconscious, but completely unconscious.

These concepts were all mixed together in pictures. The picture was half-real, half-distorted.

Being a painter, I ought to say why people's faces are painted green and red in pictures.

Painting is paint and color; it lies within our organism. Its outbursts are great and demanding.

My nervous system is colored by them.

My brain burns with their color.

But color was oppressed by common sense, was enslaved by it. And the spirit of color weakened and died out.

But when it conquered common sense, then its colors flowed onto the repellent form of real things.

The colors matured, but their form did not mature in the consciousness.

This is why faces and bodies were red, green, and blue.

But this was the herald leading to the creation of painterly forms as ends in themselves.

Now it is essential to shape the body and lend it a living form in real life.

And this will happen when forms emerge from painterly masses; that is, they will arise just as utilitarian forms arose.

Such forms will not be repetitions of living things in life, but will themselves be a living thing.

A painted surface is a real, living form.

Intuitive feeling is now passing to consciousness; no longer is it subconscious.

Even, rather, vice versa – it always was conscious, but the artist just could not understand its demands.

The forms of suprematism, the new painterly realism, already testify to the construction of forms out of nothing, discovered by intuitive reason.

The cubist attempt to distort real form and its breakup of objects were aimed at giving the creative will the independent life of its created forms.

Painting in Futurism

If we take any point in a futurist picture, we shall find either something that is coming or going, or a confined space.

But we shall not find an independent, individual painterly surface.

Here the painting is nothing but the outer garment of things.

And each form of the object was painterly insofar as its form was necessary to its existence, and not vice versa.

The futurists advocate the dynamics of painterly plasticity as the most import-ant aspect of a painting.

But in failing to destroy objectivism, they achieve only the dynamics of things.

Therefore futurist paintings and all those of past artists can be reduced from twenty colors to one, without sacrificing their impression.

Repin's picture of Ivan the Terrible could be deprived of color, and it will still give us the same impressions of horror as it does in color.

The subject will always kill color, and we will not notice it.

Whereas faces painted green and red kill the subject to a certain extent, and the color is more noticeable. And color is what a painter lives by, so it is the most important thing.

And here I have arrived at pure color forms.

And suprematism is the purely painterly art of color whose independence cannot be reduced to a single color.

The galloping of a horse can be transmitted with a single tone of pencil.

But it is impossible to transmit the movement of red, green, or blue masses with a single pencil.

Painters should abandon subject matter and objects if they wish to be pure painters.

The demand to achieve the dynamics of painterly plasticity points to the impulse of painterly masses to emerge from the object and arrive at color as an end in itself, at the domination of purely painterly forms as ends in themselves over content and things, at nonobjective suprematism – at the new painterly realism, at absolute creation.

Futurism approaches the dynamism of painting through the academism of form.

And both endeavors essentially aspire to suprematism in painting.

If we examine the art of cubism, the question arises what energy in objects incited the intuitive feeling to activity; we shall see that painterly energy was of secondary importance.

The object itself, as well as its essence, purpose, sense, or the fullness of its representation (as the cubists thought), was also unnecessary.

Hitherto it has seemed that the beauty of objects is preserved when they are transmitted whole onto the picture, and moreover, that their essence is evident in the coarseness or simplification of line.

But it transpired that one more situation was found in objects – which reveals a new beauty to us.

Namely: intuitive feeling discovered in objects the energy of dissonance, a dissonance obtained from the confrontation of two constrasting forms.

Objects contain a mass of temporal moments. Their forms are diverse, and consequently, the ways in which they are painted are diverse.

All these temporal aspects of things and their anatomy (the rings of a tree) have become more important than their essence and meaning.

And these new situations were adopted by the cubists as a means of constructing pictures.

Moreover, these means were constructed so that the unexpected confrontation of two forms would produce a dissonance of maximum force and tension.

And the scale of each form is arbitrary.

Which justifies the appearance of parts of real objects in places that do not correspond to nature.

In achieving this new beauty, or simply energy, we have freed ourselves from the impression of the object's wholeness.

The millstone around the neck of painting is beginning to crack.

An object painted according to the principle of cubism can be considered finished when its dissonances are exhausted.

Nevertheless, repetitive forms should be omitted by the artist since they are mere reiterations.

But if the artist finds little tension in the picture, he is free to take them from another object.

Consequently, in cubism the principle of transmitting objects does not arise.

A picture is made, but the object is not transmitted.

Hence this conclusion:

Over the past millennia, the artist has striven to approach the depiction of an object as closely as possible, to transmit its essence and meaning; then in our era of cubism, the artist destroyed objects together with their meaning, essence, and purpose.

A new picture has arisen from their fragments.

Objects have vanished like smoke, for the sake of the new culture of art.

Cubism, futurism, and the Wanderers differ in their aims, but are almost equal in a painterly sense.

Cubism builds its pictures from the forms of lines and from a variety of painterly textures, and in this case, words and letters are introduced as a confrontation of various forms in the picture.

Its graphic meaning is important. It is all for the sake of achieving dissonance.

And this proves that the aim of painting is the one least touched upon.

Because the construction of such forms is based more on actual superimposition than on coloring, which can be obtained simply by black and white paint or by drawing.

To sum up:

Any painted surface turned into a convex painterly relief is an artificial, colored sculpture, and any relief turned into surface is painting.

The proof of intuitive creation in the art of painting was false, for distortion is the result of the inner struggle of intuition in the form of the real.

Intuition is a new reason, consciously creating forms.

But the artist, enslaved by utilitarian reason, wages an unconscious struggle, now submitting to an object, now distorting it.

Gauguin, fleeing from culture to the savages, and discovering more freedom in the primitives than in academism, found himself subject to intuitive reason.

He sought something simple, distorted, coarse.

This was the searching of his creative will.

At all costs not to paint as the eye of his common sense saw.

He found colors but did not find form, and he did not find it because common sense showed him the absurdity of painting anything except nature.

And so he hung his great creative force on the bony skeleton of man, where it shriveled up.

Many warriors and bearers of great talent have hung it up like washing on a fence.

And all this was done out of love for nature's little nooks.

And let the authorities not hinder us from warning our generation against the clothes stands that they have become so fond of and that keep them so warm.

The efforts of the art authorities to direct art along the path of common sense annulled creation.

And with the most talented people, real form is distortion.

Distortion was driven by the most talented to the point of disappearance, but it did not go outside the bounds of zero.

But I have transformed myself in the zero of form and through zero have reached creation, that is, suprematism, the new painterly realism – nonobjective creation.

Suprematism is the beginning of a new culture: the savage is conquered like the ape.

There is no longer love of little nooks, there is no longer love for which the truth of art was betrayed.

The square is not a subconscious form. It is the creation of intuitive reason.

The face of the new art.

The square is a living, regal infant.

The first step of pure creation in art. Before it there were naïve distortions and copies of nature.

Our world of art has become new, nonobjective, pure.

Everything has disappeared; a mass of material is left from which a new form will be built.

In the art of suprematism, forms will live, like all living forms of nature.

These forms announce that man has attained his equilibrium; he has left the level of single reason and reached one of double reason.

(Utilitarian reason and intuitive reason.)

The new painterly realism is a painterly one precisely because it has no realism of mountains, sky, water. . . .

Hitherto there has been a realism of objects, but not of painterly, colored units, which are constructed so that they depend neither on form, nor on color, nor on their position vis-à-vis each other.

Each form is free and individual.

Each form is a world.

Any painterly surface is more alive than any face from which a pair of eyes and a smile protrude.

A face painted in a picture gives a pitiful parody of life, and this allusion is merely a reminder of the living.

But a surface lives; it has been born. A coffin reminds us of the dead; a picture, of the living.

This is why it is strange to look at a red or black painted surface.

This is why people snigger and spit at the exhibitions of new trends.

Art and its new aim have always been a spittoon.

But cats get used to one place, and it is difficult to house-train them to a new one.

For such people, art is quite unnecessary, as long as their grandmothers and favorite little nooks of lilac groves are painted.

Everything runs from the past to the future, but everything should live in the present, for in the future the apple trees will shed their blossoms.

Tomorrow will wipe away the vestige of the present, and you are too late for the current of life.

The mire of the past, like a millstone, will drag you into the slough.

This is why I hate those who supply you with monuments to the dead.

The academy and the critics are this millstone round your neck. The old realism is the movement that seeks to transmit living nature.

They carry on just as in the times of the Grand Inquisition.

Their aim is ridiculous because they want at all costs to force what they take from nature to live on the canvas.

At the same time as everything is breathing and running, their frozen poses are in pictures.

And this torture is worse than breaking on the wheel.

Sculptured statues, inspired, hence living, have stopped dead, posed as running.

Isn't this torture?

Enclosing the soul in marble and then mocking the living.

But you are proud of an artist who knows how to torture.

You put birds in a cage for pleasure as well.

And for the sake of knowledge, you keep animals in zoological gardens.

I am happy to have broken out of that inquisition torture chamber, academism.

I have arrived at the surface and can arrive at the dimension of the living body.

But I shall use the dimension from which I shall create the new.

144

I have released all the birds from the eternal cage and flung open the gates to the animals in the zoological gardens.

May they tear to bits and devour the leftovers of your art.

And may the freed bear bathe his body amid the flows of the frozen north and not languish in the aquarium of distilled water in the academic garden.

You go into raptures over a picture's composition, but in fact, composition is the death sentence for a figure condemned by the artist to an eternal pose.

Your rapture is the confirmation of this sentence.

The group of suprematists – *K. Malevich, I. Puni, M. Menkov, I. Klyun, K. Boguslavskaya, and Rozanova – has waged the struggle for the liberation of objects from the obligations of art.*

And appeals to the academy to renounce the inquisition of nature.

Idealism and the demands of aesthetic sense are the instruments of torture.

The idealization of the human form is the mortification of the many lines of living muscle.

Aestheticism is the garbage of intuitive feeling.

You all wish to see pieces of living nature on the hooks of your walls.

Just as Nero admired the torn bodies of people and animals from the zoological garden.

I say to all: Abandon love, abandon aestheticism, abandon the baggage of wisdom, for in the new culture, your wisdom is ridiculous and insignificant.

I have untied the knots of wisdom and liberated the consciousness of color!

Hurry up and shed the hardened skin of centuries, so that you can catch up with us more easily.

I have overcome the impossible and made gulfs with my breath.

You are caught in the nets of the horizon, like fish!

We, suprematists, throw open the way to you.

Hurry!

For tomorrow you will not recognize us.

15

Neo-Plasticism: The General Principle of Plastic Equivalence

Piet Mondrian

Although art is the plastic expression of *our* aesthetic emotion, we cannot therefore conclude that art is only "the aesthetic expression of our subjective sensations." Logic demands that art be the *plastic expression of our whole being*: therefore, it must be equally the plastic appearance of the *nonindividual*, the absolute and annihilating opposition of subjective sensations. That is, it must also be the *direct expression of the universal in us* – which is the *exact appearance of the universal outside us*.

The universal thus understood is that which *is* and *remains constant*: the more or less *unconscious* in us, as opposed to the more or less *conscious – the individual*, which is repeated and renewed.

Our whole being is as much the one as the other: *the unconscious and the conscious, the immutable and the mutable, emerging and changing form through their reciprocal action.*

This action contains all the misery and all the happiness of life: misery is caused by *continual separation*, happiness by perpetual rebirth *of the changeable*. The immutable is beyond all misery and all happiness: it is *equilibrium*.

Through the immutable in us, we are united with all things; the mutable destroys our equilibrium, limits us, and separates us from all that is other than us. It is from this equilibrium, from *the unconscious*, from *the immutable* that art comes. It attains its *plastic expression* through *the conscious*. In this way, *the appearance of art* is plastic expression of *the unconscious and of the conscious*. It shows *the relationship* of each to the other: its appearance changes, but *art* remains immutable.

Piet Mondrian, "Neo-Plasticism: The General Principle of Plastic Equivalence" (originally published 1920), pp. 132–47 (extracts) in Harry Holtzman and Martin S. James (eds. and trans.), *The New Art – The New Life: The Collected Writings of Piet Mondrian*. London: Thames and Hudson, 1987. Reprinted by permission of Thames and Hudson Ltd.

In "the totality of our being" the individual or the universal may dominate, or equilibrium between the two may be approached. This latter possibility allows us *to be universal as individuals: to exteriorize the unconscious consciously.* Then we see and hear *universally,* for we have transcended the domination of the most external. The forms of external appearance we see, the noises, sounds, and words we hear, appear to us otherwise than through our universal vision and hearing. What we *really* see or hear is the *direct manifestation of the universal,* whereas what we perceive outside ourselves as form or sound shows itself weakened and veiled. In seeking plastic expression we express our *universal perception* and thus our *universal being as individuals:* therefore, the one and the other *in equivalence.* To transcend the limitations of form and nevertheless to use limited form and descriptive word is not a true manifestation of our being, is not its *pure plastic expression: a new plastic expression is inevitable, an equivalent appearance of these opposites, therefore plastic expression in equilibrated relationship.*

All the arts strive to attain an aesthetic *plastic* of the relationship existing between the individual and the universal, the subjective and the objective, nature and spirit: therefore, all the arts without exception are *plastic.* Despite this, only architecture, sculpture, and painting are considered as plastic arts because we ordinarily experience them through individual consciousness. But for *the unconscious,* musical or verbal expression is no less *plastic* than the other arts. *Pure plastic* expression is manifested through the unconscious, while *plastic expression in limited form* is created by and represents individual consciousness.

Until the present, none of the arts has been purely plastic because individual consciousness dominated: all were more or less *descriptive, indirect, approximative.*

The individual, dominating within us and outside of us, "describes." The universal *in us* also describes but only if it is insufficiently conscious in our (individual) consciousness to manifest itself purely.

Whereas the universal *in us* becomes more and more conscious and the indeterminate grows toward the determinate, *things outside of us* retain their indeterminate form. Hence the necessity, in the measure that the unconscious (the universal in us) approaches consciousness, *to continually transform and to better determine* the capricious and indeterminate appearance of natural phenomena.

Thus the new spirit *destroys limited form* in aesthetic expression and reconstructs *an equivalent appearance of the subjective and the objective, of the content and the containing: an equilibrated duality of the universal and the individual;* and this "duality-in-plurality" creates *purely aesthetic relationship.* [...]

Disequilibrium between individual and universal creates the *tragic* and is expressed as *tragic plastic.* In whatever exists as form or corporeality, the natural dominates: this creates the tragic.

The tragic in life leads to artistic creation: *art,* because it is abstract and in opposition to the natural concrete, can anticipate the gradual disappearance of the tragic. The more the tragic diminishes, the more art gains in purity. [...]

In the vital reality of the abstract, the new man has transcended the feelings of nostalgia, joy, delight, sorrow, horror, etc.; in the *"constant" emotion of beauty,*

these feelings are purified and deepened. He attains a much more profound vision of perceptible reality.

Things are beautiful or ugly only in *time and space*. The new man's vision being liberated from these two factors, all is unified in one *unique beauty*.

Art has always *desired* this vision but, being plastic *form* and following natural appearance, was unable to realize it purely, and it remained tragic plastic while intending to be the contrary. [...]

In *painting*, Neo-Impressionism, Pointillism, Divisionism attempted to abolish the corporeality dominant in the plastic by suppressing *modeling and habitual perspective vision*. But it is only in *Cubism* that we find this built into a system. In Cubism, the tragic plastic lost most of its dominating power through *opposition of pure color and abstraction of natural form*.

Likewise in the other arts, Cubism, like Futurism and later Dadaism, has purified and demolished the dominating tragic in the plastic.

But *Abstract-Real painting or Neo-Plasticism* "freed itself" by being a *really new* plastic. At the same time it transcended the old values and conceptions that require tragic plastic.

It is generally not realized that *disequilibrium* is a malediction for humanity, and one continues to cultivate ardently the feeling of the tragic. Up to the present, the most exterior has dominated in everything. The feminine and the material rule life and society and shackle spiritual expression as a function of the masculine. A Futurist manifesto proclaiming hatred of *woman* (the feminine) is entirely justified. The *woman* in *man* is the direct cause of the domination of the tragic in art. [...]

For let us not forget that we are at a turning point of culture, *at the end of everything ancient: the separation between the two is absolute and definite*. Whether it is recognized or not, one can logically foresee that the future will no longer understand tragic plastic, just like an adult who cannot understand the soul of the child.

At the same time as it suppresses the dominating tragic, the new spirit suppresses *description* in art. Because the obstacle of form has been destroyed, the new art affirms itself as *pure plastic*. The new spirit has found its *plastic expression*. In its maturity, the one and the other are neutralized, and they are coupled into unity. Confusion in the apparent unity of interior and exterior has been resolved into an *equivalent duality forming absolute unity*. The individual and the universal are *in more equilibrated opposition*. Because they are merged in unity, description becomes superfluous: *the one is known through the other*. They are plastically expressed without use of form: *their relationship alone (though direct plastic means) creates the plastic*.

It is in *painting* that the New Plastic achieved complete expression for the first time. This plastic could be formulated because its principle was solidly established, and it continues to perfect itself unceasingly.

Neo-Plasticism has its roots in Cubism. It can equally be called *Abstract-Real painting* because the *abstract* (just like the mathematical sciences but without

attaining the absolute, as they do) can be expressed by plastic reality. In fact, this is the essential characteristic of the New Plastic in painting. It is a composition of rectangular color planes that expresses the most profound reality. It achieves this by *plastic expression of relationships* and not by natural appearance. It realizes what all painting has always sought out could express only in a veiled manner. The colored planes, as much by position and dimension as by the greater value given to color, plastically express only *relationships* and not forms.

The New Plastic brings its relationships into *aesthetic equilibrium* and thereby expresses *the new harmony.* […]

Because sculpture and painting have been able to reduce their primitive plastic means to *universal plastic means*, they can find effective plastic expression *in exactness and in the abstract.* Architecture by its very nature already has at its disposal a plastic means free of the capricious form of natural appearance.

In the New Plastic, painting no longer expresses itself through the *corporeality* of appearance that gives it a naturalistic expression. To the contrary, painting is expressed plastically by *plane within plane.* By reducing three-dimensional cor-poreality to a single plane, *it expresses pure relationship.*

However, the plastic means of architecture as well as sculpture have an advan-tage over painting through their other possibilities.

By its plastic means, *architecture* has an aesthetic and mathematical appearance, which is therefore *exact* and *more or less* abstract. *Being a composition of contrast-ing and self-neutralizing planes, architecture is the exact plastic expression of aesthetic relationship equilibrated in space.* […]

In any case, *the new spirit* must be manifested *in all the arts without exception.* That there are differences between the arts is no reason that one should be valued less than the other; that can lead to *another* appearance but not to an *opposed* appearance. As soon as one art becomes plastic expression of the abstract, the others can no longer remain plastic expressions of the natural. The two do not go together: from this comes their mutual hostility down to the present. The New Plastic abolishes this antagonism: *it creates the unity of all the arts.* […]

In painting, the New Plastic employs exteriorizing color, although plastic expression through duality of position and straight line is the purest. In verbal art equally, the plastic (at least for the present) will still remain close to the exterior. In order to achieve definiteness, verbal art will have provisionally to make use of its present means. It will have to express itself plastically through the *multiplicity* of varied relationships. Just as the New Plastic in painting makes use of its dimensional relationships, in verbal art the New Plastic uses not only this but also *content* as the relationship of opposition. Any given thing will become better understood through its multiple aspects and its different relationships; a mutiplicity of words will be expressed in a more determinate plastic. The new art of the word will itself determine to what extent it can make use of the opposition of contraries. The essential is that *the principle of opposites rules the work as a whole* as much in its composition as in the equilibrated relationship of its plastic means. Each artist will have to seek the best way to achieve this. He will use

and improve the contributions to syntax, typography, etc., already discovered by the Futurists, Cubists, and Dadaists. He will use equally all that life, science, and beauty offer. But above all he will be guided by *pure plastic perception.*

In the music of the past, we see, just as in the plastic of the other arts, a confusion of active and passive, although occasionally there is a more evident structure, more marked opposition (in the fugues of Bach, for example). But for the most part constructive plastic is veiled by *descriptive melody.* As in pictorial or sculptural plastic, most often rhythm was capricious. This was acceptable at a time when individual feeling dominated: this was its appropriate expression. It is now no longer acceptable. In music as elsewhere, the new spirit requires *an equivalent plastic of individual and universal governed by equilibrated proportion.* To achieve this it is necessary *to reduce the individual and assert the universal* in order to attain equivalent, opposing, and neutralizing duality. In sound this duality must be plastically exteriorized just as the New Plastic in the so-called plastic arts is exteriorized by a (mathematically) normal duality of opposition: *active and passive, interior and exterior, masculine and feminine, mind and matter* (which are one in the universal). But in sound that remains noise, in *rounded undulation,* how will it be possible to bring forward the one and to interiorize the other? Music will have to seek it, is already finding it. In the new music, isn't the descriptive, the old melody, already losing its dominating power? Has there not appeared in music "another color," less natural, another rhythm, more abstract? Does not music show the beginning of neutralizing opposition (for example, in some of the "experiments in style" by the Dutch composer Van Domselaer)? [...]

Without deprecating music's effort toward "the new," we must admit that even if there have already been many innovations, *the great renewal* has not yet taken place. This is equally true of painting before Neo-Plasticism. We can never appreciate enough the work and the achievement of the Cubist, Futurist, or Dada movements; but as long as they continue to use morphoplastic, even if refined or stylized, they will never attain the new mentality or completely demolish the old.

It is clear that the Neo-Plasticists want "the new" in *all* the arts and devote all their strength to this. The new is impossible to realize *experimentally* without financial means. If social and material circumstances were favorable, it would not be impossible because all the arts are basically one. But today each art needs all its own strength. The time of the Maecenas is past, and the Neo-Plasticist cannot imitate da Vinci. All he can do (and even that is not permitted him) is to use logic to expound his ideas on the other arts.

As we have said, *the plastic means of music must be interiorized. The musical scale* with its seven tones was based on morphoplastic. Just as the seven colors of the prism unite in natural appearance, so the seven tones in music merge into *apparent unity.* In their natural order, the tones, like the colors, express *natural harmony.*

Modern music has tried to annihilate this by a proportional plastic, but because it dared to touch neither the natural scale or the customary instruments, it continued natural plastic in spite of all.

The old harmony represents *natural harmony*. It is expressed in the harmony of the seven tones but not in the *equivalence of nature and spirit*, which for "the new man" is all that matters. The new harmony is a *double* harmony, a duality of spiritual and natural harmony. It is manifested as inward harmony and outward harmony: both *in interiorized outwardness*. For only *the most* outward can be plastically expressed by natural harmony; *the most* inward cannot be plastically expressed. The new harmony therefore can never be as in nature: it is the *harmony of art*.

This *harmony of art* is so totally different from natural harmony that (in the new plastic) we prefer to use the term *equivalent relationship* rather than "harmony." However, the word "equivalent" must not be taken to mean symmetrical. Equivalent relationship is plastically expressed by *contraries*, by *neutralizing oppositions*, which are not harmonious in the old sense.

The three fundamental colors, red, yellow, and blue, remain prismatic colors in spite of the distance that separates them in the spectrum, and despite Neo-Plasticism, which does not express them as they appear in the spectrum. If we express these colors according to their scientific or natural laws, we only express natural harmony in another way. Because the New Plastic wants to abolish the natural, it is logical that it places the three colors in painting, and the corresponding tones in music, in quite *different relationships of dimension, strength, color, or tonality* while still preserving aesthetic equilibrium. Can it be objected that the New Plastic is not harmonious (in the old sense of the word), that it does not express unity – precisely when *in reality it expresses unity to greater perfection?* Does it not suppress the apparent unity of the natural?

This "disharmony" (according to the old conception) will be fought and attacked everywhere in the new art so long as the new harmony is not understood. In our time, which is everywhere characterized by the striving for unity, it is most important to distinguish *real unity* from *apparent unity, universal* from *individual*. Thus we distinguish *aesthetic harmony* from *natural harmony*. As human beings we tend to conceive of unity as an *individual vision*, as an *individual idea*. Our "conscious self" seeks unity but in the wrong way. Our "unconscious self," being itself "unity," brings it naturally toward clarity, at first veiled, then clearly (when the unconscious becomes conscious, as seen above). Thus we see apparent unities (therefore natural harmonies) successively destroyed until the moment when *true unity, real harmony* is revealed.

Individual consciousness employs only naturalistic expression, even when it wants to proceed logically, even when it "reasons." But the unconscious in us warns us that in art we have to follow a special path. And if we follow it, it is not the sign of an unconscious act. To the contrary, it shows that in our ordinary consciousness there is a greater awareness of the unconscious: the unconscious pushes aside individual consciousness with all its knowledge. In art we cannot ignore the human being himself; it is his *relationship* to "what is," – not "what is" alone – that creates art.

We have a tendency to apply the old conception to art, that is, the natural conception of harmony. And it is this conception that makes us cling to the

natural sequence and relationship of the seven colors of the spectrum and the seven corresponding tones. But the art of the past already showed the way by having broken the natural sequence of colors and tones. Music too, within its old conception, is also seeking another harmony is several ways (but without achieving clarity).

If, as in Gregorian music, one tried to deepen the dominating natural by simplification and purification, one would only achieve another form of sentimental expression. Modern music has tried to free itself from the old form but instead of constructing a new appearance it simply "ignores" the old. This is the result of a structure that always preserves the old foundations. Any art movement goes astray that does not clearly represent *the new spirit.* [. . .]

In *theater and opera* the arts combine into *dramatic art.* In *gesture and mime*, since plastic exteriorization of the individual always remains dominant, the primitive conception of theater will more gradually disappear in the new art. No matter how gestures and mime are deepened, the fact remains that their motion describes "form" and does not purely and plastically express *individual-and-universal-in-equilibrated-relationship. Dramatic art*, as plastic expression of an action or a state of mind dependent upon the human figure, creates a reality within which *plastic expression of abstract reality* becomes impossible.

For the new man, theater is superfluous if not an embarrassment. As it approaches its culmination, the new spirit will interiorize gesture and mimicry: it *will realize* in daily life what theater *showed* and *described* through the outward.

However, until this point is reached, theater will retain its reason for being: it answers a need by continuing the tragic, although the latter has lost its dominating power. But in its new appearance it must be *transformed.*

The Futurists strongly felt and expressed this in their manifesto. A logical transformation is nevertheless impossible as long as the arts that collaborate in theater have not evolved into *New Plastic.*

For many of its spectators, the theater still has its reason for being as a union of all the arts that, by acting simultaneously, gives theater the power to move us more strongly and more directly than each art alone. It can arouse emotion *through beauty and through plastic exteriorization of the tragic.* That is what characterizes the theater and opera *of the past and of the present.* In fact, if we also take scenery into account, theater is a threefold, opera a fourfold plastic expression of the tragic.

The New Plastic no longer wants tragic plastic but the *plastic expression of beauty* – of beauty as truth. It wants to exteriorize *abstract beauty.* It could create an environment of abstract beauty through the *new chromoplastic in architecture*, which would replace the old scenery. The new music would do the same for opera.

The new art of the word could precede the "beautiful-as-truth" through the contraries of the verbal plastic. Words could even be "spoken" without any appearance of the human figure.

In this way the theater could become a great instigator of "the new" by presenting performances in the "New Plastic." But it will be a long time before

this comes about, because of the great material difficulties involved: since everything will have a different appearance, this will involve tremendous preparation.

The theater will therefore have to wait until the other arts are transformed: then it will follow quite naturally.

The equilibrated relationship of which the old theater was the *negative* plastic exteriorization appears in the new. The striving toward harmony does appear in the old tragedy but it plastically *expresses itself* through disharmony or fictitious harmony.

In the new art, *dance* (ballet, etc.) follows the same path as gesture and mime. It passes from art into life. Dance as a spectacle will be relinquished, for everyone will realize *rhythm* through himself. In the new dances outside of art, the tango, fox trot, etc., we can already see something of the new idea of *equilibrium through opposition of contraries.* Thus it becomes possible to experience equilibrated reality physically.

The decorative arts disappear in Neo-Plasticism, just as *the applied arts* – furniture, pottery, etc. – arise out of simultaneous action of new architecture, sculpture, and painting, and are automatically governed by the laws of the new plastic.

Thus, through the new spirit, man himself creates a new beauty, whereas in the past he only painted and described the beauty of nature. This new beauty has become indispensable to the new man, for in it he expresses *his own image in equivalent opposition with nature.* THE NEW ART IS BORN.

Part III
Mass Culture and Modernity

Introduction

The previous section showed how artists and theorists under varying historical conditions articulated a range of challenges to the positivism and rationalism of modernity. With emphasis on a slightly later period, the 1920s and 1930s, this section now focuses on differently inflected concerns around what Andreas Huyssen, in the last essay in this section, calls "the vital dialectic between the avant-garde and mass culture in industrial civilization." It brings together critical diagnoses of the culture of capitalist modernity, highlighting in particular its industrializing, technologizing, and rationalizing features. In the essays here you will notice a general shift or a widening of focus from essentialist concepts to surface, material properties and relations. The rise of technology occasions concerns, both positive and negative, with the fate of autonomous art in the face of "mass culture's" superficial, distracting, novel, and homogenizing forms. While Greenberg's is the only text to deal at length specifically with a traditional art discipline (painting), all raise the important implications of mass culture, especially photography, for the state and status of the art work. Most of these essays relate to the critical theory of the Frankfurt School,[1] a major concern of which was the critique of contemporary mass culture, or what Theodor Adorno and Max Horkheimer more precisely termed the "culture industry."[2] The focus is on the interwar period and the effects of rapid change in mass media, technology, industrialized production, and leisure, as photography, the press, radio, the gramophone, and film all commercialized and popularized the ways in which culture was produced and consumed.

Progress, democracy, capitalism, and humanism are among the major ideological foundations of modernity. Its cultural sphere is the city. Baudelaire's

famous description of the "transitory, the fugitive, the contingent" of modern life evokes the sense of flux that is a key feature of modernity. The sociologist Max Weber's insistence on capitalism's *rationalization* as the defining feature of the modern West was important for developing theories of modernity, and indeed it resurfaces in the "*Ratio*" at the core of Kracauer's argument in the first essay here. Another sociologist, Georg Simmel, from Berlin, in one of his best-known essays, "The Metropolis and Mental Life" (1903), gave an account of the modern metropolitan sensibility, which, ceaselessly stimulated, becomes ennervated and blasé: "A life in boundless pursuit of pleasure makes one blasé because it agitates the nerves to their strongest reactivity for such a long time that they finally cease to react at all."[3] Simmel also described what he called the "hypertrophy of objective culture,"[4] and commentators on the Right and the Left noted an increasing homogeneity and leveling of difference in culture; what Stefan Zweig called "the monotonization of the world."[5]

Siegfried Kracauer's (1889–1966) essay "The Mass Ornament" was originally published in Weimar Germany in 1927 in the prestigious bourgeois liberal newspaper the *Frankfurter Zeitung*, to which, between 1921 and 1933, Kracauer was a regular contributor and then *feuilleton* editor. He had trained as an architect before abandoning his practice for writing. Although perhaps best known for studies of film history,[6] his Weimar essays probe literature, theory, and the abundant surface phenomena of modern life as his attention sweeps from the detective novel to translations of the Bible, cinemas, boredom, murder trials, and beyond. In this text, his methodology is mapped in the first paragraph. Kracauer focuses his attention on the apparently superficial, the "inconspicuous surface level expressions" of society, in order to reveal more fundamental processes and relations. Thus, in this case, the "mass ornament," exemplified by the synchronized bodies of the high-kicking Tiller Girls, is "the aesthetic reflex of the rationality to which the prevailing economic system aspires." Like the rationalized capitalist production process itself, it is alienated, "an end in itself."

The critical reconstruction of reality from its superficial, ephemeral forms is an important means for diagnoses of the conditions of modernity. It is there not only in Kracauer's essays but also in the work of his contemporaries Adorno, Benjamin, and Ernst Bloch, who were all friends of his and also wrote for the *Frankfurter Zeitung*. What is particularly interesting in relation to avant-garde art practice is the parallel between this critical method and the technique of montage, especially the Dadaist photomontage produced in Berlin at the end of World War I.[7] Extracting and critically reconfiguring fragments from the metropolitan media and everyday ephemera, the Dadaists sought, as Hanne Bergius has put it, "to use the montage to reactivate the perceptive process in reception blocked by sensation."[8] As such, Dadaist montage attempted to sharpen critical perception, both to reveal and redeem the numbing of consciousness that Kracauer specifically identified as an effect of the mass media. In fact, you will notice that all the other writers in this section, with the significant exception of Clement Greenberg (who was dismissive of Dada and Surrealism), focus on Dadaist photomontage in the

course of their discussions of the dialectic between the avant-garde and mass culture. Kracauer wrote in his "Photography" essay of 1927:

> the flood of photos sweeps away the dams of memory. The assault of this mass of images is so powerful that it threatens to destroy the potentially existing awareness of crucial traits.... In the illustrated magazines, people *see* the very world that the illustrated magazines prevent them from *perceiving*. [my emphasis]... The *contiguity* of these images systematically excludes their contextual framework available to consciousness. The "image-idea" drives away the idea. The blizzard of photographs betrays an indifference toward what the things mean.[9]

Kracauer was critical of shallow reportage and aware that "A hundred reports from a factory do not add up to the reality of that factory."[10] Instead, as David Frisby puts it, the themes in "The Mass Ornament" can be seen in the context of "an increasing preoccupation with the means for distracting large sections of society from their real circumstances."[11] Within a few years, the mass ornament had become central to aestheticized politics and the mass culture (both its production *and* its consumption) of National Socialism in 1930s Germany.[12]

Walter Benjamin (1892–1940) was a highly original and eclectic thinker whose criticism reflected kaleidoscopic interests and encounters with the Jewish mystical tradition of cabbala, baroque tragic drama, Marxism, Surrealism, Paris – "capital of the nineteenth century" – and friends such as Adorno and Bloch, as well as the dramatist Bertolt Brecht.[13] In 1935, in exile from Nazi Germany, Benjamin wrote his investigation into the impact of modern, technical methods of image reproduction (photography and film) on the status and reception of works of art. Here, Benjamin shares concerns with Brecht, and the result of his reflections, "The Work of Art in the Age of Mechanical Reproduction," showed Benjamin at his most Marxist.[14] A salient and influential analysis of the altered status of art in modernity, it has now also become his most famous essay. There is a sense of urgency here; detecting no less than a change in *perception* under the conditions of modernity, Benjamin's conclusions were directed at the possible future for a new, politically conscious mass art. Five years later, in 1940, Benjamin committed suicide at the Franco-Spanish border, believing he was about to be handed over to the Gestapo.

The central concept for Benjamin's account of art's changing social functions from prehistory to advanced capitalism is that of the "aura" and its destruction. Benjamin had given a working definition in his 1931 essay "A Small History of Photography," which resurfaces in the "Work of Art": "What is aura actually? A strange weave of space and time: the unique appearance or semblance of distance no matter how close the object may be."[15] Uniqueness, originality, authenticity, and "distance" – in the sense of a special remoteness, autonomy, and separation from everyday life – are traditional, historical qualities of the art work. They correspond to other traditional notions of art such as "genius," "beauty," and "creativity," and for Benjamin they have their roots in the ritual

or cultic functions of art in earlier periods. As Huyssen notes in the final essay in this section, "aura" is that which is destroyed (twice, as if for good measure!) by Marcel Duchamp's defacement (1) of a reproduction (2) of the Mona Lisa, *L.H.O.O.Q.*, in 1919. More generally for Benjamin, these constituents of the "aura" of the work of art are destroyed by the new technical means for reproduction; especially photography and film. Autonomous art gives way to mass culture. The decay of aura does not occur in isolation, but is symptomatic of wider changes in culture. Like Kracauer, Benjamin too is essentially concerned with the massive impact of rationalization on culture.

The crucial shift, for Benjamin, is in the masses' perception. Citing (in a passage not reproduced here) the "expert" cycling enthusiast and the "absent-minded" examiner of the film, Benjamin pins his hopes on a newly politicized function for art in the age of technical reproduction. It is important to remember that he was writing from exile, in the face of the totalization of fascism in Germany and the aestheticization of politics he had already diagnosed as inherent to its rise.[16] Adapting some of Brecht's theories of "epic theater" for the medium of film (such as the positive function of montage and the idea that the distracted, alienated subject is potentially a more active and critical one),[17] he now envisaged art as departing from ritual and arriving – divested of aura – at politics.

Benjamin's essay has been widely discussed and its insights have proved significant for theories of art, modernity, mass culture, and postmodernity. However, it has also been criticized: not least for its technological determinism and tendency to ignore the social and economic determinants of reproduction. One of the earliest critiques came from Adorno in the context of a long-running exchange between the two thinkers.[18] Adorno accused Benjamin of not working dialectically *enough*; for example, he objected to Benjamin's categorical attribution to autonomous art of a "counter-revolutionary function."[19] He was condescending about the Brechtian motifs in the essay; "I feel ... it is my task to hold your arm steady until the sun of Brecht has once more sunk into exotic waters."[20] With some justification, he showed that Benjamin had singled out easy targets – Rilke and *fauve* painters[21] as courtiers of contemplation – and so challenged the efficacy of Benjamin's theory in the face of, for example, Franz Kafka or Arnold Schoenberg. But his most biting accusation was that Benjamin had succumbed to "the anarchistic romanticism of blind confidence in the spontaneous power of the proletariat in the historical process – a proletariat which is itself a product of bourgeois society."[22]

The third essay in this section is by the American art critic Clement Greenberg (1909–94). After World War II, Greenberg became the most influential spokesman for a specialized view of "Modernism" as the modern tradition in high art, its purity assured by its distinctness from classical, academic, and conservative art, but also – as the text here already makes clear – from forms of popular and mass culture.[23] Embracing Kant as "the first real modernist," Greenberg saw the essence of Modernism as self-critique or, as he put it in 1965, "the use of the characteristic methods of the discipline to criticize the discipline itself."[24] His

approach is in this and other ways close to that of Roger Fry (see Part I). Greenberg became not only "the grand guru of Abstract Expressionism"[25] in postwar America, but also a promoter of "Color Field" painting and opponent of Minimalism in the 1960s and 1970s. His eloquence and perception were evident from his earliest writings. However, the kind of autonomy from the vulgarities, impurities, and uncertainties of modern life that Greenberg and others defended for modernism has been described as "the freedom of a beautifully formed, perfectly sealed tomb."[26] His criticism has divided sympathies and had a resounding impact – both positive and negative – on art practice and on the art-historical discipline, not least because his formalist criticism provided a useful catalyst and antithesis for artists (ranging from conceptual artists to painters "returning" to figuration) and debates among social historians of art in the 1960s, 1970s, and 1980s.[27]

Included here is Greenberg's first important essay, "Avant-Garde and Kitsch," originally published in 1939 in the New-York based Trotskyite literary journal *Partisan Review* (see also Part IV).[28] It is wider-ranging in its scope than the formalist critiques of art for which Greenberg was best known in the 1960s and 1970s, in that it deals broadly with the fate of "culture," not just painting, since the mid-nineteenth century. In setting up the programmatic distinction between the art of what he called the "avant-garde" and the products of what he defined as "kitsch," Greenberg gave not only his understanding of what the avant-garde was, but also, emphatically, of what it was *not*. It should be noted of course that the designation "avant-garde" is itself contentious; Huyssen's essay as well as those in the following section make this clear.

Grimly diagnosing a terminal crisis in bourgeois culture manifest in social decay and the monumental stagnation of culture – "Alexandrianism" – Greenberg charges the (already intimidated) avant-garde with the task of defending "true culture." To do this, the avant-garde must remain true to itself, in the sense of its self-specialization, and it must be in constant process; it must "keep culture *moving*" (Greenberg's emphasis). The insidious, "virulent" oppressor is *Kitsch*; "ersatz culture," product of the industrial West, the "gigantic apparition" that for Greenberg encompasses "popular and commercial art and literature with their chromeotypes, magazine covers, illustrations, ads, slick and pulp fiction, comics, Tin Pan Alley music, tap dancing, Hollywood movies, etc., etc." What Greenberg describes here is no less than mass culture, wholesale, sharing space under the umbrella *Kitsch* with the official art of totalitarianism in 1930s Russia, Germany, and Italy. Rather than avant-garde "process," *Kitsch* trades on "effects." In painting, the difference boils down to that between Picasso and the Russian Realist painter Ilya Repin. Significantly, two different *viewers* are implicated. For the viewer of the Picasso, effort and sensitivity are demanded and enjoyment comes on reflection. For the viewer of the Repin, the spectator can look forward to "unreflective," immediate, effortless – and hence dubious – enjoyment. The example affirms the staple oppositions of "high/low," "good/bad," and "original/conventional" that recur in modernist discourse.

It is useful to situate "Avant-Garde and Kitsch" in terms of Greenberg's immediate political milieu as well as the mass movements of Stalinist communism and Hitler's fascism. It was written on the eve of World War II. Several writers have shown how the essay was part of the political shifts of the *Partisan Review*, the doubts about the integrity of Soviet communism, the influence of the exiled Leon Trotsky, and more broadly, what has been called the "de-Marxification of the American intelligentsia" that had begun around 1936.[29] Serge Guilbaut has argued:

> "Avant Garde and Kitsch" formalized, defined and rationalized an intellectual position that was adopted by many artists who failed fully to understand it. Extremely disappointing as it was to anyone seeking a revolutionary solution to the crisis, the article gave renewed hope to artists. By using kitsch as a target, as a symbol of the totalitarian authority to which it was allied and by which it was exploited, Greenberg made it possible for the artist to act. By opposing mass culture on an artistic level, the artist was able to have the illusion of battling the degraded structures of power with elitist weapons. Greenberg's position was rooted in Trotskyism, but it resulted in a total withdrawal from the political strategies adopted during the Depression: he appealed to socialism to rescue a dying culture by continuing tradition.[30]

The paradox of Greenberg's formula for the avant-garde's relations with bourgeois tradition has also been noted by T. J. Clark, discussing this essay and its equally important complement, "Towards a Newer Laocöon" (1940). As Clark put it: "It seems that modernism is being proposed as bourgeois art in the absence of a bourgeoisie or, more accurately, as aristocratic art in the age when the bourgeoisie abandons its claims to aristocracy."[31]

The last two essays in this section are more recent. It is useful to read these in conjunction with the texts by Benjamin and Greenberg because Andreas Huyssen and Victor Burgin, respectively, engage directly with them, as well as with other writers relevant to the themes of this section such as Brecht and Adorno. Burgin's "Modernism in the *Work* of Art" grapples polemically with Greenberg's essay and the nascent ideology of "pure" modernism it defends. Burgin was writing in 1976 with some years of interdisciplinary and transatlantic critical activity behind him. Focusing on organizations and groups (the WPA in 1930s America and *Lef* in 1920s Russia), media (especially photography), and critical methods (1920s Russian Formalism and 1960s Structuralism) that repudiate pristine concepts of autonomous "high" culture, Burgin problematizes Greenberg's – and modernism's – critical premises and demonstratively opens up the discursive field of both criticism and practice.

This section closes with an essay that argues for the conjunction of art and politics to redeem "the tendency to project the post-1945 depoliticization of culture back onto the earlier avant-garde movements" and "recover a sense of the cultural politics of the historical avant-garde." As such, Huyssen's "The Hidden Dialectic: Avant-Garde–Technology–Mass Culture," first published in 1980,

makes a useful overview and critical assessment of the varied attempts of nine-teenth-century writers such as Henri de Saint Simon; Benjamin, Brecht, and Adorno of the interwar period; and Peter Bürger in the late 1960s – broadly – to envisage a working relationship between culture and politics. Indeed, the particular "hidden dialectic" that Huyssen sets out to "uncover" is salient to all such attempts and is well encapsulated in Huyssen's statement, mid-way through his discussion, that "by incorporating technology into art, the avantgarde liberated technology from its instrumental aspects and thus undermined both bourgeois notions of technology as progress and art as 'natural,' 'autonomous,' and 'organic'."

The texts in this section, which all in one way or another concern the prospects for autonomous art in the face of mass culture, can be usefully read together with those in the following section (including an extract from Bürger's *Theory of the Avant-Garde*), where the focus is the contested concept of the avant-garde, the politicized question of art's autonomy, and the often fraught relations of the avant-garde with resistance and mass politics in Europe.

Notes

1 The group around the *Institut für Sozialforschung* (Institute for Social Research) at Frankfurt am Main, whose key members included Max Horkheimer, Theodor Adorno, Walter Benjamin, and Herbert Marcuse.
2 One of the most polemical and ultimately pessimistic of such studies was Theodor Adorno and Max Horkheimer's *Dialectic of Enlightenment*, written in exile from Nazi Germany and first published in 1947. In the course of their work, Adorno and Horkheimer first used the term "mass culture," later replacing it with "culture industry," "in order to exclude from the outset the interpretation agreeable to its advocates: that it is a matter of something like a culture that arises spontaneously from the masses themselves, the contemporary form of popular art." Theodor W. Adorno, "Culture Industry Reconsidered," in Adorno, *The Culture Industry: Selected Essays on Mass Culture*, ed. J. M. Bernstein (London: Routledge, 1991), pp. 98–106, p. 98.
3 Georg Simmel, "The Metropolis and Mental Life" (1902–3), in *Art in Theory 1900–1990: An Anthology of Changing Ideas*, eds. Charles Harrison and Paul Wood (Oxford: Blackwell Publishers, 1992), pp. 130–5, p. 132.
4 Ibid., p. 135.
5 Stefan Zweig, "The Monotonization of the World" (1925), in *The Weimar Republic Sourcebook*, eds. Anton Kaes, Martin Jay, and Edward Dimendberg (Berkeley: University of California Press, 1995), pp. 397–400.
6 Kracauer's 1947 study of German cinema was a pioneering work that argued that Expressionist film in the Weimar period showed psychological types and tendencies that prefigured the rise of Hitler and totalitarianism. Siegfried Kracauer, *From Caligari to Hitler: A Psychological History of the German Film* (Princeton: Princeton University Press, 1974).
7 The term "photomontage" has meant different things in different contexts; used to refer to the work of, for example, Hannah Höch, Raoul Hausmann, George Grosz,

and John Heartfield in Dada, it can refer to images constructed entirely from photographic material but can also encompass montaged compositions with text fragments, paint, drawing, and other materials, such as stamps and banknotes (such as are found in Raoul Hausmann's *The Art Critic* [1920], Tate Collection, London). For a good analysis of photomontage's political-critical functions in Berlin Dada see Brigid Doherty, "Figures of the Pseudorevolution," *October* 84 (Spring 1998), pp. 65–89. For wider accounts of photomontage's history and application see Dawn Ades, *Photomontage* (London: Thames and Hudson, 1976); Estera Milman, "Photomontage, the Event, and Historism," in *"Event" Arts and Art Events*, ed. Stephen C. Foster (Ann Arbor: UMI Research Press, 1988), pp. 203–38; the exhibition "Collage-Montage" held at the Hamburger Bahnhof, Berlin, in the triple catalogue *Das XX. Jahrhundert. Ein Jahrhundert Kunst in Deutschland*, Staatliche Museen zu Berlin (Berlin: Nicolai, 1999); and Peter Bürger, *Theory of the Avant-Garde* (see Part IV below). By the early 1930s, John Heartfield's anti-Nazi photomontages had convinced many on the organized Left of the technique's potential as "a truly revolutionary weapon in the class struggle." Alfred Kemény, "Photomontage as a Weapon in Class Struggle" (1932), in *Weimar Republic Sourcebook*, eds. Kaes, Jay, and Dimendberg, pp. 653–4.

8 Hanne Bergius, "Dada, the Montage and the Press: Catchphrase and Cliché as Basic Twentieth-Century Principles," in *Dada: The Co-ordinates of Cultural Politics* (Crisis and the Arts: The History of Dada, vol. I), ed. Stephen C. Foster (New York: G. K. Hall, 1996), pp. 107–34, p. 114. See also Hanne Bergius, "The Ambiguous Aesthetic of Dada: Towards a Definition of its Categories," *Journal of European Studies*, 9 (1979), pp. 26–38.

9 Siegfried Kracauer, "Photography" (1927), in Siegfried Kracauer, *The Mass Ornament: Weimar Essays*, trans., ed., and intro. Thomas Y. Levin (Cambridge MA: Harvard University Press, 1995), pp. 47–63, p. 58.

10 Siegfried Kracauer, *Die Angestellten* (The Employees), quoted in Detlev J. K. Peukert, *The Weimar Republic: The Crisis of Classical Modernity* (London: Allen Lane, 1991), p. 169.

11 David Frisby, *Fragments of Modernity: Theories of Modernity in the Work of Simmel, Kracauer and Benjamin* (Cambridge: Polity Press, 1985), p. 147.

12 In exile in 1942, Kracauer wrote a pamphlet, "Propaganda and the Nazi War Film." On Leni Riefenstahl's film of the 1934 rally at Nuremberg, *Triumph of the Will*, he observed that the rally's mass ornaments must have appeared to the spectators – specifically Hitler and his staff – as "configurations symbolizing the readiness of the masses to be shaped and used at will by their leaders." Kracauer, *Caligari to Hitler*, pp. 273–331, p. 302. See also essays and photographs (for example those of mass dances on the Zeppelinfeld during rallies at the Party grounds at Nuremberg), in Bernd Ogan and Wolfgang W. Weiß, *Faszination und Gewalt. Zur politischen Ästhetik des Nationalsozialismus* (Nürnberg: W. Tümmels, 1992); and more generally, *The Nazification of Art: Art, Design, Music, Architecture and Film in the Third Reich*, eds. Brandon Taylor and Wilfred van der Will (Winchester: The Winchester Press, 1990).

13 See *Aesthetics and Politics*, Afterword by Fredric Jameson (London: Verso, 1977). Of the art historians of the late nineteenth century, Benjamin was dismissive of Heinrich

Wölfflin, whose lectures he had attended, but greatly admired Alois Riegl for his attention to "materiality" and to what is "inconspicuous" and beyond the canon. See Howard Caygill, *Walter Benjamin: The Colour of Experience* (London: Routledge, 1998), p. 90.

14 A more literal translation of the title would be "The Artwork in the Age of its Technical Reproducibility." The essay was first published in the journal of the Institute for Social Research in 1936, having been modified by the institute and made less explicitly political in its terminology. The version here is the well-known English translation of Benjamin's final version, written 1936–9.

15 Walter Benjamin, "Small History of Photography," in Benjamin, *One-Way Street and Other Writings*, trans. Edmund Jephcott and Kinsley Shorter (London: NLB, 1979), pp. 240–57, p. 250.

16 Walter Benjamin, "Theories of German Fascism" (1930), in *The Weimar Republic Sourcebook*, eds. Kaes, Jay, and Dimendberg, pp. 159–64.

17 See *Brecht on Theatre: The Development of an Aesthetic*, ed. and trans. John Willett (London: Methuen, 1964). For Benjamin's own work on Brecht, including the important essay "The Author as Producer," which contains some of the ideas subsequently developed in the essay here, see Walter Benjamin, *Understanding Brecht*, trans. Anna Bostock, intro. Stanley Mitchell (London: Verso, 1998).

18 See "Presentation III," in *Aesthetics and Politics*, Afterword by Jameson. For a wider account of the dispute, "one of the most significant aesthetic controversies of our century," see Richard Wolin, *Walter Benjamin: An Aesthetic of Redemption* (Berkeley: University of California Press, 1994), pp. 163–212. A good recent article dealing from different perspectives with other "blind spots" in the essay is Frederic J. Schwartz, "The Eye of the Expert: Walter Benjamin and the Avant Garde," *Art History* 24, no. 3 (June 2001), pp. 401–44.

19 Letter from Adorno to Benjamin, London, March 18, 1936, in *Aesthetics and Politics*, Afterword by Jameson, pp. 120–6, p. 121.

20 Ibid., p. 126.

21 In the version of the essay here, Benjamin cites the painter André Derain; in the version read by Adorno he cited another *fauve*, Maurice Vlaminck.

22 Letter from Adorno to Benjamin, London, March 18, 1936, in *Aesthetics and Politics*, Afterword by Jameson, pp. 120–6, p. 123. On Adorno and the commodification of art and aestheticization of commodity, see Andreas Huyssen, "Adorno in Reverse: From Hollywood to Wagner," in Huyssen, *After the Great Divide: Modernism, Mass Culture, Postmodernism* (Bloomington: Indiana University Press, 1986), pp. 16–43.

23 Charles Harrison, "Modernism," in *Critical Terms for Art History*, eds. Robert S. Nelson and Richard Shiff (Chicago: University of Chicago Press, 1996), pp. 142–55, pp. 144–5.

24 Clement Greenberg, "Modernist Painting," in *Modern Art and Modernism: A Critical Anthology*, eds. Francis Frascina and Charles Harrison (London: Harper and Row, 1982), pp. 5–10, p. 5.

25 David and Cecile Shapiro, "Abstract Expressionism: The Politics of Apolitical Painting," in *Pollock and After: The Critical Debate*, ed. Francis Frascina (London: Harper and Row, 1985), pp. 135–51, p. 138.

26 Marshall Berman, *All That Is Solid Melts Into Air: The Experience of Modernity* (London: Verso, 1983), p. 30. Leo Steinberg takes formalist critics, specifically Greenberg and Fry, to task for what he sees as their interdictory limitation of the range of reference for the viewer of a piece of art. He sees the origins of their criticism in nineteenth-century attempts "to discipline art criticism in the manner of scientific experiment, through the isolation of a single variable [formal organization]." Thus for Steinberg: "In the formalist ethic, the ideal critic remains unmoved by the artists' expressive intention, uninfluenced by his culture, deaf to his irony or iconography, and so proceeds undistracted, programmed like an Orpheus making his way out of Hell." Leo Steinberg, *Other Criteria: Confrontations with Twentieth-Century Art* (London: Oxford University Press, 1972), p. 66.

27 See e.g. the collected essays in *Pollock and After*, ed. Frascina.

28 See Fred Orton and Griselda Pollock, "Avant-Gardes and Partisans Reviewed," in Orton and Pollock, *Avant-Gardes and Partisans Reviewed* (Manchester: Manchester University Press, 1996), pp. 141–64, p. 152. Greenberg chose this essay to open the collection of his writings *Art and Culture* (1961).

29 Serge Guilbaut, "The New Adventures of the Avant-Garde in America: Greenberg, Pollock, or from Trótskyism to the New Liberalism of the 'Vital Center'," in *Pollock and After*, ed. Frascina, pp. 153–66, p. 156. See also Orton and Pollock, "Avant-Gardes and Partisans" (the essay is also included, abridged, in *Pollock and After*).

30 Guilbaut, "New Adventures," p. 156.

31 T. J. Clark, "Clement Greenberg's Theory of Art," in *Pollock and After*, ed. Frascina, pp. 47–63, p. 54.

16

The Mass Ornament

Siegfried Kracauer

> *The lines of life are various; they diverge and cease*
> *Like footpaths and the mountains' utmost ends.*
> *What we are here, elsewhere a God amends*
> *With harmonies, eternal recompense, and peace.*
> – Hölderlin, "To Zimmer"

1

The position that an epoch occupies in the historical process can be determined more strikingly from an analysis of its inconspicuous surface-level expressions than from that epoch's judgments about itself. Since these judgments are expressions of the tendencies of a particular era, they do not offer conclusive testimony about its overall constitution. The surface-level expressions, however, by virtue of their unconscious nature, provide unmediated access to the fundamental substance of the state of things. Conversely, knowledge of this state of things depends on the interpretation of these surface-level expressions. The fundamental substance of an epoch and its unheeded impulses illuminate each other reciprocally.

2

In the domain of body culture, which also covers the illustrated newspapers, tastes have been quietly changing. The process began with the Tiller Girls. These

Siegfried Kracauer, "The Mass Ornament" (originally published 1927), pp. 75–86 in Thomas Y. Levin (ed. and trans.), *The Mass Ornament: Weimar Essays*. Cambridge, MA: Harvard University Press, 1995. Reprinted by permission.

products of American distraction factories are no longer individual girls, but indissoluble girl clusters whose movements are demonstrations of mathematics. As they condense into figures in the revues, performances of the same geometric precision are taking place in what is always the same packed stadium, be it in Australia or India, not to mention America. The tiniest village, which they have not yet reached, learns about them through the weekly newsreels. One need only glance at the screen to learn that the ornaments are composed of thousands of bodies, sexless bodies in bathing suits. The regularity of their patterns is cheered by the masses, themselves arranged by the stands in tier upon ordered tier.

These extravagant spectacles, which are staged by many sorts of people and not just girls and stadium crowds, have long since become an established form. They have gained *international* stature and are the focus of aesthetic interest.

The bearer of the ornaments is the *mass* and not the people *[Volk]*, for whenever the people form figures, the latter do not hover in midair but arise out of a community. A current of organic life surges from these communal groups – which share a common destiny – to their ornaments, endowing these ornaments with a magic force and burdening them with meaning to such an extent that they cannot be reduced to a pure assemblage of lines. Those who have withdrawn from the community and consider themselves to be unique personalities with their own individual souls also fail when it comes to forming these new patterns. Were they to take part in such a performance, the ornament would not transcend them. It would be a colorful composition that could not be worked out to its logical conclusion, since its points – like the prongs of a rake – would be implanted in the soul's intermediate strata, of which a residue would survive. The patterns seen in the stadiums and cabarets betray no such origins. They are composed of elements that are mere building blocks and nothing more. The construction of the edifice depends on the size of the stones and their number. It is the mass that is employed here. Only as parts of a mass, not as individuals who believe themselves to be formed from within, do people become fractions of a figure.

The ornament is an *end in itself*. Ballet likewise used to yield ornaments, which arose in kaleidoscopic fashion. But even after discarding their ritual meaning, these remained the plastic expression of erotic life, an erotic life that both gave rise to them and determined their traits. The mass movements of the girls, by contrast, take place in a vacuum; they are a linear system that no longer has any erotic meaning but at best points to the locus of the erotic. Moreover, the meaning of the living star formations in the stadiums is not that of military exercises. No matter how regular the latter may turn out to be, that regularity was considered a means to an end; the parade march arose out of patriotic feelings and in turn aroused them in soldiers and subjects. The star formations, however, have no meaning beyond themselves, and the masses above whom they rise are not a moral unit like a company of soldiers. One cannot even describe the figures as the decorative frills of gymnastic discipline. Rather, the girl-units drill in order to produce an immense number of parallel lines, the goal being to train the broadest mass of people in order to create a pattern of undreamed-of dimensions.

The end result is the ornament, whose closure is brought about by emptying all the substantial constructs of their contents.

Although the masses give rise to the ornament, they are not involved in thinking it through. As linear as it may be, there is no line that extends from the small sections of the mass to the entire figure. The ornament resembles *aerial photographs* of landscapes and cities in that it does not emerge out of the interior of the given conditions, but rather appears above them. Actors likewise never grasp the stage setting in its totality, yet they consciously take part in its construction; and even in the case of ballet dancers, the figure is still subject to the influence of its performers. The more the coherence of the figure is relinquished in favor of mere linearity, the more distant it becomes from the immanent consciousness of those constituting it. Yet this does not lead to its being scrutinized by a more incisive gaze. In fact, nobody would notice the figure at all if the crowd of spectators, who have an aesthetic relation to the ornament and do not represent anyone, were not sitting in front of it.

The ornament, detached from its bearers, must be understood *rationally*. It consists of lines and circles like those found in textbooks on Euclidean geometry, and also incorporates the elementary components of physics, such as waves and spirals. Both the proliferations of organic forms and the emanations of spiritual life remain excluded. The Tiller Girls can no longer be reassembled into human beings after the fact. Their mass gymnastics are never performed by the fully preserved bodies, whose contortions defy rational understanding. Arms, thighs, and other segments are the smallest component parts of the composition.

The structure of the mass ornament reflects that of the entire contemporary situation. Since the principle of the *capitalist production process* does not arise purely out of nature, it must destroy the natural organisms that it regards either as means or as resistance. Community and personality perish when what is demanded is calculability; it is only as a tiny piece of the mass that the individual can clamber up charts and can service machines without any friction. A system oblivious to differences in form leads on its own to the blurring of national characteristics and to the production of worker masses that can be employed equally well at any point on the globe. – Like the mass ornament, the capitalist production process is an end in itself. The commodities that it spews forth are not actually produced to be possessed; rather, they are made for the sake of a profit that knows no limit. Its growth is tied to that of business. The producer does not labor for private gains whose benefits he can enjoy only to a limited extent (in America surplus profits are directed to spiritual shelters such as libraries and universities, which cultivate intellectuals whose later endeavors repay with interest the previously advanced capital). No: the producer labors in order to expand the business. Value is not produced for the sake of value. Though labor may well have once served to produce and consume values up to a certain point, these have now become side effects in the service of the production process. The activities subsumed by that process have divested themselves of their substantial contents. – The production process runs its secret course in public. Everyone does his or

her task on the conveyor belt, performing a partial function without grasping the totality. Like the pattern in the stadium, the organization stands above the masses, a monstrous figure whose creator withdraws it from the eyes of its bearers, and barely even observes it himself. – It is conceived according to rational principles which the Taylor system merely pushes to their ultimate conclusion. The hands in the factory correspond to the legs of the Tiller Girls. Going beyond manual capacities, psychotechnical aptitude tests attempt to calculate dispositions of the soul as well. The mass ornament is the aesthetic reflex of the rationality to which the prevailing economic system aspires.

Educated people – who are never entirely absent – have taken offense at the emergence of the Tiller Girls and the stadium images. They judge anything that entertains the crowd to be a distraction of that crowd. But despite what they think, the *aesthetic* pleasure gained from ornamental mass movements is *legitimate*. Such movements are in fact among the rare creations of the age that bestow form upon a given material. The masses organized in these movements come from offices and factories; the formal principle according to which they are molded determines them in reality as well. When significant components of reality become invisible in our world, art must make do with what is left, for an aesthetic presentation is all the more real the less it dispenses with the reality outside the aesthetic sphere. No matter how low one gauges the value of the mass ornament, its degree of reality is still higher than that of artistic productions which cultivate outdated noble senti- ments in obsolete forms – even if it means nothing more than that.

3

The process of history is a battle between a weak and distant reason and the *forces of nature* that ruled over heaven and earth in the myths. After the twilight of the gods, the gods did not abdicate: the old nature within and outside man continues to assert itself. It gave rise to the great cultures of humanity, which must die like any creation of nature, and it serves as the ground for the superstructures of a *mytho- logical* thinking which affirms nature in its omnipotence. Despite all the variations in the structure of such mythological thinking, which changes from epoch to epoch, it always respects the boundaries that nature has drawn. It acknowledges the organism as the ur-form; it is refracted in the formed quality of what exists; it yields to the workings of fate. It reflects the premises of nature in all spheres without rebelling against their existence. Organic sociology, which sets up the natural organism as the prototype for social organization, is no less mythological than nationalism, which knows no higher unity than the unison of the nation's fate.

Reason does not operate within the circle of natural life. Its concern is to introduce truth into the world. Its realm has already been intimated in genuine *fairy tales*, which are not stories about miracles but rather announcements of the miraculous advent of justice. There is profound historical significance in the fact

that the *Thousand and One Nights* turned up precisely in the France of the Enlightenment and that eighteenth-century reason recognized the reason of the fairy tales as its equal. Even in the early days of history, mere nature was suspended in the fairy tale so that truth could prevail. Natural power is defeated by the powerlessness of the good; fidelity triumphs over the arts of sorcery.

In serving the breakthrough of truth, the historical process becomes a *process of demythologization* which effects a radical deconstruction of the positions that the natural continually reoccupied. The French Enlightenment is an important example of the struggle between reason and the mythological delusions that have invaded the domains of religion and politics. This struggle continues, and in the course of history it may be that nature, increasingly stripped of its magic, will become more and more pervious to reason.

4

The *capitalist epoch* is a stage in the process of demystification. The type of thinking that corresponds to the present economic system has, to an unprecedented degree, made possible the domination and use of nature as a self-contained entity. What is decisive here, however, is not the fact that this thinking provides a means to exploit nature; if human beings were merely exploiters of nature, then nature would have triumphed over nature. Rather, what is decisive is that this thinking fosters ever greater independence from natural conditions and thereby creates a space for the intervention of reason. It is the *rationality* of this thinking (which emanates to some extent from the reason of fairy tales) that accounts – though not exclusively – for the bourgeois revolutions of the last one hundred fifty years, the revolutions that settled the score with the natural powers of the church (itself entangled in the affairs of its age), of the monarchy, and of the feudal system. The unstoppable decomposition of these and other mythological ties is reason's good fortune, since the fairy tale can become reality only on the ruins of the natural unities.

However, the *Ratio* of the capitalist economic system is not reason itself but a murky reason. Once past a certain point, it abandons the truth in which it participates. *It does not encompass man.* The operation of the production process is not regulated according to man's needs, and man does not serve as the foundation for the structure of the socioeconomic organization. Indeed, at no point whatsoever is the system founded on the basis of man. "The basis of man": this does not mean that capitalist thinking should cultivate man as a historically produced form such that it ought to allow him to go unchallenged as a personality and should satisfy the demands made by his nature. The adherents of this position reproach capitalism's rationalism for raping man, and yearn for the return of a community that would be capable of preserving the allegedly human element much better than capitalism. Leaving aside the stultifying effect of such

regressive stances, they fail to grasp capitalism's core defect: it rationalizes not too much but rather *too little*. The thinking promoted by capitalism resists culminating in that reason which arises from the basis of man.

The current site of capitalist thinking is marked by *abstractness*. The predominance of this abstractness today establishes a spiritual space that encompasses all expression. The objection raised against this abstract mode of thought – that it is incapable of grasping the actual substance of life and therefore must give way to concrete observation of phenomena – does indeed identify the limits of abstraction. As an objection it is premature, however, when it is raised in favor of that false mythological concreteness whose aim is organism and form. A return to this sort of concreteness would sacrifice the already acquired capacity for abstraction, but without overcoming abstractness. The latter is the expression of a rationality grown obdurate. Determinations of meaning rendered as abstract generalities – such as determinations in the economic, social, political, or moral domain – do not give reason what rightfully belongs to reason. Such determinations fail to consider the empirical; one could draw any utilitarian application whatsoever from these abstractions devoid of content. Only behind the barrier of these abstractions can one find the individual rational insights that correspond to the particularity of the given situation. Despite the substantiality one can demand of them, such insights are "concrete" only in a derivative sense; in any case they are not "concrete" in the vulgar sense, which uses the term to substantiate points of view entangled in natural life. – The abstractness of contemporary thinking is thus *ambivalent*. From the perspective of the mythological doctrines, in which nature naïvely asserts itself, the process of abstraction – as employed, for example, by the natural sciences – is a gain in rationality which detracts from the resplendence of the things of nature. From the perspective of reason, the same process of abstraction appears to be determined by nature; it gets lost in an empty formalism under whose guise the natural is accorded free rein because it does not let through the insights of reason which could strike at the natural. The prevailing abstractness reveals that the process of demythologization has not come to an end.

Present-day thinking is confronted with the question as to whether it should open itself up to reason or continue to push on against it without opening up at all. It cannot transgress its self-imposed boundaries without fundamentally changing the economic system that constitutes its infrastructure; the continued existence of the latter entails the continued existence of present-day thinking. In other words, the unchecked development of the capitalist system fosters the unchecked growth of abstract thinking (or forces it to become bogged down in a false concreteness). The more abstractness consolidates itself, however, the more man is left behind, *ungoverned* by reason. If his thought midway takes a detour into the abstract, thereby preventing the true contents of knowledge from breaking through, man will once again be rendered subject to the forces of nature. Instead of suppressing these forces, this thinking that has lost its way provokes their rebellion itself by disregarding the very reason that alone could confront such forces and make them submit. It is merely a consequence of the unhampered

expansion of capitalism's power that the dark forces of nature continue to rebel ever more threateningly, thereby preventing the advent of the man of reason.

5

Like abstractness, the *mass ornament* is ambivalent. On the one hand its rationality reduces the natural in a manner that does not allow man to wither away, but that, on the contrary, were it only carried through to the end, would reveal man's most essential element in all its purity. Precisely because the bearer of the ornament does not appear as a total personality – that is, as a harmonious union of nature and "spirit" in which the former is emphasized too much and the latter too little – he becomes transparent to the man determined by reason. The human figure enlisted in the mass ornament has begun the *exodus* from lush organic splendor and the constitution of individuality toward the realm of anonymity to which it relinquishes itself when it stands in truth and when the knowledge radiating from the basis of man dissolves the contours of visible natural form. In the mass ornament nature is deprived of its substance, and it is just this that points to a condition in which the only elements of nature capable of surviving are those that do not resist illumination through reason. Thus, in old Chinese landscape paintings the trees, ponds, and mountains are rendered only as sparse ornamental signs drawn in ink. The organic center has been removed and the remaining unconnected parts are composed according to laws that are not those of nature but laws given by a knowledge of truth, which, as always, is a function of its time. Similarly, it is only remnants of the complex of man that enter into the mass ornament. They are selected and combined in the aesthetic medium according to a principle which represents form-bursting reason in a purer way than those other principles that preserve man as an organic unity.

Viewed from the perspective of reason, the mass ornament reveals itself as a *mythological cult* that is masquerading in the garb of abstraction. Compared to the concrete immediacy of other corporeal presentations, the ornament's conformity to reason is thus an illusion. In reality the ornament is the crass manifestation of inferior nature. The latter can flourish all the more freely, the more decisively capitalist *Ratio* is cut off from reason and bypasses man as it vanishes into the void of the abstract. In spite of the rationality of the mass pattern, such patterns simultaneously give rise to the natural in its impenetrability. Certainly man as an organic being has disappeared from these ornaments, but that does not suffice to bring man's basis to the fore; on the contrary, the remaining little mass particle cuts itself off from this basis just as any general formal concept does. Admittedly, it is the legs of the Tiller Girls that swing in perfect parallel, not the natural unity of their bodies, and it is also true that the thousands of people in the stadium form one single star. But this star does not shine, and the legs of the Tiller Girls are an abstract designation of their bodies. Reason speaks wherever it

disintegrates the organic unity and rips open the natural surface (no matter how cultivated the latter may be); it dissects the human form here only so that the undistorted truth can fashion man anew. But reason has not penetrated the mass ornament; its patterns are *mute*. The *Ratio* that gives rise to the ornament is strong enough to invoke the mass and to expunge all life from the figures constituting it. It is too weak to find the human beings within the mass and to render the figures in the ornament transparent to knowledge. Because this *Ratio* flees from reason and takes refuge in the abstract, uncontrolled nature proliferates under the guise of rational expression and uses abstract signs to display itself. It can no longer transform itself into powerful symbolic forms, as it could among primitive peoples and in the era of religious cults. This power of a language of signs has withdrawn from the mass ornament under the influence of the same rationality that keeps its muteness from bursting open. Thus, bare nature manifests itself in the mass ornament – the very nature that also resists the expression and apprehension of its own meaning. It is the *rational and empty form* of the cult, devoid of any explicit meaning, that appears in the mass ornament. As such, it proves to be a relapse into mythology of an order so great that one can hardly imagine its being exceeded, a relapse which, in turn, again betrays the degree to which capitalist *Ratio* is closed off from reason.

The role that the mass ornament plays in *social life* confirms that it is the spurious progeny of bare nature. The intellectually privileged who, while unwilling to recognize it, are an appendage of the prevailing economic system have not even perceived the mass ornament as a sign of this system. They disavow the phenomenon in order to continue seeking edification at art events that have remained untouched by the reality present in the stadium patterns. The masses who so spontaneously adopted these patterns are superior to their detractors among the educated class to the extent that they at least roughly acknowledge the undisguised facts. The same rationality that controls the bearers of the patterns in real life also governs their submersion in the corporeal, allowing them thereby to immortalize current reality. These days, there is not only *one* Walter Stolzing singing prize songs that glorify body culture. It is easy to see through the ideology of such songs, even if the term "body culture" does indeed justifiably combine two words that belong together by virtue of their respective meanings. The unlimited importance ascribed to the physical cannot be derived from the limited value it deserves. Such importance can be explained only by the alliance that organized physical education maintains with the establishment, in some cases unbeknownst to its front-line supporters. Physical training expropriates people's energy, while the production and mindless consumption of the ornamental patterns divert them from the imperative to change the reigning order. Reason can gain entrance only with difficulty when the masses it ought to pervade yield to sensations afforded by the godless mythological cult. The latter's social meaning is equivalent to that of the Roman *circus games*, which were sponsored by those in power.

6

Among the various attempts to reach a higher sphere, many have been willing to relinquish once again the rationality and level of reality attained by the mass ornament. The bodily exertions in the field of *rhythmic gymnastics*, for example, have aims that go beyond those of personal hygiene – namely, the expression of spruced-up states of the soul – to which instructors of body culture often add world views. These practices, whose impossible aesthetics can be ignored entirely, seek to recapture just what the mass ornament had happily left behind: the organic connection of nature with something the all too modest temperament takes to be soul or spirit – that is, exalting the body by assigning it meanings which emanate from it and may indeed be spiritual but which do not contain the slightest trace of reason. Whereas the mass ornament presents mute nature without any superstructure whatsoever, rhythmic gymnastics, according to its own account, goes further and expropriates the higher mythological levels, thereby strengthening nature's dominance all the more. It is just one example among many other equally hopeless attempts to reach a higher life form out of mass existence. Most of these depend in a genuinely romantic way on forms and contents that have long since succumbed to the somewhat justified critique of capitalist *Ratio*. In their desire to once again give man a link to nature that is more solid than the one he has today, they discover the connection to the higher sphere, not by appealing to a still unrealized reason in this world but by retreating into mythological structures of meaning. Their fate is *irreality*, for when even a glimmer of reason shines through at some point in the world, even the most sublime entity that tries to shield itself from it must perish. Enterprises that ignore our historical context and attempt to reconstruct a form of state, a community, a mode of artistic creation that depends upon a type of man who has already been impugned by contemporary thinking – a type of man who by all rights no longer exists – such enterprises do not transcend the mass ornament's empty and superficial shallowness but flee from its reality. The process leads directly through the center of the mass ornament, not away from it. It can move forward only when thinking circumscribes nature and produces man as he is constituted by reason. Then society will change. Then, too, the mass ornament will fade away and human life itself will adopt the traits of that ornament into which it develops, through its confrontation with truth, in fairy tales.

17

The Work of Art in the Age of Mechanical Reproduction

Walter Benjamin

'Our fine arts were developed, their types and uses were established, in times very different from the present, by men whose power of action upon things was insignificant in comparison with ours. But the amazing growth of our techniques, the adaptability and precision they have attained, the ideas and habits they are creating, make it a certainty that profound changes are impending in the ancient craft of the Beautiful. In all the arts there is a physical component which can no longer be considered or treated as it used to be, which cannot remain unaffected by our modern knowledge and power. For the last twenty years neither matter nor space nor time has been what it was from time immemorial. We must expect great innovations to transform the entire technique of the arts, thereby affecting artistic invention itself and perhaps even bring about an amazing change in our very notion of art.'[1]
　　　– Paul Valéry, PIÈCES SUR L'ART, 'La Conquète de l'ubiquité,' Paris.

PREFACE

When Marx undertook his critique of the capitalistic mode of production, this mode was in its infancy. Marx directed his efforts in such a way as to give them prognostic value. He went back to the basic conditions underlying capitalistic production and through his presentation showed what could be expected of

capitalism in the future. The result was that one could expect it not only to exploit the proletariat with increasing intensity, but ultimately to create conditions which would make it possible to abolish capitalism itself.

The transformation of the superstructure, which takes place far more slowly than that of the substructure, has taken more than half a century to manifest in all areas of culture the change in the conditions of production. Only today can it be indicated what form this has taken. Certain prognostic requirements should be met by these statements. However, theses about the art of the proletariat after its assumption of power or about the art of a classless society would have less bearing on these demands than theses about the developmental tendencies of art under present conditions of production. Their dialectic is no less noticeable in the superstructure than in the economy. It would therefore be wrong to underestimate the value of such theses as a weapon. They brush aside a number of outmoded concepts, such as creativity and genius, eternal value and mystery – concepts whose uncontrolled (and at present almost uncontrollable) application would lead to a processing of data in the Fascist sense. The concepts which are introduced into the theory of art in what follows differ from the more familiar terms in that they are completely useless for the purposes of Fascism. They are, on the other hand, useful for the formulation of revolutionary demands in the politics of art.

I

In principle a work of art has always been reproducible. Manmade artifacts could always be imitated by men. Replicas were made by pupils in practice of their craft, by masters for diffusing their works, and, finally, by third parties in the pursuit of gain. Mechanical reproduction of a work of art, however, represents something new. Historically, it advanced intermittently and in leaps at long intervals, but with accelerated intensity. The Greeks knew only two procedures of technically reproducing works of art: founding and stamping. Bronzes, terra cottas, and coins were the only art works which they could produce in quantity. All others were unique and could not be mechanically reproduced. With the woodcut graphic art became mechanically reproducible for the first time, long before script became reproducible by print. The enormous changes which printing, the mechanical reproduction of writing, has brought about in literature are a familiar story. However, within the phenomenon which we are here examining from the perspective of world history, print is merely a special, though particularly important, case. During the Middle Ages engraving and etching were added to the woodcut; at the beginning of the nineteenth century lithography made its appearance.

With lithography the technique of reproduction reached an essentially new stage. This much more direct process was distinguished by the tracing of the design on a stone rather than its incision on a block of wood or its etching on a

copperplate and permitted graphic art for the first time to put its products on the market, not only in large numbers as hitherto, but also in daily changing forms. Lithography enabled graphic art to illustrate everyday life, and it began to keep pace with printing. But only a few decades after its invention, lithography was surpassed by photography. For the first time in the process of pictorial reproduction, photography freed the hand of the most important artistic functions which henceforth devolved only upon the eye looking into a lens. Since the eye perceives more swiftly than the hand can draw, the process of pictorial reproduction was accelerated so enormously that it could keep pace with speech. A film operator shooting a scene in the studio captures the images at the speed of an actor's speech. Just as lithography virtually implied the illustrated newspaper, so did photography foreshadow the sound film. The technical reproduction of sound was tackled at the end of the last century. These convergent endeavours made predictable a situation which Paul Valéry pointed up in this sentence: 'Just as water, gas, and electricity are brought into our houses from far off to satisfy our needs in response to a minimal effort, so we shall be supplied with visual or auditory images, which will appear and disappear at a simple movement of the hand, hardly more than a sign' (op. cit., p. 226). Around 1900 technical reproduction had reached a standard that not only permitted it to reproduce all transmitted works of art and thus to cause the most profound change in their impact upon the public; it also had captured a place of its own among the artistic processes. For the study of this standard nothing is more revealing than the nature of the repercussions that these two different manifestations – the reproduction of works of art and the art of the film – have had on art in its traditional form.

II

Even the most perfect reproduction of a work of art is lacking in one element: its presence in time and space, its unique existence at the place where it happens to be. This unique existence of the work of art determined the history to which it was subject throughout the time of its existence. This includes the changes which it may have suffered in physical condition over the years as well as the various changes in its ownership. The traces of the first can be revealed only by chemical or physical analyses which it is impossible to perform on a reproduction; changes of ownership are subject to a tradition which must be traced from the situation of the original.

The presence of the original is the prerequisite to the concept of authenticity. Chemical analyses of the patina of a bronze can help to establish this, as does the proof that a given manuscript of the Middle Ages stems from an archive of the fifteenth century. The whole sphere of authenticity is outside technical – and, of course, not only technical – reproducibility. Confronted with its manual repro-

duction, which was usually branded as a forgery, the original preserved all its authority; not so *vis à vis* technical reproduction. The reason is twofold. First, process reproduction is more independent of the original than manual reproduction. For example, in photography, process reproduction can bring out those aspects of the original that are unattainable to the naked eye yet accessible to the lens, which is adjustable and chooses its angle at will. And photographic reproduction, with the aid of certain processes, such as enlargement or slow motion, can capture images which escape natural vision. Secondly, technical reproduction can put the copy of the original into situations which would be out of reach for the original itself. Above all, it enables the original to meet the beholder halfway, be it in the form of a photograph or a phonograph record. The cathedral leaves its locale to be received in the studio of a lover of art; the choral production, performed in an auditorium or in the open air, resounds in the drawing room.

The situations into which the product of mechanical reproduction can be brought may not touch the actual work of art, yet the quality of its presence is always depreciated. This holds not only for the art work but also, for instance, for a landscape which passes in review before the spectator in a movie. In the case of the art object, a most sensitive nucleus – namely, its authenticity – is interfered with whereas no natural object is vulnerable on that score. The authenticity of a thing is the essence of all that is transmissible from its beginning, ranging from its substantive duration to its testimony to the history which it has experienced. Since the historical testimony rests on the authenticity, the former, too, is jeopardized by reproduction when substantive duration ceases to matter. And what is really jeopardized when the historical testimony is affected is the authority of the object.

One might subsume the eliminated element in the term 'aura' and go on to say: that which withers in the age of mechanical reproduction is the aura of the work of art. This is a symptomatic process whose significance points beyond the realm of art. One might generalize by saying: the technique of reproduction detaches the reproduced object from the domain of tradition. By making many reproductions it substitutes a plurality of copies for a unique existence. And in permitting the reproduction to meet the beholder or listener in his own particular situation, it reactivates the object reproduced. These two processes lead to a tremendous shattering of tradition which is the obverse of the contemporary crisis and renewal of mankind. Both processes are intimately connected with the contemporary mass movements. Their most powerful agent is the film. Its social significance, particularly in its most positive form, is inconceivable without its destructive, cathartic aspect, that is, the liquidation of the traditional value of the cultural heritage. This phenomenon is most palpable in the great historical films. It extends to ever new positions. In 1927 Abel Gance exclaimed enthusiastically: 'Shakespeare, Rembrandt, Beethoven will make films ... all legends, all mythologies and all myths, all founders of religion, and the very religions ... await their exposed resurrection, and the heroes crowd each other at the gate.'[2] Presumably without intending it, he issued an invitation to a far-reaching liquidation.

III

During long periods of history, the mode of human sense perception changes with humanity's entire mode of existence. The manner in which human sense perception is organized, the medium in which it is accomplished, is determined not only by nature but by historical circumstances as well. The fifth century, with its great shifts of population, saw the birth of the late Roman art industry and the Vienna Genesis, and there developed not only an art different from that of antiquity but also a new kind of perception. The scholars of the Viennese school, Riegl and Wickhoff, who resisted the weight of classical tradition under which these later art forms had been buried, were the first to draw conclusions from them concerning the organization of perception at the time. However far-reaching their insight, these scholars limited themselves to showing the signifi-cant, formal hallmark which characterized perception in late Roman times. They did not attempt – and, perhaps, saw no way – to show the social transformations expressed by these changes of perception. The conditions for an analogous insight are more favourable in the present. And if changes in the medium of contempor-ary perception can be comprehended as decay of the aura, it is possible to show its social causes.

The concept of aura which was proposed above with reference to historical objects may usefully be illustrated with reference to the aura of natural ones. We define the aura of the latter as the unique phenomenon of a distance, however close it may be. If, while resting on a summer afternoon, you follow with your eyes a mountain range on the horizon or a branch which casts its shadow over you, you experience the aura of those mountains, of that branch. This image makes it easy to comprehend the social bases of the contemporary decay of the aura. It rests on two circumstances, both of which are related to the increasing significance of the masses in contemporary life. Namely, the desire of contem-porary masses to bring things 'closer' spatially and humanly, which is just as ardent as their bent toward overcoming the uniqueness of every reality by accepting its reproduction. Every day the urge grows stronger to get hold of an object at very close range by way of its likeness, its reproduction. Unmistakably, reproduction as offered by picture magazines and newsreels differs from the image seen by the unarmed eye. Uniqueness and permanence are as closely linked in the latter as are transitoriness and reproducibility in the former. To pry an object from its shell, to destroy its aura, is the mark of a perception whose 'sense of the universal equality of things' has increased to such a degree that it extracts it even from a unique object by means of reproduction. Thus is manifested in the field of perception what in the theoretical sphere is noticeable in the increas-ing importance of statistics. The adjustment of reality to the masses and of the masses to reality is a process of unlimited scope, as much for thinking as for perception.

IV

The uniqueness of a work of art is inseparable from its being imbedded in the fabric of tradition. This tradition itself is thoroughly alive and extremely changeable. An ancient statue of Venus, for example, stood in a different traditional context with the Greeks, who made it an object of veneration, than with the clerics of the Middle Ages, who viewed it as an ominous idol. Both of them, however, were equally confronted with its uniqueness, that is, its aura. Originally the contextual integration of art in tradition found its expression in the cult. We know that the earliest art works originated in the service of a ritual – first the magical, then the religious kind. It is significant that the existence of the work of art with reference to its aura is never entirely separated from its ritual function. In other words, the unique value of the 'authentic' work of art has its basis in ritual, the location of its original use value. This ritualistic basis, however remote, is still recognizable as secularized ritual even in the most profane forms of the cult of beauty. The secular cult of beauty, developed during the Renaissance and prevailing for three centuries, clearly showed that ritualistic basis in its decline and the first deep crisis which befell it. With the advent of the first truly revolutionary means of reproduction, photography, simultaneously with the rise of socialism, art sensed the approaching crisis which has become evident a century later. At the time, art reacted with the doctrine of *l'art pour l'art*, that is, with a theology of art. This gave rise to what might be called a negative theology in the form of the idea of 'pure' art, which not only denied any social function of art but also any categorizing by subject matter. (In poetry, Mallarmé was the first to take this position.)

An analysis of art in the age of mechanical reproduction must do justice to these relationships, for they lead us to an all-important insight: for the first time in world history, mechanical reproduction emancipates the work of art from its parasitical dependence on ritual. To an ever greater degree the work of art reproduced becomes the work of art designed for reproducibility. From a photographic negative, for example, one can make any number of prints; to ask for the 'authentic' print makes no sense. But the instant the criterion of authenticity ceases to be applicable to artistic production, the total function of art is reversed. Instead of being based on ritual, it begins to be based on another practice – politics.

V

Works of art are received and valued on different planes. Two polar types stand out: with one, the accent is on the cult value; with the other, on the exhibition value of the work. Artistic production begins with ceremonial objects destined to

serve in a cult. One may assume that what mattered was their existence, not their being on view. The elk portrayed by the man of the Stone Age on the walls of his cave was an instrument of magic. He did expose it to his fellow men, but in the main it was meant for the spirits. Today the cult value would seem to demand that the work of art remain hidden. Certain statues of gods are accessible only to the priest in the cella; certain Madonnas remain covered nearly all year round; certain sculptures on medieval cathedrals are invisible to the spectator on ground level. With the emancipation of the various art practices from ritual go increasing opportunities for the exhibition of their products. It is easier to exhibit a portrait bust that can be sent here and there than to exhibit the statue of a divinity that has its fixed place in the interior of a temple. The same holds for the painting as against the mosaic or fresco that preceded it. And even though the public presentability of a mass originally may have been just as great as that of a symphony, the latter originated at the moment when its public presentability promised to surpass that of the mass.

With the different methods of technical reproduction of a work of art, its fitness for exhibition increased to such an extent that the quantitative shift between its two poles turned into a qualitative transformation of its nature. This is comparable to the situation of the work of art in prehistoric times when, by the absolute emphasis on its cult value, it was, first and foremost, an instrument of magic. Only later did it come to be recognized as a work of art. In the same way today, by the absolute emphasis on its exhibition value the work of art becomes a creation with entirely new functions, among which the one we are conscious of, the artistic function, later may be recognized as incidental. This much is certain: today photography and the film are the most serviceable exemplifications of this new function.

VI

In photography, exhibition value begins to displace cult value all along the line. But cult value does not give way without resistance. It retires into an ultimate retrenchment: the human countenance. It is no accident that the portrait was the focal point of early photography. The cult of remembrance of loved ones, absent or dead, offers a last refuge for the cult value of the picture. For the last time the aura emanates from the early photographs in the fleeting expression of a human face. This is what constitutes their melancholy, incomparable beauty. But as man withdraws from the photographic image, the exhibition value for the first time shows its superiority to the ritual value. To have pinpointed this new stage constitutes the incomparable significance of Atget, who, around 1900, took photographs of deserted Paris streets. It has quite justly been said of him that he photographed them like scenes of crime. The scene of a crime, too, is deserted; it is photographed for the purpose of establishing evidence. With Atget, photo-

graphs become standard evidence for historical occurrences, and acquire a hidden political significance. They demand a specific kind of approach; free-floating contemplation is not appropriate to them. They stir the viewer; he feels challenged by them in a new way. At the same time picture magazines begin to put up signposts for him, right ones or wrong ones, no matter. For the first time, captions have become obligatory. And it is clear that they have an altogether different character than the title of a painting. The directives which the captions give to those looking at pictures in illustrated magazines soon become even more explicit and more imperative in the film where the meaning of each single picture appears to be prescribed by the sequence of all preceding ones. [...]

XII

Mechanical reproduction of art changes the reaction of the masses toward art. The reactionary attitude toward a Picasso painting changes into the progressive reaction toward a Chaplin movie. The progressive reaction is characterized by the direct, intimate fusion of visual and emotional enjoyment with the orientation of the expert. Such fusion is of great social significance. The greater the decrease in the social significance of an art form, the sharper the distinction between criticism and enjoyment by the public. The conventional is uncritically enjoyed, and the truly new is criticized with aversion. With regard to the screen, the critical and the receptive attitudes of the public coincide. The decisive reason for this is that individual reactions are predetermined by the mass audience response they are about to produce, and this is nowhere more pronounced than in the film. The moment these responses become manifest they control each other. Again, the comparison with painting is fruitful. A painting has always had an excellent chance to be viewed by one person or by a few. The simultaneous contemplation of paintings by a large public, such as developed in the nineteenth century, is an early symptom of the crisis of painting, a crisis which was by no means occasioned exclusively by photography but rather in a relatively independent manner by the appeal of art works to the masses.

Painting simply is in no position to present an object for simultaneous collective experience, as it was possible for architecture at all times, for the epic poem in the past, and for the movie today. Although this circumstance in itself should not lead one to conclusions about the social role of painting, it does constitute a serious threat as soon as painting, under special conditions and, as it were, against its nature, is confronted directly by the masses. In the churches and monasteries of the Middle Ages and at the princely courts up to the end of the eighteenth century, a collective reception of paintings did not occur simultaneously, but by graduated and hierarchized mediation. The change that has come about is an expression of the particular conflict in which painting was implicated by the mechanical reproducibility of paintings. Although paintings began to be publicly

exhibited in galleries and salons, there was no way for the masses to organize and control themselves in their reception. Thus the same public which responds in a progressive manner toward a grotesque film is bound to respond in a reactionary manner to surrealism.

XIII

The characteristics of the film lie not only in the manner in which man presents himself to mechanical equipment but also in the manner in which, by means of this apparatus, man can represent his environment. A glance at occupational psychology illustrates the testing capacity of the equipment. Psychoanalysis illustrates it in a different perspective. The film has enriched our field of perception with methods which can be illustrated by those of Freudian theory. Fifty years ago, a slip of the tongue passed more or less unnoticed. Only exceptionally may such a slip have revealed dimensions of depth in a conversation which had seemed to be taking its course on the surface. Since the *Psychopathology of Everyday Life* things have changed. This book isolated and made analyzable things which had heretofore floated along unnoticed in the broad stream of perception. For the entire spectrum of optical, and now also acoustical, perception the film has brought about a similar deepening of apperception. It is only an obverse of this fact that behaviour items shown in a movie can be analyzed much more precisely and from more points of view than those presented on paintings or on the stage. As compared with painting, filmed behaviour lends itself more readily to analysis because of its incomparably more precise statements of the situation. In comparison with the stage scene, the filmed behaviour item lends itself more readily to analysis because it can be isolated more easily. This circumstance derives its chief importance from its tendency to promote the mutual penetration of art and science. Actually, of a screened behaviour item which is neatly brought out in a certain situation, like a muscle of a body, it is difficult to say which is more fascinating, its artistic value or its value for science. To demonstrate the identity of the artistic and scientific uses of photography which heretofore usually were separated will be one of the revolutionary functions of the film.

By close-ups of the things around us, by focusing on hidden details of familiar objects, by exploring commonplace milieus under the ingenious guidance of the camera, the film, on the one hand, extends our comprehension of the necessities which rule our lives; on the other hand, it manages to assure us of an immense and unexpected field of action. Our taverns and our metropolitan streets, our offices and furnished rooms, our railroad stations and our factories appeared to have us locked up hopelessly. Then came the film and burst this prison-world asunder by the dynamite of the tenth of a second, so that now, in the midst of its far-flung ruins and debris, we calmly and adventurously go travelling. With the close-up, space expands; with slow motion, movement is extended. The enlarge-

ment of a snapshot does not simply render more precise what in any case was visible, though unclear: it reveals entirely new structural formations of the subject. So, too, slow motion not only presents familiar qualities of movement but reveals in them entirely unknown ones 'which, far from looking like retarded rapid movements, give the effect of singularly gliding, floating, supernatural motions.'[3] Evidently a different nature opens itself to the camera than opens to the naked eye – if only because an unconsciously penetrated space is substituted for a space consciously explored by man. Even if one has a general knowledge of the way people walk, one knows nothing of a person's posture during the fractional second of a stride. The act of reaching for a lighter or a spoon is familiar routine, yet we hardly know what really goes on between hand and metal, not to mention how this fluctuates with our moods. Here the camera intervenes with the resources of its lowerings and liftings, its interruptions and isolations, its extensions and accelerations, its enlargements and reductions. The camera introduces us to unconscious optics as does psychoanalysis to unconscious impulses.

XIV

One of the foremost tasks of art has always been the creation of a demand which could be fully satisfied only later. The history of every art form shows critical epochs in which a certain art form aspires to effects which could be fully obtained only with a changed technical standard, that is to say, in a new art form. The extravagances and crudities of art which thus appear, particularly in the so-called decadent epochs, actually arise from the nucleus of its richest historical energies. In recent years, such barbarisms were abundant in Dadaism. It is only now that its impulse becomes discernible: Dadaism attempted to create by pictorial – and literary – means the effects which the public today seeks in the film.

Every fundamentally new, pioneering creation of demands will carry beyond its goal. Dadaism did so to the extent that it sacrificed the market values which are so characteristic of the film in favour of higher ambitions – though of course it was not conscious of such intentions as here described. The Dadaists attached much less importance to the sales value of their work than to its uselessness for contemplative immersion. The studied degradation of their material was not the least of their means to achieve this uselessness. Their poems are 'word salad' containing obscenities and every imaginable waste product of language. The same is true of their paintings, on which they mounted buttons and tickets. What they intended and achieved was a relentless destruction of the aura of their creations, which they branded as reproductions with the very means of production. Before a painting of Arp's or a poem by August Stramm it is impossible to take time for contemplation and evaluation as one would before a canvas of Derain's or a poem by Rilke. In the decline of middle-class society, contemplation became a school for asocial behaviour; it was countered by distraction as a variant of social

conduct. Dadaistic activities actually assured a rather vehement distraction by making works of art the centre of scandal. One requirement was foremost: to outrage the public.

From an alluring appearance or persuasive structure of sound the work of art of the Dadaists became an instrument of ballistics. It hit the spectator like a bullet, it happened to him, thus acquiring a tactile quality. It promoted a demand for the film, the distracting element of which is also primarily tactile, being based on changes of place and focus which periodically assail the spectator. Let us compare the screen on which a film unfolds with the canvas of a painting. The painting invites the spectator to contemplation; before it the spectator can abandon himself to his associations. Before the movie frame he cannot do so. No sooner has his eye grasped a scene than it is already changed. It cannot be arrested. Duhamel, who detests the film and knows nothing of its significance, though something of its structure, notes this circumstance as follows: 'I can no longer think what I want to think. My thoughts have been replaced by moving images.'[4] The spectator's process of association in view of these images is indeed interrupted by their constant, sudden change. This constitutes the shock effect of the film, which, like all shocks, should be cushioned by heightened presence of mind. By means of its technical structure, the film has taken the physical shock effect out of the wrappers in which Dadaism had, as it were, kept it inside the moral shock effect.

XV

The mass is a matrix from which all traditional behaviour toward works of art issues today in a new form. Quantity has been transmuted into quality. The greatly increased mass of participants has produced a change in the mode of participation. The fact that the new mode of participation first appeared in a disreputable form must not confuse the spectator. Yet some people have launched spirited attacks against precisely this superficial aspect. Among these, Duhamel has expressed himself in the most radical manner. What he objects to most is the kind of participation which the movie elicits from the masses. Duhamel calls the movie 'a pastime for helots, a diversion for uneducated, wretched, worn-out creatures who are consumed by their worries . . . , a spectacle which requires no concentration and presupposes no intelligence . . . , which kindles no light in the heart and awakens no hope other than the ridiculous one of someday becoming a "star" in Los Angeles.'[5] Clearly, this is at bottom the same ancient lament that the masses seek distraction whereas art demands concentration from the spectator. That is a commonplace. The question remains whether it provides a platform for the analysis of the film. A closer look is needed here. Distraction and concentration form polar opposites which may be stated as follows: A man who concentrates before a work of art is absorbed by it. He enters into this work of art the

184

way legend tells of the Chinese painter when he viewed his finished painting. In contrast, the distracted mass absorbs the work of art. This is most obvious with regard to buildings. Architecture has always represented the prototype of a work of art the reception of which is consummated by a collectivity in a state of distraction. The laws of its reception are most instructive.

Buildings have been man's companions since primeval times. Many art forms have developed and perished. Tragedy begins with the Greeks, is extinguished with them, and after centuries its 'rules' only are revived. The epic poem, which had its origin in the youth of nations, expires in Europe at the end of the Renaissance. Panel painting is a creation of the Middle Ages, and nothing guarantees its uninterrupted existence. But the human need for shelter is lasting. Architecture has never been idle. Its history is more ancient than that of any other art, and its claim to being a living force has significance in every attempt to comprehend the relationship of the masses to art. Buildings are appropriated in a twofold manner: by use and by perception – or rather, by touch and sight. Such appropriation cannot be understood in terms of the attentive concentration of a tourist before a famous building. On the tactile side there is no counterpart to contemplation on the optical side. Tactile appropriation is accomplished not so much by attention as by habit. As regards architecture, habit determines to a large extent even optical reception. The latter, too, occurs much less through rapt attention than by noticing the object in incidental fashion. This mode of appropriation, developed with reference to architecture, in certain circumstances acquires canonical value. For the tasks which face the human apparatus of perception at the turning points of history cannot be solved by optical means, that is, by contemplation, alone. They are mastered gradually by habit, under the guidance of tactile appropriation.

The distracted person, too, can form habits. More, the ability to master certain tasks in a state of distraction proves that their solution has become a matter of habit. Distraction as provided by art presents a covert control of the extent to which new tasks have become soluble by apperception. Since, moreover, individuals are tempted to avoid such tasks, art will tackle the most difficult and most important ones where it is able to mobilize the masses. Today it does so in the film. Reception in a state of distraction, which is increasing noticeably in all fields of art and is symptomatic of profound changes in apperception, finds in the film its true means of exercise. The film with its shock effect meets this mode of reception halfway. The film makes the cult value recede into the background not only by putting the public in the position of the critic, but also by the fact that at the movies this position requires no attention. The public is an examiner, but an absent-minded one.

Epilogue

The growing proletarianization of modern man and the increasing formation of masses are two aspects of the same process. Fascism attempts to organize the

newly created proletarian masses without affecting the property structure which the masses strive to eliminate. Fascism sees its salvation in giving these masses not their right, but instead a chance to express themselves. The masses have a right to change property relations; Fascism seeks to give them an expression while preserving property. The logical result of Fascism is the introduction of aesthetics into political life. The violation of the masses, whom Fascism, with its *Führer* cult, forces to their knees, has its counterpart in the violation of an apparatus which is pressed into the production of ritual values.

All efforts to render politics aesthetic culminate in one thing: war. War and war only can set a goal for mass movements on the largest scale while respecting the traditional property system. This is the political formula for the situation. The technological formula may be stated as follows: Only war makes it possible to mobilize all of today's technical resources while maintaining the property system. It goes without saying that the Fascist apotheosis of war does not employ such arguments. Still, Marinetti says in his manifesto on the Ethiopian colonial war: 'For twenty-seven years we Futurists have rebelled against the branding of war as antiaesthetic...Accordingly we state:...War is beautiful because it establishes man's dominion over the subjugated machinery by means of gas masks, terrifying megaphones, flame throwers, and small tanks. War is beautiful because it initiates the dreamt-of metallization of the human body. War is beautiful because it enriches a flowering meadow with the fiery orchids of machine guns. War is beautiful because it combines the gunfire, the cannonades, the cease-fire, the scents, and the stench of putrefaction into a symphony. War is beautiful because it creates new architecture, like that of the big tanks, the geometrical formation flights, the smoke spirals from burning villages, and many others...Poets and artists of Futurism!...remember these principles of an aesthetics of war so that your struggle for a new literature and a new graphic art...may be illumined by them!'

This manifesto has the virtue of clarity. Its formulations deserve to be accepted by dialecticians. To the latter, the aesthetics of today's war appears as follows: If the natural utilization of productive forces is impeded by the property system, the increase in technical devices, in speed, and in the sources of energy will press for an unnatural utilization, and this is found in war. The destructiveness of war furnishes proof that society has not been mature enough to incorporate technology as its organ, that technology has not been sufficiently developed to cope with the elemental forces of society. The horrible features of imperialistic warfare are attributable to the discrepancy between the tremendous means of production and their inadequate utilization in the process of production – in other words, to unemployment and the lack of markets. Imperialistic war is a rebellion of technology 'which collects, in the form of 'human material,' the claims to which society has denied its natural material. Instead of draining rivers, society directs a human stream into a bed of trenches; instead of dropping seeds from airplanes, it drops incendiary bombs over cities; and through gas warfare the aura is abolished in a new way.

'*Fiat ars – pereat mundus*,' says Fascism, and, as Marinetti admits, expects war to supply the artistic gratification of a sense perception that has been changed by technology. This is evidently the consummation of '*l'art pour l'art*,' Mankind, which in Homer's time was an object of contemplation for the Olympian gods, now is one for itself. Its self-alienation has reached such a degree that it can experience its own destruction as an aesthetic pleasure of the first order. This is the situation of politics which Fascism is rendering aesthetic. Communism responds by politicizing art.

Notes

1 Quoted from Paul Veléry, *Aesthetics*, 'The Conquest of Ubiquity,' trans. Ralph Manheim, p. 225. Pantheon Books, Bollingen Series, New York, 1964.
2 Abel Gance, 'Le Temps de l'image est venu,' *L'Art cinématographique*, vol. 2, pp. 94 f., Paris, 1927.
3 Rudolf Arnheim, *Films als Kunst*, Berlin, 1932, p. 138.
4 Georges Duhamel, *Scènes de la vie future*, Paris, 1930, p. 52.
5 Duhamel, ibid., p. 58.

18

Avant-Garde and Kitsch

Clement Greenberg

One and the same civilization produces simultaneously two such different things as a poem by T. S. Eliot and a Tin Pan Alley song, or a painting by Braque and a *Saturday Evening Post* cover. All four are on the order of culture, and ostensibly, parts of the same culture and products of the same society. Here, however, their connection seems to end. A poem by Eliot and a poem by Eddie Guest – what perspective of culture is large enough to enable us to situate them in an enlightening relation to each other? Does the fact that a disparity such as this within the frame of a single cultural tradition, which is and has been taken for granted – does this fact indicate that the disparity is a part of the natural order of things? Or is it something entirely new, and particular to our age?

The answer involves more than an investigation in aesthetics. It appears to me that it is necessary to examine more closely and with more originality than hitherto the relationship between aesthetic experience as met by the specific – not the generalized – individual, and the social and historical contexts in which that experience takes place. What is brought to light will answer, in addition to the question posed above, other and perhaps more important questions.

I

A society, as it becomes less and less able, in the course of its development, to justify the inevitability of its particular forms, breaks up the accepted notions upon which artists and writers must depend in large part for communication with their audiences. It becomes difficult to assume anything. All the verities involved

Clement Greenberg, "Avant-Garde and Kitsch" (originally published in 1939), pp. 3–21 from Clement Greenberg, *Art and Culture: Critical Essays*. Boston: Beacon Press, 1961. © 1961, 1989 by Clement Greenberg. Reprinted by permission of Beacon Press, Boston.

by religion, authority, tradition, style, are thrown into question, and the writer or artist is no longer able to estimate the response of his audience to the symbols and references with which he works. In the past such a state of affairs has usually resolved itself into a motionless Alexandrianism, an academicism in which the really important issues are left untouched because they involve controversy, and in which creative activity dwindles to virtuosity in the small details of form, all larger questions being decided by the precedent of the old masters. The same themes are mechanically varied in a hundred different works, and yet nothing new is produced: Statius, mandarin verse, Roman sculpture, Beaux-Arts painting, neo-republican architecture.

It is among the hopeful signs in the midst of the decay of our present society that we – some of us – have been unwilling to accept this last phase for our own culture. In seeking to go beyond Alexandrianism, a part of Western bourgeois society has produced something unheard of heretofore: – avant-garde culture. A superior consciousness of history – more precisely, the appearance of a new kind of criticism of society, an historical criticism – made this possible. This criticism has not confronted our present society with timeless utopias, but has soberly examined in the terms of history and of cause and effect the antecedents, justifications and functions of the forms that lie at the heart of every society. Thus our present bourgeois social order was shown to be, not an eternal, "natural" condition of life, but simply the latest term in a succession of social orders. New perspectives of this kind, becoming a part of the advanced intellectual conscience of the fifth and sixth decades of the nineteenth century, soon were absorbed by artists and poets, even if unconsciously for the most part. It was no accident, therefore, that the birth of the avant-garde coincided chronologically – and geographically, too – with the first bold development of scientific revolutionary thought in Europe.

True, the first settlers of bohemia – which was then identical with the avant-garde – turned out soon to be demonstratively uninterested in politics. Nevertheless, without the circulation of revolutionary ideas in the air about them, they would never have been able to isolate their concept of the "bourgeois" in order to define what they were *not*. Nor, without the moral aid of revolutionary political attitudes would they have had the courage to assert themselves as aggressively as they did against the prevailing standards of society. Courage indeed was needed for this, because the avant-garde's emigration from bourgeois society to bohemia meant also an emigration from the markets of capitalism, upon which artists and writers had been thrown by the falling away of aristocratic patronage. (Ostensibly, at least, it meant this – meant starving in a garret – although, as will be shown later, the avant-garde remained attached to bourgeois society precisely because it needed its money.)

Yet it is true that once the avant-garde had succeeded in "detaching" itself from society, it proceeded to turn around and repudiate revolutionary as well as bourgeois politics. The revolution was left inside society, a part of that welter of ideological struggle which art and poetry find so unpropitious as soon as it begins

189

to involve those "precious" axiomatic beliefs upon which culture thus far has had to rest. Hence it developed that the true and most important function of the avant-garde was not to "experiment," but to find a path along which it would be possible to keep culture *moving* in the midst of ideological confusion and violence. Retiring from public altogether, the avant-garde poet or artist sought to maintain the high level of his art by both narrowing and raising it to the expression of an absolute in which all relativities and contradictions would be either resolved or beside the point. "Art for art's sake" and "pure poetry" appear, and subject matter or content becomes something to be avoided like a plague.

It has been in search of the absolute that the avant-garde has arrived at "abstract" or "nonobjective" art – and poetry, too. The avant-garde poet or artist tries in effect to imitate God by creating something valid solely on its own terms, in the way nature itself is valid, in the way a landscape – not its picture – is aesthetically valid; something *given*, increate, independent of meanings, similars or originals. Content is to be dissolved so completely into form that the work of art or literature cannot be reduced in whole or in part to anything not itself.

But the absolute is absolute, and the poet or artist, being what he is, cherishes certain relative values more than others. The very values in the name of which he invokes the absolute are relative values, the values of aesthetics. And so he turns out to be imitating, not God – and here I use "imitate" in its Aristotelian sense – but the disciplines and processes of art and literature themselves. This is the genesis of the "abstract."[1] In turning his attention away from subject matter of common experience, the poet or artist turns it in upon the medium of his own craft. The nonrepresentational or "abstract," if it is to have aesthetic validity, cannot be arbitrary and accidental, but must stem from obedience to some worthy constraint or original. This constraint, once the world of common, extraverted experience has been renounced, can only be found in the very processes or disciplines by which art and literature have already imitated the former. These themselves become the subject matter of art and literature. If, to continue with Aristotle, all art and literature are imitation, then what we have here is the imitation of imitating. To quote Yeats:

> Nor is there singing school but studying
> Monuments of its own magnificence.

Picasso, Braque, Mondrian, Miró, Kandinsky, Brancusi, even Klee, Matisse and Cézanne derive their chief inspiration from the medium they work in.[2] The excitement of their art seems to lie most of all in its pure preoccupation with the invention and arrangement of spaces, surfaces, shapes, colors, etc., to the exclusion of whatever is not necessarily implicated in these factors. The attention of poets like Rimbaud, Mallarmé, Valéry, Éluard, Pound, Hart Crane, Stevens, even Rilke and Yeats, appears to be centered on the effort to create poetry and on the "moments" themselves of poetic conversion, rather than on experience to be converted into poetry. Of course, this cannot exclude other preoccupations in

their work, for poetry must deal with words, and words must communicate. Certain poets, such as Mallarmé and Valéry,[3] are more radical in this respect than others – leaving aside those poets who have tried to compose poetry in pure sound alone. However, if it were easier to define poetry, modern poetry would be much more "pure" and "abstract." As for the other fields of literature – the definition of avant-garde aesthetics advanced here is no Procrustean bed. But aside from the fact that most of our best contemporary novelists have gone to school with the avant-garde, it is significant that Gide's most ambitious book is a novel about the writing of a novel, and that Joyce's *Ulysses* and *Finnegans Wake* seem to be, above all, as one French critic says, the reduction of experience to expression for the sake of expression, the expression mattering more than what is being expressed.

That avant-garde culture is the imitation of imitating – the fact itself – calls for neither approval nor disapproval. It is true that this culture contains within itself some of the very Alexandrianism it seeks to overcome. The lines quoted from Yeats referred to Byzantium, which is very close to Alexandria; and in a sense this imitation of imitating is a superior sort of Alexandrianism. But there is one most important difference: the avant-garde moves, while Alexandrianism stands still. And this, precisely, is what justifies the avant-garde's methods and makes them necessary. The necessity lies in the fact that by no other means is it possible today to create art and literature of a high order. To quarrel with necessity by throwing about terms like "formalism," "purism," "ivory tower" and so forth is either dull or dishonest. This is not to say, however, that it is to the *social* advantage of the avant-garde that it is what it is. Quite the opposite.

The avant-garde's specialization of itself, the fact that its best artists are artists' artists, its best poets, poets' poets, has estranged a great many of those who were capable formerly of enjoying and appreciating ambitious art and literature, but who are now unwilling or unable to acquire an initiation into their craft secrets. The masses have always remained more or less indifferent to culture in the process of development. But today such culture is being abandoned by those to whom it actually belongs – our ruling class. For it is to the latter that the avant-garde belongs. No culture can develop without a social basis, without a source of stable income. And in the case of the avant-garde, this was provided by an elite among the ruling class of that society from which it assumed itself to be cut off, but to which it has always remained attached by an umbilical cord of gold. The paradox is real. And now this elite is rapidly shrinking. Since the avant-garde forms the only living culture we now have, the survival in the near future of culture in general is thus threatened.

We must not be deceived by superficial phenomena and local successes. Picasso's shows still draw crowds, and T. S. Eliot is taught in the universities; the dealers in modernist art are still in business, and the publishers still publish some "difficult" poetry. But the avant-garde itself, already sensing the danger, is becoming more and more timid every day that passes. Academicism and commercialism are appearing in the strangest places. This can mean only one thing:

191

that the avant-garde is becoming unsure of the audience it depends on – the rich and the cultivated.

Is it the nature itself of avant-garde culture that is alone responsible for the danger it finds itself in? Or is that only a dangerous liability? Are there other, and perhaps more important, factors involved?

II

Where there is an avant-garde, generally we also find a rear-guard. True enough – simultaneously with the entrance of the avant-garde, a second new cultural phenomenon appeared in the industrial West: that thing to which the Germans give the wonderful name of *Kitsch*: popular, commercial art and literature with their chromeotypes, magazine covers, illustrations, ads, slick and pulp fiction, comics, Tin Pan Alley music, tap dancing, Hollywood movies, etc., etc. For some reason this gigantic apparition has always been taken for granted. It is time we looked into its whys and wherefores.

Kitsch is a product of the industrial revolution which urbanized the masses of Western Europe and America and established what is called universal literacy.

Prior to this the only market for formal culture, as distinguished from folk culture, had been among those who, in addition to being able to read and write, could command the leisure and comfort that always goes hand in hand with cultivation of some sort. This until then had been inextricably associated with literacy. But with the introduction of universal literacy, the ability to read and write became almost a minor skill like driving a car, and it no longer served to distinguish an individual's cultural inclinations, since it was no longer the exclusive concomitant of refined tastes.

The peasants who settled in the cities as proletariat and petty bourgeois learned to read and write for the sake of efficiency, but they did not win the leisure and comfort necessary for the enjoyment of the city's traditional culture. Losing, nevertheless, their taste for the folk culture whose background was the countryside, and discovering a new capacity for boredom at the same time, the new urban masses set up a pressure on society to provide them with a kind of culture fit for their own consumption. To fill the demand of the new market, a new commodity was devised: ersatz culture, kitsch, destined for those who, insensible to the values of genuine culture, are hungry nevertheless for the diversion that only culture of some sort can provide.

Kitsch, using for raw material the debased and academicized simulacra of genuine culture, welcomes and cultivates this insensibility. It is the source of its profits. Kitsch is mechanical and operates by formulas. Kitsch is vicarious experience and faked sensations. Kitsch changes according to style, but remains always the same. Kitsch is the epitome of all that is spurious in the life of our times. Kitsch pretends to demand nothing of its customers except their money – not even their time.

The precondition for kitsch, a condition without which kitsch would be impossible, is the availability close at hand of a fully matured cultural tradition, whose discoveries, acquisitions, and perfected self-consciousness kitsch can take advantage of for its own ends. It borrows from it devices, tricks, stratagems, rules of thumb, themes, converts them into a system, and discards the rest. It draws its life blood, so to speak, from this reservoir of accumulated experience. This is what is really meant when it is said that the popular art and literature of today were once the daring, esoteric art and literature of yesterday. Of course, no such thing is true. What is meant is that when enough time has elapsed the new is looted for new "twists," which are then watered down and served up as kitsch. Self-evidently, all kitsch is academic; and conversely, all that's academic is kitsch. For what is called the academic as such no longer has an independent existence, but has become the stuffed-shirt "front" for kitsch. The methods of industrialism displace the handicrafts.

Because it can be turned out mechanically, kitsch has become an integral part of our productive system in a way in which true culture could never be, except accidentally. It has been capitalized at a tremendous investment which must show commensurate returns; it is compelled to extend as well as to keep its markets. While it is essentially its own salesman, a great sales apparatus has nevertheless been created for it, which brings pressure to bear on every member of society. Traps are laid even in those areas, so to speak, that are the preserves of genuine culture. It is not enough today, in a country like ours, to have an inclination towards the latter; one must have a true passion for it that will give him the power to resist the faked article that surrounds and presses in on him from the moment he is old enough to look at the funny papers. Kitsch is deceptive. It has many different levels, and some of them are high enough to be dangerous to the naive seeker of true light. A magazine like *The New Yorker*, which is fundamentally high-class kitsch for the luxury trade, converts and waters down a great deal of avant-garde material for its own uses. Nor is every single item of kitsch altogether worthless. Now and then it produces something of merit, something that has an authentic folk flavor; and these accidental and isolated instances have fooled people who should know better.

Kitsch's enormous profits are a source of temptation to the avant-garde itself, and its members have not always resisted this temptation. Ambitious writers and artists will modify their work under the pressure of kitsch, if they do not succumb to it entirely. And then those puzzling borderline cases appear, such as the popular novelist, Simenon, in France, and Steinbeck in this country. The net result is always to the detriment of true culture, in any case.

Kitsch has not been confined to the cities in which it was born, but has flowed out over the countryside, wiping out folk culture. Nor has it shown any regard for geographical and national-cultural boundaries. Another mass product of Western industrialism, it has gone on a triumphal tour of the world, crowding out and defacing native cultures in one colonial country after another, so that it is now by way of becoming a universal culture, the first universal culture ever beheld. Today

193

the native of China, no less than the South American Indian, the Hindu, no less than the Polynesian, have come to prefer to the products of their native art, magazine covers, rotogravure sections and calendar girls. How is this virulence of kitsch, this irresistible attractiveness, to be explained? Naturally, machine-made kitsch can undersell the native handmade article, and the prestige of the West also helps; but why is kitsch a so much more profitable export article than Rembrandt? One, after all, can be reproduced as cheaply as the other.

In his last article on the Soviet cinema in the *Partisan Review*, Dwight Macdonald points out that kitsch has in the last ten years become the dominant culture in Soviet Russia. For this he blames the political regime – not only for the fact that kitsch is the official culture, but also that it is actually the dominant, most popular culture, and he quotes the following from Kurt London's *The Seven Soviet Arts:* "... the attitude of the masses both to the old and new art styles probably remains essentially dependent on the nature of the education afforded them by their respective states." Macdonald goes on to say: "Why after all should ignorant peasants prefer Repin (a leading exponent of Russian academic kitsch in painting) to Picasso, whose abstract technique is at least as relevant to their own primitive folk art as is the former's realistic style? No, if the masses crowd into the Tretyakov (Moscow's museum of contemporary Russian art: kitsch), it is largely because they have been conditioned to shun 'formalism' and to admire 'socialist realism.'"

In the first place it is not a question of a choice between merely the old and merely the new, as London seems to think – but of a choice between the bad, up-to-date old and the genuinely new. The alternative to Picasso is not Michelangelo, but kitsch. In the second place, neither in backward Russia nor in the advanced West do the masses prefer kitsch simply because their governments condition them toward it. Where state educational systems take the trouble to mention art, we are told to respect the old masters, not kitsch; and yet we go and hang Maxfield Parrish or his equivalent on our walls, instead of Rembrandt and Michelangelo. Moreover, as Macdonald himself points out, around 1925 when the Soviet regime was encouraging avant-garde cinema, the Russian masses continued to prefer Hollywood movies. No, "conditioning" does not explain the potency of kitsch.

All values are human values, relative values, in art as well as elsewhere. Yet there does seem to have been more or less of a general agreement among the cultivated of mankind over the ages as to what is good art and what bad. Taste has varied, but not beyond certain limits; contemporary connoisseurs agree with the eighteenth-century Japanese that Hokusai was one of the greatest artists of his time; we even agree with the ancient Egyptians that Third and Fourth Dynasty art was the most worthy of being selected as their paragon by those who came after. We may have come to prefer Giotto to Raphael, but we still do not deny that Raphael was one of the best painters of his time. There has been an agreement then, and this agreement rests, I believe, on a fairly constant distinction made between those values only to be found in art and the values which can be found elsewhere.

Kitsch, by virtue of a rationalized technique that draws on science and industry, has erased this distinction in practice.

Let us see, for example, what happens when an ignorant Russian peasant such as Macdonald mentions stands with hypothetical freedom of choice before two paintings, one by Picasso, the other by Repin. In the first he sees, let us say, a play of lines, colors and spaces that represent a woman. The abstract technique – to accept Macdonald's supposition, which I am inclined to doubt – reminds him somewhat of the icons he has left behind him in the village, and he feels the attraction of the familiar. We will even suppose that he faintly surmises some of the great art values the cultivated find in Picasso. He turns next to Repin's picture and sees a battle scene. The technique is not so familiar – as technique. But that weighs very little with the peasant, for he suddenly discovers values in Repin's picture that seem far superior to the values he has been accustomed to find in icon art; and the unfamiliar itself is one of the sources of those values: the values of the vividly recognizable, the miraculous and the sympathetic. In Repin's picture the peasant recognizes and sees things in the way in which he recognizes and sees things outside of pictures – there is no discontinuity between art and life, no need to accept a convention and say to oneself, that icon represents Jesus because it intends to represent Jesus, even if it does not remind me very much of a man. That Repin can paint so realistically that identifications are self-evident immediately and without any effort on the part of the spectator – that is miraculous. The peasant is also pleased by the wealth of self-evident meanings which he finds in the picture: "it tells a story." Picasso and the icons are so austere and barren in comparison. What is more, Repin heightens reality and makes it dramatic: sunset, exploding shells, running and falling men. There is no longer any question of Picasso or icons. Repin is what the peasant wants, and nothing else but Repin. It is lucky, however, for Repin that the peasant is protected from the products of American capitalism, for he would not stand a chance next to a *Saturday Evening Post* cover by Norman Rockwell.

Ultimately, it can be said that the cultivated spectator derives the same values from Picasso that the peasant gets from Repin, since what the latter enjoys in Repin is somehow art too, on however low a scale, and he is sent to look at pictures by the same instincts that send the cultivated spectator. But the ultimate values which the cultivated spectator derives from Picasso are derived at a second remove, as the result of reflection upon the immediate impression left by the plastic values. It is only then that the recognizable, the miraculous and the sympathetic enter. They are not immediately or externally present in Picasso's painting, but must be projected into it by the spectator sensitive enough to react sufficiently to plastic qualities. They belong to the "reflected" effect. In Repin, on the other hand, the "reflected" effect has already been included in the picture, ready for the spectator's unreflective enjoyment.[4] Where Picasso paints *cause*, Repin paints *effect*. Repin predigests art for the spectator and spares him effort, provides him with a short cut to the pleasure of art that detours what is necessarily difficult in genuine art. Repin, or kitsch, is synthetic art.

The same point can be made with respect to kitsch literature: it provides vicarious experience for the insensitive with far greater immediacy than serious fiction can hope to do. And Eddie Guest and the *Indian Love Lyrics* are more poetic than T. S. Eliot and Shakespeare.

III

If the avant-garde imitates the processes of art, kitsch, we now see, imitates its effects. The neatness of this antithesis is more than contrived; it corresponds to and defines the tremendous interval that separates from each other two such simultaneous cultural phenomena as the avant-garde and kitsch. This interval, too great to be closed by all the infinite gradations of popularized "modernism" and "modernistic" kitsch, corresponds in turn to a social interval, a social interval that has always existed in formal culture, as elsewhere in civilized society, and whose two termini converge and diverge in fixed relation to the increasing or decreasing stability of the given society. There has always been on one side the minority of the powerful – and therefore the cultivated – and on the other the great mass of the exploited and poor – and therefore the ignorant. Formal culture has always belonged to the first, while the last have had to content themselves with folk or rudimentary culture, or kitsch.

In a stable society that functions well enough to hold in solution the contra-dictions between its classes, the cultural dichotomy becomes somewhat blurred. The axioms of the few are shared by the many; the latter believe superstitiously what the former believe soberly. And at such moments in history the masses are able to feel wonder and admiration for the culture, on no matter how high a plane, of its masters. This applies at least to plastic culture, which is accessible to all.

In the Middle Ages the plastic artist paid lip service at least to the lowest common denominators of experience. This even remained true to some extent until the seventeenth century. There was available for imitation a universally valid conceptual reality, whose order the artist could not tamper with. The subject matter of art was prescribed by those who commissioned works of art, which were not created, as in bourgeois society, on speculation. Precisely because his content was determined in advance, the artist was free to concentrate on his medium. He needed not to be philosopher, or visionary, but simply artificer. As long as there was general agreement as to what were the worthiest subjects for art, the artist was relieved of the necessity to be original and inventive in his "matter" and could devote all his energy to formal problems. For him the medium became, privately, professionally, the content of his art, even as his medium is today the public content of the abstract painter's art – with that difference, however, that the medieval artist had to suppress his professional preoccupation in public – had always to suppress and subordinate the personal and professional in the finished,

official work of art. If, as an ordinary member of the Christian community, he felt some personal emotion about his subject matter, this only contributed to the enrichment of the work's public meaning. Only with the Renaissance do the inflections of the personal become legitimate, still to be kept, however, within the limits of the simply and universally recognizable. And only with Rembrandt do "lonely" artists begin to appear, lonely in their art.

But even during the Renaissance, and as long as Western art was endeavoring to perfect its technique, victories in this realm could only be signalized by success in realistic imitation, since there was no other objective criterion at hand. Thus the masses could still find in the art of their masters objects of admiration and wonder. Even the bird that pecked at the fruit in Zeuxis' picture could applaud.

It is a platitude that art becomes caviar to the general when the reality it imitates no longer corresponds even roughly to the reality recognized by the general. Even then, however, the resentment the common man may feel is silenced by the awe in which he stands of the patrons of this art. Only when he becomes dissatisfied with the social order they administer does he begin to criticize their culture. Then the plebeian finds courage for the first time to voice his opinions openly. Every man, from the Tammany alderman to the Austrian house-painter, finds that he is entitled to his opinion. Most often this resentment toward culture is to be found where the dissatisfaction with society is a reactionary dissatisfaction which expresses itself in revivalism and puritanism, and latest of all, in fascism. Here revolvers and torches begin to be mentioned in the same breath as culture. In the name of godliness or the blood's health, in the name of simple ways and solid virtues, the statue-smashing commences.

IV

Returning to our Russian peasant for the moment, let us suppose that after he has chosen Repin in preference to Picasso, the state's educational apparatus comes along and tells him that he is wrong, that he should have chosen Picasso – and shows him why. It is quite possible for the Soviet state to do this. But things being as they are in Russia – and everywhere else – the peasant soon finds that the necessity of working hard all day for his living and the rude, uncomfortable circumstances in which he lives do not allow him enough leisure, energy and comfort to train for the enjoyment of Picasso. This needs, after all, a considerable amount of "conditioning." Superior culture is one of the most artificial of all human creations, and the peasant finds no "natural" urgency within himself that will drive him toward Picasso in spite of all difficulties. In the end the peasant will go back to kitsch when he feels like looking at pictures, for he can enjoy kitsch without effort. The state is helpless in this matter and remains so as long as the problems of production have not been solved in a socialist sense. The same holds

true, of course, for capitalist countries and makes all talk of art for the masses there nothing but demagogy.[5]

Where today a political regime establishes an official cultural policy, it is for the sake of demagogy. If kitsch is the official tendency of culture in Germany, Italy and Russia, it is not because their respective governments are controlled by philistines, but because kitsch is the culture of the masses in these countries, as it is everywhere else. The encouragement of kitsch is merely another of the inexpensive ways in which totalitarian regimes seek to ingratiate themselves with their subjects. Since these regimes cannot raise the cultural level of the masses – even if they wanted to – by anything short of a surrender to international socialism, they will flatter the masses by bringing all culture down to their level. It is for this reason that the avantgarde is outlawed, and not so much because a superior culture is inherently a more critical culture. (Whether or not the avant-garde could possibly flourish under a totalitarian regime is not pertinent to the question at this point.) As a matter of fact, the main trouble with avant-garde art and literature, from the point of view of fascists and Stalinists, is not that they are too critical, but that they are too "innocent," that it is too difficult to inject effective propaganda into them, that kitsch is more pliable to this end. Kitsch keeps a dictator in closer contact with the "soul" of the people. Should the official culture be one superior to the general mass-level, there would be a danger of isolation.

Nevertheless, if the masses were conceivably to ask for avant-garde art and literature, Hitler, Mussolini and Stalin would not hesitate long in attempting to satisfy such a demand. Hitler is a bitter enemy of the avant-garde, both on doctrinal and personal grounds, yet this did not prevent Goebbels in 1932–1933 from strenuously courting avant-garde artists and writers. When Gottfried Benn, an Expressionist poet, came over to the Nazis he was welcomed with a great fanfare, although at that very moment Hitler was denouncing Expressionism as *Kulturbolschewismus*. This was at a time when the Nazis felt that the prestige which the avant-garde enjoyed among the cultivated German public could be of advantage to them, and practical considerations of this nature, the Nazis being skillful politicians, have always taken precedence over Hitler's personal inclinations. Later the Nazis realized that it was more practical to accede to the wishes of the masses in matters of culture than to those of their paymasters; the latter, when it came to a question of preserving power, were as willing to sacrifice their culture as they were their moral principles; while the former, precisely because power was being withheld from them, had to be cozened in every other way possible. It was necessary to promote on a much more grandiose style than in the democracies the illusion that the masses actually rule. The literature and art they enjoy and understand were to be proclaimed the only true art and literature and any other kind was to be suppressed. Under these circumstances people like Gottfried Benn, no matter how ardently they support Hitler, become a liability; and we hear no more of them in Nazi Germany.

We can see then that although from one point of view the personal philistinism of Hitler and Stalin is not accidental to the political roles they play, from another point of view it is only an incidentally contributory factor in determining the cultural policies of their respective regimes. Their personal philistinism simply adds brutality and double-darkness to policies they would be forced to support anyhow by the pressure of all their other policies – even were they, personally, devotees of avant-garde culture. What the acceptance of the isolation of the Russian Revolution forces Stalin to do, Hitler is compelled to do by his acceptance of the contradictions of capitalism and his efforts to freeze them. As for Mussolini – his case is a perfect example of the *disponibilité* of a realist in these matters. For years he bent a benevolent eye on the Futurists and built modernistic railroad stations and government-owned apartment houses. One can still see in the suburbs of Rome more modernistic apartments than almost anywhere else in the world. Perhaps Fascism wanted to show its up-to-dateness, to conceal the fact that it was a retrogression; perhaps it wanted to conform to the tastes of the wealthy elite it served. At any rate Mussolini seems to have realized lately that it would be more useful to him to please the cultural tastes of the Italian masses than those of their masters. The masses must be provided with objects of admiration and wonder; the latter can dispense with them. And so we find Mussolini announcing a "new Imperial style." Marinetti, Chirico, et al., are sent into the outer darkness, and the new railroad station in Rome will not be modernistic. That Mussolini was late in coming to this only illustrates again the relative hesitancy with which Italian Fascism has drawn the necessary implications of its role.

Capitalism in decline finds that whatever of quality it is still capable of producing becomes almost invariably a threat to its own existence. Advances in culture, no less than advances in science and industry, corrode the very society under whose aegis they are made possible. Here, as in every other question today, it becomes necessary to quote Marx word for word. Today we no longer look toward socialism for a new culture – as inevitably as one will appear, once we do have socialism. Today we look to socialism *simply* for the preservation of whatever living culture we have right now.

Notes

1 The example of music, which has long been an abstract art, and which avant-garde poetry has tried so much to emulate, is interesting. Music, Aristotle said curiously enough, is the most imitative and vivid of all arts because it imitates its original – the state of the soul – with the greatest immediacy. Today this strikes us as the exact opposite of the truth, because no art seems to us to have less reference to something outside itself than music. However, aside from the fact that in a sense Aristotle may still be right, it must be explained that ancient Greek music was closely associated with poetry, and depended upon its character as an accessory to verse to make its imitative

meaning clear. Plato, speaking of music, says: "For when there are no words, it is very difficult to recognize the meaning of the harmony and rhythm, or to see that any worthy object is imitated by them." As far as we know, all music originally served such an accessory function. Once, however, it was abandoned, music was forced to withdraw into itself to find a constraint or original. This is found in the various means of its own composition and performance.

2 I owe this formulation to a remark made by Hans Hofmann, the art teacher, in one of his lectures. From the point of view of this formulation, Surrealism in plastic art is a reactionary tendency which is attempting to restore "outside" subject matter. The chief concern of a painter like Dali is to represent the processes and concepts of his consciousness, not the processes of his medium.

3 See Valéry's remarks about his own poetry.

4 T. S. Eliot said something to the same effect in accounting for the shortcomings of English Romantic poetry. Indeed the Romantics can be considered the original sinners whose guilt kitsch inherited. They showed kitsch how. What does Keats write about mainly, if not the effect of poetry upon himself?

5 It will be objected that such art for the masses as folk art was developed under rudimentary conditions of production – and that a good deal of folk art is on a high level. Yes, it is – but folk art is not Athene, and it's Athene whom we want: formal culture with its infinity of aspects, its luxuriance, its large comprehension. Besides, we are now told that most of what we consider good in folk culture is the static survival of dead formal, aristocratic, cultures. Our old English ballads, for instance, were not created by the "folk," but by the post-feudal squirearchy of the English countryside, to survive in the mouths of the folk long after those for whom the ballads were composed had gone on to other forms of literature. Unfortunately, until the machine-age, culture was the exclusive prerogative of a society that lived by the labor of serfs or slaves. They were the real symbols of culture. For one man to spend time and energy creating or listening to poetry meant that another man had to produce enough to keep himself alive and the former in comfort. In Africa today we find that the culture of slave-owning tribes is generally much superior to that of the tribes that possess no slaves.

19

Modernism in the *Work* of Art

Victor Burgin[1]

Mukarovsky, in 1934,[2] saw among the pitfalls awaiting the art theorist with no grasp of semiology, 'the temptation to treat the work of art as a purely formal construction'. Today, nevertheless, the tendency to apply semiotic theory to visual art in the direction of a 'poetics' has flowed into an easy confluence with the existing mainstream of 'Modernist' criticism, focused on the internal life of the autonomous object. Mukarovsky's requirement that theory should 'grasp the development of art as an immanent movement which also has a constant dialectical relation to the development of the other domains of culture', remains unfulfilled.

It is worth looking again at Modernism in its relation to other visual art in the modern period in order to return it to its own position in the history of art *practice*, its place in the social production of meaning. It is worth considering whether Russian Formalism, the object of much interest in recent aesthetic theory, may be assimilated to Modernism as simply as has occasionally been implied; and whether to abandon the Modernist programme would indeed be to revert to 'representationalism', losing the ground won by visual art in the modern period (as is often assumed). The term 'Modernism' here is to be understood by reference to Clement Greenberg's writings as it is these which, *de facto*, constitute the locus of present Modernism in the visual arts.

I

A siege condition for culture is described in Clement Greenberg's 1939 essay 'Avant-Garde and Kitsch'.[3] He argues: Western culture is in crisis; before the

Victor Burgin, "Modernism in the *Work* of Art" (originally published in 1976), pp. 1–16, 23–8, 205–8 (notes) from Victor Burgin, *The End of Art Theory: Criticism and Postmodernity.* Atlantic Highlands, NJ: Humanities Press International, 1986. Reprinted by permission of Palgrave Macmillan.

modern period such crises of established values led to artistic academicism, a petrification of culture. In this present crisis, however, the unprecedented phenomenon of the avant-garde promises to 'keep culture moving'[4] by raising art to 'the expression of an absolute in which all relativities and contradictions would be either resolved or beside the point',[5] this it will accomplish by eschewing the world of 'ideological confusion and violence'.[6] Contemporaneously with the emergence of the avant-garde: 'the new urban masses set up a pressure on society to provide them with a kind of culture fit for their own consumption . . . a new commodity was devised: ersatz culture, kitsch, destined for those . . . insensible to the values of genuine culture'.[7] In kitsch, 'there is no discontinuity between art and life'.[8] Whereas the values of avant-garde art are a reflection of values 'projected' by the 'cultivated' observer, the values of kitsch are 'included' in the art object, to be instantly available for 'unreflective enjoyment' – 'Picasso paints *cause*, Repin paints *effect*'.[9] Because kitsch is so undemanding, it is the most in demand; a demand to which Hitler and Stalin alike must accede, regardless of their personal tastes. Dictators, of political necessity, must flatter the masses by 'bringing all culture down to their level'.[10] The cultural level of the masses cannot be raised within existing, capitalist, modes of production; only a socialist solution to the problems of production could grant the majority the leisure necessary to the appreciation of avant-garde art. However, the exigencies of 1939 demand that socialism be appealed to not for a new culture but, '*simply* for the preservation of whatever living culture we have right now'.[11]

At the most immediate level, Greenberg's essay is to be read as a protest at the growth of totalitarian philistinism prior to the Second World War. However, that he considers the threat to 'true' culture to be mass culture in general is clear from his indiscriminate use of the term 'kitsch'. An example of what today we might call kitsch is given by Tocqueville. He describes arriving in New York by the East River and being 'surprised to perceive along the shore, at some distance from the city, a number of little palaces of white marble, several of which were of classical architecture'. He continues, 'When I went the next day to inspect more closely one which had particularly attracted my notice, I found that the walls were of whitewashed brick, and its columns of painted wood'.[12]

There is more here than that absence of 'truth to materials' deplored by Morris and, after him, the Bauhaus. It is a defining attribute of kitsch that its styles should be derivative of established 'high' culture. In kitsch, the content most likely to succeed is presented in the form most likely to inspire respect, thus Greenberg refers to 'the faked article' and 'debased and academicised simulacra'. Greenberg is therefore correct in applying the term 'kitsch' to the official art of Russia, Germany, and Italy in the 1930s, where sentimental and propagandistic contents were pretentiously presented in conventionally 'artistic' dress. However, he also speaks of 'that thing to which the Germans give the wonderful name of *Kitsch*: popular, commercial art and literature with their chromeotype, magazine covers, illustrations, ads, slick and pulp fiction, comics, Tin Pan Alley music, tap dancing. Hollywood movies, etc., etc.' Here, all manifestations of mass culture

whatsoever are damned by association with kitsch as 'ersatz culture' in a clean sweep so broad that all that remains as 'genuine culture', 'true culture', 'superior culture', is 'art and literature of a high order'.[13]

Greenberg gives no indication of the nature of 'genuine' culture that is not a truistic assertion; there is, however, a clear echo in his essay of that definition of culture as 'the best of what has been thought and written'. As Raymond Williams has described,[14] it was the impact of industry and democracy in the nineteenth century which gave rise to a conception of culture as something separate from and 'above' society. The ideas of 'culture in opposition' variously expressed by such members of the Victorian intelligentsia as Arnold, Morris and Ruskin, were formed through their practical criticism of the social realities of their day. By degrees, however, the notion of culture as a repository of ideal values became a means not of criticising the world, but of evading it. What is nowhere apparent in Greenberg's essay is that, at the time he was writing, the notion of 'high' culture, given *a priori*, had been very widely repudiated in art practice both in America and in Europe. The sense of popular cultural identity which had emerged in the US during the 1920s was confirmed with the creation, in 1935, of the Federal Art Project section of the Works Progress Administration (renamed Works Project Administration in 1939). Established as part of the New Deal, at the time when ten million Americans were unemployed, the WPA/FAP set out to employ artists *as* artists in the full-scale production of a democratic mass culture.[15] Holger Cahill, National Director of the WPA/FAP, wrote in 1939:

> During the past seventy-five years there developed in this country a tremendous traffic in aesthetic fragments torn from their social background, but trailing clouds of aristocratic glories. Fully four-fifths of our art patronage has been devoted to it. [He complains] people who would lay down their lives for political democracy would scarcely raise a finger for democracy in the arts. They say that ... you cannot get away from aristocracy in matters of aesthetic selection ... that art is too rare and fine to be shared with the masses.[16]

With WPA, a previously élite group of culture producers oriented itself to mass society. Again in 1939, the year that 'Avant-Garde and Kitsch' appeared, the painter Stuart Davis made this defence of abstract art:

> In addition to its effect on the design of clothes, autos, architecture, magazine and advertising layout, five-and-ten-cent-store utensils, and all industrial products, abstract painting has given concrete artistic formulation to the new lights, speeds, and spaces which are uniquely real in our time. That is why I say that abstract art is a progressive social force.

Davis is contemptuous of American social realism ('the chicken yard, the pussy cat, the farmer's wife, the artist's model'), but his critique is not made in the name of timeless cultural values:

> I call the expression of domestic naturalism static. The expression remains static even in the class-struggle variety of domestic naturalism, because although the ideological theme affirms a changing society, the ideographic presentation proves a complete inability to visualise the reality of change.[17]

The dominant tendency within the WPA/FAP was documentary and didactic. The Federal Theatre staged documentary plays, 'Living Newspapers', in which the specific sources of the facts they presented were scrupulously footnoted. As part of the Federal Writers' Project the American Guide Series was produced, a combination of road guide and local history: 'a majestic roll call of national failure, a terrible and yet engaging corrective to the success stories that dominate our literature'.[18] 'Informant narratives' were commissioned, autobiographical accounts by 'ordinary' people. Such projects overlapped those of other WPA departments, notably the Farm Security Administration (FSA) programme of economic agitation on behalf of Southern tenant farmers, for which teams of writers and photographers were employed.

In America in the inter-war years 'art' approached a dismantling of the differentiation between 'high' and 'low' culture *in practice*; in ideology, however, this fact was not recognised. The documentary movement took place within clearly demarcated institutional spaces (Ben Shahn, for example, made photographs for the FSA and paintings, on the basis of the photographs, for the FAP); to adopt Benjamin's terminology,[19] US artists supplied the existing apparatus of production. European artists had already attempted to change it, and in so doing had attacked those distinctions between 'high' art and 'mass' art which had a technological base. After the First World War, avant-garde visual art practice in Europe became divided between that in which the notion of élite culture remained implicit, and that in which it was explicitly rejected. A characteristic response of artists opposed to what they saw as the class character of 'high' culture was to abandon those modes of artistic production historically most closely associated with it. Not surprisingly, this response was the most programmatic in Russia during the immediate post-revolutionary period where, by 1920, the *Lef* group of ex-Futurists and Formalists had rejected the aestheticising tendencies of 'laboratory art' (for example, Malevich, Gabo) in which the object was proclaimed as an end in itself, and had outlined the objectives of 'production art'. Alexei Gan wrote in 'Constructivism' (1922): 'Painting, sculpture, theatre, these are the material forms of the bourgeois capitalist aesthetic culture which satisfies the 'spiritual' demands of the consumer of a disorganised social order...(the constructivist) must be a Marxist-educated man who has once and for all outlived art and really advanced on industrial materials'.[20] Mayakovsky wrote: 'One of the slogans, one of the great achievements of *Lef* – the de-aestheticisation of the productional arts, Constructivism. A poetic supplement: agit-art and economic agitation: the advertisement'.[21]

While some *Lef* artists (for example, Tatlin, Popova) entered industry as designers, others embraced 'mass media'. Such an engagement had begun during

the massive propaganda and education effort of the civil war period (1917–21): 'The traditional book was, one might say, divided into separate pages, enlarged a hundred-fold, painted in brighter colours and hung up in the streets as posters. Unlike the American poster ours was not planned to be taken in at a single glance from the window of a passing car, it was meant to be read and digested at close range'.[22] With the return of 'private enterprise' under Lenin's New Economic Policy (1921), such propaganda efforts were carried into the economic sphere. In an attempt to attract people to state shops and goods, the *Agitreklama* group was formed (supervised by Mayakovsky and including Rodchenko) to produce both political and commercial posters.[23] By the late 1920s there emerged, amongst those concerned to find a way between aestheticism and utilitarianism, a demand for an 'art of fact'. The attack on traditional technologies and formats was reiterated:

> To the easel painting, which supposedly functions as 'a mirror of reality', *Lef* opposes the photograph – a more accurate, rapid, and objective means of fixing fact. To the easel painting – claimed to be a permanent source of agit – *Lef* opposes the placard, which is topical, designed and adapted for the street, the newspaper and the demonstration, and which hits the emotions with the sureness of artillery fire. In literature, to *belles lettres* and the related claim to 'reflection' *Lef* opposes reportage – 'factography' – which breaks with literary traditions and moves entirely into the field of publicism to serve the newspaper and the journal.[24]

The artistic developments within Russia which culminated in the call for 'factography' may be seen as quite continuous with the tendencies of Futurism, and coherent with Mayakovsky's prerevolutionary demand that the classics be 'cast from the steamboat of modernity'. They are therefore not to be simplistically interpreted as an attempt to accommodate political pressure. Moreover, the factographic tendency emerged independently in various international centres during the same period. As noted above, in America documentary was to become the dominant aesthetic mode of the 1930s, and there is a *Lef* sentiment, albeit a less than *Lef* conviction, in these words of the supervisor of a Chicago WPA programme: 'The poster, serving the public, is readily understandable to the man on the street. While it may go through phases in its healthy growth, it is free from the many isms that infest the allied arts . . . The poster performs the same service as the newspaper, the radio, and the movies, and is as powerful an organ of information, at the same time providing an enjoyable visual experience.'[25] In the 1920s, however, it was in Germany that the move towards an art of fact was, outside of Russia, the most pronounced. It was in Germany also that the use of photography in this move was to become the most technically developed.

Tocqueville had remarked. 'In aristocratic countries a few great pictures are produced; in democratic countries a vast number of insignificant ones'.[26] Cheaply available, photography had early fulfilled the need for large numbers of 'insignificant' pictures – family portraits, view postcards, and so on. Photography became

more significantly a 'mass medium' however, with the rapid expansion of photo-journalism in Germany, where photographically illustrated magazines were first developed, and where they had become an established success by the early 1920s.[27]

Technological developments in Germany allowed the transition from 'press photography' to 'photo-journalism': the Ermanox and the Leica cameras both appeared on the market, in small numbers, in 1924 and 1925 respectively. The Leica, a technological by-product of the film industry, incorporated technical features adapted from ciné-cameras to create a small camera, quick and easy to use, the most prominent of its advantages being its replacement of the single-exposure photographic plate by multi-exposure roll film (movie film). The Ermanox, although a plate camera which had to be used with a tripod, coupled an extraordinarily 'fast' lens (1.8, against the Leica's 3.5) with a very sensitive panchromatic plate (a relatively small one, 4½ × 6 cm), making it possible to photograph subjects in 'available light' (for example, by ordinary electric light) without the use of flash. Such new tools, used by photographers like Salomon, Man and Eisenstaedt, helped establish the idea, prevalent in the 1920s, of the camera as the representative instrument of the age.[28]

It was the phenomenological surface of industrial society to which the camera seemed to offer unprecedented access, and it is this which was celebrated in the earliest photomontages of avant-garde. Moholy-Nagy:

> In the photographic camera we have the most reliable aid to the beginning of objective vision. Everyone will be compelled to see that which is optically true, is explicable in its own terms before he can arrive at any subjective position. This will abolish that pictorial and imaginative association pattern which has remained unsuperseded for centuries and which has been stamped upon our vision by great individual painters.[29]

Vertov too had insisted on the *differences* between the world seen by the eye and the (more actual) world capable of being presented by the camera: 'The position of our bodies at the moment of observation, the number of features perceived by us in one or another visual phenomenon in one second of time is not at all binding on the film camera'.[30] Early attempts to formulate a theory of montage in the cinema had carried implications for still photography which ran counter to the conventional wisdom in which it was held to be a 'transparent' medium of representation. For example, Kuleshov's experiments with Mozhukin, in which the same shot of the actor's impassive face was successfully juxtaposed with shots of a variety of objective situations, rebuffed the naturalist idea of photographic portraits as 'mirrors of the soul' – the audience read a different expression in the face for each successive juxtaposition. Further experiments with the actor Polonsky confirmed, in Kuleshov's words, 'this property of montage to override the actor's performance'.[31]

206

Kuleshov's experiments took place between 1916 and 1917. It is unlikely that they were known to the Berlin Dadaists whose work with montage began about the same time, nevertheless, there was a general, international, interest in 'filmic' construction then. Hausmann speaks of, 'the application of the photograph and printed texts which, together transform themselves into static film'.[32] Lissitsky wrote in 'The typography of typography' (1923), 'Printed words are seen and not heard . . . A sequence of pages is a cinématographic book'.[33] Szymon Bojko has cited the graphic artist S. Telingater attempting, in 1923, 'a bioscopic book', a 'ciné book' which could be read and viewed simultaneously – one in which the sequence of pages and pictures would be reminiscent of moving picture frames'.[34] Stott reports: 'Archibald MacLeish called his prose-poem accompanying FSA photographs in *Land of the Free* (1938) a "Sound Track"'.[35]

The 'layout' of the photomagazine had gone some way towards fulfilling Brecht's demand for 'something set up, something *constructed*' in photography; in the transition in Germany from *Dada* to *Tendenzkunst*, photomontage went further. Hausmann:

> Photomontage allows the elaboration of the most dialectical formulas, by virtue of its oppositions of scale and structure. . . . Its domain of application is above all that of political propaganda and commercial publicity. The clarity necessarily demanded of political or commercial slogans increasingly influences its means of counterposing the most arresting contrasts, expelling whims of intuition.[36]

John Heartfield's work for *AIZ* was almost entirely responsible for liberating photomontage from the formulas of cubism, futurism, and 'cinématic' construction. It is probable that he learned from the surrealists (Aragon judged that Heartfield, 'superseded the best in that which was attempted in modern art, with the cubists, in that lost way of mystery in the everyday').[37] Heartfield turned the affectivity that surrealist images derive from their unresolved status in respect of fantasy and reality upon the cognition of an actual material condition of the world.

The factographic tendency in art did not survive the 1930s in any strong way. In 1932 the central committee of the CPSU dissolved all existing writers' and artists' associations in order to establish a single union of Soviet writers and analogous bodies for the other arts. It was at this time that the notion of Socialist Realism as such appears, and from this time that the Stalin/Zhdanov line was rigorously enforced. In 1933 Hitler became Chancellor of the German Reich. The Communist party was banned and *AIZ* published its last Berlin issue in February, its editors escaping to Prague, Heartfield among them, to continue publishing as *Volks-Illustrierte* until 1936.

The various WPA arts projects were all eroded during the war years or before (the WPA was officially liquidated in 1943) due to practical exigencies brought about by the war itself, but due also to repeated attacks by an increasingly conservative coalition in Congress. (Appropriations for the Federal Theatre Project, for example, were abruptly cut off as the result of a House Committee on

unAmerican Activities report in January 1939 that, 'a rather large number of employees on the Federal Theatre project are either members of the Communist Party or are sympathetic to the Communist Party'.[38])

II

Anyone aware of the 'factographic' visual art practice of the interwar years in Eastern and Western Europe and America, must be struck by the way Greenberg writes as if it had never taken place. Quite simply, within Greenberg's scheme of things, there is no *place* for it. In 'Avant-Garde and Kitsch' it is stated that, beleaguered by mass culture, the ranks of art are to be reformed around 'those values only to be found in art'. That such values exist, and that they are purely formal, is taken as self-evident. Thus the proper programme of artistic endeavour is simply established: 'Content is to be dissolved so completely into form that the work of art or literature cannot be reduced in whole or in part to anything not itself,... subject matter or content becomes something to be avoided like a plague'.[39]

In this, Greenberg's Modernism bears a close resemblance to the formalism of Roger Fry and Clive Bell. Fry attempted to extract from the work of Cézanne basic principles which could, retrospectively, be discovered in all previous painting. His interpretation of Cézanne was formed from his knowledge of the Cubists, of whom he said (1912): 'The logical extreme of such a method would undoubtedly be the attempt to give up all resemblance to natural form, and to create a purely abstract language of form – a visual music'.[40] In the same year, Bell wrote: 'To appreciate a work of art we need bring with us nothing but a sense of form and colour and a knowledge of three-dimensional space' (adding the qualification, 'the representation of three-dimensional space is neither irrelevant nor essential to all art, ... every other sort of representation is irrelevant'). And he goes on to complain of those who, 'treat created form as though it were imitated form, a picture as though it were a photograph'.[41]

Formalism is typically defined in opposition to realism. In classic realism there is assumed an unmediated presentation of the referent through the sign (unmediated that is save for 'noise' in the physical channel of communication – problems of technique exercised in the interests of conformity to some prevailing model of reality). Realism is primarily 'about' content and major debates within realism concern subject matter alone (witness the recurring 'crisis of content' in nineteenth century painting).

With the hindsight granted us by Saussure we can today see that classic realism rests on a mistaken concept of signification: the sign is assumed to be 'transparent', allowing unproblematical access to the referent (effectively the same error is committed in naïve expression theory). Cubism we can see as constituting a radical critique of realism, a practice compatible with a recognition of the dis-

junction of signifier and signified within the sign. Post-Cubist Western formalism however did not develop as a scientific aesthetics based upon a critique of the sign, but rather as a normative aesthetics based upon a notion of territoriality. Greenberg's formalism is in direct line of descent from the attempt by Bell and Fry to 'free' art from concerns not 'peculiarly its own'. With Bell, recourse is made to a Kantian ontology (a *noumenal* world 'behind' mere appearances) in order to justify abstraction, whereas Greenberg (albeit a self-avowed Kantian: 'I conceive of Kant as the first real Modernist') claims that the Modernist art object denotes nothing other than itself: 'Thus would each art be rendered "pure", and in its "purity" find the guarantee of its standards of quality as well as of its independence'.[42]

As both support an immanent analysis of art, Greenberg's ideas and those of the Russian Formalists have of late tended to be associated as similar; but there are some important differences. Attacking Symbolism, the Formalists rejected the Symbolist idea of form in which form the perceivable, was conceived in opposition to content, the intelligible. They extended the notion of form to cover all aspects of a work. Todorov:

> The Symbolists tended to divide the literary product into form (i.e. sound), which was vital and content (i.e. ideas), which was external to art. The Formalist approach was completely opposed to this aesthetic appreciation of 'pure form'. They no longer saw form as opposed to some other internal element of a work of art (normally its content) and began to conceive it as the totality of the work's various components...This makes it essential to realise that the form of a work is not its only formal element: its content may equally well be formal.[43]

Russian Formalism therefore differs substantively in this from the formalism of Bell and Fry, and from Greenberg's Modernism, in which all considerations of content are arbitrarily banished in a quasi-legal ruling.

Russian Formalism again differs importantly from Modernism in its attitude to 'tradition'. Greenberg: 'Lacking the past of art and the need and compulsion to maintain its standards of excellence, Modernist art would lack both substance and justification'.[44] This statement could serve as a prescription for academicism; in 'Avant-Garde and Kitsch' he had written, 'avant-garde culture is a superior sort of Alexandrianism. But there is one important difference: the avant-garde moves, while Alexandrianism stands still. And this, precisely, is what justifies the avant-garde's methods and makes them necessary'. As 'movement' is the central concept in Greenberg's legitimation of Modernism it is worth considering it at some greater length.

A familiar model of movement is used; the dominant version of art historical motion, it is the one we might call the 'problem/solution' model: any given 'generation' of artists attempts to solve the problems they inherited from the previous generation; the solutions they provide are only partial ones; so, in turn, their failures provide 'problems' for the succeeding generation. An early version

of this model was provided by Vasari: Giotto was more successful at rendering three-dimensional space than had been Cimabue; Masaccio represented an improvement over Giotto . . . and so on, the whole effort culminating in Michaelangelo and Raphael. This Renaissance model has been taken over into the Modern period. The basic components the historian has to deal with are 'movements' in art (produced by 'generations' of artists) and the relationship between these movements is causal. This version lends the illusion of purposive movement to what might equally well be described as a contingent succession of collapses, bringing conservation and continuity out of impermanence and waste, and providing the basis for what Edgar Wind (again, speaking of the Renaissance) called, 'a proud art which is no-one's servant, posing all its problems from within'.

Greenberg retrospectively imposes a picture of over-all 'progress' upon the Modern period:

> Manet's became the first Modernist pictures by virtue of the frankness with which they declared the flat surfaces on which they were painted. The Impressionists, in Manet's wake, abjured underpainting and glazes, to leave the eye under no doubt as to the fact that the colours used were made of paint which came from tubes or pots. Cézanne sacrificed verisimilitude, or correctness, in order to fit his drawing and design more explicitly to the rectangular shape of the canvas.

The putative goal of this progress, and there must be a goal if progress is to be assessed, was, 'the stressing of the ineluctable flatness of the surface that remained . . . Because flatness was the only condition painting shared with no other art, Modernist painting oriented itself to flatness as it did to nothing else'. But further, as:

> Modernist art continues the past without gap or break [it therefore follows] . . . Leonardo, Raphael, Titian, Rubens, Rembrandt or Watteau. What Modernism has shown is that, though the past did appreciate these masters justly, it often gave wrong or irrelevant reasons for doing so.[45]

The re-reading of old works in new contexts can refresh both the work and the context, but such a hermeneutics is not to be confused with history. Greenberg's account of art history is innocent of any reference to political, economic, sociological, or technological determinants contemporary with, and possibly operative within, the 'purely aesthetic' decisions he describes. He projects into the past a set of unargued assumptions and their reflection is returned unmodified in all but one respect, their status has been inverted – no longer mere assertions they are now indisputable facts supported by 'history'.

The Russian Formalists did not subscribe to a view of linear descent in art, but rather saw history as a succession of discontinuities, 'sideways leaps', represented in Shklovsky's image of the 'knight's move'. According to Shklovsky, 'in the liquidation of one literary school by another, the inheritance is passed down,

not from father to son, but from uncle to nephew'.[46] This conception accommodates the incorporation into art of previously peripheral, or popular, art forms. ('New forms in art are created by the canonization of peripheral forms. Pushkin stems from the peripheral genre of the album, the novel from horror stories, Nekrasov from the vaudeville, Blok from the gypsy ballad, Mayakovsky from humorous poetry.'[47]) Again, Greenberg insists upon the particular *material* attributes peculiar to painting: 'The limitations that constitute the medium of painting – the flat surface, the shape of the support, the properties of the pigment', whereas the Formalists were concerned with *abstract* 'devices', such as 'laying bare' and 'defamiliarisation', peculiar to the literary text (the Symbolists had made a fetish of the material – sound). Thus, while Greenberg's focus is upon the substance of the text, that of the Formalists was upon the ordering of the substance through the device. Eichenbaum: 'art's uniqueness consists not in the parts which enter into it, but in their original *use*'.[48]

It has been charged that Shklovsky's important notion of *ostranenie* (the device for 'making strange') had the purely aesthetic end of turning perception upon itself as its own object; as such, it might conceivably be assimilated to Greenberg's idea of Modernist painting as set exclusively upon, 'what is given in visual experience'. However, to the Formalists, the foregrounding of the device *as such*, through its self-revelatory construction, has a necessary cognitive corollary:

> Why need it be stressed that the sign is not confused with the object? Because alongside the immediate awareness of the identity of sign and object (A is A′), the immediate awareness of the absence of this awareness (A is not A′) is necessary; this antinomy is inevitable, for without contradiction there is no play of concepts, there is no play of signs, the relation between the concept and the sign becomes automatic, the course of events ceases and consciousness of reality dies.[49]

The Formalists never confused the ends of poetics with the ends of art. Such a confusion, however, is to be found in Greenberg's writings. For example, when Jakobson writes: 'the main subject of poetics is the *differentia specifica* of verbal art in relation to other arts and in relation to other kinds of verbal behaviour',[50] he is defining the role of a branch of literary studies. When Greenberg says: 'What had to be exhibited was not only that which was unique and irreducible in art in general, but also that which was unique and irreducible each particular art',[51] Greenberg is defining the role of a branch of art. Greenberg collapses the project of art into that of art criticism, which leads him to make defensive remarks *vis-à-vis* the scientific status of art; whereas the Formalists were concerned only that *criticism* should become scientific. Jakobson is explicit:

> Neither Tynyanov, nor Mukarovsky, nor Shklovsky, nor I have preached that art is sufficient unto itself; on the contrary, we show that art is part of the social edifice, a component correlating with others, a variable component, since the sphere of art

211

and its relationship with other sectors of the social structure ceaselessly changes dialectically. *What we stress is not the separation of art, but the autonomy of the aesthetic function.*[52] [my italics]

[...]

IV

In an essay of 1957 on 'The Late Thirties in New York', Greenberg writes: 'some day it will have to be told how "anti-Stalinism", which started out more or less as "Trotskyism", turned into art for art's sake, and thereby cleared the way, heroically, for what was to come'.[53] What was to come, as we know, over a period of unprecedented economic expansion in the US (which emerged at the end of the war with three-quarters of the world's invested capital and two-thirds of its industrial capacity), was the almost total 'depoliticisation' of American art.

'In July 1956', Egbert reports, 'the director of the U.S.I.A. declared before a Senate Foreign Relations sub-committee that it had become the Agency's policy to include no works by politically suspect artists in exhibitions overseas; and it was now indicated that there would be no further government sponsored exhibitions abroad of paintings executed since 1917, the year of the Bolshevik Revolution'.[54] But 1956 was also the year of Khrushchev's denunciation of Stalin at the Twentieth Congress of the CPSU. The Cold War 'thaw' which followed released a flood of modern American art upon the world in a series of US Government and Industry sponsored exhibitions. Much of the work toured was the 'abstract' art which had previously been considered politically subversive simply because it offended the philistinism of conservative politicians. Increasingly, however, abstraction came to connote not 'Bolshevism' but, by virtue of the *difference* it established in opposition to official Soviet socialist realism, 'freedom of expression' (Eco has described the mechanism of such inversions of ideological evaluation in terms of *code switching*[55]). Thereafter, throughout the programme of foreign intervention by the US in the 1960s, Modernist painting exhibited a high use-value in the promotion of American *cultural* imperialism.

The question of the 'political' effect of art is a complex one, not confined to crude cases of simple instrumentality in the service of a pre-formed 'message'. Consideration must be given not only to the internal attributes of a work but also to its production and dissemination in and across the institutions within which its meaning is constituted. Nevertheless, in its 'dialectical relation to the other domains of culture' the contents of art are not a matter of indifference, nor can they be legislated out of existence by the gratuitous adoption of the concept of an Edenic 'pure signifier'. Willy-nilly, art has meanings thrust upon it; one such meaning is a function of the *uses* to which the work may lend itself. Ideology

abhors a vacuum; the exclusion of all trace of the 'political' from the signifieds of a work may merely deliver it into complicity with the status quo.

Modernist practice, including the current post-conceptual Modernism, has accepted Greenberg's proposal that art withdraw completely from the actual world of social and political struggle in order to preserve 'the historical essence of civilisation' into an indeterminate future when all will have become 'cultivated' enough to appreciate it. At the end of 'Avant-Garde and Kitsch', in rather strangely appealing to socialism for the preservation of (bourgeois) culture, Greenberg asserts, 'Here, as in every other question today, it becomes necessary to quote Marx word for word'. He never does quote Marx; were he to do so he would find himself contradicted, for example, from the third of the *Theses on Feuerbach*:

> The materialist doctrine that men are products of circumstances and upbringing, and that, therefore, changed men are products of other circumstances and changed upbringing, forgets that it is men who change circumstances and that it is essential to educate the educator himself. Hence, this doctrine necessarily arrives at dividing society into two parts, one of which is superior to society.

The materialism to which Modernism lays claim is an undialectical positivism. It is a materialism condemned elsewhere in Marx's short text on Feuerbach in that, 'the thing, reality, sensuousness, is conceived only in the form of the object or of *contemplation*, but not as *human sensuous activity, practice*, not subjectively'. Modernist criticism characteristically seizes its 'objects' in a language which draws equally upon geometry and gastronomy in recommending them, from palette to palate, to the fine tastes of a discriminating consumer ('the plane-units multiplied in complete independence of the laws under which surfaces and their planes materialised in non-pictorial reality',[56] and, 'his paint matter is kneaded and mauled, thinned or thickened, in order to render it altogether chromatic, altogether retinal... Soutine's touch came as if from heaven'[57]). Recently, some Modernists have seized the opportunity to spice the culinary *jeu d'esprit* with the more rigorous language of 'deconstruction' and 'foregrounding'. Russian Formalism is particularly available to such misappropriation in that, as Kristeva put it, 'when it became a poetics, [it] turned out and still turns out to be a discourse on nothing or on something which does not matter'.[58]

In its implications for art theory, Formalist and structuralist analysis ranges beyond the prior categories of 'high' culture to identify 'aesthetic' strata within the general semiotic landscape, exposing the *community* of such formations across the totality of signifying practices. Its demonstration of the ubiquitousness of the 'poetic' was necessary to materialist art theory; as an end in itself however it was reductionist, yielding a universal poetics of pansemiotic features which elided all that distinguishes one signifying practice from another. However, it would be a pity if art theory/criticism/history, at a time when semiotic theory in general is filling in the spaces which the Formalists left blank (deferred until too late), and

therefore changing the appearance of the picture, should retreat from the breadth of concerns of 'classic' semiotics (the inclusion of advertising, photography, and so on); particularly as, as noted above, there is a history of such concerns in art practice in the Modern period.

Art theory should not accept only those objects pre-constituted in ideology. A rigorous theory would begin by bracketing the dominant received notions of 'high' art practice. However, as these are intimately bound up with the society which produces them, the theorist is unavoidably precipitated into an awkward self-reflexivity. (For example, he or she might consider the determining influence of his or her own class position in a society ordered according to a system of privileges.) Tocqueville early recognised the danger for self-oriented culture producers, he warned:

> By dint of striving after a mode of parlance different from the common, they will arrive at a sort of aristocratic jargon which is hardly less remote from pure language than is the coarse dialect of the people. Such are the natural perils of literature among aristocracies. *Every aristocracy that keeps itself entirely aloof from the people becomes impotent*, a fact which is as true in literature as it is in politics.[59] [my italics]

Writing in 1939, in 'Avant-Garde and Kitsch', Greenberg expresses a familiar, fearful, placing of 'the plebeian' within a scenario which assumes that Victorian opposition between 'culture and anarchy':

> It is a platitude that art becomes caviar to the general when the reality it imitates no longer corresponds even roughly to the reality recognised by the general. Even then, however, the resentment the common man may feel is silenced by the awe in which he stands of the patrons of this art. Only when he becomes dissatisfied with the social order they administer does he begin to criticise their culture. Then the plebeian finds courage for the first time to voice his opinions openly. Every man, from the Tammany alderman to the Austrian house-painter, finds that he is entitled to his opinion. Most often this resentment toward culture is to be found where the dissatisfaction with society is a reactionary dissatisfaction which expresses itself in revivalism and puritanism, and latest of all, in fascism. Here revolvers and torches begin to be mentioned in the same breath as culture. In the name of godliness or the blood's health, in the name of simple ways and solid virtues, the statue-smashing commences.[60]

Brecht, writing in 1938, saw things differently:

> There is only one ally against the growth of barbarism: the people on whom it imposes these sufferings. Only the people offer any prospects. Thus it is natural to turn to them, and more necessary than ever to speak their language.[61]

Shortly after the October revolution there were Russians who declared that their existing railway system was bourgeois, that it would be unseemly for

Marxists to use it, and that it should therefore be torn up and new 'proletarian' railways built. Stalin called these enthusiasts 'troglodytes'. In a Modernist analysis (albeit a fanciful one), railway systems might be defined as consisting essentially of tracks to support engines, and engines to run on tracks; passengers and freight would be seen as so much content extraneous to the system and serving only to retard its efficiency and speed.

'The "cultural heritage", rejection or conservation?' is actually a mystificatory problematic; the past of art is simply one of a number of terms to be engaged dialectically within a specific historical situation. Art practice has not been 'surpassed by and in the media' (Enzensburger), nor is it a sanctuary for 'higher' values, as Greenberg would have it. But this brings us closer to the historical issue.

We began with the question of the appropriation of semiotics to Modernism; throughout the positions sketched above is a tendency to place the artist, the intellectual, always on the privileged side of the break between real and imaginary, science and ideology. Such confidence occludes the current problem common to both art 'theorists' and 'practioners' (a division of labour which is *part* of the problem): The continuing appropriation of culture in general as the place from which a class (and/or 'the intelligentsia') hands down its own Name.

Notes

1 Expanded version of a paper given at the 1976 Edinburgh Festival 'Avant-garde Event'.
2 Jan Mukarovsky, 'L'Art comme fait sémiologique', *Actes du huitième congres internationale de philosophie à Prague 2–7 Septembre 1934*, Prague 1936.
3–11 Clement Greenberg, 'Avant-Garde and Kitsch', in *Art and Culture*, Beacon Press, 1961, pp. 3–21. [And ch. 18 above.]
12 Alexis de Tocqueville, *Democracy in America*, vol. 2, Vintage, 1945, p. 54.
13 Clement Greenberg, 'Avant-Garde and Kitsch' in *Art and Culture*, Beacon Press, 1961, pp. 3–21.
14 Raymond Williams, *Culture and Society 1780–1950*, Pelican, 1961.
15 A collation of its 'physical accomplishments and expenditures' estimates its total cost as $35 million. Included in its production: 2,566 murals; 180,099 easel paintings; and designs for about 2 million posters (35,000 of which were produced). (On a separate budget, the WPA building programme built thousands of art galleries.)
16 Holger Cahill, 'American Resources in the Arts', in *Art for the Millions*, ed. Francis V. O'Connor, New York Graphic Society, 1975, pp. 36–7.
17 Stuart Davis, 'Abstract Painting Today' in *Art for the Millions*, ibid., p. 126.
18 Robert Cantwell, quoted by William Stott, *Documentary Expression and Thirties America*, OUP, 1973, p. 113.
19 Cf. Walter Benjamin, 'The Author as Producer', in *Understanding Brecht*, New Left Books, 1973, pp. 85–103.

20 Alexei Gan, 'Constructivism', in Camilla Gray, *The Great Experiment: Russian Art 1863–1922*, Thames & Hudson, 1962, p. 285.
21 Vladimir Mayakovsky, *I Myself*, quoted in Richard Sherwood, 'Documents from *Lef*', *Screen*, vol. 12, no. 4, 1971–2, p. 29.
22 El Lissitsky, 'The Book from the Visual Point of View – the Visual Book', in *The Art of Book Printing*, Moscow, 1962, p. 163.
23 See *Soviet Advertising Poster 1917–1932*, Moscow, 1972.
24 'We are Searching' (Editorial, *Novy Lef*, nos. 11, 12, 1927), *Screen*, vol. 12, no. 4, 1971–2, p. 67.
25 Ralph Graham, 'The Poster in Chicago', in *Art for the Millions*, p. 181.
26 Alexis de Tocqueville, *Democracy in America*, vol. 2, Vintage, 1945, p. 54.
27 The leading work was done by the *Berliner Illustrierte*, whose half-million circulation was matched by its imitator the *Münchner Illustrierte Presse* (1923). Other publications included the Communist *Arbeiter Illustrierte Zeitung (AIZ)* (1921), and the National Socialist *Der Illustrierte Beobachter*. (*Life* appeared in 1936, *Look* in 1937, *Picture Post* in 1938.)
28 See Tim N. Gidal, *Modern Photojournalism: Origin and Evolution, 1910–1933*, Collier, 1973.
29 Laszlo Moholy-Nagy, *Painting, Photography, Film*, Massachusetts Institute of Technology, 1973, p. 28.
30 Dziga Vertov, 'Film Directors, A Revolution', *Lef*, vol. 3, in *Screen*, vol. 15, no. 2, 1944, p. 52.
31 Lev Kuleshov, 'The Principles of Montage', in *Kuleshov on Film*, University of California, 1974, p. 192.
32 Raoul Hausmann, 'Peinture Nouvelle et Photomontage', in *Courrier Dada*, Le Terrain Vague, 1958, p. 47.
33 El Lissitsky, in *Merz*, no. 4, 1923, quoted in Szymon Bojko (see below), p. 16.
34 Szymon Bojko, *New Graphic Design in Revolutionary Russia*, Praeger, 1972, p. 27.
35 William Stott, *Documentary Expression and Thirties America*, OUP, 1973, p. 212.
36 Raoul Hausmann, 'Peinture Nouvelle et Photomontage', in *Courrier Dada*, Le Terrain Vague, 1958, pp. 48–9.
37 Louis Aragon, 'John Heartfield et la beauté révolutionnaire', in *Les Collages*, Princeton University Press, 1965, p. 82.
38 Donald Drew Egbert, *Socialism and American Art*, Princeton, 1967, p. 116.
39 Clement Greenberg, 'Avant-Garde and Kitsch', in *Art and Culture*, Beacon Press, 1961, pp. 3–21.
40 Roger Fry, quoted in Lionello Venturi, *History of Art Criticism*, Dutton, New York, 1964, p. 308.
41 Clive Bell, *Art*, Capricorn, New York, 1958, pp. 28–9.
42 Clement Greenberg, 'Modernist Painting', *Arts Year Book*, 4, 1961, pp. 103–8.
43 Tzvetan Todorov, 'Some approaches to Russian Formalism', *20th Century Studies*, December 1972, p. 10.
44 Clement Greenberg, 'Modernist Painting', *Arts Year Book*, 4, 1961, pp. 103–8.
45 Ibid. ('Flatness' is of course also an attribute of film and photography.)
46 Viktor Shklovsky, quoted by Frederic Jameson in *The Prison-House of Language*, Princeton University Press, 1972, p. 53.
47 Viktor Shklovsky, *Sentimental Journey*, Cornell University Press, 1970, p. 233.

48 Boris Eichenbaum, 'The Theory of the "Formal Method" ', in *Russian Formalist Criticism*, University of Nebraska, Lincoln, 1965, p. 112.
49 Roman Jakobson, quoted by Ben Brewster in 'From Shklovsky to Brecht: A Reply', *Screen*, vol. 15, no. 2, 1974, p. 87.
50 Roman Jakobson, 'Linguistics and Poetics', *The Structuralists*, ed. De George and De George, Doubleday, 1972, pp. 85–6.
51 Clement Greenberg, 'Modernist Painting', *Arts Year Book*, 4, 1961, p. 103.
52 Roman Jakobson, quoted by Ben Brewster in 'From Shklovsky to Brecht: A Reply', *Screen*, vol. 15, no. 2, 1974, p. 86.
53 Clement Greenberg, 'The Late Thirties in New York', *Arts Year Book*, 4, 1961, p. 30.
54 Donald Drew Egbert, *Socialism and American Art*, Princeton, 1967, pp. 134–5.
55 Cf. Umberto Eco, *A Theory of Semiotics*, Indiana, 1976, pp. 286–98.
56 Clement Greenberg, 'The Late Thirties in New York', *Arts Year Book*, 4, 1961, p. 101.
57 Ibid., p. 116.
58 Julia Kristeva, 'The ruin of a poetics', *20th Century Studies*, December 1972, p. 104.
59 Alexis de Tocqueville, *Democracy in America*, vol. 2, Vintage, 1945, p. 61.
60 Clement Greenberg, 'The Late Thirties in New York', *Arts Year Book*, 4, 1961, p. 17.
61 Bertolt Brecht, 'The Popular and the Realistic', *Marxists on Literature*, ed. David Craig, Pelican, 1975, p. 421.

20

The Hidden Dialectic: Avantgarde
–Technology–Mass Culture

Andreas Huyssen

*Historical materialism wishes to retain that image of the past which
unexpectedly appears to man singled out by history at a moment of
danger. The danger affects both the content of the tradition and its
receivers. The same threat hangs over both: that of becoming a tool of
the ruling classes. In every era the attempt must be made anew to wrest
tradition away from conformism that is about to overpower it.*

—Walter Benjamin, *Theses on the Philosophy of History*

I

When Walter Benjamin, one of the foremost theoreticians of avantgarde art and
literature, wrote these sentences in 1940 he certainly did not have the avantgarde
in mind at all. It had not yet become part of that tradition which Benjamin was
bent on salvaging. Nor could Benjamin have foreseen to what extent conformism
would eventually overpower the tradition of avantgardism, both in advanced
capitalist societies and, more recently, in East European societies as well. Like a
parasitic growth, conformism has all but obliterated the original iconoclastic and
subversive thrust of the historical avantgarde of the first three or four decades of
this century. This conformism is manifest in the vast depoliticization of post-
World War II art and its institutionalization as administered culture, as well as in
academic interpretations which, by canonizing the historical avantgarde, mod-
ernism and postmodernism, have methodologically severed the vital dialectic

Andreas Huyssen, "The Hidden Dialectic: Avantgarde–Technology–Mass Culture," pp. 3–15 in
Huyssen, *After the Great Divide: Modernism, Mass Culture, Postmodernism*. Bloomington: Indiana
University Press, 1986. This essay was first published in Kathleen Woodward (ed.), *The Myths of
Information: Technology and Postindustrial Culture* (Madison, WI: Coda Press, 1980), pp. 151–64.
Reprinted by permission of Thomson Publishing Services on behalf of Routledge.

between the avantgarde and mass culture in industrial civilization. In most academic criticism the avantgarde has been ossified into an elite enterprise beyond politics and beyond everyday life, though their transformation was once a central project of the historical avantgarde.

In light of the tendency to project the post-1945 depoliticization of culture back onto the earlier avantgarde movements, it is crucial to recover a sense of the cultural politics of the historical avantgarde. Only then can we raise meaningful questions about the relationship between the historical avantgarde and the neo-avantgarde, modernism and post-modernism, as well as about the aporias of the avantgarde and the consciousness industry (Hans Magnus Enzensberger), the tradition of the new (Harold Rosenberg) and the death of the avantgarde (Leslie Fiedler). For if discussions of the avantgarde do not break with the oppressive mechanisms of hierarchical discourse (high vs. popular, the new new vs. the old new, art vs. politics, truth vs. ideology), and if the question of today's literary and artistic avantgarde is not placed in a larger socio-historical framework, the prophets of the new will remain locked in futile battle with the sirens of cultural decline – a battle which by now only results in a sense of déjà vu.

II

Historically the concept of the avantgarde, which until the 1930s was not limited to art but always referred to political radicalism as well, assumed prominence in the decades following the French Revolution. Henri de Saint Simon's *Opinions littéraires, philosophiques et industrielles* (1825) ascribed a vanguard role to the artist in the construction of the ideal state and the new golden age of the future, and since then the concept of an avantgarde has remained inextricably bound to the idea of progress in industrial and technological civilization. In Saint Simon's messianic scheme, art, science, and industry were to generate and guarantee the progress of the emerging technical-industrial bourgeois world, the world of the city and the masses, capital and culture. The avantgarde, then, only makes sense if it remains dialectically related to that for which it serves as the vanguard – speaking narrowly, to the older modes of artistic expression, speaking broadly, to the life of the masses which Saint Simon's avantgarde scientists, engineers, and artists were to lead into the golden age of bourgeois prosperity.

Throughout the nineteenth century the idea of the avantgarde remained linked to political radicalism. Through the mediation of the utopian socialist Charles Fourier, it found its way into socialist anarchism and eventually into substantial segments of the bohemian subcultures of the turn of the century. It is certainly no coincidence that the impact of anarchism on artists and writers reached its peak precisely when the historical avantgarde was in a crucial stage of its formation. The attraction of artists and intellectuals to anarchism at that time can be attributed to two major factors: artists and anarchists alike rejected bourgeois

219

society and its stagnating cultural conservatism, and both anarchists and left-leaning bohemians fought the economic and technological determinism and scientism of Second International Marxism, which they saw as the theoretical and practical mirror image of the bourgeois world. Thus, when the bourgeoisie had fully established its domination of the state and industry, science and culture, the avantgardist was not at all in the forefront of the kind of struggle Saint Simon had envisioned. On the contrary, he found himself on the margins of the very industrial civilization which he was opposing and which, according to Saint Simon, he was to prophesy and bring about. In terms of understanding the later condemnations of avantgarde art and literature both by the right (*entartete Kunst*) and by the left (bourgeois decadence), it is important to recognize that as early as the 1890s the avantgarde's insistence on cultural revolt clashed with the bourgeoisie's need for cultural legitimation, as well as with the preference of the Second International's cultural politics for the classical bourgeois heritage.

Neither Marx nor Engels ever attributed major importance to culture (let alone avantgarde art and literature) in the working-class struggles, although it can be argued that the link between cultural and political-economic revolution is indeed implicit in their early works, especially in Marx's Parisian Manuscripts and the *Communist Manifesto*. Nor did Marx or Engels ever posit the Party as the avantgarde of the working class. Rather, it was Lenin who institutionalized the Party as the vanguard of the revolution in *What Is to Be Done* (1902) and soon after, in his article "Party Organization and Party Literature" (1905), severed the vital dialectic between the political and cultural avantgarde, subordinating the latter to the Party. Declaring the artistic avantgarde to be a mere instrument of the political vanguard, "a cog and screw of one single great Social Democratic mechanism set in motion by the entire politically conscious avantgarde of the entire working class," Lenin thus helped pave the way for the later suppression and liquidation of the Russian artistic avantgarde which began in the early 1920s and culminated with the official adoption of the doctrine of socialist realism in 1934.

In the West, the historical avantgarde died a slower death, and the reasons for its demise vary from country to country. The German avantgarde of the 1920s was abruptly terminated when Hitler came to power in 1933, and the development of the West European avantgarde was interrupted by the war and the German occupation of Europe. Later, during the cold war, especially after the notion of the end of ideology took hold, the political thrust of the historical avantgarde was lost and the center of artistic innovation shifted from Europe to the United States. To some extent, of course, the lack of political perspective in art movements such as abstract expressionism and Pop art was a function of the altogether different relationship between avantgarde art and cultural tradition in the United States, where the iconoclastic rebellion against a bourgeois cultural heritage would have made neither artistic nor political sense. In the United States, the literary and artistic heritage never played as central a role in legitimizing bourgeois domination as it did in Europe. But these explanations for the death of the historical avantgarde in the West at a certain time, although critical, are not

exhaustive. The loss of potency of the historical avantgarde may be related more fundamentally to a broad cultural change in the West in the 20th century: it may be argued that the rise of the Western culture industry, which paralleled the decline of the historical avantgarde, has made the avantgarde's enterprise itself obsolete.

To summarize: since Saint Simon, the avantgardes of Europe had been characterized by a precarious balance of art and politics, but since the 1930s the cultural and political avantgardes have gone their separate ways. In the two major systems of domination in the contemporary world, the avantgarde has lost its cultural and political explosiveness and has itself become a tool of legitimation. In the United States, a depoliticized cultural avantgarde has produced largely affirmative culture, most visibly in pop art where the commodity fetish often reigns supreme. In the Soviet Union and in Eastern Europe, the historical avantgarde was first strangled by the iron hand of Stalin's cultural henchman Zhdanov and then revived as part of the cultural heritage, thus providing legitimacy to regimes which face growing cultural and political dissent.

Both politically and aesthetically, today it is important to retain that image of the now lost unity of the political and artistic avantgarde, which may help us forge a new unity of politics and culture adequate to our own times. Since it has become more difficult to share the historical avantgarde's belief that art can be crucial to a transformation of society, the point is not simply to revive the avantgarde. Any such attempt would be doomed, especially in a country such as the United States where the European avantgarde failed to take roots precisely because no belief existed in the power of art to change the world. Nor, however, is it enough to cast a melancholy glance backwards and indulge in nostalgia for the time when the affinity of art to revolution could be taken for granted. The point is rather to take up the historical avantgarde's insistence on the cultural transformation of everyday life and from there to develop strategies for today's cultural and political context.

III

The notion that culture is a potentially explosive force and a threat to advanced capitalism (and to bureaucratized socialism, for that matter) has a long history within Western Marxism from the early Lukács up through Habermas's *Legitimation Crisis* and Negt/Kluge's *Öffentlichkeit und Erfahrung*. It even underlies, if only by its conspicuous absence, Adorno's seemingly dualistic theory of a monolithically manipulative culture industry and an avantgarde locked into negativity. Peter Bürger, a recent theoretician of the avantgarde, draws extensively on this critical Marxist tradition, especially on Benjamin and Adorno. He argues convincingly that the major goal of art movements such as Dada, surrealism, and the post-1917 Russian avantgarde was the reintegration of art into life praxis, the

closing of the gap separating art from reality. Bürger interprets the widening gap between art and life, which had become all but unbridgeable in late 19th century aestheticism, as a logical development of art within bourgeois society. In its attempt to close the gap, the avantgarde had to destroy what Bürger calls "institution art," a term for the institutional framework in which art was produced, distributed, and received in bourgeois society, a framework which rested on Kant's and Schiller's aesthetic of the necessary autonomy of all artistic creation. During the 19th century the increasingly categorical separation of art from reality and the insistence on the autonomy of art, which had once freed art from the fetters of church and state, had worked to push art and artists to the margins of society. In the art for art's sake movement, the break with society – the society of imperialism – had led into a dead end, a fact painfully clear to the best representatives of aestheticism. Thus the historical avantgarde attempted to transform l'art pour l'art's isolation from reality – which reflected as much opposition to bourgeois society as Zola's *j'accuse* – into an active rebellion that would make art productive for social change. In the historical avantgarde, Bürger argues, bourgeois art reached the stage of self-criticism; it no longer only criticized previous art *qua* art, but also critiqued the very "institution art" as it had developed in bourgeois society since the 18th century.

Of course, the use of the Marxian categories of criticism and self-criticism implies that the negation and sublation (*Aufhebung*) of the bourgeois "institution art" is bound to the transformation of bourgeois society itself. Since such a transformation did not take place, the avantgarde's attempt to integrate art and life almost had to fail. This failure, later often labelled the death of the avantgarde, is Bürger's starting point and his reason for calling the avantgarde "historical." And yet, the failure of the avantgarde to reorganize a new life praxis through art and politics resulted in precisely those historical phenomena which make any revival of the avantgarde's project today highly problematic, if not impossible: namely, the false sublations of the art/life dichotomy in fascism with its aestheticization of politics, in Western mass culture with its fictionalization of reality, and in socialist realism with its claims of reality status for its fictions.

If we agree with the thesis that the avantgarde's revolt was directed against the totality of bourgeois culture and its psycho-social mechanisms of domination and control, and if we then make it our task to salvage the historical avantgarde from the conformism which has obscured its political thrust, then it becomes crucial to answer a number of questions which go beyond Bürger's concern with the "institution art" and the formal structure of the avantgarde art work. How precisely did the dadaists, surrealists, futurists, constructivists, and productivists attempt to overcome the art/life dichotomy? How did they conceptualize and put into practice the radical transformation of the conditions of producing, distributing, and consuming art? What exactly was their place within the political spectrum of those decades and what concrete political possibilities were open to them in specific countries? In what way did the conjunction of political and cultural revolt inform their art and to what extent did that art become part of

the revolt itself? Answers to these questions will vary depending on whether one focuses on Bolshevik Russia, France after Versailles, or Germany, doubly beaten by World War I and a failed revolution. Moreover, even within these countries and the various artistic movements, differentiations have to be made. It is fairly obvious that a montage by Schwitters differs aesthetically and politically from a photomontage by John Heartfield, that Dada Zurich and Dada Paris developed an artistic and political sensibility which differed substantially from that of Dada Berlin, that Mayakovsky and revolutionary futurism cannot be equated with the productivism of Arvatov or Gastev. And yet, as Bürger has convincingly suggested, all these phenomena can legitimately be subsumed under the notion of the historical avantgarde.

IV

I will not attempt here to answer all these questions, but will focus instead on uncovering the hidden dialectic of avantgarde and mass culture, thereby casting new light on the objective historical conditions of avantgarde art, as well as on the socio-political subtext of its inevitable decline and the simultaneous rise of mass culture.

Mass culture as we know it in the West is unthinkable without twentieth-century technology – media techniques as well as technologies of transportation (public and private), the household, and leisure. Mass culture depends on technologies of mass production and mass reproduction and thus on the homogenization of difference. While it is generally recognized that these technologies have substantially transformed everyday life in the 20th century, it is much less widely acknowledged that technology and the experience of an increasingly technologized life world have also radically transformed art. Indeed, technology played a crucial, if not *the* crucial, role in the avantgarde's attempt to overcome the art/life dichotomy and make art productive in the transformation of everyday life. Bürger has argued correctly that from Dada on the avantgarde movements distinguish themselves from preceding movements such as impressionism, naturalism, and cubism not only in their attack on the "institution art" as such, but also in their radical break with the referential mimetic aesthetic and its notion of the autonomous and organic work of art. I would go further: no other single factor has influenced the emergence of the new avantgarde art as much as technology, which not only fueled the artists' imagination (dynamism, machine cult, beauty of technics, constructivist and productivist attitudes), but penetrated to the core of the work itself. The invasion of the very fabric of the art object by technology and what one may loosely call the technological imagination can best be grasped in artistic practices such as collage, assemblage, montage and photomontage; it finds its ultimate fulfillment in photography and film, art forms which can not only be reproduced, but are in fact designed for mechanical reproducibility. It was Walter

Benjamin who, in his famous essay "The Work of Art in the Age of Mechanical Reproduction," first made the point that it is precisely this mechanical reproducibility which has radically changed the nature of art in the 20th century, transforming the conditions of producing, distributing, and receiving/consuming art. In the context of social and cultural theory Benjamin conceptualized what Marcel Duchamp had already shown in 1919 in *L.H.O.O.Q.* By iconoclastically altering a reproduction of the *Mona Lisa* and, to use another example, by exhibiting a mass-produced urinal as a fountain sculpture, Marcel Duchamp succeeded in destroying what Benjamin called the traditional art work's aura, that aura of authenticity and uniqueness that constituted the work's distance from life and that required contemplation and immersion on the part of the spectator. In another essay, Benjamin himself acknowledged that the intention to destroy this aura was already inherent in the artistic practices of Dada. The destruction of the aura, of seemingly natural and organic beauty, already characterized the works of artists who still created individual rather than mass-reproducible art objects. The decay of the aura, then, was not as immediately dependent on techniques of mechanical reproduction as Benjamin had argued in the Reproduction essay. It is indeed important to avoid such reductive analogies between industrial and artistic techniques and not to collapse, say, montage technique in art or film with industrial montage.

It may actually have been a new experience of technology that sparked the avantgarde rather than just the immanent development of the artistic forces of production. The two poles of this new experience of technology can be described as the aesthetization of technics since the late 19th century (world expos, garden cities, the *cité industrielle* of Tony Garnier, the *Città Nuova* of Antonio Sant'Elia, the *Werkbund*, etc.) on the one hand and the horror of technics inspired by the awesome war machinery of World War I on the other. And this horror of technics can itself be regarded as a logical and historical outgrowth of the critique of technology and the positivist ideology of progress articulated earlier by the late 19th-century cultural radicals who in turn were strongly influenced by Nietzsche's critique of bourgeois society. Only the post-1910 avantgarde, however, succeeded in giving artistic expression to this bipolar experience of technology in the bourgeois world by integrating technology and the technological imagination in the production of art.

The experience of technology at the root of the dadaist revolt was the highly technologized battlefield of World War I – that war which the Italian futurists glorified as total liberation and which the dadaists condemned as a manifestation of the ultimate insanity of the European bourgeoisie. While technology revealed its destructive power in the big *Materialschlachten* of the war, the dadaists projected technology's destructivism into art and turned it aggressively against the sanctified sphere of bourgeois high culture whose representatives, on the whole, had enthusiastically welcomed the war in 1914. Dada's radical and disruptive moment becomes even clearer if we remember that bourgeois ideology had lived off the separation of the cultural from industrial and economic reality, which of course was the primary sphere of technology. Instrumental reason,

technological expansion, and profit maximization were held to be diametrically opposed to the *schöner Schein* (beautiful appearance) and *interesseloses Wohlgefallen* (disinterested pleasure) dominant in the sphere of high culture.

In its attempt to reintegrate art and life, the avantgarde of course did not want to unite the bourgeois concept of reality with the equally bourgeois notion of high, autonomous culture. To use Marcuse's terms, they did not want to weld the reality principle to affirmative culture, since these two principles constituted each other precisely in their separation. On the contrary, by incorporating technology into art, the avantgarde liberated technology from its instrumental aspects and thus undermined both bourgeois notions of technology as progress and art as "natural," "autonomous," and "organic." On a more traditional representational level, which was never entirely abandoned, the avantgarde's radical critique of the principles of bourgeois enlightenment and its glorification of progress and technology were manifested in scores of paintings, drawings, sculptures, and other art objects in which humans are presented as machines and automatons, puppets and mannequins, often faceless, with hollow heads, blind or staring into space. The fact that these presentations did not aim at some abstract "human condition," but rather critiqued the invasion of capitalism's technological instrumentality into the fabric of everyday life, even into the human body, is perhaps most evident in the works of Dada Berlin, the most politicized wing of the Dada movement. While only Dada Berlin integrated its artistic activities with the working-class struggles in the Weimar Republic, it would be reductive to deny Dada Zurich or Dada Paris any political importance and to decree that their project was "only aesthetic," "only cultural." Such an interpretation falls victim to the same reified dichotomy of culture and politics which the historical avantgarde had tried to explode.

V

In Dada, technology mainly functioned to ridicule and dismantle bourgeois high culture and its ideology, and thus was ascribed an iconoclastic value in accord with Dada's anarchistic thrust. Technology took an entirely different meaning in the post-1917 Russian avantgarde – in futurism, constructivism, productivism, and the proletcult. The Russian avantgarde had already completed its break with tradition when it turned openly political after the revolution. Artists organized themselves and took an active part in the political struggles, many of them by joining Lunacharsky's NARKOMPROS, the Commissariat for Education. Many artists automatically assumed a correspondence and potential parallel between the artistic and political revolution, and their foremost aim became to weld the disruptive power of avantgarde art to the revolution. The avantgarde's goal to forge a new unity of art and life by creating a new art and a new life seemed about to be realized in revolutionary Russia.

 This conjunction of political and cultural revolution with the new view of technology became most evident in the LEF group, the productivist movement, and the proletcult. As a matter of fact, these left artists, writers, and critics adhered to a cult of technology which to any contemporary radical in the West must have seemed next to inexplicable, particularly since it expressed itself in such familiar capitalist concepts as standardization, Americanization, and even taylorization. In the mid-1920s, when a similar enthusiasm for technification, Americanism, and functionalism had taken hold among liberals of the Weimar Republic, George Grosz and Wieland Herzfelde tried to explain this Russian cult of technology as emerging from the specific conditions of a backward agrarian country on the brink of industrialization and rejected it for the art of an already highly industrialized West: "In Russia this constructivist romanticism has a much deeper meaning and is in a more substantial way socially conditioned than in Western Europe. There constructivism is partially a natural reflection of the powerful technological offensive of the beginning industrialization." And yet, originally the technology cult was more than just a reflection of industrialization, or, as Grosz and Herzfelde also suggest, a propagandistic device. The hope that artists such as Tatlin, Rodchenko, Lissitzky, Meyerhold, Tretyakov, Brik, Gastev, Arvatov, Eisenstein, Vertov, and others invested in technology was closely tied to the revolutionary hopes of 1917. With Marx they insisted on the qualitative difference between bourgeois and proletarian revolutions. Marx had subsumed artistic creation under the general concept of human labor, and he had argued that human self-fulfillment would only be possible once the productive forces were freed from oppressive production and class relations. Given the Russian situation of 1917, it follows almost logically that the productivists, left futurists, and constructivists would place their artistic activities within the horizon of a socialized industrial production: art and labor, freed for the first time in history from oppressive production relations, were to enter into a new relationship. Perhaps the best example of this tendency is the work of the Central Institute of Labor (CIT), which, under the leadership of Alexey Gastev, attempted to introduce the scientific organization of labor (NOT) into art and aesthetics. The goal of these artists was not the technological development of the Russian economy at any cost – as it was for the Party from the NEP period on, and as it is manifest in scores of later socialist realist works with their fetishization of industry and technology. Their goal was the liberation of everyday life from all its material, ideological, and cultural restrictions. The artificial barriers between work and leisure, production and culture were to be eliminated. These artists did not want a merely decorative art which would lend its illusory glow to an increasingly instrumentalized everyday life. They aimed at an art which would intervene in everyday life by being both useful and beautiful, an art of mass demonstrations and mass festivities, an activating art of objects and attitudes, of living and dressing, of speaking and writing. Briefly, they did not want what Marcuse has called affirmative art, but rather a revolutionary culture, an art of life. They insisted on the psycho-physical unity of human life and understood that the

political revolution could only be successful if it were accompanied by a revolution of everyday life.

VI

In this insistence on the necessary "organization of emotion and thought" (Bogdanov), we can actually trace a similarity between late 19th-century cultural radicals and the Russian post-1917 avantgarde, except that now the role ascribed to technology has been totally reversed. It is precisely this similarity, however, which points to interesting differences between the Russian and the German avantgarde of the 1920s, represented by Grosz, Heartfield, and Brecht among others.

Despite his closeness to Tretyakov's notions of art as production and the artist as operator, Brecht never would have subscribed to Tretyakov's demand that art be used as a means of the emotional organization of the psyche. Rather than describing the artist as an engineer of the psyche, as a psycho-constructor, Brecht might have called the artist an engineer of reason. His dramatic technique of *Verfremdungseffekt* relies substantially on the emancipatory power of reason and on rational ideology critique, principles of the bourgeois enlightenment which Brecht hoped to turn effectively against bourgeois cultural hegemony. Today we cannot fail to see that Brecht, by trying to use the enlightenment dialectically, was unable to shed the vestiges of instrumental reason and thus remained caught in that other dialectic of enlightenment which Adorno and Horkheimer have exposed. Brecht, and to some extent also the later Benjamin, tended toward fetishizing technique, science, and production in art, hoping that modern technologies could be used to build a socialist mass culture. Their trust that capitalism's power to modernize would eventually lead to its breakdown was rooted in a theory of economic crisis and revolution which, by the 1930s, had already become obsolete. But even there, the differences between Brecht and Benjamin are more interesting than the similarities. Brecht does not make his notion of artistic technique as exclusively dependent on the development of productive forces as Benjamin did in his Reproduction essay. Benjamin, on the other hand, never trusted the emancipatory power of reason and the *Verfremdungseffekt* as exclusively as Brecht did. Brecht also never shared Benjamin's messianism or his notion of history as an object of construction. But it was especially Benjamin's emphatic notion of experience (*Erfahrung*) and profane illumination that separated him from Brecht's enlightened trust in ideology critique and pointed to a definite affinity between Benjamin and the Russian avantgarde. Just as Tretyakov, in his futurist poetic strategy, reied on shock to alter the psyche of the recipient of art, Benjamin, too, saw shock as a key to changing the mode of reception of art and to disrupting the dismal and catastrophic continuity of everyday life. In this respect, both Benjamin and Tretyakov differ from Brecht: the shock achieved by Brecht's *Verfremdungseffekt* does not carry its function in itself but remains

instrumentally bound to a rational explanation of social relations which are to be revealed as mystified second nature. Tretyakov and Benjamin, however, saw shock as essential to disrupting the frozen patterns of sensory perception, not only those of rational discourse. They held that this disruption is a prerequisite for any revolutionary reorganization of everyday life. As a matter of fact, one of Benjamin's most interesting and yet undeveloped ideas concerns the possibility of a historical change in sensory perception, which he links to a change in reproduction techniques in art, a change in everyday life in the big cities, and the changing nature of commodity fetishism in twentieth-century capitalism. It is highly significant that just as the Russian avantgarde aimed at creating a socialist mass culture, Benjamin developed his major concepts concerning sense perception (decay of aura, shock, distraction, experience, etc.) in essays on mass culture and media as well as in studies on Baudelaire and French surrealism. It is in Benjamin's work of the 1930s that the hidden dialectic between avantgarde art and the utopian hope for an emancipatory mass culture can be grasped alive for the last time. After World War II, at the latest, discussions about the avantgarde congealed into the reified two-track system of high vs. low, elite vs. popular, which itself is the historical expression of the avantgarde's failure and of continued bourgeois domination.

VII

Today, the obsolescence of avantgarde shock techniques, whether dadaist, constructivist, or surrealist, is evident enough. One need only think of the exploitation of shock in Hollywood productions such as *Jaws* or *Close Encounters of the Third Kind* in order to understand that shock can be exploited to reaffirm perception rather than change it. The same holds true for a Brechtian type of ideology critique. In an age saturated with information, including critical information, the *Verfremdungseffekt* has lost its demystifying power. Too much information, critical or not, becomes noise. Not only is the historical avantgarde a thing of the past, but it is also useless to try to revive it under any guise. Its artistic inventions and techniques have been absorbed and co-opted by Western mass mediated culture in all its manifestations from Hollywood film, television, advertising, industrial design, and architecture to the aesthetization of technology and commodity aesthetics. The legitimate place of a cultural avantgarde which once carried with it the utopian hope for an emancipatory mass culture under socialism has been preempted by the rise of mass mediated culture and its supporting industries and institutions.

Ironically, technology helped initiate the avantgarde artwork and its radical break with tradition, but then deprived the avantgarde of its necessary living space in everyday life. It was the culture industry, not the avantgarde, which succeeded in transforming everyday life in the twentieth century. And yet – the utopian

hopes of the historical avantgarde are preserved, even though in distorted form, in this system of secondary exploitation euphemistically called mass culture. To some, it may therefore seem preferable today to address the contradictions of technologized mass culture rather than pondering over the products and performances of the various neo-avantgardes, which, more often than not, derive their originality from social and aesthetic amnesia. Today the best hopes of the historical avantgarde may not be embodied in art works at all, but in decentered movements which work toward the transformation of everyday life. The point then would be to retain the avantgarde's attempt to address those human experiences which either have not yet been subsumed under capital, or which are stimulated but not fulfilled by it. Aesthetic experience in particular must have its place in this transformation of everyday life, since it is uniquely apt to organize fantasy, emotions, and sensuality against that repressive desublimation which is so characteristic of capitalist culture since the 1960s.

Part IV
Politics and the Avant-Garde

Introduction

The selection of texts in this section throws light on some of the political contours of the avant-garde, both in terms of its actual engagement with (and by) contemporary politics and political events and in the sense of its practices *as* cultural politics. Raymond Williams's essay, "The Politics of the Avant-Garde," gives a useful introductory overview of these contours, especially in the decisive period from the late nineteenth century to World War I.[1] Across several disciplines, what precisely constitutes the "avant-garde" *itself* has sometimes been evaded, with the term being used, often in a valorizing manner, as a blanket signifier of artists, writers, or groups whose work is in some way progressive, innovative, and "modern." More interestingly, however, the concept of the avant-garde and its theorization have also been the subject of decades of critical debate and contention.[2] The difficulty in developing a coherent historical and theoretical account of the avant-garde is exacerbated by the fact that the term has frequently been used interchangeably with "modernism," particularly in the Anglo-American literature.[3] In the course of his reflections, Williams addresses this problem and, while avoiding dogmatic prescription, nonetheless proposes a general "working hypothesis" for their clarification; one worth considering in relation to the other texts in this section and indeed to the period as a whole. Significantly, Williams's points encompass not only the actual making of art, but also its distribution, publicizing, and consumption. We only need consider the decisive role played by independent exhibitions, manifestos, small journals, and the predilections of critics, for example (as texts in several sections in this volume show), for the great importance of this in the period from Post-Impressionism to World War II to become clear.

In Williams's view then, *modernism*'s beginnings are distinct from the emergence of innovative groups generally seeking to defend a particular kind of art against market forces and academic strictures. Rather, it is concurrent with "alternative, more radically innovative groupings, seeking to provide their own facilities of production, distribution and publicity." That the Vienna Secession, for example, amply meets these criteria, yet does not merit much more than a footnote in most evolutionary, "modernist" modernisms, indicates some of the disparity here. Following Williams, the *avant-garde*, on the other hand, does not emerge until groups, such as the Italian Futurists, become "fully oppositional," creative "militants" and "attack...a whole social and cultural order." This argument provides a useful starting-point for how we might consider the avant-garde in relation to modernism, but it should be noted that the essay acknowledges the complexity and ambiguity even within the most "fully oppositional" stances. For instance, notwithstanding the avant-garde's embrace of the rhetoric of revolution, we still need to ask how far it was able to resolve the contradictions between, in Williams's words: "the organized working class with its disciplines of party and union; [and] the cultural movement with its mobile association of free and liberating, often deliberately marginal, individuals." This problematic reemerged as a point of cultural-political contestation with far-reaching implications in postrevolutionary and Stalinist Russia. Boris Groys explores that territory, from a revisionist perspective, in the final essay in this section.

A comparison of the criteria by which Greenberg (in "Avant-Garde and Kitsch," Part III) identifies the avant-garde, and those applied by the German literary theorist Peter Bürger, in his influential book of 1974, *Theory of the Avant-Garde*, an extract of which is included in this section, throws up striking divergences. It is almost immediately evident that those qualities that are, in Greenberg's view, vital constituents of the integrity of avant-garde art – purity, autonomy, and the discontinuity between art and life – are just the qualities that Bürger's critical, "historical avant-garde" most seeks to *negate*. In an important essay, "Modernism and Mass Culture in the Visual Arts," Thomas Crow has pinned down the essence of why Greenberg's view of the relationship between modernism and mass culture as one of "relentless refusal" was unsatisfying for many. As he puts it:

> The problem remained, however, that the elite audience for modernism endorsed, in every respect but its art, the social order responsible for the crisis of culture. The implicit contention of early modernist theory...was that the contradiction between an oppositional art and a public with appetite for no other kind of opposition could be bracketed off, if not transcended, in the rigour of austere, autonomous practice.[4]

Broadly, it was these separating, transcending, affirmative functions in autonomous art practice that left those who believed in attempts (in Bürger's words) to "organize a new life praxis from a basis in art" cold. Bürger was writing in the

wake of the political struggles of 1968. In Germany these were explicitly histor-ically-inflected as the Left and the post-1945 student generation protested against, among other things, institutionalized complacency in the face of the Nazi past. In this context Bürger insisted on an historically specific avant-garde emerging from the experience of World War I and the Russian Revolution of 1917 and working into the 1920s. His term is "the historical avant-garde," and its application is chiefly to Dada and Surrealism, individuals such as Marcel Duchamp and John Heartfield, and aspects of Russian Constructivism, Cubism, German Expressionism,[5] and Italian Futurism. Controversially, therefore, Bür-ger's theory does not admit an avant-garde of the nineteenth century. Indeed, in his account, the antithesis of the "historical avant-garde" – where the autonomy it purportedly negates is found – is the Aestheticism of late nineteenth-century bourgeois art.[6]

The sections from the book included here are among those dealing most directly with the institution and practices of art and with Bürger's key preoccupations with avant-garde art (other chapters give greater weight to the basis for Bürger's methodology in the aesthetic theory of Kant, Schiller, Benjamin, Marcuse, Adorno, and others). However, it is also worth noting, within Bürger's polemic, his aware-ness of the avant-garde as a "profoundly contradictory endeavor" and of the paradoxes and fissures in his own theorizing. Problems he identifies include the "false" sublation of art in the culture industry and the unsustainable nature of provocation after Duchamp, for example. Yet more pessimistically, at the end of the first of the two extracts here, Bürger questions his own thesis, asking "whether a sublation of the autonomy status can be desirable at all, whether the distance between art and the praxis of life is not requisite for that free space within which alternatives to what exists become conceivable." This ambiguity has been seen as a central weakness affecting concepts throughout the analysis.[7]

In Bürger's account (here and in other passages from the book) there is the repeated, gloomy verdict that while the avant-garde's *intent* may have been the negation of the institution of autonomous art, that institution itself remained untouched. This putative "failure" of the avant-garde has been one of the most contentious points of Bürger's theory for subsequent commentators. Hal Foster, arguing, as he put it, for a need for new genealogies of the avant-garde that complicate its past and support its future, is not alone when he accuses Bürger of projecting a pristine authenticity onto the historical avant-garde by taking the "romantic rhetoric of the avant-garde, of rupture and revolution, at its own word."[8] Also taking issue with Bürger's diagnosis of the final failure of the avant-garde, Benjamin Buchloh instead sees avant-garde practice as:

> a continually renewed struggle over the definition of cultural meaning, the discovery and representation of new audiences, and the development of new strategies to counteract and develop resistance against the tendency of the ideological appar-atuses of the culture industry to occupy and to control all practices and all spaces of representation.[9]

Bürger's thesis has also been criticized for its "one-dimensional" and "undialectical" account of everyday life,[10] as well as its wholesale dismissal of the postwar "neo-avant-garde," but for all this, its role in stimulating debate has been crucial and it remains one of the most influential accounts of the European avant-garde of the 1910s and 1920s written to date.

The next text in this section, "Jugglers' Fair Beneath the Gallows," comes from the second, expanded edition of a collection of essays and reflections, in montage-like composition, by the unorthodox Marxist philosopher Ernst Bloch (1885–1977). Bloch was writing in exile from Nazi Germany and the book was *Erbschaft dieser Zeit*, or *Heritage of Our Times*, first published in Zurich in 1935. Bloch was an important participant, with his friend and opponent Georg Lukács, in the so-called "Expressionism Debate" in 1938.[11] Here, however, he was writing in response to the Nazis's simultaneous staging of two major events in June 1937, one designed to celebrate the history and culture of the "Volk" and establish the official standard for "German Art" in the Third Reich, and the other to muster a consensus of ridicule to seal the coffin of modernism, especially Expressionism, in German art. Both spectacles took place in Munich, "*Hauptstadt der Bewegung*," or "Capital of the Movement." The first was the opening of the monumental House of German Art in Munich (figures 5 and 6 below). This was a key building in Hitler's architectural scheme for Germany, widely referred to in the German press as a "temple" of art; here for Bloch, the "temple of kitsch."[12] This event was marked by an enormous pageant – part carnival, part political rally – through the city of 26 floats, 426 animals, and 6,000 people, inaugurating the first annual "Day of German Art." The second was held just a few hundred yards away, in the "hall" "under the gallows"; this was the notorious "Degenerate Art" ("*Entartete Kunst*") exhibition of the works of modern artists, declared "Jewish," "Bolshevist," and "degenerate." The works had been seized by Adolf Ziegler (a painter especially favored by Hitler) from German collections and displayed using many means to invite public ridicule.[13] Bloch's essay is, in part, a passionate defence of this art, especially Expressionist painting.

Bloch's quotations from Hitler's speech make clear the terms by which modern art was pathologized in Nazi rhetoric as a symptom of the "degeneracy" of the modern culture of the Weimar Republic.[14] What is particularly distinctive about Bloch's critique is his concept of *Ungleichzeitigkeit*; nonsimultaneity, nonsynchronicity, or, in this translation, "noncontemporaneity." It recurs through *Heritage of Our Times* and is a component of Bloch's critique of contemporary society's reactionary resort to ideas and values of the past, recouped but distorted in vain attempts to cope with the modern present. Bloch quotes Hitler: "Never was humanity closer to antiquity in appearance and in its feelings than it is today." His deep-seated suspicion of the juxtaposition in Nazi ideology of the rational "plush sofa" and "parlor" of bourgeois modernity with the irrational "primeval" of youth and the campfire opens up into a panoramic (again, montage-like) view of the perverse collision, in Nazism, of noncontemporaneous teutonic primitivism and bureaucratized, rationalized modernity.[15]

Figure 5 The interior of the "Great German Art Exhibition," Munich, 1937. (Photo by author from *Kunst im Dritten Reich* [Art in the Third Reich], no. 9, 1937.)

Figure 6 The "House of German Art," Munich, 1937. (Photo by author from *Kunst im Dritten Reich* [Art in the Third Reich], no. 2, 1938.)

Artists and intellectuals on the Left across Europe had been inspired by the revolution in Russia at the end of the war, Soviet culture to the mid-1920s, and their own hopes for the revolutionary potential of art. However, by the mid-1930s, evidence of the regimentation of Russian culture under Stalin, the campaign against formalism, and events such as the show trials of prominent

intellectuals and activists (in Moscow in 1936–8) increasingly convinced Western observers of the repressive nature of Stalinism. In America especially, many Marxist intellectuals who remained committed to *their* envisioning of the revolutionary function of the artist and writer became attracted to the ideas of the exiled Leon Trotsky.[16] Indeed, Greenberg traced the development of American abstract painting to the Trotskyite context: "Some day it will have to be told how anti-Stalinism which started out more or less as Trotskyism turned into art for art's sake, and thereby cleared the way heroically for what was to come."[17] Trotsky had been a leading figure in the Bolshevik revolution in 1917 and subsequent Russian politics; he was People's Commissar of War from 1918 to 1925, before fiercely opposing Stalin in 1925–7, for which he was persecuted and deported. In peripatetic exile, he continued to condemn Stalin and Stalinism and, in the 1930s, Nazism. Instead, he urged freedom for art and new impetus – not least from artists and writers – for the continuation of the "true" revolutionary movement. It is easy to see the appeal these ideas had for cultured left-wing intellectuals; art and revolution were to be mutually empowering and liberating. As Trotsky wrote in his letter to the founding conference of the Fourth International:

> Only a new upsurge of the revolutionary movement can enrich art with new perspectives and possibilities . . . Poets, artists, sculptors, musicians will themselves find their paths and methods, if the revolutionary movement of the masses dissipates the clouds of scepticism and pessimism which darken humanity's horizon today.[18]

By 1938, just before the outbreak of World War II, Trotsky was in exile in a suburb of Mexico City, where he was later assassinated by an agent of Stalin. He had been staying in accommodation provided by the painters Frida Kahlo and her husband Diego Rivera,[19] when André Breton, an avid admirer of Trotsky, came there on a visit. Trotsky did some cursory preparatory reading before receiving the Surrealist, including of Breton's *First Surrealist Manifesto* (see Part I).[20] A result of their several meetings, not all harmonious, was another "manifesto," "Towards a Free Revolutionary Art," published in the New York *Partisan Review* in that year at the height of the journal's "Trotskyite period" and in London soon after, and reproduced here. The text was primarily Trotsky's, but he thought it expedient to substitute Rivera's name for his own for publication.

Attributing the "intolerable situation" for art and science to the unholy alliance of reactionary politics with the "arsenal" of modern technology, the manifesto opposes its visions of a vital, true, revolutionary art to the servile, degraded, palliative, and mercenary profession under both Hitler and Stalin. The analogies with psychoanalysis, the emphasis on creative subjectivity in the constant "flowering" of the "powers of the interior world . . . common to all men" and the insistence that "the imagination must escape from all constraint" are where the influence of Breton is perhaps most discernible. For his own part, Trotsky admired Freud, but was skeptical about the Surrealists's approach to

psychoanalysis, asking whether it was not an attempt to "smother the conscious under the unconscious."[21] The manifesto also, significantly, argues not only for socialism, but also for anarchism as the crucible for creativity. In the event, the envisaged "International Federation of Independent Revolutionary Art" was never realized, but the text's significance for the period's cultural politics lies in its attempt to delineate an art of, simultaneously, freedom *and* engagement.

The last essay in this section, Boris Groys's "The Birth of Socialist Realism from the Spirit of the Russian Avant-Garde," deals with the situation for the arts in Soviet Russia as, already in the 1920s, the avant-garde came to be seen as elitist and therefore counterrevolutionary, and then as, after 1934, Socialist Realism was imposed as the official aesthetic (the conditions of which Trotsky and Breton so despaired). Groys's work in the field of Soviet studies and art history is known in particular for the revisionist argument he proposes here and elsewhere; namely that the monumental, heroic aesthetic of Soviet Socialist Realism represents not the regression to traditionalist kitsch, overpowering an "innocent" avant-garde, as it has often been understood in the West, but in many ways, can be seen as proceeding from the avant-garde's methods – such as those of Constructivism and Suprematism – and even succeeding where the latter had failed, to achieve the elimination of boundaries between art and life and a kind of *Gesamtkunstwerk* or total work of art.[22] As such, Groys challenges the "false perspective" of the museum exhibition from which he argues the avant-garde and Socialist Realism have been unhelpfully seen.[23] In so doing, Groys also complicates accounts that throw Socialist Realism into the same pot as Russian nineteenth-century realism (which includes Greenberg's *Kitsch* arch villain Repin), or indeed as the official art of Nazi Germany. Though Groys's argument is controversial, and indeed employs its *own* generalizations that can be seen as problematic, his essay offers a new perspective on Socialist Realism as well as on the political role of the avant-garde in a wider sense, the "failure" of which, as Groys casts it, echoes Bürger's diagnosis of the historical avant-garde. Groys is writing from a different perspective, but, notably, he expresses in common with Bürger ambivalence about the desirability and even viability of the autonomy of the artist and the work of art in the face of political reality. Thus, in Groys's account, "inevitably," the avant-garde artist, having negated the autonomy of art, ends up himself subordinated to political reality.

Notes

1 Williams, who died in 1988, was a well-known and prolific writer on Marxism and literature and the broader sociology of culture.
2 See Jürgen Habermas, "Modernity: An Incomplete Project," in *Postmodern Culture*, ed. Hal Foster (London: Pluto Press, 1985), pp. 3–15; *European Avant-Garde: New Perspectives*, ed. Dietrich Scheunemann (Amsterdam: Rodopi, 2000); Richard Murphy, *Theorizing the Avant-Garde: Modernism, Expressionism, and the Problem of*

Postmodernity (Cambridge: Cambridge University Press, 1999); Benjamin Buchloh, "Theorizing the Avant-Garde," *Art in America*, 72, no. 10 (Nov. 1984), pp. 19–21. For a concise critical overview of some different interpretations of "avant-garde," see Appendix 1, "The Avant-Garde," in Martha Ward, *Pissarro, Neo-Impressionism, and the Spaces of the Avant-Garde* (Chicago: University of Chicago Press, 1996), pp. 263–5.

3 See Jochen Schulte-Sasse, "Foreward: Theory of Modernism versus Theory of the Avant-Garde," in Peter Bürger, *Theory of the Avant-Garde* (1974) trans. Michael Shaw, (Minneapolis: University of Minnesota Press, 1984), pp. vii–xivii, esp. pp. xiv–xv.

4 Thomas Crow, "Modernism and Mass Culture in the Visual Arts," ch. 1 in Crow, *Modern Art in the Common Culture* (New Haven: Yale University Press, 1996), pp. 3–37, p. 11.

5 The applicability of Bürger's thesis to German Expressionism (chiefly literature and film) is explored in a recent study that also convincingly challenges Bürger's argument on several counts: Murphy, *Theorizing the Avant-Garde.*

6 Bürger's view of the late nineteenth century has been criticized as "monolithic." See Ward, *Pissarro*, p. 264.

7 Murphy, *Theorizing the Avant-Garde*, p. 28.

8 Hal Foster, *The Return of the Real: The Avant-Garde at the End of the Century* (Cambridge MA: MIT Press, 1996), pp. 4, 10, 15. Foster's criticism stems from Bürger's positing of the ("historical") avant-garde's significance as final and punctual. For Bürger, the shift in aesthetics is immediate. This is the basis for Bürger's dismissal of the "neo-avant-garde" (since any elaboration of the avant-garde can only be a rehearsal). Foster takes issue in particular with Bürger's claim that to repeat the avant-garde is to cancel its critique of the institution of autonomous art, or even to invert this critique to an affirmation of autonomous art. Benjamin Buchloh, too, argues that Bürger's contempt for contemporary art practice severely limits his vision and "testifies only to the traditional contempt of the academic critic for artists who continue to produce after criticism has declared either the climax or the death of the kind of art it favors." Buchloh, "Theorizing the Avant-Garde," p. 19.

9 Buchloh, "Theorizing the Avant-Garde," p. 21.

10 Ben Highmore, "Awkward Moments: Avant-Gardism and the Dialectics of Everyday Life," *European Avant-Garde*, ed. Scheunemann, pp. 245–64, p. 248.

11 See texts and commentry in *Aesthetics and Politics*, Afterword by Fredric Jameson, (London: Verso, 1977).

12 The architect was Paul Ludwig Troost, who died before it was built. The building still stands, and houses an important collection of modern art including many of the artists and some of the surviving works from the *Degenerate Art* exhibition. It is now known as the *Haus der Kunst.*

13 See Stephanie Barron, ed., *"Degenerate Art": The Fate of the Avant-Garde in Nazi Germany* (Los Angeles: Los Angeles County Museum of Art, 1991); Robert S. Wistrich, *Weekend in Munich: Art, Propaganda and Terror in the Third Reich* (London: Pavilion, 1995); *Die "Kunststadt" München 1937. Nationalsozialismus und "Entartete Kunst,"* ed. Peter-Klaus Schuster (Munich: Prestel, 1987), and Neil Levi, " 'Judge For Yourselves!' – The *Degenerate Art* Exhibition as Political Spectacle," *October* (Summer 1998), pp. 41–64.

14 See Adolf Hitler, "Speech Inaugurating the 'Great Exhibition of German Art'," in *Art in Theory 1900–1990: An Anthology of Changing Ideas*, eds. Charles Harrison and Paul Wood (Oxford: Blackwell, 1992), pp. 423–6.

15 Note that Groys (in the essay in this section) identifies the tendency to antique stylization as distinguishing Nazi art from art under Stalin.

16 Fred Orton, "Action, Revolution and Painting," in Orton and Pollock, *Avant-Gardes and Partisans Reviewed* (Manchester: Manchester University Press, 1996), pp. 177–203.

17 Greenberg, "The Late 30s in New York," quoted in Serge Guilbaut, "The New Adventures of the Avant-Garde in America: Greenberg, Pollock, or from Trotskyism to the New Liberalism of the 'Vital Center'," in *Pollock and After: The Critical Debate*, ed. Francis Frascina (London: Harper and Row, 1985), pp. 153–66, p. 154; see also *passim*.

18 Quoted in Orton, "Action, Revolution and Painting," p. 183.

19 For an example of Rivera's involvement in arguments for monumental revolutionary art in 1920s Mexico, see "Manifesto Issued by the Syndicate of Technical Workers, Painters and Sculptors" (Mexico City, 1922), in *Theories of Modern Art: A Sourcebook by Artists and Critics*, ed. Herschel B. Chipp (Berkeley: University of California Press, 1968), pp. 461–2.

20 The critic Meyer Schapiro sent Trotsky this and other works by Breton including *Nadja* and *The Communicating Vessels* from New York. See Mark Polizzotti, *Revolution of the Mind: The Life of André Breton* (London: Bloomsbury, 1995), p. 456.

21 Cited in ibid., p. 457.

22 Boris Groys, *The Total Art of Stalin: Avant-Garde, Aesthetic Dictatorship, and Beyond*, trans. Charles Rougle (Princeton: Princeton University Press, 1992). See also the catalog to the recent exhibition *Dream Factory Communism: The Visual Culture of the Stalin Era*, eds. Boris Groys and Max Hollein, Schirn Kunsthalle Frankfurt (Ostfildern-Ruit: Hatje Cantz Verlag, 2003). For an overview of art under Stalin from the more common Western perspective and for visual examples of Socialist Realism, see Matthew Cullerne Bown, *Art Under Stalin* (New York: Holmes & Meier, 1991).

23 See also Groys, *Total Art of Stalin*, pp. 71–2.

21

The Politics of the Avant-Garde

Raymond Williams

In January 1912 a torchlight procession, headed by members of the Stockholm Workers' Commune, celebrated the sixty-third birthday of August Strindberg. Red flags were carried and revolutionary anthems were sung.

No moment better illustrates the contradictory character of the politics of what is now variously (and confusingly) called the 'Modernist movement or the 'avant-garde'. In one simple dimension the acclamation of Strindberg is not surprising. Thirty years earlier, presenting himself, rhetorically, as the 'son of a servant', Strindberg had declared that in a time of social eruption he would side with those who came, weapon in hand, from below. In a verse contrasting Swartz, the inventor of gunpowder – used by kings to repress their peoples – with Nobel, the inventor of dynamite, he wrote:

> You, Swartz, had a small edition published
> For the nobles and the princely houses!
> Nobel! you published a huge popular edition
> Constantly renewed in a hundred thousand copies.[1]

The metaphor from publishing makes the association between the radical, experimental, popular writer and the rising revolutionary class explicit. Again, from 1909, he had returned to the radical themes of his youth, attacking the aristocracy, the rich, militarism and the conservative literary establishment. This association of enemies was equally characteristic.

Yet very different things had happened in the intervening years. The man who had written: 'I can get quite wild sometimes, thinking about the insanity of the world', had gone on to write: 'I am engaged in such a revolution against myself, and the scales are falling from my eyes.'[2] This is the transition which we shall

Raymond Williams, "The Politics of the Avant-Garde," pp. 49–63 from Raymond Williams, *The Politics of Modernism: Against the New Conformists*. London: Verso, 1989. Reprinted by permission of Verso.

come to recognize as a key movement in modern art, and which already in 1888 enabled Nietzsche to write of Strindberg's play *The Father*: 'It has astounded me beyond measure to find a work in which my own conception of love – with war as its means and the deathly hatred of the sexes as its fundamental law – is so magnificently expressed.'[3] Strindberg confirmed the mutual recognition: 'Nietzsche is to me the modern spirit who dares to preach the right of the strong and the wise against the foolish, the small (the democrats).'[4] This is still a radicalism, and indeed still daring and violent. But it is not only that the enemies have changed, being identified now as those tendencies which had hitherto been recognized as liberating: political progress, sexual emancipation, the choice of peace against war. It is also that the old enemies have disappeared behind these; indeed it is the strong and the powerful who now carry the seeds of the future: 'Our *evolution* ... wants to protect the strong against the weak species, and the current aggressiveness of women seems to me a symptom of the regress of the race.'[5] The language is that of Social Darwinism, but we can distinguish its use among these radical artists from the relatively banal justifications of a new hard (lean) social order by the direct apologists of capitalism. What emerges in the arts is a 'cultural Darwinism', in which the strong and daring radical spirits are the true *creativity* of the race. Thus there is not only an assault on the weak – democrats, pacifists, women – but on the whole social and moral and religious order. The 'regress of the race' is attributed to Christianity, and Strindberg could hail Nietzsche as 'the prophet of the overthrow of Europe and Christendom'.[6]

We have then to think again of the torches and red flags of the Workers' Commune. It is important, in one kind of analysis, to trace the shifts of position, and indeed the contradictions, within complex individuals. But to begin to understand the more general complexities of the politics of the avant-garde, we have to look beyond these singular men to the turbulent succession of artistic movements and cultural formations which compose the real history of Modernism and then of the avant-garde in so many of the countries of Europe. The emergence of these self-conscious, named and self-naming groups is a key marker of the movement in its widest sense.

We can distinguish three main phases which had been developing rapidly during the late nineteenth century. Initially, there were innovative groups which sought to protect their practices within the growing dominance of the art market and against the indifference of the formal academies. These developed into alternative, more radically innovative groupings, seeking to provide their own facilities of production, distribution and publicity; and finally into fully oppositional formations, determined not only to promote their own work but to attack its enemies in the cultural establishments and, beyond these, the whole social order in which these enemies had gained and now exercised and reproduced their power. Thus the defence of a particular kind of art became first the self-management of a new kind of art and then, crucially, an attack in the name of this art on a whole social and cultural order.

It is not easy to make simple distinctions between 'Modernism' and the 'avant-garde', especially as many uses of these labels are retrospective. But it can be taken

as a working hypothesis that Modernism can be said to begin with the second type of group – the alternative, radically innovating experimental artists and writers – while the avant-garde begins with groups of the third, fully oppositional type. The old military metaphor of the vanguard, which had been used in politics and in social thought from at latest the 1830s – and which had implied a position within a general human progress – now was directly applicable to these newly militant movements, even when they had renounced the received elements of progressivism. Modernism had proposed a new kind of art for a new kind of social and perceptual world. The avant-garde, aggressive from the beginning, saw itself as the breakthrough to the future: its members were not the bearers of a progress already repetitiously defined, but the militants of a creativity which would revive and liberate humanity.

Thus, two years before the Workers' Commune homage to Strindberg, the Futurists had published their manifestos in Paris and Milan. We can catch clear echoes of the Strindberg and Nietzsche of the 1880s. In the same language of cultural Darwinism, war is the necessary activity of the strong, and the means to the health of society. Women are identified as special examples of the weak who hold back the strong. But there is now a more specific cultural militancy: 'Take up your pickaxes, your axes and hammers, and wreck, wreck the venerable cities, pitilessly. Come on, set fire to the library shelves. Turn aside the canals to flood the museums.... So let them come, the gay incendiaries with charred fingers.... Here we are! Here we are!'[7] The directions are more particular, but we can remember, as we listen to them, Strindberg's celebration of dynamite in 'a huge popular edition'. Except that his violence had been linked with those 'who came, weapon in hand, from below': a central and traditional image of revolution. There is a significant difference in the Futurist commitment to what looks, at first glance, like the same movement: 'We will sing of great crowds excited by work, by pleasure and by riot . . . the multicoloured, polyphonic tides of revolution.'[8] Anyone with an ear for the nuances of talk of revolution, down to our own time, will recognize the change, and recognize also the confused and confusing elements of these repeated calls to revolution, many of which, in the pressures of subsequent history, were to become not only alternatives but actual political antagonists.

The direct call to political revolution, based in the workers' movements, was rising through just this period. The Futurist call to destroy 'tradition' overlaps with socialist calls to destroy the whole existing social order. But 'great crowds excited by work, by pleasure and by riot', 'the multicoloured polyphonic tides of revolution': these, while they can appear to overlap, are already – especially with the advantage of hindsight – a world away from the tightly organized parties which would use a scientific socialism to destroy the hitherto powerful and emancipate the hitherto powerless. The comparison bears both ways. Against the single track of proletarian revolution there are the 'multicoloured, polyphonic tides'. 'Great crowds excited . . . by riot' carries all the ambiguities between revolution and carnival. Moreover, and crucially, though its full development is later, there is the decisive difference between appeals to the tradition of reason

and the new celebration of creativity which finds many of its sources in the irrational, in the newly valued unconscious, and in the fragments of dreams. The social basis which had appeared to fuse when the Workers' Commune honoured Strindberg – a writer who had intensively explored these unconscious sources – could now be equally strongly contrasted: the organized working class with its disciplines of party and union; the cultural movement with its mobile association of free and liberating, often deliberately marginal, individuals.

What was 'modern', what was indeed 'avant-garde', is now relatively old. What its works and language reveal, even at their most powerful, is an identifiable historical period, from which, however, we have not fully emerged. What we can now identify in its most active and creative years, underlying its many works, is a range of diverse and fast-moving artistic methods and practices, and at the same time a set of relatively constant positions and beliefs.

We have already noticed the emphasis on creativity. This has precedents, obviously, in the Renaissance, and later in the Romantic Movement when the term, at first thought blasphemous, was invented and heavily used. What marks out this emphasis in both Modernism and the avant-garde is a defiance and finally violent rejection of tradition: the insistence on a clean break with the past. In both the earlier periods, though in different ways, there was a strong appeal to *revival*: the art and learning, the life of the past, were sources, stimuli of a new creativity, against an exhausted or deformed current order. This lasted as late as that alternative movement of the Pre-Raphaelites – a conscious modernism of its day; the present and the immediate past must be rejected, but there is a farther past, from which creativity can revive. What we now know as Modernism, and certainly as the avant-garde, has changed all this. Creativity is all in new making, new construction: all traditional, academic, even learned models are actually or potentially hostile to it, and must be swept away.

It is true that, as in the Romantic Movement, with its appeal to the folk art of marginal peoples, there is also a sidelong reference. Art seen as primitive or exotic but creatively powerful – and now within a developed imperialism available from much wider sources, in Asia and in Africa – is in several different movements, within this turbulent creative range, taken not only as exemplary, but as forms that can be woven into the consciously modern. These appeals to the 'Other' – in fact highly developed arts of their own places – are combined with an underlying association of the 'primitive' and the 'unconscious'. At the same time, however, and very marked in the competition between these movements, there is a virtually unprecedented emphasis on the most evident features of a modern urban industrialized world: the city, the machine, speed, space – the creative engineering, *construction* of a future. The contrast with the central Romantic emphases on spiritual and natural creativity could hardly be more marked.

Yet also, and decisive for its relations with politics, the range of new movements was operating in a very different social world. To the emphases on creativity and on the rejection of tradition we must add a third common factor: that all these movements, implicitly but more often explicitly, claimed to be anti-bourgeois.

243

Indeed 'bourgeois', in all its rich range of meanings, turns out to be a key to the many movements which claimed to be its opposite. Schools and movements repeatedly succeeded each other, fused or more often fragmented in a proliferation of *isms*. Within them individuals of marked singularity pursued their apparently and in some ways authentically autonomous projects, readily linked by the historian but often directly experienced as isolated and isolating. Very diverse technical solutions were found, in each of the arts, to newly emphasized problems of representation and narration, and to ways beyond what came to be seen as these constrictions of purpose and form. For many working artists and writers, these working considerations – the actual methods of their art – were always uppermost in their minds; indeed they could sometimes be isolated as evidence of the singularity and purity of art. But whichever of these ways was taken there was always a single contrast to it. Hostile or indifferent or merely vulgar, the bourgeois was the mass which the creative artist must either ignore and circumvent, or now increasingly shock, deride and attack.

No question is more important to our understanding of these once modern movements than the ambiguity of 'bourgeois'. The underlying ambiguity is historical, in its dependence on the variable class position from which the bourgeois was seen. To the court and the aristocracy the bourgeois was at once worldly and vulgar, socially pretentious but hide-bound, moralistic and spiritually narrow. To the newly organizing working class, however, not only the individual bourgeois with his combination of self-interested morality and self-serving comfort, but the bourgeoisie as a class of employers and controllers of money, was at centre stage.

The majority of artists, writers and intellectuals were in none of these fixed class positions. But in different and variable ways they could overlap with the complaints of each other class against the bourgeois reckoning of the world. There were the dealers and booksellers who, within the newly dominant cultural market, were treating works of art as simple commodities, their values determined by trading success or failure. Protests against this could overlap with the Marxist critique of the reduction of labour to a traded commodity. Alternative and oppositional artistic groups were defensive attempts to get beyond the market, distantly analogous to the working-class development of collective bargaining. There could thus be at least a negative identification between the exploited worker and the exploited artist. Yet one of the central points of their complaint against this treatment of art was that creative art was more than simple labour; its cultural and spiritual or then its aesthetic values were especially outraged as the commodity reduction took hold. Thus the bourgeois could also be seen, simultaneously or alternatively, as the vulgar, hidebound, moralistic and spiritually narrow figure of the aristocratic complaint.

There are innumerable variations on these essentially distinguishable complaints against the bourgeoisie. How each mix or variation came out politically, depended, crucially, on differences in the social and political structures of the many countries within which these movements were active, but also, in ways often

very difficult to analyse, on the proportions of the different elements in the anti-bourgeois positions.

In the nineteenth century the element derived from the aristocratic critique was obviously much stronger, but it found a metaphorical form of its own, which was to survive, pathetically, into the twentieth century, to be taken up by even the most unlikely people: the claim, indeed the assertion, that the artist was the authentic aristocrat; had indeed to be, in the spiritual sense, an aristocrat if he was to be an artist. An alternative vocabulary gathered behind this assertion, from Arnold's culturally superior 'remnant' to Mannheim's vitally uncommitted intelligentsia, and more individually in the proposition – eventually the cult – of 'the genius' and 'the superman'. Naturally the bourgeoisie and its world were objects of hostility and contempt from such positions, but the assertion did not have to be made very often to extend to a wholesale condemnation of the 'mass' that was beyond all authentic artists: now not only the bourgeoisie but that ignorant populace which was beyond the reach of art or hostile to it in vulgar ways. Any residue of an actual aristocracy could at times be included in this type of condemnation: worldly barbarians who were offensively mistaken for the true creative aristocrats.

On the other hand, as the working-class, socialist and anarchist movements developed their own kind of critique, identifying the bourgeoisie as the organizers and agents of capitalism and thus the specific source of the reduction of all broader human values, including the values of art, to money and trade, there was an opportunity for artists to join or support a wide and growing movement which would overthrow and supersede bourgeois society. This could take the form of a negative identification between the artists and workers, each group being practically exploited and oppressed; or, though more rarely, a positive identification, in which artists would commit themselves, in their art and out of it, to the larger causes of the people or of the workers.

Thus within what may at first hearing sound like closely comparable denunciations of the bourgeois, there are already radically different positions, which would lead eventually, both theoretically and under the pressure of actual political crisis, not only to different but to directly opposed kinds of politics: to Fascism or to Communism; to social democracy or to conservatism and the cult of excellence.

This synchronic range has, moreover, to be complemented by the diachronic range of the actual bourgeoisie. In its early stages there had been an emphasis on independent productive and trading enterprise, free of the constraints of state regulation and both privilege and precedent, which in practice closely accorded with the life situation and desires of many artists, who were already in precisely this position. It is not really surprising that so many artists – including, ironically, at later stages of their careers, many avant-garde artists – became in this sense good and successful bourgeois: at once attentive to control of their own production and property, and – which mattered more in public presentation – ultimate apotheoses of that central bourgeois figure: the sovereign individual. This is still today the small change of conventional artistic self-presentation.

245

Yet the effective bourgeoisie had not stopped at these early stages. As it gathered the fruits of its free and independent production it placed a heavy emphasis on the rights of accumulated (as distinct from inherited) property, and thus on its forms of settlement. Though in practice these were interlocked in variable ways with older forms of property and settlement in state and aristocracy, there was a distinctive emphasis on the morality (rather than only the brute fact) of property and order.

A particular instance, of great importance to Modernism and the avant-garde, is what came to be called the *bourgeois family.* The actual bourgeois family was not the inventor of propertied marriage, nor of the inclusion within it of male domination over women and children. The bourgeois initiative within these established feudal forms had been an emphasis on personal feeling – at first derided as sentimental – as the proper basis for marriage, and a related emphasis on the direct care of children. The fusion of these ideas of the family with the received forms of property and settlement was a hybrid rather than a true bourgeois creation.

Yet, by the time of Modernism, the contradictions of this hybrid were increasing. The emphasis on personal feeling was quickly developed into an emphasis on irresistible or even momentary desire, which it would be a thwarting of humanity to suppress. The care of children could be resented as an irksome form of control. And the repression of women, within a restrictive social system, was increasingly challenged. Nor is it any reduction of the nature of these developments to note how much more vigorous they became as the bourgeoisie moved, by its very economic success, into more funded forms. The economic constraints by which the older forms had maintained practical control were loosened not only by general changes in the economy and by the availability of new (and especially professional) kinds of work, but by a cruder consideration: that the son or daughter of a bourgeois family was financially in a position to lay claim to new forms of liberation, and in a significant number of cases could actually use the profits of the economic bourgeoisie to lead political and artistic crusades against it.

Thus the growing critique of the bourgeois family was as ambiguous as the more general critique of the bourgeois as such. With the same vigour and confidence as the first bourgeois generations, who had fought state and aristocratic monopolies and privileges, a new generation, still in majority by practice and inheritance bourgeois, fought, on the same principle of the sovereign individual, against the monopoly and privilege of marriage and family. It is true that this was most vigorous at relatively young ages, in the break-out to new directions and new identities. But in many respects a main element of modernism was that it was an authentic avant-garde, in personal desires and relationships, of the successful and evolving bourgeoisie itself. The desperate challenges and deep shocks of the first phase were to become the statistics and even the conventions of a later phase of the same order.

Thus what we have observed synchronically in the range of positions covered by the anti-bourgeois revolt we observe also, diachronically, within that evolution

of the bourgeoisie which in the end produced its own successions of distinctively bourgeois dissidents. This is a key element of the politics of the avant-garde, and we need especially to remember it as we look at forms which seem to go beyond politics or indeed to discount politics as irrelevant. Thus there is a position within the apparent critique of the bourgeois family which is actually a critique and rejection of all social forms of human reproduction. The 'bourgeois family', with all its known characteristics of property and control, is often in effect a covering phrase for those rejections of women and children which take the form of a rejection of 'domesticity'. The sovereign individual is confined by any such form. The genius is tamed by it. But since there is little option for celibacy, and only a limited option (though taken and newly valued, even directly associated with art) for homosexuality, the male campaign for liberation is often associated, as in the cases of Nietzsche and Strindberg, with great resentment and hatred of women, and with a reduction of children to elements of struggle between incompatible individuals. In this strong tendency, liberation translates desire as perpetually mobile: it cannot, in principle, be achieved in a settled relationship or in a society. Yet at the same time the claims of human liberation, against forms of property and other economic controls, are being much more widely made, and increasingly – for that is the irony of even the first phase – by women.

Thus we have seen that what is new in the avant-garde is the aggressive dynamism and conscious affront of claims to liberation and creativity which, through the whole Modernist period, were in fact being much more widely made. We have now to look at the variable forms of its actual intersections with politics. These cover, in effect, the whole political range, though in the great majority of cases there is a strong movement towards the new political forces which were breaking beyond old constitutional and imperial politics, both before the war of 1914–18 and with much greater intensity during and after it. We can briefly identify some of the main strands.

There was, first, a strong attraction to forms of anarchism and nihilism, and also to forms of revolutionary socialism which, in their aesthetic representation, had a comparably apocalyptic character. The contradictions between these varying kinds of attachment were eventually to be obvious, but there was a clear initial linkage between the violent assault on existing conventions and the programmes of anarchists, nihilists and revolutionary socialists. The deep emphasis on the liberation of the creative individual took many towards the anarchist wing, but especially after 1917 the project of heroic revolution could be taken as a model for the collective liberation of all individuals. Hostility to the war and to militarism also fed this general tendency, from the Dadaists to the Surrealists, and from the Russian Symbolists to the Russian Futurists.

On the other hand, the commitment to a violent break with the past, most evident in Futurism, was to lead to early political ambiguities. Before 1917 the rhetoric of revolutionary violence could appear congruent with the Italian Futurists' explicit glorification of violence in war. It was only after 1917, and its consequent crises elsewhere, that these came to be fully distinguished. By then

247

two Futurists, Marinetti and Mayakovsky, had moved in quite opposite directions: Marinetti to his support for Italian Fascism; Mayakovsky to his campaigning for a popular Bolshevik culture. The renewed rhetoric of violent rejection and disintegration in the Germany of the 1920s produced associations within Expressionism and related movements which by the end of the decade, and then notably with the coming of Hitler, led different writers to positions on the extreme poles of politics: to both Fascism and Communism.

Within these varying paths, which can be tracked to relatively explicit political stations, there is a very complex set of attachments which could, it seems, go either way. It is a striking characteristic of several movements within both Modernism and the avant-garde that rejection of the existing social order and its culture was supported and even directly expressed by recourse to a simpler art: either the primitive or exotic, as in the interest in African and Chinese objects and forms, or the 'folk' or 'popular' elements of their native cultures. As in the earlier case of the 'medievalism' of the Romantic Movement, this reach back beyond the existing cultural order was to have very diverse political results. Initially the main impulse was, in a political sense, 'popular': this was the true or the repressed native culture which had been overlain by academic and establishment forms and formulas. Yet it was simultaneously valued in the same terms as the exotic art because it represented a broader human tradition, and especially because of those elements which could be taken as its 'primitivism', a term which corresponded with that emphasis on the innately creative, the unformed and untamed realm of the pre-rational and the unconscious, indeed that vitality of the naive which was so especially a leading edge of the avant-garde.

We can then see why these emphases went in different political directions as they matured. The 'folk' emphasis, when offered as evidence of a repressed popular tradition, could move readily towards socialist and other radical and revolutionary tendencies. One version of the vitality of the naive could be joined with this, as witness of the new kinds of art which a popular revolution would release. On the other hand, an emphasis on the 'folk', as a particular kind of emphasis on 'the people', could lead to very strong national and eventually nationalist identifications, of the kind heavily drawn upon in both Italian and German Fascism.

Equally, however, an emphasis on the creativity of the pre-rational could be coopted into a rejection of all forms of would-be rational politics, including not only liberal progressivism but also scientific socialism, to the point where, in one version, the politics of action, of the unreflecting strong, could be idealized as necessarily liberating. This was not, of course, the only conclusion from an emphasis on the pre-rational. The majority of the Surrealists in the 1930s moved towards resistance against Fascism: of course as an active, disrupting resistance. There was also a long (and unfinished) interaction between psychoanalysis, increasingly the theoretical expression of these 'pre-rational' emphases, and Marxism, now the dominant theoretical expression of the revolutionary working class. There were many attempted fusions of the revolutionary impulse

in both, both generally and in particular relation to a new sexual politics which both derived from the contested early Modernist sources. There was also, how ever, an eventual rejection of all politics, in the name of the deeper realities of the dynamic psyche; and, within this, one influential strand of option for *conservative* forms of order, seen as offering at least some framework of control for the unruly impulses both of the dynamic psyche and of the pre-rational 'mass' or 'crowd'.

The diverse movements which went in these different and opposed directions continued to have one general property in common: all were pioneering new methods and purposes in writing, art and thought. It is then a sober fact that, for this very reason, they were so often rejected by mainstream political forces. The Nazis were to lump left, right and centre Modernists together as *Kulturbolsche-wismus*. From the middle and late 1920s, the Bolsheviks in power in the Soviet Union rejected virtually the same range. During the Popular Fronts of the 1930s there was a reassembly of forces: Surrealists with social realists, Constructivists with folk artists, popular internationalism with popular nationalism. But this did not outlast its immediate and brief occasion, and through the war of 1939–45 separate directions and transformations were resumed, to reappear in further brief alliances in the postwar years and especially, with what seemed a renewal of the original energies, in the 1960s.

Within the range of general possibilities it mattered greatly what was happening in the different countries in which the avant-garde movements were based, or in which they found refuge. The true social bases of the early avant-garde were at once cosmopolitan and metropolitan. There was rapid transfer and interaction between different countries and different capitals, and the deep mode of the whole movement, as in Modernism, was precisely this mobility across frontiers: frontiers which were among the most obvious elements of the old order which had to be rejected, even when native folk sources were being included as elements or as inspiration of the new art. There was intense competition but also radical coexistence in the great imperial capitals of Paris, Vienna, Berlin, and Petersburg, and also, in more limited ways, in London. These concentrations of wealth and power, and of state and academy, had each, within their very complexities of contact and opportunity, drawn towards them those who most opposed them. The dynamics of the imperialist metropolis were, then, the true bases of this opposition, in ways that have already been explored in the volume *Unreal City*.[9]

This was to happen again, but in essentially different ways, after the shocks of the 1914–18 war and the Russian Revolution. Paris and Berlin (until Hitler) were the new major centres, but the assembly now was not only of pioneering artists, writers and intellectuals seeking contact and solidarity in their multiplicity of movements, but to a much greater extent of political exiles and emigrés: a movement later to be repeated, with an even greater emphasis, in New York.

Thus there is a certain structural continuity within the changing situations of the metropolitan capitals. Yet, wherever the artists might be, or settle, the quite new political crises of the post-1917 world produced a diversity different in kind from the mobile and competitive diversity of the years before 1914. Thus the

Russian Modernists and avant-gardists were in a country which had passed through revolution and civil war. Blok, in *The Twelve*, could write a late Symbolist poem of twelve Red Army soldiers led by Christ through a storm towards the new world. Mayakovsky could move from the liberated detachment of *A Cloud in Trousers* (1915) to *Mystery Buffo* (1918), acclaiming the revolution, and later, after the official rejection of Modernist and avant-garde art, to the satirical observation of the supposed new world in *The Bedbug* (1929). These are examples among many, in the turbulence of those years, when the relation between politics and art was no longer a matter of manifesto but of difficult and often dangerous practice.

The Italian Futurists had a very different but comparable experience. The earlier rhetoric had led them towards Fascism, but its actual manifestation was to impose new tests, and varieties of accommodation and reservation. In the Weimar Republic there was still an active and competitive diversity, with the current running strongly against bourgeois culture and its forms. But while Piscator could move from the Spartakus League to the Proletarian Theatre, the poet Tucholsky, verifying a point in our earlier analysis, could declare that 'one is bourgeois by predisposition, not by birth and least of all by profession':[10] bourgeois, that is to say, not as a political but as a spiritual classification. The eventual crisis of the end of the Republic and the Nazi rise to power forced a polarization which can be summarily represented, among writers who had been closely involved with Expressionism, by Brecht on the revolutionary Left and Gottfried Benn on the Fascist Right.

In countries in which during this period there was no radical change of power in the state, the effects, though no less complex, were often less dramatic. There was a notable rallying of Surrealist writers to the anti-Fascist cause in France, but there, as in Britain, it was possible to sustain a certain political solidarity against war and against Fascism within a diversity of literary movements and cultural principles. In the Popular Front period, also, that element of the original avant-garde position which had rejected official cultural institutions and sought new – and in some instances, as in the early Soviet Union, new *popular* – audiences for more open kinds of art, was widely emphasized. There was the leftist tendency of the Auden and Isherwood plays, borrowing from German Expressionism; but there was also an avant-garde colouring in the social-realist and documentary film and theatre movements, offering to break from fixed fictional forms and enclosed bourgeois institutions.

Also in Britain, however, there was a significantly different tendency, in which literary Modernism moved explicitly to the right. Wyndham Lewis's Vorticism, a version of Futurism, developed idiosyncratically, but Pound's characteristically total avant-garde position ended in Fascism, and Yeats's version of the 'people', sustained at first by a broad and diverse movement, became a right-wing nationalism. The most interesting because most influential case is that of Eliot, seen from the 1920s to the 1940s as the key modernist poet. Eliot developed what can now be seen as an Ancient-and-Modern position, in which unceasing literary

experiment moved towards a conscious elite, and in which an emphasis on tradition (so distinct from earlier Modernist and avant-garde rejections of the past) was offered as in effect subversive of an intolerable because shallow and self-deceiving (and in that sense still *bourgeois*) social and cultural order.

The war of 1939–45 brought an end to many of these movements and transformed most of the earlier positions. Yet, though it requires separate analysis, the period since 1945 shows many of the earlier situations and pressures, and indeed many – though, at their most serious, altered – recurrences of position and initiative. Two new social factors have then to be noted, since continuities and similarities of technique, affiliation and manifesto can too easily be isolated in a separated aesthetic history: itself one of the influential forms of a postwar cultural modernism which had observed the complexity of the many political crises.

First, the avant-garde, in the sense of an artistic movement which is simultaneously both a cultural and political campaign, has become notably less common. Yet there are avant-garde political positions from the earliest stages – dissident from fixed bourgeois forms, but still as *bourgeois* dissidents – which can be seen as a genuine vanguard of a truly modern international bourgeoisie which has emerged since 1945. The politics of this New Right, with its version of libertarianism in a dissolution or deregulation of all bonds and all national and cultural formations in the interest of what is represented as the ideal open market and the truly open society, look very familiar in retrospect. For the sovereign individual is offered as the dominant political and cultural form, even in a world more evidently controlled by concentrated economic and military power. That it can be offered as such a form, in such conditions, depends partly on that emphasis which was once, within settled empires and conservative institutions, so challenging and so marginal.

Secondly, especially in the cinema, in the visual arts, and in advertising, certain techniques which were once experimental and actual shocks and affronts have become the working conventions of a widely distributed commercial art, dominated from a few cultural centres, while many of the original works have passed directly into international corporate trade. This is not to say that Futurism, or any other of the avant-garde movements, has found its literal future. The rhetoric may still be of endless innovation. But instead of revolt there is the planned trading of spectacle, itself significantly mobile and, at least on the surface, deliberately disorientating.

We have then to recall that the politics of the avant-garde, from the beginning, could go either way. The new art could find its place either in a new social order or in a culturally transformed but otherwise persistent and recuperated old order. All that was quite certain, from the first stirrings of Modernism through to the most extreme forms of the avant-garde, was that nothing could stay quite as it was: that the internal pressures and the intolerable contradictions would force radical changes of some kind. Beyond the particular directions and affiliations, this is still the historical importance of this cluster of movements and of remarkable individual artists. And since, if in new forms, the general pressures

251

and contradictions are still intense, indeed have in many ways intensified, there is still much to learn from the complexities of its vigorous and dazzling development.

Notes

1 Quoted in O. Lagercrantz, *August Strindberg*, London 1984, p. 97.
2 Ibid., p. 122.
3 Quoted in M. Meyer, *August Strindberg*, London 1985, p. 205.
4 Ibid.
5 Ibid.
6 Ibid.
7 U. Apollonio, ed., *Futurist Manifestos*, London 1973, p. 23.
8 Ibid., p. 22.
9 Edward Timms and David Kelley, eds, *Unreal City: Urban Experience in Modern European Literature and Art*, Manchester 1985.
10 See A. Phelan, 'Left-wing Melancholia', in A. Phelan, ed., *The Weimar Dilemma*, Manchester 1985.

22

From *Theory of the Avant-Garde*

Peter Bürger

3. The Negation of the Autonomy of Art by the Avant-Garde

In scholarly discussion up to now, the category 'autonomy' has suffered from the imprecision of the various subcategories thought of as constituting a unity in the concept of the autonomous work of art. Since the development of the individual subcategories is not synchronous, it may happen that sometimes courtly art seems already autonomous, while at other times only bourgeois art appears to have that characteristic. To make clear that the contradictions between the various interpretations result from the nature of the case, we will sketch a historical typology that is deliberately reduced to three elements (purpose or function, production, reception), because the point here is to have the nonsynchronism in the development of individual categories emerge with clarity.

A. Sacral Art (example: the art of the High Middle Ages) serves as cult object. It is wholly integrated into the social institution 'religion.' It is produced collectively, as a craft. The mode of reception also is institutionalized as collective.

B. Courtly Art (example: the art at the court of Louis XIV) also has a precisely defined function. It is representational and serves the glory of the prince and the self-portrayal of courtly society. Courtly art is part of the life praxis of courtly society, just as sacral art is part of the life praxis of the faithful. Yet the detachment from the sacral tie is a first step in the emancipation of art. ('Emancipation' is being used here as a descriptive term, as referring to the process by which art constitutes itself as a distinct social subsystem.) The difference from sacral art becomes particularly apparent in the realm of production: the artist produces as

Peter Bürger, pp. 47–54, 73–82 from *Theory of the Avant-Garde*, trans. Michael Shaw. Minneapolis: University of Minnesota Press, 1984. English translation © 1984 by the University of Minnesota. Originally published in German as *Theorie der Avantgarde*, © 1974, 1980 by Suhrkamp Verlag.

an individual and develops a consciousness of the uniqueness of his activity. Reception, on the other hand, remains collective. But the content of the collective performance is no longer sacral, it is sociability.

C. Only to the extent that the bourgeoisie adopts concepts of value held by the aristocracy does bourgeois art have a representational function. When it is genuinely bourgeois, this art is the objectification of the self-understanding of the bourgeois class. Production and reception of the self-understanding as articulated in art are no longer tied to the praxis of life. Habermas calls this the satisfaction of residual needs, that is, of needs that have become submerged in the life praxis of bourgeois society. Not only production but reception also are now individual acts. The solitary absorption in the work is the adequate mode of appropriation of creations removed from the life praxis of the bourgeois, even though they still claim to interpret that praxis. In Aestheticism, finally, where bourgeois art reaches the stage of self-reflection, this claim is no longer made. Apartness from the praxis of life, which had always been the condition that characterized the way art functioned in bourgeois society, now becomes its content. The typology we have sketched here can be represented in the accompanying tabulation (the vertical lines in boldface refer to a decisive change in the development, the broken ones to a less decisive one).

	Sacral Art	Courtly Art	Bourgeois Art
Purpose or function	cult object	representational object	portrayal of bourgeois self-understanding
Production	collective craft	individual	individual
Reception	collective (sacral)	collective (sociable)	individual

The tabulation allows one to notice that the development of the categories was not synchronous. Production by the individual that characterizes art in bourgeois society has its origins as far back as courtly patronage. But courtly art still remains integral to the praxis of life, although as compared with the cult function, the representational function constitutes a step toward a mitigation of claims that art play a direct social role. The reception of courtly art also remains collective, although the content of the collective performance has changed. As regards reception, it is only with bourgeois art that a decisive change sets in: its reception is one by isolated individuals. The novel is that literary genre in which the new mode of reception finds the form appropriate to it. The advent of bourgeois art is also the decisive turning point as regards use or function. Although in different ways, both sacral and courtly art are integral to the life praxis of the recipient. As cult and representational objects, works of art are put to a specific use. This requirement no longer applies to the same extent to bourgeois art. In bourgeois art, the portrayal of bourgeois self-understanding occurs in a sphere that lies

outside the praxis of life. The citizen who, in everyday life has been reduced to a partial function (means–ends activity) can be discovered in art as 'human being.' Here, one can unfold the abundance of one's talents, though with the proviso that this sphere remain strictly separate from the praxis of life. Seen in this fashion, the separation of art from the praxis of life becomes the decisive characteristic of the autonomy of bourgeois art (a fact that the tabulation does not bring out adequately). To avoid misunderstandings, it must be emphasized once again that autonomy in this sense defines the status of art in bourgeois society but that no assertions concerning the contents of works are involved. Although art as an institution may be considered fully formed toward the end of the eighteenth century, the development of the contents of works is subject to a historical dynamics, whose terminal point is reached in Aestheticism, where art becomes the content of art.

The European avant-garde movements can be defined as an attack on the status of art in bourgeois society. What is negated is not an earlier form of art (a style) but art as an institution that is unassociated with the life praxis of men. When the avant-gardistes demand that art become practical once again, they do not mean that the contents of works of art should be socially significant. The demand is not raised at the level of the contents of individual works. Rather, it directs itself to the way art functions in society, a process that does as much to determine the effect that works have as does the particular content.

The avant-gardistes view its dissociation from the praxis of life as the dominant characteristic of art in bourgeois society. One of the reasons this dissociation was possible is that Aestheticism had made the element that defines art as an institution the essential content of works. Institution and work contents had to coincide to make it logically possible for the avant-garde to call art into question. The avant-gardistes proposed the sublation of art – sublation in the Hegelian sense of the term: art was not to be simply destroyed, but transferred to the praxis of life where it would be preserved, albeit in a changed form. The avant-gardistes thus adopted an essential element of Aestheticism. Aestheticism had made the distance from the praxis of life the content of works. The praxis of life to which Aestheticism refers and which it negates is the means–ends rationality of the bourgeois everyday. Now, it is not the aim of the avant-gardistes to integrate art into *this* praxis. On the contrary, they assent to the aestheticists' rejection of the world and its means–ends rationality. What distinguishes them from the latter is the attempt to organize a new life praxis from a basis in art. In this respect also, Aestheticism turns out to have been the necessary precondition of the avant-gardiste intent. Only an art the contents of whose individual works is wholly distinct from the (bad) praxis of the existing society can be the center that can be the starting point for the organization of a new life praxis.

With the help of Herbert Marcuse's theoretical formulation concerning the twofold character of art in bourgeois society, the avant-gardiste intent can be understood with particular clarity. All those needs that cannot be satisfied in everyday life, because the principle of competition pervades all spheres, can find

a home in art, because art is removed from the praxis of life. Values such as humanity, joy, truth, solidarity are extruded from life as it were, and preserved in art. In bourgeois society, art has a contradictory role: it projects the image of a better order and to that extent protests against the bad order that prevails. But by realizing the image of a better order in fiction, which is semblance (*Schein*) only, it relieves the existing society of the pressure of those forces that make for change. They are assigned to confinement in an ideal sphere. Where art accomplishes this, it is 'affirmative' in Marcuse's sense of the term. If the twofold character of art in bourgeois society consists in the fact that the distance from the social production and reproduction process contains an element of freedom and an element of the noncommittal and an absence of any consequences, it can be seen that the avant-gardistes' attempt to reintegrate art into the life process is itself a profoundly contradictory endeavor. For the (relative) freedom of art vis-à-vis the praxis of life is at the same time the condition that must be fulfilled if there is to be a critical cognition of reality. An art no longer distinct from the praxis of life but wholly absorbed in it will lose the capacity to criticize it, along with its distance. During the time of the historical avant-garde movements, the attempt to do away with the distance between art and life still had all the pathos of historical progressiveness on its side. But in the meantime, the culture industry has brought about the false elimination of the distance between art and life, and this also allows one to recognize the contradictoriness of the avant-gardiste undertaking.

In what follows, we will outline how the intent to eliminate art as an institution found expression in the three areas that we used above to characterize autonomous art: purpose or function, production, reception. Instead of speaking of the avant-gardiste work, we will speak of avant-gardiste manifestation. A dadaist manifestation does not have work character but is nonetheless an authentic manifestation of the artistic avant-garde. This is not to imply that the avant-gardistes produced no works whatever and replaced them by ephemeral events. We will see that whereas they did not destroy it, the avant-gardistes profoundly modified the category of the work of art.

Of the three areas, the *intended purpose or function* of the avant-gardiste manifestation is most difficult to define. In the aestheticist work of art, the disjointure of the work and the praxis of life characteristic of the status of art in bourgeois society has become the work's essential content. It is only as a consequence of this fact that the work of art becomes its own end in the full meaning of the term. In Aestheticism, the social functionlessness of art becomes manifest. The avant-gardiste artists counter such functionlessness not by an art that would have consequences within the existing society, but rather by the principle of the sublation of art in the praxis of life. But such a conception makes it impossible to define the intended purpose of art. For an art that has been reintegrated into the praxis of life, not even the absence of a social purpose can be indicated, as was still possible in Aestheticism. When art and the praxis of life are one, when the praxis is aesthetic and art is practical, art's purpose can no longer be discovered, because

the existence of two distinct spheres (art and the praxis of life) that is constitutive of the concept of purpose or intended use has come to an end.

We have seen that the *production* of the autonomous work of art is the act of an individual. The artist produces as individual, individuality not being understood as the expression of something but as radically different. The concept of genius testifies to this. The quasitechnical consciousness of the makeability of works of art that Aestheticism attains seems only to contradict this. Valéry, for example, demystifies artistic genius by reducing it to psychological motivations on the one hand, and the availability to it of artistic means on the other. While pseudo-romantic doctrines of inspiration thus come to be seen as the self-deception of producers, the view of art for which the individual is the creative subject is let stand. Indeed, Valéry's theorem concerning the force of pride (*orgueil*) that sets off and propels the creative process renews once again the notion of the individual character of artistic production central to art in bourgeois society. In its most extreme manifestations, the avant-garde's reply to this is not the collective as the subject of production but the radical negation of the category of individual creation. When Duchamp signs mass-produced objects (a urinal, a bottle drier) and sends them to art exhibits, he negates the category of individual production. The signature, whose very purpose it is to mark what is individual in the work, that it owes its existence to this particular artist, is inscribed on an arbitrarily chosen mass product, because all claims to individual creativity are to be mocked. Duchamp's provocation not only unmasks the art market where the signature means more than the quality of the work; it radically questions the very principle of art in bourgeois society according to which the individual is considered the creator of the work of art. Duchamp's Ready-Mades are not works of art but manifestations. Not from the form–content totality of the individual object Duchamp signs can one infer the meaning, but only from the contrast between mass-produced object on the one hand, and signature and art exhibit on the other. It is obvious that this kind of provocation cannot be repeated indefinitely. The provocation depends on what it turns against: here, it is the idea that the individual is the subject of artistic creation. Once the signed bottle drier has been accepted as an object that deserves a place in a museum, the provocation no longer provokes; it turns into its opposite. If an artis today signs a stove pipe and exhibits it, that artist certainly does not denounce the art market but adapts to it. Such adaptation does not eradicate the idea of individual creativity, it affirms it, and the reason is the failure of the avant-gardiste intent to sublate art. Since now the protest of the historical avant-garde against art as institution is accepted as *art*, the gesture of protest of the neo-avant-garde becomes inauthentic. Having been shown to be irredeemable, the claim to be protest can no longer be maintained. This fact accounts for the arts-and-crafts impression that works of the avant-garde not infrequently convey.

The avant-garde not only negates the category of individual production but also that of individual *reception*. The reactions of the public during a dada manifestation where it has been mobilized by provocation, and which can range from shouting to

257

fisticuffs, are certainly collective in nature. True, these remain reactions, responses to a preceding provocation. Producer and recipient remain clearly distinct, however active the public may become. Given the avant-gardiste intention to do away with art as a sphere that is separate from the praxis of life, it is logical to eliminate the antithesis between producer and recipient. It is no accident that both Tzara's instructions for the making of a Dadaist poem and Breton's for the writing of automatic texts have the character of recipes. This represents not only a polemical attack on the individual creativity of the artist; the recipe is to be taken quite literally as suggesting a possible activity on the part of the recipient. The automatic texts also should be read as guides to individual production. But such production is not to be understood as artistic production, but as part of a liberating life praxis. This is what is meant by Breton's demand that poetry be practiced (*pratiquer la poésie*). Beyond the coincidence of producer and recipient that this demand implies, there is the fact that these concepts lose their meaning: producers and recipients no longer exist. All that remains is the individual who uses poetry as an instrument for living one's life as best one can. There is also a danger here to which Surrealism at least partly succumbed, and that is solipsism, the retreat to the problems of the isolated subject. Breton himself saw this danger and envisaged different ways of dealing with it. One of them was the glorification of the spontaneity of the erotic relationship. Perhaps the strict group discipline was also an attempt to exorcise the danger of solipsism that surrealism harbors.

In summary, we note that the historical avant-garde movements negate those determinations that are essential in autonomous art: the disjunction of art and the praxis of life, individual production, and individual reception as distinct from the former. The avant-garde intends the abolition of autonomous art by which it means that art is to be integrated into the praxis of life. This has not occurred, and presumably cannot occur, in bourgeois society unless it be as a false sublation of autonomous art. Pulp fiction and commodity aesthetics prove that such a false sublation exists. A literature whose primary aim it is to impose a particular kind of consumer behavior on the reader is in fact practical, though not in the sense the avant-gardistes intended. Here, literature ceases to be an instrument of emancipation and becomes one of subjection. Similar comments could be made about commodity aesthetics that treat form as mere enticement, designed to prompt purchasers to buy what they do not need. Here also, art becomes practical but it is an art that enthralls. This brief allusion will show that the theory of the avant-garde can also serve to make us understand popular literature and commodity aesthetics as forms of a false sublation of art as institution. In late capitalist society, intentions of the historical avant-garde are being realized but the result has been a disvalue. Given the experience of the false sublation of autonomy, one will need to ask whether a sublation of the autonomy status can be desirable at all, whether the distance between art and the praxis of life is not requisite for that free space within which alternatives to what exists become conceivable. [...]

5. Montage

It is important to clearly understand at the very onset that the concept of montage does not introduce a new category meant to replace the concept of allegory. Rather, it is a category that permits a more precise definition of a particular aspect of the concept of allegory. Montage presupposes the fragmentation of reality and describes the phase of the constitution of the work. Since the concept plays a role not only in the fine arts and in literature but also in the film, it is necessary to first clarify what it refers to in each of the various media.

Film is the stringing together of photographic images that because of the speed with which they flow past the eye of the spectator, create the impression of movement. In the film, the montage of images is the basic *technical procedure*. It is not a specifically artistic technique, but one that lies in the medium. Nonetheless, there are differences in its use. It is not the same thing when natural movements are photographed as when simulated ones are created by cutting (for example, the leaping stone lion in Potemkin, which is edited from shots of a sleeping, an awakening, and a rising marble lion). In the former case, there is also a montage of individual shots but the impression created in the film only reproduces illusionistically the natural sequence of movements, whereas in the second case, it is montage that creates the impression of movement.

Although montage is thus a technical device given with the medium itself, it has the status of an artistic principle in painting. It is no accident that, apart from 'precursors' who can always be discovered after the fact, montage first emerges in connection with cubism, that movement in modern painting which most consciously destroyed the representational system that had prevailed since the Renaissance. In the *papiers collés* of Picasso and Braque that they created during the years before the First World War, we invariably find a contrast between two techniques: the 'illusionism' of the reality fragments that have been glued on the canvas (a piece of a woven basket or wallpaper) and the 'abstraction' of cubist technique in which the portrayed objects are rendered. That this contrast is a dominant interest of the two artists can be inferred from its presence in paintings of the same period that dispense with the technique of montage.

One must proceed with great care as one attempts to define the intended aesthetic effects that may be observed in the first montage canvases. There is unquestionably an element of provocation in sticking a piece of newspaper on a painting. But this must not be overestimated, for the reality fragments remain largely subordinate to the aesthetic composition, which seeks to create a balance of individual elements (volume, colors, etc). The intent can best be defined as tentative: although there is destruction of the organic work that portrays reality, art itself is not being called into question, as it is in the historic avant-garde movements. Instead, the intent to create an aesthetic object is clear, though that object eludes judgment by traditional rules.

Heartfield's photomontages represent an entirely different type. They are not primarily aesthetic objects, but images for reading (*Lesebilder*). Heartfield went back to the old art of the emblem and used it politically. The emblem brings together an image and two different texts, an (often coded) title (*inscriptio*) and a lengthier explanation (*subscriptio*). Example: Hitler speaks, the ribcage shows an esophagus consisting of coins. Inscriptio: Adolf the Superman. Subscriptio: "swallows gold and spouts junk [literally tin]." Or the SPD poster: socialization marches on and, in a montage effect, some dashing gentlemen from industry with tophats and umbrellas out front and, somewhat smaller, two soldiers carrying a swastica banner. Inscriptio: Germany is not yet lost! Subscriptio: 'socialization marches' it says on the posters of the Social Democrats and at the same time they decide: socialists will be shot down." The clear political statement and the antiaesthetic element characteristic of Heartfield's montages should be emphasized. In a certain sense, photomontage is close to film not only because both use photography but also because in both cases, the montage is obscured or at least made difficult to spot. This is what fundamentally distinguishes photomontage from the montage of the cubists or Schwitters.

The preceding remarks do not of course claim to come anywhere close to exhausting the subject (cubist collage, Heartfield's photomontages); the aim was merely to give a sketch of all the elements the concept 'montage' takes in. Within the frame of a theory of the avant-garde, the use to which film puts the concept cannot become relevant because it is part and parcel of the medium. And photomontage will not be made the point of departure for a consideration of the concept for it occupies an intermediate position between montage in films and montage in painting, because in it, the fact that montage is being used is so often obscured. A theory of the avant-garde must begin with the concept of montage that is suggested by the early cubist collages. What distinguishes them from the techniques of composition developed since the Renaissance is the insertion of reality fragments into the painting, i.e., the insertion of material that has been left unchanged by the artist. But this means the destruction of the unity of the painting as a whole, all of whose parts have been fashioned by the subjectivity of its creator. The selection of a piece of woven basket that Picasso glues on a canvas may very well serve some compositional intent. But as a piece of woven basket, it remains a reality fragment that is inserted into the painting tel quel, without substantive modification. A system of representation based on the portrayal of reality, i.e., on the principle that the artistic subject (the artist) must transpose reality, has thus been invalidated. Unlike Duchamp somewhat later, the cubists do not content themselves with merely showing a reality fragment. But they stop short of a total shaping of the pictorial space as a continuum.

If one cannot accept the explanation that reduces to a saving of superfluous effort the principle that calls into question a technique of painting that was accepted over the course of centuries, it is principally Adorno's comments on the significance of montage for modern art that furnish important clues for an understanding of the phenomenon. Adorno notes the revolutionary quality of the

new procedure (for once, this overused metaphor is appropriate): "The semblance (*Schein*) of art being reconciled with a heterogeneous reality because it portrays it is to disintegrate as the work admits actual fragments (*Scheinlose Trümmer*) of empirical reality, thus acknowledging the break, and transforming it into aesthetic effect."[1] The man-made organic work of art that pretends to be like nature projects an image of the reconciliation of man and nature. According to Adorno, it is the characteristic of the non-organic work using the principle of montage that it no longer creates the semblance (*Schein*) of reconciliation. Even if one cannot accept in every detail the philosophy lying behind it, one will not fail to endorse this insight. The insertion of reality fragments into the work of art fundamentally transforms that work. The artist not only renounces shaping a whole, but gives the painting a different status, since parts of it no longer have the relationship to reality characteristic of the organic work of art. They are no longer signs pointing to reality, they *are* reality.

But it is doubtful that one can follow Adorno in ascribing political significance to the artistic procedures of montage. "Art wishes to confess its impotence vis-à-vis the late capitalist totality and inaugurate its abolition" (*ÄT*, p. 232). That montage was used both by the Italian futurists, of whom it can hardly be said that they wanted to abolish capitalism, and by Russian avant-gardistes after the October revolution, who were working in a developing socialist society, is not the only fact that militates against this formulation. It is fundamentally problematical to assign a fixed meaning to a procedure. Bloch's approach is more appropriate here, for he starts out from the view that the effects of a technique or procedure can vary in historically different contexts. He distinguishes between montage in late capitalism and montage in a socialist society. Even though the concrete determinations of montage that Bloch advances are occasionally imprecise, the insight that procedures are not semantically reducible to invariant meanings must be held onto.

This means that one should try to pick those of Adorno's definitions that describe the phenomenon without assigning a fixed meaning to it. The following would be an example: "the negation of synthesis becomes a compositional principle" (*ÄT*, p. 232). On the production–aesthetic side, negation of synthesis refers to what was called rejection of reconciliation on the side of aesthetic effect. If, to check Adorno's statements, one looks again at the collages of the cubists, one can see that although they allow one to discover a principle of construction, they do not show a synthesis, in the sense of a unity of meaning (one need only recall the antithesis of 'illusionism' and 'abstraction' to which reference was made earlier).

When condsidering Adorno's interpretation of the negation of synthesis as a negation of meaning (*ÄT*, p. 231), one must remember that even the withholding of meaning is a positing of it. The automatic texts of the Surrealists, Aragon's *Paysan de Paris* and Breton's *Nadja* all show the influence of the technique of montage. It is true that at the surface level, automatic texts are characterized by a destruction of coherence. But an interpretation that does not confine itself to

grasping logical connections but examines the procedures by which the text was composed can certainly discover a relatively consistent meaning in them. Similar considerations apply to the sequence of isolated events on the opening pages of Breton's *Nadja*. Although it is true that they lack the kind of narrative coherence where the last incident logically presupposes all preceding ones, there is nonetheless a connection of a different kind between events: they all follow the identical structural pattern. Formulated in the concepts of structuralism, this means that the nexus is paradigmatic, not syntagmatic. Whereas the syntagmatic pattern, the phrase, is characterized by the fact that, whatever its length, the end is always reached, the sequence is, in principle, without one. This important difference also entails two differing modes of reception.

The organic work of art is constructed according to the syntagmatic pattern; individual parts and the whole form a dialectical unity. An adequate reading is described by the hermeneutic circle: the parts can be understood only through the whole, the whole only through the parts. This means that an anticipating comprehension of the whole guides, and is simultaneously corrected by, the comprehension of the parts. The fundamental precondition for this type of reception is the assumption of a necessary congruence between the meaning of the individual parts and the meaning of the whole. This precondition is rejected by the nonorganic work, and this fact defines its decisive difference from the organic work of art. The parts 'emancipate' themselves from a superordinate whole; they are no longer its essential elements. This means that the parts lack necessity. In an automatic text that strings images together, some could be missing, yet the text would not be significantly affected. The same is true of the events reported in *Nadja*. New events of the same type could be added or some of those present could be omitted and neither additions nor omissions would make a significant difference. A change in their order is also conceivable. What is decisive are not the events in their distinctiveness but the construction principle that underlies the sequence of events.

All of this naturally has important consequences for reception. The recipient of an avant-gardiste work discovers that the manner of appropriating intellectual objectifications that has been formed by the reading of organic works of art is inappropriate to the present object. The avant-gardiste work neither creates a total impression that would permit an interpretation of its meaning nor can whatever impression may be created be accounted for by recourse to the individual parts, for they are no longer subordinated to a pervasive intent. This refusal to provide meaning is experienced as shock by the recipient. And this is the intention of the avant-gardiste artist, who hopes that such withdrawal of meaning will direct the reader's attention to the fact that the conduct of one's life is questionable and that it is necessary to change it. Shock is aimed for as a stimulus to change one's conduct of life; it is the means to break through aesthetic immanence and to usher in (initiate) a change in the recipient's life praxis.

The problem with shock as the intended reaction of the recipient is that it is generally nonspecific. Even a possible breaking through the aesthetic immanence

does not insure that the recipient's change of behavior is given a particular direction. The public's reactions to Dada manifestations are typical of the non-specificity of the reaction. It responds to the provocation of the Dadaists with blind fury. And changes in the life praxis of the public probably did not result. On the contrary, one has to ask oneself whether the provocation does not strengthen existing attitudes because it provides them with an occasion to manifest themselves. A further difficulty inheres in the aesthetics of shock, and that is the impossibility to make permanent this kind of effect. Nothing loses its effectiveness more quickly than shock; by its very nature, it is a unique experience. As a result of repetition, it changes fundamentally: there is such a thing as expected shock. The violent reactions of the public to the mere appearance of the Dadaists are an example: newspaper reports had prepared the public for the shock; it expected it. Such a nearly institutionalized shock probably has a minimal effect on the way the recipients run their lives. The shock is 'consumed.' What remains is the enigmatic quality of the forms, their resistance to the attempt to wrest meaning from them. If recipients will not simply give up or be contented with an arbitrary meaning extrapolated from just a part of the work, they must attempt to understand this enigmatic quality of the avant-gardiste work. They then move to another level of interpretation. Instead of proceeding according to the hermeneutic circle and trying to grasp a meaning through the nexus of whole and parts, the recipient will suspend the search for meaning and direct attention to the principles of construction that determine the constitution of the work. In the process of reception, the avant-gardiste work thus provokes a break, which is the analogue of the incoherence (nonorganicity) of the work. Between the shocklike experience of the inappropriateness of the mode of reception developed through dealing with organic works of art and the effort to grasp the principles of construction, there is a break: the interpretation of meaning is renounced. One of the decisive changes in the development of art that the historical avant-garde movements brought about consists in this new type of reception that the avant-gardiste work of art provokes. The recipient's attention no longer turns to a meaning of the work that might be grasped by a reading of its constituent elements, but to the principle of construction. This kind of reception is imposed on the recipient because the element necessary within the organic work when it plays a role in constituting the meaning of the whole merely serves to flesh out structure and pattern in the avant-gardiste work.

By presenting the formal methods of scholarship in literature and the fine arts as the recipient's reaction to avant-gardiste works that elude traditional hermeneutic approaches, we have attempted a genetic reconstruction of the nexus between the avant-gardiste work and those methods. In this attempted reconstruction, the break between formal methods (which are directed at procedures and techniques) and hermeneutics that seeks to discover meaning had to be given special emphasis. But such a reconstruction of a genetic nexus must not be understood to mean that specific scholarly methods should be used in dealing with certain kinds of work as, for example, the hermeneutic in the case of organic

works, the formal in the case of avant-gardiste ones. Such an allocation of methods would run counter to the thought that has been outlined here. Although it is true that the avant-gardiste work imposes a new approach, that approach is not restricted to such works nor does the hermeneutic problematic of the understanding of meaning simply disappear. Rather, the decisive changes in the field of study also bring about a restructuring of the methods of scholarly investigation of the phenomenon that is art. It may be assumed that this process will move from the opposition between formal and hermeneutic methods to their synthesis, in which both would be sublated in the Hegelian sense of the term. It seems to me that this is the point that literary scholarship has reached today.

The condition for the possibility of a synthesis of formal and hermeneutic procedures is the assumption that even in the avant-gardiste work, the emancipation of the individual elements never reaches total detachment from the whole of the work. Even where the negation of synthesis becomes a structural principle, it must remain possible to conceive however precious a unity. For the act of reception, this means that even the avant-gardiste work is still to be understood hermeneutically (as a total meaning) except that the unity has integrated the contradiction within itself. It is no longer the harmony of the individual parts that constitutes the whole; it is the contradictory relationship of heterogeneous elements. In the wake of the historical avant-garde movements, hermeneutics is neither to be simply replaced by formalist procedures nor is its use as an intuitive form of understanding to be continued as before; rather, it must be modified as the new historical situation demands. It is true, however, that within a critical hermeneutics, the formal analysis of works of art takes on greater importance as the subordination of parts to the whole, postulated by traditional hermeneutics, becomes recognizable as an interpretative system that ultimately derives from classical aesthetics. A critical hermeneutics will replace the theorem of the necessary agreement of parts and whole by investigating the contradiction between the various layers and only then infer the meaning of the whole.

Note

1 T. W. Adorno, *Ästhetische Theorie* (Frankfurt: Suhrkamp, 1970), p. 232. Hereafter abbreviated as *ÄT*.

23

Jugglers' Fair Beneath the Gallows

Ernst Bloch

Let us speak quietly, there is someone dying in the room. Dying German culture, it does not even have catacombs at its disposal inside Germany any more. Merely chambers of horrors in which it is to be exposed to the derision of the mob; a concentration camp with visits from the public.

It is getting crazy and ever crazier. What is an honest, a talented person to do in this country. His simple existence is a danger to him, he must conceal it. Every kind of talent endangers the life of the person who possesses it, apart from that of cringing. Artists, who are such, are openly threatened with castration or prison; this is no joke, such mouths do not make jokes. People have learnt to take the ridiculous seriously.

Nevertheless, they refrain from going into details. The 'Frankfurter Zeitung' writes of Hitler's speech on art: 'The Führer has given the theory and standards which are alone appropriate for the high foundation of a temple of art.' Führer and standards speak for themselves, they are not inviting, although as the same newspaper remarks, the house painter's aesthetic lecture had been given 'both with the weapons of sharp irony and with the means of philosophical discussion'. The demands are different; what seems like irony to one person appears to another to be revenge of the rejected art student of former days. An irony which declares that certain painters experience the meadows as blue, the skies as green, and the clouds as sulphurous yellow has also often existed before in the gazettes of cultural backwaters; though without the actual sharpness which is necessary for castration. And as far as philosophical discussion is concerned, the equally correct categories flowed from the correct source of supply; the philosophizing Führer has the floor: 'A radiantly beautiful human type, gentlemen, you

Ernst Bloch, "Jugglers' Fair Beneath the Gallows" (originally published in German 1937), pp. 75–80 in Bloch, *Heritage of Our Times*, trans. Neville and Stephen Plaice. Cambridge: Polity Press, 1991. English translation © 1991 by Polity Press. Reprinted by permission of Polity Press and University of California Press.

prehistoric art-stutterers, is the type of the new age, and what do you produce? Misshapen cripples and cretins, men who are closer to animals than human beings – and this is what these most dreadful amateurs dare to present as the expression of that which shapes the modern age and stamps its hallmark on it.' Naturally the philosophical discussion turns away from such allusions to the present and from its hallmark and finds the following about itself and its kind, who would not have been regarded as human among the Greeks: 'Never was humanity closer to antiquity in appearance and in its feelings than it is today.' As we noted, a commentary on the Führer's speeches is no business of ours, while there are still doctoral dissertations in the Third Reich, and their topics, so we hear, are limited. Recently a dissertation is said to have appeared on the topic 'Life and activities of purveyors to the court', and another one on 'Signposts in the age of national migration'. A chair of astrology was even 'recommended' by the Führer to the Berlin faculty of science. Given this desperate academic state of affairs, sweet fruits can be picked even from the Munich speech, the German Nobel prize is in the offing. 'Streicher[1] and Hellas' – a worthy topic, a truly philosophical discussion; this above all would be capable of furnishing the standards which 'are appropriate for the high foundation of a temple of art'. They grow potatoes in Boeotia, breed owls in Athens,[2] but Greek cannibals are unknown up to now.

Meanwhile the Munich temple has been officially opened. 'This object', says the man who commissioned it, 'is so unique and original that there is nothing to be compared with it. There is no building of which one could claim that it was the model and this one here was the copy.' Others call the same thing brutalizing neo-classicism or Aurora in oils. But nothing has yet come to light about the style in which the opposing concern – the hall of 'degenerate German art' – is built, although here we really have an object with which there is nothing to be compared. The very juxtaposition of this 'temple' and this 'hall' is unprecedented, and nothing has been heard of the temple sinking without trace in shame. The man who commissioned it could indeed lay claim to originality here: a similar proximity of evil and good, of corruption and future, of kitsch museum and picture-gallery has not as yet existed in the world. Since there has as yet been no such government in history, there has been no such reversal of values. In the 'temple' unspeakable banality (the one or two better older works, there are very few of them, stick out like Schubert in the Dreimäderlhaus).[3] Whereas in the 'hall' near the gallows hangs everything which has given a new lustre and name to German art, masters of world repute, above all Franz Marc, the pride of Germany, the great admirable artist, first a war victim, then the victim of a Marsyas who finally flays Apollo.[4] Franz Marc's marvellous work 'The Tower of Blue Horses', together with Nolde, Heckel, Kirchner, Pechstein, Beckmann, Kokoschka, Kandinsky, Schmidt-Rottluff, Chagall, Feininger, Hofer, George Grosz, Campendonck, Paula Modersohn, Klee, and Otto Dix, illuminated the chamber of horros in which the whole of Germany finds itself, and endure the inscriptions which shabby stupidity and demagogic vulgarity have pinned on them. If Picasso, and indeed Cézanne, van Gogh, and Manet were Germans, if Grünewald were

not already long dead, these masters would undoubtedly also have found accommodation here; it would be quite in order. A state which only survives by stultifying, degrading and demoralizing the people will tolerate no standard by which it could be measured; the most putrid kitsch is good enough, it does not stand out. Even the gangster loves an oleograph over the sofa on which he is snoring; even the philistine is not without a sense of beauty, his daughter plays A Virgin's Prayer, and Courths-Mahler[5] tugs at his heart-strings. Franz Marc is no match for this of course, in the gentle mystery of his animals the banal Nazi beast is judged; before the mirror of George Grosz the whole of the new antiquity recoils. What a homely effect, however, the clownish figures of Grützner, Defregger[6] and the newly arisen parlour have on it. How comfortably the bourgeois conformists and their king make themselves at home here, not lost at all, with insolent cool – let no one moan away about displays of spite, whatever people say they are displays of might.[7] But in a different way from that in which Goethe intended this and was able to intend it, the spiteful man has gained mighty power today, is erecting temples for himself and taking it out on others. Beneath every picture of real German art sticks a placard with the inscription: 'Paid for out of the taxes of the working German nation'. But the temple of kitsch cost nine million marks alone, the battle between Defregger and Cézanne has been won with the deployment of large resources.

We are not moved by what is going on in the victor. If the very lie of the Nazis is worthless, their personal truth is even more so, it can be seen just by looking at them. But it is always important to ask, even here, what intentions lie behind it, why and for what end these boundless insults? 'Miserable wretches, daubers, prehistoric stutterers, art swindlers' – these are tones which have previously only rung out from such mouths against Jews, Marxists and émigrés. All credit to resentment; but how does it have time for itself, in the midst of economic distress, a shortage of raw materials, the struggle between Church and state, and Spain? When Wilhelm II officially opened the Avenue of Victory[8] with a very similar aesthetics, along with the 'gutter art', social democracy was to be destroyed as well, and along with poor people's painting, the poor people's movement. Social democracy is finished today, in its place there is so-called German socialism, German peace; of course it does not mean what it says. Well, the (let us say) neo-classicism of the Führer's heart means itself, or simply aesthetic objects in general, almost just as little as this. Instead, the attack on art is firstly a new trap for bourgeois conformists, it flatters bad taste and malicious stupidity at the same time; philistine tones and hunting whistles mingle in an exceptionally demagogic combination. But secondly behind the slogans 'antiquity' or 'cultural bolshevism' (and also 'Stone-Age art', it does not matter that precisely) lurk the differences between Rosenberg[9] and Goebbels, the same ones which had already become apparent in the argument about Barlach.[10] They are the differences of a demagogy which seeks to have an effect, now through the plush sofa, now through youth, the campfire, and 'Irratio'. The plush sofa is the one side, it has always been part of this 'revolution'. In the meantime it had likewise been furnished with

youth, bourgeois storm-trooping, expressio and primeval times, perhaps even more effectively. Alongside the parlour there was the lure of an irrational drive, as we know; the aversion to a thoroughly rationalized existence had intensified it, certain 'non-contemporaneous' features in backward strata were fundamentally congenial to it. The drive ranges from the vague longing for women, through berserkerism, to those wild feelings, that conscious Unconscious, to which Benn[11] gave lyrical, Klages philosophical, and C. G. Jung medical expression. Paganism lives in these wishful images, the Greek kind as well, not just the barbaric kind; a Greece, however, interpreted by the blond beast, not by Hölderlin and by humanitarianism, and of course not by the plaster-figure or bull's-eye pane antiquity of the ignorant bourgeois conformist either. Our diluvial Benn has been 'out of order' for a long time, but the fact that the alternative between primeval times and 'decent art' (as the Führer says) had still not been decided in the top clique is proved precisely by the Munich speech, by the highly personal decision of the High Court supremo. Even in its afterbirths Expressionism still contained rebellious elements among the archaic ones; it represented the 'second revolution', as it were, among art students and young people who were interested in that kind of thing. The 'archaic', the 'primitive', is still desired today, as sadism, in concentration camps, and – as furor teutonicus – naturally in the coming war, continues to have an effect in the swastika, in 'victory runes' and the 'Odal',[12] in 'thing-steads'[13] and wherever decorative humbug seems to be in order. But however well-disposed big business was towards the swastika as long as it ensnared the masses, it equally never reconciled itself to the pathos of the Stone Age or of archaic degeneration. It needs punctual and domesticated employees, not primitive Teutons with Cockaigne in their dealings or with a gleam of blood in their after-sales service. Hence the excitement of the beginning and of the preparatory stage, the barbarian swindle, has to be able to disappear for the Saxons without forests as well, to disappear even in the slogans of Nazi art. It is perhaps exaggerated to say that art was the last ideological hiding-place of a 'second revolution'. But it is not exaggeratedly consistent to conclude that in the Munich speech on art a last swell of 30 June 1934,[14] that is of its suppression, died down on the remotest shore. This at least is certain: the motto of calm, fealty and order is given even to the art possible amongst the Nazis (and the slogans coined or preserved here). The SA of the irrational has played itself out on the canvas, and in particular every recollection of genuine Expressionism leads to the knacker's yard of 'degenerate art'. The wilderness is now always to have its sofa-newbuilding within it and above it, its obedient petit-bourgeois kitsch. The fact that the criticism of Franz Marc comes easy to the former picture-postcard designer Hitler is obvious anyway.

Something good is not lacking in all this evil. After his speech the Führer drove to a performance of Tristan and became engrossed in the scarcely Greek Wagner there. Wagner admittedly also has some Nazism of his own, ballyhoo, histrionics, decadent barbarism: Tristan does not deserve the sympathy in question all the same, Hans Sachs[15] even less so. But how dangerously blurring it would be

perhaps for intellectuals who are nothing but this, though at least this, yet have now been perturbed by Hitler the artist, if the Nazi heart had the cheek or the hypocrisy even to beat for Franz Marc or, in another field, for Bartók with the aim of a particular disguise. The confusion would be great; the fact that it is unfortunately not wholly impossible is demonstrated in some respects by the example of Mussolini, beneath whose rotten sceptre progressive architecture, painting and music worth discussing remain unmolested. The good element so to speak is thus that Nazi Germany arose totally of a piece; like master, like man,[16] filled with this temple art. A homogeneous system has entered into things, even art is sent to the torture chamber, the burning of books preceded the burning of people anyway, in name and kind alike. And the false messiah satiates the 'nation' with a well-paid mixture of dance on the alpine pasture over the sofa and blood and soil in the abyss.

Notes

1 Julius Streicher, 1885–1946, leader of German Socialist Party in Nuremberg, founder and editor of the anti-Semitic paper *Der Stürmer*, later joined the Nazis. He was sentenced to death at the Nuremberg trials.
2 An allusion to the proverbial German phrase 'Eulen nach Athen tragen', equivalent to 'carrying coal to Newcastle', i.e. an exercise in futility.
3 *Dreimäderlhaus* ('The House of the Three Girls'), a musical play by H. Berté, with music by Schubert.
4 Bloch here ironically reverses the Greek legend: Marsyas was a pipe-playing Silenus who challenged Apollo to a musical contest and was finally defeated by him and flayed alive.
5 Hedwig Courths-Mahler, 1867–1950, a popular sentimental writer.
6 Eduard Grützner, 1846–1925, a German painter, mainly of humorous genre pictures. Franz von Defregger, 1835–1921, painter of Tyrol peasant and historical pictures.
7 From Goethe, 'West-östlicher Divan: Wanderers Gemütsruhe'.
8 The Siegesallee in Berlin.
9 Alfred Rosenberg, 1893–1946, Nazi politician and 'philosopher', executed after the Nuremberg trials.
10 Ernst Barlach, 1870–1938, Expressionist sculptor and dramatist.
11 Gottfried Benn, 1886–1956, Expressionist poet and doctor.
12 Tribal land owned and inherited by the ancient Nordic race.
13 Pseudo-pagan amphitheatres for Nazi ceremonies.
14 The date of the so-called Röhm *putsch*. Ernst Röhm, head of the SA, had publicly demanded a 'second revolution' before Hitler brutally suppressed this threat to his supremacy.
15 Hans Sachs, 1494–1576, cobbler-poet of Nuremberg and character in *Die Meistersinger*.
16 German saying, literally 'Like master, like his pots and pans'.

24

Towards a Free Revolutionary Art

André Breton, Diego Rivera, and Leon Trotsky

We can say without exaggeration that never has civilization been menaced so seriously as today. The Vandals, with instruments which were barbarous, and so comparatively ineffective, blotted out the culture of antiquity in one corner of Europe. But today we see world civilization, united in its historic destiny, reeling under the blows of reactionary forces armed with the entire arsenal of modern technology. We are by no means thinking only of the world war that draws near. Even in times of 'peace' the position of art and science has become absolutely intolerable.

Insofar as it originates with an individual, insofar as it brings into play subjective talents to create something which brings about an objective enriching of culture, any philosophical, sociological, scientific or artistic discovery seems to be the fruit of a precious *chance*, that is to say, the manifestation, more or less spontaneous, of *necessity.* Such creations cannot be slighted, whether from the standpoint of general knowledge (which interprets the existing world), or of revolutionary knowledge (which, the better to change the world, requires an exact analysis of the laws which govern its movement). Specifically, we cannot remain indifferent to the intellectual conditions under which creative activity takes place, nor should we fail to pay all respect to those particular laws which govern intellectual creation.

In the contemporary world we must recognize the ever more widespread destruction of those conditions under which intellectual creation is possible. From this follows of necessity an increasingly manifest degradation not only of the work of art but also of the specifically 'artistic' personality. The regime of Hitler, now that it has rid Germany of all those artists whose work expressed the

André Breton, Diego Rivera, and Leon Trotsky, "Towards a Free Revolutionary Art" (originally published 1938). This English translation by Dwight MacDonald was first published in New York in *Partisan Review* IV, no. 1 (Fall 1938), pp. 49–53 and in the *London Bulletin* (Dec. 1938–Jan. 1939).

slightest sympathy for liberty, however superficial, has reduced those who still consent to take up pen or brush to the status of domestic servants of the regime, whose task it is to glorify it on order, according to the worst possible aesthetic conventions. If reports may be believed, it is the same in the Soviet Union, where Thermidorian reaction is now reaching its climax.

It goes without saying that we do not identify ourselves with the currently fashionable catchword: 'Neither fascism nor communism!' a shibboleth which suits the temperament of the philistine, conservative and frightened, clinging to the tattered remnants of the 'democratic' past. True art, which is not content to play variations on ready-made models but rather insists on expressing the inner needs of man and of mankind in its time – true art is unable *not* to be revolutionary, *not* to aspire to a complete and radical reconstruction of society. This it must do, were it only to deliver intellectual creation from the chains which bind it, and to allow all mankind to raise itself to those heights which only isolated geniuses have achieved in the past. We recognize that only the social revolution can sweep clean the path for a new culture. If, however, we reject all solidarity with the bureaucracy now in control of the Soviet Union, it is precisely because, in our eyes, it represents, not communism, but its most treacherous and dangerous enemy.

The totalitarian regime of the USSR, working through the so-called cultural organizations it controls in other countries, has spread over the entire world a deep twilight hostile to every sort of spiritual value. A twilight of filth and blood in which, disguised as intellectuals and artists, those men steep themselves who have made of servility a career, of lying for pay a custom, and of the palliation of crime a source of pleasure. The official art of Stalinism mirrors with a blatancy unexampled in history their efforts to put a good face on their mercenary profession.

The repugnance which this shameful negation of principles of art inspires in the artistic world – a negation which even slave states have never dared to carry so far – should give rise to an active, uncompromising condemnation. The *opposition* of writers and artists is one of the forces which can usefully contribute to the discrediting and overthrow of regimes which are destroying, along with the right of the proletarian to aspire to a better world, every sentiment of nobility and even of human dignity.

The communist revolution is not afraid of art. It realizes that the role of the artist in a decadent capitalist society is determined by the conflict between the individual and various social forms which are hostile to him. This fact alone, insofar as he is conscious of it, makes the artist the natural ally of revolution. The process of *sublimation*, which here comes into play and which psychoanalysis has analyzed, tries to restore the broken equilibrium between the integral 'ego' and the outside elements it rejects. This restoration works to the advantage of the 'ideal of self,' which marshals against the unbearable present reality all those powers of the interior world, of the 'self,' which are *common to all men* and which are constantly flowering and developing. The need for emancipation felt by

the individual spirit has only to follow its natural course to be led to mingle its stream with this primeval necessity – the need for the emancipation of man.

The conception of the writer's function which the young Marx worked out is worth recalling. 'The writer,' he declared, 'naturally must make money in order to live and write, but he should not under any circumstances live and write in order to make money. . . . The writer by no means looks on his work as a *means*. It is *an end in itself* and so little a means in the eyes of himself and of others that if necessary he sacrifices his existence to the existence of his work. . . . *The first condition of the freedom of the press is that it is not a business activity.*' It is more than ever fitting to use this statement against those who would regiment intellectual activity in the direction of ends foreign to itself, and prescribe, in the guise of so-called reasons of state, the themes of art. The free choice of these themes and the absence of all restrictions on the range of his exploitations – these are possessions which the artist has a right to claim as inalienable. In the realm of artistic creation, the imagination must escape from all constraint and must under no pretext allow itself to be placed under bonds. To those who urge us, whether for today or for tomorrow, to consent that art should submit to a discipline which we hold to be radically incompatible with its nature, we give a flat refusal and we repeat our deliberate intention of standing by the formula *complete freedom for art*.

We recognize, of course, that the revolutionary state has the right to defend itself against the counterattack of the bourgeoisie, even when this drapes itself in the flag of science or art. But there is an abyss between these enforced and temporary measures of revolutionary self-defense and the pretension to lay commands on intellectual creation. If, for the better development of the forces of material production, the revolution must build a *socialist* regime with centralized control, to develop intellectual creation an *anarchist* regime of individual liberty should from the first be established. No authority, no dictation, not the least trace of orders from above! Only on a base of friendly cooperation, without constraint from outside, will it be possible for scholars and artists to carry out their tasks, which will be more far-reaching than ever before in history.

It should be clear by now that in defending freedom of thought we have no intention of justifying political indifference, and that it is far from our wish to revive a so-called pure art which generally serves the extremely impure ends of reaction. No, our conception of the role of art is too high to refuse it an influence on the fate of society. We believe that the supreme task of art in our epoch is to take part actively and consciously in the preparation of the revolution. But the artist cannot serve the struggle for freedom unless he subjectively assimilates its social content, unless he feels in his very nerves its meaning and drama and freely seeks to give his own inner world incarnation in his art.

In the present period of the death agony of capitalism, democratic as well as fascist, the artist sees himself threatened with the loss of his right to live and continue working. He sees all avenues of communication choked with the debris of capitalist collapse. Only naturally, he turns to the Stalinist organizations which

hold out the possibility of escaping from his isolation. But if he is to avoid complete demoralization, he cannot remain there, because of the impossibility of delivering his own message and the degrading servility which these organizations exact from him in exchange for certain material advantages. He must understand that his place is elsewhere, not among those who betray the cause of the revolution and mankind, but among those who with unshaken fidelity bear witness to the revolution, among those who, for this reason, are alone able to bring it to fruition, and along with it the ultimate free expression of all forms of human genius.

The aim of this appeal is to find a common ground on which may be reunited all revolutionary writers and artists, the better to serve the revolution by their art and to defend the liberty of that art itself against the usurpers of the revolution. We believe that aesthetic, philosophical and political tendencies of the most varied sort can find here a common ground. Marxists can march here hand in hand with anarchists, provided both parties uncompromisingly reject the reactionary police patrol spirit represented by Joseph Stalin and by his henchman Garcia Oliver.

We know very well that thousands on thousands of isolated thinkers and artists are today scattered throughout the world, their voices drowned out by the loud choruses of well-disciplined liars. Hundreds of small local magazines are trying to gather youthful forces about them, seeking new paths and not subsidies. Every progressive tendency in art is destroyed by fascism as 'degenerate.' Every free creation is called 'fascist' by the Stalinists. Independent revolutionary art must now gather its forces for the struggle against reactionary persecution. It must proclaim aloud the right to exist. Such a union of forces is the aim of the *International Federation of Independent Revolutionary Art* which we believe it is now necessary to form.

We by no means insist on every idea put forth in this manifesto, which we ourselves consider only a first step in the new direction. We urge every friend and defender of art, who cannot but realize the necessity for this appeal, to make himself heard at once. We address the same appeal to all those publications of the left wing which are ready to participate in the creation of the International Federation and to consider its task and its methods of action.

When a preliminary international contact has been established through the press and by correspondence, we will proceed to the organization of local and national congresses on a modest scale. The final step will be the assembly of a world congress which will officially mark the foundation of the International Federation.

Our aims:

The independence of art – for the revolution.

The revolution – for the complete liberation of art!

25

The Birth of Socialist Realism from the Spirit of the Russian Avant-Garde

Boris Groys

I

Students of Soviet culture have recently devoted increasing attention to the period of transition from the avant-garde of the 1920s to Socialist Realism of the 1930s and 1940s.[1] Earlier, this transition did not seem problematic. It was usually regarded as the result of the crushing of "true, contemporary revolutionary art of the Russian avant-garde" by Stalin's conservative and despotic regime and the propagation of a "backward art" in the spirit of nineteenth-century realism. According to prevailing opinion, the shift also reflected the low cultural levels of the broad Soviet masses and Party leadership. But as this period is studied more closely, such a purely sociological explanation of the transition is no longer satisfactory.

There is an essential difference in the approach to the represented subject, rightly stressed by Soviet criticism, between nineteenth-century realism, customarily called "critical realism" in Soviet art history, and the art of Socialist Realism. Unlike the former, Socialist Realism has a positive relation to its subject. Its aim is to "celebrate Socialist reality," instead of keeping it at arm's length and treating it objectively and "realistically." This difference has also been noted by Paul Sjeklocha and Igor Mead:

> To us [Westerners] this realism implies a dispassionate analytical stance which is assumed by the artist without sentiment. If emotion enters into realism, it is generally of a critical nature intended to instruct by way of bad example rather

Boris Groys, "The Birth of Socialist Realism from the Spirit of the Russian Avant-Garde," from Hans Günther, *Culture of the Stalin Period.* New York: St. Martin's Press and London: Macmillan, 1991. Reprinted by permission of Palgrave Macmillan.

than a good.... In short, although such realism is essentially didactic, it is also essentially negative. Visionary artists have not been found among the realists. However, the Soviet State requires that its artists combine realism and visionary art.[2]

Socialist Realism shows the exemplary and the normative, which are worthy of emulation. Yet it cannot be considered a new version of classicism, although we may indeed find classical elements in Socialist Realist artistic compositions. Antiquity and the Renaissance were highly praised by Soviet critics, but the art of Socialistic Realism is without the direct antique stylization so characteristic, for example, of the art of Nazi Germany, which is in many other respects quite similar to Socialist Realism. Unlike typical West European neoclassicist art, Socialist Realism judges the reality created in the Soviet Union to be the highest achievement of the entire course of human history and does not, therefore, oppose the antique ideal to the present as a "positive alternative" or a "utopia already once realized."[3] Socialist Realism is just one of the ways in which world art in the 1930s and 1940s reverted to the figurative style after the period of relative dominance of avant-garde trends – this process embraces such countries as France (neoclassicism), the Netherlands and Belgium (different forms of magical realism), and the United States (regional painting) as well as those countries where various forms of totalitarianism became established. At the same time, the stylistic differences between Socialist Realism and other, parallel artistic movements are obvious on even the most superficial examination.

All this indicates that the Socialist Realism of the Stalin period represents an original artistic trend with its own specific stylistic features, which cannot simply be identified with other artistic principles and forms familiar from the history of art. Therefore it also becomes impossible to speak of the simple "propagation" of Socialist Realism: before something can be propagated, it must already exist. Although, like any other artistic trend, Socialist Realism belongs to its time and place, it cannot be regarded in a purely sociological and reductionist light, but should, first and foremost, be subjected to normal aesthetic analysis with the object of describing its distinctive features.

This task is not, of course, possible within the framework of the present essay. My aim, rather, is to distinguish in the most general terms between Socialist Realism and a number of other artistic phenomena with which it may be confused. By artistic means that are similar to those in conventional nineteenth-century realistic painting – above all the work of the Russian Wanderers (Peredvizhniki) – Socialist Realism seeks to express a completely different ideological content in radically changed social and historical conditions. This naturally leads to a fundamental disruption of the form of traditional realistic painting itself. Thus, difference of form proves to be bound up with a definite purpose in regard to content; to ignore this change may result in an inadequate interpretation of formal difference, as has often happened in the past.

A similar situation occurs in relation to the art of the Russian avantgarde. It is often regarded in an aestheticized, purely formal, stylistic light,[4] although such a

view is opposed to the objectives of the Russian avant-garde, which sought to overcome the traditional contemplative attitude toward art. While today, the works of the Russian avant-garde hang in museums and are sold in galleries like any other works of art, one should not forget that Russian avant-garde artists strove to destroy the museum, to wipe it out as a social institution, ensuring the idea of art as the "individual" or "hand-made" production by an artist of objects of aesthetic contemplation which are then consumed by the spectator. As they understood it, the artists of the Russian avant-garde were producing not objects of aesthetic consumption but projects or models for a total restructuring of the world on new principles, to be implemented by collective actions and social practice in which the difference between consumer and producer, artist and spectator, work of art and object of utility, and so on, disappeared. The fact that these avant-garde projects are hung in present-day museums as traditional works of art, where they are viewed in the traditional light, signals the ultimate defeat of the avant-garde, not its success. The Russian avant-garde lost its historical position: in fact, the true spirit of the Russian avant-garde was more aptly reflected by its place in the locked storerooms of Soviet museums, to which it was consigned as a consequence of its historical defeat, but from which it continued to exercise an influence on the victorious rulers as a hidden menace.

As the modern museum experiences a period of general expansion, it increasingly includes the utilitarian: museums of technology, aeronautics, contemporary utensils, and the like are constantly opening. In the past, icons, which to a great extent constituted a reference point for adherents of the Russian avant-garde, became part of museum collections; they, too, were not regarded as "works of art" by their creators or by their "consumers." Today, however, neither in Russia nor in the West is Socialist Realist art represented faithfully in museums. In Russia it vanished from the eyes of the public during the period of the "thaw," while in the West it was never seriously regarded as art. The position of Socialist Realism "outside art" is, in itself, sufficiently convincing testimony to its inner identification with the avant-garde era, when the desire to go beyond the bounds of the museum became the motivating force of artistic experiment. Like the art of the avant-garde, the art of Socialist Realism wanted to transcend the traditional "artist–spectator–aesthetic object" relationship and become the direct motivating force of social development. The collectivist project of Socialist Realism was expressed in the rejection of the artist's individual manner, of the direct perception of nature, of the quest for "expressiveness" and "picturesqueness" – rejection, in general, of all that is characteristic of traditional realistic art and, in particular, of the art of the Wanderers. As a result, Socialist Realism is often judged to be traditional realism of "low quality," and it is forgotten that Socialist Realism, far from seeking such artistic quality, strove, on the contrary, to overcome it wherever it reared its head. Socialist Realist pictures were regarded as at once works of art and utilitarian objects – instruments of Socialist education of the working people – and as a result could not but be standardized in accordance with their utilitarian function.

In this elimination of boundaries between "high" and "utilitarian" art Socialist Realism is the heir not so much of traditional art as of the Russian avant-garde: Socialist Realism may be said to be the continuation of the avant-garde's strategy by different means. This change of means is not, of course, fortuitous and will be singled out for special examination later. But it cannot be regarded merely as something imposed from outside, artificially halting the development of the avant-garde, which otherwise would have continued in the spirit of Kazimir Malevich or Alexander Rodchenko. It has already been noted that by the end of the 1920s the artists of the Russian avant-garde had begun to return to representation. While Malevich had adopted a new interpretation of traditional painting, Rodchenko, El Lissitzky, Gustaf Klutsis, and others increasingly devoted themselves to photomontage. In the framework of the avant-garde aesthetic, their activity signified a turn toward figurativeness while preserving the original avant-garde project.

This project, which consisted in moving from portraying life toward artistic shaping of life, is also the motivating force of Socialist Realism. The Russian avant-garde adopted from the West a new relationship, developed within the framework of cubism, to the work of art as a construct and made it the basis of a project for the complete reconstruction of reality on new principles. In this the work of art itself underwent fundamental changes – the Russian avant-garde displayed its constructive nature with unprecedented radicalism – which subsequently enabled the secondary aestheticization of its achievements and their interpretation exclusively in terms of the search for a new artistic form. In the 1970s a number of Soviet artists engaged in aestheticizing the achievements of Socialist Realism within the framework of the Sots Art[5] movement, making possible a new approach to Socialist Realism as a purely aesthetic phenomenon, just as the approach of pop art to commercial art stimulated its study as art.

These mechanisms of secondary aestheticization cannot be examined in this essay, but they point indirectly to the mechanisms of primary utilitarianization implemented by the Russian avant-garde and Socialist Realism and, in part, the commercial art of advertising. Behind the external, purely formal distinction between Socialist Realism and the Russian avant-garde (a distinction made relative by the photomontage period and by the art of such groupings in the 1920s as the Society of Easel Painters [OST]), the unity of their fundamental artistic aim – to build a new world by the organizational and technical methods of "socialist construction," in which the artistic, "creative," and utilitarian coincide, in place of "God's world," which the artist was able only to portray – should, therefore, be revealed. While seeming initially to be realistic, the art of "Socialist Realism" is, in fact, not realistic, since it is not mimetic. Its object is to project the new, the future, that which should be, and it is for this reason that socialist art is not simply a regression to the mimesis of the nineteenth century but belongs wholly to the twentieth century. The central issue of Socialist Realism remains, incidentally, why and how the transition from planning in the spirit of the avant-garde to planning in the spirit of realism took place. This transition was connected both with the

immanent problems of avant-garde art and with the overall process of Soviet ideological evolution in the 1920s and 1930s.

II

Art as "life-building" (*zhiznestroitel'stvo*) is a tradition that, in Russia, can be traced back at least to the philosopher Vladimir Solov'ev, who conceived of the practice of art as theurgy,[6] a conception later borrowed by the Russian Symbolists. However, the decisive step toward interpreting art as transformation rather than representation was taken by Malevich in his works and writings. For Solov'ev and the Symbolists, the precondition of theurgy was the revelation by the artist of the concealed ideal order of the cosmos (*sofiinost'*) and of society (*sobornost'*); however, Malevich's *Black Square* marked the recognition of nothingness or absolute chaos lying at the basis of all things. For Malevich the black square meant the beginning of a new age in the history of man and the cosmos, in which all given forms of cosmic, social, psychological or other reality had revealed their illusoriness.

Malevich possessed a contemplative and mystical nature and on more than one occasion rejected technical progress and social organization as artificial attempts to impose definite goals on life after the traditional aims of Christianity had been discredited. At the same time Malevich concluded from his discovery that a new restructuring of the world with the object of restoring lost harmony and a kind of "aesthetic justification of the world" was necessary.[7] Malevich conceived his "arkhitektony" or "planity" as projects for such restructuring; his suprematist compositions were at one and the same time direct contemplations of cosmic internal energies and projects for a new organization of the cosmos. It was no coincidence that, during the controversy with AKhRR (Association of Artists of Revolutionary Russia), Malevich took as his standpoint the position of "life creation,"[8] demonstrating the fundamental unity of the avant-garde's intentions despite the wide variety of its views and its internal quarrels and conflicts, from which one must detach oneself when giving an overall exposition of avant-garde attitudes. Despite the fact that such detachment leads inevitably to simplification, it does not result in fundamental distortion of the aims of the avant-garde: in their polemics with opponents in other camps, artists and theoreticians themselves reveal the high degree of similarity of their attitudes.

The logical conclusion from Malevich's concept of suprematism as the "last art" was drawn by, among others, the constructivists Vladimir Tatlin and Rodchenko, who called for the total rejection of easel painting in favor of designing the new reality directly. This rejection undoubtedly arose from the inherent logic of avant-garde artistic development and may be observed to a greater or lesser extent in the West: for example, in the activities of the Bauhaus, which, it may be noted, did not come into being without Russian influence; in the Dutch group

De Stijl; and others. However, the radicalism of the constructivist position can be explained only by the specific hopes aroused in artists by the October Revolution and its call for the total reconstruction of the country according to a single plan. If, for Marx, philosophy had to move from explaining the world to changing it, this Marxist slogan only confirmed for the artists of the Russian avant-garde their goal of relinquishing portrayal of the world in favor of its creative transformation.

These parallels between Marxist and avant-garde attitudes show that the artist with his "life-building" project was competing with a power that also had as its goal the total reconstruction of reality, though on economic and political, rather than aesthetic, principles. The project to transform the entire country – and ultimately the entire world – into a single work of art according to a single artistic design through the efforts of a collective united by common artistic conceptions, which inspired the Russian avant-garde during the first postrevolutionary years, meant the subordination of art, politics, the economy, and technology to the single will of the artist: that is, in the final analysis to the will of one Artist, since a total project of this kind cannot result from the sum of many individual efforts. Marx himself, in an observation constantly quoted in Soviet philosophy and art history, wrote that the worst architect was better than the best busy bee, since the former had in his head a unified plan of construction.

In a certain sense the avant-garde position marks a return to the ancient unity of art and technique (*tekhnē*), in which Socrates also included the activity of the legislator. The rejection by the avant-garde of the tradition of artistic autonomy in the modern age and the "bourgeois" relationship between "artist and spectator," understood as "producer and consumer," led in effect to the artist's demand for total political power in order to realize his project. The concept of this new political authority as an ideal instrument for implementing his artistic aims was especially characteristic of the early pronouncements of Russian avant-garde artists and theoreticians.

Thus, Alexei Gan, one of the theorists of Russian Constructivism, wrote:

> We should not reflect, depict and interpret reality but should build practically and express the planned objectives of the newly active working class, the proletariat, ... the master of color and line, the combiner of spatial and volumetric solids and the organizer of mass action – must all become Constructivists in the general business of the building and movement of the many millioned human mass.[9]

Statements of this kind, which occur constantly in the polemical writings of the Russian constructivists, could be multiplied. At the same time, the constructivists themselves were by no means blind to the contradictions and illusions of their own program. Ivan Puni, for example, noted that, in essence, the artist has nothing to do with manufacture, since engineers and workers have their own criteria for this.[10] However, the logic of the avant-garde's development began to overstep these sober reflections. While Rodchenko, Tatlin, and others were at first in the forefront of those struggling for the new reality, they themselves gradually

came to be accused of giving priority to purely artistic design over the demands of production and the direct formation of reality. The evolution of the avant-garde from Malevich to constructivism and, later, to Lef proceeds by way of increasingly radical demands for the rejection of traditional artistic individualism and the adoption of new social tasks.[11] In itself this evolution refutes the idea that artists were only at first victims of an illusion of omnipotence which they were obliged gradually to abandon. Quite the contrary: if it is supposed that the artist's move toward forming reality is the result of illusion, it must be acknowledged that this illusion by no means weakened but burgeoned with time.

Thus, it may be observed, both in the internal polemics of members of the avant-garde and in their confrontations with other artistic groupings, that the number of direct political accusations grew constantly. As artistic decisions were recognized more and more to be political decisions – for increasingly, they were perceived as defining the country's future – the fierceness of the controversy and the realization that positions which had formerly seemed similar were now incompatible also grew. The quest for collective creation inevitably led to a struggle for absolute leadership. The productionist position of Lef and its subsequent aspiration to equate art, technology, and politics, uniting these three contemporary modes of forming reality in a single total project, represent the extreme point of development of the avant-garde and its internal intentions. In the course of this development the avant-garde itself rejected its earlier manifestations as individualistic, aestheticist, and bourgeois. Thus, later criticism in this spirit by the theoreticians of Socialist Realism did not represent anything fundamentally new: in essence, such criticism only repeated the accusations formulated in the process of the development of the avant-garde itself. These accusations had become an integral part of the rhetoric of the avant-garde by the time of its liquidation at the end of the 1920s – coincidentally, the time when the avant-garde had achieved the peak of its theoretical, if not its purely artistic, development.

The artists of the avant-garde are commonly accused of neglecting the human factor in their plans for reconstructing the world: indeed the majority of the Russian population then held utterly different aesthetic ideas. In essence, the avant-garde intended to make use of the political and the administrative power offered it by the Revolution to impose on the overwhelming majority of the population aesthetic and organizational norms developed by an insignificant minority of artists. This objective certainly cannot be termed democratic. However, it should not be ignored that the members of the avant-garde themselves were hardly aware of the totalitarian character of their endeavor.

The artists of the avant-garde shared the Marxist belief that public taste is formed by the environment. They were "historical materialists" in the sense that they thought it possible, by reconstructing the world in which man lives, wholly to rebuild his inner mechanisms of perception and judgment. Malevich considered that, at the sight of his black square, "the sword will fall from the hero's hands and the prayer die on the lips of the saint."[12] It was not fortuitous,

therefore, that an alliance formed within the framework of Lef between the avant-garde and "vulgar sociologists" of the Boris Arvatov type: both were inspired by a belief in the direct magical effect on human consciousness of changes in the conditions of man's "material existence." The artistic engineers of the avant-garde disregarded man because they considered him to be a part or element of social or technical systems or, at best, of a universal cosmic life: for a member of the avant-garde to be an "engineer of the world" also automatically meant being an "engineer of human souls." The avant-garde artist was above all a materialist. He strove to work directly with the material "basis" in the belief that the "superstructure" would react automatically. This avant-garde "historical materialism" was also connected with its purely "aesthetic materialism." The latter consisted in the maximum revelation of "the materiality of material," "the materiality of the art work itself," concealed from the spectator in traditional painting, which used material in a purely utilitarian way to convey a definite content.[13] Such "aesthetic materialism," which gave an important fillip to the future formal development of art and is an important achievement of the Russian avant-garde, presupposes, however, a contemplative, anti-utilitarian understanding of materialism which was repudiated by the avant-garde in the context of Lef's productivism. Moreover, as already noted, a shift took place within the avant-garde toward the complete, extra-aesthetic "utilitarianism" of the project; that is, the purely aesthetic, nonutilitarian contemplative dimension of the avant-garde, which enabled its secondary aestheticization, was recognized by the avant-garde as a relic of traditional artistic attitudes that were ripe for rebuttal. In practice, the art of the avant-garde during its Lef period assumed an increasingly propagandist character that was not creative in the sense of productivism. Avant-garde artists, lacking direct access to the "basis," turned increasingly to propagandizing "Socialist construction" implemented by the political leadership on a "scientific foundation." The principal occupation of the avant-garde became the creation of posters, stage and exhibition design, and so on – in other words, work exclusively in the sphere of the "superstructure." In this respect the observation by the theorists of AKhRR, that the activities of Lef, for all its revolutionary phraseology and emphasis on its proletarian attitude toward art, differed little in essence from capitalist commercial advertising and borrowed many of its devices,[14] is justified. For AKhRR the utilitarian orientation of Lef had no specific Socialist content. It amounted to a shift on the part of the artist from cottage to mass production dictated by the general change in the technical level of manufacture in both West and East, not by the goals of "Communist up-bringing of the workers."

III

There is a widespread opinion among scholars that the transition to Socialist Realism marked the victory of AKhRR in the struggle against avant-garde trends.

It is common to see the genealogy of Socialist Realism exclusively in the turn toward representationalism taken by AKhRR as early as the 1920s (just as, in literature, it is usual to interpret the establishment of Socialist Realism as the victory of the Russian Association of Proletarian Writers [RAPP]). This point of view is based first on the external similarity between the realistic style of AKhRR and Socialist Realist style and on the fact that many artists moved from AKhRR to key positions in the new unified artistic associations of the era of Socialist Realism. The official criticism of both AKhRR and RAPP during the period preceding the proclamation of Socialist Realism is usually overlooked. As a rule it is judged to be merely a tactical move by the authorities with the object of pacifying artists from other groupings and integrating them in unified "creative unions."

However, criticism of this kind has been persistently repeated in Soviet historical writing over several decades, which alone renders untenable the view that it represented no more than a temporary tactical move. Comparison with avant-garde criticism, that is, criticism by Lef of AKhRR, reveals both a similarity and a difference, prompting a revision of some established ideas.

The turn toward realism in Russian postrevolutionary art is placed at different times. It is dated by some as early as the formation of AKhRR in 1922, while others place it in 1924–5. At the same time, critics belonging to the avant-garde camp and those who were already laying the foundations of the theory of Socialist Realism displayed a noticeable coincidence in assessing the reasons for this turn and the reasons for its significance. Their common view was that rebirth of representational easel painting was connected with the New Economic Policy (NEP) and the emergence of a new stratum of art consumers with definite artistic tastes. Critics holding avant-garde views cited artistic reaction as corresponding to economic and political reaction. The landscapes, portraits, and genre scenes with which AKhRR and so many other groups of the time, such as the Society of Easel Painters (OST) and "Bytie" ("Being"), supplied the market aroused a similar response. These paintings were regarded as symptoms of the same process, although AKhRR was welcomed for its mass approach and its progressive character, while OST was praised for a higher level of professionalism. A. Fedorov-Davydov, for example, who became a leading critic and art historian during the Stalin period, noted as early as 1925 the general turn by both Soviet and West European art towards realism, singling out neoclassicism in France and Italy and expressionism in Germany. He observed that neoclassicism, although "close to the proletariat in its striving for organization, order and discipline," could not serve as a basis for proletarian art because of its quality of stylization while expressionism saw things in too gloomy a light, and concluded that the attention to detail of neoclassicism should be combined with the passion of expressionism – advice which, in a slightly amended form, would be heeded in the Stalin period. Turning to Soviet experience, Fedorov-Davydov wrote:

> In order to understand and evaluate AKhRR, we must understand what kind of realists they are. We shall scarcely be mistaken if we say that they understand realism

in the sense of naturalistic, figurative – in essence, genre – realism. It is in this, disregarding the question of talent, that, perhaps, the reason lies for their inability genuinely to reflect the revolution. Enthusiasm and the heroic cannot be conveyed by the passive methods of naturalism.[15]

The same judgment was passed by Ia. A. Tugendkhol'd, who sympathized with AKhRR's turn toward realism. Writing of the current AKhRR's exhibition, he referred to the "naturalism of AKhRR painting" and concluded: "They were large illustrations in color, but not what AKhRR expected, not the painting genuinely needed by us in the sense of 'heroic realism' – which was found in Vasilii Surikov and, in part, in I'lia Repin and Sergei Ivanov."[16] The arguments heard later during the era of Socialist Realism may easily be recognized here. One further quotation, from Alfred Kurella, who also played an important role in preparing the ground for Socialist Realism, underlines this point. In an article characteristically entitled "Artistic Reaction Behind the Mask of Heroic Realism" ("Khudozhestvennaia reaktsiia pod maskoi geroicheskogo realizma"), Kurella wrote of the necessity for "organizing the ideology of the masses by the specific means of representational art";[17] failing to find what he wanted in AKhRR, he accused it of naturalism.

These accusations of naturalism, which constituted the initial reaction not only of avant-garde critics but also of the future theoreticians of Socialist Realism and opponents of avant-garde art, were later repeated officially during the campaign against AKhRR in the late 1920s and early 1930s, which preceded the formation of Socialist Realism. It was at this time that AKhRR was accused of fellow-traveling ideology, lack of involvement in the achievements of the Revolution and Socialist construction, and refusal to participate directly in Socialist construction as its "vanguard," as well as of "disparaging criticism" and "Communist arrogance." These accusations are also rehearsed in contemporary Soviet historical writings. E. I. Sevost'ianov, longtime head of Iskusstvo publishing house, provides a characteristic view of the 1930s artistic situation in a special article devoted to this problem. The author quotes sympathetically the observations of critics of the 1930s concerning the "imitative Wanderer approach of AKhRR" and the necessity for criticism to struggle simultaneously against "formalist tricks" and "passive naturalism."[18] Similar quotations exist in many other Soviet publications, reminding us that a struggle against groupings of the likes of RAPP and RAPKh (Russian Association of Proletarian Artists, which had emerged from AKhRR) – by that time the avant-garde had been effectively eliminated – preceded the appearance of Socialist Realism.

In recalling the actual context of the period, we should note that it coincided with the liquidation of NEP – that is, of the milieu in which, according to the general view, the art of groupings like AKhRR had developed. The transition to the 1930s and the Five-Year Plans meant the implementation of measures that had been proposed in their time by the left ("plundering the peasantry," accelerated industrialization, and so forth), although by other methods and in a

different historical context. Amid conditions of intensifying centralization, the program of "building Socialism in one country" and the "growing enthusiasm of the masses," Vladimir Mayakovsky was proclaimed the greatest poet of the age and the Leninist slogan "it is necessary to dream" was quoted with increasing frequency in the press. In these new circumstances Socialist Realism put into effect practically all the fundamental watchwords of the avant-garde: it united the artists and gave them a single purpose, erased the dividing line between high and utilitarian art and between political content and purely artistic decisions, created a single and easily recognizable style, liberated the artist from the service of the consumer and his individual tastes and from the requirement to be original, became part of the common cause of the people, and set itself not to reflect reality but to project a new and better reality.

In this respect Socialist Realism was undoubtedly a revival of the ideals of the avant-garde after a definite period in which individualized artistic production with its purely reflective, mimetic character had dominated. Most importantly, a break with tradition was made in the very role and function of the artist in society. Socialist Realist painting, like the work of the avant-garde, is above all a political decision concerning how the future should look, and is judged by purely political criteria. The Socialist Realist artist renounces his role as an observer detached from real life and becomes a part of the working collective on equal terms with all its other parts. However, all the obvious similarity in the way the avant-garde and Socialist Realism conceptualize the role of art does not provide an answer to a key question: why is there so little external, purely visual similarity between the avant-garde and Socialist Realism?

IV

Apart from the inherent laws of artistic development whereby, after a period of time, art changes its course and begins to move in a new direction, the reason for the changed character of the visual material with which the avant-garde had worked lay primarily in the changed position of the artist in Soviet society as it evolved. Avant-garde art was a reductionist art that adhered to the principle of newness – it was advancing from Malevich's black square as the sign of absolute zero and absolute rejection of the world as it is. The art of the 1930s was confronted by a "new reality," whose authors were political leaders, not the artistic avant-garde. If avant-garde artists had striven to work directly with the "basis," utilizing political power in a purely instrumental way, clearly by the 1930s work with the basis could be implemented only by the political authorities, which did not brook competition.

A similar situation developed in philosophy. While Marxist philosophy had proclaimed the primacy of practice over theoretical cognition, this primacy was understood initially to denote the gaining by the philosopher of political power

with the aim of changing the world instead of knowing it. But as early as the late 1920s and the beginning of the 1930s the primacy of social practice could only be understood as the primacy of decisions by the political leadership over their theoretical interpretation, leading to the ultimate liquidation of the philosophical schools that had earlier emerged.[19] Similarly, artists, nurtured on the principle of the primacy of transformation over representation, could not but recognize, following their own logic, the dominance of the political leadership in the strictly aesthetic sphere as well. The artists left this sphere in order to subordinate political reality to themselves, but in so doing they destroyed the autonomy of the artist and the work of art, thus subordinating the artist himself to political reality "at the second move." Having made social practice the sole criterion of truth and beauty, Soviet philosophers and artists inevitably found themselves obliged to recognize political leaders as better philosophers and artists than themselves, thus renouncing the traditional right of primacy.

In these circumstances the question of the artist's role in society and the objective significance of his activity at a point where both the representation and transformation of reality had escaped his control naturally arose again. Lef had already marked out this new role, which consisted in agitation and propaganda for the decisions of the political leadership. The emergence of this role signaled too a significant shift in the conciousness of artists and of Soviet ideologists as a whole.

The theoreticans of the avant-garde proceeded from the conviction that modification of the "basis" would lead almost automatically to change in the "superstructure" and that, in consequence, purely "material" work with the basis was sufficient to achieve a changed view of the world, a changed aesthetic perception. In the late 1920s and early 1930s this widespread opinion was judged to be "vulgar sociologism" and sharply criticized. The sum of ideological, aesthetic, and other conceptions, the superstructure was proclaimed to be relatively independent and situated in a "dialectical," rather than a one-sided causal, relationship with the basis: defining the superstructure, the basis is "strengthened" as well as "weakened" by it. This new emphasis on the superstructure, brought about in the first instance by the disillusionment with the prospects for world revolution in the developed Western countries (as a result of the "unreadiness" of the proletariat), made art a definite, partially autonomous area of activity. Art, together with philosophy, literature, history, and other "superstructural" forms of activity, was given the task, if not of defining the overall face of the new reality, then, at any rate, of promoting its formation in a particular sphere: specifically, by forming the consciousness of Soviet citizens, who in their turn stood in a dual, dialectical relationship to this reality as both its creators and its "products."

Of the many examples that illustrate this development, we may cite a few of the later pronouncements by Soviet art theorists. They do not differ in essence from the principles worked out in the 1930s, though they are more elaborate. In a 1952 article by N. Dmitrieva entitled "The Aesthetic Category of the Beautiful" ("Esteticheskaia kategoriia prekrasnogo"), the author describes such Stalinist

projects as canals, hydroelectric stations, irrigation programs, and industrial installations: "This is the formation of being according to the laws of beauty," writes Dmitrieva.[20] According to her, the beautiful is the "harmoniously organized structure of life, where everything is mutually coordinated and every element forms a necessary link in the system of the whole."[21] In essence, therefore, the beautiful coincides for the author with "systematic practical activity" and does not reside in art alone as a specific form of activity. The beautiful is, in the first instance, reality itself, life itself, if it is beautifully organized, but "the beautiful in art nevertheless does not fully coincide with the beautiful in life,"[22] since art fixes the attention on "the typical features of beauty" of each given period; "typical" here means not the "statistical mean" but the common aesthetic ideal of the age, that is, the artistic norm for the formation of reality itself. The beautiful in art, reflecting the "typically beautiful in life," thus may play a formative role in relation to reality.

G. Nedoshivin takes a similar position in his article "On the Relationship of Art to Reality" ("Ob otnoshenii iskusstva k deistvitel'nosti"), emphasizing the educative role of art as being "inseparable from its cognitive role."[23] Art, like science, simultaneously cognizes and forms life, doing this, however, not theoretically but in typical images. The typical is again oriented toward practical social goals, toward the future and the "dream." Many similar observations could be cited. All, in essence, are interpretations of Stalin's renowned directive to writers to "write the truth."

To write or "depict" the truth meant for Soviet criticism of that time to show the objectives toward which social practice in reality strove, not to impose objectives upon society from outside, as formalism tried to do, or to observe the movement of society toward these objectives as this really happened, which "uninspired naturalism" did. However, such a purpose presupposes that social practice develops not spontaneously but with the object of realizing certain definite ideals in the mind of the "architect" of this process, who is distinguished from "the very best bee." Naturally, the political leadership, namely Stalin, was seen in the role of architect.

It was, indeed, to Stalin that the avant-garde role of creator of "the beautiful in life itself," that is, the task of "transforming" rather than "representing" life, passed during the 1930s. The political leadership responded to the demand by philosophy and art for political power in order to realize in practice their plans for reconstructing the world by appropriating philosophical and aesthetic projects to itself. Stalin, as the artist of reality, could transform it in accordance with a unified plan, and by the logic of the avant-garde itself, could demand that others standardize their style and direct their individual efforts toward harmony with the style of life Stalin envisioned. The demand to "paint life" has meaning only when that life becomes a work of art. The avant-garde had previously rejected this demand, since, according to the formula "God is dead," it no longer perceived the world as the work of God's art. The avant-garde artist laid claim to the vacant place of the total creator, but in fact this place had been filled by political

authority. Stalin became the only artist, the Malevich, so to speak, of the Stalin period, liquidating the avant-garde as a competitor in accordance with the logic of the struggle – a logic which was not foreign to avant-garde artists either, who willingly resorted to administrative intrigues.

Socialist Realism, despite its collectivist ideals, strove for a single, unified style, as did suprematism, for example, or the analytical art of Filonov. It should not be forgotten that the stylistic variety of the avant-garde was associated with the constant rifts and struggles among leading artists, a situation reminiscent in this respect of the struggle during the early stages of evolution of the Communist Party. Within each faction, however, discipline and the striving for standardization prevailed, making, for example, the faithful disciples of Malevich almost indistinguishable. Such standardization inevitably resulted from the ideology of the avant-garde, which apparently scorned the individualism of a "unique artistic manner" and stressed adherence to the "objective laws of composition." The new world could not be built on a polystylistic basis, and the cult of the personality of the single, unique artist-creator was, therefore, deeply rooted in avant-garde theory and practice. Of course, individual variations were always possible within the framework of a school, but these were as a rule explained by the necessity for broadening the sphere of reality that was embraced, that is, in terms of the individual nature of the specific task and not that of the artist.

A similar situation confronts the student of the art of the Stalin period. Contemporary artists were in essence "followers of Stalin" (by analogy with "followers of Malevich"), who all worked in the "Stalinist style," but with variations depending on whether their task was to portray the great future, celebrate the workers in the factory or in the field, struggle against the imperialist inciters of war, or depict the building of socialism in a particular national republic. In all these situations style underwent definite changes, while at the same time the general trend was toward the elimination of these subject-related differences. Thus, artists, particularly during Stalin's last period, described in detail and with pride how they had succeeded in freeing themselves from all tokens of individual style and even of the "nontypical" characteristic of the represented subject.[24]

The criticism of the Stalin period constantly demanded that artists bring their vision closer to the "normal" vision of "normal" Soviet people, the creators of the new life. In the last years of Stalin's rule the "team method" of manufacturing pictures, directed at overcoming completely the individuality of a particular painter, was widely practiced. Thus, the Soviet artist of the Stalin period did not occupy the position of a realistic reflector of the new reality – this was precisely the position that had been condemned in the case of AKhRR. The artist of Socialist Realism reflected not reality itself but the ultimate goal of its reconstruction: he was at once passive and active in that he varied and developed Stalin's thinking about it.

The difference between Socialist Realism and the avant-garde consists not in their relationship to art and its goals but in the area of application of this new relationship: while the avant-garde – at any rate in its pre-Lef period – directed

287

itself toward forming actual material reality, Socialist Realism set itself above all the goal of forming the psychology of the new Soviet person. The writer, following Stalin's well-known definition, is "an engineer of human souls." This formulation points both to continuity with the avant-garde (the writer as engineer) and to a departure from it, since a new area of application is provided for the avant-garde principle of engineering design after responsibility for projecting reality itself has been assumed by others. At the same time this role proved to be more an honorary one, since the initial slogan of the Five-Year Plan, "technology decides everything," was soon replaced by another – "the cadres decide everything."

However, the problem of projecting the New Man presents the artist with tasks other than those of projecting material reality. In the absence of what might now be called "genetic engineering," the artist is inevitably tied to unchanged human appearance – from which also emerges the necessity of turning again to traditional painting. This represents not only the statement of achieved successes but also an acknowledgment of certain limits. It is in this sense that Socialist Realism is "realistic": realism here is equated with realpolitik, which is opposed to the utopianism of the avant-garde. The task of educating the New Man proved much more difficult than had been initially supposed.

The transition from the avant-garde to Socialist Realism was thus dictated by the logic of development of the avant-garde idea of projecting a new reality, not by concessions to the tastes of the mass consumer, as has often been claimed. There is no doubt that the avant-garde was foreign to the ordinary spectator. It is equally beyond doubt that the return to easel painting during the NEP was influenced by the new mass demand for art. However, the centralization of Soviet art from the beginning of the 1930s made it totally independent of consumer tastes, an independence on which, we may note, the theoreticians of Lef had insisted from the very outset. The art of Socialist Realism does not give ordinary spectators the opportunity to identify with it, since it is opposed to them as an educative institution. With the passing of time the Union of Soviet Artists gained great economic power and relative economic independence, even from official institutions and their tastes, since the union itself determined purchasing policy. No link existed at any level between the ordinary consumer and the union, and the art of Socialist Realism interested the ordinary Soviet person as little as did the art of the avant-garde. In the absence of economic criteria or sociological surveys, the unprecedented success during the post-Stalin era of an artist like Il'ia Glazunov provides an indirect indication of the spectator's real tastes. Other examples may also be cited, which indicate that the mass spectator in the Soviet Union, while inclined toward realistic painting, was by no means oriented toward Socialist Realist painting.

At all events, in fulfilling its basic mission of projecting the New Man, Socialist Realism was limited from the outset, as has been stated, by the unchanging quality of the human countenance and the necessity to take this into account. Lef, too, was obliged to reckon with this constant factor when, at the end of the

1920s, the artists of the Russian avant-garde began to use the human face and figure in their propaganda montages. However, for the art of Socialist Realism representation of the human being occupied a central place; indeed, all other purposes were subsumed by it. As the theoreticians of Socialist Realism recognized from the beginning, this circumstance restricted compositional opportunities and expressive means of painting. The subject of representation became the expression of the human face and the pose of the human body, testifying to the person's inner spiritual state.

Practically all art criticism of the Stalin period devoted itself to endless analyses of the poses and facial expressions portrayed in Soviet pictures in relation to the psychological content they were supposed to convey. The methods and criteria of such analyses, as well as relevant examples, cannot be examined here in greater detail. It is sufficient to state that with time artists and critics jointly elaborated a distinctive and complex code for external appearance, behavior, and emotional reaction characteristic of the "true Soviet man." This code embraced the most varied spheres of life. Highly ritualized and semanticized, it enables any person brought up in Stalinist culture to judge from a single glance at a picture the hierarchical relationships between the figures, the ideological intentions of the artist, the moral character of the figures, and so on. This canon was elaborated over many years prior to Stalin's death, when it began to disintegrate gradually. Painters and critics painfully worked out a new canon under the presupposition that reliance on classical models of the past was impossible. Their main goal was to define which poses and facial expressions should be considered "flabby," "decadent," and bourgeois or, conversely, energetic, but energetic in the Soviet, not the Western, especially the American, style, that is, with a genuine understanding of the prospects for historical progress. They determined which pose could be considered inspired but not exalted, calmly brave but not static, and so on. Today, Socialist Realism is perceived as somewhat colorless by comparison with the classics. But in making such a comparison it should not be forgotten that Socialist Realism lacked the opportunity for prolonged, consistent, and unbroken development that was enjoyed by the classics. If we recall that its entire evolution occupied no more than a quarter of a century, we must acknowledge that, by the end of Stalin's rule, Socialist Realism had achieved a very high degree of internal unity and codification.

Tugendkhol'd set out quite clearly at the very inception of this process the reasons for the turn by Soviet art from the basis to the superstructure. In his essay "The Painting of a Revolutionary Decade" ("Zhivopis' revoliutsionnogo desiatiletiia"), which is still insufficiently "dialectical" from the standpoint of later Soviet art history but is as a result quite clearly written, he argues against the notion of the left that its practice was based on a materialist view of the world. Tugendkhol'd quotes Punin in this connection, who wrote: "Being defines consciousness, consciousness does not define being. Form = being. Form–being defines consciousness, that is, content. . . . Our art is the art of form, because we are proletarian artists, artists of a Communist culture."[25] Tugendkhol'd expresses the following objection:

> For Punin [form] is the command given by the age, at once Russian and Western, proletarian and bourgeois. In other words, this form is set by the objective conditions of the age, which are identical for all. Punin did not understand that, since the form of the age is obligatory to all, the difference between proletarian and non-proletarian art consists not in form but in the idea of utilizing it . . . it is in the fact, too, that [in our country] the master of the locomotives and machines is the proletariat itself that the difference between our industrialism and Western industrialism lies; this is our content.[26]

Thus, Tugendkhol'd directly links the appearance of man in art to the discovery of the relative independence of the superstructure from the level of production. Man and his organizing attitude toward technology are at the very heart of the definition of the new social system, which is thereby given a psychological foundation. In art the concentration on the figure of Stalin as the creator of the new life *par excellence* represents the extreme expression of this new "cult of personality."

Tugendkhol'd also notes that the decisive move toward the portrayal of man was connected with the death of Lenin, when "everyone felt that something had been allowed to pass away."[27] In the future the image of Lenin and, later, Stalin would stand at the center of Soviet art as the image of the ideal, the exemplar. The numerous portraits of Lenin and Stalin, which may seem monotonous to the contemporary observer, were not monotonous to the artists and critics of that period: each was intended to "reveal a side of their multi-faceted personality" (recalling Christ's iconography, which defines different, dogmatically inculcated means of presenting the personality of Christ in its various aspects). These portraits posed a definite risk to the artist, since they represented not only an attempt at an external likeness but also a specific interpretation of the personality of the leaders that had no less ideological and political significance than a verbal or literary interpretation. Characteristically, when the critics failed to find this type of clear-cut interpretation in the portrait and when the interpretation was seen as "unoriginal," it was invariably condemned as a failure.

By the end of Stalin's rule Socialist Realist art had begun to move increasingly toward the creation of an integral, monumental appearance of Soviet cities and, ultimately, a unified appearance of the entire country. Plans were drawn up for the complete reconstruction of Moscow in accordance with a single artistic concept, and painting was being increasingly integrated with architecture while, conversely, buildings of a functional character – factories, underground stations, hydroelectric stations, and so forth – began to take on the character of works of art. Portraits of Lenin and Stalin as well as other leaders, not to mention the "typical workers and peasants," over time became increasingly depersonalized and depsychologized. The basic canon was already so formalized and ritualized that it was now possible to construct a unified reality from elements created in preceding years.

This new monumental style bore little external resemblance to the avant-garde, yet in many respects it realized the latter's aims: total aestheticization of reality

and the rejection of individualized easel painting and sculpture that lacked a monumental purpose. The importance of museums began, correspondingly, to decline: an exhibition of gifts to Stalin was mounted in the Pushkin Museum of West European Art in Moscow.

Neither may this syle be considered a simple restoration of the classical. It is true, of course, that the Academy of Arts was reorganized at this time and the struggle against the "undervaluation of the old Russian Academy of Arts" began at its very first sessions. At the same time the "Chistiakov system," named after the teacher of many of the Wanderers,[28] began to be propagated. The campaign sought to demonstrate that the Wanderer artists descended directly from the Russian classical school, whereas earlier interpretations had focused on their break with the academic tradition.

A new approach to justifying the necessity of "a solicitous attitude toward the cultural heritage" also dates from this time. While, previously, this necessity had been based on the theory that each class creates progressive art during the period of its rise and reactionary art during the period of its decline and that Soviet art should, therefore, imitate the art of periods of progressive development, such as, for example, the art of antiquity, of the Renaissance, and of nineteenth-century Russian realism (the avant-garde was regarded here as the art of decline and decadence), now this theory, too, deriving from the very first declarations of the Party leadership in the area of cultural policy,[29] was accused of representing "vulgar sociologism." The new, far more radical justification advanced was that, in essence, all "the genuinely good art of the past" expressed the interests not of a definite class – even if progressive – but of an entire people and thus, given the total victory and the "flourishing"[30] of the people, could be fearlessly imitated.

Despite all these obvious references to the past, the art of the Stalin period is not classical in the same sense as, for example, the art of the Renaissance or the art of the French Revolution. Antiquity was still ultimately rated an age of slave-owning, and the hero of Soviet books on the period was, above all, Spartacus. The same is true of all other historical epochs: all were regarded as no more than preparatory stages on the road toward the contemporary Soviet age and never as independent models or exemplars. In the profoundest sense Socialist Realism remained the heir of the avant-garde to the end. Like the avant-garde, it regarded the present age as the highest point of history and the future as the embodiment of the aspirations of the present. Any stylization was, therefore, foreign to it, and, for all the monumentality of their poses, Lenin was represented without any feeling of clumsiness in jacket and cap and Stalin in semi-military jacket and boots.

This teleological perception of history led inevitably to an instrumentalization of the artistic devices of the past and to what, seen from the outside, was taken as eclecticism but was in fact not eclecticism. The art of previous ages was not regarded by Soviet ideology as a totality that should not be arbitrarily dismembered. In accordance with the Leninist theory of two cultures in one, each historical period was regarded as a battleground between progressive and reactionary forces, in which the progressive forces ultimately aimed at the victory of

Socialism in the USSR (even if the clash took place in the remote past), while the reactionary forces strove to block this. Such an understanding of history naturally led to quotation from the past of everything progressive and rejection of everything reactionary. Viewed externally, this approach seems to result in extreme eclecticism, since it violates the unity of style of each era, but in the consciousness of Soviet ideology, it possessed the true unity of everything progressive, popular and eternal, and rejected everything ephemeral and transitory associated with the class structure of society.

Ideas of the progressive or reactionary quality of a given phenomenon have naturally changed with time, and what is or is not subject to quotation has changed correspondingly. Thus, in the art of Socialist Realism quotation and "eclecticism" have a semantic and ideological, rather than an aesthetic, character. The experienced Soviet spectator can always readily decipher such an "eclectic composition" which, in fact, possesses a unified ideological significance. However, this also means that Socialist Realism should not be conceived of as a purely aesthetic return to the past, contrasting with the "contemporary style" of the avant-garde.

The real difference between the avant-garde and Socialist Realism consists, as has already been stated, in moving the center of gravity from work on the basis (the technical and material organization of society) to work on the superstructure (engineering the New Man). The shift from basis to superstructure was necessary because work on the former became the exclusive prerogative of Stalin and the Party.

If, thereby, Socialist Realism finally crushed the avant-garde – to regard the avant-garde as a purely aesthetic phenomenon, which contradicts the spirit of the avant-garde itself – at the same time it continued, developed, and, in a certain sense, even implemented its program. Socialist Realism overcame the reductionism of the avant-garde and the traditional contemplative standpoint associated with this reductionism (which led to the success of the Russian avant-garde in the "bourgeois" West) and instrumentalized the entire mass of culture of the past with the object of building a new reality as *Gesamtkunstwerk*. The practice of Socialist Realism is based not on a kind of primordial artistic contemplation, like Malevich's *Black Square*, but on the sum total of ideological demands, which in principle make it possible freely to manipulate any visual material (this ability, it may be noted, enabled the preservation of the principles of Socialist Realism even after Stalin's death, although, visually, Soviet art also underwent definite changes).[31]

By the same token Socialist Realism took the principle, proclaimed by the avant-garde, of rejecting aesthetics to its extreme. Socialist Realism, free of any concrete aesthetic program – despite the apparent strictness of the Socialist Realist canon, it could be changed instantly in response to political or ideological necessity – is indeed that "non-art" the avant-garde wanted to become. Socialist Realism is usually defined as art "Socialist in content and national in form," but this also signifies "avant-garde in content and eclectic in form," since "national"

denotes everything "popular" and "progressive" throughout the entire history of the nation. Avant-garde purity of style is, in fact, the result of the still unconquered attitude of the artist toward what he produces as an "original work" corresponding to the "unique individuality" of the artist. In this sense the eclectic may be regarded as the faithful expression in art of a truly collectivist principle.

The collectivism of Socialist Realism does not, of course, mean anything like democracy. At the center of Socialist Realism is the figure of the leader, who is simultaneously its principal creator (since he is the creator of Socialist reality itself, which serves as the model for art) and its main subject. It is in this sense that Stalin is also a *Gesamtkunstwerk*. As leader, Stalin has no definite style – he appears in different ways in his various personas as general, philosopher and theoretician, seer, loving father, and so on. The different aspects of Stalin's "multifaceted personality," usually incompatible in an ordinary person, seem eclectic in turn, violating standard notions of the original, self-contained human personality: thus, Stalin – as a figure in the Stalin myth – unites in himself the individual and the collective, taking on superhuman features which the artist of the avant-garde, although he too strives to replace the divine project with his own, nevertheless lacks.

If, at first glance, the transition from the original style of the avant-garde to the eclecticism of Socialist Realism appears to be a step backwards, this is only because the judgment is made from a purely aesthetic standpoint based on the unity of what may be called the "world museum." But Socialist Realism sought to become the world museum itself, absorbing everything progressive and worthy of preservation and rejecting everything reactionary. The eclecticism and historicism of Socialist Realism should, therefore, be seen not as a rejection of the spirit of the avant-garde but as its radicalization: that is, as an attempt ultimately to identify pure and utilitarian art, the individual and the collective, the portrayal of life and its transformation, and so on, at the center of which stands the artist-demiurge as the ideal of the New Man in the new reality. To repeat: overcoming the concrete, historically determined aesthetic of the avant-garde meant not the defeat of the avant-garde project but its continuation and completion insofar as this project itself consisted in rejecting an aestheticized, contemplative attitude toward art and the quest for an individual style.

Notes

1 H. Günther, "Verordneter oder gewachsener Kanon?" in *Wiener Slawistischer Alma-nach*, vol. 17 (Vienna, 1986), pp. 305–28.
2 Paul Sjeklocha and Igor Mead, *Unofficial Art in the Soviet Union* (Berkeley: University of California Press, 1967), p. 35.
3 Annemarie Gethmann-Siefert, "Das klassiche als das Utopische. Überlegungen zu einer Kulturphilosophie der Kunst," in Rudolf Bockholdt, ed., *Über das Klassische* (Frankfurt a.M.: Suhrkamp, 1987), pp. 47–76.

4 Lodder links this aestheticization of the Russian avant-garde in the West with the Berlin exhibition of 1922. Christina Lodder, *Russian Constructivism* (New Haven, CT: Yale University Press, 1985), pp. 227–30.

5 *Sots-art* (New York: The New Museum of Contemporary Art, 1986). This source is the catalogue of an exhibition of works by an unofficial Russian art movement of the 1970s and 1980s, which played with the icons of the Stalinist era. See also B. Groys, *The Total Art of Stalinism: Avant-Garde, Aesthetic Dictatorship, and Beyond*, trans. C. Rougle (Princeton, NJ: Princeton University Press, 1992), pp. 75ff.

6 Vladimir Solov'ev, *Sobranie sochinenii* (Brussels: Foyer Oriental Chrétien, 1966), 6: 90.

7 K. Malevich, "God Is Not Cast Down," in K. Malevich, *Essays on Art*, ed. Troels Anderson, trans. Xenia Glowacki-Prus and Arnold McMillin (Copenhagen: Borgen, 1968), 1: 188–223.

8 K. Malevich on AKhRR, in H. Gassner and E. Gillen, eds., *Zwischen Revolutionskunst und Sozialistischem Realismus* (Cologne: DuMont, 1979).

9 Gan, as quoted in Lodder, *Russian Constructivism*, pp. 98–9.

10 Lodder, *Russian Constructivism*, p. 77.

11 B. Arvatov, "Über die Reorganisation der Kunstfakultaten an den VChUTEMAS," 1926, in Gassner and Gillen, *Zwischen Revolutionskunst*, pp. 154–5.

12 K. Malevich, *Suprematismus – die gegenstandslose Welt* (Cologne: DuMont, 1962), p. 57.

13 H. Gassner, *Alexander Rodschenko: Konstruktion 1920* (Frankfurt a.M., 1984), pp. 50–1.

14 Gassner and Gillen, *Zwischen Revolutionskunst*, pp. 286–7.

15 A. Fedorov-Davydov, "Vopros o novom realizme v sviazi s zapadnoevropeiskimi techeniiami v iskusstve" (1925), in his *Russkoe i sovetskoe iskusstvo* (Moscow: Iskusstvo, 1975), p. 24.

16 Ia. A. Tugendkhol'd, "Zhivopis' revoliutsionnogo desiatiletiia" (1927), in his *Iskusstvo oktiabr'skoi epokhi* (Leningrad, 1930), p. 34.

17 Gassner and Gillen, *Zwischen Revolutionskunst*, p. 288.

18 E. I. Sevost'ianov, *Esteticheskaia priroda sovetskogo izobrazitel'nogo iskusstva* (Moscow: Sovetskii khudozhnik, 1983), p. 206.

19 Iegoshua Iakhot, *Podavlenie filosofii v SSSR (20–30 gody)* (New York: Chalidze Publications, 1981).

20 N. Dmitrieva, "Esteticheskaia kategoriia prekrasnogo," *Iskusstvo*, Jan.–Feb. 1952, p. 78.

21 Ibid.

22 Ibid., p. 79.

23 G. Nedoshivin, "Otnoshenie iskusstva k deistvitel'nosti," *Iskusstvo*, July–Aug. 1950, pp. 80–90.

24 Iu. Neprintsev, "Kak ia rabotal nad kartinoi *Otdykh posle boia*," *Iskusstvo*, July–Aug. 1952, pp. 17–20.

25 Punin, as quoted in Tugendkhol'd, "Zhivopis' revoliutsionnogo desiatiletiia," p. 24.

26 Ibid., pp. 24–5.

27 Ibid., p. 31.

28 A. M. Gerasimov, "Zadachi khudozhestvennogo obrazovaniia," in *Akademiia khudozhestv SSSR: Pervaia i vtoraia sessii* (Moscow, 1949), p. 62.

29 Alexander Bogdanov, "The Proletarian and the Art" (1918), in J. Bowlt, ed., *Russian Art of the Avant-Garde: Theory and Criticism 1902–1934* (New York: Viking, 1976), p. 177.

30 A. Stambok, "O nekotorykh metodologicheskikh voprosakh iskusstvoznaniia," *Iskusstvo*, Sept.–Oct. 1952, pp. 42–6.

31 This was evident in, for example, the "Aspekte sowjetischer Kunst der Gegenwart," exhibition at the Museum Ludwig (Cologne, 1981).

Part V
Identity and Appropriation

Introduction

The texts in this section address a range of general and more specialized topics, but a common concern they share is with the construction of "mythic" identities and the need for their critical deconstruction. In this respect they are broadly in tune with the methodological rethinking of art history as a discipline that was conducted with the most urgency in the 1970s and 1980s, when structuralist, Marxist, feminist, and psychoanalytic theory was marshaled under the hopeful banner of "The New Art History."[1] They deal less with the immanent characteristics of artworks than with ideological constructs of identity – sexual, racial, cultural, economic, and political – as these are mediated through aesthetic production and reception. From the readings here it is possible to consider how art practice may both *affirm* and *destabilise* such cultural constructs. (Gauguin's Tahitian paintings and Surrealist objects are cases in point in this section.) The first three essays focus on canonical aspects of European modernism and employ different methods to critique their "mythic" discourses of racial and sexual dominance. The others investigate specific aspects of Cubist collage, Dada, and the Surrealist object to posit other new interpretations of how such practices involve distance from and intersection with wider life and cultural politics.

Abigail Solomon-Godeau's 1989 essay "Going Native" was nominally occasioned by a blockbuster exhibition of the work of Paul Gauguin in Paris. Proceeding from Roland Barthes's notion of myth as a socially constructed reality, it unfolds into a wider interrogation and outright debunking of the mythologization of Gauguin by himself, contemporary critics, and recent art historians as "noble savage." By extension, it is also a critique of the ways in which traditional art history and curatorial practice actually privilege and affirm certain recurring fantasies and discourses of power: in this case, for example, sexual and racial/colonial power as they are played out in Gauguin's Breton and Tahitian works and

in his writings of those periods. Part of Solomon-Godeau's deconstruction bears upon late nineteenth-century criticism of Gauguin. As such, it is interesting to consider her points about beliefs in the artist's "privileged access" to "that which is primordially internal"; indeed the whole myth of the "journey in," in relation to G. Albert Aurier's essay (Part II), which promoted Gauguin as one of the "blessed, the eyelids of their souls unsealed," just as – significantly – he was about to depart for Tahiti in 1891.

Beyond its specific implications for the historical figure of Gauguin and his work, the essay can also be read as a useful introduction to some of the main points of contention in critiques of primitivism that formed a wide-ranging debate in art history the 1980s,[2] peaking in the unease and controversy aroused by the massive exhibition *"Primitivism" in 20th-Century Art: Affinity of the Tribal and the Modern* at New York's Museum of Modern Art in 1984.[3] Solomon-Godeau's essay addresses the late nineteenth-century metropolitan construction of place as discursive object ("Brittany," "Tahiti," "the Orient," and so on), and analyzes other elements in the "primitivizing imagination" such as the predilection for stasis, atavism, the flight from modernity, and the "fantasmatic construction of a purely feminized geography." These she sees as articulations of both colonial and patriarchal fantasies of power. The text has been criticized for its exclusive focus on the gendered discourse of primitivism (at the cost of other sources for Gauguin's imagery within his own Parisian literary milieu),[4] but it remains a strident critique of patriarchal constructions of both the Other and the discourse of art history.[5]

In the early 1970s, feminists working within art history issued a radical challenge to the conventional, established discipline (revolving around formal analysis, attribution, authentication, celebration of individual artistic genius, and so on) by calling into question not only the absence of women artists from the canon, but more significantly, the ideological presuppositions (social, racial, sexual) of art-historical practice as a whole.[6] As Griselda Pollock argued:

> Art history takes an aspect of . . . cultural production, art, as its object of study; but the discipline itself is also a crucial component of the cultural hegemony by the dominant class, race and gender. Therefore it is important to contest the definitions of our society's ideal reality which are produced in art historical interpretations of culture.[7]

Carol Duncan's essay, "Virility and Domination in Early Twentieth-Century Vanguard Painting" (1973), can be read, 30 years on, as part of the early phases of that challenge. Looking back, writing in the 1990s, Duncan traced its urgency to the Civil Rights and anti-Vietnam campus protests of 1968 (she was then a graduate student at Columbia University) – a "crisis [that] exposed art history's striking lack of a developed self-critical tradition" – and to a new wave of feminism.[8]

The central contention of Duncan's essay is that the stylistic innovation and sexually uninhibited, "virile" imagery of the "vanguard" painting of Fauvism,

German Expressionism, and Cubism is celebrated by art historians as the visual expression of a liberated consciousness. However, precisely such images, she argues, are dependent upon the domination and exploitation of others, particularly of lower-class women, and thus embody "on a sexual level the basic class relationships of capitalist society." As an example of the self-consciously anti-bourgeois stance of this vanguard we might consider the "manifesto" of the Expressionist group Die Brücke (The Bridge), which appeared in 1906 as a woodcut text in primitivized type, by Ernst Ludwig Kirchner. It reads:

> With faith in evolution, in a new generation of creators and appreciators, we call together all youth. And as youth, who carry the future, we want to create for ourselves freedom to live opposite the complacent older forces. He belongs with us, who represents, with immediacy and authenticity, that which drives him to create.[9]

Duncan employs a vocabulary of violence and even mortal combat in describing these artists's representations of female subjects: Van Dongen's painting is "ruthless," Kirchner's is "violent," their women are "reduced to flesh," "like conquered animals," as the artist has "annihilated all that is human in his opponent." Kirchner is the artist more than any other who bears the brunt of Duncan's invective. It should be pointed out that, of course, Duncan's choice of examples as well as her readings of their content are themselves no less selective than those exercised in the masculinist art history she critiques. For example, the woman in Kirchner's *Tower Room, Self-Portrait with Erna*, whom Duncan describes as "another faceless nude" who "stands obediently before the artist," was Erna Schilling, with whom Kirchner lived from 1912 until his death in 1938. She is identified in the painting's title, and the image could be read as a double portrait of the couple. Indeed, Kirchner made a series of woodcuts in 1918 which included the couple, symmetrically posed, *both* naked and barely sexually differentiated. It is a measure of how blurred the line between domination and liberation in such images can be that another art historian has claimed, referring to these woodcuts: "For Kirchner a prerequisite for becoming fully human, and therefore also for creating art, is the broadening of psychic discrimination into the essence of countersexuality."[10] Even were it not for this, given that (male and female) nudity was commonplace in Die Brücke and other bohemian milieux, we might ask how one of necessity reads such acquiescent "obedience" from the figure.[11]

Writing two decades later, Lisa Tickner addresses again, though differently, the tangled relations between modernism and sexual difference in an essay entitled "Men's Work? Masculinity and Modernism," of which an extract is reproduced here. The critical reassessment of the gendered politics of vision and representation from feminist perspectives brought many insights into how meanings of sexual difference are produced in art, the politics of the "gaze" (especially the male gaze), and the patriarchal structures of the institutions of art. However, only

more recently has similarly nuanced attention been focused on masculinity and male sexuality in art.[12] Tickner's points here about crises of both femininity *and* masculinity wrought by political and psychological anxieties around sexual difference offer a different perspective on articulations of apparently aggressive "virility" (in this case, in and around the British Vorticist movement) than Duncan's diagnosis of the male vanguard's sexual domination, economic exploitation, and psychological objectification of women.

Duncan ends her essay with important points about the complex modern relationship between the vanguard artist, the collector, and the object in his possession, and problematizes the position of a female viewer of such works. Considerations of patronage and patterns of collecting are also central to David Cottington's essay in this section, "What the Papers Say: Politics and Ideology in Picasso's Collages of 1912," though the author uses them to reach different conclusions.[13] His concern is with the material circumstances in which Picasso's work – especially the *papiers collés* that occupy such a crucial place in histories of modernism – were produced and consumed. This in turn provides a means to trace and account for Picasso's "artistic identity" from about 1909 onwards. His discussion highlights the paradox of the artist's aesthetic and economic freedom on the one hand, and indexation to a close-knit specialist market, with politically and aesthetically discerning tastes, on the other. Cottington explores the ideological discourses underpinning taste and demand in this milieu, a market where the appetite for the new and radically innovative coexisted with the determining weight of a self-conscious and fundamentally conservative national tradition. His points about the increasing withdrawal of aesthetic radicals from political engagement in favor of the "superior truth" of autonomous art can be considered in interesting ways in relation to Bürger's criteria for an avant-gardiste critique of the autonomy of bourgeois art (Part IV).

Hanne Bergius is a German scholar who has written widely on Dada.[14] This section includes a translation into English (for the first time) of her essay, "Dada as 'Buffoonery and Requiem at the Same Time'," published in 1981 in a volume dealing with the theme of the fool in visual culture.[15] Bergius traces a heritage for the Dadaist concept of folly from the Middle Ages on, through Erasmus, Rabelais, Panizza, and beyond, but situates its critical undertaking clearly in the context of the crisis of World War I, the Zurich Dadaists's marginalization (culturally and geographically, as exiles) and the failure of revolutionary hopes in Germany immediately after the war. The fool of the Middle Ages has been described, in terms that come close to the Dadaists's procedure, as a "demonized antithesis to the world of accepted public order [who] soon shows that the existing 'order' is in itself highly questionable, indeed an inverted world."[16] Hugo Ball articulated something of the mixture of the absurd and deadly serious in Dada when he wrote, in the last weeks of the Cabaret Voltaire's existence: "What we call dada is a farce of nothingness in which all higher questions are involved; a gladiator's gesture, a play with shabby leftovers, the death warrant of posturing morality and abundance."[17] Bergius traces two important transform-

ations of the physical Dada cabaret. First, her discussion of Dada as "world cabaret" or "teatrum mundi" suggests that it embraces folly as a global human condition as it was understood by Erasmus:

> Had I a hundred tongues, a hundred mouths
> A voice of iron, I could not count the types
> Of fool, not yet enumerate the names
> Of every kind of folly.[18]

Second, she highlights the ways in which Dada became "a comprehensive cabaret of the media" through, for example, the tactic of hoax newspaper reports. The media-conscious public operation of Dada – here, an aspect of the Dadaist's "narcissistic" existence – is as important an aspect of its public operation and "search for identity" as its humor and self-irony.[19]

In 1995 a touring exhibition under the piquant title "Fetishism" was staged at various venues in England.[20] Included here is an essay by Dawn Ades that originally accompanied the exhibition, examining the complex and often ambivalent relationship of Surrealism to fetishism.[21] As she shows, Surrealism's use of the fetish and fetishism brought it onto ethnographic, psychoanalytic, and sexual-political terrain in often subversive and provocative ways. "Fetishism" refers generally to an obsessive concern with, or love for, particular objects or body parts. The famous rhetorical challenge issued by Georges Bataille, Breton's vociferous opponent and leader of a whole swathe of Surrealist dissidents, "I defy any lover of modern art to adore a painting as a fetishist adores a shoe," attests to the power of the fetish. Ironically, there *are* instances of Surrealist "adoration" of a modern painting to this extent: for example, de Chirico's painting *The Enigma of a Day* (1914), before which a reclining Breton had himself photographed by Man Ray, had "a lasting fetish value for the Surrealists."[22]

The appeal of the fetish to Surrealists lay in part in its tantalizing objectification of an irrational (and hence subversive) attachment. As Ades shows, it articulated a connection to both fear and desire, whether in the Freudian sense – where the fetish, related to fears of castration, symbolically substitutes for the absent maternal penis – or in the Marxian sense of the "commodity fetish." It also tapped into popular quasi-ethnographic notions of savage fetishism in the African colonies.[23] In his concise history of the evolution of the term "fetish," William Pietz highlights the irony inherent in both the psychosexual and political-economic (Marxist) use of the term in the late nineteenth century:

> If primitives irrationally over-valued the desire-gratifying powers of mistakenly divinized material objects, so moderns falsely looked to capitalized economic objects as the magical source of wealth and value. Thus both the new scientists of sex and the new critics of political economics turned an idea used by the civilized to distinguish themselves from primitives back onto those who identified themselves as non-fetishists.[24]

301

The Surrealists must have delighted in their own appropriation and reenactment of the irony.

The texts in this section can be read as case studies of their particular objects of enquiry, but, taken together with those in the preceding sections, they should also stimulate reflection on the ways in which art historians have challenged their own discipline from within and, in so doing, furthered its critical heterogeneity.

Notes

1 See *The New Art History*, eds. A. L. Rees and Frances Borzello (London: Camden Press, 1986).

2 The "primitive" as a category can be extended to representations of, for example, provincial regions of France in the nineteenth century; see Fred Orton and Griselda Pollock, "Les Données Bretonnantes: La Prairie de Représentation," in Orton and Pollock, *Avant-Gardes and Partisans Reviewed* (Manchester: Manchester University Press, 1996), pp. 53–88.

3 See especially Hal Foster, "The 'Primitive' Unconscious of Modern Art," *October* 34 (Fall 1985), pp. 45–70, and Marianna Torgovnick, "William Rubin and the Dynamics of Primitivism," in Torgovnick, *Gone Primitive: Savage Intellects, Modern Lives* (Chicago: University of Chicago Press, 1990), pp. 119–37.

4 Nancy Perloff, "Gauguin's French Baggage: Decadence and Colonialism in Tahiti," in *Prehistories of the Future: The Primitivist Project and the Culture of Modernism*, eds. Elazar Barkan and Ronald Bush (Stanford: Stanford University Press, 1995), pp. 226–69.

5 An important pioneering text was Edward Said, *Orientalism* (New York: Pantheon, 1978); see also Linda Nochlin, "The Imaginary Orient," *Art in America* (May 1983), pp. 118–31, 187–91. For an alternative reading of the politics of modernist primitivism see Patricia Leighten, "The White Peril and *L'Art nègre:* Picasso, Primitivism, and Anticolonialism," *Art Bulletin* 72, no. 4 (Dec. 1990), pp. 609–30. For a good introduction to theories of the interrelation of class, race, and gender across disciplines with essays by key postcolonialist writers such as Edward Said, Homi Bhabha, and Gayatri Spivak, see *Postcolonial Criticism*, eds. Bart Moore-Gilbert, Gareth Stanton, and Willy Maley (London: Longman, 1997).

6 For an important pioneering essay see Linda Nochlin, "Why Have There Been No Great Women Artists?" (first published 1971), in Linda Nochlin, *Women, Art and Power and Other Essays* (London: Thames and Hudson, 1989), pp. 145–58.

7 Griselda Pollock, "Vision, Voice and Power: Feminist Art Histories and Marxism," in Griselda Pollock, *Vision and Difference: Femininity, Feminism and Histories of Art* (London: Routledge, 1988), pp. 18–49, p. 20.

8 Carol Duncan, Preface, *The Aesthetics of Power: Essays in Critical Art History* (Cambridge: Cambridge University Press, 1993), pp. xi–xvi, p. xii.

9 Translation by the author.

10 Günther Gerken, *Ernst Ludwig Kirchner Holzschnittzyklen* (1980), quoted in Donald E. Gordon, *Expressionism: Art and Idea* (New Haven: Yale University Press, 1987), p. 54. A major painting from the period, *Striding into the Sea* (1912;

Stuttgart, Staatsgalerie), also shows a barely differentiated male and female figure, their poses echoing one another.

11 See Jill Lloyd, *German Expressionism: Primitivism and Modernity* (New Haven: Yale University Press, 1991). For a very different reading of Kirchner's *Girl Under a Japanese Umbrella* than Duncan's, see also Gordon, *Expressionism*, pp. 29–30.

12 On the necessity and implications of such considerations with particular regard to Surrealism, see David Hopkins, "Male Shots," *Tate Magazine* 26 (Autumn 2001), pp. 24–30. See also Lisa Tickner, *Modern Life and Modern Subjects: British Art in the Early Twentieth Century* (New Haven: Yale University Press, 2000).

13 See also Francis Frascina, "Realism and Ideology: An Introduction to Semiotics and Cubism," ch. 2 in Charles Harrison, Francis Frascina, and Gill Perry, *Primitivism, Cubism, Abstraction: The Early Twentieth Century* (New Haven: Yale University Press, 1993), pp. 87–183.

14 See e.g. Hanne Bergius, *Das Lachen Dadas: Die Berliner Dadaisten und ihre Aktionen* (Gießen: Anabas, 1989) and Hanne Bergius, "The Ambiguous Aesthetic of Dada: Towards a Definition of its Categories," *Journal of European Studies* 9 (1979), pp. 26–38.

15 *Unter der Maske des Narren*, ed. Stefanie Poley (Stuttgart: Gerd Hatje, 1981), pp. 208–20.

16 Jürgen Keimer, "Nicht Mensch – Nicht Gott – Nicht Teufel," in ibid., pp. 202–7, p. 206. (Author's translation.)

17 Hugo Ball, *Flight Out of Time: A Dada Diary*, trans. Ann Raimes, ed. and intro. John Elderfield (Berkeley: University of California Press, 1996), p. 65.

18 The *Aeneid* as adapted and quoted by Erasmus of Rotterdam, *Praise of Folly* (1509), trans. Betty Radice, intro. A. H. T. Levi (London: Penguin, 1971), p. 130.

19 On the "complex sense of humor" of the Dadaists, see Richard Sheppard, "Radical Cheek, or Dada Reconsidered," in Sheppard, *Modernism – Dada – Postmodernism* (Evanston, IL: Northwestern University Press, 2000), pp. 171–206, esp. pp. 198–9.

20 "Fetishism" was shown at the South Bank Centre, London; the Brighton Museum and Art Gallery; the Castle Museum and Art Gallery, Nottingham; and the Sainsbury Centre for Visual Arts, Norwich.

21 The ambivalence of the Surrealist fetish is discussed in relation to objects by Alberto Giacometti in Hal Foster, *Compulsive Beauty* (Cambridge MA: MIT Press, 1993), pp. 91–8.

22 Denis Hollier, "Surrealist Precipitates: Shadows Don't Cast Shadows" (trans. Rosalind Krauss), in Rosalind Krauss et al., *October: The Second Decade, 1986–1996* (Cambridge, MA: MIT Press, 1997), pp. 2–24, p. 11. Originally in *October* 69 (1994), pp. 110–32.

23 William Pietz, "Fetish," in Robert S. Nelson and Richard Shiff, eds., *Critical Terms for Art History* (Chicago: University of Chicago Press, 1996), pp. 197–207.

24 Ibid., p. 201.

26

Going Native

Abigail Solomon-Godeau

The recent Gauguin retrospective on view at the Grand Palais conformed in all its essentials to the familiar form of the blockbuster. The week before its opening, Gauguin was the cover story in mass-media publications such as *Telerama* and *Figaro*. From the moment the show opened, lines routinely stretched from the entrance of the Grand Palais to the metro station; I was told that an average of 7,000 people saw the show each day. The accompanying scholarly apparatus conforms equally to expectations: a seven-pound, 300-franc catalogue produced by a Franco-American *equipe*, brimming with facts and factoids; a three-day symposium uniting scholars from several countries; corporate sponsorship on both sides of the Atlantic – Olivetti in France, AT&T in the States; and satellite exhibitions of both the graphic work of the Pont-Aven school and historical photographs of Polynesia. Also attendant upon the show were disputes, if not polemics, concerned with problems of dating in publications such as *The Print Collector's Newsletter*, and the reissue of numerous older Gauguin monographs.

Consistent with this discursive presentation of the artist and his work – a presentation which, for short, may be designated business as usual – the physical presentation of the exhibition and the catalogue are insistently concerned with a certain inscription of the artist. For example, at various strategic points, the viewer is confronted with over-life-size photographic blow-ups of Gauguin. And departing from the overall stylistic/chronological organization of the show, the very last room is consecrated to a medley of Gauguin's self-portraits, revealing a progression (if that is the right term) from the rather *louche Autoportrait avec chapeau* (1893–4) to the lugubrious *Autoportrait près de Golgotha* (1896). In other words, there are at least two narratives proposed by this exhibition: one structured around a temporal, formal trajectory (the stylistic evolution and development of the artist's work), and the other around an agon-

Abigail Solomon-Godeau, "Going Native," originally published in *Art in America* 77 (July 1989), pp. 119–29, 161 (notes). Reprinted by permission of Brant Publications, Inc.

istic and heroicized presentation of the artist's life. The former narrative is produced through curatorial strategies of selection and exclusion; the latter through the interpolation of Gauguin as a biographical subject – for example, the use of text panels chronicling his activities, his travels, his mistresses. These two narratives are unified under the mystic sign of the promethean artist; thus, fully in keeping with the exigencies of a secular hagiography that characterizes mainstream, culturally dominant approaches to art, the catalogue offers us a full-page photograph of Gauguin's hand.

This shamanlike image is as good a point of entry as any other into the myth of Gauguin, and by extension, into the discourse of artistic primitivism which Gauguin is taken to exemplify. Gauguin's position is here quite central insofar as he is traditionally cast as the founding father of modernist primitivism. I am less concerned here, however, with primitivism as an esthetic option – a stylistic choice – than with primitivism as a form of mythic speech. Further, it is one of my themes that the critical interrogation of myth is a necessary part of art-historical analysis. Myth, as Roland Barthes famously defined it, is nothing more or less than depoliticized speech – consistent with the classical definition of ideology (a falsification or mystification of actual social and economic relations). But mythic speech is not only about mystification, it is also, and more crucially, a *productive* discourse – a set of beliefs, attitudes, utterances, texts and artifacts that are themselves constitutive of social reality. Therefore, in examining mythic speech, it is necessary not only to describe its concrete manifestations, but also to carefully attend to its silences, its absences, its omissions. For what is not spoken – what is unspeakable, mystified or *occulted* – turns always on historical as well as psychic repressions.

Second only to the life of his equally mythologized contemporary Vincent van Gogh, Gauguin's life is the stuff of which potent cultural fantasies are created. And indeed have been. Preeminently, the myth is associated, in both the popular and the art-historical imagination, with Gauguin's ten years spent in Polynesia and – integrally linked – his assumption of the role of savage. Simultaneously, Gauguin's life is also deemed tragic and accursed. A glance through the card catalogue yields some of the following titles: *Oviri: The Writings of a Savage, The Noble Savage: A Life of Paul Gauguin, Gauguin's Paradise Lost, La vie passionée de Paul Gauguin, Poètes et peintres maudit, Les maudits, Gauguin: Peintre maudit*, and – my personal favorite – *Gauguin: Sa vie ardente et misérable*.

Even during his lifetime Gauguin was associated with the flight from, variously, bourgeois life and respectability, the wear and tear of life in the cash nexus, a wife and children, materialism, "civilization." But no less mythically important than the things escaped are the things sought – the earthly paradise, its plentitude, its pleasure, its alluring and compliant female bodies. To admirers of Gauguin during his lifetime and the period immediately after – I refer here to such indispensable and powerful promoters as Albert Aurier, Charles Morice, Daniel de Montfried, and most crucially, Victor Segalen[1] – Gauguin's voyage of life was perceived in both the most literal and gratifyingly symbolic sense as a voyage ever further

outward, to the periphery and margins, to what lies outside the parameters of the superego and the polis. On a biographical level, then, Gauguin's life provides the paradigm for primitivism as a white, Western and preponderantly male quest for an elusive object whose very condition of desirability resides in some form of distance and difference, whether temporal or geographical.

In the myth of Gauguin "the man," we are thus presented with a narrative (until quite recently, one produced exclusively by men) that mobilizes powerful psychological fantasies about difference and otherness, both sexual and racial. On a formal level – or perhaps I should say, on the level of Gauguin the artist – another narrativization is at work. Here, the salient terms concern originality and self-creation, the heroism and pathos of cultural creation, a telos of avant-gardism whose movement is charted stylistically or iconographically.

Common to both the embrace of the primitive – however defined – and the celebration of artistic originality is the belief that both enterprises are animated by the artist's privileged access, be it spiritual, intellectual or psychological, to that which is primordially internal. Thus, the structural paradox on which Gauguin's brand of primitivism depends is that one leaves home to discover one's real self; the journey out, as writers such as Conrad have insisted, is, in fact, always a journey in; similarly, and from the perspective of a more formally conceived criticism, the artist "recognizes" in the primitive artifact that which was imma-nent, but inchoate; the object from "out there" enables the expression of what is thought to be "in there." The experience of the primitive or of the primitive artifact is therefore, and among other things, valued as an aid to creation, and to the act of genius located in the artist's exemplary act of recognition.

Is it the historic Gauguin that so perfectly incarnates this mythology, or is it the mythology that so perfectly incarnates Gauguin? Did Gauguin produce this discourse, or did the discourse produce him? From whichever side we tackle this question, it must be said that Gauguin was himself an immensely persuasive purveyor of his own mythology. But the persuasiveness of Gauguin's primitivism – both as self-description and as esthetic project – attests to the existence of a powerful and continuing cultural investment in its terms, a will to believe to which 100 years of uncritical commentary bears ample witness. Mythic speech cannot be dispelled by the facts it ignores or mystifies – the truth of Brittany, the truth of Polynesia, the truth of Gauguin; rather, it must be examined in its own right. And because myth's instrumentality in the present is of even greater moment, we need to attend to its avatars in the texts of contemporary art history. Thus, while it is fruitless to attempt to locate an origin of primitivist thought, we can at any point along the line attempt to unpack certain of primitivism's con-stituent elements, notably the dense interweave of racial and sexual fantasies and power – both colonial and patriarchal – that provides its raison d'être and which, moreover, continues to inform its articulation. Insofar as Gauguin is credited with the invention of modernist primitivism in the visual arts, such an investigation needs to reckon both with Gauguin's own production – literary as well as artistic – and with the successive levels and layers of discourse generated around it.

For my purposes here, it is sufficient to begin in 1883, when at the age of 35, Gauguin makes his decisive break with his previous life as a respectable bourgeois and paterfamilias; terminated from the investment firm of Bertin in the wake of the financial crash of 1882, he resolves to become a full-time artist. Three years later he leaves his wife, Mette Gad Gauguin, and his five children in Copenhagen and returns to Paris. Then begins his restless search for "luxe, calme et volupté," a troubled quest for another culture that's purer, closer to origins and – an equally insistent leitmotif – cheaper to live in.

By July 1886, he is installed at Pont Aven, at the Pension Gloanec. It is during this first Breton sojourn that he begins to present himself, quite self-consciously, as a savage. Simultaneously, and in concert with other artists – notably Emile Bernard – he begins to specifically adumbrate the goals and intentions of a primitive art. Brittany is thus presented in Gauguin's correspondence, and in the subsequent art-historical literature, as the initial encounter with cultural Otherness, a revivifying immersion in a more archaic, atavistic and organic society. Such a view of Brittany is exemplified by Gauguin's often quoted comment, "I love Brittany: there I find the wild and the primitive. When my wooden shoes ring on this stony soil, I hear the muffled, dull, and mighty tone I am looking for in my painting." Daniel de Montfried, Gauguin's close friend and subsequent memorialist, tied the move to Brittany specifically to Gauguin's ambitions for his art: "He hoped to find a different atmosphere from our exaggeratedly civilized society in what, he thought, was a country with archaic customs. He wanted his works to return to primitive art."[2]

Since the publication of Fred Orton and Griselda Pollock's important essay of 1980, "Les Données Bretonnantes," which significantly does not even appear in the Grand Palais catalogue's bibliography, this conception of Brittany as somehow primitive, severe and eminently folkloric has been revealed as itself a mythic representation. Indeed, Pollock and Orton's evocation of Pont Aven in the late 1890s suggests nothing so much as Provincetown in the 1950s – an international artists' colony, and a popular site for tourism, coexisting with, and forming the economy of, a relatively prosperous and accessible region whose diversified economy was based on fishing (including canning and export), agriculture, kelp harvesting and iodine manufacturing.

Far from constituting the living vestiges of an ancient culture, many of the most visually distinctive aspects of Breton society (preeminently the clothing of the women) postdated the French Revolution; they were, in fact, as Orton and Pollock demonstrate, aspects of Breton *modernity*.[3] But from the perspective of an inquiry into the terms of a nascent primitivism, what needs be emphasized is the construction of Brittany as a discursive object; in keeping with analogous constructions such as Orientalism, we might call this construction "Bretonism." Accordingly, the distance between the historical actuality of Brittany in the later 1880s and the synthetist representation of it is not reducible to a distance from or a distortion of an empirical truth, but must be examined as a discursive postulate in its own right. Of what, then, does this postulate consist?

On a formal level, the developments one observes in Gauguin's work of 1886–90, and indeed in the work of the Pont Aven circle as a whole, have little to do with Brittany, whether real or imagined. These years encompass the first two Breton sojourns, punctuated by the 1887 trip to Panama and Martinique, and the crucial encounter with tribal arts and culture at the 1889 Universal Exhibition. Gauguin's jettisoning of phenomenological naturalism with respect to color, atmosphere and perspective, and his assimilation of, variously, Japonisme, French popular imagery and Emile Bernard's cloisonnisme, all of which had long since been discursively constituted as the primitive, did not require Brittany for its realization.

On the level of motif, however, Bretonism signals a new interest in religious and mystical iconography – Calvaries, self-portraits as Christ, Magdalens, Temptations and Falls. To be sure, this subject matter is not separable from the emerging precepts of Symbolism itself, any more than Gauguin's self-portraiture as Christ or magus is separable from his personal monomania and narcissism. In this respect, Synthetism, cloisonnisme, primitivism and the larger framework of Symbolism all represent diverse attempts to negotiate what Pollock and others have termed a crisis in representation – a crisis whose manifestation is linked to a widespread flight from modernity, urbanity and the social relations of advanced capitalism.

To commentators such as Camille Pissarro, Symbolism was itself a symptom of bourgeois retrenchment in the face of a threatening working class:

> The bourgeoisie, frightened, astonished by the immense clamor of the disinherited masses, by the insistent demands of the people, feels that it is necessary to restore to the people their superstitious beliefs. Hence the bustling of religious symbolists, religious socialists, idealist art, occultism, Buddhism, etc., etc.[4]

And he reproached Gauguin for "having sensed this tendency" and, in effect, pandering to it. But from either perspective, it seems clear that Bretonism fulfills a desire for the annihilation of what is deemed insupportable in modernity, which in turn requires that the Brittany of Bretonism be conceived as feudal, rural, static and spiritual – the Other of contemporary Paris.

Stasis – being outside of time and historical process – is particularly crucial in the primitivizing imagination, insofar as what is required is an imaginary site of psychic return. The "return to origins" that Gauguin claimed as his artistic and spiritual trajectory is emblematized in another frequent quotation: "No more Pegasus, no more Parthenon horses! One has to go back, far back ... as far as the dada from my childhood, the good old wooden horse."[5] Gauguin's words limn an atavism that is anterior to, and more profound in its implications, than the search for a kind of ethnographic origin in either Brittany or the South Seas.

This atavism has its lineage in Rousseauist thought, in various kinds of temporal exoticism, in certain currents in Romanticism, and – closer to Gauguin's own time – in a new interest in the child and the child's perception. While it might be possible to argue that Gauguin's numerous images of children – Breton girls and

308

adolescents, naked little boys (some of them quite strikingly perverse) – themselves constitute an element of Bretonism, it is also possible that the prevalence of children, like that of unindividuated Breton women, masks something largely absent from the Bretonist vision – namely, adult men and their activities. Why should the character – physiognomic, sartorial or spiritual – of Breton men be of no interest? While there is no simple answer to this question, I would like to suggest that the absence of men from Bretonism may be structurally similar to the absence of men in the 19th-century *discours prostitutionelle*. In other words, in the same way that discussions of *proxénètisme* and other forms of male entrepreneurial relations to prostitution are elided, it may well be that what is at work in these discourses is a fantasmatic construction of a purely feminized geography. In this respect, Bretonism thus supplies a vision of an unchanging rural world, populated by obliquely alien, religious women and children, a locus of nature, femininity and spirituality. And as the Grand Palais catalogue so ingenuously puts it: "In the artistic itinerary of Gauguin, le Pouldu would remain as 'the first of his Tahitis,' his 'French Tahiti.' "[6] And lest we think that Bretonism is a late 19th-century phenomenon, here is a description of Breton women written in 1973: "The feminine population of Brittany was both earthy and undifferentiated, the women possessing a shared character which took form in a sort of animal nature, the result of centuries of ritualized response to an established role."[7]

In any event, the appearance of female nudes in Gauguin's work during the first stay in Brittany (the only ambitious female nude anterior to the Brittany work is the "realist" *Suzanne Coussant* of 1881) participates in many of the same structures of desire as does Bretonism itself. Significantly, it was during the Breton period that Gauguin elaborated his peculiar mythology of the feminine – a hodgepodge of Wagnerian citations, fin-de-siècle *idées reçues* about woman's nature, Strindbergian misogyny, French belles-lettriste versions of Schopenhauer and so forth and so on. Modern art-historical literature abounds in grotesquely misogynist exegeses of the meanings in Gauguin's representations of women.[8] In terms of my larger argument, it is enough to note that like the putatively archaic, mysterious and religious Bretonne, the deflowered maiden, the naked Eve and the woman in the waves (all from the Breton period) alike reside in that timeless and universal topos of the masculine imaginary – femininity itself.

Unmistakably, in Gauguin's writing and in his art, the quest for the primitive becomes progressively sexualized, and we must ask if this is a specific or a general phenomenon. From 1889 on, there is an explicit linkage of the natural and Edenic culture of the tropics to the sensual and the carnal – nature's plenitude reflected in the desirability and compliance of "savage women." "The first Eves in Gauguin's Eden," as one art historian refers to them, appear in 1889 (the two versions of *Eve Bretonne, Ondine, Femmes se baignent*, and, in the following year, *Eve Exotique*). Much psychobiographic ink has been spilled over the fact that the head of the *Eve Exotique* derives from a photograph of Gauguin's mother – Aline Chazal. But if we recall that Eve means mother to begin with, and that, biblically speaking, Eve is

the mother of us all, Gauguin's use of his mother's photograph could mean any number of things. Given the ultimate unknowability of an artist's intentions, motivations and psychic structures, there seems little point in psychoanalyzing the subject through the work. Of far greater importance to my mind is an analysis of the availability and indeed the self-evidence of the constellation Eve/Mother/Nature/Primitive to the patriarchal imaginary as a cultural and psychic construction.

Again, we are confronted with a form of mythic speech that can by no means be historically relegated to the era of Symbolism. I quote a contemporary art historian:

> What better symbol for this dream of a golden age than the robust and fertile mother of all races? . . . Gauguin's Eve is exotic, and as such she stands for his natural affinity for tropical life. His was more than a passing taste for the sensuality of native women; of mixed origin – his mother had Peruvian as well as Spanish and French blood – he was deeply aware of his atavism, often referring to himself as a pariah and a savage who must return to the savage.[9]

And from another art historian:

> Although Gauguin's imagery clearly emerges out of the 19th century tradition of the fatal woman, it rejects the sterility of that relationship. On the contrary, the ceramic [the *Femme noire*] suggests a fruitful outcome to the deadly sexual encounter by representing the Femme Noire as full-bellied and almost pregnant: the female uses the male and kills him, but she needs the phallus and its seed to create new life. So the fated collaboration is productive, even though fatal for the male. Gauguin's imagery is basically an organic and natural one.[10]

The leitmotifs that circulate in these citations (chosen fairly randomly, I might add) – strange references to mixed blood, persistent slippages between what Gauguin said or believed or represented and what is taken to be true, the naturalizing of the cultural which, as Barthes reminds us, is the very hallmark of mythic speech – all these suggest that Gauguin's mythologies of the feminine, the primitive, the Other, are disturbingly echoed in current art-historical discourse. Furthermore, insofar as femininity is conventionally linked, when not altogether conflated, with the primitive (a linkage, incidentally, that reaches a delirious crescendo in the fin-de-siècle), is there, we might then ask, a mirror version of this equivalence in which the primitive is conflated with the feminine? Is primitivism, in other words, a gendered discourse?

One way to address this question is by tracking it through Gauguin's own itinerary. By 1889, he had already resolved to make his life anew in Tahiti. Significantly, he had also considered Tonkin and Madagascar; all three were French colonial possessions. Tahiti, the most recent of these, had been annexed as a colony in 1881 (it had been a protectorate until then). Gauguin's primitivism was not free-floating, but followed, as it were, the colonizing path of the tricouleur. From Brittany he wrote to Mette Gauguin the following:

May the day come soon when I'll be myself in the woods of an ocean island! To live there in ecstasy, calmness and art. With a family, and far from the European struggle for money. There in Tahiti I shall be able to listen to the sweet murmuring music of my heart's beating in the silence of the beautiful tropical nights. I shall be in amorous harmony with the mysterious beings of my environment. Free at last, without money trouble, I'll be able to love, to sing, to die.[11]

In this as in other letters, Gauguin makes very explicit the equation tropics/ecstasy/amorousness/native. This was mythic speech at the time Gauguin articulated it, and it retains its potency to this day; one has only to glance at a Club Med brochure for Tahiti to appreciate its uninterrupted currency.

Insofar as we are concerned with Polynesia as a complex and overdetermined representation as well as a real place in time and history, we may start by asking what kinds of associations were generated around it in 19th-century France. From the moment of their "discovery" – a locution which itself demands analysis – by Captain Samuel Wallis in 1767, the South Sea Islands occupied a distinct position in the European imagination. Renamed La Nouvelle Cythère shortly after by Louis-Antoine Bougainville, Tahiti especially was figured under the sign of Venus: seductive climate, seductive dances, seductive (and compliant) women.

In the expeditionary literature generated by Captain Cook, Wallis, Bougainville and the countless successive voyagers to the South Seas, the colonial encounter is first and foremost the encounter with the body of the Other. How that alien body is to be perceived, known, mastered or possessed is played out within a dynamic of knowledge/power relations which admits of no reciprocity. On one level, what is enacted is a violent history of colonial possession and cultural dispossession – real power over real bodies. On another level, this encounter will be endlessly elaborated within a shadow world of representations – a question of imaginary power over imaginary bodies.

In French colonial representation, the non-reciprocity of these power relations is frequently disavowed. One manifestation of this disavowal can be traced through the production of images and texts in which it is the colonized who needs and desires the presence and the body of the colonizer. The attachment of native women – often the tragic passion – for their French lovers becomes a fully established staple of exotic literary production even before the end of the 18th century.

The perception of the Maori body – entering European political and representational systems much later than the black or Oriental body – can be seen to both replicate and differ from the earlier models for knowing the Other's body. Like that of the African, the body of the South Sea Islander is potentially – and simultaneously – monstrous and idealized. In the Polynesian context, these bodily dialectics were charted on a spectrum ranging, on the one hand, from cannibalism and tattooing to, on the other, the noble savage (usually given a Grecian physiognomy) and the delightful *vahine*. It is the fantasmatic dualism of cannibalism and *vahine* which alerts us to the central homology between the Polynesian body

311

and the African body in European consciousness. For as Christopher Miller has pointed out in relation to Africanist discourse: "The horror of monstrousness and the delight of fulfillment are counterparts of a single discourse, sharing the same conditions of possibility: distance and difference...."[12] The Maori body has its own specificity; it did not conform altogether to the model of the black African body. On the contrary, 18th- and 19th-century images of the Maori – and they are overwhelmingly of women – work to produce a subject who, if not altogether "white," is certainly not inscribed within the conventional representation schema for "black." This in turn may account for the perpetual problem posed by the "origin" of the Maori. If neither Black, White nor Yellow (the overarching racial categories systematized in such summas of racialism as Joseph Gobineau's *Essai sur l'inégalité des races humaines*), the Maori race, along with its placelessness, was clearly disturbing for 19th-century racial theory. In this respect, it would be amusing to think that the "problem" of Maori origins was unconsciously allegorized in Gauguin's *D'où venons-nous, Que sommes-nous, Où allons-nous?*

The Polynesian body had another specific valence which was structured around the perception of its putative androgyny, androgyny here understood in a morphological sense. As Victor Segalen, following countless previous descriptions, specified: "The woman possesses many of the qualities of the young man: a beautiful adolescent [male] comportment which she maintains up to her old age. And diverse animal endowments which she incarnates with grace."[13] Conversely, the young male Maori was consistently ascribed feminine characteristics. This instability in gendering was given explicit expression in the encounter Gauguin described in *Noa Noa* which hinged on his "mastery" of homosexual desire for a young Maori who trekked for him in search of wood to make his carvings.

The logic at work in the literary and iconic production of La Nouvelle Cythère was explicitly structured by the erotic fascination organized around the figure of the young Polynesian woman. "There should be little difficulty," wrote one frigate captain in 1785, "in becoming more closely acquainted with the young girls, and their relations place no obstacles in their way."[14] We may recall too that the mutiny on the Bounty was in part a consequence of the crew's dalliances with the native women. In any case, from the 18th century on, it is possible to identify various modalities in which the South Sea Islands are condensed into the figure of the *vahine* who comes effectively to function as metonym for the tropic paradise *tout court*. Indeed, Maori culture as a whole is massively coded as feminine, and glossed by constant reference to the languor, gentleness, lassitude and seductiveness of "native life" – an extension of which is the importance in Polynesian culture of bathing, grooming, perfuming, etc. By the time the camera was conscripted to the discursive production of the Maori body (in the early 1860s, a good 20 years before Gauguin's arrival) these conventions of representation were fully established.

In examining popular representational modes – whether graphic or photographic – one can situate them with respect to the high-cultural forms to which they relate as iconographic poor relations. Hence, we move from Rococo *vahines*

to "naturalist" or academic representations of unclothed Tahitians in the later 19th century, underpinned, as they clearly are, by the lessons of academic painting and its protocols of pose and comportment.

There was, as well, a fully developed literary tradition concerning Tahiti and to a lesser extent the Marquesas, ranging from what are now deemed high-cultural productions such as Herman Melville's *Typee* and *Omoo*, to enormously successful mass-cultural productions such as the *Marriage of Loti* by Pierre Loti (the pen name of Julien Viaud). "Serious" primitivists such as Gauguin and Victor Segalen dismissed books such as the *Marriage of Loti* as sentimental trash – "*proxynètes de divers*," Segalen called them – but to read Segalen's *Les Immemoriaux* or to contemplate Gauguin's strangely joyless and claustral evocations of Tahiti and the Marquesas is to be, in the final instance, not at all far from Loti.

In short, the "availability" of Tahiti and the Marquesas to Gauguin was as much a function of 100 years of prior representation as was its status as French possession, which additionally entitled Gauguin to a 30 percent reduction on his boat ticket and a spurious mission to document native life. Both forms of availability are eloquently symbolized in the 1889 Universal Exhibition whose literal center was composed of simulacra of native habitations, imported native inhabitants and tribal objects. William Walton, a British journalist, indicated the scale and ambition of this colonial Disneyland in his "Chefs d'oeuvre de l'Exposition Universelle": "The colonial department includes Cochin Chinese, Senegalese, Annamite, New Caledonian, Pahouin, Gabonese and Javanese villages, inhabitants and all. Very great pains and expense have been taken to make this ethnographic display complete and authentic."[15]

In addition to these villages, there was a model display of 40-odd dwellings constituting a "History of Human Habitation" as well as a display of "The History of Writing" including inscriptions taken from Palenque and Easter Island. The importance of this lexicon of exoticism for Gauguin should not be – but usually is – underestimated. Over a period of several months, Gauguin was frequently within the precincts of the exhibition (the Synthetist exhibition at the Café Volponi ran simultaneously). Thus, the experience of the primitive "framed" within the Pavilion of the Colonies or the History of Human Habitation is analogous to the primitivist discourse "framed" by the imperialism that is its condition of existence and the context of its articulation.

To acknowledge this framing is but a first step in demythifying what it meant for Gauguin to "go native." There is, in short, a darker side to primitivist desire, one implicated in fantasies of imaginary knowledge, power and rape; and these fantasies, moreover, are sometimes underpinned by real power, by real rape. When Gauguin writes in the margin of the *Noa Noa* manuscript, "I saw plenty of calm-eyed women. I wanted them to be willing to be taken without a word, brutally. In a way [it was a] longing to rape,"[16] we are on the border between the acceptable myth of the primitivist artist as sexual outlaw, and the relations of violence and domination that provide its historic and its psychic armature.

In making an argument of this nature, one can also make reference to the distinction between the Polynesian reality and Gauguin's imaginary reconstruction of it. In 1769, the population of Tahiti was reckoned at about 35,000 persons. By the time of Gauguin's arrival in Papeete in 1891, European diseases had killed off two thirds of the population. Late 19th-century ethnographers speculated that the Maori peoples were destined for extinction. The pre-European culture had been effectively destroyed; Calvinist missionaries had been at work for a century, the Mormon and Catholic missionaries for 50 years. The hideous muumuus worn by Tahitian women were an index of Christianization and Western acculturation. According to Bengt Danielsson, the only Gauguin specialist who diverges from mythic speech, "virtually nothing remained of the ancient Tahitian religion and mythology...; regardless of sect, they all attended church – at least once a day. Their Sundays were entirely devoted to churchgoing."[17]

Not only had the indigenous religion been eradicated, but the handicrafts, barkcloth production, art of tattoo and music had equally succumbed to the interdiction of the missionaries or the penetration of European products. The bright-colored cloth used for clothing, bedding and curtains that Gauguin depicted was of European design and manufacture.

Gauguin did, of course, indicate his dissatisfaction with Papeete as a provincial town dominated by colonials and demoralized and deracinated *indigènes*. In later years, in the Marquesas, he saw fit to regularly (and publicly) denounce the practice of intermarriage between the resident Chinese and the Polynesians. But the tourist/colonialist lament for the loss of the authentic, primitive culture it seeks to embrace is itself a significant component of the primitivist myth. For within this pervasive allegory, as James Clifford points out, "The non-Western world is always vanishing and modernizing. As in Walter Benjamin's allegory of modernity, the tribal world is conceived as a ruin."[18]

In France, Gauguin had imagined Tahiti to be a sensual land of cockaigne where a bountiful nature provided – effortlessly – for one's needs. This was also what the colonial pamphlets he had read told him. In fact, installed in his house 30 miles from Papeete, Gauguin was almost entirely reliant on the extremely expensive tinned food and biscuits from the Chinese trading store. Bananas and breadfruit, a staple of the Tahitian diet, were gathered by the men once a week on excursions to the highlands. Fishing, which provided the second staple food, was both a collective and a skilled activity. Ensconced in his tropical paradise, and unable to participate in local food-gathering activities, Gauguin subsisted on macaroni and tinned beef and the charity of Tahitian villagers and resident Europeans. Throughout the years in Tahiti and later in the Marquesas, Gauguin's adolescent mistresses were not only his most concrete and ostentatious talisman of going native, they were also, by virtue of their well-provisioned extended families, his meal tickets.

There are, of course, as many ways to go native as there are Westerners who undertake to do so. Gauguin scrupulously constructed an image of himself as having a profound personal affinity for the primitive. The Polynesian titles he gave

most of his Tahitian works were intended to represent him to his European market, as well as to his friends, as one who had wholly assimilated the native culture. In fact, and despite his lengthy residence, Gauguin never learned to speak the language, and most of his titles are either colonial pidgin or grammatically incorrect.[19] His last, rather squalid years in the Marquesas included stints as a journalist for a French newspaper and a series of complicated feuds and intrigues with the various religious and political resident colonial factions.

It is against this background that we need to reconsider the text of *Noa Noa*. It has been known for quite a long time that much of the raw material of the text – notably that pertaining to Tahitian religion and mythology – was drawn from Gauguin's earlier *Ancien culte mahorie*, of which substantial portions were copied verbatim from Jacques Antoine Meorenhout's 1837 *Voyages aux îles du grand océan*.[20] Thus, when Gauguin writes in *Noa Noa* that his knowledge of Maori religion was due to "a full course in Tahitian theology" given him by his 13-year-old mistress Teha'amana, he is involved in a double denial; his avoidance of the fact that his own relation to the Maori religion was extremely tenuous, merely the product of a text he had just appropriated, and his refusal to acknowledge that Teha'amana, like most other Tahitians, *had* no relation to her former traditions.

I will return to this paradigmatic plagiarism shortly, but first I want to say a few more words about what we might call Teha'amana's structural use value for the Gauguin myth. Certainly, and at the risk of stating the obvious, it is clear that Teha'amana's function as Gauguin's fictive conduit to the ancient mythologies is entirely overdetermined. No less overdetermined is the grotesque afterlife of Gauguin's successive *vahines* in the modern art-historical literature. Conscientiously "named," their various tenures with Gauguin methodically charted, their "qualities" and attributes reconstituted on the "evidence" of his paintings and writing, their pregnancies or abortions methodically deduced, what is at work is an undiminished investment in the mythos of what could be termed primitivist reciprocity. This is a form of mythic speech that Gauguin produces effortlessly in the form of the idyll or pastorale, as in the following passage from *Noa Noa*:

> I started to work again and my house was an abode of happiness. In the morning, when the sun rose the house was filled with radiance. Teha'amana's face shone like gold, tinging everything with its luster, and the two of us would go out and refresh ourselves in the nearby stream as simply and naturally as in the Garden of Eden, *fenua nave nave*. As time passed, Teha'amana grew ever more compliant and affectionate in our day to day life. Tahitian *noa noa* imbued me absolutely. The hours and the days slipped by unnoticed. I no longer saw any difference between good and evil. All was beautiful and wonderful.[21]

The lyricism of Gauguin's own idealized description of life in Tahiti with its piquant allusions to the breaking of bourgeois norms and strictures – most spectacularly in the vision of a 50-year-old man frolicking with his 13-year-old

mistress – is one of the linchpins of the Gauguin myth. All the more necessary to instate less edifying perspectives on Eden, as in Gauguin's 1897 letter to Armand Seguin:

> Just to sit here at the open door, smoking a cigarette and drinking a glass of absinthe, is an unmixed pleasure which I have every day. And then I have a 15-year-old wife [this was one of Teha'amana's successors] who cooks my simple every-day fare and gets down on her back for me whenever I want, all for the modest reward of a frock, worth ten francs a month.[22]

Such oppositions give some notion of the rich range of material available to the Gauguin demythologizer. More pointedly still, they call attention to one of the particularly revealing aspects of what I may as well now call Gauguinism, namely, the continuing desire to both naturalize and make "innocent" the artist's sexual relations with very young girls, as symptomatically expressed in Rene Huyghe's parenthetical assurance in his essay on Gauguin's *Ancien culte mahorie* that the 13-year-old Tahitian girl is "equivalent to 18 or 20 years in Europe."[23]

Huyghe's anodyne assurance that the female Maori body is *different* from its Western counterpart is paradoxically motivated by the desire to normalize a sexual relationship which in Europe would be considered criminal, let alone immoral. But the paradox is fundamental, for what is at stake in the erotics of primitivism is the impulse to domesticate, as well as possess. "The *body* of strangeness must not disappear," writes Hélène Cixous in *La Jeune Née*, "but its strength must be tamed, it must be returned to the master."[24] In this respect, the image of the savage and the image of the woman can be seen as similarly structured, not only within Gauguin's work, but as a characteristic feature in the project of representing the Other's body, be it the woman's or the native's. Both impulses can be recognized in Gauguin's representational practice.

In the Polynesian pictures as in the Breton work, images of men are singularly rare. Frequently, and in conformity with the already-represented status of the Maori, they are feminized. Nothing suggests that there is anything behind the men's pareros, while Gaugin is one of the first European artists to depict his female nudes with pubic hair. In this regard it is interesting to note that Gauguin's supine nude Breton boy (male nudes appear only in the Breton period) has had his penis strangely elided. But while there is nothing quite comparable to this odd avoidance of masculine genitalia in his images of women, and although they are figured with all the conventional tropes of "natural" femininity – fruits with breasts, flowers and feathers with sex organs – there is nonetheless something in their wooden stolidity, their massive languor, their zombielike presence that belies the fantasy they are summoned to represent.

What lies behind these ciphers of femininity? By way of approaching this question, I want to reintroduce the issue of Gauguin's plagiarisms. For the scandal of the appropriation of Moerenhout may be seen to have broader implications. Copied

for use in *L'Ancien culte mahorie*, it resurfaces in the later *Noa Noa*. Parts of the same text reappear in *Avant et après*. A paragraph from the French colonial office pamphlet touting Tahiti for colonial settlement appears in a letter to Mette Gauguin.

In addition to the appropriation of others' texts, Gauguin tends to constantly recycle his own. Bits and pieces of *The Modern Spirit and Catholicism* surface in letters and articles. In his personal dealings with artists during his years in France, there is another kind of appropriation: Emile Bernard, for example, claimed that Gauguin had in effect "stolen" his Synthetism, and there is no question that Bernard's work comprised a far more developed and theorized Symbolism when the two artists first became friends in Brittany. From 1881 through the '90s, one can readily identify a Pissarroesque Gauguin, a van Goghian Gauguin, a Bernardian Gauguin, a Cézannian Gauguin, a Redonian Gauguin, a Degasian Gauguin and, most enduringly and prevalently, a Puvisian Gauguin. And as for what is called in art history "sources," Gauguin's oeuvre provides a veritable lexicon of copies, quotations, borrowings and reiterations.

Drawing upon his substantial collection of photographs, engraved reproductions, illustrated books and magazines and other visual references, Gauguin, once he jettisoned Impressionism, drew far more from art than from life. Consider, for example, Gauguin's repeated use of the temple reliefs from Borobudur and wall paintings from Thebes. His borrowings from the Trocadero collections, and from the tribal artifacts displayed at the Universal Exhibition, are obvious. In certain cases, he worked directly from photographs to depict Maori sculptures that he never saw; photographs were often the source of individual figures as well. The Easter Island inscription from the Universal Exhibition appears in *Merahi Metue no Tehamana*. Manet's *Olympia* and Cranach's *Diana* are reworked as *Te arii vahine*. A double portrait of two Tahitian women comes directly from a photograph. Certain of Gauguin's ceramic objects are modeled on Mochican pottery. Woodcuts by Hiroshige provide the motif for a Breton seascape.

For some of Gauguin's contemporaries, this bricolage was the very essence of what they understood to be Gauguin's brand of Symbolism, as in Octave Mirbeau's description of Gauguin's "unsettling and savory mingling of barbarian splendor, Catholic liturgy, Hindu meditation, Gothic imagery and obscure and subtle symbolism."[25] For less sympathetic observers, such as Pissarro, "All in all . . . it was the art of a sailor, picked up here and there."[26]

All of which suggests that in Gauguin's art the representation of the feminine, the representation of the primitive, and the reciprocal collapse of one into the other, has its analogue in the very process of his artistic production. For what is at issue is less an invention than a reprocessing of already constituted signs. The life of Gauguin, the art of Gauguin, the myth of Gauguin – approached from any side we confront a Borgesian labyrinth of pure textuality. Feminine and primitive, Breton and Maori, are themselves representable only to the extent that they exist as already-written texts, which yet continue to be written. "When myth becomes form," cautioned Barthes, "the meaning leaves its contingency behind, it empties

itself, it becomes impoverished, history evaporates, only the letter remains."[27] In contrast to the recent and elaborate rehabilitation of the primitivizing impulse, Pissarro, closer to the history that the Gauguin myth occludes, always retained his clarity of judgment: "Gauguin," he wrote, "is always poaching on someone's land; nowadays, he's pillaging the savages of Oceania."[28]

Notes

1 By profession a doctor in the French navy, and by avocation a diarist and writer, Victor Segalen (1878–1919) was an influential producer of toney literary exotica. His first naval tour of duty was in Oceania, and he arrived in Tahiti a few months after Gauguin's death. Subsequently, he purchased many of Gauguin's effects, including manuscripts, art works, photographs, albums, etc. Segalen's essays on Gauguin are anthologized in the posthumous collection *Gauguin dans son dernier décor et autres textes de Tahiti*, Paris, 1975. Upon Segalen's return to France, he wrote his novel *Les Immemoriaux* (1905–6), an imaginary reconstruction of Maori life which he characterized as attempting "to describe the Tahitian people in a fashion equivalent to the way Gauguin saw them." Subsequently, Segalen was posted to China for four years (1909–13), a sojourn that resulted in the novel *Rene Leys*, as well as two collections of essays, *Steles* and *Briques et Tuiles*. His *Essai sur l'exoticisme*, published posthumously, is a meditation on the nature of [Western] exoticism – a desire for the Other.

2 Cited in John Rewald, *Gauguin*, NY, 1938, p. 11.

3 Fred Orton and Griselda Pollock, "Les Données Bretonnantes: La Prairie de la Representation," *Art History*, Sept. 1980, pp. 314, 329.

4 *Camille Pissarro: Letters to His Son Lucien*, ed. John Rewald, New York, 1943, p. 171.

5 Cited in Robert Goldwater, *Primitivism in Modern Painting*, New York, 1938, p. 60.

6 Claire Frèches-Thory, "Gauguin et la Bretagne 1886–1890," *Gauguin* (exhibition catalogue), Paris, Galeries nationels du Grand Palais, 1989, p. 85.

7 Wayne Anderson, *Gauguin's Paradise Lost*, New York, 1971, p. 33.

8 Examples are legion, but Wayne Anderson's book, cited above, is one of the worst offenders. Its central thesis is that Gauguin's work is unified around the theme of the woman's life cycle, wherein the crucial event is the loss of virginity, which, as Anderson has it, may be understood as homologous to the Crucifixion of Christ. Not surprisingly, this theory promotes a fairly delirious level of formal and iconographical analysis.

9 Henri Dorra, "The First Eves in Gauguin's Eden," *Gazette des Beaux Arts*, Mar. 1953, pp. 189–98, p. 197.

10 Vŏjtech Jirat-Wasiutynski, "Paul Gauguin's Self-Portraits and the Oviri: The Image of the Artist, Eve, and the Fatal Woman," *The Art Quarterly*, Spring 1979, pp. 172–90, p. 176.

11 *Lettres de Gauguin à sa femme et ses amis*, ed. Maurice Malingue, Paris, 1946, p. 184.

12 Christopher L. Miller, *Blank Darkness: Africanist Discourse in French*, Chicago, 1985, p. 28.

13 Victor Segalen, "Homage à Gauguin," *Gauguin dans son dernier décor*, p. 99 [my translation].

14 C. Skogman, *The Frigate Eugenie's Voyage Around the World*, cited in Bengt Danielsson, *Love in the South Seas*, London, 1954, p. 81.

15 Cited in Christopher Gray, *Sculpture and Ceramics of Paul Gauguin*, Baltimore, 1967, p. 52.

16 Paul Gauguin, *Noa Noa*, ed. and intro. Nicholas Wadley, trans. Jonathan Griffin, London, 1972, p. 23. There are a number of editions of *Noa Noa* in keeping with its complicated production and publication history. Originally planned by Gauguin as a collaboration between himself and Charles Morice, he later declared himself dissatisfied with the literary improvements and narrative reorganization that Morice had imposed. At least three different versions are in print, not counting translations.

17 Bengt Danielsson, *Gauguin in the South Seas*, London, 1965, p. 78.

18 James Clifford, "Histories of the Tribal and the Modern," *Art in America*, April 1985, pp. 164–72, p. 178.

19 See in this regard, Bengt Danielsson, "Les titres Tahitiens de Gauguin," *Bulletin de la Société des Études Oceaniennes*, Papeete, nos. 160–1, Sept.–Dec. 1967, pp. 738–43.

20 See Rene Huyghe, "Le clef de Noa Noa," in Paul Gauguin, *Ancien culte mahorie*, Paris, 1951. Gauguin's spelling of *mahorie* is incorrect in any language.

21 Gauguin, *Noa Noa*, p. 37.

22 Letter to Armand Séguin, Jan. 15, 1897. Cited in Danielsson, *Gauguin in the South seas*, p. 191.

23 Huyghe, "La clef de Noa Noa," p. 4.

24 Cited in Josette Féral, "The Powers of Difference," in *The Future of Difference*, eds. Hester Eisenstein and Alice Jardine, NJ, 1980, p. 89.

25 Octave Mirbeau, "Paul Gauguin," *L'Echo de Paris*, Feb. 16, 1891. Reprinted in Mirbeau, *Des artistes*, Paris, 1922, pp. 119–29.

26 *Camille Pissarro*, p. 172.

27 Roland Barthes, "Myth Today," *Mythologies*, ed. and trans. Annette Lavers, New York, 1978, p. 139.

28 *Camille Pissarro*, p. 221.

27

Virility and Domination in Early Twentieth-Century Vanguard Painting

Carol Duncan

In the decade before World War I, a number of European artists began painting pictures with a similar and distinctive content. In both imagery and style, these paintings forcefully assert the virile, vigorous and uninhibited sexual appetite of the artist. I am referring to the hundreds of pictures of nudes and women produced by the Fauves, Cubists, German Expressionists and other vanguard artists. As we shall see, these paintings often portray women as powerless, sexually subjugated beings. By portraying them thus, the artist makes visible his own claim as a sexually dominating presence, even if he himself does not appear in the picture.

This concern with virility – the need to assert it in one's art – is hardly unique to artists of this period. Much of what I am going to say here is equally relevant to later twentieth-century as well as some nineteenth-century art.[1] But the assertion of virility and sexual domination appears with such force and frequency in the decade before World War I, and colors the work of so many different artists, that we must look there first to understand it. It is also relevant to ask whether these artists sought or achieved such relationships in reality, whether their lives contradict or accord with the claims of their art. But that is not the question I am asking here. My concern is with the nature and implications of those claims as they appear in the art and as they entered the mythology of vanguard culture. In this I am treating the artists in question not as unique individuals, but as men whose inner needs and desires were rooted in a shared historical experience – even if the language in which they expressed themselves was understood by only a handful of their contemporaries.

Carol Duncan, "Virility and Domination in Twentieth-Century Vanguard Painting." First published in *Artforum* (Dec. 1973), pp. 30–9; the version reprinted here was later revised and reprinted in Norma Broude and Mary Garrard (eds.), *Feminism and Art History: Questioning the Litany.* New York: Harper and Row, 1982. Reprinted by permission of Carol Duncan.

The material I explore inevitably touches on a larger issue – the role of avant-garde culture in our society. Avant-garde art has become the official art of our time. It occupies this place because, like any official art, it is ideologically useful. But to be so used, its meaning must be constantly and carefully mediated. That task is the specialty of art historians, who explain, defend and promote its value. The exhibitions, courses, articles, films and books produced by art historians not only keep vanguard art in view, they also limit and construct our experience of it.

In ever new ways, art history consistently stresses certain of its qualities. One idea in particular is always emphasized: that avant-garde art consists of so many moments of individual artistic freedom, a freedom evidenced in the artist's capacity for innovation. Accounts of modern art history are often exclusively, even obsessively, concerned with documenting and explicating evidence of innovation – the formal inventiveness of this or that work, the uniqueness of its iconography, its distinctive use of symbols or unconventional materials. The presence of innovation makes a work ideologically useful because it demonstrates the artist's individual freedom as an artist; and *that* freedom implies and comes to stand for human freedom in general. By celebrating artistic freedom, our cultural institutions "prove" that ours is a society in which all freedom is cherished and protected, since, in our society, all freedom is conceived as individual freedom. Thus vanguard paintings, as celebrated instances of freedom, function as icons of individualism, objects that silently turn the abstractions of liberal ideology into visible and concrete experience.

Early vanguard paintings, including many of the works I shall discuss, are especially revered as icons of this kind. According to all accounts, the decade before World War I was the heroic age of avant-garde art. In that period, the "old masters" of modernism – Picasso, Matisse, the Expressionists – created a new language and a new set of possibilities that became the foundation for all that is vital in later twentieth-century art. Accordingly, art history regards these first examples of vanguardism as preeminent emblems of freedom.

The essay that follows looks critically at this myth of the avant garde. In examining early vanguard painting, I shall be looking not for evidence of innovation (although there is plenty of that), but rather for what these works say about the social relations between the sexes. Once we raise this question – and it is a question that takes us outside the constructs of official art history – a most striking aspect of the avant garde immediately becomes visible: however innovative, the art produced by many of its early heroes hardly preaches freedom, at least not the universal human freedom it has come to symbolize. Nor are the values projected there necessarily "ours," let alone our highest. The paintings I shall look at speak not of universal aspirations but of the fantasies and fears of middle-class men living in a changing world. Because we are heirs to that world, because we still live its troubled social relations, the task of looking critically, not only at vanguard art but also at the mechanisms that mystify it, remains urgent.

I

Already in the late nineteenth century, European high culture was disposed to regard the male-female relationship as the central problem of human existence. The art and literature of the time is marked by an extraordinary preoccupation with the character of love and the nature of sexual desire. But while a progressive literature and theater gave expression to feminist voices, vanguard painting continued to be largely a male preserve. In Symbolist art, men alone proclaimed their deepest desires, thoughts and fears about the opposite sex. In the painting of Moreau, Gauguin, Munch and other end-of-the-century artists, the human predicament – what for Ibsen was a man–woman problem – was defined exclusively as a male predicament, the woman problem. As such, it was for men alone to resolve, transcend or cope with. Already there was an understanding that serious and profound art – and not simply erotic art – is likely to be about what men think of women.

Symbolist artists usually portrayed not women but one or two universal types of woman.[2] These types are often lethal to man. They are always more driven by instincts and closer to nature than man, more subject to its mysterious forces. They are often possessed by dark or enigmatic souls. They usually act out one or another archetypal myth – Eve, Salomé, the Sphinx, the Madonna.

Young artists in the next avant-garde generation – those maturing around 1905 – began rejecting these archetypes just as they dropped the muted colors, the langorous rhythms and the self-searching artist-types that Symbolism implied. The Symbolist artist, as he appears through his art, was a creature of dreams and barely perceptible intuitions, a refined, hypersensitive receiver of tiny sensations and cosmic vibrations. The new vanguardists, especially the Fauves and the Brücke, were youth and health cultists who liked noisy colors and wanted to paint their direct experience of mountains, flags, sunshine and naked girls. Above all, they wanted their art to communicate the immediacy of their own vivid feelings and sensations before the things of this world. In almost every detail, their images of nudes sharply contrast to the virgins and vampires of the 1890s. Yet these younger artists shared certain assumptions with the previous generation. They, too, believed that authentic art speaks of the central problems of existence, and they, too, defined Life in terms of a male situation – specifically the situation of the middle-class male struggling against the strictures of modern, bourgeois society.

Kirchner was the leader and most renowned member of the original Brücke, the group of young German artists who worked and exhibited together in Dresden and then Berlin between 1905 and 1913. His *Girl Under a Japanese Umbrella* (ca. 1909) asserts the artistic and sexual ideals of this generation with characteristic boldness. The artist seems to attack his subject, a naked woman, with barely controlled energy. His painterly gestures are large, spontaneous,

sometimes vehement, and his colors intense, raw and strident. These features proclaim his unhesitant and uninhibited response to sexual and sensual experience. Leaning directly over his model, the artist fastens his attention mainly to her head, breasts and buttocks, the latter violently twisted toward him. The garish tints of the face, suggesting both primitive body paint and modern cosmetics, are repeated and magnified in the colorful burst of the exotic Japanese umbrella. Above the model is another Brücke painting, or perhaps a primitive or Oriental work, in which crude shapes dance on a jungle-green ground.

Van Dongen's *Reclining Nude* (1905–6), a Fauve work, is similar in content. Here, too, the artist reduces a woman to so much animal flesh, a headless body whose extremities trail off into ill-defined hands and feet. And here, too, the image reflects the no-nonsense sexuality of the artist. The artist's eye is a hyper-male lens that ruthlessly filters out everything irrelevant to the most basic genital urge. A lustful brush swiftly shapes the volume of a thigh, the mass of the belly, the fall of a breast.

Such images are almost exact inversions of the *femmes fatales* of the previous generation. Those vampires of the 1890s loom up over their male victims or viewers, fixing them with hypnotic stares. In Munch's paintings and prints, females engulf males with their steaming robes and hair. The male, whether depicted or simply understood as the viewer-artist, is passive, helpless or fearful before this irresistibly seductive force which threatens to absorb his very will. Now, in these nudes by Kirchner and Van Dongen, the artist reverses the relationship and stands above the supine woman. Reduced to flesh, she is sprawled powerlessly before him, her body contorted according to the dictates of his erotic will. Instead of the consuming *femme fatale*, one sees an obedient animal. The artist, in asserting his own sexual will, has annihilated all that is human in his opponent. In doing so, he also limits his own possibilities. Like conquered animals, these women seem incapable of recognizing in him anything beyond a sexually demanding and controlling presence. The assertion of that presence – the assertion of the artist's sexual domination – is in large part what these paintings are about.

In the new century, even Munch felt the need to see himself thus reflected. His *Reclining Nude*, a watercolor of 1905, is a remarkable reversal of his earlier *femmes fatales*. Both literally and symbolically, Munch has laid low those powerful spirits along with the anxieties they created in him. This nude, her head buried in her arms, lies at his disposal, while he explores and translates into free, unrestrained touches the impact of thighs, belly and breasts on his senses and feelings.

Most images of female nudity imply the presence (in the artist and/or the viewer) of a male sexual appetite. What distinguishes these pictures and others in this period from most previous nudes is the compulsion with which women are reduced to objects of pure flesh, and the lengths to which the artist goes in denying their humanity. Not all nudes from this decade are as brutal as Van Dongen's, but the same dehumanizing approach is affirmed again and again. Nudes by Braque, Manguin, Puy and other Fauves are among scores of such

images. They also occur in the work of such artists as Jules Pascin, the Belgian Realist Rik Wouters and the Swiss Félix Vallotton (*The Sleep*, 1908). *Nude in a Hammock* (1912), by Othon Friesz, is a Cubistic version of this same basic type of sleeping or faceless nude. So is Picasso's more formalistically radical *Woman in an Armchair* (1913), where all the wit and virtuoso manipulation of form are lavished only upon the body, its literally hanging breasts, the suggestive folds of its underwear, etc. Indeed, Picasso's Cubist paintings maintain the same distinction between men and women as other artists of this decade did – only more relentlessly; many of these other artists painted portraits of women as authentic people in addition to nudes. Max Kozloff observed the striking difference between Picasso's depictions of men and women in the Cubist period:

> The import of *Girl With a Mandolin* perhaps becomes clearer if it is compared with such contemporary male subjects as Picasso's *Portrait of Ambroise Vollard*. The artist hardly ever creates the image of a woman as portrait during this period. He reserved the mode almost entirely for men. . . . In other words, a woman can be typed, shown as a nude body or abstracted almost out of recognition, as in *Ma Jolie*, where the gender of the subject plays hardly any role, but she is not accorded the particularity and, it should be added, the dignity of one-to-one, formalized contact furnished by a portrait. More significant is the fact that Vollard is presented as an individual of phenomenal power and massive, ennobled presence, while the female type often gangles like a simian, is cantilevered uncomfortably in space, or is given bowed appendages.[3]

The artistic output of the Brücke abounded in images of powerless women. In Heckel's *Nude on a Sofa* (1909) and his *Crystal Day* (1913), women exist only in reference to – or rather, as witnesses to – the artist's frank sexual interests. In one, the woman is sprawled in a disheveled setting; in the other, she is knee-deep in water – in the passive, arms-up, exhibitionist pose that occurs so frequently in the art of this period. The nude in *Crystal Day* is literally without features (although her nipples are meticulously detailed), while the figure in the other work covers her face, a combination of bodily self-offering and spiritual self-defacement that characterizes these male assertions of sexual power. In Kirchner's *Tower Room, Self-Portrait with Erna* (1913), another faceless nude stands obediently before the artist, whose intense desire may be read in the erect and flaming object before him. In a less strident voice, Manguin's *Nude* (1905) makes the same point. In the mirror behind the bed, the nude is visible a second time, and now one sees the tall, commanding figure of the artist standing above her.

The artists of this decade were obsessed with such confrontations. In a curious woodcut, published as *The Brothel* (ca. 1906), the French Fauve Vlaminck played with the tension inherent in that confrontation. What activates the three women in this print is not clear, but the central nude raises her arms in ambiguous gesture, suggesting both protest and self-defense. In either case, the movement is well contained in the upper portion of the print and does not prevent the artist from freely seizing the proffered, voluptuous body. Evidently, he has enjoyed the struggle and purposely leaves traces of it in the final image.

Matisse's painting of these years revolves around this kind of contest almost exclusively, exploring its tensions and seeking its resolution. Rarely does he indulge in the open, sexual boasting of these other artists. Matisse is more *galant*, more bourgeois. A look, an expression, a hint of personality often mitigate the insistent fact of passive, available flesh. In the nice, funny face of *The Gypsy* (1905–6), one senses some human involvement on the part of the artist, even as he bent the lines of the model's face to rhyme with the shape of her breasts. Matisse is also more willing to admit his own intimidation before the nude. In *Carmelina* (1903), a powerfully built model coolly stares him down – or, rather, into – a small corner of the mirror behind her. The image in that mirror, the little Matisse beneath the awesome Carmelina, makes none of the overt sexual claims of Manguin's *Nude* or Kirchner's *Tower Room*. But the artful Matisse has more subtle weapons. From his corner of the mirror, he blazes forth in brilliant red – the only red in this somber composition – fully alert and at the controls. The artist, if not the man, masters the situation – and also Carmelina, whose dominant role as a *femme fatale* is reversed by the mirror image. Nor is the assertion of virility direct and open in other paintings by Matisse, where the models sleep or lack faces. Extreme reductions and distortions of form and color, all highly deliberated, self-evident "aesthetic" choices, transpose the sexual conflict onto the "higher" plane of art. Again, the assertion of virility becomes sublimated, metamorphosed into a demonstration of artistic control, and all evidence of aggression is obliterated. As he wrote in "Notes of a Painter" (1908), "I try to put serenity into my pictures. . . . "[4]

The vogue for virility in early twentieth-century art is but one aspect of a total social, cultural and economic situation that women artists had to overcome. It was, however, a particularly pernicious aspect. As an ethos communicated in a hundred insidious ways, but never overtly, it effectively alienated women from the collective, mutually supportive endeavor that was the avant garde. (Gertrude Stein, independently wealthy and, as a lesbian, sexually unavailable to men, is the grand exception.) Like most of their male counterparts, women artists came primarily from the middle classes. It is hardly conceivable that they would flaunt a desire for purely physical sex, even in private and even if they were capable of thinking it. To do so would result in social suicide and would require breaking deeply internalized taboos. In any case, it was not sexuality per se that was valued, but male sexuality. The problem for women – and the main thrust of women's emancipation – was not to invert the existing social-sexual order, not to replace it with the domination of women; the new woman was struggling for her own autonomy as a psychological, social and political being. Her problem was also the woman problem. Her task was also to master her own image.

Accordingly, the German artist Paula Modersohn-Becker confronted female nudity – her own – in a *Self-Portrait* of 1906. Fashioned out of the same Post-Impressionist heritage as Brücke art and Fauvism, this picture is startling to see next to the defaced beings her fellow artists so often devised. Above the naked female flesh are the detailed features of a powerful and determined human being.

Rare is the image of a naked woman whose head so outweighs her body. Rare, that is, in male art. Suzanne Valadon, Sonia Delaunay-Terk and other women of this period often painted fully human female beings, young and old, naked and clothed. Among male artists, only Manet in the *Olympia* comes close. But there the image-viewer relationship is socially specified. Olympia is literally flesh for sale, and in that context, her self-assertiveness appears willful and brash – a contradiction to the usual modesty of the nude. As a comment on bourgeois male–female relationships, the *Olympia* is both subversive and antisexist; it is, however, consciously posed as male experience and aimed, with deadly accuracy, at the smug and sexist male bourgeoisie. Modersohn-Becker, on the other hand, is addressing herself, not as commodity and not even as an artist but as a woman. Her effort is to resolve the contradiction Manet so brilliantly posed, to put herself back together as a fully conscious and fully sexual human being. To attempt this, with grace and strength to boot, speaks of profound humanism and conviction, even while the generalized treatment of the body and its constrained, hesitant gestures admit the difficulty.

II

Earlier, I suggested that the powerless, defaced nude of the twentieth century is an inversion of the Symbolist *femme fatale*. Beneath this apparent opposition, however, is the same supporting structure of thought.[5] In the new imagery, woman is still treated as a universal type, and this type, like the Sphinxes and Eves of the previous generation, is depicted as a being essentially different from man. In the eyes of both generations of artists, woman's mode of existence – her relationship to nature and to culture – is categorically different from man's. More dominated by the processes of human reproduction than men, and, by situation, more involved in nurturing tasks, she appears to be more *of nature* than man, less in opposition to it both physically and mentally. As the anthropologist Sherry Ortner has argued, men see themselves more closely identified with culture, "the means by which humanity transcends the givens of natural existence, bends them to its purposes, controls them in its interests." Man/culture tends to be one term in a dichotomy of which woman/nature is the other: "Even if woman is not equated with nature, she is still seen as representing a lower order of being, less transcendental of nature than men."[6]

However different from the Symbolists, these younger artists continued to regard confrontations with women as real or symbolic confrontations with nature. Not surprisingly, the nude-in-nature theme, so important to nineteenth-century artists, continued to haunt them. And like the older artists, they, too, imagined women as more at home there than men. Placid, naked women appear as natural features of the landscape in such works as Heckel's *Crystal*

Day, Friesz's *Nude in a Hammock* and numerous bathers by Vlaminck, Derain, Mueller, Pechstein and other artists. The bacchante or the possessed, frenzied dancer is the active variant of the bather and frequently appears in the art of this period. Nolde's *Dancers with Candles* (1912) and Derain's *The Dance* (ca. 1905) equally represent women as a race apart from men, controlled by nature rather than in control of it.

Myths cultivated by artists would seem to contradict this dichotomy. Since the nineteenth century, it was fashionable for male artists to claim a unique capacity to respond to the realm of nature. But while they claimed for themselves a special intuition or imagination, a "feminine principle," as they often called it, they could not recognize in women a "masculine principle." The pictures of women produced in this epoch affirm this difference as much as Symbolist art. Women are depicted with none of the sense of self, none of the transcendent, spiritual autonomy that the men themselves experienced (and that Modersohn-Becker so insisted upon). The headless, faceless nudes, the dreamy looks of Gauguin's girls, the glaring mask of Kirchner's *Girl Under a Japanese Umbrella*, the somnambulism of the *femmes fatales* – all of these equally deny the presence of a human consciousness that knows itself as separate from and opposed to the natural and biological world.

The dichotomy that identifies women with nature and men with culture is one of the most ancient ideas ever devised by men and appears with greater or lesser strength in virtually all cultures. However, beginning in the eighteenth century, Western bourgeois culture increasingly recognized the real and important role of women in domestic, economic and social life. While the basic sexual dichotomy was maintained and people still insisted on the difference between male and female spheres, women's greater participation in culture was acknowledged. In the nineteenth century the bourgeoisie educated their daughters more than ever before, depended on their social and economic cooperation and valued their human companionship.

What is striking – and for modern Western culture unusual – about so many nineteenth- and twentieth-century vanguard nudes is the absoluteness with which women were pushed back to the extremity of the nature side of the dichotomy, and the insistence with which they were ranked in total opposition to all that is civilized and human. In this light, the attachment of vanguard artists to classical and biblical themes and their quest for folk and ethnographic material takes on special meaning. These ancient and primitive cultural materials enabled them to reassert the woman/nature–man/culture dichotomy in its harshest forms. In Eve, Salomé, the Orpheus myth and the primitive dancer, they found Woman as they wanted to see her – an alien, amoral creature of passion and instinct, an antagonist to rather than a builder of human culture. The vanguard protested modern bourgeois male–female relationships; but that protest, as it was expressed in these themes, must be recognized as culturally regressive and historically reactionary. The point needs to be emphasized only because we are told so often that vanguard tradition embodies our most progressive, liberal ideals.

The two generations of artists also shared a deep ambivalence toward the realm of woman/nature. The Symbolists were at once attracted to and repelled by its claims on them. Munch's art of the nineties is in large part a protest against this male predicament. From his island of consciousness, he surveys the surrounding world of woman/nature with both dread and desire. In paintings by Gauguin, Hodler and Klimt (especially his "Life and Death" series), woman's closeness to nature, her effortless biological cooperation with it, is enviable and inviting. She beckons one to enter a poetic, nonrational mode of experience – that side of life that advanced bourgeois civilization suppresses. Yet, while the realm of woman is valued, it is valued *as* an alien experience. The artist contemplates it, but prefers to remain outside, with all the consciousness of the outside world. For to enter it fully means not only loss of social identity, but also loss of autonomy and of the power to control one's world.

The same ambivalence marks the twentieth-century work I have been discussing, especially the many paintings of nudes in nature. In these images, too, the realm of woman/nature invites the male to escape rationalized experience and to know the world through his senses, instincts or imagination. Yet here, too, while the painter contemplates his own excited feelings, he hesitates to enter that woman/nature realm of unconscious flesh, to imagine himself *there*. He prefers to know his instincts through the objects of his desire. Rarely do these artists depict naked men in nature. When they do, they are almost never inactive. To be sure, there are some naked, idle males in Kirchner's bathing scenes, but they are clearly uncomfortable and self-conscious-looking. More commonly, figures of men in nature are clothed, both literally and metaphorically, with social identities and cultural projects. They are shepherds, hunters, artists. Even in Fauve or Brücke bathing scenes where naked males appear, they are modern men going swimming. Unlike the female bather, they actively engage in culturally defined recreation, located in historical time and space. Nowhere do these men enter nature – and leave culture – on the same terms as women. Now as in the 1890s, to enter that world naked and inactive is to sink into a state of female powerlessness and anonymity.

Matisse's *Joy of Life* (*Bonheur de vivre*) of 1905–6 seems to be an exception. In this sun-drenched fantasy, all the figures relate to nature, to each other and to their own bodies in harmony and freedom. No one bends to a force outside oneself. Yet, even in this Arcadia, Matisse hesitates to admit men. Except for the shepherd, all the figures with visible sexual characteristics are women. Maleness is suggested rather than explicitly stated. Nor is the woman/nature–man/culture dichotomy absent: culturally defined activities (music-making and animal husbandry) are male endeavors, while women simply exist as sensual beings or abandon themselves to spontaneous and artless self-expression.

No painting of this decade better articulates the male–female dichotomy and the ambivalence men experience before it than Picasso's *Demoiselles d'Avignon* of 1906–07. What is so remarkable about this work is the way it manifests the

structural foundation underlying both the *femme fatale* and the new, primitive woman. Picasso did not merely combine these into one horrible image; he dredged up from his psyche the terrifying and fascinating beast that gave birth to both of them. The *Demoiselles* prismatically mirrors her many opposing faces: whore and deity, decadent and savage, tempting and repelling, awesome and obscene, looming and crouching, masked and naked, threatening and powerless. In that jungle-brothel is womankind in all her past and present metamorphoses, concealing and revealing herself before the male. With sham and real reverence, Picasso presents her in the form of a desecrated icon already slashed and torn to bits.

If the *Demoiselles* is haunted by the nudes of Ingres, Delacroix, Cézanne and others,[7] it is because they, too, proceed from this Goddess-beast and because Picasso used them as beacons by which to excavate its root form. The quotations from ancient and non-Western art serve the same purpose. The *Demoiselles* pursues and recapitulates the Western European history of the woman/nature phantom back to her historical and primal sisters in Egypt, ancient Europe and Africa in order to reveal their oneness. Only in primitive art is woman as sub- and superhuman as this.[8] Many later works by Picasso, Miró or de Kooning would recall this primal mother-whore. But no other modern work reveals more of the rock foundation of sexist antihumanism or goes further and deeper to justify and celebrate the domination of woman by man.

Although few of Picasso's vanguard contemporaries could bear the full impact of the *Demoiselles* (Picasso himself would never again go quite as far), they upheld its essential meaning. They, too, advocated the otherness of woman, and asserted with all their artistic might the old idea that culture in its highest sense is an inherently male endeavor. Moreover, with Picasso, they perpetuated it in a distinctly modern form, refining and distilling it to a pure essence: from this decade dates the notion that the wellsprings of authentic art are fed by the streams of male libidinous energy. Certainly artists and critics did not consciously expound this idea. But there was no need to argue an assumption so deeply felt, so little questioned and so frequently demonstrated in art. I refer not merely to the assumption that erotic art is oriented to the male sexual appetite, but to the expectation that significant and vital content in *all* art presupposes the presence of male erotic energy.

The nudes of the period announce it with the most directness; but landscapes and other subjects might confirm it as well, especially when the artist invokes aggressive and bold feeling, when he "seizes" his subject with decisiveness, or demonstrates other supposedly masculine qualities. Vlaminck, although primarily a landscape painter, could still identify his paintbrush with his penis: "I try to paint with my heart and my loins, not bothering with style."[9] But the celebration of male sexual drives was more forcefully expressed in images of women. More than any other theme, the nude could demonstrate that art originates in and is sustained by male erotic energy. This is why so many "seminal" works of the period are nudes. When an artist had some new or major artistic statement to

make, when he wanted to authenticate to himself or others his identity as an artist, or when he wanted to get back to "basics," he turned to the nude. The presence of small nude figures in so many landscapes and studio interiors – settings that might seem sufficient in themselves for a painting – also attests to the primal erotic motive of the artist's creative urge.

Kirchner's *Naked Girl Behind a Curtain* (dated 1907) makes just this connection with its juxtaposition of a nude, a work of primitive art and what appears to be a modern Brücke painting. The *Demoiselles,* with its many references to art of varied cultures, states the thesis with even more documentation. And, from the civilized walls of Matisse's *Red Studio* (1911) comes the same idea, now softly whispered. There, eight of the eleven recognizable art objects represent female nudes. These literally surround another canvas, *The Young Sailor* (1906), as tough and "male" a character as Matisse ever painted. Next to the *Sailor* and forming the vertical axis of the painting is a tall, phallic grandfather clock. The same configuration – a macho male surrounded by a group of nude women – also appears in the preparatory drawings for the *Demoiselles,* where a fully clothed sailor is encircled by a group of posing and posturing nudes. Picasso eventually deleted him but retained his red drinking vessel (on the foreground table) and made its erect spout a pivotal point in the composition.[10] Another phallocentric composition is Kirchner's much-reproduced *Self-Portrait with Model* (1910). In the center, Kirchner himself brandishes a large, thick, red-tipped paintbrush at groin level, while behind him cringes a girl wearing only lingerie.

That such content – the linking of art and male sexuality – should appear in painting at precisely the moment when Freud was developing its theoretical and scientific base indicates not the source of these ideas but the common ground from which both artist and scientist sprang. By justifying scientifically the source of creativity in male sexuality,[11] Freud acted in concert with young, avant-garde artists, giving new ideological shape and force to traditional sexist biases. The reason for this cross-cultural cooperation is not difficult to find. The same era that produced Freud, Picasso and D. H. Lawrence – the era that took Nietzsche's superman to heart – was also defending itself from the first significant feminist challenge in history (the suffragist movement was then at its height). Never before had technological and social conditions been so favorable to the idea of extending democratic and liberal-humanistic ideals to women. Never before were so many women and men declaring the female sex to be the human equals of men, culturally, politically and individually. The intensified and often desperate reassertions of male cultural supremacy that permeate so much early twentieth-century culture, as illustrated in the vanguard's cult of the penis, are both responses to and attempts to deny the new possibilities history was unfolding. They were born in the midst of this critical moment of male–female history, and as such, gave voice to one of the most reactionary phases in the history of modern sexism.

Certainly the sexist reaction was not the only force shaping art in the early twentieth century. But without acknowledging its presence and the still uncharted

shock waves that feminism sent through the feelings and imaginations of men and women, these paintings lose much of their urgency and meaning. Moreover, those other historical and cultural forces affecting art, the ones we already know something about – industrialization, anarchism, the legacy of past art, the quest for freer and more self-expressive forms, primitivism, the dynamics of avant-garde art-politics itself, and so on – our understanding of these must inevitably be qualified as we learn more about their relationship to feminism and the sexist reaction.

Indeed, these more familiar issues often become rationalizations for the presence of sexism in art. In the literature of twentieth-century art, the sexist bias, itself unmentionable, is covered up and silently approved by the insistence on these other meanings. Our view of it is blocked by innocent-sounding generalizations about an artist's formal courageousness, his creative prowess or his progressive, humanistic values. But while we are told about the universal, genderless aspirations of art, a deeper level of consciousness, fed directly by the powerful images themselves, comprehends that this "general" truth arises from male experience alone. We are also taught to keep such suspicions suppressed, thus preserving the illusion that the "real" meanings of art are universal, beyond the interests of any one class or sex. In this way we have been schooled to cherish vanguardism as the embodiment of "our" most progressive values.

III

Our understanding of the social meanings of the art I have been considering – what these artists imply about society and their relationship to it – especially needs reevaluation. Much avant-garde painting of the early twentieth century is seen as a continuation of the nineteenth-century traditions of Romantic and Realist protest. Most of the artists whose names appear here were indeed heirs to this tradition and its central theme of liberation. Like others before them, they wished for a world in which man might live, think and feel, not according to the dictates of rationalized, capitalist society, but according to his own needs as an emotionally and sensually free human being.

The Fauves and the Brücke artists especially associated themselves with the cause of liberation, although in different national contexts. The French artistic bohemia in which the Fauves matured enjoyed a long tradition of sympathy and identification with vanguard politics.[12] In the first decade of the century, the anarchist ideas that so many Neo-Impressionists had rallied to in the previous generation were still nurtured. (Picasso, too, moved in anarchist circles in Barcelona before he settled in Paris.) The heyday of the artist bomb-thrower was over, but the art-ideology of the avant garde still interpreted flamboyant, unconventional styles of art and behavior as expressions of anarchist sentiments. The young Fauves understood this, and most of them enjoyed (at least for a time) being

publicized as wild anarchists out to tear down the establishment. Germany, on the other hand, more recently organized as a modern, bourgeois state, had only begun to see artist-activists; traditionally, dissident German artists and intellectuals withdrew from society and sought solace in transcendental philosophies. In accord with this tradition, Brücke artists were programatically more hostile to cities than the Fauves, and more fervent nature-lovers.[13] They were also more organized and cohesive as a group. In a Dresden shop, they established a communal studio where they worked and lived together in what we would call today an alternative lifestyle. Yet, however distinct from the Fauves, they embraced many of the same ideals. At the outset, they announced their opposition to the rationalism and authoritarianism of modern industrial life. The banner they waved was for free, individual self-expression and the rehabilitation of the flesh.

The two groups shared both an optimism about the future of society and the conviction that art and artists had a role to play in the creation of a new and freer world. For them, as for so many of their vanguard contemporaries and successors, the mission of art was liberation – individual, not political. Liberal idealists at heart, they believed that artists could effect change simply by existing as individual authentic artists. In their eyes, to exercise and express one's unfettered instinctual powers was to strike a blow against, to subvert, the established order. The idea was to awaken, liberate and unleash in others creative-instinctual desires by holding up visions of reality born of liberated consciousness. That only an educated, leisured and relatively non-oppressed few were prepared to respond to their necessarily unconventional and avant-garde language was generally ignored.

The artist, then, exemplified the liberated individual *par excellence*, and the content of his art defined the nature of liberated experience itself. Such ideas were already present in the nineteenth century, but in that decade before World War I, young European painters took to them with new energy and excitement. More than anything else, the art of this decade depicts and glorifies what is unique in the life of the artist – his studio, his vanguard friends, his special perceptions of nature, the streets he walked, the cafés he frequented. Collectively, early vanguard art defines a new artist type: the earthy but poetic male, whose life is organized around his instinctual needs. Although he owes much to the nineteenth century, he is more consciously anti-intellectual – more hostile to reason and theory – and more aggressive than any of his predecessors. The new artist not only paints with heart and loins, he seizes the world with them and wrenches it out of shape. And he not only experiences his instinctual nature with more intensity than those trapped in the conventional guilt-ridden world; his bohemian life offers him more opportunities to gratify his purely physical needs.

According to the paintings of the period, sexually cooperative women are everywhere available in the artist's environment, especially in his studio. Although they were sometimes depicted as professional models posing for their hourly wage, they usually appear as personal possessions of the artist, part of his specific studio and objects of his particular gratification. Indeed, pictures of studios, the

inner sanctum of the art world, reinforce more than any other genre the *social* expectation that "the artist" is categorically a male who is more consciously in touch with his libido than other men and satisfies its purely physical demands more frequently. The nudes of Van Dongen, Kirchner and Modigliani often read as blatant pre- or postcoital personal experiences, and, according to much Brücke art, that communal studio in Dresden was overrun by naked, idle girls.

However selective these views of bohemia are, some social reality filters in – enough to identify the nameless, faceless women who congregate there in such numbers and offer their bodies with such total submission. Their social identity is precisely their availability as sex objects. We see them through the eyes of the artist, and the artist, despite his unconventional means, looked at them with the same eyes and the same class prejudices as other bourgeois men. Whatever the class situation of the actual models, they appear in these pictures as lower-class women who live off their bodies. Unlike generalized, classical nudes, they recline in the specified studio of the artist and take off contemporary – and often shabby – clothes. The audience of that time would instantly recognize in them the whole population of tarty, interchangeable and *socially* faceless women who are produced in quantity in modern, industrialized societies: mistresses of poor artists drawn from the hand-to-mouth street world of bohemia, whores, models (usually semi-professional whores), and an assortment of low-life entertainers and barflies. Whatever their dubious callings, they are not presented as respectable middle-class women. Indeed, by emphasizing their lower-class identity, by celebrating them as mere sexual objects, these artists forcefully reject the modesty and sexual inhibitedness of middle-class women as well as the social demands their position entitles them to make. Thus the "liberated" artist defined his liberation by stressing the social plight of his models and his own willingness to exploit them sexually.

For, despite the antibourgeois stance of these artists and their quest for a liberated vision, they rarely saw the social oppression before them, particularly that yoke which the bourgeoisie imposed upon womankind at large and on poor women in particular. The women that Toulouse-Lautrec painted and sketched were surely no better off socially than the women in these pictures. But where he could look through class differences and sordid situations, and still see sympathetic human beings, these young men usually saw only sexually available objects. Usually but not always. Two paintings of the same cabaret dancer, painted by Derain and Vlaminck on the same day, make a significant contrast. The woman in Derain's work, *Woman in Chemise* (1906), looks uncomfortable and unsure of herself before the gaze of the artist. Her awkward, bony body is self-consciously drawn together, and a red, ungainly hand, exaggerated by the artist, hovers nervously at her side. The artist's social superiority and the model's shabbiness are acknowledged, but not enjoyed or celebrated. Despite her dyed hair and make-up, the woman is seen as an authentic subjective presence who commands serious attention, unbeautiful but human. In Vlaminck's *Dancer at the "Rat Mort"* (1906) the same woman in the same pose is a brassy, inviting tart,

a mascara-eyed sexual challenge. Set against a pointillist burst of color – those dots that were so beloved by the previous generation of anarchists – she is all black stockings, red hair, white flesh and a cool, come-on look. Vlaminck, the avowed anarchist, is as thrilled by her tawdry allure as any bourgeois out for an evening of low life.

The socially radical claims of a Vlaminck, a Van Dongen or a Kirchner are thus contradicted. According to their paintings, the liberation of the artist means the domination of others; his freedom requires their unfreedom. Far from contesting the established social order, the male–female relationship that these paintings imply – the drastic reduction of women to objects of specialized male interests – embodies on a sexual level the basic class relationships of capitalist society. In fact, such images are splendid metaphors for what the wealthy collectors who eventually acquired them did to those beneath them in the social as well as the sexual hierarchy.

However, if the artist is willing to regard women as merely a means to his own ends, if he exploits them to achieve his boast of virility, he in his turn must merchandise and sell himself, or an illusion of himself and his intimate life, on the open avant-garde market. He must promote (or get dealers and critic friends to promote) the value of his special credo, the authenticity of his special vision, and – most importantly – the genuineness of his antibourgeois antagonism. Ultimately, he must be dependent on and serve the pleasure of the very bourgeois world (or enlightened segments of it) that his art and life appear to contest.[14] Here he lives a moral-social contradiction that is the corollary to his psychological dilemma before the sphere of woman/nature. The artist wants to but cannot escape the real world of rationalized bourgeois society. He is as tied to it economically as he is bound within its cultural and psychological constructs.

The enlightened art collector who purchased these works, then as now, entered a complex relationship with both the object he purchased and the artist who made it. On the most obvious level, he acquired ownership of a unique and – if he had taste – valuable and even beautiful object. He also probably enjoyed giving support and encouragement to the artist, whose idealism he might genuinely admire. At the same time, he purchased a special service from the artist, one that is peculiarly modern. In the sixteenth, seventeenth and eighteenth centuries, the wealthy patron often owned outright both the object he purchased and its erotic content. Frequently he specified its subject and even designated its model, whose services he might also own. The work bore witness not to the artist's sexual fantasies or libertine lifestyle (the artist could hardly afford such luxuries), but to the patron's. The erotic works commissioned by famous eighteenth-century courtesans were equally addressed to their male benefactors. In these twentieth-century images of nudes, however, the willfully assertive presence of the artist stands between the patron and the erotic situation represented. It is clearly the artist's life situation that is depicted; it is for him that these women disrobe and recline. And the image itself, rendered in a deliberately individual and spontaneous style, is saturated with the artist's unique personality. The collector, in fact, is

acquiring or sharing another man's sexual-aesthetic experience. His relationship to the nude is mediated by another man's virility, much to the benefit of his own sense of sexual identity and superiority. For these nudes are not merely high-culture versions of pornography or popular erotica. Often distorted and bestial, they are not always very erotic, and they may appeal to homosexual males as much as to heterosexuals. They are more about power than pleasure.

The relationship between the collector and the artist may be read in the monographs that art historians and connoiseurs so often write about painters of nudes. These usually praise the artist's frank eroticism, his forthright honesty and his healthy, down-to-earth sensuality. Often there are allusions to his correspondingly free sex life. The better writers give close and detailed analyses of individual works, reliving the artist's experience before the nude. At some point, higher, more significant meanings are invoked, things about the human condition, freedom, art and creativity – or, if the writer is a formalist, about the artist's coloristic advances, his stylistic precocity or his technical innovations. It is the moment of rationalization, the moment to back away and put abstractions between oneself and the real content of the paintings.

The collector could enjoy the same closeness to and the same distance from that content. What ensues in that collapsing and expanding space is a symbolic transference of male sexual mana from bohemian to bourgeois and also from lower to upper classes. The process began with the artist, who adopted or cultivated the aggressive, presumably unsocialized sexual stance of the sailor or laborer. The content of his art – his choice of nameless, lower-class women and his purely physical approach to them – established the illusion of his nonbourgeois sexual character. In acquiring or admiring such images, the respectable bourgeois identifies himself with this stance. Consciously or unconsciously, he affirms to himself and others the naked fact of male domination and sees that fact sanctified in the ritual of high culture. Without risking the dangers that such behavior on his own part would bring, he can appropriate the artist's experience and still live peacefully at home. For he cannot afford, and probably does not want, to treat his wife as an object. He needs and values her social cooperation and emotional presence, and to have these, he must respect her body and soul.

What the painting on the wall meant to that wife can only be imagined. A Van Dongen or a Kirchner was scandalous stuff, and few matrons were prepared to accept such works on their aesthetic merits. But no doubt there were women who, proud of their modernity, could value them as emblems of their own progressive attitudes and daring lack of prudery. Finally, we can speculate that some women, frightened by suffragist and emancipation movements, needed to reaffirm – not contest – their situation. The nude on the wall, however uncomfortable it may have been in some respects, could be reassuring to the wife as well as the husband. Although it condoned libertinism, it also drew a veil over the deeper question of emancipation and the frightening thought of freedom.

Notes

1 See my "Esthetics of Power," *Heresies* 1 (1977).
2 For the iconography of late nineteenth-century painting, I consulted A. Comini, "Vampires, Virgins and Voyeurs in Imperial Vienna," in *Woman as Sex Object*, ed. L. Nochlin, New York, 1972, pp. 206–21; M. Kingsbury, "The Femme Fatale and Her Sisters," in ibid., pp. 182–205; R. A. Heller, "The Iconography of Edvard Munch's *Sphinx*," *Artforum*, January 1970, pp. 56–62; and W. Anderson, *Gauguin's Paradise Lost*, New York, 1971.
3 M. Kozloff, *Cubism and Futurism*, New York, 1973, p. 91.
4 Matisse, in H. Chipp, *Theories of Modern Art*, Berkeley, Los Angeles, London, 1970, pp. 132–3.
5 S. Ortner, "Is Female to Male as Nature Is to Culture?" *Feminist Studies*, Fall 1972, pp. 5–31.
6 Ibid., p. 10.
7 R. Rosenblum, "The 'Demoiselles d'Avignon' Revisited," *Art News*, April 1973, pp. 45–8.
8 The crouching woman at the lower right, especially as Picasso rendered her in preparatory studies, is a familiar figure in primitive and archaic art. See Douglas Fraser, "The Heraldic Woman: A Study in Diffusion," *The Many Faces of Primitive Art*, ed. D. Fraser, Englewood Cliffs, NJ, 1966, pp. 36–99. Anyone familiar with these symmetrical, knees-up, legs-spread figures can have little doubt that Picasso's woman was inspired by one of them. Grotesque deities with complex meanings, they are often in the act of childbirth, and in primitive villages they frequently occupied the place above the door to the men's lodge, the center of culture and power. Often, they were meant to frighten enemies and were considered dangerous to look at. They surely functioned ideologically, reinforcing views of women as the "other." Picasso intuitively grasped their meaning.
9 Vlaminck, in Chipp, *Theories*, p. 144.
10 Leo Steinberg discusses the phallic meaning of this object in "The Philosophical Brothel, Part I," *Art News*, Sept. 1972, pp. 25–6. The juxtaposition of the phallus and the squatting nude especially recalls the self-displaying figures Fraser studies (see note 8), since they were sometimes flanked by phalli.
11 Philip Rieff, *Freud: The Mind of the Moralist*, New York, 1959, ch. 5.
12 F. Nora, "The Neo-Impressionist Avant-garde," in *Avant-garde Art*, New York, 1968, pp. 53–63; and E. Oppler, *Fauvism Re-examined*, New York and London, 1976, pp. 183–95.
13 B. Myers, *The German Expressionists*, New York, 1957; and C. S. Kessler, "Sun Worship and Anxiety: Nature, Nakedness and Nihilism in German Expressionist Painting," *Magazine of Art*, Nov. 1952, pp. 304–12.
14 R. Poggioli, "The Artist in the Modern World," in M. Albrecht, J. Barnett, and M. Griff, eds., *The Sociology of Art and Literature: A Reader*, New York, 1970, pp. 669–86.

28

Men's Work? Masculinity and Modernism

Lisa Tickner

Artistic Subjectivities: "Masculinity as Masquerade"

During the nineteenth century, "art" and "artist" acquired new resonances. The economic basis for artistic practice shifted decisively from church, state, or private commission to commodity production, and by the early years of the twentieth century (late, in Britain), we find the small coteries of a self-consciously "modernist" avant-garde, if no general agreement on subject or style. The hold of the Royal Academy as the principal educational and exhibiting institution was broken well before 1900.[1] The established art press, with new titles and the appointment of newspaper critics, had begun catering to a general and amateur interest among the cultivated bourgeoisie as well as to specialists and professionals.[2] Combative artists (like Whistler) made good copy. The *Künstlerroman* or artist-novel reached the zenith of its popularity between about 1885 and the First World War, and large numbers of fictional and semi-documentary accounts of the artist and artistic life were avidly consumed by an expanding public.[3] In the same period, a concern with sexuality and sexual identity emerged as the mark of the modern in art, literature, and social behavior. Feminism and the social and literary phenomenon of the "new woman" helped throw femininity into crisis.[4] The influx of women artists trained in the new public art schools of the Victorian period and in ateliers abroad led to anxieties about the "feminization" of art, that it would be swamped by "a flood of mediocrity."[5] These fears were compounded by the social and economic insecurity of the avant-garde and by a sense of British impotence in the face of European, and specifically Parisian, creativity. Artistic masculinity – at least in some quarters – was also in crisis, and new kinds of harsh,

Lisa Tickner, extracts (pp. 46–56, 70–6 [excerpted notes]) from "Men's Work? Masculinity and Modernism" in Norman Bryson, Michael Ann Holly, and Keith Moxey (eds.), *Visual Culture: Images and Interpretations*. Hanover, NH: Wesleyan University Press, 1994. © 1994 by Wesleyan University Press and reprinted by permission of Wesleyan University Press.

procreative, and virile masculinities were appropriated in response to what was perceived as the depleted and effeminate influence of women, the Royal Academy, and what Gaudier-Brzeska called the disgusting softness of modern life.[6]

If we are to account for the formation and effects of gendered artistic subjects – which is different from tracing the work back to gender, insistently and unproblematically, and only in the case of women – we have to find a place for historical agency.[7] We need a concept of the active subject as both structured and structuring, neither the dupe of history nor the "possessor of her own soul who has hewn out her individual path to well-deserved fame – as an admitted Genius."[8] (Thus Ethel Ducat's praise of Anne Estelle Rice in *Votes for Women*: an unconscious parody of the language of avant-garde heroism as it was informed by the discourse of possessive individualism.) This research is not biography, but it needs the biographer's materials – letters, diaries, memoirs, notebooks – if we are to glimpse something of how men and women aspired to new and modern artistic identities that left their traces on the work.

To become an artist at the turn of the century was not only a social matter of training and opportunity, it was also a question of aspiration, of *imagining* oneself an artist. Fact and fiction, history and biography, psychology and journalism, merged and overlapped in the mapping of an artistic "type" and, hence, in the provision of raw material for new identities.[9] There is little to be gained by insisting on the common sense distinction between "real people" and discursive fictions. Identification, the founding process of subjectivity, assimilates aspects, attributes, or properties of "others" who may just as well be fictional as not. Mythological components inhabit and determine biographical narratives, which in turn effect not only how artists are perceived (the "additional configurations of responses" linked with them as a socially delimited group) but also how artists understand and produce their *own* identities (in what Ernst Kris and Otto Kurz refer to as the psychology of "enacted biography").[10] The enormous popularity of the artist as a character in fiction, biography, and journalism at the turn of the century meant that no one setting out on an artistic career did so as innocently as they might have taken up bookkeeping or architecture or medicine. The artist was a special kind of being with a special kind of life rather than an ordinary being with particular kinds of skills.

Such questions are increasingly discussed as a problem for women, who could have the skills but not the specialness and were doomed to the category of "lady artist." But I want to suggest that masculinity was also in crisis in the years after 1900 or, to put it more locally, that a combination of factors made the assertion of a virile and creative masculinity both imperative and problematic. Some of these originated in the art world itself and others pressed upon it from outside.

The humiliations of the Boer War (1899–1902), the *Report of the Inter-Departmental Committee on Physical Deterioration* of 1904 (though it refuted rumors that 60 percent of Englishmen were unfit for active service), an apparent increase in the number of mentally defective persons discussed in the *Report of the Royal Commission on the Care and Control of the Feeble-Minded* of 1908, a drop in

the birthrate of almost 30 percent between the mid-1870s and 1910, a concern for the well-being of the empire in the face of German economic strength and military preparedness: all this led to talk of moral, physical, and intellectual decline.[11] Much of the debate was couched in the terms of social Darwinism.[12] Darwin had proposed that nations as well as individuals were subject to the law of the "survival of the fittest" and had himself appeared to lend credence to the Victorian ideology of "separate spheres" by claiming that sexual divergence was part of the evolutionary process: the higher the order of civilization, the more refined and distinct the attributes of masculinity and femininity. Eugenicists, who formed the principal strand within social Darwinism, used this argument to claim that national decline could only be reversed by "manly" men and "womanly" women regenerating the population. Social Darwinism crossed the political spectrum. In the hands of eugenicists, it helped promote widespread anxieties about the "masculinization" of modern women and the "effeminacy" of the men they would mate with and breed.

Many men (and also women) *were* disturbed by the impact of modern life on traditional definitions of sexual identity and by the impact of feminism. The measure of this concern is popular antisuffrage propaganda, which can only be called hysterical. It depicts, graphically, the oppression of men by domineering viragoes or, more frequently, the preemptive strike: the symbolic rape or "castration" of presumptuous women.[13] It has its gentler modes, but what recurs insistently is the fear of what women's emancipation will do to men. It is as though masculinity and femininity are mutually exclusive and mutually damaging. The bottom line is castration or – and it amounts to the same thing perhaps – the feminizing of the virile institutions of civic life: "everywhere," as Almroth Wright put it, "one epicene institution, one cock-and-hen show."[14] It was not clear in 1910 that women would win the vote, but they had several times come close to it. What was clear was that, with the vote or without it, the processes of modernization were irreversible, and they brought women more fully into the fabric of daily public life.[15]

The impact of these changes on men's sense of their masculinity is harder to gauge and impossible to generalize. We might speculate, however, that the encroachment by women on hitherto masculine arenas (clerical work, local politics, medicine, the universities, certain kinds of sport) – however tentative – together with the spectacle of ferocious industrial muscle made for some uncertainty as to the nature of a *modern* masculinity.[16] A womanly woman was a woman with all the maternal and domestic virtues, but manliness was more obviously complicated by class and by the unresolved question of how the defining drives of masculinity (such as lust and aggression) were properly sublimated in civilized life.

Such issues had their local and "artistic" application. The social standing and economic security of the artist had declined since the middle of the nineteenth century. Women were becoming artists with a new sense of organization and self-consciousness, perceiving themselves as a group that suffered from certain difficulties but to which new possibilities were opening. Societies of women artists

339

were becoming less defensive and more vocal. The Women's International Art Club, open to all women who had studied in Paris and did "strong work," had more than one hundred members from seventeen different countries by 1900, when its first London exhibition was held in the Grafton Galleries.[17] In 1910 the exhibition included work by women artists of the past. There is a real sense of women exploring their capacities and their heritage at this moment, in the face of those critical discourses that secured their work as "feminine" and hence deficient. The numbers of women artists, their invasion of the art schools, their raised profile in the periodicals (first as "surplus" women needing a discreet alternative to governessing, but then as "new" women determined on independence and a career), their role as consumers of the new "art" furnishings, "art" needlework, "art" everything: All this contributed to an uneasy sense that art as a predominantly masculine activity was being feminized and domesticated.

The note of self-conscious virility in the rebellion of an Augustus John or a Wyndham Lewis was intended to distance them from any of this bourgeois "artiness"; from the senility of the *arrière garde*; and from the 1890s dandyism of Beardsley or Whistler.[18] As an aesthetic stance, dandyism was compromised by the backlash from the Oscar Wilde trial of 1895 and by what Wyndham Lewis almost called the bourgeoisification of bohemia.[19] The exquisite pose and rapier wit of the "Butterfly"[20] would no longer serve. A new, blunter, more modern, more brutal (more *masculine*) combatant was required to do battle against twentieth-century philistinism and the dead weight of tradition. (Ezra Pound complained that he was always having to tell young men to square their shoulders, wipe their feet, and *remember the date on the calendar*.)[21]

John became a gypsy patriarch complete with Romany caravan to the outspoken envy of Wyndham Lewis, who wrote to his mother that John was "going to camp on Dartmoor, with a numerous retinue, or a formidable staff, . . . or any polite phrase that occurs to you that might include his patriarchal menage," and later that "John will end by building a city, and being worshipped as the sole man therein – the deity of Masculinity."[22] John's two portraits of Lewis invite us to mark the transition from the Rugby schoolboy and Slade art student (c. 1903) to the bohemian aesthete and "incarnate loki" of Montparnasse (c. 1905).[23] Cloaked and hatted like a Spanish grandee, the silk bookmarks fluttering from slender, leather-bound volumes of poetry, Lewis prowled the streets of Paris before 1909, harrassing the seamstresses. But he outgrew his apprenticeship to John's persona and adopted something more Nietzschean: the herdsman, the crowdmaster, the Tyro, the primitive mercenary, the Enemy.[24] Henri Gaudier-Brzeska found his sculptural inspiration in the preclassical and tribal collections of the British Museum, as well as his creative, sexual, antibourgeois identity, first as "the modern Cellini" and then as "the savage messiah."[25]

John, as the "image of Jove turned gypsy,"[26] adopted a carelessly lyrical style, an expressive brushstroke, and Italianate allusions in the struggle to find a visual medium for the essentially conservative and inchoate myth of a fecund Arcadia in the present. (*Lyric Fantasy*, 1910–1911, one of the only large works, was never

completed. Neither his painting conditions nor his pastoral figure subjects were appropriate to modernism as that was conceived after 1910, and certainly after 1914.) Lewis sketched out his overlapping personae in the *Blast* manifestoes, in his autobiographical novel *Tarr* (1918, revised 1928), and in short stories and self-portraits such as *Self Portrait as a Tyro* (1920–1). His pre-war work is marked by an obsession with the crowd – the crowd his hero Cantleman opposes is both "feminine" and "blind" – and by the use of a vocabulary of geometric (that is, as for Worringer, "masculine")[27] forms to invoke both the structure of the industrial city and the alienating tenor of modern urban life. The "square bluntness"[28] so valued in Gaudier's work by Ezra Pound is modern by virtue of its distance both from the smooth transitions of classical carving and from the expressive modeling of the Rodinesque. But it is also construed as modern – by Pound and others – because it is phallic, most phallic, in fact, in the "hieratic head" of Pound himself. There is an easy traffic between this idea of the modern necessity for a "virile art" and Gaudier's role as the savage messiah.

The irony is that this free-ranging masculinity required emancipated women to support it. John, Lewis, and Gaudier-Brzeska *expected* women to be emancipated enough to sleep with them, to forgo fidelity, in the case of John and Lewis to bear their children out of wedlock, and in the case of Lewis and Gaudier to help support their art financially.[29] None of these men was wedded to traditional ideas of womanliness. All of them believed women could be talented and independent. But an imperious and often promiscuous, heterosexual masculine egoism ran through their relations with women nevertheless. And the women themselves were often divided or insecure. Few had Gwen John's presence of mind and passionate selfishness. Nina Hamnett was distracted by *la vie de boheme* and ignored Sickert's advice to keep callers to their settled hours.[30] Carrington felt she was "not strong enough to live in this world of people and paint."[31] Sophie Brzeska's trilogy failed to emerge from her several hundred pages of autobiographical notes. Life drained talent, often enough in the interests of men and with women's blessing. Bloomsbury was an exception, at least for Vanessa Bell.[32] Its homosexual component ironized hearty masculinity, and, for all the intricacies of its sexual relationships, sexual conquest and a sense of virility did not permeate its work (which was, of course, precisely Lewis' complaint).

I think there is evident here such a thing as "masculinity as masquerade," not in any sense that would directly complement Joan Riviere's analysis of "Womanliness as Masquerade" (1929)[33] but in three related ones. First, we can speak generally of identification as the means by which the personality is constituted and specified: "All the world's a stage / and all the men and women merely players."[34] There is a powerful sense of charades about John's imagery and behavior, but the point is that he chose to produce himself as an artistic subject through a series of identifications with the attributes of a nomadic, liminal, and acapitalist group. The process is particularly vivid with John because it is relatively transparent and impinges so directly on his work. But it illuminates the ways in which younger artists played with the appropriation of other, more mythic, and

341

– mythically – more potent masculinities, out of context, as part of their opposition to the conventional codes of middle class masculinity.

Second, we might deepen this first sense of masquerade as a kind of fantasy identification by exploring the operations of masquerade as a form of defense. This notion of defense is the crux of Riviere's case study. She opens with a reference to Sandor Ferenczi's claim that homosexual men may exaggerate their heterosexuality as a defense. She proceeds by stating that "women who wish for masculinity" (her case study is of an intellectual woman who usurps the masculine position of public speaker) "may put on a mask of womanliness to avert anxiety and the retribution feared from men."[35] We can adapt the structure of her (and Ferenczi's) argument metaphorically. Men moving into art – an area identified with "feminine" sensibility and increasingly occupied by women art students – might feel the need with Nevinson and Marinetti to distinguish *Vital English Art* from the pastimes of women and schoolgirls and to adopt the mask of a heightened and aggressively heterosexual masculinity.[36]

Riviere oscillates in her paper between seeing the masquerade as a travesty – a defense and disguise – and as womanliness itself (womanliness *is* the masquerade). This latter position is the one taken by later commentators, including Stephen Heath who goes on to suggest that there is a corresponding male term for the woman's masquerade – male display or, in Lacan's term, *parade*. He quotes from Virginia Woolf's *Three Guineas*, observing that "all the trappings of authority, hierarchy, order, position make the man, his phallic identity," and then from Eugenie Lemoine Luccione: "If the penis was the phallus, men would have no need of feathers or ties or medals. . . . Just like the masquerade, [parade] betrays a flaw: no one has the phallus."[37] The difficulty here – apart from that of theorizing the asymmetry of "masquerade" to "parade" – is that once we generalize either concept to illuminate a whole gendered identity, we lose its usefulness as a term for a particular symptom and strategy. I want to retain as a backdrop the general association between femininity and masquerade, on the one hand, and masculinity and parade, on the other. But I also argue that the concept of masquerade as a negotiated strategy for gendered survival offers some purchase on the specific, contradictory, and idiosyncratic masculinities of my artist-protagonists.

Augustus John and Wyndham Lewis (who partly learned it from John) were very good at parade: not the civic display of "feathers or ties or medals," but its bohemian antidote. Bohemian parade conjured a masculinity even more phallic in its flamboyance, its sexuality, and its studied neglect of the sartorial niceties that connoted in turn the constraints of duty, decency, and social decorum. As early as 1858, a character in Mary Jackson's novel *Maud Skillicorne's Penance* complains that young artists are "gross in their habits and tastes, snobbish in their appearance aping foreigners in wearing dirty moustaches and antediluvian cloaks."[38] This was not a bad description of Wyndham Lewis in Paris almost half a century later. Bohemian clothing had become a cliché, the garb of minor artists and the merely arty. John retreated further into gypsydom. Lewis made the knight's move and adopted an ironic black suit. Nevinson and the rest of the "Slade coster

gang" went for "black jerseys, scarlet mufflers and black caps or hats." ("We were the terror of Soho and violent participants, for the mere love of a row, at such places as the anti-vivisectionist demonstrations at the 'Little Brown Dog' at Battersea.")[39]

The appropriation of bits of working class clothing into a rougher masculinity than their families had fitted them for is characteristic of the attempt to modernize the tired particularities of artistic identity. It is also, paradoxically, characteristic of parade. The infusion of virility, which is the staple metaphor distinguishing modernity from 1890s aestheticism, comes not from the hierarchical trappings of the desk-bound bourgeoisie but from an invocation of what are perceived as the uncultivated and, hence, unfettered masculinities of the manual and the marginal: costers, navvies, gypsies, "savages."[40] My point is that this is of more than incidental or biographical interest. The proper study of womankind is not always or necessarily woman: masculinity is a problem for feminism (as well as for women and, arguably, men), and both feminism and art history, in focusing on these emergent and provisional masculinities, can illuminate something of modernism's "myth of its own origins" and interests. [...]

Notes

1 The impact of the Slade (opened 1871), the New English Art Club (from 1886), and the Academy Reform Movement (1886–7) all took their toll.

2 See *The Art Press: Two Centuries of Art Magazines* (London, 1976; *Studio International* 193, no. 983 (Sept./Oct. 1976) (special issue on art magazines), particularly John Tagg, "Movements and Periodicals: The Magazines of Art." *The Studio*, founded in 1893, offered feature articles, art criticism, and instruction in various arts and crafts techniques; its readership included professionals, students, amateurs, and the cultivated middle class in general, to which *The Studio* offered itself as "the recognised vehicle of modern art knowledge."

3 The genre of the artist-novel stretches from the late eighteenth century and Goethe's *Werther and Wilhelm Meister*, to Joyce's *Stephen Dedalus* and beyond. It embraces a host of minor and forgotten authors (Ouida, Gertrude Jewsbury, Gilbert Cannan), and some of the canonical fiction of the period (Balzac, James, Proust, Joyce). Henri Murger's immensely influential *Scenes de la vie de bohème* (1845) was first translated as *The Bohemians of the Latin Quarter* in 1887 and reappeared with different titles in 1901, 1908 and 1920. George du Maurier's *Trilby* was published in 1894, reputedly selling 100,000 copies in the first three months. Directly and through stage adaptations (including Puccini's *La Bohème*, dramatic versions of *Trilby*, and a whole host of Trilbyana), Murger and du Maurier represent the furthest reach of the artist-novel in terms of sales, public popularity, and innumerable citations in memoirs and other works of fiction. But scores of artist-novels were published between about 1885 and 1920, many of them, like *Trilby*, which first appeared in *Harper's Bazaar*, reaching an expanding public in serial form. The best-known avant-garde *Künstlerroman* is Joyce's *Portrait of the Artist as a Young Man* (1914), but Wyndham Lewis's *Tarr* (1918; rev. ed. 1928) is comparably innovatory.

4 On the "new woman," see A. R. Cunningham, "The 'New Woman' Fiction of the 1890s," *Victorian Studies* (December 1973); Elaine Showalter, *A Literature of Their Own: British Women Novelists from Brontë to Lessing* (1977; reprint, London, 1978), ch. 7; Gail Cunningham, *The New Woman and the Victorian Novel* (London, 1978); and Rosalind Rosenberg, *Beyond Separate Spheres: The Intellectual Roots of Modern Feminism* (New Haven, 1982), ch. 3, all of which cite further sources.

5 Octave Uzanne, *The Modern Parisienne* (London, 1907), 129–30.

6 Ezra Pound recalled Gaudier-Brzeska's conversation as a flow of remarks jabbing the air: "it might be exogamy, or the habits of primitive tribes, or the training of African warriors, or Chinese ideographs, or the disgusting 'mollesse' of metropolitan civilization … " (Ezra Pound, *Gaudier-Brzeska: A Memoir* [1916; reprint, Hessle, Yorkshire, 1960], 39–40). The identification of the "virile" with the "primitive," the laudatory use of "phallic," and the appeal to a mythically potent masculinity – one unenfeebled by urban life – recur in writings by Lewis, Pound, Gaudier-Brzeska, and others. "The artist of the modern movement is a savage," proclaimed the *Blast* "Manifesto II" (20 June 1914). These claims reverse, if they do not improve, the common, casual, and racist evaluation of tribal cultures as either primitive or degenerate.

7 Two recent articles illuminate the problems of subjectivity and authorship in art historical analysis: J. R. R. Christie and Fred Orton, "Writing on a Text of the Life," *Art History* II (Dec. 1988); and Griselda Pollock, "Agency and the Avant-Garde," *Block* 15 (Spring 1989).

8 Ethel Ducat, *Votes for Women*, 26 May 1911.

9 See Rudolph and Margot Wittkower, *Born Under Saturn: The Character and Conduct of Artists: A Documented History from Antiquity to the French Revolution* (London, 1963). The Wittkowers dismiss the idea of a specifically artistic "type" but point to the efficacy of nineteenth-century psychologists such as Cesare Lombroso in helping to produce one.

10 Ernst Kris and Otto Kurz, *Legend, Myth, and Magic in the Image of the Artist: A Historical Experiment* (New Haven, 1979), 2 n. 1 (citing R. Linton [1943] on "additional configurations of responses"), and 132 ("enacted biography").

11 The analogy with Roman decadence was made in *The Decline and Fall of the British Empire*, published anonymously by the Tory pamphleteer Elliott Mills in 1905, and was subsequently taken up in Baden-Powell's *Scouting for Boys* (1908), Balfour's 1908 address on "Decadence," and elsewhere. I am indebted to Samuel Hynes, who discusses these and related sources in "The Decline and Fall of Tory England," ch. 2 of *The Edwardian Turn of Mind* (Princeton, 1968). The concern with *moral* decline was enhanced by the trial of Oscar Wilde in 1895 and by the publication in the same year of the English translation of Max Nordau's *Degeneration*. Nordau argued that all characteristically modern art showed evidence of the decadence threatening the human race. He was widely cited or echoed in conservative criticism of the post-impressionists in 1910 and by opponents of futurism, vorticism, and other manifestations of pre-war modernism.

12 "Social Darwinism" is a convenient term for a variety of applications of evolutionary theory to social theory between the 1870s and 1914. Darwin's cousin, Francis Galton, coined the term "eugenics" in 1883, but eugenic theories were also influenced by the social philosopher Herbert Spencer, who had first used the expression "the survival of the fittest" in 1864. There is an extensive literature, but see Ray-

mond Williams' chapter, "Social Darwinism," in *Problems in Materialism and Culture* (London, 1980); Jeffrey Weeks, *Sex, Politics and Society: The Regulation of Sexuality since 1900* (London and New York, 1981), ch. 7; Jane Lewis, *Women in England 1870–1920* (Oxford, 1984); David Green, "Veins of Resemblance: Photography and Eugenics," *Oxford Art Journal* 7, no. 2 (1984).

13 On pro- and antisuffrage imagery, see Tickner, *The Spectacle of Women.* Feminism, femininity, and evolutionary theory are discussed on pp. 185–92.

14 Sir Almroth Wright, *The Unexpurgated Case Against Women's Suffrage* (London, 1913), 60.

15 See among others Patricia Hollis, ed., *Women in Public 1850–1900* (London, 1979); and Lee Holcombe, *Victorian Ladies at Work: Middle Class Working Women in England and Wales 1850–1914* (Newton Abbot, 1973).

16 As Elsie Clews Parsons commented in 1916: "Womanliness must never be out of mind, if masculine rule is to be kept intact" (*Social Rule: A Study of the Will to Power* [New York, 1916], 54). On the argument that fears of women's "masculinization" (by work, higher education, or the vote) masked fears of men's concomitant feminization, see Peter Gabriel Filene, *Him/Her/Self: Sex Roles in Modern America* (1974; reprint, New York, 1976), 72–7.

17 See Charlotte Yeldham, *Women Artists in Nineteenth-Century England and France* (London, 1984), ch. 2, part 3 ("Societies of Women Artists"). Germaine Greer, *The Obstacle Race: The Fortunes of Women Painters and Their Work* (London, 1979), also lists women's exhibitions at this period (pp. 321–3).

18 *Rhythm,* invoking Watts and (indirectly) Burne Jones, painted a picture of the Victorian idealist as "an artist such as the *Girl's Own Paper* would be charmed with"; a "slim man of gentle manners … [who] paints the soul." Dan Phaër, "Types of Artists 1. The Victorian Idealist," *Rhythm* 2, no. 5 (June 1912).

19 Part 3 of Wyndham Lewis' *Tarr* is devoted to the "Bourgeois-Bohemians". Lewis at one point considered this as a title for the whole novel. The essential edition is now *Tarr. The 1918 Version,* ed. Paul O'Keeffe (Santa Rosa, 1990); scrupulous and illuminating.

20 Whistler's monogram was the butterfly (with a sting in its tail).

21 See for example Pound's letter to Margaret Anderson (Sept. 1917) in which he referred to writing articles that can be reduced to "Joyce is a writer, GODDAMN your eyes, Joyce is a writer, I tell you Joyce etc etc. Lewis can paint, Gaudier knows a stone from a milk-pudding. WIPE your feet!!!!!!" *The Letters of Ezra Pound 1907–1941,* ed. D. D. Paige (London, 1951), 179. Note also his letter (ibid., 80) to Harriet Monroe, 30 Sept. 1914, regarding T. S. Eliot: "He has actually trained himself *and* modernised himself *on his own.* The rest of the *promising* young have done one or the other but never both (most of the swine have done neither). It is such a comfort to meet a man and not have to tell him to wash his face, wipe his feet, and remember the date (1914) on the calendar."

22 Wyndham Lewis (in Paris, having seen Gwen John) to his mother, c. 1904, and again, c. 1907: *The Letters of Wyndham Lewis,* ed. W. K. Rose (London, 1963), 11–12, 31.

23 See Augustus John on Lewis as "our new Machiavelli" in *Chiaroscuro: Fragments of Autobiography* (London, 1952), 73: "In the cosmopolitan world of Montparnasse, P. Wyndham Lewis played the part of an incarnate loki, bearing the news and sowing discord with it. He conceived the world as an arena, where various insurrectionary

forces struggled to outwit each other in the game of artistic power politics." (Lewis left Rugby School by December 1897 and the Slade in 1901.) See Rose, *Letters of Windham Lewis*, 2, n. 38, on Lewis' years in Paris c. 1902–9.

24 Lewis' Nietzschean manifesto is "The Code of a Herdsman," first published in *The Little Review* 4, no. 3 (July 1917) as "Imaginary Letters, III": "Above all this sad commerce with the herd, let something veritably remain 'un peu sur la montagne.'" "The Crowd Master" appears in *Blast* 2 (1915) 98. Tyros (satires, "forbidding and harsh") first appeared in Lewis' *Tyros and Portraits* exhibition at the Leicester Galleries, April 1921, which included his *Self Portrait as a Tyro* (1920–1). In 1921 and 1922, Lewis edited two issues of *The Tyro, a Review of the Arts of Painting, Sculpture and Design* (Egoist Press). The first section of the *Blast* "Manifesto" (20 June 1914) announces, "We are Primitive Mercenaries in the Modern World." Two of Lewis' biographers borrow their titles from his self-characterization as the Enemy: Geoffrey Wagner, *Wyndham Lewis: A Portrait of the Artist as the Enemy* (London, 1957), 22 ff.; and Jeffrey Meyers, *The Enemy: A Biography of Wyndham Lewis* (London, 1980), 107–8.

25 See Pound's monograph on Gaudier-Brzeska, 47, n. 22: "He accepted himself as 'a sort of modern Cellini.' He did not *claim* it, but when it was put to him one day, he accepted it mildly, quite simply, after mature deliberation." And H. S. Ede, *Savage Messiah* (1931; reprint, London, 1972), 136: In Brodkzy's presence Gaudier-Brzeska "seemed to be thrown into a vivid energy.... Brodzky... [called him] 'Savage' and 'Redskin.' It pleased Pik [Gaudier] to be thought elemental, and Brodzky and Zosik [Sophie] would call him 'Savage Messiah,' a name deliciously apropos." Horace Brodzky himself recalled that Gaudier-Brzeska was "continually talking 'savage,' and 'barbaric' and gloated over the free and erotic life of the South Seas" (*Henri Gaudier-Brzeska 1891–1915* [London, 1933], 56).

26 Laurence Housman (alluding to John's presence in William Orpen's painting of *The Café Royal*), *Manchester Guardian*, 25 May 1912.

27 See "Cantleman's Spring-Mate," *Blast* 1 (20 June 1914): 94. Lewis' interest in Worringer is discussed by Geoffrey Wagner, *Wyndham Lewis*, 110, 153–5.

28 Pound (*Gaudier-Brzeska*) cites with approval Lewis' description of the "peculiar soft bluntness" in works such as Gaudier-Brzeska's *Stags* and *Boy with a Coney* (p. 26); and holds out for the "squarish and bluntish work" (including *Birds Erect*) as examples of the artist's "personal combinations of forms" (pp. 78–9). Brodzky (*Henri Gaudier-Brzeska*) quotes Pound – "Yes, Brzeska is immortalising me in a phallic column" – and stresses the phallic qualities of the head as intended from the beginning by sculptor and sitter (p. 62). Lewis described the finished work as "Ezra in the form of a marble phallus" (quoted by Cork, *Vorticism and Abstract Art*, 182).

29 John's numerous and complex liaisons and their progeny are dealt with by Michael Holroyd, *Augustus John: A Biography*, rev. ed. (Harmondsworth, 1976). Lewis had three illegitimate children and conducted a range of concurrent relationships before, and during, his marriage (see Meyers, *The Enemy*). Kate Lechmere (for *Blast*) and then, in the 1920s, Anne Estelle Rice and Jessica Dismorr, among others, lent him money. In the case of Lechmere and Dismorr, this soured their relations. The diary of Gaudier's mistress Sophie Brzeska, whose name he took, is in Cambridge University Library. It is fraught with arguments about money and sex. Before we thank John Quinn and Ezra Pound as enlightened patrons of Gaudier-Brzeska, we should recall

Sophie's dwindling savings and the washing, cleaning, cooking, and mending at which Gaudier sneered but of which he was the beneficiary. ("At least," Sophie remarked sarcastically, "I have saved a genius for humanity.")

30 "You are young and can stand a lot but you won't always be. Save your precious nerves. You must not be perpetually in a state of purposeless excitement. The grounds must be allowed to settle and the coffee to clear.... Don't stand any nonsense from your men friends and lovers. Keep them *tyrannically* to their settled hours – like a dentist – the hours that suit you – and them so far as possible. Don't give anyone any rights. Exact an absolute obedience to time *as the price of any intercourse at all*. Don't be a tin kettle to any dog's tail, however long." Walter Sickert to Nina Hamnett, 1918, quoted by Denise Hooker, *Nina Hamnett: Queen of Bohemia* (London, 1986), 114.

31 Quoted by Paul Levy, "The Colours of Carrington," *Times Literary Supplement*, 17 Feb. 1978, p. 200. (Dora Carrington used only her second – ungendered – name.) There is a new biography: Gretchen Gerzina, *Carrington: A Biography* (London, 1989).

32 Vanessa Bell was tied into Bloomsbury aesthetics by an intricate network of kinship and love, as sister of Virginia Woolf, wife to Clive Bell, and lover first of Roger Fry and subsequently Duncan Grant. Curiously, both Bell and Carrington devoted their lives to men who were chiefly homosexual. But Grant, as a painter himself, was, unlike Lytton Strachey, able to demonstrate an active interest in his partner's work. And Bell took the practical step of founding her own exhibition society in the Friday Club. She was thus in a better position than the women excluded or marginalized by rival avant-garde coteries. See Richard Shone, "The Friday Club," *The Burlington Magazine* 117 (May 1975); and Frances Spalding, *Vanessa Bell* (London, 1983).

33 Joan Riviere, "Womanliness as a Masquerade," *The International Journal of Psychoanalysis* 10 (1929); reprinted with an article by Stephen Heath, "Joan Riviere and the Masquerade," in *Formations of Fantasy*, ed. Victor Burgin, James Donald, and Cora Kaplan (London, 1986). I am grateful to Whitney Davis and Claire Pajaczkowska for comments on the "masquerade," though I have no space to develop them here.

34 Jacques speaks the lines of William Shakespeare's *As You Like It*, but "Totus mundus facit histrionem" was a commonplace written on the wall of Shakespeare's theater, The Globe.

35 Riviere, from Burgin, Donald, and Kaplan, eds., *Formations of Fantasy*, 35.

36 Nevinson and Marinetti's futurist manifesto *Vital English Art* (1914), which damned effeminacy and called for an art that was "strong, virile and anti-sentimental," was published in full in the *Observer* (7 June 1914). It is reproduced in C. R. W. Nevinson, *Paint and Prejudice* (London, 1937), 58–60. Masculinity and femininity are assymetrically placed, of course, in relation to the masquerade as symptom or strategy. The defense of an aggressively heterosexual masculinity would be a defense against narcissism and the fantasized retribution of more virile men, there being no symmetrical economy of masculinity in which women would be the source of retribution.

37 Virginia Woolf, *Three Guineas* (1938; reprint, Harmondsworth, 1977), 23; Eugenie Lemoine-Luccioni, *La Robe* (Paris, 1983), 34; both quoted by Stephen Heath in *Formations of Fantasy*, 56.

38 Mary Jackson, *Maud Skillicorne's Penance*, vol. 1 (1858), 89, quoted in Bo Jeffares, *Artist in Nineteenth Century Fiction*, 67.

39 C. R. W. Nevinson, *Paint and Prejudice*, 26. He lists Wadsworth, Allinson, Claus, Ihlee, Lightfoot, Curry, and Spencer as fellow members of the "gang." There is no space here to go into the fascinating question of women's bohemian dress, but, Dorelia's gypsy finery aside, there is some suggestion (particularly with Nina Hamnett and Dora Carrington) that it veered towards bobbed hair, colored stockings or socks, and children's shoes: a carefully cultivated modern artist-ness that combined the New Womanly with the prepubertal. Like another of Riviere's patients, they treated the whole thing with levity and parody. Perhaps that was the form of their masquerade.

40 Augustus John's biographer speaks of his "inverted dandyism." He had, as Wyndham Lewis recalled, "a carriage of the utmost arrogance"; and Edward Thomas reported that "with his long red beard, ear-rings, jersey, check-suit and standing six feet high,...a cabman was once too nervous to drive him" (quoted in Holroyd, *Augustus John: A Biography*, 359). On John and gypsies, see ibid., (especially pp. 45, 356–60, 397, 401, 408–9); Malcolm Easton and Michael Holroyd, *The Art of Augustus John* (London, 1974), 12–13; and Malcolm Easton, *Augustus John: Portraits of the Artist's Family* (Hull, 1970). The 1909 caravan trip was photographed by Charles Slade, whose brother Loben married Dorelia's sister Jessie. There are prints in the National Portrait Gallery archives.

29

What the Papers Say: Politics and Ideology in Picasso's Collages of 1912

David Cottington

The move Picasso made in 1912 away from the austerity of hermetic Cubism and towards a more explicit acknowledgment of life outside the studio has been carefully charted in histories of Cubism. Most recently Pierre Daix noted his change of companion, Eva for Fernande, and of locality, the café terraces of Montparnasse for the village bohemia of Montmartre, as contributory factors in the development of an art of everyday life whose iconography was that of the café table.[1] Shortly after moving to his new studio on the Boulevard Raspail in October, Picasso began to explore the pictorial possibilities of *papiers collés* in a series of small charcoal drawings on paper that addressed subjects of everyday city life with a new freshness, making deft and lighthearted use of newspapers, food and drink labels, and sheet music.

It is now more than twenty years since Robert Rosenblum first suggested that readings of these works other than the conventional purely formalistic ones were possible; readings that acknowledged the subject matter contained in the fragments of collaged material and that turned on the confrontation between visual and verbal signifiers. Rosenblum's main points were three: first, that close inspection showed it to be inconceivable that Picasso was not in these *papiers collés* making direct and repeated use of the subject matter of the fragments; second, that he was hugely enjoying the potential he had discovered for visual and verbal puns of a kind Rosenblum found comparable to the writing of Joyce; third, that these works "establish[ed] with startling vividness, Cubism's connections with the new imagery of the modern world," that

David Cottington, "What the Papers Say: Politics and Ideology in Picasso's Collages of 1912," pp. 350–9 from *Art Journal* (Winter 1988), published by the College Art Association. © 1988 by David Cottington. Reprinted by permission of David Cottington.

in this light, the cubist sensibility to the kaleidoscopic assault of words and adver-
tising images to be found in the most commonplace urban situations represents the
first full scale absorption into high art of the typographical environment of our
century.[2]

Rosenblum's suggestions opened up a field of inquiry that was subsequently
cultivated assiduously by others; with two exceptions, until very recently this
work has elaborated his ideas but not advanced from or reflected upon them.
The exceptions – Françoise Will-Levaillant in 1976 and Rosalind Krauss in 1981 –
both offered semiological readings of collage that did so significantly, and that in
the latter case served as the vehicle for a critique of the very premises of Rosen-
blum's approach.[3]

Despite these developments all of the contributors have shared the fundamen-
tal, familiar, and profoundly questionable modernist assumption of the autonomy
of Picasso's art practice. From the structuralism of Krauss's semiotics to the
subjectivism of Rosenblum's punstery this practice is regarded as existing inde-
pendently of Picasso's social experience; whether, as in the former, the product of
a linguistic system or, as in the latter, the expression of Picasso's sensibility, the
papiers collés and their origination are severed from any social context. For
Rosenblum indeed they are self-evidently and unproblematically "high art." Yet
the notion of high art is not a given, immutable one; it is a *social* construct, and
the practices that are understood to be framed by it are social practices, however
individual they may be. Much recent art-historical work on the modern and other
periods has, of course, made this point repeatedly, and developed its complex
implications. Not for Cubism, however, until recently; and thus the appearance in
the last two or three years of studies of aspects of Cubism that explore contextual
issues is welcome. Of these, Patricia Leighten's article of December 1985 on
Picasso's collages of 1912–13 has been perhaps the most interesting so far in its
emphasis on the relevance of political events and ideologies to Picasso's art
practice and its attempt at a political reading of these works in particular. Mar-
shaling evidence of the artist's youthful immersion in Barcelona anarchism of the
1890s, Leighten argued that the collages represent a commitment to antimilitar-
ism on Picasso's part, consistent not only with that early experience but also with
the – in anarchist terms – implicitly social radicalism of the Cubist project itself.[4]

Such an insistence on the relevance for Picasso of the world beyond his own
social milieu is itself valuable, and Leighten's article is in specific respects illumin-
ating and informative, first in its tracing of Picasso's affiliations and allegiances
within the anarcho-symbolist movement, and second (and particularly) in its
demonstration that the preponderance of Balkan War dispatches in the artist's
papiers collés was almost certainly not coincidental. Of the fifty-two works of 1912
and 1913 that contain newspaper text, at least half deal with the Balkan Wars then
taking place and the economical and political state of Europe, and most of these
were produced in the autumn and winter of 1912; in other words, the majority of
those *papiers collés* that were the result of Picasso's first experimentation with the

technique featured this subject.[5] It would appear, further, that these cuttings were carefully selected by Picasso, cut and positioned with a concern for their specific subject matter. What cannot be deduced from these facts alone, however, is the *nature* of his interest in such dispatches and their identifiable subject. *How* do these cuttings signify in each work as a whole? And how might they have done for Picasso in 1912? If we are to answer these questions we must first ask other ones that address the wider contexts within which not only Picasso's practice but his cultural milieu were situated. How did this milieu relate to the Parisian avant-garde? And that avant-garde to the social formation as a whole? By what criteria was the former distinct? What discourse(s) prevailed in it? And how did these relate to Picasso's Cubism?

What lies behind such questions is the recognition that what really matters is the *kind* of contextualization that is offered. In the past decade, Cubist studies have been considerably enriched by the examination of the influence on Cubism of, *inter alia*, the philosophy of Bergson, neo-Symbolist poetics, Futurism, and simultaneity. Crucially, however, what is yet lacking is any thorough account of what might be called the middle terms in the equations thus drawn between aspects of Cubism and the leading intellectual currents of the time: those material factors of discourse, ideology, relations of production within and through which, in the historical conjuncture of the prewar decade, Cubism was constituted. The following is an attempt to adumbrate such an account, and to indicate how it might be brought to bear on Picasso's experimentation with collage. It suggests not only a reading of the 1912–13 work by Picasso that departs in crucial respects from that of Leighten but also some conclusions of a broader kind regarding Picasso in 1912 and, beyond this, the nature of the "relative autonomy" of Cubism in general.[6]

As Antonio Gramsci wrote, nationalism is the popular religion of modern societies, "the particular form in which the hegemonic ethico-political element presents itself in the life of the state and the country." As such, it was the ideological terrain over which the struggle between rival hegemonic elements in the pre–World War I decade in France was conducted.[7] On the ascendant since the first Moroccan crisis of 1905, nationalism's status as popular religion was unequivocally established by the reprise of that diplomatic incident, which occurred in 1911. With certain significant exceptions, a patriotic fever dominated, from the end of 1911, every aspect of public life in France. The Paris correspondent of the *Daily Telegraph* noted this development; in March 1912, describing the spring review of the Paris garrison reservists, an annual affair usually ignored by the city's inhabitants, he declared:

> The most remarkable demonstration of patriotism I ever remember having seen here was made today. For a couple of hours this evening I have been hearing at frequent intervals the tramp of boots, the crashing and rolling of regimental bands, and roars of cheers along the boulevards beneath my windows.... I repeat that I have never seen such a demonstration of military patriotism in Paris before. The change

in the French national temper is one of the most remarkable events in Europe today.[8]

French society was not monolithic, however, and the popular religion of bellicose nationalism did not penetrate all sectors of it evenly in the prewar decade. On the one hand, there existed rival notions of it; on the other, there were social milieux in which it met with little sympathy. Among the politically organized working class in particular, antimilitarist feeling was profound until the very last days of peace; this was reflected first in the 1914 parliamentary election successes of the SFIO (Section Française de l'Internationale Ouvrier) socialists, whose campaign centered on a rejection of the extension of military service, and second, and more consistently, within the syndicalist movement, where patriotism was rejected as a property and a weapon of the bourgeoisie, and the argument that the proletariat has no country was repeatedly made in the pages of *La Guerre Sociale*.[9] Within the Parisian aesthetic avant-garde also there were milieux that, until 1913 at least, shared little of the prevailing sentiment of nationalism; unlike the socialists and syndicalists, however, it was here rejected not for consciously political reasons but as part of a withdrawal from political engagement that had begun about 1906, in favor of a commitment to aestheticism, a belief in the superior truth of art.

In 1905–6 there began a shift to the right in the political temper of France of such fundamental importance for the cultural as well as the political life of the nation that it has been seen as a historical watershed.[10] Taking the form both of realignments of parliamentary forces and of a change of public mood expressed by support for authoritarian government and the growth of right-wing groups such as Action française, it was precipitated partly by the first Moroccan crisis of 1905, partly – and more fundamentally – by the collapse in the same year of the parliamentary alliance of the Bloc des Gauches, and the concomitant growth of syndicalist autonomism. There had been, before 1905, a decade of collaboration between the working class and the liberal bourgeoisie, expressed in narrowly political terms by a *rapprochement* between syndicalism and parliamentary social-ism and (from 1899) between the latter and the Radicals, and in broader terms in movements such as the universités populaires and the anticlerical youth leagues;[11] it found its most resonant symbol in the Dreyfusard cause.

After 1905, the syndicalist movement, disillusioned by the results of its collab-oration with parliamentarism, reaffirmed its commitment to economism (and to the general strike as the primary instrument of revolution) and its distrust of political parties. At the same time it made a significant break with anarchism.[12] This came as a double blow to many liberal intellectuals, members of the literary and artistic avant-garde among them, for it at once sounded the death knell for the universités populaires and other institutions of class collaboration (in which future members of the Cubist circle such as Gleizes, Léger, Mercereau, and Apollinaire had participated), and brought to an end an era of partnership – of sorts – in anarcho-symbolism, between aesthetic and political revolutionaries, when for many of the former the two terms could indeed be seen as synonymous.

The editorial secretary of *Vers et Prose* was André Salmon, one of the most promising of the young poets sympathetic to Symbolism and a member of the Montmartre-based *fantaisiste* group of poets, whose unofficial leader, according to André Billy, was Apollinaire. On the latter's initiative, the *fantaisiste* review, *Le Festin d'Esope*, was founded in 1903 and lasted for nine months. Billy described the poetry of the group as "made up of irony, insouciance, melancholy, offhandedness, of a certain manner of taking nothing as tragic"; it was "contrary to those tendencies . . . which were serious, social, humanitarian." The *fantaisiste* morality was noctambulism and idleness, their friendships those of the bar and the studio.[20] It was no accident that they were based in Montmartre: La Butte was then at the height of its reputation as an artistic bohemia in which, as André Warnod described it, a "mixture of authentic crooks, forgers, thieves and still worse, young fallen women and rakes in flight from their respectable families composed the background" for the *humoriste* artists such as Forain, Willette, Léandre, Steinlen. Artists and villains fraternized in what Warnod called "the snobbery of the gutter."[21] This bohemian image attracted many aesthetic radicals like the *fantaisistes*, young men of the middle class eager to escape the constrictions of social convention.

Not that its associations alone brought the disaffected bourgeoisie to Montmartre; many came for its art as well. From about 1903 it was frequented by a relatively new kind of art collector, the *dénicheur*. Although a few single-minded amateurs had patronized the Impressionists and Postimpressionists in the 1880s and 1890s, from the turn of the century speculation in the work of new or unknown artists became more viable in the Paris market – a fact reflected in the foundation in 1904, for primarily speculative motives, of André Level's collecting group, La Société de la Peau de l'Ours.[22] This brought into the market a growing number of younger collectors of relatively modest means who were prepared to put their faith in artists of their own generation and to declare their independence of prevailing taste. Many of these were from outside France, attracted to Paris by its artistic reputation and less constrained by the conventionality that dominated the taste of the French public: Gertrude and Leo Stein from America; Wilhelm Uhde, Adolphe Basler, Alfred Flechtheim from Germany; Hermann Rupf from Switzerland; Vincenc Kramář from Prague. Those Frenchmen who collected the work of young unknowns were generally from comfortable bourgeois backgrounds – André Level, Roger Dutilleul, and Georges Aubry were from professional families, Frank Haviland's father an industrialist – and, secure in their mastery of existing social values, they were free to assert their own individuality through their purchases of unorthodox art. For these collectors, their comparative lack of financial resources was a challenge, compelling them to collect the work of unfamiliar artists and to trust to their own judgment in doing so; the pleasure of "déniching" a bargain being often equal, as Uhde acknowledged, to that of aesthetic contemplation of the prize.[23]

Works of art at this level of the market were, clearly, to be found not so much in the leading galleries or even the Salons (with the exception of the unjuried

Indépendants) as in smaller, out-of-the-way galleries and in the studios of the artists themselves – if these could be tracked down – both of which were proliferating in turn-of-the-century Montmartre. Hence Wilhelm Uhde, although he bought all the paintings that Braque showed at the 1906 *Indépendants* and five of the six he entered in that of 1907, preferred to explore the small galleries and *bric-à-brac* shops in the artistic *quartiers*. It was on such an exploration that he came across Père Soulier's bedding shop on the rue des Martyrs, and from him bought Picasso's *Tub* for ten francs.[24] Leo Stein also began by buying from the *Salon d'Automne* and the *Indépendants*, but once acquainted with the artists whom he patronized, their dealers, and their circle of friends, he made his purchases through these channels instead.[25] André Level acknowledged that he was stunned by the vitality of the 1903 *Salon d'Automne*, but he, too, made his acquisitions directly from the artists or from the small galleries who took their work, visiting Montmartre "two or three times a fortnight" in order to do so. Roger Dutilleul bought initially from small left-bank galleries, and later only from Kahnweiler; Olivier Saincère paid regular calls to the artists of Montmartre.[26]

The aesthetic interests of these *dénicheurs* were correlative with their pleasure in déniching: while they sought out work that asserted its independence of prevailing taste – in particular that of the respectable avant-garde – and was formally innovative, they bought only work that was still annexed to what they saw as the Great Tradition of French painting. It was in no way the intention of these collectors to challenge traditional aesthetic values. "What interested me as a collector," Uhde later wrote of Picasso and Braque, "was the *grande peinture* with which these painters maintained the tradition of the Louvre."[27] Level, too, acknowledged the centrality for him of the French cultural heritage; for all the youthfulness and boldness that he valued in the art he bought for the Peau de l'Ours, this art yet shared a distinct aesthetic that declared "a marked return to solidity, composition, a loftily conceived tradition."[28] And he recognized the same aesthetic predilections on the part of Kahnweiler, who, he observed, "knew how to find among the artists whom the leading Parisian dealers had scorned the best practitioners of the youthful, independent, and yet traditional art of the first years of the twentieth century."[29]

Such collector-dealers thus shared with other members of the Montmartre community beliefs and aesthetic allegiances that, in the context of the prewar decade, can be seen as elements of a distinct ideological discourse, whose principal points of articulation were a commitment to aestheticist avant-gardism, a corresponding indifference (until 1913 at least) to the hegemony of nationalism, and an attachment to traditional aesthetic values. This discourse provided one level of context for Picasso's art practice.

It was accompanied by another – that of patronage. From 1905 the attention paid Picasso by the *dénicheurs* was sufficiently regular for him to avoid the necessity of hawking his work around the dealers or showing in the salons. His rhythm of working, and the scale of his paintings, were, however, still in a "salon" mode.

His progress was punctuated by large works summarizing his thematic and formal interests in each phase of it, each preceded by numerous studies; thus the *Saltimbanques* in 1905, the *Two Nudes* in 1906, the *Demoiselles d'Avignon* in 1907, the *Three Women* in 1908–9. These paintings were public in orientation: despite being seen at the time of their completion by relatively few people, their intended audience was a strategic, influential, and growing circle of artists, critics, and connoisseurs. They were, among other things, vehicles for the enhancement of his reputation, and their success in this respect is reflected in the rapidity with which the news of his commencement of each major work spread through the Montmartre grapevine.[30]

After the *Table with Loaves and Bowl of Fruit* of early 1909, however, there was an abrupt change in both the rhythm and scale of Picasso's production: he painted no more large works preceded by studies in this manner until the *Woman in an Armchair* project of 1913; very few large works at all, indeed, in the intervening years. This was matched, at precisely the same moment, by an equally marked development in his patronage situation. First, Vollard, who, alarmed by the artist's early Cubism, had stopped buying from Picasso in 1907 and 1908, began to buy again: in early 1909 the *Table with Loaves* and two other works, and five more on Picasso's return from Horta in late summer. Second, the Steins bought even more major works than in previous years: eight in 1908, six in 1909. Third, other collectors joined the circle: Sergei Shchukin, Frank Haviland, Roger Dutilleul all made their first purchases in these months.[31] Fourth, and most crucial, Kahnweiler began early in 1909 to buy increasing numbers of paintings from him: as against twelve in 1908 he bought at least thirty-five in 1909, some of them works of 1906 and 1907 that he had previously ignored. From this date until the war, assisted and partly financed by the other patrons, he underwrote Picasso's entire output, thereby mediating between him and the art public, freeing him of the need to seek sales, success, and renown on his own.

This development had several consequences for Picasso. For one thing, it meant that he was for the first time financially comfortable, a fact that he signaled by moving, upon his return to Paris from Horta in the fall of 1909, from his bohemian quarters at the Bateau-Lavoir to an elegant apartment on the Boulevard de Clichy. Also, he entered at that time into that close relationship of artistic give-and-take with Braque which lasted through 1912, and he gravitated towards a different social milieu: visiting the dealers regularly and attending fashionable avant-garde *soirées*, those of the Steins, Paul Poiret, and Haviland in particular.[32] These alterations in his way of life could perhaps be characterized, as Daix implies, as a process of *embourgeoisement* of the artist; but there are more useful ways of looking at them. The developments outlined here amounted to a change in Picasso's mode of production, the consequences of which for his art were twofold.

In the first place, they contributed to an enhancement of certain features of his artistic identity, and to the confirmation and clarification of his ideological allegiances. From 1909 Picasso relied more closely than before on a circle of

friends and patrons that was ideologically homogeneous. Whether as dealers and collectors (such as Kahnweiler, Uhde, the Steins, and Dutilleul) they were committed to the discovery of contemporary *maîtres*, or as poets (such as Apollinaire, Salmon, and Jacob) they subscribed to the principles of neo-Symbolism, or (like Braque) to a formalism extrapolated from Cézanne's late work, the members of this circle shared a profound attachment to that aestheticism earlier described, the principal features of which were a belief in the social autonomy and superior truth of art and a commitment to traditional aesthetic values. This circle thus not only confirmed Picasso's sense of his own abilities and lessened that drive for recognition which had propelled the previous rhythm of his work, but also represented a cohesive and distinct grouping within the artistic avant-garde. Itself self-consciously and defensively avant-garde in relation to the incomprehension both of the latter and of the art public, this grouping was correspondingly supportive of Picasso's preoccupation with the nature and workings of his painterly imagination.

And in the second place, the change in Picasso's mode of production determined in central respects the very appearance and specific qualities of the paintings. The point is worth emphasizing: it is not simply that such changes *enabled* Picasso to pursue pictorial concerns of a technical and formal kind on a smaller and more private scale, but that they *entailed* this pursuit. As Terry Eagleton has argued, in discussing literary production:

> If literary modes of production are historically extrinsic to particular texts, they are equally internal to them: the literary text bears the impress of its historical mode of production as surely as any product secretes in its form and materials the fashion of its making.... One might add, too, that every literary text in some sense internalises its social relations of production – that every text intimates by its very conventions the way it is to be consumed, encodes within itself its own ideology of how, by whom and for whom it was produced. Every text obliquely posits a putative reader, defining its producibility in terms of a certain capacity for consumption.[33]

The observation is applicable to Picasso. His mode of artistic production before 1909 entailed, in the ways outlined above, large salon-type paintings such as the *Demoiselles*. After 1909 the audience for his paintings was a private one, a small, self-selected elite of *cognoscenti* responsive to formal pictorial innovation and intertextual play but committed to a fundamentally conservative aesthetic: on the one hand, collectors discreetly hailed by Kahnweiler's unostentatious gallery; on the other, the poet habitués of the Bateau Lavoir and, crucially, his close partner, Braque. The paintings were then correspondingly private in orientation, stylistically dense and difficult to read, elliptical and playful in their references, accessible only to initiates. In place of the former rhythm of progression from project to project, after early 1909 Picasso worked through an open series of paintings, approaching each fresh canvas both as a point of departure for the development of a relatively consistent set of pictorial ideas and as the site of

prolonged technical experimentation, engendering thereby a complexity of pictorial structure distinct from that which characterized his earlier work.

Fundamental to these ideas and experiments was a project of interrogation of conventions of pictorial realism, a concern to find more adequate means of representing his and Braque's social experience. The texture of that experience can be read in their paintings of the period, in the repeated, half-veiled references to tokens of popular culture, as in *the Woman with a Guitar ("Ma Jolie")* (1911–12), and sly sexual double meanings, such as that of the mirror and keyhole in *The Dressing-Table* (1910).[34] But it was displaced in the painting process, refracted through the circumstances of Picasso's art practice and his absorption with a linguistic play of devices of illusionism that became increasingly Mallarmist:

> To evoke purposely in a shadow the silent object, with words that are never direct but allusive, subdued to an equal silence, requires an endeavor close to creation; it becomes credible within the limits of the idea that is uniquely called into play by the magic of letters until, of course, some visual illusion sparks. Poetry, that spellbinding ray![35]

Having presented an outline reconstruction of the cultural force field surrounding Picasso's Cubism – the pressures of material forces by and through which his art practice was constituted – I now return to the *papiers collés*. Of thirty-one *papiers collés* that Picasso made in November and December 1912 using newspaper cuttings, charcoal, and ink alone, and which were almost all carefully cut and positioned so as to make use of the content of the cutting, at least fourteen have as that content reports on the First Balkan War, whose progress was anxiously followed in France and widely feared as the spark that would ignite a European conflagration.[36] Unless he simply chose whatever news item was the lead in *Le Journal*, which is unlikely for reasons I shall discuss, Picasso selected these reports (as well as, occasionally, accounts of economic affairs) quite deliberately; and he made use of their content in a number of ways. The clearly public, national-political character of these two subjects contrasted sharply with the intimacy of the café table still lifes in which they were employed. Often Picasso established a correlation between this "background of events" against which daily café life was conducted and the background–foreground relationships in the pictorial space. In the *Glass and Bottle of Suze*, for example, the cuttings that lie around the edges of the rectangle, in the background of the Cubist space, are reports on the Balkan War and a socialist anti-militarist demonstration.[37] On the oval blue café table in the center and the foreground stand a bottle of Suze and a glass. Is it coincidence that the newspaper cuttings that Picasso used to describe these objects, rather than form the background, contain what seem to be passages from the *roman feuilleton* of the day, about love and personal affairs? For these are then part of the more intimate world of the *subject* of the work, the author, Picasso (or us the viewer; the point remains the same).

This is not the principal level of meaning of the work, however. In the context of Picasso's work immediately preceding, the contents of the newspaper cuttings are secondary; what is primary is the substitution of ready-made surfaces and references to objects for painted and drawn ones – and the possibilities this substitution contains for spatial ambiguity and contradiction, for manipulating awareness of the fact of two dimensions and the illusion of three. Before we decipher the objects – and thus beyond them the ambience and the "background of events" – we are made aware of how all this is *contingent* on the illusionism and sleight of hand that Picasso has deployed. His own creative presence is central to the work.

In the *Glass and Bottle of Suze* this presence was perhaps veiled and muted by the visual richness, the colors and textures. In works immediately following, however, such was not the case. As Daix acknowledged of the *papiers collés* that Picasso produced in late November and early December:

> never before had the painter so completely destroyed the mystery of his work, never before did he present himself to the scrutiny of the spectator, not only without the tricks of the trade, but using means that are within everyone's grasp. And never before had a painter asserted his power as a creator, as a poet in the strongest sense of the word.[38]

An example of this is the *Table with Bottle, Wineglass, and Newspaper.* On a piece of paper spare, strong, and graceful lines describe the objects. They do so in a way that derives from earlier Cubist research by Picasso, and that incorporates both a succinct laying bare of the signifier and an abstract level of formal harmony between lines and shapes. At the center of this composition, and articulating it by its size, shape, and color is a cutting from *Le Journal* of December 4, 1912. It presents a pun on "un coup de thé[âtre]." Suggesting *coupe de thé* (cup of tea), thereby smuggling in by proxy a fourth object, and slyly contradicting the bottle shape to which it refers, label-like. This, and the wit of it, are the most apparent features of the work, and they are a closed world of interreference. Or *almost* closed; for the newspaper cutting refers (and deliberately so, or Picasso would have cut it off) to the Balkan War,[39] and this leads us to the associations with sitting at a café, reading a newspaper. But the very interest and presence of the wit and the formal conundrum *distance* this; much as war is distanced by the media through which we learn about it.

There are other similar examples. In *Guitar, Sheet Music, and Glass*, a work from early in the series and texturally richer than the others, Picasso indicated the presence both of a newspaper and the background of events that it mediated. Again the report was from the Balkans, and again it was cut and positioned so as to distance this, and to reinforce the foregrounding both of the more immediate and intimate aspects of café experience and of Picasso's formal artifice in the consciousness of the putative viewer. This functions both visually in that the cutting is in the corner of the work, outside the close grouping of shapes and

papers that wittily make up the still life, and verbally in providing the foil for a range of punning associations that are personal and private.[40] In *Table with Bottle and Wineglass*, one of the last and most schematic of the group, a single cutting serving as both newspaper and label contains within itself the background–foreground division. The juxtaposition of the public crisis ("La Négociation.../és sont à Londres") to the suggestion of a private drama ("Un dra/Parisien/"), signals a rich polarity of meanings with a succinctness that is consistent with the rest of the drawing and is one of its cardinal qualities.[41] In contrast to this, finally, is a pair of works, both entitled *Table with Bottle* coupled by an obvious formal reciprocity, the full significance of which lies in the content of the respective cuttings. In the former, the newspaper – which covers the entire paper, except for the cut-out bottle shape in the center and is both the background to the still life and the ground on which Picasso has drawn it – is the entire economic affairs page of *Le Journal* of December 8, 1912. In the latter the cutting – which isolates and foregrounds the bottle – is devoted to an item on "La G[uerre contre] l'Avarie" (the war against syphilis) from the same paper, but not, as close inspection reveals, from the same *sheet* of paper.[42] The particular relationship here proposed between background/public events and foreground/private concerns, and the role played by Picasso's creative imagination in the establishment of it, could hardly be more clearly indicated.

To argue, then, as Daix has, that Picasso's *papiers collés* "expressed a deep inner need to shatter the bounds of traditional painting, the noble conception of art," and as Rosenblum did, that "Picasso embraced the realism of the printed word that abounded in the city," is misleading. On the other hand, to read the references to war and pacifist demonstrations as indicative of Picasso's antimilitarism, as Leighten does, is attractive but ultimately unsatisfactory, for it ignores the questions of how the cuttings signify in relation to each work as a whole, and of the *terms* on which Picasso incorporated such extraneous material into his art. The comparison to Joyce, which Rosenblum offered, is instructive here. For *Ulysses* is perhaps the most extended and memorable attempt in our literature to represent the language and consciousness characteristic of the modern urban experience. As Raymond Williams observed:

> in *Ulysses*...there is not only search but discovery: of an ordinary language, heard more clearly than anywhere in the realist novel before it; a positive flow of that wider human speech which had been screened and strained by the prevailing social conventions...the greatness of *Ulysses* is this community of speech.[43]

In the subject matter of his late-1912 *papiers collés* Picasso introduced the visual equivalent of "that wider human speech" into art. And in a sense his breaking beyond – in the materials he employed in these – the conventions of what could or could not be used as art material *did* hold out the possibility of discovering for art that "ordinary language" of everyday urban visual culture. But in Picasso's handling of these new materials and freedoms, that culture and – in the Balkan

War works – its political preoccupations of the moment were distanced, mediated, used as background in the ways described above. Thus the possibility that he opened up was precluded for him from the very beginning: what was important for Picasso was that he perform the magic, make art out of nothing. It was an expansion of art's empire by the colonization of other, formerly independent areas, that Picasso achieved, not the breaking-down of the frontiers between them. Radically innovative though these *papiers collés* were, they were yet in ideological terms representations of an aestheticist individualism that underpinned conventional – and in the context of the debates of 1912 fundamentally conservative – attitudes to the relations between fine art and a wider visual culture.

This is, necessarily, a summary account of the material determinants of Picasso's art practice in 1912, and of how an understanding of these might be brought to bear on a reading of a specific body of work. As such it undoubtedly raises more questions than it has attempted to answer; indeed two quite fundamental questions at once suggest themselves. The first concerns the applicability of this approach to the development of the Cubist movement itself. Up to the present, studies of Cubism have largely ignored the question of the social grounding of its practices, either representing these in terms of the clichés of *belle époque* artistic rebelliousness or, as in recent work, containing the examination of them within an understanding of the Parisian aesthetic avant-garde as an intellectual community impervious to the shocks and pressures of everyday social life and events except in the most indirect of ways. What the above account has tried to demonstrate is the importance, for any historical understanding of Cubism, of reconstructing the discourses of the avant-garde, uncovering their ideological subtexts and material underpinnings. The pre-World War I Paris in which these discourses were elaborated needs therefore to be the object of much further study by historians of Cubism: we need to know more about the components and origins both of hegemonic nationalism and of the aesthetic avant-garde, about the relation between the two, and between the latter and the intellectually and morally dominant groups within the social formation.[44] This study should include an examination of the cultural left wing in the prewar years and its relationship with the Cubist movement; though more complex than Leighten appears to imply, such a relationship existed, and was of significance for the subsequent development of modernism.[45]

The second question concerns the theoretical assumptions of the above account, which may be seen as unduly mechanistic in its correlation of art practice with ideology. I do not suggest that Picasso's practice was unproblematically ideological, or that the *papiers-collés* are "explained" by, or signify only with respect to, the ideological affiliations here traced – far less that they reflect Picasso's ideology. Such crude claims are clearly untenable. Indeed, current poststucturalist theoretical debate is highlighting the complexity of the relationship between notions of ideology and subjectivity,[46] and the implications of this for a rethinking of Picasso's art are fascinating. What *is* suggested, simply and

centrally, is that if our understanding of Cubism is to get beyond the subjectivism not only of formalist readings but also of idealist contextualizing we must uncover its material determinants, its ideological discourses. How Picasso's paintings depart from such discursive constraints is perhaps the next question; but how they relate to them is surely the first.

Notes

1 Pierre Daix and Joan Rosselet, *Picasso: The Cubist Years, 1907–1916*, London, 1979, pp. 89–91.

2 Robert Rosenblum, "Picasso and the Typography of Cubism," in *Picasso, 1881–1973*, ed. John Golding and Roland Penrose, London, 1973, p. 75. The article was based on a talk given at the 1965 Annual Meeting of the College Art Association of America.

3 Françoise Will-Levaillant, "La Lettre dans la peinture Cubiste," in Université de St. Etienne, *Travaux IV: Le Cubisme*, St. Etienne, 1973; Rosalind Krauss, "In the Name of Picasso," *October*, 16 (Spring 1981).

4 Patricia Leighten, "Picasso's Collages and the Threat of War, 1912–13," *Art Bulletin*, 67:4 (December 1985), pp. 653–72. For other contextual explorations, see Michael Leja, " 'Le Vieux Marcheur' and 'les deux risques': Picasso, Prostitution, Venereal Disease, and Maternity, 1899–1907," *Art History*, 8:1 (March 1985), pp. 66–81; also David Cottington, "Cubism, Law, and Order: the Criticism of Jacques Rivière," *Burlington*, 126:981 (Dec. 1984), pp. 744–50.

5 *Leighten* (cited n. 4), p. 667. See also n. 36 below.

6 For an attempt to provide such an account in depth, see: David Cottington, "Cubism and the Politics of Culture in France, 1905–1914" (Ph.D. dissertation, London University, 1985).

7 Antonio Gramsci, *Quaderni dal Carcere*, ed. V. Gerratana, Turin, 1975, p. 1084; Eugen Weber, *The Nationalist Revival in France, 1905–1914*, Berkeley, 1959. On the rival nationalisms, see: Cottington (cited n. 6), chs. 2 and 7.

8 *Daily Telegraph* (March 10, 1912), p. 8.

9 The best general account in English of the politics of the period is J. M. Mayeur and M. Rébérioux, *The IIIrd French Republic from Its Origins to the Great War, 1871–1914*, Cambridge, 1984. On syndicalism, see: J. Juillard, "La CGT devant la guerre, 1900–1914," *Le Mouvement Social* (Oct.–Dec. 1964).

10 D. Thomson, *Democracy in France since 1870*, Oxford, 1969.

11 L. Dintzer, F. Robin, and L. Grelaud, "Le Mouvement des Universités populaires," *Le Mouvement Social*, 35 (April–June 1961), pp. 3–29.

12 In the 1906 Charter of Amiens. See: F. F. Ridley, *Revolutionary Syndicalism in France*, Cambridge, 1968.

13 Camille Mauclair, "La réaction nationaliste en art," *La Revue* (January 15, 1905), pp. 151–74.

14 Henri-Martin (sic), *L'Action Intellectuelle: Notations d'Esthétique*, Paris, 1908, p. 18.

15 Ibid.

16 *Poème et Drame*, 1 (Oct. 1912).

17 Ibid., 1:4 (May 1913) pp. 13–14.

18 Marcel Raymond, *De Baudelaire au Surréalisme*, Paris, 1933; Leroy C. Breunig, "The Chronology of Apollinaire's *Alcools*," *Publication of the Modern Language Society*, 67 (Dec. 1952) pp. 907–26; Michel Décaudin, *La Crise des Valeurs Symbolistes*, Toulouse, 1960.

19 André Gide, "Contre Mallarmé," *La Nouvelle Revue Française*, 1 (Feb. 1909), pp. 96–8.

20 André Billy, *L'Epoque Contemporaine*, Paris, 1956, p. 133.

21 André Warnod, *Les Berceaux de la Jeune Peinture*, Paris, 1950, pp. 23–4, 165. On the cultural character of Montmartre at this time, see also: André Salmon, *Souvenirs Sans Fin (1): L'Air de La Butte*, Paris, 1945; Jeanine Warnod, *Le Bateau-Lavoir, 1892–1914*, Paris, 1975.

22 On the Société de la Peau de l'Ours, see: André Level, *Souvenirs d'un Collectionneur*, Paris, 1959; Guy Habasque, "Quand on vendait La Peau de l'Ours," *L'Oeil* (March 1956). On the prewar Paris art market, see: Malcolm Gee, "Dealers, Critics, and Collectors of Modern Painting: Aspects of the Parisian Art Market, 1910–30" (Ph.D. dissertation, London University, 1977); Cottington (cited n. 6), ch. 3.

23 Wilhelm Uhde, *Von Bismarck bis Picasso*, Zurich, 1938, pp. 127–8.

24 Ibid.

25 L. Stein, *Appreciation*, New York, 1947, pp. 66–9.

26 F. Berthier, "La Collection Roger Dutilleul," (thesis, Sorbonne, 1977) p. 23. For Level (cited n. 22), p. 18, Montmartre was at this period "the uncontested center for artists."

27 Wilhelm Uhde, "Le Collectionneur," *Style en France* 5:2 (Jan.–March 1947), p. 62.

28 André Level, preface to sale catalogue, *Collection de la "Peau de l'Ours,"* Paris, Hotel Drouot, 1914.

29 Level (cited n. 22), p. 71.

30 Ibid., p. 23.

31 Daix, in Daix and Rosselet (cited n. 1), p. 67; Fernande Olivier, *Picasso and His Friends*, London, 1964, p. 116. Dutilleul's first Cubist purchase from Kahnweiler was made in November 1908: Braque's *House Among Trees*, a work from the summer of that year, which was in the exhibition at Kahnweiler's gallery, no. 13. He paid 100 francs for it. *Donation Masurel*, Paris, Musée de Luxembourg, 1980, p. 58.

32 Olivier (cited n. 31), p. 135.

33 Terry Eagleton, *Criticism and Ideology*, London, 1976, p. 48.

34 Daix and Rosselet (cited n. 1), Cat. 430 and 356.

35 From Mallarmé's *Magie* of 1893; quoted by Daniel-Henry Kahnweiler, "Mallarmé et la Peinture," *Les Lettres*, 3:3, Paris, 1948.

36 See: Daix and Rosselet (cited n. 1), pp. 287–95, Cat. 513, 517, 523–30, 532–9, 542–54. It is possible that more than fourteen are on the Balkan conflict; some of the texts in Daix and Rosselet's reproductions are illegible. By checking them against copies of papers of the period, I have been able to confirm, with some minor exceptions, Daix's deductions on dating made from internal evidence in the cuttings. On the response to the Balkan conflict, see: Weber (cited n. 7); also E. Malcolm Carroll, *French Public Opinion and Foreign Affairs, 1870–1914*, London, 1931, ch. XII.

37 Daix and Rosselet (cited n. 1), Cat. 523. Daix states that Picasso's choice of the latter item "was probably intentional," p. 289.

38 Ibid., p. 128. Daix argues that "the newspapers were used very quickly after Picasso received them. The order of their dates corresponds to a logical stylistic order," p. 188.

39 Ibid., Cat. 542. The headline "UN COUP DE THÉÂTRE" (Sensational Development) refers to the Balkan War; Picasso retained in the cutting the subheading, "La Bulgarie, la Serbie, le Monténégro sign[ent]," so that despite the pun's being primary, the reference to the Balkan War (specifically, the armistice) remained clear. On the pun described above, see also: Rosenblum (cited n. 2), p. 52.

40 Daix and Rosselet (cited n. 1), Cat. 513. The cutting is from *Le Journal* of November 18, 1912, not, as Daix states, November 10. Picasso cut across a headline on the left, which had read "Aux portes de Constantinople/un cortège/de cholériques," retaining only "Constantinople," which gives unmistakably the Balkan reference. On the pun and associations around "Le Jou[rnal]," see: Rosenblum (cited n. 2), p. 51. "La bataille s'est engagé" may, among other meanings, be a reference to the challenge presented (and clearly understood as such by Picasso) by the *Salon de la Section d'Or*.

41 Daix and Rosselet (cited n. 1), Cat. 554.

42 Ibid., Cat. 551 and 552. The economic-affairs page of *Le Journal* of Dec. 8, 1912 was page seven, whereas the item on syphilis was on page five.

43 Raymond Williams, *The Country and the City*, London, 1973, p. 294.

44 For an overview of the last of these relationships, see: Jeanne Laurent, *Arts et Pouvoirs en France de 1793 à 1981: Histoire d'une Démission artistique*, St. Etienne, 1982.

45 See: Madeleine Rébérioux, "Avant-garde esthétique et avant-garde politique: Le socialisme français entre 1890 et 1914," in *Esthétique et Marxisme*, Paris, 1974; also Cottington (cited n. 6), ch. 10.

46 For a survey of this debate, and in particular the contribution of Julia Kristeva, see: Steven Burniston and Christopher Weedon, "Ideology, Subjectivity, and the Artistic Text," in *On Ideology*, Birmingham (UK): Centre for Contemporary Cultural Studies, 1983.

30

Dada as "Buffoonery and Requiem at the Same Time"[1]

Hanne Bergius

In founding the Cabaret Voltaire, the Dadaists engaged the "dandyism of the poor"[2] – the "low art" of tricksters, conjurers, puppeteers, tightrope walkers, and comedians – as an affront to the academically oriented art of the theater, salons and galleries. Hugo Ball, one of the founders of Dada, brought them to life in his novel *Flametti*.[3] In order to release art from privacy, the Berlin Dadaists Grosz and Heartfield published regular reports on *variété* and the cinema in their weekly journal *Neue Jugend*,[4] because "your view of the world is colorful in *variété* alone..."[5] The Dadaists saw in itinerant people a metaphor for their own mobility and "homelessness." They honored the restless tramp Chaplin, propeled by mechanistically functioning life yet all the while casually, playfully, and cheekily deflecting its blows, as both "the world's greatest artist" and "good Dadaist."[6]

The exile situation in Switzerland sharpened Ball's awareness of his position in a cultural vacuum. As far as the Dadaists were concerned, the educational capital of bourgeois culture, this "vast sum of intellect [*Geist*]"[7] was at the mercy of a "junk sale."[8] Long before its economic inflation, the war let loose an inflation of cultural values – a "bankruptcy of ideas."[9] Evoking Voltaire, the Dadaists made use of "educational and art ideals as *variété* program – that is our kind of 'Candide' against the times,"[10] as Ball announced. The historical model for the dadaist role of the Fool emerged in the eighteenth century and was defined by the stark contradiction of folly and reason.[11] The Dadaists saw in Voltaire's provocative conception of society as "*ce théâtre et d'orgueil et d'erreur*,"[12] a critical approach that they also used as an anti-German tactic. "Voltaire treated serious things humorously: the German *Geist* never forgave him," so it went in the eighteenth century, "between the German *Geist* and Voltaire stood the secret horror, from which Gretchen, before the hidden Mephistopheles, cannot defend

herself."[13] The French rationalist was rejected by the German rationalists as too radical, and even in the year of Voltaire's death, the *Frankfurter Gelehrten Anzeigen* recommended its readers "to put aside and forget [that] French comic's brazen offspring."[14] To the enlightened German bourgeoisie of this period, all kinds of revolt against society, every joke and laugh at its expense, every individual urge and will to originality were seen as eccentric, notorious symptoms of outsider culture – as ridiculous folly. Besides Voltaire, the Dadaists's other "role models in folly" included Swift, Rabelais, Panizza, Stirner, Nietzsche, Bakunin, Salamo(!), and the Fool of the late Middle Ages.

Constantly reflecting antidadaistically and skeptically relativizing its positions, Dada found its ancestry as perpetual traveler in the Fool of the late Middle Ages. This figure, involuntarily outcast, traveling the waterways, corresponded to the Dadaists's own border situation. Rimbaud's *Bateau Ivre* had already provided the metaphor of the Ship of Fools in the late nineteenth century. Foucault described the madman of the late Middle Ages, who was first singled out from society, as "prisoner of his own departure" whose journey "is at once a rigorous separation and final passage."[15] His situation, caught on the threshold of two worlds that are not his, gave Dada a symbolism that Hausmann defined as "floating between two worlds." "When we have broken with the old [world] but are not yet able to create the new one, satire, the grotesque, caricature, the clown and the puppet appear, and it is the profound purpose of these forms of expression to allow us to perceive and feel a different life by demonstrating the marionette-like nature of things, by apparent and real petrification."[16]

The break with the bourgeois world meant rigorous separation, but it did not entirely rule out dialogue with the "old world," however grotesque the forms it could adopt were. The dadaist awareness of folly stretched from a sense of absurdity to the insight that society was ripe for comedy, "ripe for dada." In the dadaist Fool's game, an ambivalence oscillated between the rational intention to reveal the hostile and unforgiving powers of society and the irrational penetration of reality. Knowledge of the gigantic destructive war machinery and the victory of the anachronistic powers in European societies was not only a challenge to the Dadaists, but actually produced the "madness"[17] of their art. The dadaist insight that life and death are "one and the same" – "and life negates itself. You dead life"[18] – was described by Michel Foucault in his study *Madness and Society* in the passages dealing with the late Middle Ages, pinpointing an important element of the Fool's game: "man disarms fear in advance, making it an object of derision . . . by constantly renewing it during the spectacle of life, by scattering it among the vices, quirks, and eccentricities of all men. Destruction through death means nothing any more because it already means everything, for life itself consists only of hackneyed clichés, hollow words, empty ringing, and fools' bells."[19]

Within the dadaist Fool's game, bourgeois society – and not least art – was exposed by the omnipresence of death as lies and illusion. A clearly apparent mortal fear fueled the rapidly escalating dadaist actions and productions. "Catch

the speeding times before the Devil gets you and before the rotary presses sing the song of the grave,"[20] wrote Grosz to his friend Otto Schmalhausen. The Dadaist attempted eccentrically to defend himself from the fear of doom and the presence of death with his laughter, his game of folly, and sham irony. He concluded from the unresolved contradictions: "Dada is the cabaret of the world just as the world is the Dada cabaret. Dada is God, spirit, matter and roast veal at the same time."[21] With dadaist exclusivity, the world was equated with the cabaret and the cabaret with the world. Dada's total work of destruction [*Gesamtzerstörwerk*] emerged from the spirit of the cabaret, for the cabaret was not only scenic orientation, but also an existential and ambiguously clarifying symbol. In it, the metaphor of the "theatrum mundi," divine world theater that had dramatized its defining hierarchical order – God's government – as the unshakeable course of the world, came back to life as folly. In place of God, a similar nameless decree was at work in the dadaist "circus mundi," though here it appeared to emerge from the "turbulence of dear worldly life" (Grosz) itself. The theological baldachin had collapsed and in its place an "unholy harlequinade"[22] unfolded. In his hymn to the lost God, Hugo Ball took stock: "You are the Almighty, Almighty, magnificent, a burning vessel on your head. In reason and unreason, in the kingdoms of the dead and the living, your metal throat looms and your spoke roars..."[23] Richard Huelsenbeck also revealed a God of chaos in his poems entitled "Fantastic Prayers" ["*Phantastische Gebete*"],[24] and Hans Arp devised the parodic eulogy "woe our good Kaspar is dead."[25] This loss of orientation meant that the artists were inwardly "torn, dismembered, dissevered":[26] "Individual life died, melody died. The singular meant nothing any more. People were overwhelmed by surging thoughts and perceptions, symphonic feelings. Machines appeared and replaced individuals. Complexes and beings arose, superhumanly and superindividually horrific. Terror became a being with a million heads...new battles, collapses and ascensions, new festivities, heaven and hell. A world of abstract demons swallowed the single utterance, destroyed the 'I,' and swung seas of colliding feelings against one another. The most delicate vibrations and the most unheard-of mass monsters appeared on the horizons, amassed, crossed, and blended into one another."[27]

A cynically illusionistic world of images is opened up by the "Seven Schizophrenic Sonnets"[28] by Hugo Ball and the grotesque portrait of the times, "The Idiot,"[29] by Huelsenbeck. The world was chaos without meaning. Aim and purpose were ruled by chance and haunted by destruction. The "Wheel of Destiny" (Baader), present in many dadaist montages and collages, appeared only to follow the momentum of technological and economic impulses. With the awareness that "the world of systems was going to ruin," Dada began "its game with shabby remnants," "its Fool's game out of nothingness, in which all the highest questions are involved."[30] The Dadaist was, as a modern Fool, the dandy,[31] who took mass society's "unholy harlequinade,"[32] the "blessed cabinet of abnormalities,"[33] as his mirror, "before which he should live and die"[34] – for he drew all his power from the world that he negated. He was thoroughly aware

of his own dependence on the society that he despised. Thus he needed to demonstrate his independence, in striking the pose of the dandy, all the more. "Raised up above the world of the bourgeois though the double power of exterior and inner vision...we laughed heartily. So we destroyed, snubbed, mocked, and laughed. We laughed at them all. We laughed at ourselves as much as at the Kaiser, King, and Fatherland, beer-belly and dummy. We took laughter seriously; only the laughter guaranteed the seriousness with which we carried out our anti-art on the way to self-discovery."[35]

The Dadaist abhorred resignation. He demonstrated his "superiority" through a strict asceticism that did not rule out access to reality. He acted "the laughing equanimity that played the hangman's game with life out of the desire no longer to have to respond to the European swindle."[36] The Dadaist himself relinquished the world that in turn denied him. "The dancing spirit over the world's morals" (Huelsenbeck), that practiced the "balancing act above the abyss of murder, violence and theft" (Hausmann), was itself that of a Narcissus. His Fool's dance, his "tragic-absurd dance,"[37] referred to the self in a narcissistic self-blinding to fear, emptiness, and disempowerment.

"Our cabaret is a gesture. Every word that is spoken and sung here says at least one thing; that this humiliating age has not succeeded in winning our respect. What would be respectable and impressive about it? Its cannons? Our great drum drowns them out. Its idealism? That has long since become a laughing-stock, in both its popular and academic editions. The grandiose slaughters and cannibalistic heroics? Our voluntary foolishness and enthusiasm for illusion will destroy them."[38]

Hausmann accurately described the dadaist role of the fool as that of the "de-classed."[39] Furthermore, the Dadaists's attempts to ally with the workers' movements in Berlin were – as Grosz reported, despite his membership of the KPD – marked by cynical swings back and forth, for unlike the *Proletkult*, the dadaists believed that the working class should find its culture for itself. They recognized attempts by petty bourgeois intellectuals to interfere there as a warping of proletarian culture and a vain undertaking on the part of the intellectuals. Besides that, and out of a certain antipathy towards organization, the Dadaist valued the "revolutionary sensibility" above "practical politics" (Aragon).[40] The Dadaist role therefore remained focused on the negation of its own culture. It was banished to an interim field. The Dadaists's symbolic aggression escalated. "Everything should live, but one thing must stop – the bourgeois, the fat sod, the greedy-guts, the little piggy of intellectuality, the doorman of all wretchedness" (Huelsenbeck).[41]

The conflict with the norms of bourgeois society and that society's exclusion of all tendencies that contradicted its rational self-image had already appeared in the early Expressionist revolt – the milieu from which the Dadaists emerged. The socially critical consciousness of artists before the war was especially heightened in the campaign led by Franz Jung, a Berlin Dadaist, for the well-known and important psychoanalyst Otto Gross,[42] which was published in 1913 in

"Revolution."[43] The conflict erupted because Gross's father, a famous professor of criminology from Graz, declared his rebellious and opium-addicted son (then already 33 years old) mentally unstable and had him put into an asylum. This brought into focus for the artists the harshness and censorship that was deployed against their antibourgeois radicalism. The artists reacted with solidarity against the forced internment: "The asylum guards, trust holders, state officials stick together. We, who have nothing to lose, stick together too. We circumvent them, we destroy their position, we undermine their property. Our pamphlets are more powerful than their connections," wrote Rubiner on the solidarity campaign, as it increased in scale.[44]

In a letter to Maximilian Harden, the editor of *Zukunft*, Otto Gross referred to the relativity of bourgeois norms: "And one thing I am still charged with: that I do not agree with society's form as it exists. Whether one can view this as proof of a mental disturbance depends on how one defines the norm of mental health ... if one, who comes from the upper echelons of society, who has a good – in society's view – career open to him, if I have broken with that society: in that, very many people will see a sign of madness."[45]

The biographies of the Berlin Dadaists Baader and Grosz also reveal experiences of social exclusion and singling out. Baader[46] lived as Jesus *redivivus* in a solipsistic, megalomanic system of madness. As "President of the world globe" he provoked an outrage comparable with Don Quixote and ended up several times in an asylum through his calls on numerous leading political and intellectual greats of the time. At the same time, Grosz was driven by the "norms" of the reality of war to a "madness of melancholy,"[47] but also to hatred and desperation so that he was taken into a mental hospital during his military service and made "harmless."[48] Grosz despised war propaganda's slogans of "comradeship, equality of the troops, faithful love of one's superiors ... "[49] as a "Hell's sabbath of distortion." A portrait of a moronic soldier as an image of the spirit of subordination was published by Grosz under the title "No-one Can Copy Him from Us" in the portfolio *Gott mit uns* (*God with Us*).[50] His flabby lips, sloping brow, puffy eyes and the flat back of his head are all physiognomic characteristics of feeble-mindedness, as they were already indicative of the Fool of the late Middle Ages. I refer to the representation of the Fool of Duke Philip the Good in Burgundy. The drawing, from the "Recueil d'Arras," is a representation of the Fool in the large society scene in the Palace of Versailles.[51]

"Europe's decaying culture"[52] produced images of madness that served the Dadaists as socially critical metaphors. Grosz's works, *Riot of the Insane*,[53] *Bloody Carnival*,[54] and *Dedicated to Oskar Panizza*,[55] for example, along with the representation of war cripples by Dix,[56] evoked a society overshadowed by death and ending in paralysis. The madness is the new presence of death in life. *Dedicated to Oskar Panizza* inaugurated as a "giant picture of Hell ... a gin lane of grotesque dead and lunatics ... a swarm of possessed half-animals – that this epoch is sinking into destruction – of that I am unshakeably convinced; our sullied paradise."[57] Following the suppression of the proletarian uprisings in

Germany and especially in Berlin in 1919, Grosz broadened his metaphor of the lunatic asylum to a jail, with the proletariat as feeble-minded madmen watched over by brutal guards. The rounds in the prison compound[58] were a reminder of how society, contrary to its social rhetoric of "Light and Fresh Air for the Proletariat," "forcibly interned" revolutionaries in the cause of restoring law and order. While the proletarian uprisings meant as real a threat to bourgeois society as artists' loyalties did for the proletariat, the Dadaists's symbolic aggression in the cabaret, in Dada soirées and tours, were somewhat less dangerous. The Dadaists's revolt was an up-ending of bourgeois morals. It amounted to an "antagonistic complement" to the bourgeoisie and as such, it could be seen not only as an opponent of bourgeois culture but also as its "product and element."[59] The Dadaists deployed courage and dandyist asceticism against "fear and fat" (Huelsenbeck); against beer-bellied complacency they opposed their extreme agility. Against law and order they propagated "disturbance and disorder" (Hausmann).

Beyond the opposition, the Dadaist tracked down collective, unsublimated fantasies and attempted effectively to bring them to life. He operated in the role of a "collective shadow figure," as C. G. Jung attributed it to the Fool.[60] "It is as if he hides profound content beneath an inferior shell."[61] Hence, Dada endowed the "holiness of the senseless" with the dimension of a "being" wreaking revenge on bourgeois reason. The dadaists presented as artefacts in their collages and montages that which social value processes disposed of and rejected – "a child's discarded doll or a bright cloth are more urgent expressions than some donkey in oils seeking eternal posterity in endless parlours."[62] In the same way, they also tried to release the underlying layers suppressed by morality and culture and to reflect the night-side of bourgeois life that established itself especially in the urban underground. Their works and poetry emerged from expeditions in the city. The Dadaists found as yet unaffected aggression and libidinous projections in the sphere of triviality and in trivial myths. It is understandable that many Dadaists felt an affinity with the fifth social class, the unorganized "lumpenproletariat" because it was in the "holy mob" that collective fantasies were lived out. Its members were "prostitutes, subproletarians, collectors of lost objects, opportunist criminals, layabouts, lovers in the midst of an embrace, religious lunatics, drunkards, chain-smokers, the unemployed, gluttons, tramps, thieves, critics, hypersomniacs, riff-raff…We are the dregs, the dross, contempt. We are the unemployed, the unemployable, and the unwilling to work."[63]

The Dadaists recognized in the conflict between their "own" and the "foreign," between the "born individuals" and the "brainwashed and imposed upon" of social normality,[64] the unresolved problem of the cultural crisis. This, according to Otto Gross, would have to be converted into a revolutionary movement by means of the liberation of the powers suppressed in the unconscious, through "sovereign social and innate-ethical preformation."[65] Therefore, the child and madness were regarded as the enclaves in which the obligations of

reality were invalid and in which imagination and aggression could find free expression.

"The new theories we have been advancing are of great consequence for this field" (of lunatic asylums – H.B.), Ball wrote. "The child-like quality I mean borders on the infantile, on dementia, and on paranoia. It comes from the belief in a primordial memory, in a world that has been suppressed and buried beyond recognition, but that is liberated in art by unrestrained enthusiasm and in the asylum is released by illness."[66] At play in these ideas was the proximity of genius and madness (Hugo Ball mentions Lombroso in the same context[67]), as well as the metaphor of childhood, which has related, since Baudelaire, to genius. As rudimentary expression, Dada itself belonged to the sphere of the child as well as the lunatic. Dada parodied the winged horse of literature, Pegasus, with its little wooden horse. Hannah Höch and Sophie Taeuber-Arp created self-ironic, exemplary, weightless models with dolls and marionettes.[68] Dressed as Arlecchina[69] in a doll's costume, standing, locked eye-to-eye with her doll, Hannah Höch drew on a Fool's pose – as Hans Holbein the Younger depicted it, for example: "A Fool who appears to admire his own sceptre."[70] Indifference made it possible for the Dadaists to activate the spheres of the child and of madness, to present the pointless and aimless game as a positive aesthetic model of existence, and to liberate themselves through the artistic drive to experiment and adventure. Dancing weightlessness and the energetic release of tension were therefore also aspects of the dadaistic Fool's dance. This took on central significance as a kind of primal origin of art for Raoul Hausmann and for Sophie Taeuber-Arp in particular, and it became a key motif in many montages. Sophie Taeuber-Arp's dance of "The Song of the Flying Fish and Seahorse" was described by Ball as "dance full of spikes and fishbones, full of shimmering sun and sparkle and of cutting sharpness. The lines shatter on her body…"[71] The dance can be compared with the acrobatic levity of a tightrope dancer, who performs her trapeze number in the air, for the seated audience, at the highest existential stakes.

With the dadaistic combination of genius, madness, and childhood, the suspicion arises that in the dadaistic turn away from bourgeois artistry there is rooted a demand just as strong as that which has been relinquished. In the mask of the dandy, for whom the artist was still too bourgeois, the Dadaist could give the bourgeois his opinion, without revealing himself, his vulnerability, and his consternation. He maintained his ironic distance and challenging stance, without, however, betraying his incognito. His anonymity was grounded in the conventionality of the everyday.

"The Dadaist," wrote Serner in his handbook for swindlers, "is the desperado … who gets up to mischief as prophet, artist, anarchist, as statesman, briefly as Rasta."[72] The Dadaists were presidents and women presidents. Vaché could have been compared with an everyday rowdy as he let loose with a revolver on a theater audience. He was also the dandy of the barracks, who carried out his service, and occasionally bad service, as a soldier. Cravan fought as a boxer; to his friends, George Grosz played the profit-hungry "merchant from Holland." "I ripped, so

to speak, three other personages out of my inner imaginary life... I believe myself in these imaginary pseudonyms: 1. Grosz, 2. Count Ehrenfried, the nonchalant aristocrat with the manicured fingernails, concerned only to cultivate himself, in a word: the distinctive aristocratic individualist, 3. The doctor Dr. William King Thomas, the more American practical-materialistic equalizer in the mother figure of Grosz."[73] This "Georg Ehrenfried" also signed his letters with the titles Knight von Thorn, Count Orfyren-Bessler, Lord Edward Hatton-Dixon, Count Diagnoso. "Grosz" took the names "George le boeuf," "your faithful Carissimo in the sewage tank," and "your trusty six-day bicycle race George." The "doctor Dr. William King Thomas" also greeted his friend with "Your faithful old Prof. Mechan. Inventor of the artificial arsehole."[74] In an analogy to his photomontage work, Grosz's friend and Dada comrade-in-arms John Heartfield always appeared dressed as a mechanic. Richard Huelsenbeck published "En Avant Dada" (1920) as a privy councilor. Hausmann was a photographer, monteur, philosopher, fashion designer, and dancer. Baader caused a sensation as an election candidate, Jesus *redivivus*, as a cherry-tree cultivator, and prophet. Duchamp came to terms with life inconspicuously as a librarian and as Rrose Sélavy;[75] as femme fatale, he incorporated the ambiguous play with reality into his existence. Francis Picabia, obsessive automobile owner and driver, incidentally also a "jesus *rastaquouère*," mounted his countless "fille(s) née(s) sans mère."[76] In his various roles, the Dadaist was always the dandy, who strove incessantly to be superior: the only thing of importance: to be daily the greatest person.[77] The remains of heroism were salvaged in the mass age in the modern Fool, who sought above all to defend his autonomy. Along with the strategies of disguise came the necessity for the dandy to be silent. Otto Mann described him as "the most effective secret, he is not dumb... he is more mysterious than speech. In his intellectual stance his power can be felt everywhere. But never to be traced to his origins... he is always surprising, always baffling."[78] He baffles his "victims," dupes them, and stays in disguise. If, away from public life, the Dadaist did not embody the union in one person of actor and spectator – the dandy's rule: "play yourself to yourself"[79] – then he needed an audience. For since life was nonsensical, the only sense of the da-dandy lay in the self-realization of the provocative subject and in his indignation. Without the resonance of the crowd, the Dadaist had no point of reference. In the pose of the dandy, he attempted to leap the gulf that separated the artist and public. Whereas the court jester of the past related to the court audience, could be sure of princely protection, and had a clearly defined function as "banisher of melancholy,"[80] with the transition from courtly melancholy and aristocratic "ennui" to bourgeois society, the Fool became increasingly redundant. Benjamin recognized the isolation of the artist in the figure of Baudelaire, who continued to play the role of the Fool in the nineteenth century as a dandy: "he had something about him of the actor who has to play the role of a writer before the stalls and a society that the real writer already no longer needs and that gives him his stage only as an actor."[81]

The dadaist cabaret, Dada soirées and tours, were attempts to reconnect with the function of "melancholy banishment." Yet, as "a game of folly out of nothing" they were failed attempts because they were basically subcultural manifestations. As such, they could only chalk up a certain degree of success where they managed to trump and co-opt for their own means the culture of leisure controled by the media and cultural industries. The way in which the Dadaists dealt with the press was calculating as much as it was fateful. For when the game was roped back into the mechanism of society, the Fool's exposing function was diminished in its effectiveness. The rift between artist and public became visible and appeared almost unbridgeable as long as the economy of leisure was omnipotent. Dada proceeded from the recognition that there was no possible retreat from the commercialization of all areas of life, including "high art" . . . Dada saw that its "real impetus" was the commercial and that, at the end of the day, its "indifference towards the masses, art and humanity" would be eclipsed by the affected behavior of the educated bourgeoisie. The Dadaists intended to "turn this swindle, as a bluff, back against the bourgeois himself,"[82] " . . . because Dada, that is the bluff . . . [and] as Dada can be equated with the bluff, so the bluff is the truth."[83] Because the bourgeoisie was characterized by pretension, fashion, and convention, Dada reflected back on the bourgeoisie its terrible pretentiousness by means of its puzzle game. For this purpose, it invented a grotesque arsenal of hoaxes, illusions, surprises, and bluffs. "Fiat modes pereat ars,"[84] a portfolio of eight lithographs by Max Ernst, parodied a society losing itself in fashions and conventions with the image of a dressmaker's dummy. Blindness, paralysis, and imprisonment in crushing apparatus were among the dadaist images of the bourgeois "imprisonment" of human nature. Dada did not fight heroically against heteronomy, instead, it infiltrated it – like the "good Dadaist" Chaplin – with its apparent conformity. The Dadaist entered the arena of industrial mass culture with the business practices of a market barker. Dada confronted the commodity's deception with its own advertising agency, "that will lead everyone to happiness." Where the progressive market economy accelerated its circulation, dadaist works and performances took on sharper contours and more clashing colors. Dada wanted to assert itself in the public market. Baudelaire had already had his writer in "Perte d'Auréole"[85] lose his halo in the chaos, which meant that the artist could no longer escape the conditions of mass society and its metropolitan forms. Everyday forms of publication such as small ads, posters, newspaper reports, as well as hoax reports, headlines, slogans, telegrams, postcards, letters, program sheets, invitations, catalogs, flyers, magazines, advertising, campaigns, and tours were all part of dadaist self-presentation. The business practices of the capitalist world were as well-suited to the dadaists as the sensational performance in the arena to the circus artist. As important as this was for the circus artist looking to trump his competitors, so the Dadaist too did not shy from deploying his disarming con tricks as ironic competitive principles. He invented enormous dadaistic advertising fireworks. As a mockery of the "typical methods of the wannabe politicians, founders, philosophers [and] prophets"

(Herzfelde) of the postwar period, the Dadaist invented coups (Dada against Weimar) and founded a Nikolassee Republic, a dadaistic "World Authority," an "Intertelluric Academy in Potsdam," a "Freedom Party," a "Central Council," an "Anational Council of Unpaid Workers," and no less than a "Gender Center." The Dadaists staged "World Congresses," International Dada Fairs, open-air meetings, and proceedings against writers they did not approve of – against Maurice Barrès, for example. They founded societies for research into dadaist language, "une société anonyme pour l'exploitation du vocabulaire dadaiste" – and appointed a "Congrès international pour la détermination des directives et la défense de l'Esprit Moderne" – a "Ministery of the Spirit." Dada made a fool of the bourgeois. The ambiguous, bluffing foolery with the institutionalizations and with the strategies of the media and advertising cast these targets in a dim light. The rules of profit, competition, and retail, in the supply of which the sensation-riddled media competed and outdid one another as if on a battlefield, not only set the tone for the Dadaists's stance and their propagandistic tactics, but also permeated, as a formal principle, their artistic and literary works, and character-ized their montage-like, fragmentary, staccato quality. Events were, so to speak, atomized and disintegrated in a disorientating variety of single instances.

The dadaist performances were comparable with a "circus of elevated gravity" in which the spectators went "quietly mad."[86] In a lost image of the Cabaret Voltaire by Janco,[87] Arp gave a lively description of the reactions of the audience and the dadaist play with them: "On the stage of a motley, overcrowded bar, several weird and wonderful figures can be seen, representing Tzara, Janco, Ball, Huelsenbeck, Emmy Hennings, and my humble self. We are making pandemon-ium. The audience around us are shouting, laughing, and gesticulating. We reply with sighs of love, belches, poems, with 'moo moo' and 'miaow miaow' like medieval bruitists. Tzara is wiggling his behind like the belly of an oriental dancer. Janco is playing an invisible violin and bowing down to the ground. Frau Hen-nings, with the face of a Madonna, attempts the splits. Huelsenbeck bangs relentlessly on the kettledrum as Ball accompanies him, as chalky pale as a ghost."[88]

Arp saw the cabaret as a "prankster's pseudo-manoeuvre," in which a "ma-cabre skit, a little dance of death" was never lacking.[89] The Berlin Dada evenings were more aggressive. For example, at the Berlin Dada soirées, simultaneous poems, sound poems, and bruitist poems were mixed up and thrown together. Tap-dance performances, antimusical demonstrations by Golyscheff, a dadaist dance with masks, a wooden-puppet dance by Musikdada Preiss, futurist poetry recitals, provocative aggression against the audience, dadaist manifestos, Berlin "jungle songs" by Mehring, the race between a typewriter and a sewing-machine, improvised sketches, and loud interruptions from the crowd came in staccato succession. The Dadaists transformed themselves into "thought jugglers," "brain somersaulters" (Grosz), into eccentric Americans and barking pamphletists.

The futurist influence on the forms the dada soirées took is unmistakable. It was not only the provocative performances of the Futurists, but also the scenic

inventory and the antidramaturgy, set down by Marinetti in his manifesto "The Variété,"[90] that influenced the Dadaists. The futurist concept of variété as "boiling pot of all laughter, all smiles and every derisive cackle, every contortion and every grimace of future humanity"[91] pervaded the Cabaret Voltaire. Both tendencies shared the desire not to present themselves as a "humorous magazine."[92] However, while the Futurists laid the most emphasis on "distraction from material pain,"[93] in order to "rejuvenate the face of the world [with] great futuristic merriment,"[94] Dada focused on the derisive exposure of its audience. Whereas the Futurists sought to transform variété through superlative sensations and attractions into "a theater of shock effects, of records and of psychomadness,"[95] Dada opened the "cabaret of people,"[96] whose nonsensical mechanism cut the bourgeois public off from its habitual and well-trodden ways of reassuring itself through the normality of everyday life. Dada created a cabaret not only of total confusion, but also of profound skepticism.

In addition to the cabaret and soirées, Dada attempted to reach as large an audience as possible by the means of exhibitions, Dada balls, Dada fairs, Dada carnivals, and other operations. At the Dada meeting on the Plaine Carrouge near Geneva, for example: "three days earlier, grotesquely-dressed sandwich-board men had walked through the town with huge, brightly-colored signs, which announced that at three in the afternoon the dadaist leader Walter Serner would give the 'cosmos a kick in the pants.' The Plaine was thronged with people at the appointed time and Dr. Serner arrived, a little late, in a sleeveless tailcoat with a green waistcoat, flanked by about a dozen dadaists wearing green ties and carrying megaphones in their hands, on the specially-erected podium, from which he declaimed his manifesto with a piercing roar..."[97]

This spectacle could only be read about in the newspapers, however; it never actually took place. Dada exploited the one-dimensional experience of the bourgeois, whose consciousness was interchangeable with the press, in order to confound him. There were other further hoaxes that already declared the bourgeois a fool under the heading "the international voluntarily insane." In this way, the Dada cabaret became a comprehensive cabaret of the media, of Americanism's cultural-industrial sphere, of the national assembly, of the church, and so on.[98]

The great extent to which the dadaist needed for his own self-affirmation the public that he so despised and for which he refused to make any compromises is evident in his obsession with activating the media and "living" from their reactions. The public sphere formed the basis of his narcissistic fool's existence, for the flip-side of his eccentric performances was the fear of slipping into obscurity. The dadaist's performances, which acted out his independence and smiling equanimity, escalated into self-assertion in the face of the objective conditions of mass society. The Dadaist found himself confronted with an audience that, as "monde oublieux," already had Baudelaire's "vieux saltimbanque" at its mercy.[99] Hausmann's assemblage, "The Spirit of our Time,"[100] was the Dadaist's opponent, since this spirit "only had the abilities that chance had glued to its skull; the brain was empty."[101] That meant that the dadaist impresario was

vulnerable to the public's forgetfulness if he did not constantly retain his public profile and newsworthiness. Obscurity resulting from diffusion was for Dada both the object and the fate of its art. The power of the audience to decide on the "to be and not to be" of the artist could be felt in this. Therefore, so as not to perform like an ageing clown before empty seats, at the zenith of its "fame" after a two- to three-year fool's game, Dada chose to retreat.

Dada's legacy was the recognition that in a society emptied of meaning and marked by rigor mortis, it was impossible to create yet another culture-bound subject. In a society "that had no more integrity whatsoever to give,"[102] buffoonery was the only option for self-assertion. As such, Dada's effect also to a great extent determined its content.

The ultimate consequence for the Dadaists was not to be creative, because artistic activities were only a "refuge" (Tzara). The Dadaists already had a role model in Rimbaud. After a brief appearance in the arena of literature, he abandoned it and went into exile. Yet even this act was recognized by Vaché as an impossible way out – the same comedy was doomed to repeat itself everywhere.

Dada was banished to an interim field. Its inability to form relationships and bonds revealed itself in the further course of history as the flip-side of the search for identity.

Notes

1 Hugo Ball, *Die Flucht aus der Zeit* (1927), Luzern 1946, p. 78.
2 Hugo Ball, *Flametti oder vom Dandyismus der Armen* (1918) Frankfurt a.M. 1975.
3 Ibid.
4 *Neue Jugend*, Berlin, May and June 1917.
5 George Grosz, *Briefe 1913–1959* ed. Herbert Knust, Hamburg 1979, p. 62.
6 "Dada Telegram: 'The international Dada Company sends Charlie Chaplin, the world's greatest artist and good Dadaist, its support. We protest against the boycott of Chaplin's films in Germany.' Grosz, Heartfield, Huelsenbeck, Hausmann, Bloomfield, Picabia, Guttmann, Arp, Tzara, Serner, Schwitters, Ernst, Kobbe, Herzfelde, Archipenko, Chirico, Hustaedt, Noldan, Piscator," in *Der Dada* no. 3, Berlin 1920, p. "4371."
7 Ball, *Die Flucht aus der Zeit*, p. 88.
8 Ibid., p. 92.
9 Ibid.
10 Ibid., p. 94.
11 Cf. Wolfgang Promies, *Die Bürger und der Narr oder das Risiko der Phantasie*, Munich 1966.
12 *Oeuvres Complètes de Voltaire*, Nouvelle Edition, Paris 1877 (reprint 1967), vol. IX, p. 477.
13 Cited in Promies, op. cit., p. 114.
14 Ibid., p. 115.
15 Michel Foucault, *Wahnsinn und Gesellschaft*, Frankfurt a. M. 1969, pp. 28–9.

16 Raoul Hausmann, "Die neue Kunst," in *Führer durch die Abteilung der November-gruppe, Kunstausstellung Berlin*, 1921, issue 1 of the Novembergruppe's publications, Berlin 1921, p. 9.

17 Louis Aragon, "John Heartfield oder die revolutionäre Schönheit," Paris, May 1935, in Wieland Herzfelde, *John Heartfield. Leben und Werk*, Dresden 1971, p. 125.

18 Carl Einstein, "Bebuquin oder Die Dilettanten des Wunders," in *Gesammelte Werke*, ed. Ernst Nef, Wiesbaden 1962, p. 232.

19 Foucault, op. cit., p. 34.

20 Grosz, *Briefe*, p. 62.

21 Alexis (pseudonym Richard Huelsenbeck), "Ein Besuch im Cabaret Dada," in *Dada Almanach*, Berlin 1920, p. 140.

22 Grosz, *Briefe*, p. 32.

23 Hugo Ball, *Tenderenda der Phantast* (1914–20), Zurich 1967, p. 77.

24 Richard Huelsenbeck, *Phantastische Gebete*, Zurich 1967, p. 77.

25 Hans Arp, "Die Schwalbenhode," in *Dada Almanach*, Berlin 1920, pp. 145–6; cf. Reinhard Döhl, *Das literarische Werk Hans Arps 1903–1930. Zur poetischen Vorstellungswelt des Dadaismus*, Stuttgart 1967, p. 115.

26 Andeheinz Mößer ed., 'Hugo Balls Vortrag über Wassily Kandinsky in der Galerie Dada in Zürich am 7.4.1917,' in *Deutsche Vierteljahrsschrift für Literaturwissenschaft und Geistesgeschichte*, 51, 1977, p. 688.

27 Ibid., p. 689.

28 Hugo Ball, 'Sieben schizophrene Sonette – Narrenfest – Der Büßer,' in *Gesammelte Gedichte*, Zurich 1963, pp. 34–45.

29 Richard Huelsenbeck, 'Der Idiot,' in *Cabaret Voltaire*, ed. Hugo Ball, Zurich 1916, p. 18.

30 Ball, *Die Flucht aus der Zeit*, p. 92.

31 Cf. Hanne Bergius, 'Der Dadandy – das Narrenspiel aus dem Nichts,' in *Dada in Europa*, Ex. Cat. 15, *Europäische Kunstausstellung*, Berlin 1977, pp. 3/12ff.

32 Grosz, *Briefe*, p. 32.

33 George Grosz, 'Gesang an die Welt,' in *Gedichte und Gesänge*, Litomysil 1932, n.p.

34 With reference to the dandyist attitude: Baudelaire citied in *Baudelaire, in Selbstzeugnissen und Bilddokumenten*, ed. Pascal Pia, Paris 1958, p. 68. Further literature on the dandy: 'Baudelaire, Le Dandy,' in *Curiosités esthétiques, L'Art romantique*, Paris 1962, pp. 481ff; Otto Mann, *Der Dandy. Ein Kulturproblem der Moderne*, Gerabronn 1962; E. Carassus, *Le mythe du dandy*, Paris 1971; Sebastian Neumeister, *Der Dichter als Dandy. Kafka, Baudelaire, Thomas Bernhard*, Munich 1973.

35 Hans Arp, cited in Döhl, op. cit., p. 45.

36 Raoul Hausmann, 'Dada ist mehr als Dada,' in *Am Anfang war Dada*, ed. G. Kämpf and Karl Riha, Gießen 1972, p. 89.

37 Hans Arp, cited in Döhl, op. cit., p. 42.

38 Ball, *Die Flucht aus der Zeit*, p. 85.

39 Cf. Raoul Hausmann, "Viking Eggeling, Zweite präsentistische Deklaration gerichtet an die internationalen Konstruktivisten," in *MA*, vol. VII, no. 5/6, Vienna 1922.

40 Louis Aragon, cited in Maurice Nadeau, *Geschichte des Surrealismus*, Hamburg 1965, p. 77.

41 Richard Huelsenbeck, 'Der neue Mensch,' in *Neue Jugend*, Berlin May 1917.

42 Emanuel Hurewitz, *Otto Gross, Paradies-Sucher zwischen Freud und Jung*, Zurich 1979.

43 *Revolution*, vol. 1, no. 5, Munich 1913.

44 Ludwig Rubiner in ibid., p. 2.

45 Otto Gross cited in Hurewitz op. cit., p. 13.

46 Cf. *Johannes Baader Oberdada, Schriften, Manifeste, Flugblätter, Billets, Werke und Taten*, ed. Hanne Bergius, Norbert Miller, Karl Riha, Lahn / Gießen 1977.

47 Grosz, *Briefe*, p. 46.

48 Ibid., p. 48.

49 Ibid., p. 45.

50 George Grosz, 'No-one Can Copy Him from Us,' 1919, ill. in Alexander Dückers, *George Grosz, Das druckgraphische Werk*, Berlin 1979, MIII, 9. "No-one can copy him from us" was a comment of Wilhelm II's on the Hauptmann von Köpenick.

51 Information from Inas Schwebes, Berlin, whose dissertation on representations of the Garden of Love in the Middle Ages included investigation of the subject of the Fool. The painting in Versailles is a copy made in the sixteenth century after a lost Netherlandish original from the early fifteenth century. P. Post, "Ein verschollenes Jagdbild Jan van Eycks," in *Jahrbuch der preußischen Kunstsammlungen*, vol. 52, Berlin 1931, pp. 120ff.

52 Grosz, *Briefe*, p. 47.

53 Grosz, 'Krawall der Irren,' 1915/16 (Kleine Grosz Mappe), ill. in Dückers, op. cit., MII6.

54 Grosz, 'Blutiger Karneval,' 1915/16, ill. in Dückers, op. cit., E40.

55 Grosz, 'Widmung an Oskar Panizza,' 1917–18, Staatsgalerie Stuttgart, ill. in Uwe M. Schneede ed., *George Grosz, Leben und Werk*, Stuttgart 1975, p. 55.

56 Otto Dix, 'Kartenspielende Kriegskrüppel,' 1920, ill. in Fritz Löffler, *Otto Dix, Leben und Werk*, Dresden 1977, no. 30. Dix, 'Prager Straße,' 1920, ill. in Löffler, no. 31. Dix, '45% Erwerbsfähig,' 1920, ill. in Löffler, no. 28.

57 Grosz, *Briefe*, pp. 56f.

58 Grosz, 'Licht und Luft dem Proletariat,' 1919, ill. in Dückers, op. cit., MIII4.

59 Cf. Helmut Kreuzer, *Die Bohème. Analyse und Dokumentation der intellektuellen Subkultur vom 19. Jahrhundert bis zur Gegenwart*, Stuttgart 1971, pp. 45ff.

60 C. G. Jung, 'Zur Psychologie der Schelmenfigur,' in *Der göttliche Schelm, ein indianischer Mythenzyklus*, ed. C. G. Jung, Karl Kerenyi, Paul Radin, Zurich 1954, p. 205.

61 Ibid.

62 Hausmann, *Am Anfang warDada*, p. 27.

63 Ludwig Rubiner, *Der Mensch in der Mitte*, Berlin/Wilmersdorf 1917, p. 19.

64 Otto Gross, 'Vom Konflikt des Eigenen und des Fremden,' in *Freie Straße, Um Weisheit und Leben, 4. Folge der Vorarbeit*, Berlin 1916, p. 3.

65 Otto Gross, 'Protest und Moral im Unbewußten,' in *Die Erde*, vol. 1, Berlin 1919, p. 682.

66 Ball, *Die Flucht aus der Zeit*, p. 104.

67 Ibid.

68 Sophie Taeuber-Arp, 'Marionetten,' ill. in *Zweiklang. Sophie Taeuber-Arp / Hans Arp*, ed. Ernst Scheidegger, Zurich 1960, pp. 18–20. Hannah Höch, 'Dada Puppen,' 1916/18, ill. in Heinz Ohff, *Hannah Höch*, Berlin 1968, ill. 27.

69 Hannah Höch, ca. 1921, ill. in *Hannah Höch*, ed. Götz Adriani, Cologne 1980 (inner jacket).

70 Border drawing in Erasmus von Rotterdam, *Das Lob der Torheit* [In Praise of Folly], Basel 1515, Öffentliche Kunstsammlung Basel, Kupferstichkabinett.

71 Hugo Ball, 'Die Tänzerin Sophie Taeuber-Arp' (1917), in *Zweiklang*, p. 24.

72 Walter Serner, *Letzte Lockerung*, Berlin 1964, p. 15.

73 Grosz, *Briefe*, pp. 30f.

74 Cf. ibid. Trans. *Note*: Grosz uses the word "Aaschloch," which is an untranslatable play on the German for "arsehole" ("Arschloch") and the German for "carrion" ("Aas), D.L.

75 Man Ray, 'Rrose Selavy,' 1921, ill. in *Marcel Duchamp*, ex. cat. Paris 1977, p. 104.

76 Picabia called his machine-erotic drawings "fille née sans mère," ill. in *Francis Picabia*, Paris 1976, ill. 44.

77 Ball, *Die Flucht aus der Zeit*, p. 60.

78 Mann, *Der Dandy*, p. 77.

79 Cf. Serner, *Letzte Lockerung*.

80 Cf. Wolfgang Lepenies, *Melancholie und Gesellschaft*, Frankfurt a.M. 1972, chapter "Der Hofnarr."

81 Walter Benjamin, *Zentralpark*, Frankfurt a. M. 1974, p. 158.

82 Raoul Hausmann, 'Objektive Betrachtung des Dadaismus,' in *Der Kunsttopf* 3, Berlin 1920, p. 64.

83 Hausmann, 'Dada in Europa,' in *Der Dada* no. 3, Berlin 1920, p. "642 kg."

84 Max Ernst, 'Fiat modes pereat ars,' 8 lithographs, 1919, ill. in *Max Ernst*, catalogue raisonnée, no. 65–73.

85 Sebastian Neumeister, op. cit., p. 70; I. Wohlfahrt, 'Perte d'Auréole: The Emergency of the Dandy,' *Modern Language Notes* 85, 1970.

86 Carl Einstein, 'Bebuquin oder Die Dilettanten des Wunders' in *Gesammelte Werke*, p. 235.

87 Marcel Janco, 'Cabaret Voltaire,' 1917.

88 Hans Arp, cited in Döhl, p. 44.

89 Ibid.

90 F. T. Marinetti, 'Das Variété,' 1913, in Umberto Apollonio, *Der Futurismus, Manifeste und Dokumente einer künstlerischen Revolution 1909–1918*, Cologne 1966, pp. 170ff.

91 Ibid., p. 171.

92 Ibid., p. 175.

93 Ibid., p. 176.

94 Ibid.

95 Ibid., p. 175.

96 Raoul Hausmann, 'Das Kabarett zum Menschen,' in *Schall und Rauch*, no. 3, Berlin 1920, p. 2.

97 Cited in Hanne Bergius, 'Christian Schad als Dada-Präsident in Genf,' in *Christian Schad*, Berlin 1980, p. 11.

98 Cf. *Johannes Baader Oberdada*.

99 Neumeister, *Der Dichter als Dandy*, p. 70.

100 Raoul Hausmann, 'Der Geist unserer Zeit,' 1921, Paris, Musée d'Art Moderne, CNAG, ill. in *Dada in Europa*, ex. cat., p. 3/7.

101 Ibid., p. 3/50.

102 Benjamin, *Zentralpark*, p. 161.

31

Surrealism: Fetishism's Job

Dawn Ades

Georges Bataille once proposed that the proper scope of a dictionary should not be the passive act of defining the meaning of a word, but that of addressing the job of work it had to do: 'A dictionary's job would begin from the moment that it stopped giving the meaning, but rather the tasks, of words.'[1]

The word 'fetishism', of obscure origins and disputed etymology, has worked its way through the rationalising discourses of the European Enlightenment; connoting over-valuation and displacement, its job was to signal error, excess, difference and deviation. Perhaps one of the key phantoms of the dream of reason, it helped to structure and enforce distinctions between the rational and irrational, civilised and primitive, normal and abnormal, natural and artificial. Thus the adoption of the term successively by Marx, and nineteenth-century psychologists, to refer to forms of irrational valuation within their own society, had a satirical edge. In Surrealism, however, there is a change in its fortunes. Having served to affirm the powerlessness of mind and body to act rationally, fetishism was to intervene in the Surrealist subversion of utilitarian and positivist values, or, as Carl Einstein put it, 'to change the hierarchies of the values of the real'.[2]

The peculiar capacity of the word both to adapt to and resist change may be a function of the very obscurity of its origins – which has prompted an obsessive interest in its etymology. A contrast might be drawn with the word 'taboo', which could be seen as belonging to the same type of mysteries relating to power, desire and superstition as those to which 'fetishism' was initially attached. The difference lies in the fact that 'taboo', however its meanings may have developed, was a word

Dawn Ades, "Surrealism: Fetishism's Job," pp. 67–87 from Anthony Shelton (ed.), *Fetishism: Visualising Power and Desire*. London: South Bank Centre and The Royal Pavilion, Art Gallery and Museums, Brighton in association with Lund Humphries Publishers, 1995. Reprinted by permission of Dawn Ades.

that belonged to the same cultural space as those concepts to which it referred. 'Taboo' is a Polynesian word. As Freud said in *Totem and Taboo*: 'It is difficult for us to find a translation for it, since the concept connoted by it is one we no longer possess. It was still current among the ancient Romans, whose "sacer" was the same as the Polynesian "taboo" . . . '[3] Unlike 'fetish', taboo was a term internal to the culture whose beliefs it connoted. The term fetish evolved in the course of encounters between Africans and Europeans on the coast of West Africa from the sixteenth century on, but, as William Pietz has argued, 'These cross-cultural spaces were not societies or cultures in any conventional sense. From this standpoint, the fetish must be viewed as proper to no historical field other than that of the history of the word itself, and to no discrete society or culture, but to a cross-cultural situation formed by the ongoing encounter of the value codes of radically different social orders.'[4]

Our idea in this exhibition was to assemble objects to which the term 'fetish' has been applied, in some of its disparate arenas, tracing the history of the word's activities and investigating continuities and discontinuities. We divided the exhibition into three parts: first, those things described as 'fetishes' by European traders and explorers in West Africa; second, a room devoted to Surrealism; and finally, a section including both street culture and fashion that has been dubbed fetish, and works by contemporary artists which could be related to any of the usages of the term. These are divisions that could correspond roughly to the concerns of ethnography, psychoanalysis and sexual politics. They were, though, intended to be porous, not watertight.

An obvious reason for the centrality of Surrealism in this exhibition is its involvement in both ethnography and psychoanalysis, in which notions of fetishism have played such a crucial role. Surrealism was constituted in an awareness of what Foucault later called the 'confrontation, in a fundamental correlation', of ethnology and psychoanalysis. 'Since *Totem and Taboo*, the establishment of a common field for these two, the possibility of a discourse that could move from one to the other without discontinuity, the double articulation of the history of individuals upon the unconscious of culture, and of the historicity of those cultures upon the unconscious of individuals, has opened up, without doubt, the most general problems that can be posed with regard to man.'[5]

The Surrealists' embrace of other cultures was defined by their rejection of the values of their own. 'Latin civilisation has passed its zenith, and for my part I demand that we forgo, unanimously, any attempt to save it. It seems just now to be the last rampart of bad faith, senility and cowardice . . . '[6] Their attitudes, though not wholly escaping the primitivising stance of the colonial world, are more complex than is sometimes admitted. Recent critiques of the Surrealists' attitudes to non-Western cultures are a useful corrective to a romanticisation of their position, but do not necessarily take into account the full complexity of this position historically.[7]

The pejorative character of the term was put to subversive effect in the counter exhibition organised by the Surrealists and the French Communist Party at the

time of the huge Colonial Exhibition in Paris in 1931, which celebrated the extent of French territorial colonisation. African and Oceanic art were exhibited, and mural paintings by French artists allegorised the supposedly harmonious and patriotic relations between France and its colonies.[8] The Surrealists joined the anti-colonial campaign to expose these as myths and protest against exploitation and repression in the colonies, preparing and distributing a tract, 'Ne visitez pas l'exposition coloniale!', and helping devise an exhibition entitled *La Vérité sur les Colonies* (The truth about the colonies). A photograph reproduced in *Le Surréalisme au Service de la Révolution* shows a vitrine of exhibits labelled 'European Fetishes' containing three statues including a Catholic image of the Virgin and Child, and a charity collecting box in the form of a black child. The use of the term 'fetish' is doubly provocative. To describe these European objects as fetishes exposes the Western ideological assumptions behind the term, and by redirecting its object backwards, as it were, to Western things, serves to defamiliarise and denude them. Moreover, to juxtapose the Virgin with the black child begging-bowl was to make comparisons between religious and economic 'fetishism', a complex relationship which precisely inheres within the term itself. Whether or not the organisers of the Anti-Colonial Exhibition were aware of it, the term did initially contain the Protestant viewpoint that Catholic idols compared in a number of ways with African *fetissos*.

The Surrealists were inveterate collectors of things from all over the world, from Paris flea market detritus to grand sculptures from Oceania or Pre-Columbian America. Photographs of Breton in his studio show him surrounded by objects of all kinds, massed like charms to protect him from things modern and utilitarian. However, only a few of these are actually described as 'fetishes'.[9]

The 'correlation through confrontation' of ethnology and psychoanalysis is especially vivid in the review *Documents* (1929–30); edited by Georges Bataille, this gathered many dissident Surrealists, like Michel Leiris, Robert Desnos and André Masson, in its pages. Although the juxtaposition of cultures characterises all Surrealist reviews, in *Documents* – and partly because, unlike the official Surrealist reviews, it was never the organ of a movement with its own project – contrasts, contradictions and comparisons force a radical revision of the hierarchies and values created by man and his artefacts, from whatever culture.

Documents represents a reaction against treating ethnographic objects as art; this serves, not to enforce a distinction between them and 'Western art', with only the latter properly entitled to such 'elevated' concepts as 'beauty', but to propose a similar process of addressing art as part of a specific cultural continuum among other artefacts. But there is also, in *Documents*, a strong sense of loss in much of the writing about modern art; as Bataille says in a key text in the last issue of *Documents*, 'L'esprit moderne et le jeu des transpositions', even the best of modern art belongs more to the history of art, emasculated and academic, than to human urgencies. It lacks the capacity to express either admissable or inadmissable experiences or needs. 'I defy,' he writes, 'any lover of modern art to adore a painting as a fetishist adores a shoe.'[10] By 'play of transpositions' Bataille

means, as Denis Hollier points out, the symbolism of psychoanalysis, especially dream symbolism, targeting thereby the Surrealists.[11] The opposition Bataille sets up between symbolic transpositions and the fetish is clear, and this points to a crucial issue in relation to the Surrealist object. Bataille's polemic also throws into relief two important earlier pieces of critical writing in *Documents*: Carl Einstein's 'André Masson: Étude ethnologique', and Michel Leiris's 'Alberto Giacometti'.[12] Under pressure from similar preoccupations each chooses a term from outside traditional aesthetic rhetoric, both of which in different ways are implicated in the drawing together of psychoanalysis and ethnology: Einstein takes the term totem, while Leiris places fetishism at the heart of his short piece on Giacometti. Each centres on issues of identity, the relation between self and the external world and the problem of creativity, which the words *totem* and *fetish* focus in quite different ways.

There is a somewhat contradictory character to this section on Surrealism. While ideas and themes that can be seen to correspond to various usages of the word fetish abound in Surrealist writing and visual manifestations – above all, as we shall see, in the Surrealist object – there is a certain reserve in the use of the term itself. The reasons for this are probably rooted in a new awareness, itself a consequence of the opening of ethnology into psychoanalysis, of the prejudicial character and the nature of the power relations that fetishism had signified.

The prevalence of 'fetishism' as an explanatory tool in the study of 'primitive religion' came under attack from Marcel Mauss by the end of the nineteenth century. He pointed out that the term should only ever be addressed to the thing itself, and not to a spirit distinct from it; in his 1898 review of Mary Kingsley's *Travels in West Africa* he argued that 'fetish' should designate at most certain amulets, and subsequently rejected it altogether, on the grounds that it prejudiced the understanding of the specific conceptions of magic within a given society.[13] Effectively, he was banning the word; 'so-called fetish-objects,' he argued, 'are never any old things chosen at random; this could only be true for the superficial eye of an outsider. On closer inspection it should be obvious that such objects are 'always defined by the code of magic or religion'' in question.'[14] Mauss's ideas were a powerful influence on the Surrealists and on that overlapping group that included Georges Bataille, centred on the review *Documents*. It was the apparently arbitrary character attached to the notion of the fetish that persuaded Mauss to drop the term as a dangerous caricature: a caricature with its roots in such notorious travellers' accounts as that of the Dutch merchant William Bosman in 1703. Bosman's African informant (significantly, an educated man, aware of the gulf between different social, religious and economic structures) told him that:

> the number of their Gods was endless and innumerable. For (said he) any of us being resolved to undertake anything of importance, we first of all search out a God to prosper our designed Undertaking; and going out of doors with this Design, take

the first creature that presents itself to our Eyes, whether Dog, Cat, or the most contemptible Animal in the World, for our God; or perhaps instead of that any inanimate that falls in our way, whether a stone, a piece of Wood, or any thing else of the same Nature.[15]

Peitz comments on the puzzlement of early travellers and traders at exchange practices which operated so massively in the Europeans' favour: 'Gold is much prized among them, in my opinion more than by us, for they regard it as very precious: nevertheless they traded it very cheaply, taking in exchange articles of little value in our eyes.'[16]

It was precisely this radical disjunction, this gap between estimations of the value of a material object signalled by fetishism as a key term in the study of primitive religions that had led to its 'figurative' adoption by Marx and then by nineteenth-century psychologists. In the fourth section of the first chapter of *Capital*, 'The mystery of the fetishistic character of commodities', Marx's use of the term is, as Peitz has argued, both 'theoretically serious and polemically satirical':[17]

> The mercantilists (the champions of the monetary system) regarded gold and silver, not simply as substances which, when functioning as money, represented a social relation of production, but as substances which were endowed by nature with peculiar social properties. Later economists, who look back on the mercantilists with contempt, are manifestly subject to the very same fetishistic illusion as soon as they come to contemplate capital. It is not so very long since the dispelling of the physiocratic illusion that land-rents are a growth of the soil, instead of being a product of social activity!'[18]

The fetishisation of capital, not less than the fetishisation of commodities, which Marx argues was a simpler form of bourgeois economic production, is an illusion, whose mysterious origins are analogous to

> the nebulous world of religion. In that world, the products of the human mind become independent shapes, endowed with lives of their own, and able to enter into relations with men and women. The products of the human hand do the same thing in the world of commodities. I speak of this as the *fetishistic character* which attaches to the products of labour, so soon as they are produced in the form of commodities.[19]

What is striking about these passages in which the notion of fetish is used as a satirical weapon to attack the value systems of bourgeois society is the way in which distinctions between what is natural and what is produced by human labour seem almost fortuitously to reverberate with the etymological complexity of the term itself. Whether or not Marx bore this in mind, the proposed derivation of fetish via the pidgin *fetisso*, from the Portuguese *feitiço*, meaning

witchcraft or charm, which derived from the Latin *factitius*, meaning 'made' or 'manufactured', gives the adoption of this term an interest exceeding that of the surface or foreground satirical analogy with the superstitious overestimations of primitive religious forms of belief. Although apparently buried deep beneath the sense of witchcraft, the Latin and then early Christian meaning of *factitius* as 'man-made', as opposed to the God-made natural world, often therefore with the sense of something fabricated, artificial or deceptive as opposed to genuine, further thickens the value-constructions loading the word.

Like Marx, the nineteenth-century psychologists of sexuality adopted the term fetishism from the study of religions. They show a fascination characteristic of the nineteenth century with its etymology. Alfred Binet, for instance, who first proposed it in his 'Le Fétichisme dans l'amour' (*Revue Philosophique*, 1887) as an appropriate term for a particular sexual deviation within psycho-sexual research, gave alternative derivations. To his own etymology of the word, 'from Portuguese *fetisso*, enchanted, magic thing (*"chose fée"*); *fetisso* from *fatum*, fate', he adds a footnote to the effect that Max Müller attached the word *fetisso* to the Latin *factitius*, '*chose factice, sans importance*', rather than *fatum*.[20]

Binet is confident that it has a real object within the scientific study of religions. Fetishism, he argues, which was disdainfully called by Max Müller the '*culte des brimborions*', played a capital role in the development of religions, and even if they did not start with it, all were involved with it in some way and some ended there. The great battle of images, that has raged since the early Christian era, 'sufficiently proves the universality and the power of our tendency to confound the divinity with the material, palpable sign which represents it. Fetishism holds no less a place in love ...'[21]

There is an interesting stress here on the importance of the material sign, the embodied character of the amorous illusion. Binet's analysis of fetishism quickly spread in the growing literature on the psychology of sex, and it was in this context rather than in the sense that Freud was to give the term, that we should begin to examine Surrealism's use of it.

Binet emphasised that what was described was not a 'psychological monstrosity'; 'everybody is more or less fetishist in love.' He defined a *grand* and a *petit* fetishism, of which only the former could be described as a form of 'genital madness'. The fetish object could be an inanimate object or any fraction of the body. Some parts of the body, though, were more likely to become fetishes than others: hand, foot, hair and eye. Binet's examples, many of which are taken from Charcot and Magnan's clinical studies, do include cases of women fetishists. Krafft-Ebing, however, who extensively revised his *Psychopathia Sexualis* to incorporate fetishism, notes that cases where fetishism assumes pathological importance have so far only been observed in men.[22] He does not rule out the possibility of female instances, although such, he says, have not yet been the object of study. Krafft-Ebing's purpose in classifying pathological forms of sexuality was, unlike Binet, in large measure forensic: he was concerned with its potentially criminal extensions, ranging from theft (of handkerchiefs, hair etc) to violence on the body. But he agrees

with Binet on the crucial point that fetishism is proof of the intimate connection between mind and body. Fetishism, Krafft-Ebing argued, can only be acquired; it cannot be congenital. 'Every case requires an event which affords the ground for the perversion.'[23]

It can only be individual, and he quotes Binet: 'In the life of every fetishist there may be assumed to have been some event which determined the association of lustful feeling with the single impression.'[24] Almost certainly this was an event in early youth, connected with the first awakenings of the *vita sexualis*, whose circumstances were usually forgotten, although the result of the association was retained.

Here we are obviously on the threshold of Freud's discovery, or claim, as to what that event invariably was (for the male child): shock at the discovery of the lacking maternal penis. However, the conditions for that discovery – that is the existence of the castration complex – were still absent. There was agreement that the associations were subjective, probably not wholly accidental, that the imagination was a key ingredient, and above all that the fetish object took on an independent value – that it was, in terms of normal sexuality, irrationally overvalued.

The fetish-object may be articles of female attire, as in the case of the nurse-maid's costume, frequently boots and shoes (Mirbeau's *Diary of a Chambermaid*, on which Buñuel's film was based, could well have been drawn from one of these case studies), gloves or underclothing.[25] Attachment to such inanimate objects should not be confused with the normal love of man for a handkerchief, shoe or glove etc which 'represented the mnemonic symbol of the beloved person – absent or dead – whose whole personality is reproduced by them. The patho-logical fetishist has no such relations. The fetish constitutes the entire content of his idea.'[26] Only the presence of the fetish could allow for erotic experience with a person, and often the presence of another was unnecessary for erotic stimulation. Merely the sight of such an object could be enough, though other senses were often involved – smell, touch and hearing.

Parts of the body particularly likely to become the object of fetish worship were hair, foot, hand and eyes. Binet gives the case of a young man whose sexual interest was displaced on to the eye, and imagined the nostrils as the seat of the female sexual organs – a case which seems to involve a double displacement. Another example in Krafft-Ebing was the young man who loved the foot of a lame woman. His ambition was to marry a chaste, lame girl who would free him of his crime by 'transferring his love for the sole of her foot to the foot of her soul'.[27] This attraction to the base which is often a part of the fetish's attraction formed an important part of Bataille's analysis of seduction, whose relation to the fetish we shall examine below.

The power of the word is rooted in a certain set of constants, which William Peitz argues provide a continuity despite the variability of the arenas in which it operates.[28] He defines these as follows: first, its irreducible materiality; the fetish is not identical with an idol, which is an acknowledged stand-in. Second, it is

characterised by what Peitz calls 'singularity and repetition'; 'The fetish has an ordering power derived from its status as the fixation or inscription of a unique originating event that has brought together previously heterogeneous elements into a novel identity.'[29] This apparently is characteristic of African culture of the fetish, where Peitz quotes McGaffey's statement that 'a "fetish" is always a composite fabrication'. We need to distinguish two aspects to this 'ordering power of the fetish' in the context of Surrealism: there is both the unique and singular event which invested a material object or body-part with special power, which in psychoanalytic terms was compulsively repeated, and also the notion of heterogeneity, which was endowed with an illusion of unity or meaning (social, religious, psychological) through the operation of desire. The third constant is the notion of value: the displacement, reversal or overestimation of value, which is attached to the term 'fetish' and is perhaps its clearest and most consistent feature. Finally, the relation between fetish and the human body, whose functions and health the former may control and order.

As what Michel Foucault called the 'model perversion', fetishism had become, in the move to classify and control the deployment of sexuality, 'the guiding thread for analysing all the other deviations'.[30] The Surrealists, whose emphasis on pleasure and the body deliberately flouted the 'socialisation of procreative behaviour', were nonetheless ambivalent about sexual fetishism. The fact that fetishism had been so obsessively studied as a type of pathological sexual aberration in the context of a France paranoid about falling birth rates, and insistent on reproduction as a moral and patriotic duty and the only proper aim of sexual activity, invested it for the Surrealists with a positive value.[31] Their insistence on erotic pleasure as an aim in itself quite unmarked by any sense of patriotic or familial duty takes on in this light a clearly oppositional quality to the pathologisation of deviance. However, the Surrealists – above all, Breton himself – were bound to the idea of the reciprocity of heterosexual love; although there is some debate in the 'Recherches sur la sexualité', limits to the free discussion of the body exist although they are different from those imposed by the notion of normality.[32] Fetishism is in effect pressed into service in different ways by Surrealism, the very ambivalence of the term, occupying a kind of *terrain vague* between public and private spaces, dream and waking, the interior and the exterior, Europe and its others, matching Surrealism's own situation.

Surrealism's relationship with the fetish depends crucially on the latter's materiality, and was closely bound up with the emergence of the Surrealist object. As Dalí put it:

> What matters is the way in which the [Surrealist] experiments revealed the *desire for the object*, the tangible object. The desire was to get the object at all costs out of the dark and into the light, to bear it all winking and flickering into the full daylight. That is how the *dream objects* Breton first called for in his 'Introduction to the discourse on the paucity of reality' were first met with.[33]

Breton's 'Introduction to the discourse on the paucity of reality' contains one of his rare usages of the term 'fetish', and also, not by chance, the first formulation of the idea of the Surrealist object:

> Do not forget if for no other reason the belief in a certain practical necessity prevents us from ascribing to poetic testimony an equal value to that given, for instance, to the testimony of an explorer. Human fetishism, which must try on the white helmet, or caress the fur bonnet, listens with an entirely different ear to the recital of our expeditions. It must believe thoroughly that it *really has happened*. To satisfy this desire for perpetual verification, I recently proposed to fabricate, in so far as possible, certain objects which are approached only in dreams and which seem no more useful than enjoyable. Thus recently, while I was asleep, I came across a rather curious book in an open-air market in Saint-Malo. The back of the book was formed by a wooden gnome whose white beard, clipped in the Assyrian manner, reached to his feet. The statue was of ordinary thickness, but did not prevent me from turning the pages, which were of heavy black cloth. I was anxious to buy it and, upon waking, was sorry not to find it near me. It is comparatively easy to recall it. I would like to put into circulation certain objects of this kind, which appear eminently problematical and intriguing. I would accompany each of my books with a copy, in order to make a present to certain persons. Perhaps in that way I should help to demolish these concrete trophies which are so odious, to throw further discredit on those creatures and things of 'reason'.[34]

Breton is interested in the fetishist not, in the first instance, because of his sexual obsessions *per se*, but as someone who is convinced by his imagination. This can best be illustrated with reference to the almost contemporary and much better known *Manifesto of Surrealism*, where Breton outlines the two types of being who do not suffer from sclerosis of the imagination: children and the insane. For them, the world is not restricted to the purely utilitarian and functional. Things outside the immediate reach of the waking senses can be experienced as real. In his example of the fetishist who must touch the white helmet or the fur, it is the conjunction of the actual material substance, the 'irreducible materiality' of the fetish object, and the imaginative leap at a moment of intense experience that has given it such power, whatever its psychological roots. That which had been bracketed as outside rational behaviour and activity became almost by definition the arena of Surrealist exploration. The fetishist offered a supreme example of the reconciliation of imagination and reality. The fetish object – fur, bonnet, apron; the examples from the case studies are numerous and specific – was an undeniable material substance, but at the same time could not register in the world of utilitarian reality. It had individual psychological value but no social value. As Breton put it: 'Must poetic creations assume that tangible character of extending, strangely, the limits of so-called reality?'[35] In this sense, then, the fetishist, as Breton said in the passage quoted above, could understand the Surrealist poet, exploring the tangible inventions of language, loosened from its utilitarian function. 'What is to prevent me from throwing disorder into this

order of words, to attack murderously this obvious aspect of things? Language can and should be torn from this servitude. No more descriptions from nature, no more sociological studies ... '[36] Since conviction of the reality of social conventions is riveted in us through its clichés, for 'it is from them we have acquired this taste for money, these constraining fears, this feeling for the native land, this horror of our destiny', to destabilise language is to shake these convictions, and also to question the assumed border between real and imaginary.

Breton's attack on the despised objects of utility sets the Surrealist object in direct confrontation with Le Corbusier's 'type-objects', hygienic and pros-thetic.[37] Dalí's proposal for the construction of Surrealist objects, as a new form of communal activity for the movement, was directly prompted by Breton's dream object. Dalí, however, reforges the direct link with psycho-sexual concerns which was marginal to Breton's invocation of the fetish, through his notion of the 'Surrealist object functioning symbolically'.[38] These composite, elaborate con-structions touch at several points the themes noted above for the fetish, although they should not be simply collapsed into it. The very fact that Dalí describes them as 'symbolically' functioning objects opens up some distance between them and the classical fetish, pulling them into relation with dreamwork. Dalí divorces these objects from any formal considerations, and they have nothing in common with the early constructivist experiments in kineticism.

> OBJECTS OF SYMBOLIC FUNCTION:
> *These objects, which have a minimal mechanical function, are based on phantasms and representations susceptible of being provoked by the realisation of unconscious acts ...*
> The incarnation of these desires, their manner of objectivising themselves by substitution and metaphor, their symbolic realisation constitute the typical process of sexual perversion, which resembles in every respect the process of poetic fact.

Dalí simultaneously sets up a psychoanalytical context through the classifica-tory terminology of 'normal' and 'perverted' sexuality, and then subverts it, by equating the object with Surrealism's poetic aims, thereby bringing into question the scientific aims of the psychologists: 'the object itself and the phantasms that its functioning can unleash always constitute a new and absolutely unknown series of perversions, and consequently of poetic facts'. The idea of an almost endless inventiveness at the service of a perverse erotic imagination, the categorising psychologist's nightmare, serves to underline the gap between the Surrealists' interests in the research and experimentation in sexuality and that of the 'scien-tists'. It was part of the project of the Surrealist object in the early 1930s that it should be 'practised by all'. Coming closer to fetishism than to dream symbolism, Dalí proposes that everyone should produce their own, given the irreducible individuality of the erotic imagination. 'The objects depend only on the amorous imagination of each person and are extraplastic' – that is, outside formal and aesthetic considerations. Of the four objects reproduced, two are by men, two by women (André Breton, Valentine Hugo, Dalí and his companion Gala). As

far as Dalí was concerned, there was no gender bar to the realisation of these desires.

Dalí's 'Objets Surréalistes' concluded with accounts of these four objects which are basically descriptive rather than analytical, and were necessitated by the very complexity of the objects, the details of whose materials, construction and mobility were quite hard to determine from the photographs. He described his own 'article' as follows:

> Inside a woman's shoe is placed a glass of warm milk in the centre of a soft paste coloured to look like excrement.
>
> A lump of sugar on which there is a drawing of the shoe has to be dipped in the milk, so that the dissolving of the sugar, and consequently of the image of the shoe, may be watched. Several extras (pubic hairs glued to a lump of sugar, an erotic little photograph, etc) make up the article, which has to be accompanied by a box of spare sugar and a special spoon used for stirring leaden pellets inside the shoe.[39]

Dalí's comments on an object by the poet Paul Éluard are intriguing in the very direct link he sets up with the ethnographic objects. Éluard had included a wax taper in his object, and Dalí says 'wax was almost the only material which was employed in the making of sorcery effigies which were pricked with pins, this allowing us to suppose that they are the true precursors of articles operating symbolically...'[40] Herbert Read's comment in the 'Foreword' to the 1937 exhibition *Surrealist Objects and Poems* at the London Gallery makes a more general link between the Surrealist object – whether found, made or chosen – and ethnographic objects. He does so in terms that unintentionally highlight the contradiction that lies at the heart of Surrealism's embrace of the other – the 'savage': 'Imagine, therefore, that you have for a moment shed the neuroses and psychoses of civilisation: enter and contemplate with wonder the objects which civilisation has rejected, but which the savage and the Surrealist still worship.'[41]

The Surrealist object has a rich ancestry; apart from Breton's dreamed object, the bearded book dwarf mentioned above, there were other both verbal and visual sources: the classic Surrealist image based upon the conjunction of two or more dissimilar realities on a plane foreign to them ('beautiful as the chance encounter of the sewing machine and umbrella on a dissecting table'); collages governed by a similar principle of displacement and disorientation; the game of the *cadavre exquis*; a variety of Dada objects and constructions, and Duchamp's 'assisted readymades'. Its immediate origin, though, was Giacometti's *Suspended Ball*, a source Dalí acknowledges but distinguishes from his own proposal of the symbolically functioning object on the grounds that it was still a sculpture, while the Surrealist object was exclusively made from found or readymade materials, and had nothing to do with aesthetics.

A drawing of *Suspended Ball* is included among the 'dumb, mobile objects' by Giacometti reproduced in SASDLR. *Suspended Ball*, which exists in both the original plaster form and in a wooden version, shockingly links violence to desire; the cleft

pendant ball seems to hover over a curved wedge, which is waiting to slice further into the ball, but is also perhaps a magnified segment of it. Analogies between the ball and both eye and genitals point to a long obsession of the Surrealists, and most immediately to Buñuel and Dalí's 1929 film *Un Chien Andalou*, whose opening scene of the slitting of the young woman's eye was celebrated in *Documents* by Georges Bataille: 'The eye could be brought closer to the cutting edge, whose appearance provokes at the same time acute and contradictory reactions: precisely what the makers of *Un Chien Andalou* must horribly and obscurely have experienced when in the first images of the film they determined the bloody loves of the two protagonists . . . '[42] *Suspended Ball*, as has often been noted, confuses gender in its analogies with the human body and the motions of sex.[43]

A comic-horror sequence in *Un Chien Andalou* also plays on fetishistic displacements and substitutions across gender. A young man and young woman confront each other; the man suddenly clasps his hand to his mouth as though his teeth were about to fall out, and then removes it to reveal the lower part of his face as though wiped clean, as if he has no mouth. The girl reacts by furiously applying lipstick to her own mouth; however, hairs now grow on the man's face. The young woman claps her hand to her mouth in dismay, and quickly examines her armpit, which is now completely hairless. The man continues to look at her with hair growing on his mouth; she puts her tongue out at the man, and leaves the room, returning to put her tongue out once again at the hairy-mouthed man. This hilarious sequence compresses an extraordinary range of sexual signifiers into a dance between genders, starting with the horror-provoking castration symbol of the empty face (the original film direction was that the man should pucker his mouth until it appeared like a slit), through the masquerade as the woman frantically applies lipstick, to the final display by the woman of a comically waving phallic tongue.

Breton's 'L'Objet Fantôme' (the Phantom Object), published in the same issue of SASDLR as Dalí's 'Objets Surréalistes' and later incorporated into *Les Vases Communicants*, included a critique of these elaborate constructions.[44] Breton begins by drawing a sharp distinction between fantasy prompted by religious fear and modern monsters of the imagination like Picasso's *Clarinet Player*, Duchamp's *Bride* or Dalí's *Great Masturbator*. He opens with a quotation from Engels: 'The beings outside time and space created by the clergy and nourished by the imagination of ignorant and oppressed crowds are only the creation of a morbid fantasy, the subterfuges of philosophical idealism, the bad products of a bad social regime.' Breton wants to refute charges brought against the Surrealists by the dissident group centred on *Documents*, which had been leading a campaign to discredit the Surrealists by implicating them as idealists.

The deviation of works such as those by Duchamp or Dalí, modern monsters, which at first sight appear 'repellent and indecipherable', should not be confused with the metaphysical imaginary of Bosch or Blake. 'The variable theory which presides over the birth of this work . . . shouldn't let us forget that preoccupations rigorously personal to the artist, but essentially linked to all people, here find

a means of expression through a form of deviation.' Breton argues that such works can be analysed for their latent content, and then proceeds to do so for his drawing of an envelope with eye-lashes and a handle – the phantom object. Favourable though he is to the idea of the Surrealist object, whose adoption, he says, he recently insisted upon, he nonetheless finds it loses in power through being too systematically determined.

> They offer to interpretation a less vast scope ... than objects less systematically determined. The voluntary incorporation of latent content – filleted in advance – into the manifest content serves here to weaken the tendency to dramatisation and magnification used in the opposite case by censorship. Without doubt such objects, too particular and too personal in conception, will always lack the astonishing power of suggestion enjoyed by chance by certain quite ordinary objects, for example the gold-leaf electroscope ...

Out of Breton's objection to the symbolically functioning objects – his own as well as Dalí's – emerged the simpler type of Surrealist object, such as Oppenheim's *Fur Breakfast*. Here there is an elision between fetish and dream object, in which the condensation and displacements typical of dream work take on material form.

Michel Leiris's 'Alberto Giacometti', published in *Documents* in 1929, continues the challenge to Surrealism posed by that review, which took the form of contesting value and meaning across a similar field of objects. Facing the problem of the 'private and particular' – the relation between individual expression and communicability – Leiris eschews the idea of the universalising function of the symbolic dreamwork. Fetishism alone occupies the central place in his argument.

Fetishism, for Leiris, now as in ancient times, 'remains at the basis of our human existence'.[45] He distinguishes, however, between a true fetishism, and a counterfeit version to which too much of our lives is devoted, in the form of the worship of 'our moral, logical and social imperatives'. True fetishism is a different order of relation between the self and the outer world altogether. It is desire in its true form – love which demands another pole, external to itself, and is projected from the interior, 'clad in a solid carapace which imprisons it within the limits of a precise thing ... into the vast strange chamber called space'. Few works made by the human hand respond to the exigencies of this true fetishism; most art is deeply boring. The reason that certain moments, objects or events stand out with inexplicable force and clarity in our memory is that they witnessed this sudden confirmation of desire from the outside, in what could be truly called a crisis. 'It is a matter of moments when the outside seems brusquely to respond to the summation that we launch towards it from the inside, when the external world opens up for our heart to enter into it and establish with it a sudden communication.' Leiris delicately builds up a framework for perceiving Giacometti's *Man and Woman, Reclining Woman* or *Personnages* (1929) as material traces of such moments of intense experience. They are essentially autonomous, and unjustifiable from any

logical or rational perspective which may demand of art a comfortable copy or ideal model of the external world. Leiris's description of the figure and its fetish alone in space closely corresponds to the open cage-like tracery of Giacometti's sculptures and the mysterious interpenetration of their forms.

The memory traces left by these moments of crisis are often embodied in events that appear in themselves 'futile, denuded of symbolic value and in some way gratuitous', like the fetish object. Leiris instances some of his own memories of this order: 'In a luminous street in Montmartre, a negress from the Black Birds troupe holding a bunch of roses in her two hands, a steamer I was aboard moving slowly away from the quay... meeting in a Greek ruin a strange animal which must have been a kind of giant lizard ... ' Leiris finds Giacometti's sculptures, like *Man and Woman* or *Reclining Woman*, the precise equivalents of this type of memory – records of a psychical crisis, a confirmation of one's existence in a space not bounded by the imperatives of false fetishism but outlined rather by the operation of our own desire, which can be nothing other than 'l'amour – réel-lement amoureux – de nous-mêmes ... '.

And yet – what price should we give the capricious character of Leiris's own memories? They seem in effect to be almost too perfectly structured, correspond-ing to three of his – and Bataille's – preoccupations at the time: with the implications of 'negrophilia' in Paris (Black Birds), with the overturning of old notions of 'the primitive mind' (travel from here to there), and finally with the collapse of Latin civilisation (dinosaur in the ruins of Greece). Perhaps it should be enough to note that they operate in this text as a hint of another layer behind the psychoanalytical discourse of the fetish. Leiris was reading Freud's *Totem and Taboo* at the time, and comments in his diary a couple of months before finishing the Giacometti article:

> The theories of contemporary psychologists and sociologists (Freud, Durkheim, Lévy-Bruhl) on primitive mentality are necessarily subject to caution, these scholars having made no direct observations but worked from materials provided by the ethnographers. As far as totemism is concerned, for example, the different observers bring out very different forms, depending upon the country... Moreover, these observations cannot have been made in an absolutely objective frame of mind; they are tendentious, and falsified in origin by the interpretation whose germ they already contain.
>
> It seems that to explain the life of primitives most of these people have invented '*robinsonnades*' which represent in their field the equivalent of those that Marx mocked in the classical economists.[46]

Leiris was evidently aware of the tainted nature of the term fetishism within ethnographic discourse, whose shadow he nonetheless invokes.

Dalí once referred to Feuerbach's 'conception of the object as being primitively only the concept of the second self... Accordingly it must be the "you" which acts as "medium of communication", and it may be asked if what at the present

moment haunts Surrealism is not the possible body which can be incarnated in this communication.'[47]

Bellmer's object-sculptures are haunted by this idea of the 'possible body'. They have their origins both in the 'little fetishism' that Binet described as inseparable from all human love, but also undeniably in the sadism that Krafft-Ebing argued could be closely related to fetishism. In 'L'Anatomie de l'Amour', Bellmer claims that desire has its point of departure not in the whole, but in the detail. The body fragment isolated and compulsively repeated also points to male anxiety about lack in the Freudian sense of the fetish. In Bellmer, this overlaps with the earlier type of sexual fetishism – desire takes the fragment 'fatally' for the whole: its efficacity relies above all on the fact that it has an independent identity. Only thus, Bellmer writes, can it be doubled, multiplied, displaced in the realisation of the image of desire:

> From the moment that the woman reaches the level of her experimental vocation, accessible to permutations, algebraic promises, susceptible of yielding to transubstantial caprices, from the moment that she is extendible, retractible ... – we shall be better instructed as to the anatomy of desire, than the practice of love itself could do.[48]

Bellmer imagines removing the barrier between woman and her image. He gives a fearful example of this: a photographic document of a female victim who had been wrapped in wire 'provoquant des saillants bour-soufflés de chair, des triangles sphériques irréguliers, allongeant des plis, des lèvres malpropres, multipliant des seins jamais vus d'emplacement inavouable',[49] which Bellmer compares with the multi-breasted Diana of Ephesus. This document prompted Bellmer's own experiments of photographing the body wrapped in string, one example of which was used for the cover of *Le Surréalisme, même* (Spring 1958). Comparisons have been made between Bellmer's 'monstrous dictionary of analogies/ antagonisms' of body parts and the decadent dream-fantasy of one of the male lovers in Rémy de Gourmont's *Le Songe d'une femme*. However, there is a crucial difference. Paul Pelasge dreams of plants and bodies that metamorphose into one another in a cinematic slow motion of inflated fragments: 'now her two small sharp breasts become irritated and tremble; they become balloons; they stifle the naked woman who was offering herself; they settle down on their short stem; they are two large white mushrooms topped with a pink shell'.[50] Bellmer's body parts multiply and are displaced, but never metamorphose into something else. The leg, for example, 'perceived in isolation and in isolation appropriated by memory, should go forth to live its own life in triumph, free to double itself, to attach itself to a head, to sit down, cephalopod, on its open breasts while straightening the back that is its thighs';[51] but it remains, essentially and irreducibly, like the fetish, itself.

Parallels have often been drawn between the Surrealist object and photographs – parallels that are clearly laid out in SASDLR when the objects were reproduced

facing Man Ray's photograph *The Primacy of Matter over Thought*. But if we draw in the idea of fetishism, some intriguing differences emerge. The body is the site for much of Surrealist photography, usually the female body. Brassaï's nudes, acephalous and phallicised, themselves seem to symbolise the fetish as Freud defined it. The Surrealist object – especially in its first incarnation as Dalí's notion of the symbolically functioning object – posits rather the absence of the body: shoe, gloves, a mirror, a bicycle seat. They are like symbolic narratives of erotic sensations, each highly personal in character.

Jacques-André Boiffard's photographs of three big toes, which accompanied Bataille's 'Le Gros Orteil' are photographic paradigms of a fetishised body fraction. The heavy chiaroscuro isolates the toe from its body; as reproduced in *Documents*, the toe is cropped from the original photograph of the foot and enlarged, dramatised and magnified in a wholly fetishistic process. The toe itself, though, is erect, its aggressive verticality confounding the base horizontality of its normal position. In the text, Bataille turns the 'classic fetishism of the foot' to account in terms of his arguments about 'base seduction' contrasting with the seduction of ideal beauty. The 'sacrilegious charm' of the foot of the Spanish Queen, which obsessed the Count of Villamediana and led to his death at the hands of the King, rested, Bataille argues, in the fact that it did not significantly differ from the hideous and deformed foot of a tramp.[52]

Five photographs of Paris monuments by Boiffard, illustrating Robert Desnos's 'Pygmalion et le sphinx',[53] rather blank belly-shots of elaborate lumps of stone, raise the notion of the fetish in the context of the 'ethnological journeys' the Surrealists made in the heart of their own city. Like the statue of Étienne Dolet, place Maubert, which, Breton recounts in *Nadja*, always simultaneously attracted him and filled him with an insupportable malaise, there is a disproportion between their apparent role and their effect.[54] Desnos is interested in the contradiction between the materiality, the heavy weight of these statues and the elevated aspirations they are meant to symbolise, underlined grotesquely in monuments to speed, flight or telecommunications. They may, even more appropriately, be taken as fetishes to a nation's idea of progress, military might and glory, and thus classic examples of the mechanism of disavowal – that, at any rate, is the way the Surrealists saw them. Monuments, it was once suggested, are to history as the fetish is to the maternal phallus. In order to deny the absence of something that doesn't exist, you fill the gap, blanking out the absence and endowing this *material* object with the lineaments of your desire.

Aragon, in *Paris Peasant*, imagines the stone statues of capital cities becoming idols of a new religion, before which the people would come to worship and sacrifice. 'We have the phallophoria of Trafalgar Square, where one-armed Nelson is the witness of a nation's hysteria. And Frémiet's Joan of Arc . . . not to mention the magnificent apotheosis of Chappe at the foot of a telegraphic scaffold.'[55] Boiffard's photographs of these monuments are reminders that the fetish could work for the Surrealists in playful and satirical, as well as perverse and sexual, ways.

Notes

1 'Un dictionnaire commencerait à partir du moment où il ne donnerait plus le sens mais les besognes des mots', Georges Bataille, 'Informe', *Documents*, No. 7, Paris, 1929, p. 382.

2 Carl Einstein, 'André Masson: Étude Ethnologique', *Documents*, No. 2, 2nd year, p. 95.

3 Sigmund Freud, *Totem and Taboo*, London, 1965, p. 18.

4 William Pietz, 'The Problem of the Fetish', *Res* No. 9, Spring 1985, pp. 10–11.

5 Michel Foucault, *The Order of Things: An Archaeology of the Human Sciences*, London, 1985, p. 379.

6 André Breton, 'Introduction to the discourse on the paucity of reality' (1925), in *What is Surrealism?*, ed. Franklin Rosemont, Pluto Press, London, 1978, p. 27.

7 See for example Marianna Torgovnik, *Gone Primitive*, Chicago, 1990, or Nicholas Thomas's 'Colonial Surrealism: Luis Buñuel's *Land Without Bread*, *Third Text*, Spring 1994, p. 25.

8 See Charles-Robert Ageron, 'L'Exposition coloniale de 1931: mythe républicain ou mythe impériale?', *Les Lieux du mémoire*, Vol. 1, Paris, 1984.

9 A major sale of Breton's and Éluard's collections, 'Sculptures d'Afrique, d'Amérique, d'Océanie' at the Hôtel Drouot in 1931, coincided with the Colonial Exhibition. The catalogue listed two masks described as 'Fétiches M'Gallé' from the Ogoué region of Gabon. Éluard's list of ethnographic objects sold to Roland Penrose in 1937 describes only three of the African sculptures, the Gabon 'reliquaries', as fetishes, thus suggesting an attempt (if misplaced) to be precise in the use of the term.

10 Georges Bataille, 'L'esprit moderne et le jeu des transpositions', *Documents*, No. 8, 2nd year, 1920, p. 489. Taking a cue from Mauss, the term 'fetish' is occasionally queried in *Documents*. A photograph of three rare Benin forged iron sculptures is reproduced (opposite, significantly, an anamorphic painting and two of Dalí's an-drogynous/body fragment paintings of 1928, *Bathers* and *Female Nude*); the commentary asks: 'Fetish trees? but perhaps also genealogical trees, or even trees flowering with freshly cut heads: it is difficult for the ethnographers to decide the nature of these most mysterious of trees ...' (*Documents*, No. 4, 1929, p. 230). See James Clifford, 'On Ethnographic Surrealism', in *The Predicament of Culture*, Harvard, 1988, for a further discussion of *Documents* and ethnography, and Jean Jamin, 'L'ethnographie mode d'inemploi: de quelques rapports de l'ethnologie avec le malaise dans la civilisation', in *Le mal et la douleur*, ed. J. Hainard and R. Kaehr, Musée d'Ethnographie, Neuchâtel, 1986.

11 Denis Hollier, *Against Architecture* (1974), MIT, 1989, p. 112.

12 Carl Einstein, 'André Masson, Étude ethnologique', *Documents*, No. 2, 1929, p. 93; Michel Leiris, 'Alberto Giacometti', *Documents*, No. 4, 1929, p. 209.

13 Marcel Mauss, *Œuvres Complètes*, Paris, 1968, Vol. 1, p. 560. To Mauss's disgust, Kingsley persistently used the term 'joujou' ('French, used by the natives'). Curiously, this was the subject of one of Marcel Griaule's 'critical dictionary' entries, which he discusses in terms close to those one might expect for 'fetish'. 'The first Portuguese ... who landed on the African coast, facing the immense problems of the beliefs, mysteries, powers, gods, black spirits, resolved them all immediately into a

single word: DjouDjou . . . A ridiculous word from an ethnographic point of view, but a very elegant one if put in its place, that is if one considers it as nothing but a term of African *lingua franca [sabir]* and the *lingua franca [sabir]* of exhibitions.' *Documents*, No. 6, 1930, pp. 367–8.

14 Adrian Pettinger, 'Why Fetish?', *Perversity: New Formations*, No. 19, Spring 1993, p. 92.

15 William Peitz, 'The Problem of the Fetish 1', *Res*, No. 9, Spring 1985, p. 8.

16 William Peitz, 'The Problem of the Fetish 2', *Res*, No. 13, Spring 1987, p. 41.

17 William Peitz, 'Fetishism and Materialism', in *Fetishism as Cultural Discourse*, ed. Emily Apter and William Peitz, Cornell University, 1993, p. 130.

18 Karl Marx, *Capital*, London, 1942, p. 57.

19 Ibid. p. 46.

20 Alfred Binet, 'Le fétichisme dans l'amour', *Revue Philosophique*, part 1, August 1887, part 2, September 1887, p. 144. Mutations in the etymology of fetishism continue: the catalogue to the 1994 V&A exhibition *Revolt into Style* gives the meaning 'charming', a novel derivation from 'charm' in the magical sense.

21 Ibid. p. 145.

22 Dr R. von Krafft-Ebing, *Psychopathia Sexualis* (1886), translation by F. J. Rebman of the revised and expanded twelfth German edition, London, n.d. [*c*.1922], p. 218.

23 Ibid.

24 Ibid.

25 As Krafft-Ebing pointed out (in *Psychopathia Sexualis*, op. cit.), his examples were all of female clothing because most of the cases he and other psychologists had studied were men, but he did not rule out the possibility of female fetishists, and indeed among Binet's examples, drawn from Charcot's and Magnon's cases, was one of a woman who developed a fetishistic attachment for a man's voice.

26 Ibid. p. 218.

27 Ibid. case 95, p. 230.

28 William Peitz, 'The Problem of the Fetish 1', *Res*, No. 9, p. 7.

29 Ibid.

30 Michel Foucault, *The History of Sexuality*, London, 1984, p. 154. Surrealism itself profoundly influenced later radical critiques such as Foucault's *History of Sexuality*, and was responsible for publishing some of the first writings of two of the most influential figures in Structuralist thought in the fields of psychoanalysis and ethnography: Lacan and Lévi-Strauss.

31 See Robert Nye, 'The medical origins of sexual fetishism', in *Fetishism as Cultural Discourse*, op. cit. The poet Apollinaire, who coined the term 'surréaliste', wrote a play entitled *Les Mamelles de Tirésias*, a piece of mildly satirical propaganda for childbearing, presented as à 'drame surréaliste'.

32 *Recherches sur la sexualité*, Archives du Surréalisme, Paris, 1990, translated as *Investigating Sex*, ed. José Pierre, Verso, London, 1992. The first two 'conversations' were published in *La Révolution Surréaliste*, No. 10/11, 1928.

33 Salvador Dalí, 'The object as revealed in Surrealist experiment', *This Quarter*, Paris, 1932, p. 199. I have slightly altered the translation, which rendered Breton's 'Introduction au discours sur le peu de réalité' as 'Introduction to the discourse on the poverty of reality'.

34 'Introduction to the discourse on the paucity of reality', in *What Is Surrealism?*, ed. Franklin Rosement, Pluto Press, London, 1978, p. 26.

35 Ibid. p. 25.

36 Ibid.

37 Le Corbusier, *The Decorative Art of Today*, London, 1925. See also Briony Fer, 'The hat, the hoax, the body', in *The Body Imaged*, eds K. Adler and M. Pointon, Cambridge, 1993.

38 Salvador Dalí, 'Objets Surréalistes', SASDLR, No. 3, 1931, p. 16.

39 Salvador Dalí, 'The object as revealed in Surrealist experiment', op. cit. p. 206.

40 Ibid.

41 Herbert Read. Foreword to *Surrealist Objects and Poems*, London Gallery Ltd, London, 1937.

42 Georges Bataille, 'L'oeil', *Documents*, No. 4, 1929, p. 216.

43 See Yves Bonnefoy, *Giacometti*, Paris, 1991, p. 196; and Hal Foster, *Compulsive Beauty*, MIT, 1993, p. 92; also Rosalind Krauss, 'Alberto Giacometti', in *Primitivism in 20th Century Art*, ed. W. Rubin, New York, 1984, for a discussion of Giacometti and 'hard primitivism'.

44 André Breton, 'L'Objet Fantôme', op. cit. p. 20 (author's translation).

45 Michel Leiris, *Documents*, No. 4, 1929, p. 209 (author's translation).

46 Michel Leiris, *Journal 1922–1989*, Paris, 1992, p. 157.

47 Salvador Dalí, 'The object as revealed in Surrealist experiment', op. cit. p. 202.

48 Hans Bellmer, 'L'Anatomie de l'Amour', *Le Surréalisme en 1947*, Paris, 1947, p. 108 (author's translation).

49 Ibid. p. 109.

50 Rémy de Gourmont, *Le Songe d'une femme*, Paris, 1916, p. 145 ('Voilà que ses deux seins menus et aigus s'exaspèrent et tremblent; ils deviennent des ballons; ils étouffent la femme nue qui s'offrait; ils se couchent sur leur tige courte; ils sont deux grands champignons blancs surmontés d'une coque rose . . .').

51 Bellmer, op. cit. p. 109.

52 Georges Bataille, 'Le Gros Orteil', *Documents*, No. 6, 1929, p. 297.

53 Robert Desnos, 'Pygmalion et le Sphinx', *Documents*, No. 1, 1930, p. 33.

54 André Breton, *Nadja* (1926), Paris, 1964, p. 25.

55 Louis Aragon, *Paris Peasant* (1926), London, 1971, p. 167.

Index

NOTE: Page numbers in bold indicate a text by an author. Page numbers in italic indicate an illustration. Page numbers followed by *n* indicate information is in a note.

"absolute artistic volition," 82–5
Abstract Expressionism, 159, 220
abstraction, 53, 54, 57–60; American art, 203, 212, 236; and avant-garde, 190; Kandinsky on, 98, 99, 106, 121; Mondrian on Abstract-Real painting, 147–9; and rationalization, 170–1; Worringer on, 57–9, 60, 80, 85–91
academies and Futurism, 30, 31, 135
academism *see* Alexandrianism
Ades, Dawn, 8, 301–2, **381–99**
Adorno, Theodor, 156, 157, 158, 160, 161, 233; culture industry, 155, 221; on montage, 260–1; negation of synthesis, 261
advertising: and Dadaism, 374; and Socialist Realism, 281
"aesthetic materialism," 281
aestheticism, 222, 233, 254–8; and avant-garde in France, 353–4, 356, 362; Worringer on, 79–91; *see also* autonomy of art
Agitreklama, 205
Ainalov, D. V., 124
AIZ, 207, 216*n*
AKhRR, 278, 281–4
alchemy, 55
Alexandrianism, 159, 189, 191, 209

alienation effect, 158, 227–8
allegory and montage, 259
American art: abstraction, 203, 212, 236; documentary movement, 204, 205; historical avant-garde, 220, 221; Modernist movements, 203–4, 205, 207–8; and politics, 212
American Guide Series, 204
anarchism, 219–20, 237, 247, 272, 331–2, 350, 352–3
Ancient Greece, 93, 175; music, 199–200*n*; Nazi neo-classicism, 266, 267, 268, 275, 282; *see also* classical art
Anderson, Wayne, 318*n*
androgyny of Maori body, 312
Anquetin, Louis, 65*n*
anthropism, 89
Anthroposophy, 55, 62
anti-bourgeois movements, 219–23, 243–7; Dadaism, 366–71, 374–5, 376
antithesis, 108, 110, 117, 119
Apollinaire, Guillaume, 42*n*, 43, 352, 354, 355, 358
apperceptive activity, 80–1
Aragon, Louis, 8, 44, 48, 207, 261, 369, 396
Arbeiter Illustrierte Zeitung (*AIZ*), 207, 216*n*

architecture: Benjamin on reception of, 185; and Neo-Plasticism, 149

Aristotle, 190, 199–200*n*

"arkhitektony," 278

Arnold, Matthew, 203, 245

Arp, Hans, 183, 368, 375

art for art's sake *see* aestheticism; autonomy of art

art collectors, 300, 334–8, 355–6

"art of fact," 205

art history: and avant-garde, 321; feminist critique, 298; Modernist view, 209–11; "New Art History," 297

art theory and semiotics, 213–15

art/life dichotomy, 221–3, 226–7, 233, 254–8

artist-novel, 337

"artistic volition," 82–5

artists: and creativity, 122–3; as popular identity, 337, 338; and visual image, 13–14; women as, 325–8, 337, 338, 339–40

Arvatov, Boris, 223, 226, 281

Association of Artists of Revolutionary Russia (AKhRR), 278, 281–4

astrology, 55

Atget, Eugène, 181–2

Aubry, Georges, 355

Auden, W. H., 250

"aura" of work of art, 157–8, 177, 178; destruction of aura, 183, 186, 224

Aurier, G.-Albert, 56–7, 60, **71–8**, 298, 305

Austrian art: *Ver Sacrum* editorial, 18–20

authenticity, 176–7, 179

automatism, 8, 42–4, 258, 261–2

autonomy of art: negation by avant-garde, 222, 223, 233, 253–8, 300; Russian avant-garde rejection of, 279; *see also* aestheticism

avant-garde, 188–200; and aestheticism, 353–4, 356, 362; art/life dichotomy, 221–3, 226–7, 233; defining concept, 231–2; elitism/egalitarianism dichotomy, 4, 54, 191–2, 204; as expression of freedom, 321; failure of, 233; geography of, 249–50; historical avant-garde, 8, 219–29, 232–3; ideology of Russian avant-garde, 276; and kitsch, 159–60, 192–200, 201–3; and mass culture, 156–7, 160–1, 223–9; negation of autonomy of art, 222, 223, 233, 253–8, 300; neo-avant-garde, 234, 257; and politics, 189–90, 197–9, 219–23, 231–95, 331–2, 352–3; in present day, 251; and Socialist Realism, 274–95; and technology, 223–9, 280–1; virility and domination in art, 298–300, 320–35; women artists, 325–8, 337, 338; *see also* Modernism

Baader, Johannes, 368, 370, 373

Bahr, Hermann, 3

Balkan Wars and *papiers collés*, 350, 359, 360, 361–2

Ball, Hugo, 300–1, 366, 368, 372, 375; Dada Manifesto, 5–6, *7*, **33–4**, 60

ballet: and mass ornament, 166; and Neo-Plasticism, 153

Barlach, Ernst, 267

Baron, Jacques, 44

Barthes, Roland, 297, 305, 310, 317–18

Barzun, Henri-Martin, 353–4

Basler, Adolphe, 355

Bataille, Georges, 301, 381, 383–4, 387, 392, 394, 396

Baudelaire, Charles, 54, 155–6, 373, 374

Bauhaus, 9, 11*n*, 202, 278

Beardsley, Aubrey, 340

beauty: cult of, 179; and Neo-Plasticism, 152, 153; *see also* aestheticism

Beckmann, Max, 9, 266

Beethoven, Ludwig van, 95

Bell, Clive, 1, 2, 3, 4, 57, 208, 209, 347*n*

Bell, Vanessa, 341

Bellmer, Hans, 395

Benjamin, Walter, 156, 161, 204, 218, 233, 314; "aura" of work of art, 157–8, 177, 178; on Baudelaire, 373; criticisms of, 158; and hidden dialectic of avant-garde, 227–8; mechanical reproduction of art, 5, 157, **174–87**, 223–4

Benn, Gottfried, 198, 250, 268
Berenson, Bernard, 1
Bergius, Hanne, 156, 300–1, **366–80**
Bergson, Henri, 5, 54, 351
Berlin Dada, 223, 225, 366, 375
Berliner Illustrierte, 216*n*
Bernard, Émile, 21, 56, 307, 308, 317
Billy, André, 355
Binet, Alfred, 386–7, 395
"bioscopic books," 207
black, 110, 112, 113
Blanche, Jacques-Émile, 21
Blast manifestos, 341, 344*n*, 346*n*
Blaue Reiter Almanac, 66*n*
Blavatsky, Mme Helena, 67*n*
Bloch, Ernst, 156, 157, 234, 261, **265–9**
Blok, Alexander Alexandrovich, 211, 250
blue, 101, 110, 111–12, 117
Böcklin, Arnold, 60, 98, 99
body: exotic other, 311–13, 316; and
 fetishism, 387, 388, 395, 396; *see also*
 female nude; sexuality
"body culture," 172, 173
Boguslavskaya, K., 145
bohemian lifestyle: *fantaisistes*, 355; and
 masculine identity, 342–3; and
 women, 332–4, 340–1
Boiffard, Jacques-André, 44, 396
Bojko, Szymon, 207
Bosman, William, 384–5
Boulanger, Gustave, 74
bourgeois art, 254–6
bourgeois family, 246–7
bourgeoisie: anti-bourgeois movements,
 219–23, 243–5; and avant-garde
 artist, 331–5; Dada's break with,
 366–71, 374–5, 376; Williams on,
 243–7
Brancusi, Constantine, 2, 190
Braque, Georges, 45*n*, 188, 190; nudes,
 323–4; and Picasso, 259, 356, 357,
 358, 359
Brassaï, 396
Brecht, Bertolt, 157, 158, 160, 161, 207,
 214, 250; *Verfremdungseffekt*, 227–8
Breton, André, 56, 60, 66*n*; Bürger on,
 258, 261–2; and fetishism, 301, 383,

388–90, 392–3; "First Manifesto of
 Surrealism," 8, **36–49**, 389; *Nadja*,
 261, 262, 396; "Second Manifesto
 of Surrealism," 8; "Towards a Free
 Revolutionary Art," 236–7,
 270–3
"Bretonism," 307–9
Breunig, Leroy, 354
Brik, Lilya, 226
Brodsky, Horace, 346*n*
Brücke, Die, 299, 322, 324, 330, 331,
 332, 333
bruitism, 5, 6
Brzeska, Sophie, 341, 346–7*n*
Buchloh, Benjamin, 233, 238*n*
Buñuel, Luis, 392
Bürger, Peter, 8, 161, 221–3, 232–4, 237,
 253–64, 300
Burgin, Victor, 160, **201–17**
Burne-Jones, Sir Edward, 98
"Bytie," 282

cabaret/Cabaret Voltaire, 5, 300–1, 366,
 368, 375, 376
cabbala, 55
Cahill, Holger, 203
Campendonck, Heinrich, 266
capitalist production process: Benjamin on,
 174–5; of kitsch, 193; and mass
 ornament, 167–8; and rationalism,
 169–71
captions, 181
Carlyle, Thomas, 43*n*
Carrà, Carlo, 60
Carrington, Dora, 341, 348*n*
Carrive, Jean, 44
Central Institute of Labor (CIT), 226
Cézanne, Paul, 1, 2, 3, 4, 190, 210; Fry on,
 15, 16, 17, 208; Kandinsky on, 99,
 125–6*n*; Matisse on, 24, 26
Chagall, Marc, 266
chants nègres, 6
Chaplin, Charlie, 366, 374
Chardin, Jean Baptiste Siméon, 26
Chazal, Aline, 309–10
Cheetham, Mark, 62
Chien Andalou, Un (film), 392

childhood: and genius, 372; and Surrealism, 36, 48
children in Gauguin's work, 308–9
Chirico, Giorgio de, 42*n*, 45*n*, 60, **128–9**, 199, 301
"Chistiakov system," 291
"ciné books," 207
cinema *see* film
city, 155–6
Cixous, Hélène, 316
Clark, T. J., 160
classical art: Malevich on, 132–3; Nazi neo-classicism, 266, 267, 268, 275, 282; and Socialist Realism, 275, 291; *see also* ancient Greece
Clifford, James, 314
cloisonism/cloisonnisme, 56, 308
clothing: of avant-garde artists, 342–3; and fetishism, 387
code switching, 212
collage *see* montage; *papiers collés*
collectors, 300, 334–8, 355–6
colonialism, 298, 382–3
color: Fry on, 15, 16; Kandinsky on, 100–21; Malevich on, 140, 141; Matisse on, 24–5; Mondrian and New Plasticism, 149, 150, 151–2
"Color Field" painting, 159
Columbus, Christopher, 37
Communism, 160, 187; and avant-garde, 248; revolutionary art, 271–3; *see also* Soviet Russia
complementary colors, 25
composition: Kandinsky on, 105, 106–8; Malevich on classical art, 133; Matisse on, 22, 24
Constructivism, 6, 8, 35, 51, 204, 233, 237, 278–81; and technology, 225, 226, 280–1
cosmos and Socialist Realism, 278
Cottington, David, 300, **349–65**
Courbet, Gustav, 27
Courths-Mahler, Hedwig, 267
courtly art, 253–4
Cravan, Arthur, 372
creativity: Kandinsky on, 122–3; Malevich on, 133–5, 143; and Modernism, 243

Créteil, Abbaye de, 63*n*
Crevel, René, 44
"critical realism," 274–5
Crow, Thomas, 232
Cubism, 7, 54, 208–9, 233, 298–9; Fry on, 208; ideological background, 362–3; Malevich on, 61, 132, 140, 141–2; Mondrian on, 148–9, 150; *papiers collés*, 259, 260, 300, 349–51, 359–63; Picasso's paintings of women, 324, 328–9, 330; and Socialist Realism, 277
cults: ritual and art, 157–8, 179–80
"cultural Darwinism," 241
culture: definitions of, 203; and Marxist theory, 221–3; and sexual difference, 326–8; and social class, 200*n*, 214; *see also* mass culture; primitive culture
culture industry, 155, 221

Dada, Der, 53–4, 377*n*
Dada Berlin, 223, 225, 366, 375
Dada Paris, 223, 225
Dada Zurich, 223, 225, 300
Dadaism, 223, 233; Benjamin on, 183–4, 224; Bürger on, 257–8, 263; Dada Manifesto, 5–6, **33–4**; Fool in, 300–1, 366–80; Mondrian on, 148, 150; photomontage, 156–7, 207; reception of, 263; technology and art, 224–5
Daix, Pierre, 349, 357, 360, 361
Dalí, Salvador, 200*n*, 388, 390–1, 392, 394–5
dance: and Neo-Plasticism, 153; *see also* ballet; Tiller Girls
dandyism, 340; and Dada, 366, 369, 372, 373
Danielsson, Bengt, 314
David (Michelangelo), 133, 134
Davis, Stuart, 203–4
de Chirico *see* Chirico, Giorgio de
de Kooning, Willem, 329
De Stijl, 62, 278–9
decadence, 344*n*
Décaudin, Michel, 354
decorative arts and Neo-Plasticism, 153
Defregger, Franz von, 267

"Degenerate Art" exhibition, 234, *235*, 266–9
Delacroix, Ferdinand Victor Eugène, 103, 126*n*
Delaunay, Robert, 63*n*
Delaunay-Terk, Sonia, 63*n*, 326
Delteil, Joseph, 44
demythologization, 169, 170
dénicheurs, 355–6
Denis, Maurice, 1, 2, 21, 57
Derain, André, 45*n*, 183, 327, 333
Desnos, Robert, 41*n*, 44, 48, 383, 396
Desvallières, George, 21
dialectic, 55, 62, 156–7
disequilibrium, 147, 148
Dismorr, Jessica, 346*n*
dissonance and Cubism, 141–2
Divisionism, 148
Dix, Otto, 266, 370
Dmitrieva, N., 285–6
documentary movement in America, 204, 205
Documents (Surrealist review), 383–4, 392, 396
Doesburg, Theo van, 62
Dongen, Kees van, 299, 323, 333
Douglas, Charlotte, 55
dramatic art and Neo-Plasticism, 152
dreams and dream objects: Breton on, 38–9, 40, 389–90
du Maurier, George, 343*n*
Ducasse, Isidore, 44
Ducat, Ethel, 338
Duchamp, Marcel, 45*n*, 158, 224, 233, 257, 373, 391, 392
Duhamel, Georges, 184
Dujardin, Edouard, 65*n*
Duncan, Carol, 298–300, **320–36**
Dutilleul, Roger, 355, 356, 357, 358

Eagleton, Terry, 358
Eastern spiritualism, 55
Eco, Umberto, 212
effeminacy, 339, 340
Egbert, Donald Drew, 212
Egyptian architecture, 92*n*
Eichenbaum, Boris, 211

Einstein, Carl, 381, 384
Eisenstein, Sergei, 226
Eliot, T. S., 188, 200*n*, 250–1, 345*n*
elitism of avant-garde, 4, 54, 191–2, 204
Éluard, Paul, 44, 66*n*, 190, 391, 397*n*
emblems, 260
empathy theory, 58, 79–85, 90
Engels, Friedrich, 8, 220, 392
Enlightenment, 169
Enzensberger, Hans Magnus, 215, 219
equilibrium, 62, 146, 147, 148, 149, 153
equivalent relationships, 151
Erasmus, Desiderius, 301
Ermanox camera, 206
Ernst, Max, 45*n*, 374
erotic: Gauguin and primitive, 309–10, 311, 312–13, 315–16; *see also* female nude; sexuality
essentialism, 62
ethnology: and fetishism, 384, 394; *see also* primitive culture
eugenics, 339
Eve myth, 322, 326–7
exhibition of art, 179–80, 181–2
expression in art: Matisse on, 21–7, 56
Expressionism, 233, 298–9; critiques of, 53; film, 161*n*; in Nazi Germany, 198, 234, 250, 268; "New Objectivity" follows from, 50–1; and Socialist Realism, 282; Worringer's influence on, 57–8; *see also* Brücke, Die
"Expressionism Debate," 234

"factography," 205, 207–8
fairy tales, 41, 168–9, 173
fantaisisme, 354, 355
fantasy, 121
Farm Security Administration (FSA), 204
fascism: and avant-garde, 222, 248; Benjamin on, 175, 185–7; Breton on, 273; and Futurism, 5, 199, 248, 250; and kitsch, 160, 198
Fauves, les, 4, 26, 158; and politics, 331–2; virility and domination in art of, 298–9, 322–5
fear of space, 85–6
Federal Art Project, 203–4

Federal Theatre project, 204, 207–8
Federal Writers' Project, 204
Fedorov-Davydov, A., 282–3
Feininger, Lionel, 11*n*, 266
female nude: and fetishism, 396; Futurist
 ban on, 136–7; Gauguin's nudes, 309,
 316, 326–7; Matisse on, 22–3; virility
 and domination in avant-garde art, 299,
 320, 322–5, 326–8, 328–30, 333–5;
 women artists, 327; women models,
 332–4; women's responses to, 335
feminism: and avant-garde, 330–1, 337;
 and masculinity, 343; and social
 Darwinism, 339
"feminization": of art, 337–8, 340; of
 men, 339, 340
femmes fatales, 323, 326–7, 328
Fer, Briony, 62
Ferenczi, Sandor, 342
Festin d'Esope, Le, 355
"Fetishism" (exhibition), 301
fetishism and Surrealism, 301–2, 381–99;
 etymology of "fetish," 381–2
Feuerbach, Ludwig Andreas, 394–5
Feuilles libres, 41*n*
Fiedler, Leslie, 219
film: Benjamin on, 176, 177, 181, 182–3,
 184, 185; Burgin on montage, 259;
 and politics, 156, 162*n*
Filonov, Pavel, 287
Flandrin, Jean Hippolyte, 27
Flechtheim, Alfred, 355
folk art, 200*n*, 248
fool in Dada, 300–1, 366–80
Forain, Jean Louis, 355
form: Kandinsky on, 103–8, 121; Malevich
 on zero of form, 130, 143; in Socialist
 Realism, 289–90; Symbolist/
 Formalist conceptions, 209
formalism, 208–12; Fry and Bell, 1, 164*n*,
 208; Russian Formalism, 201,
 209–12, 213
Foster, Hal, 8, 67*n*, 233
Foucault, Michel, 367, 382, 388
Fourier, Charles, 219
France: nationalism in, 351–2
Frankfurt School, 155

Frankfurter Zeitung, 156
freedom: and avant-garde, 321, 331–2;
 Breton on, 37; of expression, 272–3
Frémiet, Emanuel, 27
Freud, Sigmund, 182, 330; Breton and
 Surrealism, 8, 38–9, 42, 236–7; and
 fetishism, 386, 387, 394; on "taboo,"
 382
Friday Club, 347
Friesz, Othon, 324
Frisby, David, 157
Fry, Roger, 1–2, 4, **13–17**, 159, 347*n*; on
 Cézanne, 15, 16, 17, 208; on Cubism,
 208; formalist criticism, 1, 57, 164*n*,
 208, 209
Futurism, 205, 232, 233; and Cubism,
 351; and Dadaism, 375–6; and
 fascism, 5, 199, 248, 250; Malevich
 on, 132, 135–45; Marinetti and
 manifesto, 4–5, 28–32; and
 masculinity, 347*n*; Mondrian on, 148,
 150, 152; and Suprematism, 61–2,
 135–45; and technology, 225, 226;
 and war, 186, 187; Williams on,
 242–3, 247–8

galleries in Paris, 355–6
Galton, Francis, 344*n*
Gan, Alexei, 204, 279
Gance, Abel, 177
Garcia Oliver, Juan, 273
Gastev, Alexey, 223, 226
Gaudier-Brzeska, Henri, 338, 340, 341
Gauguin, Mette Gad, 307
Gauguin, Paul, 2, 3, 16, *57*, 322; Aurier on
 symbolism in, 56–7, 71–3, 76–8;
 female nudes, 309, 316, 326–7;
 Malevich on, 143; Solomon-Godeau
 on primitive, 297–8, 304–19
gaze, 299–300
gender: masculinity and modernism,
 299–300, 337–43; and Mondrian, 62;
 and primitivism, 298, 310; virility and
 domination in avant-garde art, 298–9,
 320–36
genius: Breton on, 44; Bürger on, 257; and
 childhood, 372

geometric style, 86–8, 121
Gérard, Francis, 44
German Gothic, 58
Germany: avant-garde, 227–8;
 photography in, 205–6; *see also*
 Dadaism; Expressionism; Nazism
Giacometti, Alberto, 384, 393–4;
 Suspended Ball, 391–2
Gide, André, 191, 354
Giotto, 25, 210
Glazunov, Il'ia, 288
Gleizes, Albert, 63*n*, 352
Gobineau, Joseph, 312
Goebbels, Joseph, 198, 267
Goethe, Johann Wolfgang von, 103, 109,
 126*n*
Goncharova, Natalia Sergeyevna, 2
Gothic, 58
Gourmont, Rémy de, 395
Gramsci, Antonio, 351
Grant, Duncan, 347
green, 101, 110, 112
Greenberg, Clement, 155, 156–7, 158–60,
 188–200, 232, 236; Burgin's
 critique, 160, 201–3, 208–12, 213,
 214
grey, 113
Griaule, Marcel, 397–8*n*
Gris, Juan, 63*n*
Groos, Karl, 91*n*
Gross, Otto, 369–70, 371
Grossberg, Carl, 9
Grosz, George, 9, 161–2*n*, 226, 227, 266,
 267; and Dada, 366, 367–8, 369,
 370–1, 372–3
Groys, Boris, 8, 62, 232, 237, **274–95**
Grützner, Eduard, 267
Guérin, Charles, 21
Guest, Eddie, 188
Guilbaut, Serge, 160

Habermas, Jürgen, 221, 254
Hamnett, Nina, 341, 348*n*
Hamsum, Knut, 42*n*
harmony: Kandinsky on, 108; and Neo-
 Plasticism, 150–2
Hart Crane, Harold, 190

Hartlaub, Gustav, 1, 9, **50–1**
Hausmann, Raoul, 5, 53–4, 367, 369, 372,
 376–7; photomontage, 161–2*n*, 207
Haviland, Frank, 355, 357
Heartfield, John, 162*n*, 207, 223, 227,
 366, 373; Bürger on, 233, 260
Heath, Stephen, 342
Heckel, Erich, 266, 324, 326
Hennings, Emmy, 375
Herbert, James, 4
hermeneutics and avant-garde, 263–4
Herzfelde, Wieland, 226
"high art," 213–14, 224–5
Hildebrand, Adolf, 89–90, 91*n*
historical avant-garde, 8, 219–29, 232–3
historical materialism, 218, 280, 281
Hitler, Adolf, 198, 202, 260; and art, 234,
 265–9, 270–1
Höch, Hannah, 161–2*n*, 372
Hodler, Ferdinand, 92*n*, 108, 326–7
Hofer, Carl, 266
Hofmann, Hans, 200*n*
Hollier, Denis, 384
Horkheimer, Max, 155
House of German Art, Munich, 234, *235*,
 265–9
Huelsenbeck, Richard, 5, 6, 33, 368, 369,
 373, 375
human figure: Matisse on, 22–3, 25
humoristes, 355
Huyghe, Rene, 316
Huysmans, Joris-Karl, 55–6, **69–70**
Huyssen, Andreas, 155, 158, 159, 160–1,
 218–29

icon art, 195, 276
Idea/ideist art, 56–7, 60, 73–8
Idealism, 74; Victorian idealist artist, 345*n*
"idealization," 125*n*
identity, 297–302; and artists, 338;
 masculinity as masquerade, 341–3
images: Breton on Surrealism, 46–8
imagination: appeal of art to, 14–15, 17
imitation: Greenberg on avant-garde, 190,
 191; imitation impulse, 83–4; *see also*
 reproduction of art
immutability of art, 62, 146–7

Impressionism, 132, 210; Aurier on, 72, 73; Kandinsky on, 98; Matisse on, 23; and Post-Impressionism, 16–17

Indépendants, 355–6

"inner necessity," 59–60, 107–9, 120–1, 123

Institute for Social Research, 161*n*, 163*n*

"institution art," 222

International Federation of Independent Revolutionary Art, 273

intuition: Malevich on, 138–40, 141–3

Isherwood, Christopher, 250

Italian primitives, 2–3, 15, 57, 117

Italy: Mussolini and avant-garde, 199; *see also* Futurism

Ivanov, Sergei, 283

Jackson, Mary, 342

Jacob, Max, 358

Jakobson, Roman, 211–12

Janco, Marcel, 6, 375

Jeanneret, Charles-Edouard, 67*n*

John, Augustus, 340–1, 342, 348*n*

John, Gwen, 341

"joujou," 397*n*

Joyce, James, 191, 343*n*, 345*n*, 361

Jung, C. G., 268, 371

Jung, Franz, 369–70

Jungen, die, 3

Kafka, Franz, 158

Kahlo, Frida, 236

Kahnweiler, Daniel-Henry, 356, 357, 358

Kandinsky, Wassily, 2, 54, 56, 58, *59*, 190, 266; on spiritual in art, 59–60, **93–127**

Kant, Immanuel, 158, 209, 222, 233

Keats, John, 200*n*

Kingsley, Mary, 384

Kirchner, Ernst Ludwig, 58, 266, 299; female nude, 322–3, 324, 326–7, 328, 329, 330, 333

kitsch, 159–60, 192–200, 201–3

Klages, Ludwig, 268

Klee, Paul, 45*n*, 54, 190, 266

Klimt, Gustav, 3, 326–7

Klinger, Max, 60

Kluge, Alexander, 221

Klutsis, Gustaf, 277

Klyun, I., 145

Kokoschka, Oskar, 266

Kondakoff, N., 126*n*

Kozloff, Max, 324

Kracauer, Siegfried, 156–7, **165–73**

Krafft-Ebing, Richard von, 386–7, 395

Kramár, Vincenc, 355

Krauss, Rosalind, 350

Kremlev, A. N., 124

Kris, Ernst, 338

Kristeva, Julia, 213

Kulbin, Nikolai I., 59, 124

Kuleshov, Lev, 206–7

Kunstblatt, Das, 9

künstlerroman, 337

Kunstwollen, 58

Kurella, Alfred, 283

Kurz, Otto, 338

"laboratory art," 204

Lacan, Jacques, 342

Land of the Free (film), 207

language: of colors, 102–17; and Dada, 6, 34

Lautréamont, Comte de, 47–8

Le Corbusier, 67*n*, 390

Léandre, Charles, 355

Lechmere, Kate, 346*n*

Lef, 160, 204–5, 226, 280–1, 282, 285, 288–9

Léger, Fernand, 63*n*, 352

Leica camera, 206

Leighten, Patricia, 350–1, 361, 362

Leiris, Michel, 383, 384, 393–4

Lenin, Vladimir Ilyich, 220, 290, 291

Leonardo da Vinci, 16, 26, 27

Lesebilder, 260

Level, André, 355, 356

Lewis, Wyndham, 250, 340, 341, 342, 343*n*, 344*n*

liberation *see* freedom

libraries and Futurism, 30, 31

"life-building/life creation," 278, 279

light and shade in Post-Impressionist art, 15

Limbour, Georges, 44
linear design, 15–16; geometric line, 88
Lipps, Theodor, 58, 80–1, 85, 88, 90
Lissitsky, El, 207, 226, 277
literature: artist-novel, 337; kitsch, 196;
 Modernism, 204, 250–1; pulp fiction,
 258; Socialist Realism, 282; on Tahiti,
 313; *see also* poetry
lithography, 175–6
Littérature, 8
logic: Breton on, 38
Lombroso, Cesare, 344*n*, 372
London, Kurt, 194
"lost inheritance," 2–3
Loti, Pierre, 313
Lotze, Rudolf Hermann, 91*n*
Luccione, Eugenie Lemoine, 342
Lukács, Georg, 221, 234
Lunacharsky, Anatoli, 225

Macdonald, Dwight, 194–5
MacLeish, Archibald, 207
madness: Breton on, 37–8; and fool in
 Dada, 366, 367, 369–72
Maeterlinck, Count Maurice, 123
male nudes, 326–8
Malevich, Kazimir, 54, 56, *61*, 277; *Black
 Square* and Socialist Realism, 62, 278,
 280–1, 284, 287, 292; Suprematism,
 59, 61–2, **130–45**, 278
Malkine, Georges, 44
Mallarmé, Stéphane, 56, 179, 190–1, 354
Man Ray, 45*n*, 301, 396
Manet, Édouard, 26, 210, 326
"Manet and the Post-Impressionists"
 (exhibition), 1–2
Manguin, Henri Charles, 323–4
manifestation of art, 256–7
Mann, Otto, 373
Mannheim, Karl, 245
Maori body, 311–13
Marc, Franz, 58, 66*n*, 266, 267, 268
Marcuse, Herbert, 225, 226, 233, 255–6
Marinetti, F. T., 186–7, 199, 248, 342; and
 Futurist Manifesto, 4–5, **28–32**;
 "variété" and Dada, 376
"marvellous": Breton on, 8, 40–1

Marx, Karl, 174–5, 199, 213, 220, 226,
 272, 279; and fetishism, 381, 385–6
Marxism: and avant-garde, 220, 236,
 248–9, 279; and culture, 221–3; and
 Soviet ideology, 284–5; and
 Surrealism, 8
Masaccio, 210
masculinity: domination in avant-garde art,
 298–9, 320–36; and modernism,
 299–300, 337–43
masquerade: masculinity as, 341–2
mass culture, 155–61; avant-garde and
 "hidden dialectic," 223–9; and
 Dadaism, 374; "kitsch," 159–60,
 192–200, 201–3; mechanical
 reproduction, 157–8, 174–87, 223–4;
 Modernism and work of art, 201–15,
 232; ornament *see* mass ornament;
 public reception, 181–2
mass ornament, 156–7, 162*n*, 165–8,
 171–3
Masson, André, 45*n*, 383
materialism, 82, 94, 213; and avant-garde
 in Russia, 280–1, 287–8; historical
 materialism, 218, 280, 281
mathematics as art, 88
Matisse, Henri, 2, 4, **21–7**, 45*n*, 56, 60,
 190; and female nude, 22–3, 325,
 328, 330; Fry on, 16; Kandinsky on,
 99
Mauclair, Camille, 353
Mauss, Marcel, 384
Mayakovsky, Vladimir, 204, 205, 211, 223,
 248, 250, 284
Mazdaznan, 55
Mead, Igor, 274–5
mechanical reproduction of art, 157–8,
 174–87, 223–4; *see also* kitsch
media and Dadaism, 301, 374–5, 376
Meier-Graefe, Julius, 1
Melville, Herman, 313
Menkov, M., 145
Mercereau, Alexandre, 352
Metaphysical Painting, 60
metropolis, 156
Metzinger, Jean, 63*n*
Meyerhold, Vsevolod Emillevich, 226

Michelangelo, 16, 133, 134
Miller, Christopher, 312
mime and Neo-Plasticism, 152
mind: Breton on, 39–40
Minimalism, 159
Mirbeau, Octave, 317, 387
Miró, Joán, 190, 329
Modernism, 158–9, 201–17; and
 masculinity, 299–300, 337–43;
 Williams on, 231, 232, 240, 241–3,
 246–7, 250–1; *see also* avant-garde;
 mass culture
Modersohn-Becker, Paula, 266, 325–6
Modigliani, Amedeo, 333
Moerenhout, Jacques Antoine, 315,
 316–17
Moholy-Nagy, Laszlo, 206
Mondrian, Piet, 54, 56, 62, **146–53**, 190
Monet, Claude, 23
montage, 156–7, 206–7; Bürger on,
 259–61; *see also papiers collés*;
 photomontage
Montfried, Daniel de, 305, 307
Montmartre, 349, 355, 356
Monument to the Third International
 (Tatlin), 6, 8, 35
Moréas, Jean, 354
Moreau, Gustave, 45*n*, 55–6, 69–70,
 322
Morice, Charles, 305, 319*n*
Morise, Max, 44, 48
Morris, William, 202, 203
movement: and avant-garde, 209–10;
 Kandinsky on spiritual in art, 95–8,
 109–12; Malevich on Futurism,
 137–8; Matisse on sculpture, 23; in
 Post-Impressionism, 16, 17
Mueller, Otto, 327
Mukarovsky, Jan, 201
Müller, Max, 386
Munch, Edvard, 307, 323
Münchner Illustrierte Presse, 216*n*
Munich: House of German Art, 234, *235*,
 265–9
Murger, Henri, 343*n*
museums: Futurist view of, 30, 31; and
 Socialist Realism, 276, 291

music and art, 13, 14; effect of color,
 100–19; as imitative art, 199–200*n*;
 Neo-Plasticism and harmony, 150–2
Mussolini, Benito, 198, 199, 269
mystery and creation, 128–9
mysticism, 55
mythologization, 168–9, 171, 172, 173; of
 Gauguin as primitive, 297–8, 304–18

naive art, 248
National Socialism *see* Nazism
nationalism in France, 351–2
naturalism, 73, 83; and art of savage, 131,
 133; in Russia, 283
nature: Kandinsky on, 117–21; savage art
 as repetition of, 131–40; and sexual
 difference, 326–7, 328
naturism, 354
Naville, Pierre, 44
Nazism, 157, 198–9, 249; and art, 234,
 235, 265–9, 270–1; neo-classicism,
 266, 267, 268, 275, 282; *see also*
 Hitler, Adolf
Nedoshivin, G., 286
negation of synthesis, 261, 264
negative empathy, 81
Negt, Oskar, 221
Nekrasov, Nikolai Alexeievich, 211
neo-avant-garde, 234, 257
neo-classicism in Nazi Germany, 266, 267,
 268, 275, 282
Neo-Impressionism, 98, 148
Neo-Plasticism, 62, 63, 146–53
neo-Symbolist poetry, 351, 354–5, 358
Nerval, Gérard de, 43–4
Neue Jugend, 366
"Neue Sachlichkeit, Die," 9, 50–1
Nevinson, C. R. W., 342–3, 348*n*
"New Art History," 297
New Man, 288, 292, 293
New Objectivity, 9, 50–1
New Plastic *see* Neo-Plasticism
New Right, 251
"new woman," 337
New Yorker, The, 193
Nietzsche, Friedrich, 5, 54, 60, 224, 241,
 247

nihilism, 247
"noble savage," 311
Nolde, Emil, 58, 266, 327
Noll, Marcel, 44
nonconformism and Surrealism, 49
"noncontemporaneity," 234
nonsynchronism, 234, 253
Nordau, Max, 344*n*
Novalis, 48*n*, 88
nude *see* female nude; male nudes

objectism/objectivism: and Cubism,
 141–2; and Futurism, 137, 138, 141
objectivity *see* "New Objectivity"
objects: Surrealist object, 388–93
occultism, 55
Old Masters, 19
Oppenheim, Meret, 393
orange, 114–15
ornament, 118, 121; mass ornament,
 156–7, 162*n*, 165–8, 171–3
Orpheus myth, 326–7
Orphism, 63*n*
Ortner, Sherry, 326
Orton, Fred, 307
Ozenfant, Amédée, 67*n*

painting: Aurier on, 76, 78; Benjamin on
 mass culture, 181–2, 184–5;
 Kandinsky on, 100–23; Modernist
 view of, 210, 211; Russian avant-
 garde's rejection of, 278–9, 290–1;
 and Soviet Realism, 281–4
papiers collés, 259, 260; political and
 ideological context, 300, 349–63
parade, 342–3
Paris: and avant-garde, 349, 351–9, 362;
 monuments and fetishism, 396
Paris Dada, 223, 225
Parrish, Maxfield, 194
Parsons, Elsie Clews, 345*n*
Partisan Review, 159, 160, 194, 236
Pascin, Jules, 324
patrons, 334, 356–8
Paul-Boncour, Joseph, 353
Peau de l'Ours, Le, 355, 356
Pechstein, Max, 266, 327

Péladan, "Sar," 4, 26, 27, 123
perception and mass culture, 158, 178,
 184–5
Péret, Benjamin, 44
Phalange, La, 354
phallus: in avant-garde, 330; and masculine
 identity, 342
phantom objects, 392–3
photography: as evidence, 180–1; and
 fetishism, 395–6; as mass medium,
 205–6; reproduction of art, 176, 177,
 179, 223–4
photo-journalism, 206
photomontage, 156–7, 206–7, 260, 277
physical training, 172
Picabia, Francis, 45*n*, 373
Picasso, Pablo, 2, 45*n*, 190, 331; collectors
 and patrons, 356–8; modes of
 production, 356–9; paintings of
 women, 324, 328–9, 330; *papiers
 collés*, 259, 260, 300, 349–51,
 359–63; Repin comparison, 159, 194,
 195, 197, 202
Picon, Gaëtan, 44
Piero della Francesca, 15
Pietz, William, 301, 382, 385, 387–8
Piscator, Erwin, 250
Pissaro, Camille, 308, 317, 318
Pittura Metafisica, 60
placards, 205
place, 298; Picasso in Paris, 349, 351–9,
 362
"planity," 278
plastic art: Constructivism, 35; Mondrian
 on, 147; *see also* Neo-Plasticism
Plato, 200*n*; cave allegory, 74
Poème et Drame, 353
"poems without words," 6
poetics, 201, 211–12
poetry: of avant-garde, 190–1; and music,
 199–200*n*; neo-Symbolist, 351,
 354–5, 358
Pointillism, 148
Poiret, Paul, 357
politics: and art, 212–15; and avant-garde,
 189–90, 197–9, 219–23, 231–95,
 331–2, 352–3; and film, 156, 162*n*;

and mass culture, 158, 160–1, 185–7;
 Nazism and art, 234, 265–9; and
 Picasso's *papiers collés*, 349–54,
 359–63; revolutionary art, 270–3;
 Socialist Realism and avant-garde,
 274–95; *see also* Communism; fascism;
 Nazism; Soviet Russia; totalitarianism
Pollock, Griselda, 298, 307, 308
Polynesia: Gauguin in, 310–18
Pont-Aven group, 56, 307–9
Pop art, 220, 221
popular culture *see* mass culture
Popular Fronts, 249, 250
portrait photography, 180
positive empathy, 81
Post-Impressionism, 1–3, 13–17
posters, 205
Pound, Ezra, 190, 340, 341
Pre-Raphaelites, 99, 243
pre-rational, 248–9
primitive culture: and abstraction, 58,
 85–90; and fetishism, 301, 381–6,
 391, 394; Gauguin as savage, 297–8,
 304–18; Malevich on art of the savage,
 131–40; and Modernism, 243, 248,
 343, 344*n*
"primitives, the" (C14/15 artists), 2–3,
 15, 57, 117
Primitives/primitivism (C19/20 artists),
 53, 94; Gauguin, 297–8, 305–18;
 Primitivism in 20th-Century Art
 exhibition, 298; virility and
 domination in avant-garde art, 328–9
printing, 175–6
"production art," 204, 253–4, 257
productivism, 225, 226, 279–80; *see also*
 Constructivism
prolecult, 225, 226
propaganda in Russia, 204–5, 281, 289
"psychic automatism," 8
psychoanalysis: and fetishism, 386–8, 394;
 and film, 182, 183; sublimation,
 271–2; and Surrealism, 236–7, 248;
 see also Freud
psychology and need for art, 84–91
Puget, Pierre, 23
pulp fiction, 258

Puni, Ivan, 145, 279
Punin, Nikolai, 289–90
puns: Picasso's *papiers collés*, 349, 360
Pushkin, Alexander, 211
Puvis de Chavannes, Pierre, 56, 78
Puy, Jean, 323–4

Raphael: Matisse on, 26–7
RAPKh, 283
RAPP, 282, 283
rationalism/rationalization: and capitalism,
 169–71; and mass culture, 156, 158,
 168–9, 171–2, 173; utilitarian reason,
 139; *Verfremdungseffekt*, 227
Raymond, Marcel, 354
Read, Herbert, 65*n*, 391
Realism, 60, 84, 121, 208–9; and ideist art,
 73–4; Malevich on, 132, 135, 143–5;
 and Socialist Realism, 237, 274–5,
 277–8, 282–4
reason *see* rationalism/rationalization
reception: Benjamin on architecture, 185;
 Bürger on avant-garde, 254, 257–8,
 262–3; of Dadaism, 263; of mass
 culture, 181–2
red, 102, 103, 113–14, 117, 118–19
Redon, Odilon, 56
religion and fetishism, 386
Renaissance art: Malevich on, 133, 134
Renoir, Pierre Auguste, 26
Repin, Ilya, 141, 283; Picasso comparison,
 159, 194, 195, 197, 202
reproduction of art, 157–8, 174–87,
 223–4; *see also* kitsch
Reverdy, Pierre, 46–7
revolutionary socialism, 247, 248–9,
 270–3
Revue Hébdomadaire, 26
Revue rouge, 353
rhythm: Kandinsky on, 109; and Neo-
 Plasticism, 150, 153; in Post-
 Impressionism, 14, 16, 17
rhythmic gymnastics, 173
Rice, Anne Estelle, 338, 346*n*
Riefenstahl, Leni, 162*n*
Riegl, Alois, 58, 82–3, 86–7, 88–9, 163*n*,
 178

Rilke, Rainer Maria, 158, 183, 190
Rimbaud, Arthur, 190, 367
ritual and art, 157–8, 179–80
Rivera, Diego, 236, **270–3**
Riviere, Joan, 341, 342
Rockwell, Norman, 195
Rodchenko, Alexander, 205, 226, 277, 278, 279–80
Rodin, Auguste, 26, 27
Röhm, Ernst, 269*n*
Roller, Alfred, 3
Roman art, 178
romanism, 354
Romanticism, 54, 63, 88, 91*n*, 200*n*, 243
Rosenberg, Alfred, 267
Rosenberg, Harold, 219
Rosenblum, Robert, 349–50, 361
Rossetti, Dante Gabriel, 98, 99
Rouault, Georges, 56
Royal Academy, 337, 338
Royère, Jean, 354
Rozanova, Olga, 145
Rubiner, Ludwig, 370
Rupf, Hermann, 355
Ruskin, John, 203
Russia *see* Soviet Russia
Russian Association of Proletarian Artists (RAPKh), 283
Russian Association of Proletarian Writers (RAPP), 282, 283
Russian Formalism, 201, 209–12, 213

sacral art, 253–4
Sacred Spring *see Ver Sacrum*
Saincère, Olivier, 356
Saint-Pol-Roux, Pierre-Paul, 40
Saint Simon, Henri de, 161, 219, 220
Salmon, André, 355, 358
Salomé myth, 322, 326–7
Salon d'Automne, 356
Saturday Evening Post, 188, 195
Saussure, Ferdinand de, 208
savage *see* primitive culture
Schiller, Friedrich von, 222, 233
Schilling, Erna, 299
Schmarsow, August, 84
Schmidt-Rottluff, Karl, 266

Schoenberg, Arnold, 158
Schopenhauer, Arthur, 54, 60, 87, 92*n*
Schorske, Carl E., 3
Schwitters, Kurt, 223
scientific organization of labor, 226
sculpture: "agonising quality of the cubic," 89–90; Matisse on, 23, 24; and Neo-Plasticism, 149
Secession movement, 3–4
Second International, 220
Segalen, Victor, 305, 312, 313
Segantini, Giovanni, 98, 99
self-alienation, 90–1
semiotics, 201, 213–15, 350; *see also* sign/ signification
Semper, Gottfried, 82–3
sensation: Benjamin on perception, 178; Matisse on, 22–3, 24, 25–6
Serner, Walter, 5, 372, 376
Seurat, Georges Pierre, 2, 45*n*
Sevost'ianov, E. I., 283
sexism in avant-garde art, 330–1
sexuality: and fetishism, 386–7, 388, 395; masculinity and modernism, 337–43; virility and domination in avant-garde art, 299–300, 320–35; *see also* erotic
Shahn, Ben, 204
Shchukin, Sergei, 357
Sheppard, Richard, 58, 66*n*
Shklovsky, Viktor, 210–11
shock techniques, 227–8, 262–3
Sickert, Walter, 341
sign/signification: Cubism, 208–9; "significant form," 2, 57; signs in ideist art, 74, 75; *see also* semiotics
Signac, Paul, 21, 25
Simenon, Georges, 193
Simmel, Georg, 156
simultaneity, 6, 351
Sisley, Alfred, 23
Sjeklocha, Paul, 274–5
social class: avant-garde and elite, 4, 191–2, 204; and culture, 200*n*, 214; and kitsch, 196–7; Williams on bourgeoisie, 243–7; of women in avant-garde bohemia, 333–4; *see also* bourgeoisie

social Darwinism, 338–9
social realism in American art, 203–4
socialism *see* Communism; Marxism;
 revolutionary socialism
Socialist Realism, 62, 207, 220, 222, 250;
 human subjects, 289–90; ideology of,
 276, 284–9, 291–3; and kitsch, 194;
 transition from avant-garde to, 8, 237,
 274–95
Société de le Peau de l'Ours, La, 355, 356
Society of Easel Painters (OST), 277, 282
Socrates, 279
solipism and Surrealism, 258
Solomon-Godeau, Abigail, 297–8,
 304–19
Solov'ev, Vladimir, 278
"soluble fish," 49
Sots Art movement, 277
"sound poems," 6
Soupault, Philippe, 8, 42–3, 44, 48, 49
Soviet Russia: avant-garde, 221, 225–8,
 235–6, 237, 249–50, 274–95; Breton
 on, 271, 272–3; Burgin on, 204–5;
 Formalism, 201, 209–12, 213; kitsch
 in, 194, 195, 197, 201–3; Socialist
 Realism, 207, 237, 274–95;
 technology cult, 225–7; *see also* Stalin,
 Joseph
Spencer, Herbert, 344*n*
Sphinx, 322
spiritual in art, 55–60; Kandinsky on,
 93–127
spiritual dread of space, 85–6
Stalin, Joseph, 215, 221, 235–6, 273; and
 kitsch, 198, 199, 202; and Socialist
 Realism, 286–8, 290, 291, 293; *see
 also* Soviet Russia
Stein, Gertrude, 325, 355, 357, 358
Stein, Leo, 355, 356, 357, 358
Steinbeck, John, 193
Steinberg, Leo, 164*n*
Steiner, Rudolf, 62
Steinlen, Théophile Alexandre, 355
Stevens, Wallace, 190
Stockholm Workers' Commune, 240, 241,
 243
Stolzing, Walter, 172

Stott, William, 207
Stramm, August, 183
Streicher, Julian, 269*n*
Strindberg, August, 240–1, 242, 247
Stuck, Franz von, 98
Studio, The, 343*n*
"stylization," 125*n*
subconscious: Malevich on, 138–40
subjectivity, 76, 79–80
sublation of art, 255, 258
sublimation, 271–2
suffragism, 339
supernaturalism, 43–4
"superstructure," 285, 289, 290, 292
Suprematism, 8, 59, 61–2, 132, 135–45,
 237, 278
Surikov, Vasilii, 283
Surrealism, 60, 200*n*; Breton's definition,
 44; Bürger on, 233, 258, 261–2; and
 fetishism, 301–2, 381–99; First
 Manifesto, 8, 36–49, 389; and Freud,
 8, 38–9, 42, 236–7, 248; and politics,
 248, 250; Second Manifesto, 8; and
 solipism, 258; Surrealist object,
 388–93
Swedenborg, Emanuel, 55, 57, 73
Symbolism, 5, 54, 60, 209, 308; Aurier's
 ideist art, 55–6, 71–8; masculine
 portrayal of women, 322; neo-
 Symbolist poetry, 351, 354–5, 358
syndicalism, 352–3
synthetism, 56, 63, 76, 308, 317

"taboo," 381–2
Taeuber-Arp, Sophie, 372
Tahiti: Gauguin in, 310–18
Taine, Hippolyte Adolphe, 37
Tatlin, Vladimir, 6, 8, **35**, 226, 278,
 279–80
technology, 155; aesthetics of, 285–6; and
 avant-garde, 223–9, 280–1;
 reproduction of art, 157–8, 174–87,
 223–4
Teha'amana (Gauguin's mistress), 315–16
Telingater, S., 207
Tendenzkunst, 207
theater and Neo-Plasticism, 152–3

Theosophy, 55, 59, 62
theurgy, 278
"thing in itself," 87, 88
Third International: Monument to, 6, 8, 35
"thought-writing," 42–3
Tibullus, Albius, 86
Tickner, Lisa, 5, 299–300, **337–48**
Tiller Girls, 156, 165–8, 171
time: philosophy of, 54–5
Titian: Matisse on, 26–7
Tocqueville, Alexis de, 202, 205, 214
Todorov, Tzvetan, 209
Tolstoy, Leo, 1
totalitarianism: and art, 271–2; and kitsch, 159, 160, 198–9, 202; *see also* fascism; Nazism; Soviet Russia
totemism, 384, 394
Toulouse-Lautrec, Henri de, 10*n*, 333
tradition: Benjamin on, 179; and Russian Formalism, 209
tragic plastic, 147, 148
transcendentalism, 4, 54, 60
Tretyakov, Sergei, 194, 226, 227–8
triangle, 95–6, 109, 125*n*
Triumph of the Will (film), 162*n*
Troost, Paul Ludwig, 238*n*
Trotsky, Leon, 160, 236–7, **270–3**
Tucholsky, Kurt, 250
Tugendkhol'd, Ia. A., 283, 289–90
Tzara, Tristan, 5, 6, 33, 258, 375

Uccello, Paolo, 45*n*
Uhde, Wilhelm, 355, 356, 358
Ungleichzeitigkeit, 234
Union of Austrian Artists, 18–20
Union of Soviet Artists, 288
United States *see* American art
universal: Mondrian on, 146, 147
Universal Exhibition (1889), 308, 313
"utilitarian" art, 277, 281
utilitarian reason, 139

Vaché, Jacques, 372, 377
Valadon, Suzanne, 326
Valéry, Paul, 56, 174, 176, 190–1, 257
Vallotton, Félix, 324

van Dongen, Kees, 299, 323, 333
Van Gogh, Vincent, 2, 56, 126*n*
vanguard painting *see* avant-garde
variété, 366, 376
Vasari, Giorgio, 210
Venus de Milo, 133, 134
Ver Sacrum editorial, 3–4, **18–20**
Vereinigung bildener Künstler Österreichs, 18–20
Verfremdungseffekt, 27–8
verism, 51
vermilion, 101
Vers et Prose, 354, 355
Vertov, Dziga, 206, 226
Viaud, Julien, 313
Vienna Genesis, 178
Vienna Secession, 3–4, 18–20, 232
violet, 114–15
virility: domination in avant-garde art, 298–9, 320–36; and masculine identity, 300, 341–3
Vischer, Friedrich, 91*n*
Vischer, Robert, 91*n*
Vitrac, Robert, 44, 48
Vlaminck, Maurice de, 2, 163*n*, 324, 327, 329, 333–4
volition, 58, 80; "artistic volition," 82–5
Volkelt, Johannes, 91*n*
Volkonsky, Prince S. M., 124
Vollard, Ambroise, 357
Voltaire, François Marie Arouet de, 366–7
Vorticism, 5, 250, 300

Wagner, Richard, 54, 268
Walden, Herwath, 54
Walton, William, 313
Wanderers, the, 142, 275, 276, 283, 291
war: Benjamin on, 186; and Futurism, 5; technology and art, 224–5; *see also* Balkan Wars; World War I
Ward, Martha, 56
Warnod, André, 355
Weber, Max, 156
Whistler, James Abbott McNeill, 340
white, 110, 112–13
Wickhoff, Franz, 178
Wilde, Oscar, 55, 126*n*

"will to form," 58
Will-Levaillant, Françoise, 350
Willette, Adolphe, 355
Williams, Raymond, 203, 231–2, **240–52**, 361
Wind, Edgar, 210
Wittkower, Rudolph and Margot, 344*n*
Wölfflin, Heinrich, 1, 91*n*, 162–3*n*
women: and art history, 298–9; as artists, 325–8, 337, 338, 339–40; and bohemian lifestyle, 332–4, 340–1; and culture, 326–7; in Gauguin's work, 309–10; Mondrian on tragic in art, 148; responses to female nude, 335; as threat in social Darwinism, 339; *see also* female nude
Women's International Art Club, 340
Woolf, Virginia, 342
Workers' Commune, Stockholm, 240, 241, 243

Works Progress Administration (WPA), 160, 203–4, 205, 207–8
"world cabaret," 301
World War I, 63, 224–5, 300
Worringer, Wilhelm, 57–9, 60, **79–92**
Wouters, Rik, 324
WPA, 160, 203–4, 205, 207–8
Wright, Almroth, 339

Yeats, W. B., 190, 191, 250
yellow, 101, 102, 110–12
Young, Andrew, 44

Zakharina-Unkovsksaia, A., 125*n*
zero of form, 130, 143
Zhdanov, Andrei Alexandrovich, 221
Ziegler, Adolf, 234
Zurich Dada, 223, 225, 300
Zweig, Stefan, 156

Series Editor: Dana Arnold

Showcasing an unprecedented set of canonical and critical works in art history, this series presents previously published classic and contemporary works across key topics. The **Blackwell Anthologies in Art History** series represents a complete reference devoted to the best that has been taught and written on a given subject or theme in art history.

Publishing in the Blackwell Anthologies in Art History series:

Architecture and Design in Europe and America, 1750-2000

Edited by ABIGAIL HARRISON MOORE & DOROTHY C. ROWE

2005 | 512 pages / 1-4051-1530-0 HB / 1-4051-1531-9 PB

Asian Art
An Anthology

Edited by REBECCA BROWN & DEBORAH HUTTON

2005 | 456 pages / 1-4051-2240-4 HB / 1-4051-2241-2 PB

Italian Art of the 15th Century

Edited by ROBERT MANIURA, GABRIELE NEHER & RUPERT SHEPHERD

2006 | 384 pages / 1-4051-1598-X HB / 1-4051-1599-8 PB

Late Antique, Medieval, and Mediterranean Art

Edited by EVA HOFFMAN

2006 | 384 pages / 1-4051-2071-1 HB / 1-4051-2072-X PB

Post-Impressionism to World War II

Edited by DEBBIE LEWER

2005 | 424 pages / 1-4051-1153-4 HB / 1-4051-1152-6 PB

Sixteenth-century Italian Art

Edited by MICHAEL COLE

2005 | 384 pages / 1-4051-0840-1 HB / 1-4051-0841-X PB

For full details on these volumes, including future books in the series, visit our website at **www.blackwellpublishing.com**